The
Life
of
Jeanne Guyon

by

Thomas C. Upham

The
Life
of
Jeanne Guyon

SeedSowers Publishing House
PO Box 3317
Jacksonville, FL 32206
800.228.2665

Reprinted in the U.S.A. by
SeedSowers Publishing House

1984

EDITOR'S PREFACE.

IF few readers will agree with every sentiment recorded in these pages, yet it will not be too much to expect that every one should admire the fervent zeal, marked and steady consistency, as well as leading and striking ability of the subject of them. Madame Guyon must claim our sympathy in her sufferings, and if in any age it could be said that the world was not worthy of her, especially it would be so in that of Louis XIV. The few dazzling lights in that dark age serve to exhibit its dense darkness. A depraved Court, with intense profession of religion; a dissolute and extravagant nobility, with a beguiled and besotted populace; military glory sought abroad, while at home La Belle France saw the same soldiery striking their swords into the hearts of the freest and most faithful citizens, and thus staining every honour in the detestable butchery of the Dragonnades; dishonour at last drooping its withering blight over every promising field; every energy and every sin; every profession and every vice; such preachers as have perhaps since the apostles' days never been surpassed for impassioned vehemence and power of oratory, and yet crowds unrepentant, as if to show that man's heart cannot be softened but by the Holy Spirit's influences; narrowness and profusion; little-mindedness and vaulting ambition,—all these, amongst many others, were traits that marked the age in which lived, and preached, and suffered, and died Madame Guyon. To have done what she did, against all hindrances of malice, disappointment, and power, is enough to prove her to

have possessed ability of the highest order; and to have done these deeds as she did them, shows that the root of the matter was in her. The friend of Fénelon, like him she was persecuted for the truth's sake. Having really too much light for a disciple in the Roman Church, yet she had not strength to escape from it, and found her tomb in it. That Church can fairly claim no glory from Fénelon and Pascal, and Arnauld and Madame Guyon. These are enough to show us that great light may exist in great darkness, and great love in an atmosphere of internal chilliness. Louis XIV. and his abettors, Popes and Bishops, were more right in discerning the tendency of such views than those who held them. They were essentially antagonistic to Romanism, and must have developed more and more into division. So far as Fénelon and Madame Guyon diverged from received Romanism, they were Protestants, and as such, Louis XIV. and Bossuet condemned them. The only credit which the Church of Rome can claim from her Jansenist members, is that of having persecuted them. Madame Guyon was a martyr to their clear and quick-sighted hatred of the truth. And, if we mistake not, from the life before us, among many fruitful lessons, this may be learned, that while it is no slight toil to attain truth in such a system, yet it is possible; and therefore while the sound Protestant rejoices in his own privileges and clearer light, he will pray for such as are feeling after the truth, shackled by the trammels of corrupt authority. As God had a people in the dark days before our Reformation, for we are not severed from the early Church by an abyss of centuries, but are connected with them by the lines of essential truth, so now He may have and has a people working in chains and thraldom of mind, while the soul enlightened is free. With these remarks the Life of Madame Guyon, revised so as to leave its entirety uninjured, and may-be, more acceptably useful, is commended to the Christian reader. What she was in spite of great impediments, let every Christian strive to be with his great advantages.

PREFACE.

I HAD read the life and writings of Madame Guyon with interest, and I think with profit. The impression was similar to that made upon the minds of others, that her history and her opinions are too valuable to be lost. They make a portion, not only of ecclesiastical history, but of the history of the human mind. Under these circumstances, and in the hope of contributing something to the cause of truth and of vital religion, I have undertaken the present work.

In giving some account of Madame Guyon's life, I have made great use of her Autobiography. The origin of this remarkable work, entitled in French, in which language alone it has been printed in full, *La Vie de Madame de la Mothe Guyon, écrite par elle-même*, was this. After her return from Italy in 1686, La Combe, her spiritual Director, in accordance with the authority allowed him by his Church, an authority to which she readily submitted, required her to make a written record of her past life. This she did for the most part, when she was shut up, a year or two afterwards, in tne Convent of St. Marie in Paris. She proposed to make a selection of incidents; but La Combe, fearful that the delicacy of her feelings might prompt ner to multiply omissions, required her to write everything.

To this she at last consented, especially as she did not, and could not well suppose, that a Biography, written under such circumstances, would ever be given to the public.

To the information derived from her Autobiography, I have added numerous facts, derived from her other writings, and other sources. So that I speak with considerable confidence when I say, that the reader will find, in the following pages, a full account of the life and labours of this remarkable woman.

The latter portion of the work is occupied, in a considerable degree, with the acquaintance which was formed in the latter part of her life between Madame Guyon and Fénelon, Archbishop of Cambray ; with the influence which was exerted by her over that truly distinguished man ; with the religious opinions which were formed and promulgated under that influence, and with the painful results which he experienced in consequence. The discussions in this part of the work turn chiefly upon the doctrine of pure or unselfish love, in the experience of which Fénelon thought, in accordance with the views of Madame Guyon, and it seems to me with a good deal of reason, that the sanctification of the heart essentially consists. It is true, that they insist strongly upon the subjection of the will ; but they maintain, as they very well may maintain, that such a love will certainly carry the will with it.

The work is committed to the reader, not without a sense of its imperfections, but still in the hopes that something has been done to illustrate character, and to confirm the truth.

THOMAS C. UPHAM.

TABLE
OF
CONTENTS

CONTENTS.

LIFE AND RELIGIOUS EXPERIENCE

OF

MADAME GUYON.

CHAPTER I.

Time and place of her birth—Her parentage—Sickness in her infancy—Her residence at the Ursuline Seminary at Montargis—Duchess Montbason—Residence at the Benedictine Seminary—A dream—Early religious impressions—Singular experiment on the strength of her faith—Unfavourable results—Taken home—Treatment received there.

Jeanne Marie Guyon was born the 13th of April 1648, and baptized on the 24th of May. Her father's name was Claude Bouvières de la Mothe. The place of her birth was Montargis, a French town of some note, situated about fifty miles to the south of Paris, in the part of France known previously to the French Revolution as the province of Orleanois.

Of her parents we know but little. They were very worthy people, holding a highly honourable position among the leading families of Montargis, and both of them, especially the father, were deeply impressed with religious sentiments. Her father bore the title of Seigneur or Lord de la Mothe Vergonville. Her father and mother had both been previously married ; and both had children previous to their second marriage. The father had a son and daughter ; the mother had a daughter. The subject of this Memoir, whose remarkable personal and religious history has made her an object of interest to succeeding ages, was the offspring of this second marriage. Her maiden name was Jeanne Marie Bouvières de la Mothe.

In very early infancy she was so afflicted, that her life was for

some time despaired of. To this period she refers in after life, with feelings which her religious experience was naturally calculated to inspire. Her life had its vicissitudes, its trials, its deep sorrows; but in view of the sanctification which had attended them, she was deeply thankful that God had been pleased to spare her. " It is owing," she says, " to thy goodness, O God, that there now remains to me the consolation of having sought and followed thee; of having laid myself upon the altar of sacrifice in the strength of pure love; of having laboured for thine interests and glory. In the commencement of my earthly existence, death and life seemed to combat together; but life proved victorious over death. Oh, might I but hope, that, in the conclusion of my being here on earth, life will be for ever victorious over death! Doubtless it will be so, if thou alone dost live in me, O my God, who art at present my only life, my only love."

In the city of Montargis, where her father resided, was a seminary for the instruction of young girls, under the care of the Ursuline Nuns, a sisterhood of religious persons, who bind themselves, in addition to other vows, to occupy themselves in the education of children of their own sex. At the age of two years and a half, she was placed at the Ursuline Seminary, but remained there only for a short time. When she was taken from it she remained for a time at the residence of her parents; but for some reason not clearly understood, but probably in part from an imperfect view of the value of parental influence, was left by her mother chiefly in the care of the domestics of the family. In after life she refers to this period as one in which her mental and moral culture, such as she was even then capable of receiving, was not properly attended to. She speaks of it also as a period in which she incurred, in repeated instances, those dangers, from which she sometimes narrowly escaped, which are incidental to the sports and to the thoughtless and venturesome spirit of childhood. But God, who had designs of mercy for her soul, and through her instrumentality for the souls of others, protected her.

In the year 1652, a lady of distinguished rank, the Duchess of Montbason, came to reside with the Benedictines, another religious body established at Montargis. The daughter of M. De la Mothe was then four years of age. At the solicitation of the Duchess, an intimate friend of her father, who said it would be a source of great satisfaction to her to have the company of his little daughter, she was placed with the Benedictines. " Here I saw," she says, in the account of her life which she afterwards wrote, " none but good examples; and as I was naturally disposed to yield to the influence of such examples, I followed them when I found nobody to turn me in another direction. Young as I was, I loved to hear of God, to be at church, and to be dressed in the habit of a little nun."

While resident here, though early in life, she appears to have been the subject of some religious impressions. She speaks in particular of a dream, in which she seemed to have a very distinct conception of the ultimate misery of impenitent sinners, as making a deep impression on her mind. Aroused by the images of terror, and operated upon by other circumstances calculated to awaken her religious sensibilities, she became very thoughtful, and exhibited a considerable interest in religious things. She was too young to appreciate fully the relation existing between herself and the Deity; but the idea of God was so far developed to her opening but vigorous conceptions, that she inwardly and deeply recognised His claims to her homage and her love. She endeavoured to conform to these convictions, not only by doing whatever seemed to be the will of God, but by openly and frankly expressing her determination to lead a religious life. Happy in these solemn views and determinations, she one day, with a frankness perhaps greater than her prudence, remarked in the presence of her associates, that she was ready to become a martyr for God. The girls who resided with her at the Benedictines, not altogether pleased that one so young should go so far before them in a course so honourable, and supposing perhaps that they discovered some ingredients of human pride mingling with religious sincerity, came to the conclusion to test

such enlarged pretensions. They persuaded her that God in His providences had suddenly but really called her to the endurance of that martyrdom for which she had exhibited and professed a mind so fully prepared. They found her true to what she had previously professed. And having permitted her to offer up her private supplications, they conducted her to a room selected for the purpose, with all those circumstances of deliberateness and solemnity, which were appropriate to so marked an occasion. They spread a cloth upon the floor, upon which she was required to kneel, and which was destined to receive her blood. One of the older girls then appeared in the character of an executioner, and lifted a large cutlass, with the apparent intention of separating her head from her body. At this critical moment, overcome by her fears, which were stronger than her young faith, she cried out, *that she was not at liberty to die without the consent of her father*. The girls, in the spirit of triumph, declared that it was a mere excuse to escape what was prepared for her. And assuring her that God would not accept as a martyr one who had not a martyr's spirit, they insultingly let her go.

This transaction, so cruel in its application, although it probably originated in thoughtlessness more than unkindness, had a marked effect upon her mind. Young as she was, she was old enough to perceive, that she had not only been open but voluntary in her professions; that she had been tried, and been found wanting. Those religious consolations, which she had previously experienced, departed. Something in her conscience reproached her, that she either wanted courage or faith, to act and to suffer, under all circumstances and without any reserve, in the cause of her heavenly Father. It seemed to her, in the agitation of her spirit, that she had offended Him, and that there was now but little hope of His support and favour. Thus, as in many other similar cases, the religious tendency, unkindly crushed in the very bud of its promise, withered and died.

During her residence at the House of the Benedictines, she was treated with great kindness. In one instance only was she the subject of punishment, and this in consequence of the mis-

apprehension, or the designed misstatement of her young asso-
ciates. Her health, however, was exceedingly delicate; and
soon after she was taken home in consequence. She complains
that she was again left almost exclusively in the care of domes-
tics; and consequently did not meet with that attention to her
morals and manners, which was desirable. Certain it is, as a
general statement, that domestics cannot discharge, in behalf of
young children, all those duties which may reasonably and justly
be expected of parents. It might be unjust, however, even where
appearances are unfavourable, to ascribe to parents intentional
neglect, without a full knowledge of all the circumstances.

CHAPTER II.

Placed a second time at the Ursuline Seminary—Character and kindness of her paternal
half-sister—Interview with Henrietta Maria, the Queen of England, at her father's house
Explanations of this interview—References to her moral and religious feelings—Trans-
ferred from the care of the Ursulines to that of the Dominicans—A Bible left in her
room—Her study of it—Proposes to partake of the Eucharist—Remarks.

EACH of her parents had a daughter in their first marriage.
These, acting on the principles of personal consecration recog-
nised in the Roman Catholic Church, had devoted themselves to
a religious life in the Ursuline Convent, and thus became asso-
ciated in its system of instruction. After spending some time
at home in a manner not very profitable, Mademoiselle Jeanne
Marie was once more placed at the Ursulines with them. She
was now in the seventh year of her age. The father, sensible
that her education had hitherto failed to receive sufficient atten-
tion, commended her to the especial care of his own daughter,
as the best qualified of the two half-sisters, by kindness of dispo-
sition as well as in other respects, to aid in the development of
her mind and formation of her manners. As she recalled with
gratitude the dealings of God with her in her younger years,
she spoke in affectionate terms of this sister, as a person cha-

racterized alike by good judgment and religious sentiments, and especially fitted to train up young girls.

" This good sister," she says, " employed her time in instructing me in piety, and in such branches of learning as were suitable to my age and capacity. She was possessed of good talents, which she improved well. She spent much time in prayer, and her faith seemed strong and pure. She denied herself every other satisfaction, in order that she might be with me and give me instruction. So great was her affection for me, that she experienced, as she told me herself, more pleasure with me, than anywhere else. Certain it is, that she thought herself well paid for her efforts, whenever I made suitable answers. Under her care I soon became mistress of most of those things which were suitable for me."

At this period an incident occurred, which requires some explanation. The period of which we are now speaking was subsequent to the great Civil War in England, which resulted in the death of Charles I., the establishment of a new government, and the expulsion of the royal family. Charles had married Henrietta Maria, the daughter of Henry IV., and sister of Louis XIII. of France. She fled from England to her own country in 1644 ; residing for the most part, in sorrow and poverty, in the Convent of Chaillot, at that time a village in the neighbourhood of Paris, but now a part of the city itself. She died in 1669 ; and her death furnished occasion for one of the most celebrated of the funeral orations of Bossuet.

Some years after her flight she visited Montargis ; and as the family of M. De la Mothe held a high rank in that city, and especially as there were probably some common grounds of religious sympathy, it will not be surprising that Henrietta Maria should have honoured them with a visit. While she was at the Seminary of the Ursulines, she was frequently sent for by her father. On one of these occasions she found at her father's house the *Queen of England*. She was then near eight years of age. " My father told the Queen's Confessor, that, if he wanted a little amusement, he might entertain himself with me. and

propound some questions to me. He tried me with several very
difficult ones, to which I returned such correct answers, that he
carried me to the Queen, and said to her, ' Your Majesty must
have some diversion with this child.' She also tried me, and
was so well satisfied and pleased with my lively answers and
my manners, that she not only requested my father to place me
with her, but urged her proposition with no small importunity,
assuring him that she would take particular care of me, and
going so far as to intimate, that she would make me Maid of
Honour to the princess, her daughter. Her desire for me was
so great, that the refusal of my father evidently disobliged her.
Doubtless it was God who caused this refusal, and in doing so
turned off the stroke which might have probably intercepted my
salvation. Weak as I then was, how could I have withstood
the temptations and distractions incidental to a connexion with
persons so high in rank ?"

Her paternal half-sister continued her affectionate care, but
her authority was limited ; she could not control, in all respects,
the other girls who boarded there, with whom the younger
sister, Jeanne Marie, was sometimes obliged to associate, and
from whom she acknowledges that she contracted some bad
habits. She ceased to be entirely strict and scrupulous as to
the truth ; she became in some degree peevish in her temper,
and careless and undevout in her religious feelings, passing
whole days without thinking of God. But happily she did not
remain long under the power of such vicious tendencies and
habits. Her sister's unwearied watchfulness and assiduity were
the means, with the Divine blessing, of recovering her from this
temporary declension. And she remained at the Seminary some
time longer, always making rapid improvement when in the
enjoyment of good health, and conciliating the esteem of her
associates and instructors, by her regular and virtuous deport-
ment, and by proficiency in knowledge.

At ten years of age she was taken home again; she was
placed at the Dominican convent, probably the same of which
De la Force gives so particular an account in his work. entitled

Nouvelle Description de la France. It was founded in 1242. " I stayed," she says, " only a little while at home. The reason was this : A nun of the Dominican Order, who belonged to a distinguished family, and an intimate friend of my father, solicited him to place me in her convent, of which she was Prioress. This lady had conceived a great affection for me ; and promised my father that she would take care of me herself, and make me lodge in her own chamber. But various troubles arose in the religious community which necessarily occupied her attention, so that she was not in a situation to take much care of me."

Her opportunities for intellectual improvement, during her residence in the Dominican convent, were interrupted in some degree by sickness ; but with a mind of naturally enlarged capacity, which seemed to have an instinct for knowledge, she could hardly fail to improve. At this place she was left more by herself than had been customary with her. But her solitary hours were not unprofitable ones. One circumstance is worthy of particular notice. The pupils of the convent, although they received religious instruction in other ways, do not appear to have been in possession of the Bible, and to have nad the use of it in private. A Bible, however, had been providentially left, by whose instrumentality, or from what motive, is unknown, in the chamber which was assigned to Mademoiselle De la Mothe. Young as she was, she seems to have had a heart to appreciate, in some degree, the value of this heaven-sent gift. *" I spent whole days,"* she says, *" in reading it, giving no attention to other books or other subjects from morning to night, and having great powers of recollection, I committed to memory the historical parts entirely."* It is highly probable that these solitary perusals of the Bible had an influence on her mind through life, not only in enlarging its sphere of thought and activity, but by teaching her to look to God alone for direction, and by laying deep and broad the foundations of that piety which she subsequently experienced.

She remained at this convent eight months. When she entered upon the twelfth year of her age, she proposed to partake

of the sacrament of the Eucharist. For some time previous she
had been remiss in religious duties. Some jealousies and dis-
affections, as is not unfrequently the case, had sprung up among
the younger members of her father's family. A feeling of dis-
satisfaction and melancholy seems to have entered her mind;
and, as if weary of God, she gave up what little religious in-
clination and feeling she had, saying, "she was none the better
for it," and wickedly implying in the remark, that the troubles
connected with religion exceeded the benefits resulting from it.
It would not be correct to say that she had given up religion,
but rather many favourable feelings and outward practices
connected with religion. Although she had been interested in
religion, it does not appear that she possessed those qualities
which really constitute it. Prompted, partly by example, and
partly by serious impressions, she had sought it, but had not
found it. Her religious interest varied at different times. At
one time, in particular, it seems to have been very great. She
seems to have had convictions of sin, some desires to live in
God's guidance and favour; she formed good resolutions; she
had a degree of inward consolation. But when we examine
these experiences closely, we shall find that such desires, con-
victions, and resolutions, which often lay near the surface of the
mind without stirring very much its inward depths, were, in her
case at least, the incidents and preparatives of religion, rather
than religion itself. The great inward Teacher, the Holy Ghost.
had not as yet subdued the natural life, and given a new life in
Christ. She herself intimates, that her religion was chiefly
in appearance, and that self, and not the love of God, was at
the bottom.

The suggestion to partake of the sacrament of the Supper,
and thus by an outward act at least, to array herself more dis-
tinctly on the Lord's side, seems to have originated with her
father. In order to bring about what he had near at heart, he
placed her again at the Ursuline Seminary. Her paternal half-
sister, who appears to have had some increased and leading
responsibility as an instructress, pleased with the suggestion,

but at the same time aware of her unfortunate state of mind, laboured assiduously to give rise to better inward dispositions. The labours of this patient and affectionate sister, who knew what it was both to believe and to pray, and for whom religion seems to have had a charm above everything else, were so effectual, that Jeanne Marie now thought, as she expresses it, " *of giving herself to God in good earnest.*" The day at length arrived ; she felt that the occasion was too important to be trifled with ; she made an outward confession of her sins, with apparent sincerity and devoutness, and partook of the sacramental element for the first time with a considerable degree of satisfaction. But the result showed that the heart was not reached. The season and its solemnity passed away, without leaving an effectual impression. The sleeping passions were again awaked. " My faults and failings," she says, " were soon repeated, and drew me off from the care and the duties of religion." She grew tall ; her features began to develop themselves into that beauty which afterwards distinguished her. Her mother, pleased with her appearance, indulged her in dress. The combined power of her personal and mental attractions were felt in the young and unreflecting attachments of persons of the other sex. The world resumed its influence, and Christ was in a great degree forgotten.

Such are the changes which often take place in the early history of religious experience. To-day there are serious thoughts, awakened and quickened feelings, and good resolutions ; everything wears a propitious aspect. To-morrow, purposes are abandoned, feelings vanish ; and the reality of the world takes the place of the anticipations of religion. To-day the hearts of mothers and sisters, and of other friends, who have laboured long and prayed earnestly for the salvation of those who are dear to them, are cheered and gladdened. To-morrow they find the solicitations to pleasure prevailing over the exhortations to virtue ; and those who had been serious and humble for a time, returning again to the world. But often these alternations of feeling, which it is not easy always to explain, have an

important connexion, under the administration of a higher and Divine providence, with the most favourable results.

They may, in many cases, be regarded as constituting a necessary part of that inward training, which the soul must pass through, before it reaches the position of true submission and of permanent love. They show us the great strength of that attachment which binds us to attractions which perish, the things of time and sense. They leave a deep impression of the forbearance and long-suffering of God. They teach the necessity of the special and powerful operations of Divine grace, without which the heart, naturally alienated from all attachment to the true object of its love, would perish in its worldly idolatry.

CHAPTER III.

ABOUT this time the Roman Catholic Church of France, desirous to spread abroad the Christian religion, was enlarging its missions in the East. Among the individuals who engaged in this benevolent work, was a nephew of M. De la Mothe. His name was De Toissi, of whom some account is given in the History of Foreign Missions, *Relation des Missions Etrangères*, under the name of De Chamesson. This young man, with one of the French bishops, the titular bishop of Heliopolis, had commenced his journey to the place of his labours in Cochin China; and in passing through Montargis, had called at the residence of his uncle. His visit was short; but as he was about to leave his native land perhaps for ever, and on business too that was infinitely dear to humanity and religion, it was full of interest. He was one of those who could say in the sweet language of

the subject of this Memoir, when in after life she suffered in prison and in exile,

> " My country, Lord, art thou alone ;
> No other can I claim or own;
> The point, where all my wishes meet,—
> My Law, my Love, life's only sweet."

" I happened," she says, " at that time to be gone walking with my companions, which I seldom did. At my return he was gone. They gave me an account of his sanctity, and of the things he had said. I was so touched with it, that I was overcome with sorrow. I cried all the rest of the day and of the night."

This was one of those incidents in the Providence of God, which come home to the heart. How often has the mere sight of a truly pious man brought the hardened sinner under conviction ! How often have those who have been unmoved by the most eloquent religious appeals, been deeply affected by the most simple and unpretending words, when uttered under circumstances favourable to such a result. When she heard the statement of the deep and devoted piety of her cousin De Toissi, her thoughts, from contrast rather than resemblance, naturally reverted to herself. She remembered how often God had called her ; and how often she had listened without obeying, or had obeyed without persevering. "What !" she exclaimed to her confessor and religious teacher, " am I the only person in our family to be lost ! Alas ! help me in my salvation." Her whole soul was roused to a sense of her situation. She recalled with deep compunction her repeated seasons of seriousness and religious inquiry, and of subsequent declension. " Alas !" she exclaimed, " what grief I now sustained for having displeased God ! What regrets ! What exclamations ! What tears of sorrow !" Once more she applied herself to her soul's salvation, apparently with great sincerity and earnestness ; but without being able to find the simple way of acceptance by *faith*. She resisted her passions, which were liable to be strongly moved, with considerable success. She asked the forgiveness of those

whom she had displeased. Appreciating, in some degree, the relation between religion and practical benevolence, she visited the poor, gave them food and clothing, and taught them the catechism. She spent much time in private reading and praying. She purchased and read some of the practical and devotional books which were most highly valued among her people, such as the Life of Madame de Chantal and the works of St. Francis de Sales. She inscribed the name of the Saviour in large characters upon a piece of paper ; and so attached it to her person as to be continually reminded of Him. With an erroneous notion of expiating sin by her own suffering, she subjected herself to various bodily austerities. Determining to leave nothing undone, she made a vow, in imitation of Madame de Chantal, of ever aiming at the highest perfection, and of doing the will of God in everything. This was an important resolution, which would have been followed by the happiest consequences, if it had not been made in her own strength, and in ignorance of the great renovating principle, that all true strength is derived from God through Christ by *faith*. Among other things, she came to the resolution, if Providence should permit, to enter a convent, and in the apparent hopelessness of aid from any other source, to secure her spiritual interests and her salvation by becoming a nun. This part of her plan, which showed the depth of her feeling, was frustrated by her father, who was tenderly attached to her, and, while he was earnestly desirous that his daughter might become truly religious, believed that she might possess religion without separating from her family, and without an entire seclusion from the world.

The Lord of Life, no doubt, beheld and sympathized in the anxiety which she felt, and in the efforts she made. God is not indifferent to those who *strive* to enter in. He numbers all their tears ; He registers all their resolves. How can it be otherwise? If the state of mind be that of true striving after God, He himself has inspired it. He sometimes permits those whom He determines eventually to bless, to strive long, and perhaps to wander in erroneous ways. But they will ultimately understand

much better than they otherwise would have done, the direction and the issue of the true path. They have a lesson to learn which cannot well be dispensed with; and God therefore is willing that they should learn it. What that lesson is, it is not always easy to say, in individual cases. Perhaps the remains of self-confidence exist within them, which can be removed only by the experience of the sorrows which are attendant upon the errors it invariably commits. And accordingly God leaves them to test the value of human wisdom. They try it; they fall into mistakes; they are overwhelmed with confusion; and then, and not till then, they see the necessity of reposing all their confidence in Him who alone can guide them in safety.

Mademoiselle De la Mothe continued in this state of mind about a year. What led to the termination of religious prospects so flattering, it is difficult to state. There is some reason for thinking, however, that the love of God, not far from this time, began to be disturbed by the accession and influence of a love which was more mixed and earthly in its origin. She relates that her father with his family left the city of Montargis, in order to spend some days in the country; and that he took with him a very accomplished young gentleman—a near relation. This young man, of whom she speaks in high terms for his religious sentiments, as well as his intellectual and other accomplishments, became much attached to her. She was still only in her fourteenth year. This individual, notwithstanding her immature age, made propositions of marriage. And this, after a suitable time, would probably have been the result, with the cordial consent of all parties, but their relationship was so near as to bring them within the degrees of consanguinity prohibited in the Roman Catholic Church. This obstacle could have been removed by a dispensation from the Papal See; but still it was so serious that her father did not think it proper to give his consent. Still they were mutually pleased, and spent much time in each other's company. At this time she says, significantly and penitently, that she " began to seek in the creature what she had previously found in God."

She says, " I left off prayer. I became as a vineyard exposed to pillage, whose hedges, torn down, gave liberty to all the creatures to ravage it. *I began to seek in the creature what I had found in God.* And thou, O my God! didst leave me to myself, *because I left thee first,* and wast pleased, in permitting me to sink into the horrible pit, to make me see and feel the necessity of maintaining a state of continual watchfulness and communion with thyself. Thou hast taught thy people, that thou wilt destroy those who, by indulging wrongly-placed affections, depart from thee. (Ps. lxxiii. 27.) Alas! their departure alone causes their destruction; since in departing from thee, the Sun of Righteousness, they enter into the region of darkness and the shadow of death. And there, bereft of all true strength, they will remain. It is not possible that they should ever rise again, unless thou shalt revisit them; unless thou shalt restore them to light and life, by illuminating their darkness, and by melting their icy hearts. Thou didst leave me to myself, because I left thee first. But such was thy goodness, that it seemed to me, that thou *didst leave me with regret.*"

" I readily gave way," she says, " to sallies of passion. I failed in being strictly conscientious and careful in the utterance of the truth. I became not only vain, but corrupt in heart. Although I kept up some outward religious appearances, religion itself, as a matter of inward experience, had become to me a matter of indifference. I spent much time, both day and night, in reading romances, those strange inventions to destroy youth. I was proud of my personal appearance, so much so, that, contrary to my former practices, I began to pass a good deal of my time before the mirror. I found so much pleasure in viewing myself in it, that I thought others were in the right, who practised the same. Instead of making use of this exterior, which God gave me as a means of loving Him more, it became to me the unhappy source of a vain and sinful self-complacency. All seemed to me to look beautiful in my person; but, in my declension and darkness, I did not then perceive that the outward beauty covered *a sinful and fallen soul.*"

But this was not the judgment then passed upon her by the world,—so severe in the exaction of its own claims, but so indulgent in mitigating the claims of God. Under a form outwardly beautiful, and veiled by manners that had received the most correct and advantageous culture, it was not easy for man to perceive the elements and workings of a heart which harboured moral and religious rebellion. In the eye of the world, incapable of penetrating beyond the exterior, which delights in elegance of form and perfection of manners, there was but little to blame, and much to praise ; but in the eye of God it was not possible for outward beauty to furnish a compensation for inward deformity. And in using the phrase inward deformity, we do not mean that she was worse than many others who have a reputation for good morals. Estimating her by the world's standard, she had her good qualities as well as those of an opposite character—her excellences as well as her defects. Nevertheless, there was that wanting which constitutes the soul's true light—without which all other beauty fades, and all other excellence is but excellence in name—*the love of God in the heart.*

CHAPTER IV.

Removal from Montargis to Paris—Louis XIV.—Characteristics of the age—Effect of her removal to Paris upon her character—Her personal appearance at this period—Offers of marriage—Is married to M. Guyon in March 1664—Notices of the family of M. Guyon.

In the year 1663, M. De la Mothe removed his family to Paris,—a step obviously not calculated to benefit his daughter in a religious sense. Paris was at that time, as now, the centre of scientific culture and the arts, of refinement of manners and of fashionable gaiety. Louis XIV. was then the reigning sovereign of France—a man of considerable powers of intellect, and of great energy of will—in whom two leading desires predominated—the one to make France great, the other to make himself the source and centre of her greatness. The greatness of France.

sustained and illustrated in the wisdom and splendour of her great monarch, was the central and powerful element of his system of action. Hence the expense and labour bestowed upon the royal palaces, and all the great public works of a national character ; hence his vast efforts to enrich and beautify Versailles, his principal residence ; hence his desire to attach to his person and court the most distinguished of his nobles. His munificence to men of literature, his patronage of the arts, the pomp and ceremony which characterized all great public occasions, all sprung from the same source.*

All France, and particularly Paris, felt an influence so well adapted to harmonize with the tendencies of the human heart. It was an age characterized by many noble efforts in literature and the arts, and equally by unfounded pretensions, vanity, and voluptuousness. Almost everything, especially in the capital, was calculated to dispossess humility, and to impart an exaggerated turn of mind. The sights and sounds, the displays of wealth, in every street; the crowded populace, intoxicated with the celebrity of their sovereign and of their nation ; the vulgar and the fashionable amusements without end ; all were calculated to divert the mind from serious reflection—to lead it to sympathize with the senses, and to dissociate it from its own inward centre ; a state of things which would have been a severe trial even to established piety.

This state of things had an unfavourable effect upon Mademoiselle De la Mothe ; and she intimates, in the record of her feelings, that she began to entertain exaggerated ideas of herself, and that her *vanity increased.* Her parents, as well as herself, led astray by the new state of society in which they found themselves, spared no cost in obtaining whatever might make her appear to advantage. The world, illuminated with false lights to her young vision, seemed to be in reality what it was chiefly in appearance, and consequently presented itself as an object worth conquering and possessing. At this period she gave to it, more warmly and unreservedly than at any other, that kindling

* Thirty-six thousand labourers were employed at Versailles at one time

heart and expanded intellect, which she afterwards gave to reli-
gion. She was tall and well-made in her person; refined and
prepossessing in her manners, and possessed of remarkable
powers of conversation. Her countenance, formed upon the
Grecian model, and characterized by a brilliant eye and expan-
sive forehead, had in it a natural majesty, which impressed the
beholder with a sentiment of deep respect, while it attracted by
its sweetness. Her great powers of mind (a mind which in the
language of one of the writers of the French Encyclopédie was
formed for the world, *"fait pour le monde"*) added to the im-
pression which she made on her entrance into Parisian society.

Under these circumstances her future husband, M. Jacques
Guyon, a man of great wealth, sought her in marriage. He
was not the only person whose attention was directed to her.
" Several apparently advantageous offers of marriage," she says,
" were made for me; but God, *unwilling to have me lost,* did
not permit them to succeed." In accordance with the custom
of the time and country, (a custom oftentimes but little pro-
pitious to those who are most deeply concerned,) the arrange-
ments in this important business were made by her father and
her suitor with but little regard to her opinions and feelings
She did not see her designated husband till a few days before
her marriage; and then she did not find her affections united to
him. She gives us distinctly to understand in her Autobio-
graphy, that there were other individuals who sought her, with
whom she could have more fully sympathized, and could have
been more happy. But a regard for the opinions of her father,
in whom she had the greatest confidence, (although in this case
he seems to have been influenced too much by the great wealth
of M. Guyon,) overruled every other consideration. She signed
the articles of marriage, without being permitted to know what
they were, on the 28th of January 1664, but was not married
till the 21st of March. She had then nearly completed her six-
teenth year. Her husband was thirty-eight.

Of the family of her husband we know but little. His father,
a man of activity and talent, acquired considerable celebrity by

completing the Canal of Briare, which connects the Loire with the Seine. This great work (the more remarkable for being the first important one of the kind undertaken in France) was commenced in the reign of Henry IV., under the auspices of his distinguished minister, the Duke of Sully. After the death of Henry, and the retirement of Sully from the administration of affairs, the work was suspended till 1638, when Louis XIII. made arrangements, on liberal terms, with two individuals, Messrs. Jacques Guyon and another individual named Bouteroue, to complete it. Guyon, entirely successful in an undertaking beset with difficulties, was not only brought into public notice, but became very wealthy. He was also rewarded with a patent of nobility at the hands of Cardinal Richelieu, the then leading minister. His wealth, as well as an honourable and noble position in society, seems to have been inherited by his only son, to whom Mademoiselle De la Mothe was thus united in marriage.

CHAPTER V.

Remarks on her marriage—Treatment she experienced at her husband's house—Unkindness of her mother-in-law—The great incompatibleness of her situation and her character— Her situation considered in its relation to the designs of Providence—Her account of the trials she endured.

In this union, great wealth and noble rank did not compensate for diversity of disposition and great disparity of age. It could hardly be expected that Madame Guyon, with all her advantages of beauty, talent, and honourable position in society, could be entirely satisfied, at sixteen years of age, with a husband twenty-two years older than herself, whom she had seen but three days before her marriage, who had obtained her through the principle of filial obedience, rather than through warm and voluntary affection.

" No sooner," she says, " was I at the house of my husband than I perceived it would be for me *a house of mourning.* In

my father's house every attention had been paid to my manners. In order to cultivate propriety of speech and command of language, I had been encouraged to speak freely on the various questions which were started in our family circle. There everything was characterized by elegance. But in the house of my husband, his mother, who had long been a widow, regarded nothing else but saving. The elegance of my father's house, which I regarded as the result of polite dispositions, they sneered at as pride. In my father's house whatever I said was listened to with attention, and often with applause; but here, if I had occasion to speak, I was listened to only to be contradicted and reproved. If I spoke well, they said I was endeavouring to give them a lesson in good speaking. If I uttered my opinions on any subject of discussion, I was charged with desiring to enter into a dispute; and instead of being applauded, I was simply told to hold my tongue, and scolded from morning till night. I was very much surprised at this change, and the more so as the vain dreams of my youth anticipated an increase, rather than a diminution of the happiness and consideration which 1 had enjoyed."

She was placed by her marriage in a wrong position—a position untrue to the structure of her mind and unfavourable to her happiness. Nothing else could have been expected from an arrangement in which so little regard had been paid to the mutual relations of the parties, in respect to years, early habits, and mental qualities. When considerable unhappiness is experienced in married life, it naturally implies a very considerable diversity in the relative situation and in the character of the parties. But this is not always the case. Sometimes a little diversity in views and a little want of correspondence and sympathy in feelings, furnishing occasion for an irritation which is not great but constant, may be the means of very seriously imbittering life. The mind of Madame Guyon was not in harmony with her situation. Other persons, it is true, with less experience of past domestic happiness, and with less talent and refinement, might, perhaps, have reconciled themselves to the situation.

and have regarded it as in many respects a desirable one. Her husband was not without some good qualities. What his personal appearance was, we have no record. But it is obvious, that he secured a degree of respect in the circle in which he moved; and he had a degree of affection for his wife, which, under favourable circumstances, might have increased, and have rendered their union happy. But his good feelings were perverted by his physical infirmities and sufferings, and by the influence of his mother,—a woman without education, and apparently possessed of but little liberality of natural feeling,— who retained in old age, and in the season of her wealth, the habits of labour and of penurious prudence formed in her youth. His ill health rendered it necessary for him to keep a woman as a nurse, who, by her assiduity and skill in seasons of sickness and suffering, had gained a considerable control over his mind. This woman sympathized with the mother-in-law, and contributed all in her power to render the situation of the young wife, now in the bloom of youth and in the fulness of her fresh and warm affections, as unpleasant as possible.

Madame Guyon was both mentally and morally out of her true position. The individuals into whose immediate society she was introduced were characterized by a want of intellect and scientific and literary culture, which was not compensated either by moral and religious excellencies, or by the virtues of the heart. They not only did not appreciate her, but practically, if not always intentionally, set themselves against her. They were not only blind to her merits, but rude to her sympathies and hopes, and negligent of her happiness. Certainly this was not the situation for a woman of great intellect and great sensibility; a woman who was subsequently admitted into the most distinguished circles in France; a woman who honourably sustained a controversy with the learning and genius of Bossuet, and gave a strong and controlling impulse to the mind of Fénelon; a woman, whose moral and religious influence was such, that Louis XIV., in his solicitude for the extirpation of what he deemed heresy, thought it necessary to imprison her for

years in the Bastile and the prison of Vincennes; who wrote poems in her imprisonment, which Cowper thought it no dishonour to translate; and one who has exerted an influence which has never ceased to be felt, either in Europe or in America.

But there she was, and she felt and knew that her earthly hopes were blasted. But she did not then perceive, what she afterwards knew, that God placed her there in His providence, as He made Joseph a slave in Egypt, "*for her good.*" God had formed her for Himself. He loved her too much to permit her to remain long in harmony with a world which, in its vanity and its corruption, He could not love. He knew what was requisite in order to accomplish His own work; He knew under what providences the natural life would retain its ascendency, and the soul would be lost; and under what providences grace would be rendered effectual, and the soul would be saved. Such are the relations between mind and place, that no man ever is what he is, independently of his situation. The mind has no power of acting in entire separation from the relations it sustains; it knows nothing where there are no objects to be known; loves nothing where there are no objects to be loved; does nothing where there is nothing to be done. Its powers of perception, its capabilities of affectionate or malevolent feeling, its resources of "volitional" or voluntary determination, develop their strength and moral character in connexion with the occasions which call them forth. Let any man read the Life of St. Augustine, particularly in connexion with what he has himself said in his Confessions, or the Life of Francis Xavier, of Archbishop Leighton, of George Fox, of Baxter, of Wesley, of Brainerd, of Henry Martyn—and then say, if different circumstances (a situation, for instance, comparatively exempt from temptation and toil) would have developed the same men, the same strength of purpose, the same faith in God, the same purity of life. In the religious life we are the creatures, not only of grace, but of position, or more strictly and truly, of grace acting by position. This doctrine throws light and beauty over the broad field of God's providences, and shows us why many have passed to glory

through great tribul tion. Tribulation was necessary to bring them, if not to the true life of God in the first instance, to that fulness and brightness of the inward life which they have experienced. So that those, who grow in grace by suffering, may do well to remember, that probably nothing but seasons of trial would have fitted them for the reception and effectual action of that grace which is their consolation and their hope.

This view Madame Guyon subsequently took of the subject —she saw that everything had been ordered in mercy. In her Life she says, "I should have some difficulty in writing these things to you, which cannot be done without apparently giving offence to charity, if you had not required me to give a full account, without omitting anything. But there is one thing which I feel it a duty to request; and that is, that in these things we must endeavour to *behold the hand of God*, and not look at them merely *on the side of the creature*. I would not give any exaggerated idea of the defects of those persons by whom God had permitted me to be afflicted. My mother-in-law was not destitute of moral principles; my husband appeared to have some religious sentiments, and certainly was not addicted to open vices. It is necessary to look at everything *on the side of God*, who permitted these things only because they were connected with my salvation, and because He would not have me perish. Such was the strength of my natural pride, that nothing but some dispensation of sorrow would have broken down my spirit, and turned me to God." And again,—"Thou hast ordered these things, O my God, for my salvation! In goodness thou hast afflicted me. Enlightened by the result, I have since clearly seen that these dealings of thy providence were necessary, in order to make me die to my vain and haughty nature. I had not power in myself to extirpate the evils within me. It was thy providence that subdued them."*

Her statement of some of her trials I shall endeavour to give in a very abridged form, adjusting anew in some cases the arrangement of the facts.—"The great fault of my mother-in-law,

* La Vie de Madame Guyon, Part I , ch 6

who was not without sense and merit, was, that she possessed an *ungovernable self-will.* This trait was extraordinary in her; it had never been surmounted in her youth, and had become so much a fixed, inflexible trait of her character, that she could scarcely live with anybody. From the beginning she had conceived a strong aversion to me, so much so, that she compelled me to do the most humiliating things. I was made the constant victim of her humours. Her great occupation was to thwart me continually; and she had the art and the cruelty to inspire my husband with the like unfavourable sentiments.

" For instance, in situations where it was proper to have some regard to rank or station in life, they would make persons who were far below me in that respect take precedence of me,—a thing which was often very trying to my feelings, and especially so on account of my mother, who was very tenacious of what was due to honourable station in life, and who, when she heard of it from other persons (for I was careful not to say anything about it myself), rebuked me for want of spirit in not being able to maintain my rank. Another source of unhappiness was the disposition to prevent my visiting my father's family. My parents complained that I came to see them so seldom, little knowing the obstacles I had to encounter. I never went to see them without having some bitter speeches at my return. My mother-in-law, knowing how tenderly I felt on that point, found means to upbraid me in regard to my family, and spoke to me incessantly to the disadvantage of my father and mother.

" The place assigned for my residence in my husband's house, was the room which properly belonged to my mother-in-law. I had no place into which I could retire as my own; and if it had been otherwise, I could not have remained alone in it for any length of time without offence. Kept thus continually in her presence, she took the opportunity to cast unkind reflections upon me before many persons who came to see us; and to complete my affliction, the person chosen to act as nurse to my husband entered into all the plans of those who persecuted me. She kept me in sight like a governess, and treated me in a very singular

manner, considering the relations actually existing between us. For the most part I bore with patience these evils, which I had no way to avoid ; but sometimes I let some hasty answer escape me, which was to me a source of grievous crosses and violent reproaches for a long time together ; and when I was permitted to go out of doors, my absence added but little to my liberty. The footman had orders to give an acconnt of everything I did ; and what contributed to aggravate my afflictions, was the re membrance of my former situation, and of what I might have enjoyed under other circumstances. I could not easily forget the persons who had sought my affections, dwelling by contrast on their agreeable manners, on the love they had for me, and on the dispositions they manifested. All this made my situation very gloomy, and my burden intolerable.

" It was then I began to eat the bread of sorrow, and mingle my drink with tears. But my tears, which I could not forbear shedding, only furnished new occasion for attack and reproach. In regard to my husband, I ought perhaps to say, that it was not from any natural cruelty that he treated me as he did. He seems to have had a real affection for me, but being naturally hasty in his temper, his mother found the art of continually irritating him against me. Certain it is, that when I was sick, he was very much afflicted. Had it not been for his mother and the waiting-maid, we might have lived happily together.

" As it was, my condition was every way deplorable. My mother-in-law secured her object. My proud spirit broke under her system of coercion. Married to a person of rank and wealth, I found myself a slave in my own dwelling, rather than a free person. This treatment so impaired the vivacity of my nature, that I became dumb like ' the lamb that is shearing.' The expression of thought and feeling, which was natural to me, faded from my countenance. Terror took possession of my mind. I lost all power of resistance. Under the rod of my despotic mistress, I sat dumb and almost idiotic. Those who had heard of me, but had never seen me before, said one to another, ' Is this the person who sits thus silent like a piece of statuary, that was

famed for such an abundance of wit?' I looked in various directions for help, but I found no one with whom I could communicate my unhappiness,—no one who might share my grief, and help me to bear it. To have made known my feelings and trials to my parents, would only have occasioned new crosses. I was alone and helpless in my grief."

CHAPTER VI.

Her trials result in a renewed disposition to seek God—Of the connexion of Providential events with the renewal of the heart—The birth of her first child, and its effect upon her mind—Losses of property—Experience of severe sickness—Death of her paternal half-sister at Montargis, and of her mother at Paris—Result of these afflictions upon her mind —Renewed efforts of a religious nature—Her reading—Her interviews at her father's house with an exiled lady of great piety—Remarks—Her interviews with her cousin, M De Toissi, Missionary to Cochin China—Her conversation with a Religious of the Order of St. Francis—Her conversion.

SUCH are the expressions which convey to us her sense of her trials. In this extremity, it occurred to her (alas! that we learn this lesson so often from sorrows alone) that, in the deficiency of all hope in creatures, there might be *hope and help in God.* It is true that she had turned away from Him; and having sought for solace where she had not found it, and where she ought not to have sought it, she felt ashamed to go back. But borne down by the burdens of a hidden Providence (a Providence which she did not then love because she did not then understand it), she yielded to the pressure upon her, and began to look to Him in whom alone there is true assistance.

She had now been married about a year. A number of things occurred about this time worthy of notice, and tend to illustrate the operations of grace in connexion with the position in which we are placed in Providence. If it is not strictly true that God saves us by His providences—a remark which is sometimes made—I think we may regard it as essentially true that He saves us by His grace, dispensed and operating in connexion

with His providences. Providences test the disposition of the mind ; they not only test it, but alter it and control it to some extent, and may be the means of placing it in a position the most favourable for the reception of inward Divine teaching.

One circumstance, which was calculated to have a favourable effect upon the mind of Madame Guyon, was the birth of her first child. God was pleased to give her a son, to whom she gave the name of Armand Jacques Guyon. This event, appealing so strongly to family sympathies, was naturally calculated to interest and soften the feelings of those who had afflicted her. And this was the case. But this was not all. It brought with it such new relations ; it opened such new views of employment and happiness, and imposed such increased responsibilities, that it could hardly fail to strengthen the renewed religious tendency which had already begun to develop itself. Under the responsibility of a new life added to her own, she began to realize that, if it were possible for her not to need God for herself, she must need Him for her child.

God, in His dispensations, mingled judgments and mercies. Another circumstance, was the loss of a part of the property of the family. The revenues, accruing to the family from the Canal of Briare, completed by her husband's father, were very great. Louis XIV., whose wars and domestic expenditures required large sums of money, took from them a part of this income. The family, besides their usual place of residence in the country, had a valuable house in Paris, in connexion with which also a considerable sum of money was lost at this time. If the birth of a son tended to conciliate and to make things easy, the loss of property had a contrary effect. Her mother-in-law, who seems to have been an avaricious woman, was inconsolable at these losses ; which, in the perversity of her mind, she made the occasion of new injuries and insults to her daughter-in-law, saying with great bitterness, that the family had been free from afflictions till she came among them, and that all their troubles and losses came with her.

Another circumstance, was a severe sickness in the **second**

year of her marriage. The situation of her husband's affairs was such as to require his constant presence in Paris. After much opposition of her mother-in-law, she obtained her consent for a time to reside there with him, but not until she had called in the aid of her father, who insisted upon it. She went to the Hôtel de Longueville, where her husband stayed. She was received with every demonstration of kindness from Madame De Longueville, and from the inmates of the house; and there were many things, notwithstanding the generally unpleasant position of her domestic relations, which tended to render her residence in the city agreeable. Here she fell sick, and the prospect was that she would soon die. So far as the world was concerned, she felt that it had lost, in a great degree, its attractions, and she was willing to go. The priest who attended her, mistaking a spirit of deadness to the world, originating in part from her inability to enjoy it, for a true spirit of acquiescence in God's dispensations, thought well of her state. She seemed to him to be truly religious. But this was not her own opinion. She had merely begun to turn her eye, as it were, in the right direction. " My sins were too present to my mind," she says, " and too painful to my heart, to permit me to indulge in a favourable opinion as to my acceptance with God. This sickness was of great benefit to me. Besides teaching me patience under violent pains, it served to give newer and more correct views of the emptiness of worldly things. It had the tendency to detach me in some degree from self, and gave me new courage to suffer with more resignation than I had ever done."

But this was not all. Death had begun to make inroads in her family circle. Her paternal half-sister, at the Ursuline Convent, died two months before her marriage. She seems to have been a woman gentle in spirit and strong in faith, who lived in the world as not of the world; and died in the beauty and simplicity of Christian peace. The loss of a sister, so deservedly esteemed and loved by Madame Guyon, could not possibly be experienced without making the earth less dear, and heaven more precious. In the second year of her marriage, she

experienced the separation of another strong tie to earth, by the loss of her mother. " My mother departed this life," she remarks, " in great tranquillity of spirit, having, besides other virtues, been in particular very charitable to the poor. God, who seems to have regarded with favour her benevolent disposition, was pleased to reward her, even in this life, with such a spirit of resignation, that, though she was but twenty-four hours sick, she was made perfectly easy about everything that was near and dear to her in this world."

It is easy to see, in the light of these various dispensations, that God, who builds His bow of promise in the cloud, had marked her for His own. He had followed her long, and warned her often. He stopped her pathway to the world; but He left it open to heaven. He drew around her the cords of His providence closely, that she might be separated, in heart and in life, from those unsatisfying objects which, in her early days, presented to her so many attractions. It was God who was present in all these events; and, through an instrumentality of His own selection, was laying His hand painfully but effectually upon the idols which she had inwardly cherished, sometimes trying her by mercies, where mercy might affect her heart, but still more frequently and effectually by the sterner discipline of outward disappointment and inward anguish.

Not in vain, He who understands the nature of the human heart, and the difficulty of subjecting it, thus adjusted everything in great wisdom, as well as in real kindness. The trials which He had sent were among those which work out "the peaceable fruits of righteousness." By these various providences, afflicting as they were, she was led to the determination (a determination from this time never abandoned), *once more to seek God*. She had sought Him before, but she had not found Him. But, in turning from God to the world, she had found that which gave no satisfaction. Bitterly had she learned, that if there is not rest in God, there is rest nowhere. Again, therefore, she formed the religious resolve—a resolve which God enabled her not only to form, but to keep. Her feelings at this

time are well expressed in a well-known hymn, which is designed to describe the state of a sinner who has seen the fallacy and the unsatisfying nature of all situations and hopes out of Christ.

" Perhaps He will admit my plea;
 Perhaps will hear my prayer;
But if I perish, I will pray,
 And perish only there.

" I can but perish if I go;
 I am resolved to try;
For if I stay away, I know
 I must for ever die."

Fully determined to seek God, in all time to come, she adopted those measures which seemed to her best. They show her sense of need and her deep sincerity ; but they indicate also how difficult it is for the natural heart, especially under certain systems of religious belief and practice, to detach itself from its own methods and supposed merits, and in true simplicity of spirit to follow Him who is " *the way, the truth, and the life.*" Although they were in some sense only preparatory, they had a connexion with the great lesson which she was destined ultimately to learn. Among other things which seemed to be necessary in her present state, she ceased to give that attention to her outward appearance which she had done formerly. Fearful that she might either excite or increase emotions of vanity, she diminished very much the time occupied at the mirror. In addition, she commenced doing something for the religious benefit of the servants of the family. She likewise began a process of inward examination, often performing it very strictly, writing down her faults from week to week, and comparing the record at different periods, to see whether she had corrected them, and to what extent. The Sabbath was a day strictly observed, and the place of worship was not only regularly visited, but was attended with some beneficial results. She made such progress in certain respects, that she began to see and appreciate, much more correctly than at any former period, the defects of her character and life, and to feel sentiments of sincere compunction. She laid aside all reading incompatible with her present position, and confined her attention chiefly to the most devout works. One of these books, which, notwithstanding its Roman

Catholic origin, is much esteemed among Protestants, was the celebrated *Imitation of Christ*, by Thomas-à-Kempis—a work widely read among devout people of all denominations of Christians. Under a simple and unpretending exterior, corresponding in this respect with the humble spirit of its author, whoever he may have been, it contains the highest principles of Christian experience. Some of the works of Francis de Sales also, which she had read at an early period of her life, were consulted by her at this time with great interest.

God, in His benevolence, was pleased to add other instrumentalities. During her visit to Paris, and at other times, she had opportunities of being at her father's house. After the death of her mother, her respect and affection for her father seemed especially to require it. She there became acquainted with a lady, whom she speaks of as being an *exile*—very possibly some person driven from England by the civil wars. This exiled lady came to her father's house in a state of destitution; and he offered her an apartment, which she accepted for a long time. Instructed in the vanities of the world by the trials she had experienced, she had sought and had found the consolations of religion, and loving God, "worshipped Him in spirit and in truth." Her gratitude to M. De la Mothe was naturally shown in acts of kindness to his daughter, Madame Guyon. And these favourable dispositions were increased by her talents, her beauty, and sorrows; and still more by what she noticed of her sincere and earnest desire to know more, and experience more, of the things of religion.

Madame Guyon eagerly embraced this opportunity of religious conversation; and from this pious friend thus raised up by Providence to instruct her, she seems to have received the first distinct intimations, that she was erroneously seeking religion *by a system of works without faith.* This devout lady remarked, on her various exterior works of charity, that she had the virtues of " *an active life,*" that is to say, the virtues of outward activity, of outward doing, but that she had not the " truth and simplicity of the life within." In other words, that

her trust was in herself rather than in God, although she might not be fully aware of it. But Madame Guyon says significantly, " *My time had not yet come ; I did not understand her.* Living in the Christian spirit, she served me more by her *example* than by her words. God was in her life. I could not help observing on her *countenance* something which indicated a great enjoyment of God's presence. I thought it an object to try to be like her outwardly—to exhibit that exterior aspect of Divine resignation and peace, which is characteristic of true inward piety. I made much effort, but it was all to little purpose. I wanted to obtain, by efforts made in my own strength, that which could be obtained only by ceasing from all such efforts, and trusting wholly in God."

In narrating these various providential dispensations and instrumentalities, we cannot avoid noticing how much it costs to bring a soul to the knowledge of God. This recital does not present anything peculiarly new ;—anything which does not occur in many other cases. The human mind is so wedded to its natural perverseness, that it is not brought into harmony with God at once. Even those conversions, which appear to be especially prompt and sudden, have in many cases been preceded by a long preparatory training, which is not the less real, because it has been unseen and unknown. Generally speaking, we see efforts frequently renewed, resolves made and broken, alternations of penitential tears and of worldly joys, advice and warning received to-day and rejected to-morrow, and very fre quently a long series of disappointments and sorrows, before the mind is so humbled as to renounce its earthly hopes, and to possess all things in God by becoming nothing in itself. But this state of things, which so frequently happens, and is really so afflicting, teaches us the lesson of patience and of hope. Tears may have been wiped away, and resolutions broken ; yet those tears, which seemed in vain, and those resolutions which seemed worse than in vain, may have been important and even indispensable links in the chain of providential occurrences. We repeat, therefore, that conversions long delayed, although cal-

culated to try and to purify our patience, ought not to extinguish our hope. "In due season we shall reap, if we faint not."

Another individual had a share in that series of providences which God saw to be necessary. This was M. De Toissi, the nephew of M. De la Mothe. He had been to Cochin China, and after an absence of about four years, had returned on business connected with the mission. He visited the house of M. De la Mothe, where his cousin, Madame Guyon, was exceedingly glad to see him. She knew his character. She remembered what was said of his conversation and appearance when he visited her father's house. In her state of mind, groping about in solitude and desolation of spirit, she eagerly sought conversations with pious persons. This pious cousin, impelled by natural affection as well as by a regard for the interests of religion, did all that he could to encourage her in her search after God. Other things gave him an increased interest in the case, such as her personal accomplishments, her great talents, the wealth of her family, her position in society, and her comparative youth—circumstances particularly adverse to the humble and pure spirit of religion. And it was not easy for one to see the possessor of them seeking religion, with a full determination to be satisfied with nothing else, without feeling a deep interest in the result. Madame Guyon very freely and ingenuously stated her views of her inward state to her cousin—the faults of her character, her inward sense of her alienation from God, her efforts and discouragements. He expressed the deepest interest in her case. He prayed for her, and gave such advice as he was able. With earnest exhortations he cheered her onward, not doubting that God's wisdom and goodness would bring all well in the end.

These interviews had an encouraging effect. He was in a state of inward and continual communion with God; that state of mind, probably, which, in accordance with the nomenclature of the higher experimental writers, she variously denominates, in her religious works, as the state of "Recollection," or of

"Recollection in God." This state of continual prayer affected her much, although unable at that time to understand its nature. She also noticed, with interest and profit, the conversation between him and the exiled lady resident at her father's house. As is the case with all truly pious persons, they seemed to understand each other's hearts. "They conversed together," she says, "in a *spiritual language*." They had that to speak of, which souls unconverted can never know,—a Saviour, sins forgiven, and joy and peace in believing.

The example and the exhortations of De Toissi could not fail to make a deep impression. Many were the tears she shed when he departed. She renewed her solemn resolutions. She endeavoured to imitate him in his state of continual prayer, by offering up to God ejaculations, either silent or spoken, moment by moment. On the system of mere human effort, she seems to have done all that she could do. But still she did not *understand;* a cloud hung over one of the brightest intellects when left to itself—so perplexing to human wisdom, and so adverse to the natural heart is the way of forgiveness and justification *by faith alone.* Those know it who experience it, and those only; but *her* hour had not yet come. More than a year had passed in this state of mind, and with such efforts—but apparently in vain. With all the appliances mentioned, with afflictions on the one hand to separate her from earthly objects, and encouragements on the other to allure her to heaven, she still seems to have remained without God and without hope in the world. So much does it cost, in a fallen world like this, to detach a soul from its bondage and to bring it to God! God has not only spread the feast, in the salvation which He has offered through His Son, but, by means of ministers, both providential and personal, He goes out into the highways, and compels them to come in.

God was pleased to send one more messenger. "Oh, my Father!" says Madame Guyon, in connexion with the incidents we are about to relate, "it seems to me sometimes, as if thou didst forget every other being, in order to think only of my

faithless and ungrateful heart." There was a devout man of the Religious Order of St. Francis—his name is not given—who spent five years in solitude, for spiritual renovation and communion with God. With a heart subdued to the world's attractions, and yet inflamed for the world's good, he went out into the field of labour. He thought that God called him to labour for the conversion of a person of some distinction, in the vicinity of M. De la Mothe. But his labours there proved fruitless—or rather, resulted only in the trial of his own faith and patience. The humble Franciscan, revolving in his mind where he should next go and announce the Divine message, was led by the inward monitor, in connexion with the indications of Providence, to go to the house of M. De la Mothe, with whom he seems to have had some acquaintance in former times. M. De la Mothe, a man in whom the religious tendency was strong, was exceedingly glad to see him, and to receive his instructions, especially as he was then out of health, and had not much expectation of living long. His daughter, Madame Guyon, desirous of rendering him every assistance in his increasing infirmities, was then at her father's house, although her own health was very infirm. Her father was not ignorant either of her outward or inward trials. She had conversed with him with entire frankness on her religious state and the exercises of her mind, her dissatisfaction with her present spiritual condition, and her earnest desire to avail herself of every favourable opportunity to receive religious instruction. Her father, influenced by the representations she made, as well as by his high sense of the piety and religious wisdom of the Franciscan, not only advised but strongly urged her to consult with him.

Attended by a kinswoman, as seemed to be proper, she visited the Franciscan, and stated her conviction of her need of religion, and her often-repeated and long-continued efforts made without effect. When she had done speaking, the Franciscan remained silent for some time, in inward meditation and prayer. He at length said : " *Your efforts have been unsuccessful, Madame, because you have sought without, what you can only find within*

Accustom yourself to seek God in your heart, and you will not fail to find Him."

It is very probable that she had heard a similar sentiment before ; but if so, it came to her as religious truth always does come to those in their natural state, who are permitted to hear, before grace has enabled them to understand. But now the hour of God's providence and of special mercy had arrived. Clearly and strongly did the Divine Spirit apply a truth which otherwise would have fallen useless to the ground. These few words, somewhat singular in expression, obviously convey the great principle, that religion does not and cannot consist in outward working—in a mere round of ceremonial duties—in anything which comes exclusively under the denomination of an external action. But, on the contrary, it is inward in the sense of having its seat in the heart's affections, and in accordance with the great scriptural doctrine, that the *"just shall live by faith."* From the moment that Madame Guyon heard these words, she was enabled to see the error she had committed,— that of endeavouring to obtain God by a system of outward operations,—by the mercenary purchase of formal services, rather than by the natural and Divine attraction of accordant sympathies. Speculatively, there may be a God objective, a God outward, a God recognised by the intellect as a great and majestic Being living in the distance. And in certain respects this is a view of God which is not at variance with the truth. But still God can never be known to us as *our* God, He can never be brought into harmony with *our* nature, except as a God *inward*, a God received by faith and made one with us by love, and having His home in the sanctified temple of the heart. " *Believe* in the Lord your God ; so shall ye be established. *Believe* his prophets ; so shall ye prosper " (2 Chron. xx. 20).

" Having said these words," she says, " the Franciscan left me. They were to me like the stroke of a dart which pierced my heart asunder. I felt at this instant deeply wounded with the love of God ;—a wound so delightful, that I desired it never might be healed. These words brought into my hear*

what I had been seeking so many years; or rather they made me discover what was there, which I did not enjoy for want of knowing it. Oh, my Lord! thou wast in my heart, and demanded only the turning of my mind inward, to make me feel thy presence. Oh, infinite Goodness! thou wast so near, and I ran hither and thither seeking thee, and yet found thee not. My life was a burden to me, and my happiness was within myself. I was poor in the midst of riches, and ready to perish with hunger near a table plentifully spread and a continual feast. Oh Beauty, ancient and new! Why have I known thee so late? Alas, I sought thee where thou wast not, and did not seek thee where thou wast! It was for want of understanding these words of thy Gospel: ' *The kingdom of God cometh not with observation, neither shall they say, Lo, here! or lo, there! for behold, the kingdom of God is within you.*' This I now experienced, since thou didst become my King, and my heart thy kingdom, where thou dost reign a Sovereign, and dost all thy will.

" I told this good man, that I did not know what he had done to me; that my heart was quite changed; that God was there; for from that moment He had given me an experience of His presence in my soul,—not merely as an object intellectually perceived, but as a thing really possessed after the sweetest manner. I experienced those words in the Canticles: ' *Thy name is as precious ointment poured forth; therefore do the virgins love thee.*' For I felt in my soul an unction, which healed in a moment all my wounds. I slept not all that night, because thy love, O my God! flowed in me like delicious oil, and burned as a fire which was going to destroy all that was left of self in an instant. I was all on a sudden so altered, that I was hardly to be known either by myself or others. I found no more those troublesome faults, or that reluctance to duty, which formerly characterized me. They all disappeared, as being consumed like chaff in a great fire.

" I now became desirous that the instrument hereof might become my Director,* in preference to any other. This good

* DIRECTOR.—The office of Director and the office of Confessor, sometimes arise in the

father, however, could not readily resolve to charge himself with
my conduct, though he saw so surprising a change effected by
the hand of God. Several reasons induced him to excuse him-
self: first, my person, then my youth, for I was only twenty
years of age; and lastly, a promise he had made to God, from
a distrust of himself, never to take upon himself the direction
of any of our sex, unless God, by some particular providence,
should charge him therewith. Upon my earnest and repeated
request to him to become my Director, he said he would pray
to God thereupon, and bade me do so too. As he was at prayer,
it was said to him, ' Fear not that charge; she is my spouse.'
This, when I heard it, affected me greatly. 'What!' (said I
to myself,) ' a frightful monster of iniquity, who have done so
much to offend my God, in abusing His favours, and requiting
them with ingratitude,—and now, thus to be declared His
spouse!' After this he consented to my request.

" Nothing was more easy to me now than to practise prayer.
Hours passed away like moments, while I could hardly do any-
thing else but pray. The fervency of my love allowed me no
intermission. It was a prayer of rejoicing and of possession,
wherein the taste of God was so great, so pure, unblended and
uninterrupted, that it drew and absorbed the powers of the soul
into a profound recollection, a state of confiding and affectionate
rest in God, existing without intellectual effort. For I had now
no sight but of Jesus Christ alone. All else was excluded, in
order to love with greater purity and energy, without any mo-
tives or reasons for loving which were of a selfish nature."

Such are the expressions in which she speaks of the remark-
able change which thus passed upon her spirit,—an event which
opened new views, originated new feelings, instituted new rela-
tions, and gave new strength. Too important in itself and its
relations to be forgotten under any circumstances, we find her
often recurring to it with those confiding, affectionate, and

same person, and the terms appear in some instances to be used as synonymous with each
other. Strictly speaking, however, it is not the business of the Director to hear confessions,
but simply to give religious counsel, in those various circumstances in which Christians,
especially in the beginning of the religious life, are found to need it.

.rateful sentiments, which it was naturally calculated to inspire.
One of her poems, which Cowper has translated, expresses well
the feelings which we may suppose to have existed in her at this
time.

LOVE AND GRATITUDE.

" All are indebted much to thee,
 But I far more than all ;
From many a deadly snare set free,
 And raised from many a fall.
Overwhelm me from above,
Daily with thy boundless love.

" What bonds of gratitude I feel,
 No language can declare ;
Beneath the oppressive weight I reel,
 'Tis more than I can bear ;
When shall I that blessing prove,
To return thee love for love ?

" Spirit of Charity ! Dispense
 Thy grace to every heart ;
Expel all other spirits thence ;
 Drive self from every part.
Charity divine ! Draw nigh ;
Break the chains in which we lie.

" All selfish souls, whate'er they feign,
 Have still a slavish lot ;
They boast of liberty in vain,
 Of love, and feel it not.
He, whose bosom glows with thee.
He, and he alone, is free.

" O blessedness all bliss above,
 When thy pure fires prevail !
LOVE* *only teaches what is love ;*
 All other lessons fail ;
We learn its name, but not its powers,
Experience only makes it ours."

CHAPTER VII.

Remarks on intellectual experience, in distinction from that of the heart—Of that form of
experience which is characterized by joy—Her experience characterized especially by the
subjection of the will—Of the course to be pursued in translating from the writings of
Madame Guyon—Her remarks on the union of the human with the Divine will—Her
remarks on faith—Conversation with a Franciscan—Immersion of her soul in God, and
her contemplation of all things in Him.

MADAME GUYON, recognising an important distinction, re-
garded the change at this period as not merely an intellectual
illumination, but as truly a change of the *heart.* Undoubtedly
she had received new light. She had been led to see the ex-
treme perversity and blindness of the natural mind. She had
now a clearer perception both of what God is, and of what He
requires ; and especially of the way of forgiveness and salvation

* God is *Love,* 1 John iv 8.

by faith in Christ alone. But perception is not love. The righting of the understanding is not necessarily identical with the rectification of the sensibilities. The understanding, enlightened of God, will sometimes dictate what the heart, in its opposition to God, will be slow to follow. This was not her case. Her understanding was not only enlightened, but her heart was renewed.

No sound was heard but that of the " still small voice," which speaks inwardly and effectually. There was no dream, no vision, no audible message. Her change was characterized, not by things seen, but by operations experienced; not by revelations imparted from without, and known only as existing without, but by affections inspired by the Holy Ghost from within, and constituting, from the time of their origin, a part of the inward consciousness.

Joy was a marked characteristic of her first experience of the new life. But, taught by the great inward Teacher, she was enabled to perceive from the first, that it would not be safe to estimate either the reality or the degree of her religion by the amount of her happiness. There is not only such a thing as joy, but such a thing as *religious* joy—in the language of the Scriptures, "joy in the Holy Ghost." But this is a very different thing from saying, that joy and religion are the same thing. Joy is not only not religion, but it does not always arise from religious causes. The grounds of its origin are numerous, and sometimes very diverse. A new speculative truth, new views at variance with the truth, or even the pleasant intimations of a dream or vision, whether more or less remarkable, (to say nothing of physical and providential causes,—causes connected with the state of our health and situation in life,) may be followed by a pleasurable excitement which may be mistaken for true religion. Certain it is, however, that no joys can be regarded as really of a religious nature and as involving the fact of religion, which are not attended with repentance for sin and faith in Jesus Christ, with the renovation of the desires and the subjection of the will. The views of Madame Guyon on this

subject were distinct and decided. She took the Saviour for her
example. She did not seek joy, but God,—God *first*, and what
God sees fit to give afterwards. She believed and knew, if she
gave herself to God wholly, without reserve, God would take
care of her happiness.

The leading and decisive characteristic of her religious ex-
perience was the subjection and loss of her own will in its union
with the Divine will. It may be expressed in a single term,
union. " As thou, Father, art in me, and I in thee, that they
also may be ONE in us." On this subject, a number of her re-
marks may properly be introduced here, with a few preliminary
statements. Madame Guyon's literary education, although it
compared well with that of other French ladies at that time,
was, in some respects, defective. The institutions for young
ladies, not excluding the celebrated Seminary of St. Cyr, esta-
blished a few years after, did not profess, and were not able to
give, that thorough mental training which was had in the French
colleges and universities. And the greatest natural ability will
not necessarily compensate for defects in education. Her style
of writing is eloquent and impressive in a high degree, but a
critical eye will discover in it deficiencies, which are to be as-
cribed, in part, to the cause just intimated. The theological and
experimental terms which she uses, sometimes have a specific
meaning, not unknown perhaps in some of the mystic writers, but
which can certainly be ascertained only by an intimate know-
ledge of her own experience, character, and writings. Take, as
an illustration of this remark, the word *" puissances,"* which is
literally rendered by the English word, *powers ;* but the latter
term gives only an indefinite idea of the sense which she attaches
to the original term. She uses it in its mental application,
meaning the *mental* powers, but not all of them. She distin-
guishes between the will (*volonté*), the understanding (*entende-
ment*), and the *puissances ;* meaning generally by the *latter* term,
the propensive and affectional part of our nature, not excluding
the appetites ; what we sometimes denominate by the single
expression, the natural sensibilities. It would not be sufficient,

therefore, merely to translate her words by rendering tnem with the words and methods of expression that formally correspond to them. A translation of words is not necessarily a translation of ideas. It is necessary first to ascertain what she meant, and then to embody her ideas in such a mode of expression as will convey to the English reader just that meaning which she herself would have conveyed if she had used the English language with the Anglo-Saxon mind. Her statements on the same subject are often fragmentary ; broken in parts, uttered in various and remote places of her works, and accompanied more or less with digressions and repetitions. What I give as a translation is, in some cases, of the nature of an *interpreted* translation, a translation of the spirit rather than of the letter. A *true* translation of what she *was* and of what she *meant* can be made in no other way.

With these remarks, we give some of her views. " The union oetween the soul and God may exist in various respects. There may be a union of the human and the Divine perceptions. There may be a union of the desires and affections to some extent and in various particulars. But the most perfect union, that which includes whatever is most important in the others, is the union of the human and the Divine will. A union of the affections, independently of that of the will, if we can suppose such a thing, must necessarily be imperfect. When the will, which sustains a pre-eminent and controlling relation, is in the state of entire union with God, it necessarily brings the whole soul into subjection ; it implies necessarily the extinction of any selfish action, and brings the mind into harmony with itself, and into harmony with everything else. From that moment our powers cease to act from any private or selfish regards. They are annihilated to *self*, and act only in reference to God. Nor do they act in reference to God in their own way and from their own impulse ; but move as they are moved upon, being gradually detached from every motion of their own.

" In the presence of the light of faith, every other light necessarily grows dim and passes away, as the light of the moon and

stars gradually passes away, and is extinguished in the broader and purer illumination of the rising sun. This light now arose in my heart. Believing with this faith, the fountains of the heart were opened, and I loved God with a strength of love corresponding to the strength of faith. Love existed in the soul; and, throwing its influence around every other principle of action, constituted, as it were, the soul's dwelling-place. God was there. According to the words of St. John, ' *He that dwelleth in love, dwelleth in God. God is love.*' "

When the pious Franciscan, her spiritual Director, questioned her in relation to her feelings towards God, she answered, " I love God far more than the most affectionate lover among men loves the object of his earthly attachment. I make this statement as an illustration, because it is not easy to convey my meaning in any other way. But this comparison, if it furnishes an approximation to the truth, fails to discover the truth itself."

" This love of God," she adds, " occupied my heart so constantly and strongly, that it was very difficult for me to think of anything else. Nothing else seemed worthy of my attention. So much was my soul absorbed in God, that my eyes and ears seemed to close of themselves to outward objects, and to leave the soul under the exclusive influence of the inward attraction. My lips also were closed. Not unfrequently vocal prayer, that form of it which deals in particulars, ceased to utter itself, because my mind could not so far detach itself from this one great object as to consider anything else. When the good Father, the Franciscan, preached at the Magdalen Church, at which I attended, notwithstanding the importance and interest which attached to his religious addresses, I found it difficult, and almost impossible, to retain any definite idea of what he said. He preached there on three successive occasions about this time; and the result was always the same. I found that thy truth, O my God, springing from the original source, as if thy Divine and eternal voice were speaking truly, yet inaudibly in the soul, made its impression on my heart, and there had its effect, without the mediation of words.

"**This** immersion in God absorbed all things; that is to say, seemed to place all things in a new position relatively to God. Formerly I had contemplated things as dissociated from God; but now I beheld all things in the Divine union. I would no more separate holy creatures from God, regarded as the source of their holiness, than I could consider the sun's rays as existing distinct from the sun itself, and living and shining by virtue of their own power of life. This was true of the greatest saints. I could not see the saints, Peter, and Paul, and the Virgin Mary, and others, as separate from God, but as being all that they are, from Him and in Him, in oneness. I could not behold them out of God; but I beheld them all in Him."

CHAPTER VIII.

Of the very marked and decisive nature of her conversion—Ceases to conform to the world in her diversions and modes of dress—Birth of her second son—Her views of providence in connexion with her position in life—Of the discharge of her duty to her family and to others—Her great kindness and charity to the poor—Her efforts for the preservation of persons of her own sex—Her labours for the conversion of souls—Conversation with a lady of rank—Happy results—Domestic trials—Unkindness of her stepmother and of her maid-servant—Partial alienation of her husband's affections—Conduct of her eldest son—Her solitary state.

MADAME GUYON dates this great change as taking place on Magdalen's day, the 22d of July 1668.* She was then a little more than twenty years of age.

The change experienced in the transition from the life of nature to the life of God in the soul, is very different in different persons. In the case of Madame Guyon, slowly progressive in its preparatory steps, it was very decisive and marked at the time of its actually taking place. It was obviously a great crisis in her moral and religious being—one in which the pride and obstinacy of the natural heart were broken down, and in which, for the first time, she became truly willing to receive Christ alone as her hope of salvation.

* La Vie de Madame Guyon Part I. chap. x. § 5

A gospel change implies the existence of a new nature,—a nature which has life in it; and which, having the principle of life in itself, puts forth the acts of life. And thus the fact, both of its existence and of its character, is verified. The true life always shows itself outwardly, in its appropriate time and way. " *By their fruits,*" says the Saviour, " *ye shall know them.*" No other evidence will or ought to compensate for the absence of this. This evidence Madame Guyon gave. From the moment that she gave herself to the Lord to be His, in the inner spirit as well as the outward action, the language of her heart, like that of the apostle Paul, was, " *Lord, what wilt thou have me to do ?*"

" I bade farewell for ever," she says, " to assemblies which I had visited, to plays and diversions, dancing, unprofitable walks, and parties of pleasure. The amusements and pleasures so much prized and esteemed by the world, now appeared to me dull and insipid—so much so, that I wondered how I ever could have enjoyed them." For two years previously she had left off the curling of her hair—a very general and favourite practice at that time. From this time it became her object, in her dress. modes of living, and personal habits generally, as well as interior dispositions, to conform to the requisitions of the Inward Monitor, the Comforter and Guide of holy souls.

Sustaining the relations of a wife, a mother, and a daughter, and seeing now more clearly into the ways and requisitions of Providence, she endeavoured, from higher motives and in a better manner than ever before, to discharge the duties which she owed to her father, husband, and children. God had been pleased to give her another son. Her first son she frequently names as being made, through the perverting influence of her stepmother, a son of trial and sorrow. The second son, who gave better promise both for himself and others, was born in 1667. We have scarcely anything recorded of him, except the few painful incidents of his early death. These new relations furnished opportunities of duty and occasions of trial, which ceased from this time, at least in a great degree, to be met in the strength of worldly motives, or by the acts of worldly wis

dom. God, in whom alone she felt she could trust, became her wisdom and strength, as well as her consolation.

We may truly say, whatever allowance it may be necessary to make for human infirmity, that God was her portion. She could say with the Psalmist, "The Lord is my fortress and deliverer—my strength, in whom I will trust." The views which she took of religious truth and duty, were of an elevated character, without being mixed, so far as we can perceive, with elements that are false and fanatical. Even at this early period of her experience, the religious impulse, as if it had an instinctive conviction of the end to which it was tending, took a higher position than is ordinary, but without failing to be guided by the spirit of sound wisdom. If she was a woman who both by nature and grace felt deeply, she was also a woman who thought clearly and strongly. She distinctly recognised, not only intellectually, but, what is far more important, *practically*, that God orders and pervades our allotment in life ; that God is *in* life, not in the mitigated and merely speculative sense of the term, but really and fully ; not merely as a passive spectator, but as the inspiring impulse and soul of all that is not sin ; *in* life, in *all* life, in *all* the situations and modifications of life, for joy or for sorrow, for good or for evil. The practical as well as speculative recognition of this principle may be regarded as a first step towards a thorough walking with God. A heart unsubdued, in which worldly principles predominate, does not like to see God in all things, and tries unceasingly to shake off the yoke of Divine providence. To the subdued heart, on the contrary—in which Christian principles predominate—that yoke always is, and of necessity always *must* be, just *in proportion* as such principles predominate, " the yoke which is easy and the burden which is light." Early did this heaven-taught woman learn this ; and she was willing to apply to her own situation, and responsible relations, what she had thus learned. It is one thing to have the charge of a family, and another to know and to feel that this responsible position is the arrangement and the gift of *Providence*. Providence, whose eye is unerring, had

placed her in that relation ; and whatever cares or sorrows might attend her position, she felt that, as a woman, and emphatically as a *Christian* woman, she must recognise it as the place which God had appointed, and as involving the sphere of duty which God had imposed.

But her care was not limited to her family, to the exclusion of other appropriate objects of Christian benevolence. She had means of doing good, which she did not fail to employ. The income of her husband's property, or rather the property of which he had the control at this time, stated in the French currency, was about forty thousand livres annually—a very large income at that period. Of this amount, a certain portion was placed in her hands by her husband, to be expended by her as she might think proper ; and, accordingly, as God gave her opportunity, and in imitation of that Saviour whom she now followed, she did what she could for the poor and the sick, discharging, without any hesitation, duties which would be exceedingly unpleasant and irksome to a mind not supported by Christian principle. " I was very assiduous," she remarks in her life, " in performing deeds of charity. I had feelings of strong compassion for the poor, and it would have been pleasing to me to have supplied all their wants. God in His providence had given me an abundance ; and, in the employment of what He had thus bestowed upon me, I wished to do all that I could to help them. I can truly say, that there were but few of the poor in the vicinity where I lived who did not partake of my alms. I did not hesitate to distribute among them the very best which could be furnished from my own table. It seemed as if God had made me the only almoner in this neighbourhood. Being refused by others, the poor and suffering came to me in great numbers. My benefactions were not all public. I employed a person to dispense alms privately, without letting it be known from whom they came. There were some families who needed and received assistance, without being willing to accept of it as a gratuity ; and I reconciled their feelings with their wants, by permitting them to incur the formality of a debt. I

speak of giving, but, looking at the subject in the religious light, I had nothing to give. My language to God was—'*Oh, my Divine Love, it is thy substance—I am only the steward of it—I ought to distribute it according to thy will.*' "

Her efforts for the good of others were not limited to gifts of food and clothing. Ruinous vices prevailed in France during the reign of Louis XIV. The profligacy of the Court, though less intense than that which was exhibited subsequently in the Regency of the Duke of Orleans and the reign of Louis XV., could hardly fail to find imitators among the people. This will explain some further efforts to do good. In a number of instances, with a forethought creditable to her sound judgment as well as her piety, she informs us that she caused poor young girls, especially such as were particularly characterized by beauty of person, to be taught some art or trade ;—that, having employment and means of subsistence, they might not be under a temptation to adopt vicious courses, and thus throw themselves away. This was not all. Inspired with the sentiments which animate the hearts of some pious females of later times, she did not consider it inconsistent with religion to endeavour to reclaim those of her sex who had fallen into the grossest sins. God made use of her to reclaim several females, one of whom was distinguished by her family connexions as well as her beauty, who became not only reformed, but truly penitent and Christian, and died a happy death. " I went," she says, " to visit the sick, to comfort them, to make their beds. I made ointments, aided in dressing wounds, and paid the funeral expenses incurred in the interment of those who died. I sometimes privately furnished tradesmen and mechanics, who stood in need of assistance, with the means that were requisite to enable them to prosecute their business." It is very obvious, that in outward charity she did much—perhaps all that could reasonably be expected.

But further, under the influences of her new life, which required her to go about doing good, she laboured for the spiritual as well as the temporal benefit of others—for the good of their

souls as well as for that of their bodies. Before the day dawned, prayers ascended from her new heart of love. " So strong, almost insatiable, was my desire for communion with God, that I arose at four o'clock to pray." Her greatest pleasure, and, comparatively speaking, her only pleasure, was to be alone with God, to pray to Him, and to commune with Him. She prayed for others as well as herself. She says, " I could have wished to teach all the world to love God." Her feelings were not inoperative. Her efforts corresponded with her desires. She says that God made use of her as an instrument in gaining many souls to Himself. Her labours, however, were more successful in some cases than in others. Speaking of one of the female relatives of her husband, who was very thoughtless on religious subjects, she remarks, " I wanted her to seek the religious state, and to practise prayer. Instead of complying, she said that I was entirely destitute of all sense and wisdom in thus depriving myself of all the amusements of the age ; but the Lord *has since opened her eyes to make her despise them.*"

" A lady of rank," she writes, " took a particular liking to me, because my person and manners were agreeable. She said that she observed in me something extraordinary. My impression is, that my spiritual taste reacted upon my physical nature, and that the inward attraction of my soul appeared on my very countenance. A gentleman of fashion one day said to my husband's aunt, ' I saw your niece, and it is very visible that she lives in the presence of God !' I was surprised at hearing this, as I did not suppose that a person so much addicted to the world could have any very distinct idea of God's presence, even in the hearts of his own people. This lady proposed to me to go with her to the theatre. I refused, as, independently of my religious principles, I had never been in the habit of going to such places. The reason which I first gave was, that my husband's continual indisposition rendered it inconvenient and improper. Not satisfied with this, she continued to press me very earnestly. She said that I ought not to be prevented by my husband's indispositions from taking some amusement; that the business of

c

nursing the sick was more appropriate to older persons; and that I was too young to be thus confined. This led to more particular conversation. I gave her my reasons for being particularly attentive to my husband in his ill health. I told her that I entirely disapproved of theatrical amusements, and regarded them as especially inconsistent with the duties of a Christian woman. The lady was far more advanced in years than I was; but my remarks made such an impression on her, that she never visited such places afterwards.

" I was once in company with her and another lady, who was fond of talking, and had read the Christian Fathers. They had much conversation in relation to God. The learned lady, as might be expected, talked very learnedly of Him. This sort of merely intellectual and speculative conversation, in relation to the Supreme Being, was not much to my taste. I scarcely said anything; my mind being drawn inwardly to silent and inward communion with the great and good Being, about whom my friends were speculating. The next day the lady came to see me. The Lord had touched her heart; she came as a penitent, as a seeker after religion; she could hold out in her opposition no longer. But I at once attributed this remarkable and sudden change, as I did not converse with her the day previous, to the conversation of our learned and speculative acquaintance. But she assured me it was otherwise. She said, it was not the other's conversation which affected her, but my *silence;* adding the remark, that my silence had something in it which penetrated to the bottom of her soul, and that she could not relish the other's discourse. After that time we spoke to each other with open hearts on the great subject.

" It was then that God left indelible impressions of grace on ner soul; and she continued so athirst for Him, that she could scarcely endure to converse on any other subject. That she might be wholly His, God deprived her of a most affectionate husband : He also visited her with other severe crosses. At the same time He poured His grace so abundantly into her heart, that He soon conquered it, and became its sole master. After

the death of her husband and the loss of most of her fortune, she went to reside on a small estate which yet remained situated about twelve miles from our house. She obtained my husband's consent to my passing a week with her, to console her under her afflictions. I conversed much with her on religious subjects. She possessed knowledge, and was a woman of uncommon intellectual power; but being introduced into a world of new thought as well as new feeling, she was surprised at my expressing things so much above what is considered the ordinary range of woman's capacity. I should have been surprised at it myself, had I reflected on it. But it was God who gave me the gift of perception and utterance for her sake; He made me the instrument, diffusing a flood of grace into her soul, without regarding the unworthiness of the channel He was pleased to use. Since that time her soul has been the temple of the Holy Ghost, and our hearts have been indissolubly united."

Religion, so far as it *is* religion, is *always* the same; the same in all lands and ages; the same in its nature and results; always allied to angels and God, and always meeting with the opposition of that which is not angelic and not of God. It is not surprising, therefore, that Madame Guyon's new heart should meet with opposition from the world's old one.

"When the world saw that I had quitted it, it persecuted me, and turned me into ridicule. I became the subject of its conversation, fabulous stories, and amusement. Given up to its irreligion and pleasures, it could not bear that a woman, little more than twenty years of age, should thus make war against it, and overcome it." That youth should quit the world was something; but that ﹁ealth, intelligence, and beauty, combined with youth, should quit it, was much more. On merely human prin ciples it could not well be explained. Some were offended; some spoke of her as a person under mental delusion; some attributed her conduct to stupidity, inquiring very significantly, "What can all this mean? This lady has the reputation of knowledge and talent. But we see nothing of it."

But God was with her. About this time she and her hus

band went into the country on some business. She did not leave her religion on leaving her home. The river Seine flowed near the place where they stayed. " *On the banks of the river,*" she says, "*finding a dry and solitary place, I sought intercourse with my God.*" Her husband did not accompany her there. She went alone to the banks of the Seine, to the waters of the beautiful river. It was indeed a solitary place; but can we say that she who went there went alone? *God was with her*—God, who made the woods and the waters, and in the beginning walked with His holy ones amid the trees of the garden. " The communications of Divine love," she adds, " were unutterably sweet to my soul in that retirement." And thus, with God for her portion, she was happy in the loss of that portion which was taken away from her.

" Let the world despise and leave me,	" Man may trouble and distress me,
They have left my Saviour too ;	'Twill but drive me to thy breast ;
Human hearts and looks deceive me ;	Life with trials hard may press me ,
Thou art not, like them, untrue.	Heaven will bring me sweeter rest."

Happy would it have been, if she had been exposed only to the ridicule and the opposition of those who were without. Among the members of her own family still less than ever, with the exception of her father, did she find any heart that corresponded fully to her own. It seems to have been the great object of her mother-in-law, who was exceedingly desirous to retain the influence over her son which she had exercised previous to his marriage, to weaken and destroy his affection for his wife. Her object was cruel as it was wicked, although she probably justified herself in it, from the fear that the benevolent disposition of Madame Guyon, both before and after experiencing religion, might result in a waste of the property of the family, if she should possess all that influence with her husband, to which such a wife was entitled. " My mother-in-law," she says, " persuaded my husband that I let everything go to wreck. and that, if she did not take care, he would be ruined." The mother-in-law was seconded by the maidservant, and he became

unsettled and vacillating in his affections—not constant in his love ; sometimes, and perhaps always, when separated from their influence, truly and even passionately affectionate ; at other times, and more frequently, distrustful and cruel.

In this perplexed and conflicting state of mind, we find his language and his conduct equally conflicting. Sometimes he speaks to her in the language of violence and abuse, sometimes in a relenting spirit and with affection. He was not pleased with the religious change in his wife. " My husband," she says, " was out of humour with my devotion ; it became insupportable to him. ' *What !*' says he, ' *you love God so much that you love me no longer.*' So little did he comprehend that the true conjugal love is that which is regulated by religious sentiment, and which God himself forms in the heart that loves Him." At other times, when left to his better nature, he insisted much on her being present with him ; and frankly recognising what he saw was very evident, he said to her, " *One sees plainly that you never lose the presence of God.*"

The sorrow, therefore, which pained her life before her conversion, remained afterwards. It was a wound of the heart, deep and terrible, which cannot well be appreciated or expressed. To a woman who possesses those confiding and affectionate inclinations which characterize and adorn the sex, there *can* be no compensation for an absence of love,—least of all, in that sacred and ennobling relation, in which she gives up her heart, in the fond expectation of a heart's return. It is true, that it was a marriage, in the first instance, without much acquaintance ; but still it was not without some degree of confidence, and still less without hope. Madame Guyon always refers to this painful subject with dignity and candour,—not condemning others with severity, and willing to take a full share of blame to herself. These trials would never have been known from her pen, had they not been written at the express command of her spiritual Director ; and she had no expectation that her statements would be made public.

The waiting-maid " became." she says, " every day more

haughty. It seemed as if Satan incited her to torment me. And what enraged her most was, that her vexatious treatment, fretfulness, impertinent complaints and rebukes, had ceased to trouble me. Inwardly supported, I remained silent. It was then that she thought that if she could hinder me from going to partake of the holy Sacrament, she would give me the greatest of all vexations. She was not mistaken, O divine Spouse of holy souls! since the only satisfaction of my life was to receive and honour thee. The church at which I worshipped was called the Magdalen Church. I loved to visit it. I had done something to ornament it, and to furnish it with the silver plates and chalices of the Communion service. It was there, when things were in such a situation at my house as to allow me to do it, that I retired and spent hours in prayer. It was there, with a heart filled with love, that I partook of the holy Sacrament. This girl, who knew where my affections were, and how to wound them, took it into her head to watch me daily. Sometimes I evaded her, and had my seasons of retirement and prayer. Whenever she discovered my going thither, she immediately ran to tell my mother-in-law and my husband.

" One ground of complaint was the length of time which I spent in religious services. Accordingly, when the maid-servant informed them that I had gone to the church, it was enough to excite their angry feelings. I had no rest from their reproofs and invectives that day. If I said anything in my own justification, it was enough to make them speak against me as guilty and sacrilegious, and to cry out against all devotion. If I remained silent, the result was merely to heighten their indignation, and to make them say the most unpleasant things they could devise. If I were out of health, which was not unfrequently the case, they took occasion to come and quarrel with me at my bedside, saying, that my prayers and my sacramental communions were the occasions of my sickness. As if there were nothing else which could make me ill, but my devotions to thee, O my Lord!"

The mother-in-law endeavoured also to alienate the respect and

affections of her eldest son. And she too well succeeded; although there is reason to think that he came to better dispositions in after life. So deep and sacred is a mother's love, this seems to have affected the feelings of Madame Guyon more keenly than anything else in her domestic afflictions. " The heaviest cross," she says, " which I was called to bear, was the loss of my eldest son's affections and his open revolt against me. He exhibited so great disregard and contempt of me, that I could not see him without severe grief." One of her pious friends advised her, since she could not remedy it, that she must suffer it patiently, and leave everything to God.

In general, she thought it best to bear her domestic trials in silence. As a woman of prayer and faith, she regarded them as sent of God for some gracious purpose, and was somewhat fearful of seeking advice and consolation from any other than a Divine source. Indeed she could not well do otherwise, having but few friends whom it would have been prudent to have consulted upon these things. Her own mother was dead. The half-sister, whom she loved so much, and with whom she had been accustomed in earlier life to take counsel, was no longer living. The two sisters of her husband, constituting with him all the children of their family, who seem to have had no unfavourable dispositions, were almost constantly absent at the Benedictine Seminary. They were brought up under the care of the prioress, Genevieve Granger, whom we shall have occasion to mention hereafter. " Sometimes," she remarks on one occasion, " I said to myself, Oh that I had but any one who would take notice of me, or to whom I might unbosom myself! what a relief it would be! But it was not granted me."

These domestic trials were alleviated, in some degree, by the satisfaction which she took in her two younger children. They were both lovely. The third child was a daughter, born in 1669. Of her she speaks in the warm terms of admiration and love, dictated by the observation of her lovely traits of character, as well as by the natural strength of motherly affection. She represents her as budding and opening under her eye into an

object of delightful beauty and attraction. She loved her for her loveliness, and for the God who gave her. When she was deserted by the world, when her husband became estranged from her, she pressed this young daughter to her bosom, and felt that she was blessed. This too, this cherished and sacred pleasure, was soon destined to pass away.

CHAPTER IX.

We are to consult our own improvement and good, as well as of others—Desires to be wholly the Lord's—Efforts to keep the outward appetites in subjection— Remarks—The inordinate action of all parts of the mind to be subdued—Austerities may be practised without the idea of expiation— The monks of La Trappe—Temptations to go back to the world—Visit to Paris—The errors committed there—Grief—Journey to Orleans and Touraine—Temptations and religious infidelities and falls repeated—Incident on the banks of the Loire—Remarks upon her sins—Visit to St. Cloud—Sorrow—Inquiries on holy living.

" Thou shalt love thy neighbour as *thyself.*" Our own vine-yard is not to be neglected. True Christianity verifies its exist-ence and its character, not merely in doing good to others, but partly, at least, in the regulation of our own inward nature. It is not enough to visit the sick and teach the ignorant, to feed the hungry and clothe the naked, while we leave our own appetites and passions unsubdued, unregulated.

The subject of this Memoir, however warm-hearted and diffu-sive may have been her charity to others, felt that there were duties to *herself.* Something within her, told her that God's providence, which searches through all space and reaches all hearts, had designated her, not merely as a subject of forgive-ness, but as a subject of *sanctifying* grace; not merely as a sinner to be saved, but as a living Temple in which His own Godhead should dwell. And He who, in dwelling in the soul, constitutes its true life, inspired desires within her, corresponding to these designs.

Referring to the great change, which she dates specifically as

having taken place on the 22d of July 1668, she says, " I had a
secret desire given me *from that time*, to be wholly devoted to
the disposal of my God. The language of my heart, addressing
itself to my heavenly Father, was, What *couldst* thou demand of
me, which I would not willingly sacrifice or offer thee ? Oh,
spare me not! It seemed to me that I loved God too much,
willingly or knowingly to offend Him. I could hardly hear God
or our Lord Jesus Christ spoken of, without being almost trans-
ported out of myself."

In accordance with these views, she endeavoured to recognise
practically the Saviour's direction, " Whether ye eat or drink,
or whatsoever ye do, do all to the glory of God." And also
that other direction, " If thy right eye offend thee, *pluck it out
and cast it from thee ;* for it is profitable for thee, that one of
thy members should perish, and not that thy whole body should
be cast into hell." It is hardly necessary to say, that no man
can properly be accounted as wholly the Lord's, whose appetites
are not under control. It is possible that such a person may be
a Christian in the ordinary and mitigated sense of the term.
He may possess a soul to which the blood of the Atonement has
been applied ; but still it is a soul which is neither fully nor
adequately renovated. If it be true that the penalty of the
Divine law, in its application to him as an individual, has been
satisfied, it is equally true, I think, that the new creation of the
gospel, the reign inwardly of the Holy Ghost, has not yet fully
come. The great work of sanctification must be carried on and
rendered complete. And the inward man cannot be sanctified
without the sanctification, in some proper sense of the terms, of
that which is outward. And accordingly she was enabled, with
that assistance which God always gives to those who add faith
to their efforts, to subdue and to regulate this important part of
our nature.

Some of the methods she took seem to imply an undue degree
of violence to principles of our nature, which are given us for
wise purposes, and in their appropriate action are entirely inno-
cent. But there is a principle involved in the practical subjec-

tion of the appetites, which will in part justify her course. It is, that an inordinate exercise of the appetites is to be overcome by what may be termed an inordinate repression; which, under other circumstances, would neither be necessary nor proper.

She refused for a time to indulge them in anything, in order that she might regain her lost control, and be enabled afterwards to employ them aright. She curbed them strongly and strictly, not only to break their present domination, but to annul the terrible influence of that law of habit which gave to their domination its permanency and power. "I kept my appetites," she says, "under great restraint; subjecting them to a process of strict and unremitting mortification. It is impossible to subdue the inordinate action of this part of our nature, perverted as it is by long habits of vicious indulgence, unless we deny to it, for a time, the smallest relaxation. Deny it firmly that which gives it pleasure; and if it be necessary, give to it that which disgusts; and persevere in this course, until, in a certain sense, it has no choice in anything which is presented to it. If we, during this warfare with the sensual nature, grant any relaxation, giving a little here and a little there, not because it is right, but because it is *little*, we act like those persons who, under pretext of strengthening a man who is condemned to be starved to death, give him, from time to time, a little nourishment, and thus prolong the man's torments, while they defeat their own object.

"And these views will apply," she adds, "to the propensive and affectional part of our nature, as well as the appetites; and also to the understanding and will. We must meet their inordinate action promptly. The state in which we are *dying to the world*, and the state in which we are *dead to the world*, seem clearly set forth by the apostle Paul *as distinct from each other*. He speaks of bearing about in the body the dying of the Lord Jesus; but lest we should rest here, he fully distinguishes this from the state of *being dead, and having our life hid with Christ in God*. It is only by a total death to self that we can experience the state of Divine union, and be lost in God.

" But when a person has once experienced this loss of self, and has become *dead to sin*, he has no further need of that extreme system of repression and mortification which, with the Divine blessing, had given him the victory. The end for which mortification was practised is accomplished, and all is become new. It is an unhappy error in those who have arrived at the conquest of the bodily senses, through a series of long and unremitted mortifications, that they should still continue attached to the exercise of them. *From this time, when the senses have ceased from their inordinate action, we should permit them to accept, with indifference and equanimity of mind, whatever the Lord sees fit in His providence to give them—the pleasant and the unpleasant, the sweet and the bitter.*

" And having obtained the victory over the appetites, he who seeks after entire holiness will pass on to other parts of our fallen nature, and endeavour to subject the wandering intellect, the misplaced affections, and the inordinate will. Severely repressive acts, analogous to the cutting off the right hand, or the plucking out of the right eye, must be put forth here also. And success may be expected, if the efforts of the creature, which are always utter weakness without the inspiration of God and the Divine blessing, are attended with prayer, faith, and the spirit of serious and devout recollection."

Her views of austerities or acts of mortification, in her Autobiography, as they are interpreted and perhaps somewhat modified in her Short Method of Prayer, and her other works, are less objectionable than some might suppose, who have not carefully examined them. It is very probable, that her earliest views on this subject were incorrect and dangerous. But after she had become emancipated (which was the case at an early period of her experience) from certain early impressions, it is obvious that she regarded acts of austerity and mortification as having relation to the laws of our nature, and not as furnishing an atoning element; as disciplinary and not as *expiatory*—a distinction which is radical and of great consequence.

I doubt not that the distinction which separates the idea of

expiation from austere and self-mortifying acts, and makes them
merely *disciplinary,* would be found to hold good in many in-
stances; but, without pretending to say how far this may be
the case, I will relate here a single incident which will illustrate
what I mean. The monks of the celebrated monastery of La
Trappe, in France, after the reform effected there by M. De Rancé,
were exceedingly strict in their mode of life. The deprivations
they endured, and the austerities they imposed upon themselves,
seemed to be as great as human nature is well capable of en-
during. A person visited the monastery, and witnessing the
austerities practised, he expressed his admiration of their self-
denial in rejecting those indulgences so common among other
persons. The monks, laying their hands on their hearts, with
a look of deep humiliation, replied in words to this effect :—
" We bless God that we find Him all-sufficient without the pos-
session of those things to which you have referred. We reject
all such possessions and indulgences, but without *claiming any
merit for it. Our deepest penances are proper subjects of repent-
ance.* We should have been here to little purpose, had we not
learned that our penitential acts, performed with too little feeling,
are not such as they should be ; and that our righteousness is
not free from imperfection and pollution. Whatever we may
endure, or for whatever reason it may be done, we ascribe all
our hopes of mercy and acceptance to the blood of Christ
alone."*

The subjection of the appetites, which has a close connexion
with mental purity, and is exceedingly important, constitutes
but a small part of that physical and mental contest and victory
to which the Christian is called. His whole nature, every
thought and every feeling, every act of the desires and of the
will, is to be brought into subjection to the law of Christ.
Madame Guyon, with the great powers of analysis and reflection
she possessed, fully understood this. It was her desire and
purpose, both in body and in spirit, to be wholly the Lord's.

* Account of the Monastery of La Trappe, and of the Institution of Port Royal, by
Mary Anne Schimmelpenninck vol. i, p. 140.

But she found that the contest, which she was summoned to carry on with other and higher parts of her nature, was more trying and less successful.

Under the influence of principles which are good when they are not inordinate, she found to her great grief that she still loved to hear and to know more than a sanctified Christianity would allow. Man, under the influence of the natural life, is disposed to diffuse himself—to overleap the humbling barriers of God's providence, and to mingle in what is not his own. The principle of curiosity, always strong, but especially so in a mind like hers, was not only not dead, but what is still more important, it ceased to be properly regulated. It was still a matter of interest with her to see and be seen, and to experience the pleasures of worldly intercourse and conversation.

At one time the contest in this direction was very considerable. Satan knew how and where to aim his arrows. He had sagacity enough to perceive that she was not a woman that could easily be subduced by appeals and temptations applied to her physical nature, but that they must be made to her great powers of intellect, her pride of character, and desire of personal admiration and personal influence. The suggestion came insidiously, but it entered deeply into the heart. For two years she had laboured faithfully in the cause of Christ We do not mean to say that she had been without sin, but that she had struggled faithfully, though sometimes unsuccessfully against sin, and without ever thinking for a moment of yielding quietly to its solicitations and influences ; and it was not till after all this favourable probation that the secret whisper, breathed out gently and with great art, came to her soul. It came from the source of all evil, and was applied with Satanic skill. Is it possible that I must so far give up all to God, that I shall have nothing left for the world ? In this age of refinement and pleasure, when everything is awake to intelligence, and when there is apparently but one voice of joy, is it necessary, or even reasonable, that my eye should be shut and my ears closed, and my lips silent ? The assault was made with so much adroitness, that her religious resolution,

after having been strenuously sustained for some time, began
to waver.

In connexion with this state of things, she speaks of a visit
of some length in Paris—her usual residence being a short dis-
tance out of the city. In expressions which convey an ominous
import to the religious mind, she says, " *I relaxed in my usual
religious exercises, on account of the little time I had.*" Reli-
gious declensions generally begin in this way. When she went
to Paris, she seems to have been comparatively in a good reli-
gious state. She speaks of God's grace to her—of His continual
presence and care. She had experienced some heavy tempta-
tions and trials before, but does not appear to have yielded to
them in any great degree. But she felt here as she had not felt
before, since she professed to walk in a new life—the dangerous
power of the heart, even of the *Christian* heart, whenever left
to itself, and unrestrained by Divine grace. Speaking of her
internal state, she says, " I seemed to myself to be like one of
those young brides, who find a difficulty after their marriage, in
laying aside their self-indulgence and self-love, and in faithfully
following their husbands into the duties and cares of life." To
a mind not fully established in the religious life, or temporarily
shaken in its religious principles, Paris was a place full of
hazard. She found the temptation great ; and it is a sad com-
mentary on human weakness, that she in some degree yielded
to it.

She says, " *I did many things which I ought not to have done.*"
What these things were, we do not fully know. She mentions,
however, as one thing which gave her trouble, that she felt an
improper gratification in receiving the attention of others. In
other words, her vanity still lived. There were a number of
persons in the city, apparently persons without experimental re-
ligion, who were extremely fond of her ; and it was one of her
faults that she allowed them to express their personal regard in
too strong terms, without checking it as she ought. It appears
also that she regarded herself as having conformed too much to
the dress of the Parisian ladies. Among other things which

indicate her sense of her danger and actual unfaithfulness to God, she speaks of promenading in the public walks of the city —a practice not necessarily improper or sinful. She did not do it merely out of complaisance to her friends, nor for the physical pleasure and benefit which might be expected from the practice; but partly, at least, from the unsanctified feeling of personal display, the desire of seeing and of *being seen.* But deeply did she lament these falls.

" As I saw that the purity of my state was likely to be sullied by a too great intercourse with the world, I made haste to finish the business which detained me at Paris, in order to return to the country. It is true, O God, I felt that thou hadst given me strength enough, in connexion with thy promised assistance, to avoid the occasions of evil. But I found myself in a situation of peculiar temptation. And I had so far yielded to the evil influences to which I had been exposed, that I found it difficult to resist the vain ceremonies and complaisances which characterize fashionable life. Invited to join in the pleasures to which the world was so generally and strongly devoted, I was very far from tasting the satisfaction which they seemed to give to others. ' *Alas !*' said I, ' *this is not my God, and nothing beside Him can give solid pleasure.*'

" I was not only disappointed, but I felt the deep sorrow which always afflicts unfaithful souls. I cannot well describe the anguish of which I was the subject. It was like a consuming fire. Banished from the presence of my Beloved, my bridegroom, how could I be happy ! I could not find access to Him, and I certainly could not find rest out of Him. I knew not what to do. I was like the dove out of the Ark ; which, finding no rest for the sole of its foot, was constrained to return again ; but finding the window shut, could only fly about without being able to enter."

Her husband, with a keen eye, saw her position, and we may well suppose secretly rejoiced at it. It was no disquiet to him, looking at the matter in the worldly light, that she had made her appearance in the fashionable companies of the most gay

and fashionable city in world. And still he could not but see
that the snare, which was thus laid for the faith and piety of
his wife, in the attractions and assemblies of Paris, had in some
degree failed. He was not ignorant that she had seen her
danger, and exhibited the wisdom and the decision to flee from
it. But certainly, if her religious principle was thus severely
tested at Paris, there could be no hazard to it, in her making
an excursion into the country, among mountains and rivers,
and others of God's great works. This, obviously, was a very
natural suggestion. It was proposed, therefore, that she should
take a distant journey. Her husband could go with her, and
was ready to do it. His state of health was such, that it could
hardly fail to be beneficial. And if her own health should not
be improved, as would be very likely, it would certainly contri-
bute to her happiness. And it was an incidental consideration
which had its weight, that Montargis, the place of her early life,
could be visited in the way. Orleans, too, which was in the
tour, was a celebrated and beautiful city. Nor was it a small
thing to an imaginative mind like hers, to tread the banks and
to behold the scenery of the magnificent Loire. With that
great river there were some interesting recollections connected.
Not many years before, its waters had been wedded to those of
the Seine by the Canal of Briare—an astonishing work, a monu-
ment of the enterprise of her husband's father, and the principal
source of the wealth of her family. Hence arose the journey
to the distant province of Touraine, in the spring or summer
of 1670.

But this journey also was attended with temptation and sin.
During the life of her husband, she generally journeyed in a
carriage, and with such attendants and equipage as were thought
suitable to her position in society, or as her husband's desires
and tastes might dictate. As she travelled from town to town,
in the Orleanois and down the Loire, known in history and
song, her eye betrayed her heart, and she found the spirit of
worldly interest again waking up within her. But the com-
pany of others, involving as it does the suggestions and solicita-

tions of unsanctified nature, is sometimes more dangerous than the sight of cities or of the works of nature and art. In that part of France her father's family and her husband's had been known, so that her movements were not likely to be kept secret. Her personal reputation had preceded her. Her powers of conversation were remarkable, and were always felt when she was disposed to exert them. Men were taken also with her beauty and wealth. " In this journey," she says, " abundance of visits and applauses were bestowed upon me; and I, who had already experienced the pangs of being unfaithful to God, found emotions of vanity once more springing to life within me. Strange as it may appear, and after all the bitterness I had experienced, I loved human applause, while I clearly perceived its folly. And I loved that in myself which caused this applause, while in the conflict of my mind's feelings, I desired to be delivered from it. The life of nature was pleased with public favour; but the life of grace made me see the danger of it, and dread it. Oh, what pangs the heart feels in this situation! Deep was the affliction which this combat of grace and nature cost me! What rendered my position the more dangerous was, that they not only praised my youth and beauty, but passed compliments upon my virtue. But this I could not receive. I had been too deeply taught that there is nothing but unworthiness and weakness in myself, and that all goodness is from God."

" We met with some accidents," she says, " in this journey, which were sufficient to have impressed and terrified any one. And it is proper for me to say, with gratitude, that though the corruptions of my nature prevailed against me, my heavenly Father did not desert me. He kept me submissive and resigned in dangers, where there seemed to be no possibility of escape. At one time, on the banks of the Loire, we got into a narrow path, from which we could not well retreat. The waves of the river washed the base of the narrow road before us, and partly undermined it, so that it was necessary for our footman to support one side of the carriage. All around me were terrified; but God kept me in tranquillity. Indeed, sensible of my weak-

ness, and fearful that I might still more dishonour Him, I seemed to have a secret desire, that He would take me out of the temptations of the world, by some sudden stroke of His providence."

In the sorrow and depression of her spirit, she went in search of religious friends and teachers, to confess and lament her backslidings. But they did not, or perhaps could not, enter into her feelings. "They did not condemn," she says, "what God condemned; and treated those things as excusable and proper, which seemed to me to be disapproved and even detestable in His sight. But in saying that they wholly extenuated my faults, or did not consider them very great, I ought to add, that they did not understand (nobody but myself *could* understand) how much God had done for me. Instead of measuring my faults by the mercies and graces which God had conferred upon me, they only considered what I was, in comparison *with what I might have been*. Hence their remarks tended to flatter my pride, and to justify me in things which incurred the Divine displeasure.

"It is an important remark, that a sin is not to be measured merely by its nature, *in itself considered;* but also by the state of the person who commits it; as the least unfaithfulness in a wife is more injurious to a husband, and affects him more deeply, than far greater acts of unkindness and neglect in his domestics. I had given myself to God in a bond of union more sacred than any human tie. Was it possible, then, to bestow my thoughts and affections on another, without offending Him to whom my soul had already betrothed itself? My trials were connected, in part, with the fashions of those gay times, the modes of dress, and methods of personal intercourse. It seemed to me that the dress of the ladies, with whom, in my journey to Orleans and Touraine, I was led almost necessarily to associate, was hardly consistent with Christian, or even natural modesty and decorum. I did not wholly conform to the prevalent modes, but I went too far in that direction.

"My associates, seeing that I covered my neck much more than was common for females at that time, assured me that I

was quite modest and Christian-like in my attire; and as my husband liked my dress, there could be nothing amiss in it. But something within me told me that it was not so. The Christian knows what it is to hear the voice of God in his soul. This inward voice troubled me. It seemed to say, Whither art thou going, thou 'whom my soul loveth?' Divine love drew me gently and sweetly in one direction; while natural vanity violently dragged me in another. I was undecided; loving God, but not wholly willing to give up the world. My heart was rent asunder by the contest."

This was indeed a sad state. But there was another marked difference between the present and her former state. In the days of her life of nature, she not only sinned, but had in reality no disposition to do otherwise. She *loved* to sin. Renovated now, though imperfect—sincerely desirous to do right, though often failing to do so—she could not fall into transgression without the deepest sorrow and torment of mind. Sin had lost the sweetness which once characterized it. She began to perceive, that even the smallest transgression cannot fail to separate from God.

If, under the impulse of an unsanctified curiosity, she gave an unguarded look—if in a moment of temptation she uttered a hasty reply to the rebukes and accusations of others—(moral delinquencies which some might not regard as very great)—it cost her bitter tears. Even when she dispensed her munificent charity, which brought consolation to the poor and suffering, she sometimes found, with sorrow of heart, that the donation which ought to have been made with "*a single eye*," was corrupted by a glance at the rewards of self-complacency and of worldly applause.

"The God of love," she says, "so enlightened my heart, and so scrutinized its secret springs, that the smallest defects became exposed. In my conversation I could often discover some secret motive which was evil, and was in consequence compelled to keep silence. And even my silence, when examined by the aid of the Divine light, was not exempt from imperfection. If I

was led to converse about myself, and said anything in my own
favour, I discovered pride. And I could not even walk the
streets, without sometimes noticing in my movements the impulse
of the life of self." She seemed to be in the condition described
in the seventh chapter of Romans—a description which will
apply both to the struggles of the enlightened sinner when
deeply convicted of his transgressions, and to the inward con-
flicts of the partially sanctified Christian. "I delight in the
law of God after the inward man; but I see another law in my
members, warring against the law of my mind, and bringing me
into captivity to the law of sin."

"It must not be supposed, however," she adds, "that God
suffered my faults to go unpunished. O my God!—with what
rigour dost thou punish the most faithful, the most loving and
beloved of thy children! The anguish which the truly devout
soul experiences, when it sees sin in itself, is inexpressible.
The method which God takes inwardly to correct those whom
He designs to purify radically and completely, must be felt, in
order to be understood. This anguish of the soul can perhaps
best be expressed by calling it a secret burning—an internal
fire; or perhaps it may be compared to a dislocated joint, which
is in incessant torment, until the bone is replaced. Sometimes
such a soul is tempted to look to men and to seek consolation in
the creature; but this is in violation of God's designs upon it
and it cannot in that way find any true rest. It is best to endur.
patiently, till God sees fit, in His own time and way, to remove
the agony.

In this divided state of mind, continually striving for a better
religious state, and yet continually faltering and failing in her
resolutions, she received an invitation to make one in a fashion-
able party to visit St. Cloud. This beautiful village, situated
on the banks of the Seine, at the distance of only six miles from
Paris, was then, as it is now, the resort of fashionable society.
Celebrated for its natural scenery, its park, and the magnificent
palace and gardens of the Duke of Orleans, it was the chosen
spot for the residences of many families of wealth and taste

Other ladies, with whom she was well acquainted, were invited to the festival; and their solicitations were employed to induce her to go with them. She yielded, but not without condemning herself for doing it.

"I went," she says, "through a spirit of weak compliance, and from the impulse of vanity. Everything connected with the entertainment was magnificent. It was an occasion especially adapted to meet the wants and views of the votaries of worldly pleasure. The ladies who attended me, wise in worldly wisdom, but not in the things of religion, relished it. But as for me, it filled me with bitterness. I pleased others; but I offended Him whom I ought most to have pleased. Rich were the tables that were spread, but I could eat nothing. The sounds of festivity and joy arose on every side; but it was not possible for me to enjoy anything. Pleasure shone in the looks of other visitants, but sorrow was written upon mine. O what tears did this false step cost me! My Beloved was offended. For above three long months, He withdrew entirely the favours of His presence. I could see nothing but an angry God before me."

One important lesson which she learned from these temptations and follies—a lesson as important as any which the nature of the Christian life renders indispensable—was that of her entire dependence on Divine grace. "I became," she says, "deeply assured of what the prophet hath said, '*Except the Lord keep the city, the watchman waketh but in vain!*' When I looked to thee, O my Lord! thou wast my faithful keeper; thou didst continually defend my heart against all kinds of enemies. But, alas! when left to myself, I was all weakness. How easily did my enemies prevail over me! Let others ascribe their victories to their own fidelity: as for myself, I shall never attribute them to anything else than thy paternal care. I have too often experienced, to my cost, what I should be without thee, to presume in the least on any wisdom or efforts of my own. It is to thee, O God, my Deliverer, that I owe everything! And it is a source of infinite satisfaction, that I am thus indebted to thee."

From this time, she gave her mind to the great subject of holy living, with a deep and solemn earnestness, which she had never experienced before. She began to realize the tremendous import of those solemn words of the Saviour, *" No man can serve two masters ; for either he will hate the one and love the other ; or else he will hold to the one and despise the other. Ye cannot serve God and mammon."*

There is but one way for the Christian to walk in. It is not possible that there should be any other. *" A strait and narrow way,"* it is true ; but still, properly speaking, not a *difficult way.* Undoubtedly it is difficult to a heart naturally averse to it, to enter into it, and to become entirely naturalized to it. Sometimes the difficulty is very great ; but when once the process is fairly begun, and the influence of old habits is broken, the difficulty is, in a great degree, removed ; and it becomes true, as the Saviour has said, that His " yoke is easy, and His burden is light."

But people do not understand this ; FIRST, because, in a multitude of cases, they do not make the experiment at all—they do not *even enter into the way ;* and SECONDLY, because they do not persevere in the experiment sufficiently long to render it a fair one. But whether difficult or not, whether the difficulty continues for a longer or shorter time, it is God's way, and therefore the only true and safe way. But why is it described as a strait and narrow way ? I answer, because it is a way in which every step is regulated by God's will. It is a way of one principle, and cannot therefore be otherwise than both strait and narrow. Any deviation from that will, however slight it may be, is necessarily a step out of the way. It is not only the way *which leads to life,* as the Scriptures express it ; but it does of itself constitute a life, *because he, who is in God's will, is in life, and life is in him.* " This," says the apostle John, " is the record,—That God hath given to us eternal life ; and this life is in His Son. *He that hath the Son hath life ; and he that hath not the Son of God hath not life."* (1 John v. 11, 12.)

CHAPTER X.

In this season of temptation and penitence, of trial and of comparative despondency, she looked around for advice and assistance. Not fully informed in respect to the nature of the inward life, she felt perplexed at her own situation. In the first joy of her spiritual espousals, she looked upon herself, as is frequently the case, not only as a sinner forgiven for the sins past, but what is a very different thing, as a sinner saved from the commission of sin for the present, and in all future time. Looking at the subject in the excited state of her young love, when the turbulent emotions perplex the calm exercises of the judgment, she appears to have regarded the victory which God had given her, as one which would stand against all possible assaults ; the greatness of her triumph for to-day scarcely exceeding the strength of her confidence for to-morrow. She felt no sting in her conscience ; she bore no cloud on her brow.

How surprised, then, was she to find, after a short period, and a more close and thorough examination, that her best acts were mingled with imperfection and sin ; and that every day, as she was increasingly enlightened by the Holy Ghost, she seemed to discover more and more of motives to action, which might be described as sinful. After all her struggles and hopes, she found herself in the situation of being condemned to bear about a secret but terrible enemy in her own bosom. Under these circumstances, it was natural to look around for some religious person who might render her some assistance. Were others in the same situation ? Was it our destiny to be always sinning and always repenting ? Was there really no hope of deliverance

from transgression till we might find it in the grave ? Such were some of the questions which arose in her mind. Who could tell her what to do, or how to do it ?

This was not an age which was distinguished for piety, particularly in France. Pious individuals undoubtedly there were, but piety was not its characteristic. We cannot well forget that it was in this age that the Port-Royalists acquired a name which will long be celebrated. From time to time some gay young people of Paris, or the provinces, sick of the vanities of the world, went into religious retirement, and were known no more, except by pious works and prayers. Others, like the celebrated M. Bouthillier de Rancé, possessed of talents that would have signalized almost any name, found their career of aspiring worldliness coming in conflict with the arrangements of Providence, and were ultimately led in the way, which at the time seemed full of sorrow and perplexity, to adore the hand which secretly smote them. We cannot well forget, that the daughters of the great Colbert, the Sully of the age of Louis XIV., ladies alike distinguished by character and by position, set an illustrious example, in a corrupt period of the world, of sincere, decided, and unaffected piety. This was the age and country of Nicole and Arnauld, of Pascal and Racine. In the retirement of La Trappe, as well as in the cells of Port-Royal, at St. Cyr, and, strange to say, within the terrible walls of the Bastille, prayers ascended from devout hearts.* And may we not say, that, in every age and every country, God has a people ; that in periods of religious declension, as well as at other times, He has His followers, few though they may be, who are known, appreciated, and beloved by Him whose favour alone is life ?

But Madame Guyon did not find those helps from personal intercourse which would have been desirable. Christian friends of deep piety and of sound judgment were few in number. But there were some such to whom she had access ;—one of whom,

* I refer, among other instances, to Father Seguenot, a priest of the Congregation of the Oratory, and to M. de St. Claude, a distinguished Port-Royalist, and a man of great piety, both confined in the dungeons of the Bastille.

in particular, Genevieve Granger, the devout and judicious Prioress of a community of Benedictines established a short distance from the place of her residence, she often mentions. To her she had been introduced some years before by the Franciscan, whom Providence had employed as the special means of her conversion. The acquaintance was rendered the more natural and easy, because her husband's sisters had been for some time under the care of the Prioress. To her, more freely and more fully than to any other, she made known the temptations she had experienced, and the falls of which she had been guilty.

This pious woman understood Madame Guyon's religious position, and encouraged her much in her hopes and purposes of a new and amended life. She probably had some foresight of the position which Providence might call her to occupy, and of the influence she might exert. She explained to her the great difficulty of uniting a conformity with the world, even to a limited extent, with an entire fulfilment of Christian obligations. Her own personal experience was calculated to add weight to her suggestions. Adopting the principle, that it is possible for us, even amid the temptations of the present life, *to live wholly to God*, she was unwilling to see any one, especially such a person as Madame Guyon, adopting a standard of feeling and action below the mark of entire consecration and perfect faith and love.

Madame Guyon, at this period, began to have a more distinct and realizing perception of what is implied in a sanctified life. Some portions of her reading, as well as her personal experience, had been favourable to this result. In the Life of Madame de Chantal, which she had read with great interest, she found the doctrine of holiness, so far as it may be supposed to consist in a will subjected to God, and in a heart filled with love, illustrated in daily living and practice, as well as asserted as a doctrine. The writings of Francis de Sales are characterized, in distinction from many other devout writings of the period in which he lived, by insisting on continual walking with God, on the entire surrender of the human will to the divine, and on the existence of pure love. The writings of this devout and learned man

seem to have been her constant companions through life. The
Imitation of Christ, generally ascribed to Thomas-à-Kempis, is
animated by the same spirit of high Christian attainment. All
these writers, under different forms of expression, agree in
strenuously teaching that the whole heart, the whole life, should
be given to God; and that in some true sense this entire sur-
render, not excluding, however, a constant sense of demerit and
of dependence on God, and the constant need of the applica-
tion of Christ's blood, is in reality not less practicable than it is
obligatory.

Her mind, therefore, had been prepared to receive promptly,
and to confide strongly in, the suggestions and admonitions of the
Benedictine Prioress. The few facts which can be gathered from
the writings of Madame Guyon, are enough to show that Gene-
vieve Granger was a woman who combined strength of intellect
with humble piety. The world did not know her, but she was
not unknown to Him who made the world. She may be de-
scribed as one of those who live in the world without the de-
basements of a worldly spirit, and of whom it can be said, that
" *the secret of the Lord is with them that fear Him.*" And it is
well for those who are seeking religion, or inquiring the me-
thods of progress in religion, to learn of those who have thus
been taught.

At this most interesting juncture an incident occurred, some-
what remarkable, which made a deep impression on her mind.
She went to attend some religious services in the celebrated
church of Notre Dame at Paris. As the weather was inviting,
she did not take a carriage as usual, but decided to walk, al-
though her house was some miles distant. She was attended,
however, by a footman, as she generally was at this period of
her life. Just as they had passed one of the bridges over the
Seine, a person appeared at her side and entered into conversa-
tion;—a man religiously solemn and instructive in his appear-
ance and intercourse, but so poor and almost repulsive in his
attire, that, at their first meeting, thinking him an object of
charity, she offered him alms.

" This man spoke to me," she says, " in a wonderful man-
ner, of God and Divine things. His remarks on the Holy
Trinity were more instructive and sublime than I had heard on
any other occasion, or from any other person. But his conver-
sation was chiefly personal. I know not how it was, but he
seemed in some way to have acquired a remarkable knowledge
of my character. He professed to regard me as a Christian, and
spoke especially of my love to God, and my numerous charities;
and, while he recognised all that was good in me, he felt it his
duty to speak to me plainly of my faults. He told me that I
was too fond of my personal attractions; and enumerated, one
after another, the various faults and imperfections of my life.
And then, assuming a higher tone, he gave me to understand
that God required not merely a heart of which it could only be
said, it is forgiven, but a heart which could properly, and in
some real sense, be designated as *holy ;* that it was not sufficient
to escape hell, but that he demanded also the subjection of our
nature, and the utmost purity and height of Christian attainment.
The circumstance of his wearing the dress of a mendicant, did
not prevent his speaking like one having authority. There was
something in him which commanded my silence and profound
respect. The Spirit of God bore witness to what he said. The
words of this remarkable man, whom I never saw before, and
whom I have never seen since, penetrated my very soul. Deeply
affected and overcome by what he said, I had no sooner reached
the church than I fainted away."

Previously, Madame Guyon had learned the great lesson of
recognising God in His providences; and, under the influence
of this indispensable knowledge, she could not doubt who it was
that was speaking to her in the voice of His servants. Aroused
by what she had experienced of her own weakness, and startled
into solemn thought by these repeated warnings, *she gave her-
self to the Lord anew.*

And here we may mark a distinct and very important crisis
in the history of her spiritual being. Taught by sad experi-
ence, she saw the utter impossibility of combining the love of the

world with the love of God. " From this day, this hour, if it
be possible, I will be wholly the Lord's. The world shall have
no portion in me." Such was the language of her heart,—such
her solemn determination. She formed her resolution after
counting the cost,—a resolution which was made in God's
strength, and not in her own; which, in after life, was often
smitten by the storm and tried in the fire; but, from this time
onward, so far as we know anything of her history, was never
consumed,—was never broken. She gave herself to the Lord,
not only to be His in the ordinary and mitigated sense of the
terms, but to be His *wholly*, and to be His *for ever*—to be His
in body and in spirit—to be His in personal efforts and influence
—to be His in all that she *was*, and in all that it was *possible
for her to be*. There was no reserve.

Her consecration, made in the spirit of entire self-renounce-
ment, was a consecration to God's will, and not *to her own;* to
be what God would have her to be, and not what her fallen nature
would have her to be. Two years after this time, she placed her
signature to a written Act of Covenant or Act of Consecration;
but the act itself she made previously, made it *now*, and made
it *irrevocable*. In its substance it was written in the heart, and
was witnessed by the Holy Ghost. God accepted the offering
of herself, for He knew it to be sincere, because He himself, who
is the Author of every good purpose, had inspired it.

Desire, even *religious* desire, without a strong basis of *sin-
cerity*, often stops short of affecting the will; but, in religion
especially, desire without will is practically of no value. Madame
Guyon not only desired to be, but resolved to be holy. Her *will*
was in the thing—the will, which constitutes in its action the
unity of the whole mind's action, and which is the true and only
certain exponent of the inward moral and religious condition.

And here we find the great difficulty in the position of many
religious men at the present time. They profess to desire to be
holy, and perhaps they do desire it. They pray for it as well as
desire it. But, after all, it is too often the case that they are *not
willing to be holy*. They are not ready, by a consecrating act,

resting on a deliberate and solemn purpose, to place themselves in a position, which they have every reason to think will, by God's grace, result in holiness. This may be regarded, perhaps, as a nice distinction; but when rightly understood, it seems to me to lie deep and unchangeable in the mind. In the cases to which we refer, the desire, whatever may be its strength, is not strong enough to control the volition. The will, therefore, is not brought into the true position. The will, considered in relation to the other powers of the mind, constitutes the mind's unity. The will is wanting. The man, therefore, is wanting.

Many already dead to all claims of personal merit in the matter of salvation, and thinking that they may now live on their own stock, and in the strength of their own vitality and power, do not understand (alas, how few do understand it!) that they must not only die to their own MERITS, but must die to their own LIFE; that they must not only die to Christ on the cross that they may *begin* to have the true life, but that they must die to Christ on the cross that they may *continue* to have life. In other words, they must not only be so broken and humbled as to receive Christ as a Saviour from hell; but must be willing also, renouncing all natural desire and all human strength, and all of man's wisdom and man's hope, and all self-will, to receive Him as a Saviour, moment by moment, from sin.

And this they are not *willing* to do; and therefore, although they have God's promise to help them, they will not purpose and resolve to do it. Their wills do not correspond with what *must* be, with what God *requires* to be, and cannot do otherwise than require to be, just so far as He carries on and completes the work of sanctification in the soul; namely, that God's own hand must lay the axe of inward crucifixion unsparingly at the root of the natural life; that God in Christ, operating in the person of the Holy Ghost, must be the principle of inward inspiration *moment by moment*, the crucifier of every wrong desire and purpose, the Author of every right and holy purpose, the light and life of the soul.

But upon this altar of sacrifice, terrible as it is to the natural

mind, Madame Guyon did not hesitate to place herself, believing that God would accomplish His own work in His own time and way. She invited the hand of the destroyer, that she might live again from the ruins of that which should be slain. He who does not willingly afflict His children, but pities them as a Father, accepted the work thus committed to Him. It is sometimes the case that God subdues and exterminates that inordinate action of the mind, which is conveniently denominated the life of nature, by the inward teaching and operation of the Holy Ghost, independently, in a considerable degree, of the agency of any marked providences. Such cases, however, are rare. Much more frequently it is done by the appropriate application of His providences, in connexion with the inward influence.

It was this combined process, to which the subject of this Memoir, in the spirit of a heart that seeks its own destruction, submitted herself. She had given herself to God without reserve; and He did not long withhold or conceal the evidence of her acceptance. The one followed the other without delay and without misgiving. Knowing that her resolutions, and spirit of self-sacrifice, independently of His foresight and assistance, would be of no avail, He arranged a series of physical and moral adjustments, which resulted in blow after blow, till the pride of nature, which sometimes stands like a wall of adamant, was thoroughly broken. It was then, and not till then, that her soul entered into that state of purity and rest, which she has significantly denominated its state of " *simplicity ;*" a state in which the soul has but one motive, that of *God's will,* and but one source of happiness, that of *God's glory.*

The first thing He did was to smite her beauty with that dreadful scourge, the small-pox. The summer was over; her ear no longer listened to the waters of the Loire ; the festivities of St. Cloud and Paris had passed away. On the 4th of October 1670, the blow came upon her like lightning from heaven. This dreadful disease was not then shorn of its terrors by that merciful Providence which directed the philosophic mind of Jenner in the discovery of its wonderful preventive. And she

was thus smitten when she was a little more than twenty-two years of age. When it was discovered that the hand of the Lord was thus upon her, her friends exhibited great emotion. They came around her bedside, and almost forgetting that her life was in danger, deplored in feeling language the mysterious and fatal attack, which was thus made upon charms which had been so much celebrated.

"Before I fell under this disease," she says, "I resembled those animals destined for slaughter, which on certain days they adorn with greens and flowers, and bring in pomp into the city, before they kill them. My whole body looked like that of a leper. All who saw me said they had never seen such a shocking spectacle. But the devastation without was counterbalanced by peace within. My soul was kept in a state of contentment, greater than can be expressed. Reminded continually of one of the causes of my religious trials and falls, I indulged the hope of regaining my inward liberty by the loss of that outward beauty which had been my grief. This view of my condition rendered my soul so well satisfied, that it would not have exchanged its condition for that of the most happy prince in the world.

"Every one thought I should be inconsolable. Several of my friends came around me, and gave utterance to their regret and sympathy in view of my sad condition. As I lay in my bed, suffering the total deprivation of that which had been a snare to my pride, I experienced a joy unspeakable. I praised God in profound silence. None ever heard any complaints from me, either of my pains or of the loss which I sustained. Thankfully I received everything, as from God's hand ; and I did not hesitate to say to those who expressed their regret and sympathy, that I rejoiced at that in which they found so much cause of lamentation.

"When I had so far recovered as to be able to sit up in my bed, I ordered a mirror to be brought, and indulged my curiosity so far as to view myself in it. I was no longer what I was once. It was then that I saw that my heavenly Father had not been

unfaithful in His work, but had ordered the sacrifice in all its reality. Some persons sent me a sort of pomatum, which they said would have the effect of filling up the hollows of the small-pox, and restoring my complexion. I had myself seen wonderful effects from it upon others; and the first impulse of my mind was to test its merits in my own case. But God, jealous of His work, would not suffer it. The inward voice spoke. There was something in my heart which said, ' *If I would have had thee fair, I would have left thee as thou wert.*'

" Fearful of offending God by setting myself against the designs of His providence, I was obliged to lay aside the remedies which were brought me. I was under the necessity of going into the open air, which made the hollows of my face worse. As soon as I was able, I did not hesitate to go into the streets and places where I had been accustomed to go previously, in order that my humiliation might triumph in the very places where my unholy pride had been exalted.

" During these afflictions, the trials in connexion with my husband's family continued. At the commencement of my sickness, I was so much neglected by my mother-in-law that I was on the point of dying for want of succour. Such was the state of my husband's health at this time, that I was necessarily left, in a great degree, to her care. She would not allow any physician but her own to prescribe for me; and yet she did not send for him for some time, although he was within a day's journey of us. He came at last, when I had providentially received some assistance from another source, and when he could be of but little service to me. In this extremity I opened not my mouth to request any human succour. I looked for life or death from the hand of God, without testifying the least uneasiness at so strange a course of conduct. The peace I enjoyed within, on account of that perfect resignation in which God kept me by His grace, was so great, that it made me forget myself in the midst of such violent maladies and pressing dangers.

" And if it was thus in my sickness, it could not well be expected that my mother-in-law would exhibit any more favourable

dispositions after my recovery. She did not cease at all in her unkind efforts to alienate my husband's affections from me. And now, as God had smitten and taken away whatever there was of beauty in my countenance, he seemed to be more susceptible tnan ever of any unfavourable impressions. In consequence, the persons who spoke to him to my disadvantage, finding themselves more listened to than formerly, repeated their attacks upon me more frequently and more boldly. Others changed, but God did not change. Thou only, O my God! didst remain the same. Thou didst smite me without, but didst not cease to bless me within. In augmenting my exterior crosses, thou didst not cease to increase my inward graces and happiness."

But the work of God was not yet accomplished. If He had smitten and demolished one dear idol, there were others which remained. God had given her two sons. The eldest was in the sixth year, the youngest in the fourth year of his age. She loved them both; but one was especially the son of her affections. The eldest she loved with some alternations of feeling, and in deep sorrow. The same causes which operated to disturb and alienate her husband's affections, had their influence here. The second son was not thus injured. In the favourable opening of his young affections and intellect, he filled the measure of a mother's fondness and hopes. Her heart was fixed upon him. But God, who knew on which side danger lay, took her Jacob, and left her Esau.

He was seized with the same terrible disease. "This blow," she says, "struck me to the heart. I was overwhelmed; but God gave me strength in my weakness. I loved my young boy tenderly; but though I was greatly afflicted at his death, I saw the hand of the Lord so clearly that I shed no tears. I offered him up to God; and said in the language of Job, 'The Lord gave, and the Lord hath taken away. Blessed be his name.'"

During these successive trials, she recognised the hand that smote her, and blessed it. Her prayer was that God, in the work of destruction, would take from her entirely the power of displeasing Him. "Art thou not strong enough," she exclaimed,

D

" to take from me this unholy duplicity of mind, and to make me one with thyself?" She says that it was a consolation to her to experience the rigours of God. She loved God's justice. She rejoiced in His holy administration, however it might touch and wither all her worldly prospects. She felt that He was right as well as merciful, just as well as good; and that both justice and mercy are to be praised.

About this time we find the first mention of her attempts at poetry. Poetry is the natural expression of strong feeling. She felt, and she wrote. Voltaire, in discrediting her religious pretensions, speaks lightly also of her effusions in verse. It would require a more intimate knowledge of French poetical diction than I profess to have, to give an opinion of her poetry, so far as the *expression* is concerned. But I do not hesitate to say, with great confidence, that this portion of her writings, with some variations, undoubtedly exhibits in a high degree the *spirit* of poetry. There is in it the highest kind of thought, the deepest feeling. The following poem, translated by Mr. Cowper, whom some critics, I think, would not place below Voltaire, either as a writer or judge of poetry, may be regarded as expressive, in some particulars, of her religious experience at this time :—

DIVINE JUSTICE AMIABLE.

Thou hast no lightnings, O thou Just!
 Or I their force should know;
And, if thou strike me into dust,
 My soul approves the blow.

The heart that values less its ease,
 Than it adores thy ways,
In thine avenging anger sees
 A subject of its praise.

Pleased I could lie, conceal'd and lost,
 In shades of central night;
Not to avoid thy wrath, thou know'st,
 But lest I grieve thy sight.

Smite me, O thou whom I provoke!
 And I will love thee still.
The well-deserved and righteous stroke
 Shall please me, though it kill.

Am I not worthy to sustain
 The worst thou canst devise?
And dare I seek thy throne again,
 And meet thy sacred eyes?

Far from afflicting, thou art kind,
 And in my saddest hours,
An unction of thy grace I find
 Pervading all my powers.

Alas! thou *spar'st* me yet again,
 And when thy wrath should move,
Too gentle to endure my pain,
 Thou sooth'st me with thy love.

I have no punishment to fear;
 But, ah! that smile from thee
Imparts a pang far more severe
 Than woe itself would be

CHAPTER XI.

In all the trials which she was thus called to endure, it may be said of her, as it was of Job, that she *" sinned not, nor charged God foolishly."* The sincerity of her consecration to God had been tried ; and, through the grace of God, it *had not been found wanting.*

It is possible, that the suggestion may arise in the minds of some, that God compensated her outward trials by giving an increase of inward consolation. And such was the case, undoubtedly—for He never fails *" to temper the wind to the shorn lamb."* The hand which afflicted did not allow her to sink under the blow.

" I had a great desire," she says, " for the most intimate communion with God. For this object, my heart went forth in continual prayer. He answered my supplication richly and deeply. The sensible emotion and joy which I experienced, were sometimes overwhelming. My heart was filled with love as well as with joy ; with that love which seeks another's will, and which is ready to relinquish and sacrifice its own.

" But this state of mind did not always continue. At other times my mind seemed to be dry, arid, *' unemotional ;'* and not fully understanding the nature of His dealings with men, it seemed to me at such times that God, being offended for something, had left me. The pain of His *absence* (for such I supposed it to be) was very great. Thinking it to be for some fault of mine that He had thus left me, I mourned deeply,—I was inconsolable. I did not then understand, that in the progress of the inward death, I must be crucified not only to the outward

joys of sense, and to the pleasures of worldly vanity, but also, which is a more terrible and trying crucifixion, th t I must die to the joys of God, in order that I might fully live to the will of God. If I had known that this was one of the s⁺ tes through which I must pass, in order to experience the full power of sanctifying grace, I should not have been troubled."

During the year 1671, the hand of the Lord, considered in comparison with its former dealings, seems to have been stayed. God had found her faithful; and her soul, without having entered into the state of permanent rest and union, experienced, amid all her trials, a high degree of inward consolation and peace. She was patient and faithful in the discharge of domestic duties, regular and watchful in her seasons of private devotion, and prompt in performing the duties of kindness and benevolen e to others. We do not mean to say that she was without tiials; but, whatever they were, she was greatly supported under them. And both by the griefs she suffered, and the duties she discha ged, and the supports and consolations which were afforded her the process of inward crucifixion was continually going on.

There were some things, however, even in her course at this time, which she was afterwards led to regard as faults. She was more attached to the retirement, the exercises, and the pleasures of devotion, than she was to the efforts, mingled as they oftentimes were with temptations and trials, of present and practical duty. As God had not fully taken up His abode in her heart,—which is the only appropriate and adequate corrective of dangers from this source,—she found Him, in *particular seasons and places*. And the consequence was, that she not only loved such seasons and places, and sought them very much, but sometimes loved them, and sought them in such a way and to such a degree, *as to interfere with the wants and happiness of others*. It is thus that self-will, the last inward enemy which is subdued, may find a place even in our most sacred things, *but never without injury*.

The principle which she adopted, at a subsequent and more enlightened period of her Christian experience, was, that the

true place of God, when we speak of God's place anywhere out of the heart, is *in His providences.* It is true, indeed, that God's kingdom is in the heart. "The kingdom of God," says the Saviour, "is within you." But it is true, also, that He holds His kingdom there, and reigns there, in connexion with His providences.

And it may properly be added, that the providences of God include both time and place, in the widest sense. So far from excluding times and places, set apart for devotion or other purposes, they recognise and establish them; but they *hold them also in strict subordination.* These Divine providences are in themselves, and emphatically so, the *time of times and the place of places.*

Undoubtedly, in an important sense of the terms, the religious man's place is his closet. "Enter into thy closet," says the Saviour, "and pray to thy Father, who seeth in secret." The closet is an indispensable place to him. But whenever he goes there in violation of God's providences, it ceases to be a place of God's appointment, and *he goes there without God.* It is God himself who consecrates the place, and makes it a profitable one. And accordingly, the times and places which are erected within the sphere of God's providences, and in harmony with them, are right and well; and all other times and places are wrong.

"All my crosses," she says, "would have seemed little, if I might have had liberty, in those seasons when I desired it, to be alone and to pray. But my mother-in-law and husband restricted me much. The subjection under which I was thus brought, was exceedingly painful to me. Accordingly, when it was understood that I had retired for prayer, my husband would look on his watch, to see if I stayed above half an hour. If I exceeded that time, he grew very uneasy, and complained.

"Sometimes I used a little artifice to effect my purposes. I went to him, and asked him, saying nothing of any devotional exercises, if he would grant me an hour, only one hour, to divert myself in some way, or in any way, that might be pleasing to my own mind. If I had specified some known worldly amuse-

ment, I should probably have obtained my request. But as he could hardly fail to see that I wanted the time for prayer, I did not succeed.

" I must confess that my imperfect religious knowledge and experience caused me much trouble. I often exceeded my half-hour; my husband was angry, and I was sad. But it was I myself, in part at least, who thus gave occasion for what I was made to suffer. Was it not God, as well as my husband, who placed this restriction upon me? I understood it afterwards, but did not understand it then. I ought to have looked upon my captivity as a part of God's providences and as an effect of His will. If I had separated these things from the subordinate agent, and looked upon them in the true divine light, I might have been contented and happy. When months and years had passed away, God erected His temple fully in my heart. I learned to pray in that divine retreat; and from that time I went no more out."

She thought, therefore, that at this period she might have failed, in some degree, in her duty to her husband and family, in consequence of not fully understanding the will of God in His providences. And this view of things perhaps gives significancy to a remark of her husband, that " she loved God so much that she had no love left for him." We will give one or two other facts, which involve the same principle. She had a beautiful garden, and in the time of fruits and flowers, she often walked there. But such was the intensity of her contemplations on God, that her eye seemed to be closed, and she knew nothing, comparatively speaking, of the outward beauty which surrounded her. And when she went into the house, and her husband asked her how the fruits were, and the flowers, she knew but little about it. And this gave him considerable offence.

Again, it oftentimes happened that things were related in the family, which were entitled to consideration. Others conversed and listened and remembered; but so entirely absorbed was her mind that she was scarcely able to do either. And when these topics subsequently came up, it was found that she knew

nothing of them. This seemed to indicate a want of respect for the feelings of others, if not an obvious disregard of duty.

The highest form of Christian experience is always in harmony with present duty. It admits no kind of feeling, and no degree of feeling, which is inconsistent with the requirements of our present situation. The highest love to God does not require us to violate our duty to our neighbour, or even to our enemy. It does not require us to violate our duty. When our religious experience stops in "emotionality," it is apt to do this; when it but partially controls the desires, it is not always a safe guide; but when it breaks down all self-will, and truly establishes the throne of God in the centre of the soul, it does all things right and well; first, by estimating all things in themselves and their relations, just as they ought to be estimated, and then by corresponding to this just estimate by an equally just conduct. To this state she had not as yet fully attained.

During this period of her personal history we first find mention made of Francis de la Combe. This somewhat distinguished individual is closely connected with her history. He was born at Thonon, a flourishing town of Savoy, on the borders of the Lake of Geneva.

In early life he was the subject of religious impressions, and attached himself to the Barnabites, one of the Orders in the Roman Catholic Church. He was possessed of a high degree of natural talent, improved by a finished education. He was tall and commanding in his personal appearance, and naturally eloquent. He seems to have given his whole heart to God's work. He was frequently employed in religious missions, by those on whom the responsibility of such movements rested in the French Church, particularly in the year 1679, and about that time, when he was sent to the province of Chablais, in Savoy, in which his native town, Thonon, was situated, he also laboured as a missionary at Annecy, another town of Savoy, not far from Chambery.

He published a small treatise, entitled *A Short Letter of In-*

struction, in which he endeavours to point out the principles of growth and of the highest possible attainment in the Christian life. His principal published work was his Analysis of Mental Prayer—*Orationis Mentalis Analysis*.

Some portions of his religious correspondence have been preserved. His letters to Madame Guyon are to be found, some of them, in the collections of her writings, and others in the large collection of the works of Bossuet.

In June or July of 1671, a letter was brought to Madame Guyon from her half-brother, Father La Mothe, by La Combe, who was then young, but came highly recommended from La Mothe, who wished his sister to see him, and to regard and treat him as one of his most intimate friends. Madame Guyon says, that she was unwilling at this time to form new acquaintances; but desirous of corresponding to the request of her brother, she admitted him. The conversation turned chiefly upon religious subjects. With the clear insight of character which she possessed, she could not fail to become deeply interested in La Combe, as one on whom many religious interests might depend. But still she could not at that time fully decide whether she should regard him as truly a possessor of religion, or as merely a seeker after it. "I thought," she says, "that he either loved God, or was disposed to love Him—a state of things which could not fail to interest me, as it was the great desire of my heart that everybody should experience this Divine love." As God had already made use of her as an instrument in the conversion of three persons, members of the order to which he belonged, she indulged the hope that she might be made a benefit to him. And she now felt a desire to continue the acquaintance.

La Combe left her, but he was not satisfied. Providence had brought him in contact with a mind to which either grace or nature, or both in combination, had given power over other minds. He desired, therefore, to see more and to hear more. And, accordingly, he repeated the visit after a short time. Madame Guyon remarks that La Combe, who seems to have

been a man not only of intelligence but of vivacity and gene·
rosity of feeling, was very acceptable to her husband. On this
second visit, he conversed with her husband freely. During the
interview, he was taken somewhat unwell; and with the view
of recovering himself in the open air, he went out and walked
in the garden. Soon after, Madame Guyon, at the particular
request of her husband, went out for the purpose of seeing him,
and of rendering any assistance which might be needed. She
availed herself of the opportunity which was thus afforded, to
explain to him what she denominates the interior or inward way,
" *la voie de l'intérieur ;*" a way which is inward because it rests
upon God, in distinction from the outward, that rests upon man.
He was prepared to receive her remarks, because he inwardly
felt the need of that form of experience involved in them, and
because he perceived from her countenance, her conversation,
and her life, that she possessed that of which he felt himself to
be destitute.

La Combe always admitted afterwards, that this conversation
formed a crisis in his life. Her words, attended by Divine
power, sank deep into his soul. Then and there he formed the
purpose, with Divine assistance, to be wholly the Lord's. " God
was pleased," says Madame Guyon, " to make use of such an
unworthy instrument as myself, in the communication of His
grace. He has since owned to me, that he went away at that
time changed into quite another man. I ever afterwards felt an
interest in him ; for I could not doubt that he would be a ser-
vant of the Lord. But I was far from foreseeing, that I should
ever go to the place of his residence."

It is evident that she was growing in grace. The world had
lost, in an increased degree, its power. Her inward nature had
become more conformed to the requisitions of the gospel law.
We have evidence of this in various ways. Among other things,
speaking of Paris, she remarks, in connexion with a visit which
she was obliged to make there, " Paris was a place now no
longer to be dreaded, as in times past. It is true, there were
the same outward attractions, the same thronging multitudes ;

but the crowds of people served only to draw me into deeper religious recollection. The noise of the streets only augmented my inward prayer."

She adds, " Under the pressure of the daily troubles and afflictions which befell me, I was enabled, by Divine grace, to keep my will, O my God! subservient to thine. I could say practically, ' Not my will, but thine be done.' When two well-tuned lutes are in perfect concert, that which is not touched renders the same sound as that which is touched. There is the same spirit in both, the same sound—one pure harmony. It was thus that my will seemed to be in harmony with God's will.

" This was the result of grace. Grace conquered nature; but it was nature in its *operations*, rather than in its *essence*. My will was subdued in its operations in particular cases, so that I could praise the Lord for entire acquiescence; but there still remained in it a secret tendency, when a favourable opportunity should present, to break out of that harmony, and to put itself in revolt. I have since found, in the strange conditions I have been obliged to pass through, how much I had to suffer before the will became fully broken down, annihilated, as it were, not only in its selfish operations, but in its selfish tendencies, and changed in its very nature. How many persons there are who think their wills are quite lost when they are far from it. In hard temptations and trials, they would find that a will submissive is not a will lost; a will not rebellious, is not a will annihilated. Who is there who does not wish something for himself—wealth, honour, pleasure, conveniency, liberty, something? And ne who thinks his mind loose from all these objects, because he possesses them, would soon perceive his attachment to them, if ne were once called upon to undergo the process of being wholly deprived of them. On particular occasions, therefore, although the will might be kept right in its operations, so as to be in harmony with the Divine will, he would still feel the sharp struggle coming out of the will's life; and his consciousness would testify, that he is rendered victorious, moment by moment, only by Divine grace."

CHAPTER XII.

Thus passed the year 1671. I am particular in the periods of time, for, by connecting the dealings of God and the progress of the inward life with specific times and situations, we can hardly fail to have a clearer idea of the incidents which are narrated. Another year found her renewedly consecrated to God, and growing wiser and holier through the discipline of bitter experience. Her trials had been somewhat less in this year than in the preceding, but still not wholly suspended ; and as God designed that she should be wholly His, there were other trials in prospect designed to aid in this result.

Some remarkable impressions or presentiments may be explained on natural principles, but there are others of which it might not be easy to give a satisfactory account in that manner. I have been led to this remark from an incident in her history, on a morning of July, in 1672. " At four o'clock in the morning," she says, " I awoke suddenly with a strong impression or presentiment that my father was dead ; and though at that time my soul had been in very great contentment, yet such was my love for him, that the impression I had of his death affected my heart with sorrow, and my body with weakness."

I do not mention this incident, because I think it very important. It was not a mere transitory impression, but a presentiment so sudden, so deeply imprinted, so controlling, as to take entire possession of the mind. She was so deeply affected, that she says she could hardly speak.

She had been residing some days at a monastery, the Prioress of which was a personal friend, some leagues from her usual

residence. She had gone there for religious purposes, and left
her father residing at her house. On the afternoon of the same
day in which she experienced the strong presentiment, a man
arrived at the monastery in great haste. He brought a letter
from her husband, in which he informed her of her father's
dangerous illness. She immediately set out to visit him, but on
arriving she found him dead.

To her father she was tenderly attached. " His virtues," she
says, " were so generally known that it is unnecessary to speak
of them. I pass them in silence, or only with the simple re-
mark, that as he passed through the scenes and trials of his
closing days, he exhibited great reliance on God. His patience
and faith were wonderful." Thus another tie to the earth was
sundered; and the freedom of the soul, which is liable to be
contracted and shackled even by the domestic affections, when
they are but partially sanctified, grew wider and stronger from
the bonds that were broken.

Another affliction was near at hand. He who gives himself
to God, to experience under His hand the transformations of
sanctifying grace, must be willing to give up all objects, how-
ever dear they may be, which he does not hold in strict subor-
dination to the claims of Divine love, and which he does not
love IN and FOR God alone. The sanctification of the heart, in
the strict and full sense of the term, is inconsistent with a
divided and wandering affection. A misplaced love, whether
it be wrong in its degree or its object, is as *really*, though ap-
parently not as *odiously*, sinful, as a misplaced hatred.

She had a daughter, an *only* daughter—young, it is true, only
three years of age, or but a little more than three years of age—
and yet, in her own language, " *as dearly beloved as she was
truly lovely.*" " This little daughter," says the mother, " had
great beauty of person ; and the graces of the body were equalled
by those of the mind ; so that a person must have been insen-
sible both to beauty and to merit not to have loved her. Young
as she was, she had a perception of religious things, and seems
to have loved God in an extraordinary manner. Often I found

her in some retired place, in some corner, praying. It was her habit, whenever she saw me at prayer, to come and join with me; and if at any time she discovered that I had been praying without her, feeling that something was wrong, or that something was lost, she would weep bitterly, and exclaim in her sorrow, " Ah, mother, you pray, but I do not pray.' When we were alone, if she saw my eyes closed, as would naturally be the case in my seasons of inward recollection, she would whisper, ' Are you asleep?' and then would cry out, ' Ah, no! You are praying to our dear Jesus;' and dropping on her knees before me, she would begin to pray too.

" So strongly did she express her desire and determination to give herself to the Lord, and to be one with Him in spirit, that it gave occasion for reproof on the part of her grandmother. But still she could not be prevailed upon to alter her expressions. She was very dutiful—many were her endearments— and she was innocent and modest as a little angel. Her father doted on her. To her mother she was endeared much more by the qualities of her heart than by those of her beautiful person. I looked upon her as my great, and almost my only consolation on earth; for she had as much affection for me as her surviving brother, who had been subjected to the most unhappy influences, had aversion and contempt. She died of an unseasonable bleeding. But what shall I say—she died by the hands of Him who was pleased to strip me of all." Her daughter died in July 1672.

In the latter part of the year 1670, more than a year and a half previous to the period of which we are now speaking, she had anew given herself to God, in great sincerity, and, as it seemed to her, without any reserve. In all the trials to which He had seen fit to subject her, no whisper of complaint, no word or murmur, had ever escaped her lips. But she had not as yet committed her religious purposes to the formality of a written record At least we have no mention of any such thing. It was a mental purpose, a simple transaction between her soul and God, of which God alone was the witness. It was possible,

however, that she might forget that she might be faithless
There were yet many and heavy trials before her.

Her pious and deeply experienced friend, Genevieve Granger,
did not cease to sympathize in the various trials which Madame
Guyon had been called to pass through, to pray for her, and
advise her. Among other things, she wished to add new solem-
nity and interest to her consecration,—a consecration made on
principles of an entire and permanent surrender of herself to God.
She selected, as a day especially appropriate to her purpose, the
22d of July

It was on that day and month, four years before, after years
of inquiry and struggle, that she had first believed on the Lord
Jesus Christ in such a manner as to bring into her soul the
sense of forgiveness, and to fill it with inward peace. It was,
therefore, a day to be remembered with gratitude; as we find
that it was remembered through her whole life. Genevieve
Granger, in the course of that friendly correspondence which had
existed between them for some years, sent word to her, that she
wished her to notice the approaching anniversary of that day in
a special manner, by acts of worship and by alms. She wished
her also to examine, and if she approved of it, to sign what
might perhaps be called a marriage-covenant with the Saviour,
which she had herself drawn up, in very concise terms, for
Madame Guyon's use. Perhaps she had in mind that interest-
ing passage of the Scriptures, " The marriage of the Lamb is
come, and his wife hath made herself ready; and to her was
granted that she should be arrayed in fine linen, clean and
white; *for the fine linen is the righteousness of saints.*" (Rev.
xix. 7, 8.) These suggestions, coming from a source which she
had been accustomed greatly to respect, could not fail to be at-
tended to. And especially so, as they corresponded entirely
with her own views and feelings. The act or covenant of Con-
secration, drawn up in accordance with those expressions of
Scripture which speak of the Church as the bride or spouse of
God, with her signature appended, was as follows :—

I henceforth take Jesus Christ to be mine. I promise to receive Him as a husband to me. And I give myself to Him, unworthy though I am, to be His spouse. I ask of Him, in this marriage of spirit with spirit, that I may be of the same mind with Him,—meek, pure, nothing in myself, and united in God's will. And, pledged as I am to be His, I accept, as a part of my marriage portion, the temptations and sorrows, the crosses and the contempt which fell to Him.

<div align="right">

Jeanne M. B. de la Mothe Guyon.

</div>

Sealed with her ring.

This transaction, simple in appearance but carried through with sincere and earnest solemnity of spirit, was much blessed to her. She felt that there was a sanctity in the relation thus voluntarily established, which it would have been the highest impiety, as it would have caused the deepest sorrow, ever knowingly to violate. She had an inward and deeper sense of consecration, both of body and spirit, such as she had not experienced at any time before. God himself has condescended to say, speaking of those who constitute His true people, " I am MARRIED to them." (Jer. iii. 14.)

In examining the record of her life, I find an incident mentioned without date; but from the connexion in which it appears, I refer it to this period. " My husband and I," she says, " took a little journey together, in which both my resignation and humility were exercised; yet without difficulty or constraint, so powerful was the influence of divine grace. We all of us came near perishing in a river. The carriage, in passing through the water, sank in the moving sand at the bottom, which rendered our position very dangerous. Others threw themselves out of the carriage in excessive fright. But I found my thoughts so much taken up with God, that I had no distinct sense of the danger to which we were really exposed. God, to whom my mind was inwardly drawn, delivered me from the perils to which we were exposed, with scarcely a thought on my part of avoiding them. It is true, that the thought of being drowned passed

across my mind, but it caused no other sensation or reflection, than that I felt quite contented and willing that it should be so, if it were my heavenly Father's choice.

" It may be said, and perhaps with some reason, that I was rash in not exhibiting more anxiety, and in not making greater effort to escape. But I am obliged to add, in justification of myself, that it is better to perish, trusting calmly in God's providence, than to make our escape from danger, trusting in ourselves. But what do I say? *When we trust in God, it is impossible to perish.* At least it is so in the spiritual sense. *Trust itself is salvation.* It is my pleasure, my happiness, to be indebted to God for everything. In this state of mind, I cannot fail to be content in the trials which He sees fit to send upon me. In the spirit of acquiescence in God's will, I would rather endure them all my life long, than put an end to them in a dependence on myself."

CHAPTER XIII.

Birth of a son—Her religious state—Death of Genevieve Granger—Their intimacy—Remarks on this affliction and on worldly attachments and supports—Her second visit to Orleans—Interview with a Jesuit—Remarks—Undue spiritual eartnestness or spiritual impetuosity—Writes to a person of distinction and merit for advice—Withdraws her request—Result and remarks—Distinction between the wholly and the partially sanctified mind—Lawsuit—Conduct in connexion with it—Remarks.

ONE of the incidents of the year 1673, to which these series of events now bring us, was the birth of her fourth child, a son, whom Providence had given her in the place of the too much idolized boy, whom she had lost two years before. This son, who seems to have proved himself worthy of her affections, grew up to manhood. But the grace of God enabled her to love him with that pure and chastened affection which holds everything in subordination to the Divine will.

At the time of the birth, and during the early period of the life of this child, she speaks of herself as being the subject of

great inward support and consolation. Her feelings may per-
haps be expressed in the language of the Psalmist—language
which, in various ages of the world, has. found a response in
many pious bosoms, "Blessed be the Lord, because He hath
heard the voice of my supplications. The Lord is my strength
and my shield. *My heart trusted in Him, and I am helped ;
therefore my heart greatly rejoices ; and with my song will I
praise Him.*" (Ps. xxviii. 6, 7.)

But this season of consolation was succeeded by a trial unex-
pected and severe, in the sickness and death of her friend and
confidant, Genevieve Granger. To her she had often gone for
advice and support, when her way seemed dark and her heart
was sorrowful. Many were the hours which she had passed
with her in religious conversation ; and perhaps she looked to
her more than was entirely consistent with a simple and un-
wavering dependence on God alone.

It increased her affliction, that she was not present in her last
sickness and at her death. She was at the time at a place called
St. Reine. Near the close of the life of the Prioress, some one
spoke to her in relation to Madame Guyon, to awaken her from
a lethargy into which she had fallen. Her mind rallied at a
name so dear, and she made the single remark, " I have always
loved her *in* God and *for* God." These were her last words.
She died soon after.

" When I received this news," says Madame Guyon, " I must
confess, that it was one of the most afflicting strokes which I
had ever experienced. I could not help the thought that, if I
had been with her at the time of her death, I might have spoken
to her, and might have received her last instructions. She had
been a great help to me. In some of my afflictions, it is true, I
could not see her. Efforts were made to prevent it. This was
especially the case for a few months before her death. But still,
such was our sympathy of spirit, that the remembrance—the
thought of what she might have said or done—was a support to
me. The Lord was merciful, even in this renewed and heavy
affliction. He had taught me inwardly, before her death, that

my attachment to her, and my dependence on her, were so great, that it would be profitable for me to be deprived of her." But the necessity of this event did not prevent its being keenly painful to nature.

"Oh, adorable conduct of my God!" she exclaims. "There must be no guide, no prop for the person whom thou art leading into the regions of darkness and death. There must be no conductor, no support to the man whom thou art determined to destroy by the entire destruction of the natural life." Everything upon which the soul rests, *out of God*, must be smitten, whether reputation, or property, or health, or symmetry of person, or friends, or father, or mother, or wife, or husband, or children.

He who loses his life, shall find it. Well does she add, "We are found by being lost; we are saved by being destroyed; we are built up by being first demolished. Man erects his inward temple with much industry and care; and he is obliged to do it with such materials as he has. All this structure and superstructure is a new-modelling and building up of the old Adam. But all this is removed and destroyed when God comes into the soul, and builds a new and Divine temple not made with hands, and of materials which endure for ever. Oh, secrets of the incomprehensible wisdom of God, unknown to any besides Himself and to those whom He has especially taught—yet man, who has just begun his existence, wants to penetrate and set bounds to it! Who is it that hath known the mind of the Lord, or who hath been His counsellor? It is a wisdom only to be known through death to *self*, which is the same thing as death to everything that sets itself up in opposition to the true light."

In the latter part of the year 1673, she visited Orleans a second time, at the marriage of her brother. While there, she became acquainted with a Jesuit, who exhibited some interest in her religious experience. She corresponded to this desire with much vivacity and very fully. But she began to see that it is not only necessary to do the right thing, but to do it *in the right spirit.*

"I was too forward," she says, "and free in speaking to him

of spiritual things, thinking I was doing well; but I experienced
an inward condemnation for it afterwards. The conversation,
in itself considered, might not have been objectionable; but the
manner of it, or rather the inward spirit of it, was to some degree
wrong. And I was so sensible that the spirit of nature, in dis-
tinction from the spirit of grace, dictated in part what I said,
and was so afflicted at it, that I was kept, with Divine aid, from
falling into the like fault again. How often do we mistake
nature for grace! Sanctification does not necessarily imply a
want of earnestness. Far from it. A holy soul, feeling the
importance of holiness as no other one can, cannot be otherwise
than earnest. But that holy earnestness which comes wholly
from God, is entirely inconsistent with the presence and opera-
tion of all those influences, whatever they may be, which are
separate from God."

There is much truth in these views, for there is undoubtedly
such a thing as spiritual forwardness, eminently religious in ap-
pearance, but sometimes much less truly and purely religious
than it seems. This state of mind is not, generally speaking,
destitute of the religious element; but it is constituted of the
religious element, impelled and influenced, in a greater or less
degree, *by the natural element.*

Another incident indicates her progress in inward sanctifica-
tion. " One day," she says, " laden with sorrow, and not know-
ing what to do, I wished to have some conversation with an
individual of distinction and merit, who often came into our
vicinity, and was regarded as a person deeply religious. I wrote
him a letter, requesting the favour of a personal interview, for
the purpose of receiving from him some instruction and advice.
But reflecting on the subject, it seemed to me that I had done
wrong. The Spirit of God seemed to utter itself in my heart,
and to say, ' What! dost thou seek for ease? Art thou unwill-
ing to bear the Lord's hand, which is thus imposed upon you?
Is it necessary to be so hasty in throwing off the yoke, grievous
though it be?'

" In this state of mind, I wrote another letter, and withdrew

my request, stating to him that my first letter had been written, I had reason to fear, without a suitable regard to God's providence and will, and partly, at least, from the fearful or selfish suggestions of the life of nature; and as he knew what it was to be faithful to God, I hoped he would not disapprove of my acting with this Christian simplicity. I supposed, from the high reputation which he enjoyed as a Christian, that he would have appreciated my motives, and have received this second communication in the Christian spirit in which I hoped it was written.

" On the contrary, he resented it highly. And I think we may well inquire, what explanation shall we give of this sort of Christianity ? That this person was religious, in the imperfect or mitigated sense of the term, I doubt not. He seems to have been regarded as *eminently* religious ; but it is still true, that his religion, whatever may have been the degree of it, was mixed up, pervaded and animated, more or less, on different occasions, with the life and activities of nature. Certain it is, that the life of nature, or that life which has self and not God for its basis, was not wholly slain within him. He could not say, under all circumstances, ' It is well. Thy will be done !' "

In connexion with this individual, referring to the important results which characterize the experience of what she appropriately terms *inward death*, she says, that the soul, which comes out of it in the brightness of the new spiritual resurrection, " is purified from its selfishness, like gold in the furnace, and finds itself clothed in those dispositions and Divine states which shone in the life of Jesus Christ. Formerly, although it had submitted itself to God in the matter of its salvation through Christ, it was still proud of its own wisdom, and inordinately attached to its own will; but now, in the crucifixion of nature and in the life of sanctification, it seeks all its wisdom from God, renders obedience with the simplicity of a little child, and recognises no will but God's will Formerly, selfishly jealous of what it considered its rights, it was ready to take fire on many occasions, however unimportant ; but now, when it comes in conflict with others, it yields readily and without reluctance It does not

yield, after a great effort and with pain, as if under a process of discipline, but naturally and easily. Formerly, even when it could justly be said to be religious to some extent, it was puffed up at times with more or less of vanity and self-conceit, but now, it loves a low place, poverty of spirit, meekness, humiliation. Formerly, although it loved others, it loved itself more, and placed itself above them ; but now, rejoicing equally in the happiness of others, it possesses a boundless charity for its neighbour, bearing with his faults and weaknesses, and winning him by love. The rage of the wolf, which still remained in some degree, and sometimes showed itself, is changed into the meekness of the lamb."

Such are the accurate terms in which she discriminates between the Christian life in its ordinary appearance of partial sanctification, and the same life when it becomes a "new Christ," by experiencing a more full and complete regeneration into the purity, simplicity, and beauty of the Divine image.

About this time, a matter occurred which illustrates her character in other respects. A certain person, whose name is not given, prompted either by malice or by avarice, attempted, by false pretences, to extort a large sum of money from her husband. The claim, which had the appearance of being one of long standing, was for two hundred thousand livres, which the claimant pretended was due to him from Madame Guyon and her brother conjointly. The claimant was supported in his unjust demand, by the powerful influence of the king's eldest brother, the Duke of Orleans. They tampered with her brother, who was so young and inexperienced as not to understand the merits of the case, in such a manner as to obtain his signature to certain important papers which were to be used in the trial. They had given him to understand that, if they succeeded in the establishment of their claim, he should not pay anything.

Madame Guyon felt that a great wrong was about to be done. Her husband, perplexed by the apparent intricacy of the affair, or perhaps terrified by the influence of the Duke of Orleans, was unwilling to contend. And it furnished occasion, without

any good reason, for new dissatisfaction with his wife. When the day of trial came, after her usual religious duties, she felt it her duty to take the unusual course of going personally to the judges, and making her representations of the case before them.

" I was wonderfully assisted," she says, " to understand and explain the turns and artifices of this business. The judge whom I first visited, was so surprised to see the affair so different from what he thought it before, that he himself exhorted me to see the other judges, and especially the Intendant, or presiding judge, who was just then going to the Court, and was quite mis-informed about the matter. God enabled me to manifest the truth in so clear a light, and gave such power to my words, that the Intendant thanked me for having so seasonably come to undeceive and set him to rights in the affair. He assured me, that if I had not taken this course, the cause would have been lost. And as they saw the falsehood of every statement, they would not only have refused the plaintiff his claim, but would have condemned him to pay the costs of the suit, if it had not been for the position of the Duke of Orleans, who was so far led astray by the plaintiff, as to lend his name and influence to the prosecution. To save the honour of the prince, it was de-cided that we should pay the plaintiff fifty crowns; so that his claim of two hundred thousand livres was satisfied by the pay-ment of one hundred and fifty. Thus moderately and speedily ended an affair, which at one time appeared very weighty and alarming. My husband was exceedingly pleased at what I had done."

Independently of the grace of God, which gave to her char-acter its crowning excellence, we have in some incidents of this kind an evidence of what she was by nature,—of her clearness of perception, firmness of purpose, and eloquence. She had a mind formed by the God who made it to influence other minds. It was only necessary to see her and to hear her, in order to feel her ascendency,—not an ascendency derived from position, but which carried its title in itself;—not an ascendency assumed, but given.

CHAPTER XIV.

1674—Commencement of her state of privation—Account of it—Method of proceeding, in correctly estimating this part of her life—Analysis and explanation of this state—Joy not religion, but merely an incident—Remarks—Advice of Monsieur Bertot—Unfavourable results—Advice of another distinguished individual—Unkind treatment experienced from him—Correspondence with a Jesuit—Remarks.

In the beginning of the year 1674, Madame Guyon entered into what she terms her state of *privation or desolation.* It continued, with but slight variations, for something more than six years.

Her experience at this time was in some respects peculiar, so much so as to require explanations at some length, both to make it understood in itself, and in some degree profitable to others. " I seemed to myself cast down," she says, " as it were, from a *throne of enjoyment,* like Nebuchadnezzar, to live among beasts, —a very trying and deplorable state, when regarded independently of its relations, and yet exceedingly profitable to me in the end, in consequence of the use which Divine Wisdom made of it. Considered in comparison with my former state of enjoyment, it was a state of emptiness, darkness, and sorrow, and went far beyond any trials I had ever yet met with."

The desolation which she speaks of, particularly in its incipient state, was not a privation of desire, of hope, and of holy purpose,—but of *sensible* consolations. The Christian life, in the highest sense of the term, is a *life of faith.* This is generally admitted and understood; but it does not appear to be equally well understood, that to live by emotions, to draw our activity and our hope from sensible joys, is to live by *sight* rather than by faith. Joy is not life, but merely an incident of life.

God designed to make her His own, in the highest and fullest sense; He wished her to possess the true life, the life unmingled with any element which is not true; a life which flows directly and unceasingly from the Divine nature. And in order to do

this, it became with Him, if we may so express it, a matter of necessity, that He should take from her every possible inward support, separate and distinct from that of unmixed, naked faith. " We walk by *faith*," says the Apostle, " and not by sight." (2 Cor. v. 6, 7.) And again, " The life which I now live in the flesh, I live by the *faith* of the Son of God, who loved me, and gave himself for me." (Gal. ii. 20.)

Accordingly, He so ordered it in His providences, that those inward consolations, which had hitherto supported her so much in her trials, should be taken away; except those which are based upon the exercise of pure or simple belief in the Divine word and character. The joys which arise from this source, although they may temporarily be perplexed and diminished by counteracting influences, arise by a necessary and unchangeable law, and can never fail to exist. But a large portion of her inward consolations, as is generally the case at this period of religious experience, arose from other causes and in other ways, connected in some respects and to some extent, it is probable, with the faith she possessed, but not directly based upon it. All this God saw fit to take away. And not making the proper distinctions in the case, and estimating her situation more by what she had lost than by what she retained, it seemed to her, that *all* peace, *all* consolation was gone. So far as joy was concerned, her heart was desolate.

And this was not all. In this state of things, she committed the great mistake of looking upon the absence of joy as evidence of the *absence of the Divine favour*. After mentioning that she was left without friends and other sources of consolation, she adds, " To complete my distress, *I seemed to be left without God himself*, who alone could support me in such a distressing state." The mistake was an easy and perhaps a natural one, but it was none the less a mistake vital in its principle and terrible in its consequences. Since she had consecrated herself to the Lord to be wholly His, God had been pursuing a course adapted to secure her whole heart to Himself. He had tried her sometimes in one direction, and sometimes in another, and through grace

had found her faithful. But during all these trials she was sustained, with the exception of a few short intervals, by inward consolations. There was, generally speaking, a high state of pleasant and frequently of joyous emotionality. So that, instead of living upon " every word which proceeds from God's mouth," in other words, instead of living upon God's will, which, whatever may be thought to the contrary, is and can be the only true bread of life, she was living upon her *consolations.* Strange it is, that we find it so difficult to perceive, that the joys of God are not God himself.

It is true, undoubtedly, that we may enjoy the will of God in the joys of God ; that is to say, while we may take a degree of satisfaction in the consolations themselves, we may rejoice in them chiefly and especially as indicative of the Divine will. But in the earlier periods of Christian experience, we are much more apt to rejoice in our joys, than to rejoice in *the God of our joys.* The time had come, in which God saw it necessary to take away this prop on which she was resting, in some degree at least, without knowing it.

She could love God's will, trying though it often was to her natural sensibilities, when it was sweetened with consolations. But the question now proposed to her was, whether she could love God's will, when standing, as it were, alone, when developing itself as the agent and minister of Divine providences which were to be received, endured, and rejoiced in, in all their bitterness, simply because they were from God ?

This was a question which, under the circumstances of the case, could not well be tested, except in connexion with that state of inward aridity, which, *in itself considered,* cannot properly be designated as painful and still less as condemnatory, but which is sometimes described as a lifeless or *dead* state ;— that is to say, dead in respect to a particular kind or class of emotions—a state which is without life in the sense of its being *unemotional.* God's hand is in this result ; and it is well that it should be so. As men may make a god of their own intellect, by being proud of their intellect ; or may make a **god** of their

own will, by being proud of their will; so they may make a god
of their joyous emotions, by taking a wrongly-placed pleasure in
them. And just so far as this is the case, God, in the exercise
of His gracious administration, takes away such emotions. He
turns their channels back; He smites our earthly delights, and
opens the sources of providential sorrow, and overwhelms them,
and they disappear. And in doing this, He does not take away
men's religion, but rather takes away an idol; or if that term
be too strong, He certainly takes away that which perplexes
and injures religion.

We hope we shall not be understood as denying or doubting
the existence of true Christian joy. Certain it is, that there
are true joys, joys which God approves, *joys of faith*, as well as
other joys. And we may add, I think, with great confidence,
that these joys exist by a *necessary law*. He who has faith has
the *joys of faith;* and what is more, *he cannot help having them.*
And not only this, he may justly regard them as an evidence or
sign of a good religious state. And as such *a sign* he may re-
joice in his joys, as well as in the object of his joys, if he will
do it cautiously and wisely. But whenever, by an inward pro-
cess, we rejoice in the joys of faith in *themselves*, and not as a
sign, instead of rejoicing in the *objects of faith*, such as God,
God's inherent goodness and holiness, God's promise, and the
like, caring in reality nothing about God and His approbation,
but only about the *happiness* He gives, thus placing the gifts
before the GIVER, our experience is entirely upon a wrong track,
and will result soon, if it continue thus, in the destruction of
faith itself.

In the case of Madame Guyon, it is very true, that the joys
of faith, sometimes more and sometimes less, remained with her
amid all her trials. But the joy which she took *in her joy*, in
distinction from the joy in the *God* of her joy, and also all other
joys not founded in faith, were taken away. And so great
was the change, although ordered in the greatest mercy, that
she seemed to be like one smitten. cast out, and hopelessly deso-
late; like Nebuchadnezzar, as she expresses it, who was sud-

denly deprived of his power and his glory, and dwelt among
the beasts of the field. Sad condition, as it seemed to her; and
in some respects, undoubtedly, it was very trying. Especially
when she regarded it as an evidence, as she did, that she had
committed some aggravated sins, although she did not under-
stand what they were, and that God was displeased with her on
account of them. Having lost her consolations, she supposed
that she had lost all. Not being happy, or at least not so
happy as she had been, she concluded that she was not a Chris-
tian, or at least not so much a Christian as she had been. And
this impression reacted upon her own mind, and rendered her
more unhappy still, and tended to increase the sad conviction,
that she had in some manner grievously offended God.

She herself subsequently understood this. "I have learned,"
she says, " from this season of deprivation, that the prayer of the
heart, the earnest desire and purpose of the soul, to be and to
do what the Lord would have us,—when, in consequence of not
being attended with excited and joyous emotion, it appears most
dry and barren,—is nevertheless not ineffectual in its results,
and is not to be regarded as a prayer offered in vain. And all
persons would assent to this, if they would only remember, that
God, in answering such a prayer, gives us what is best for us,
though not what in our ignorance we most relish or wish for. If
people were but convinced of this great truth, far from com-
plaining all their life long, they would regard the situation in
which God sees fit to place them, as best suited to them, and
would employ it faithfully in aiding the process of inward cruci-
fixion. And hence the afflictive incidents attending upon such
a situation, in causing us inward death, would procure the true
life. It is a great truth, wonderful as it is undeniable, that all
our happiness, temporal, spiritual, and eternal, consists in one
thing, namely, in resigning ourselves to God, and in leaving
ourselves with Him, to do with us and in us just as He pleases.

" When we arrive at this state of entire and unrestricted de-
pendence on God's Spirit and providence, we shall then fully
realize, that what we experience is just what we need, and that

if God is truly good, He could not do otherwise than He does. All that is wanting is, to leave ourselves faithfully in God's hands. The soul must submit itself to be conducted, from moment to moment, by the Divine hand ; and to be annihilated, as it were, by the strokes of His providence without complaining, or desiring anything besides what it now has. If it would only take this course faithfully, God would be unto it, not only eternal Life, but eternal Truth. We should be guided into the truth, so far as it might be necessary for us, although we might not fully understand the method of its being done.

"But the misfortune," she adds, "is, that people wish to *direct God*, instead of resigning themselves to *be directed by Him.* They wish to take the lead, and to follow in a way of their own selection, instead of submissively and passively following where God sees fit to conduct them. And hence it is, that many souls, who are called to the enjoyment *of God himself,* and not merely to the *gifts of God,* spend all their lives in pursuing and in feeding on little consolations ; resting in them as in their place of delights, and making their spiritual life to consist in them."

These remarks were written—many years after the period to which our attention is now particularly directed—to her surviving children, after she had been the subject of persecution and imprisonment for the Gospel's sake. "For you, my dear children," she adds, "if my chains and my imprisonment any way afflict you, I pray that they may serve to engage you to seek *nothing but God for Himself alone,* and never to desire to possess Him but by the death of your whole selves Never, as the children of God, seek to be anything in your own ways and life ; but rather to enter into the most profound nothingness."

But at this time, all seemed to her to be gone. And what had a tendency to confirm her the more in these desponding views, was the course taken by some, in whose opinions in respect to her religious state, she naturally placed a considerable degree of confidence. I refer, in part, to the mistaken but well-meant course of Monsieur Bertot, a man of learning and piety, whom,

at the suggestion of Genevieve Granger, she had some time be-
fore selected as her spiritual Director. She went to Paris to
consult him. His advice was, that she should begin anew her
religious efforts by practising those incipient methods of religious
reading and prayer, which were calculated to make a religious
impression, just as if she had either not known what religion
was, or did not now possess it.

This advice she was not disposed to receive, because there was
something in her which seemed to tell her that it was mistaken
advice, and not applicable to her case. Bertot, who was a con-
scientious man, thinking that some other person might be more
judicious, or more successful, as her spiritual counsellor, wrote
to her that he wished to resign the office of her Director. This
course, on the part of one in whom she had so much confidence,
made a deep impression on the mind of Madame Guyon. She
says, " I had no doubt that God had revealed to him, that I had
become a transgressor ; and that he regarded the state of inward
desolation into which I had fallen, as a certain mark of my re-
probation."

She mentions another individual, who was probably one of
the Jansenists,—a party which at that time possessed much
influence in France, and has since been historically celebrated.
" He was a man," she says, " who held a high position in the
Church ; polite in his manners, obliging in his temper, and who
had a good share of talent." Pleased with Madame Guyon,
and desirous to bring her into harmony with himself on some
points of religious doctrine in which they seem to have differed,
he often visited her. This intimacy was after a time broken
off, and he added himself to the number of those who at this
time formed and expressed unfavourable opinions in regard to
her state.

" The inability," she says, " I was now in, in consequence of
my discouragements and depression, of doing those exterior acts
of charity I had done before, served this person with a pretext
to publish that it was owing to him, and under his influence
and advice, that I had formerly done them. Willing to ascribe

to himself the merit of what God alone by His grace had enabled me to do, he went so far as to make a distinct allusion to me in his sermons, as one who had once been a bright pattern in religious things to others, but now had lost my interest in them, and had become a scandal. I myself have been present at such times, and what he said, noticed and understood as it was by others, was enough to weigh me down with confusion I received what he said, however, with submission and patience, believing as I did that God was offended with me, and that I abundantly merited much worse treatment.

"Confused, like a criminal that dares not lift up his eyes, I looked upon the virtue of others with respect. I could see more or less of goodness in those around me, but in the obscurity and sorrow of my mind I could seem to see nothing good, nothing favourable in myself. When others spoke a word of kindness, and especially if they happened to praise me, it gave a severe shock to my feelings, and I said in myself, 'They little know my miseries; they little know the state from which I have fallen.' And, on the contrary, when any spoke in terms of reproof and condemnation, I agreed to it as right and just.

"It is true, that nature wanted to free herself from this abject condition, but could not find out any way. If I made an effort, if I tried to make an outward appearance of righteousness by the practice of some good thing, my heart in secret rebuked me as guilty of hypocrisy, in wanting to appear what I was not. And God, who thought it best that I should suffer, did not permit anything of this kind to succeed. O how excellent are the crosses of providence! All other crosses are of no value.

"I was often very ill and in danger of death; and darkness brooded upon the future as well as upon the present; so that knew not how to prepare myself for that change, which sometimes seemed near at hand. Some of my pious friends wrote to me, requesting an explanation of some things, which the gentleman, whom I have mentioned, spread abroad concerning me; but I had no heart to justify myself, and did not under-

take to do it, although I knew myself innocent of unfavourable things which were said. One day being in great desolation and distress, I opened the New Testament, and chanced to meet with these words, which for a little time gave me some relief,—*My grace is sufficient for thee ; for my strength is made perfect in weakness.*"

Even the pious Franciscan, whom God had employed as an instrument in effecting her great moral and religious change, was perplexed about her case, and incapable of giving her any profitable advice. With this individual she had kept up an occasional correspondence at his request. In her inward deprivation and sorrow, she received a letter which tended to increase the discouragement she already experienced, and to add keenness to her pangs.

Another individual, a Jesuit, who had formerly held her piety in high estimation, " wrote to me," she says, " in a similar strain. No doubt, it was by the Divine permission, that they thus contributed to complete my desolation. I thanked them in my reply, for the Christian and friendly interest they had taken in me, and commended myself to their prayers. It was painful to be thus unfavourably estimated by those who had the reputation of being people of piety ; but there was a greater pain, which, on the principle of contrast, made this pain appear to be less. I refer to the deep sorrow I had experienced in connexion with the thought of having displeased God."

These facts show us how little dependence we can safely place on mere human judgments. On the principle on which these persons judged Madame Guyon, what would have been thought of hundreds and thousands of Christians, the most eminent for their devotedness to God, who have been inwardly and outwardly afflicted? We ought not to forget, that here on earth Christianity is on the battle-field of its trials,—trials which are often doubtful in their issue,—and not in the victorious repose of the New Jerusalem. It may conquer, it is true ; and it may " enter into rest ;" but this does not imply, that the enemy will not renew the contest, and that the rest will not be disturbed.

We conquer in our armour; and here on earth at least, we must
rest, so far as rest is given us, *with our armour on.*

CHAPTER XV.

Events of the year 1676—Sickness of her husband—His character—Their reconciliation—
His pious dispositions near the close of his life—His death—Occupied in the settlement
of her estate—Chosen as arbiter in a lawsuit—Result—Reference to her inward disposi-
tions—Separation from her mother-in-law—Remarks.

THIS state of things continued for nearly two years. Years
do not pass, nor even days, without their character and their
incidents; sometimes bright with joy, but not less frequently
stained and dark with sorrow.

The physical infirmities of her husband increased; and it
seemed to be obvious that the end of his life was rapidly ap-
proaching.

He seems to have been a man of considerable powers of
intellect, of energy of character, and of strong passions. He
was too high-spirited and proud, not to be jealous of his own
rights, and of his personal position and influence. He both loved
and hated strongly; but both his love and his hatred were
characterized by sudden alternations of feeling. His feelings
towards his wife were of a mixed character. She says of him
expressly, notwithstanding the trials she experienced at his hand,
"he loved me much. *When I was sick, he was inconsolable.*"
And she adds, making an exception undoubtedly of certain in-
dividuals, who had insidiously obtained a control over him,
"Whenever he heard of other persons having made unfavourable
remarks in relation to me, he felt it keenly, and expressed him-
self in terms of exceeding indignation. And I have great con-
fidence, if it had not been for the unpropitious influence of his
mother and the maid-servant, we should have been very happy
in each other. Faults he had undoubtedly. And most men, I
suppose, have some defects of character, some undue passions

and it is the duty of a reasonable woman to bear them peaceably, without irritating them by unkind or unsuitable opposition."

That he loved her, therefore, there can be no doubt. But his affection, marked and passionate, was modified by a sense of intellectual inferiority humbling to his pride. Add to this the disparity of their age, and the benevolence of heart which characterized the one, and the habits of parsimony and acquisition, bordering perhaps upon avarice, which seemed to characterize the other. Again, the one was religious, a seeker of religion when she married, and soon afterwards a possessor of it. The other was without religion in experience, although he seems always to have had some respect for it. The one loved God, the other loved the world. It is not surprising, therefore, that his mother, a woman of art and energy, should have been successful in diminishing his affection for his wife, and for some short periods of time, in totally perverting it.

When left to himself, he acknowledged and felt his wife's ascendency. His pride in her, when it was permitted to take that direction, added strength to his affection ; and at such times he gave no ground of complaint by withholding the testimonies of confidence and love. On some occasions, driven to a sort of madness of exasperation, originating from the sources of influence which have been mentioned, combined with the goadings of physical suffering, he was unjust and cruel in a high degree. But it is some satisfaction to know, that he had perception enough, and love enough left, to acknowledge the wrong in his better moments. In such a spirit, he made some conciliatory remarks some years before, in his journey to St. Reine. " He appeared very desirous," she says, " of having me attend him, and was not willing to have any other. And he made the remark, referring to those who had afflicted me, if they were not in the habit of speaking against you, I should be more satisfied and easy, and you would be more happy."

As the clouds were gathering over him, and the sun of his life seemed about to be setting, Madame Guyon felt that she could no longer consistently or rightly submit to an interference

E

even on the part of his mother. She asserted her rights with dignity and decision, as she might have done without any failure of propriety at a much earlier period. Feeling that at this solemn crisis there should be a full reconciliation between herself and her husband, and that what remained of life to them should be spent in a different manner, uninfluenced and unmarred by others, she approached the matter of their differences, not merely in the spirit of a woman and a wife, but in that also of a Christian.

" I took some favourable opportunity," she says, "and drawing near his bed, I kneeled down; and admitting that I probably had done things which had displeased him, I assured him that I had not wronged him in any case deliberately and intentionally. And, for whatever I had done amiss, under whatever circumstances, I now begged his pardon. He had just awoke from a sound sleep. Strong emotion deeply marked his countenance, and he said, ' It is I who have done wrong rather than yourself. It is I who beg *your* pardon. I did not deserve you.' "

From this time he had his eye fully open to the arts practised upon him. He felt that he, who assumes the responsibility of coming between husband and wife, and of disturbing their happiness by alienating their affections, does an evil not more terrible in its results, than malicious and morally reprehensible in its character. It was her privilege to watch at his bedside during the remainder of his days; to wipe away the drops of anguish from his brow ; and to speak words of Christian consolation to his dying heart. And she did this, when her own soul was inwardly tried by the deepest fears and sorrows.

She advanced much afterwards in the knowledge of the Scriptures and in Christian experience; but even at this time, and with all the perplexities and sorrows which weighed down her mind, there can be no doubt, that her sympathy, advice, and prayers were of unspeakable value. On a dying couch, such a friend and adviser may justly be regarded as a special gift of Heaven.

For twenty-four days immediately preceding his death, she

scarcely left his bedside. The alleviation of physical suffering was not the only result of her watchings and labours. God was pleased to bless them also to his spiritual good. In his last days, when all earthly prospects grew dark, the light of religion began to open its dawning in the soul. In the mild radiance of that light, feeble though it was, he died. He was resigned and patient in his sickness; and died, so far as could be judged, in the exercise of truly Christian dispositions, after having received the sacramental element in an humble and edifying manner. His death took place on the morning of the 21st of July 1676. " I was not present," she says, " when he expired. Out of tenderness to me, he had requested me to retire."

Thus her own person had been smitten; and within a few years she had seen her beloved son and daughter taken from her, and her father and her husband, after short intervals, laid in the grave. And she was a woman whose heart, from its first young beat to its dying throb, gushed out with sensibility. This was one of the marked traits of her character, which existed naturally almost in excess. No daughter loved her parents more tenderly; no mother possessed more depth and sacredness of maternal affection; no wife appreciated more fully the sacred nature and the value of the conjugal relation. But of those who sustained these invaluable relations, how many were gone! Like summer flowers, or like leaves of autumn, they had fallen on her right hand and left. She stood alone; smitten within as well as without; and without a single friend to console her. But did she repine? Did she indulge in a murmuring spirit?

So far from complaining and rebelling, she knew well the hand of the Lord; and her soul did not hesitate a moment to bow in submission before it. It was not the sullenness of despair, which yields because it cannot do otherwise; but the calmness of Christian submission and hope. She could say with the Psalmist, in allusion to the ties of earth which had been separated, however painful the process was to the natural affections, " O Lord, truly I am thy servant: I am thy servant, and

*the son of thy handmaid ; thou hast loosed my bonds ; I will offer
to thee the sacrifice of thanksgiving, and will call upon the name
of the Lord"* (Ps. cxvi. 16, 17). This was the passage of Scrip-
ture which particularly occurred to her mind in connexion with
these events. She knew, whatever trials might exist here, that
there was a hidden mercy concealed beneath them ; and that
a rest, pure and permanent, remains for the people of God.

She was twenty-eight years of age when she was thus left a
widow, having been married twelve years and four months.
Having buried two of her children, she was now left, with three
others ; two sons, and an infant daughter, born but a few
months before the death of her husband.

God may be regarded, in a special sense, as the friend and
father of the widow and the orphan. "The Lord," says the
Psalmist, "preserveth the stranger, and *relieveth the fatherless
and the widow"* (Ps. cxlvi. 9). The aspects of Providence, in
many respects, were dark before her, both within and without.
But God did not desert her ; and, in His goodness, which does
not "willingly grieve and afflict the children of men," He would
not desert her in her sorrowing state. She could say with the
apostle, "We are troubled on every side, yet not distressed ; we
are perplexed, but not in despair ; persecuted, but not for-
saken ; cast down, but not destroyed ; always bearing about
in the body the dying of the Lord Jesus, that the life also of
Jesus might be made manifest in our body" (2 Cor. iv. 8-10).
Unshaken in her Christian integrity, true to the altar of sacri-
fice on which she had placed herself, her first and great inquiry
now, as it had been in times past, was, "Lord, what wilt thou
have me to do?"

She seemed to have an inward conviction that the time had
nearly come in God's providence, when she would be enabled to
devote herself exclusively to the cause of religion. But she
knew that God does not require of us duties contradictory in
their nature ; and that her first cares and labours were especi-
y due to her family.

The administration of a large estate devolved, in a consider-

able degree, upon herself. This was the first business to which Providence, whose indications she regarded with great care, seemed to lead her. She says, "I had received no training in matters of business, and was in a great degree ignorant of them. But being called in the Divine providence to attend to this matter, I received from God that strength and wisdom which were necessary for the occasion. I believe that I omitted nothing which it was necessary or proper for me to do. I arranged all my husband's papers; I paid all the legacies which he required to be paid; and did all without assistance from any one, excepting always that Divine assistance which God never failed to give me, whenever He imposed any special burden.

"My husband," she adds, "had a large amount of writings and papers of various kinds left with him, to which other persons had a right. These also required my attention. I took an exact inventory of them; and had them sent severally to their owners, which, without Divine assistance, would have been very difficult for me; because, my husband having been a long time sick, everything was in the greatest confusion. This circumstance, which naturally arrested the attention of the persons to whom the papers were sent, gained me the reputation of a woman of skill in business—a reputation to which I regarded myself as having but very little claim. Another affair, which occurred at this time, added to this favourable impression."

There were a number of persons in the neigbourhood where her husband resided, who fell into a dispute in relation to a piece of property. And not being able to settle it, they chose, rather than to bring it before the courts, to refer it to him. As he was acquainted with most of these persons, and had a particular esteem for some of them, he took charge of the business, although not very appropriate to his situation and his mental habits. There were no less than twenty-two persons concerned in this affair, which rendered it one of considerable delicacy and perplexity. Either for want of time, or distrusting his ability to settle the dispute alone, he employed some persons skilled in the law, to assist him in the examination of the papers, which

were laid before him, and to aid him in forming a just opinion. It was at this stage of the business that he died.

"After his death," she says, " I sent for the persons who were concerned, and proposed to return them their papers. They were troubled, anticipated the greatest evils, and perhaps the ruin of some of their number, if a settlement of the difficulties could not be had. In this state of things they proposed to me to take the place of my deceased husband, and to act as judge between them. A proposition, apparently so impracticable and absurd, could not have been entertained for a moment, had it not been for the urgency and the real necessities of the parties concerned. This gave to the proposition the aspect of a Christian duty. I laid it before the Lord; and relying on His strength and wisdom, felt it my duty to try. I found it necessary to give my mind fully to the business, which I had thus, as it seemed to me with the Divine approbation, voluntarily assumed. And accordingly, laying aside all other business, I shut myself up in my closet about thirty days, not going out at all except to my meals and to religious worship. All this time was necessary in order to understand the merits of the case. I at length completed the examination, formed my final opinion upon the subject, and drew it up in writing. The parties were summoned together; and without reading it or knowing what my decision was, they accepted it and signed it. I afterwards learned that they were so well pleased with what I had done, that they not only commended it much, but published it abroad everywhere. The hand of the Lord was in it. It was God who gave me wisdom. So ignorant was I then, and so ignorant am I now, of affairs of this nature, that when I hear persons conversing about them, it appears to me like Arabic."

At this period, and during a number of years, her life, considered in its outward relations, was retired, domestic, and in many respects quiet. The time had not come which was destined to open to her the path of more public duty. *Inwardly* she was still desolate. Her sorrow was unappeasable. But though it seemed to her that God had left her, she acknowledged fully the

rectitude of all His dealings, and felt that she could not leave *Him*. She followed Him in tears like the Syrophenician woman.

After the death of her husband she made some attempts towards a reconciliation with her mother-in-law. On the following Christmas-day, in particular, she approached her, and said to her with much affection, " My mother, on this day was the King of Peace born. He came into the world to bring peace to us. I beg *peace of you* in His name." But her stern heart was unmoved ; or, if it were otherwise, she would not let it appear. The question then arose whether she should leave her. A number of persons in whom she placed confidence advised her earnestly to do it, believing as they did that she had already suffered enough from that source. She had doubts about it. She was fearful of offending God by desiring to throw off a cross, heavy though it was, which it seemed to her that Divine wisdom imposed upon her. Undoubtedly she was correct. But the same Providence which imposed this cross upon her, in its own time removed it. In the winter of 1677, the winter following the death of her husband, and a few weeks after the conversation to which we have just now referred, her mother-in-law gave her notice, in express terms, that *they could no longer live together*.

" This," says Madame Guyon, " was fairly giving me my discharge. My scruples were now removed. I took measures to retire from the house where we had resided together, as quietly as possible, as I did not wish to give occasion for surmises and evil remarks. During the period of my widowhood thus far, I had not made any visits, except such as were of pure necessity and charity. I did not wish to speak of my troubles to others, or to make them known in any way. God had taught me to go to Him alone. *There is nothing which makes nature die so deeply and so quickly, as to find and to seek no earthly support, no earthly consolation.* I went out, therefore, from my mother-in-law in silence. In the cold of mid-winter, when it was difficult to obtain suitable accommodation elsewhere, I went out to

seek another habitation, with my three surviving children, and my little daughter's nurse."

We leave her mother-in-law here. The Scripture says in language, which has a true and mighty meaning to the holy heart, "*Judge not, that ye be not judged.*" There is a God above us, who is not ignorant of those weaknesses, temptations, and sorrows, existing in every heart, which are known to Him only. Until we have the attribute of omniscience, which is requisite for a perfectly just judgment, let us never condemn others, however defective their characters may be, without leaving a large place for pity and forgiveness. Such, I think, were obviously the feelings of Madame Guyon in relation to this unhappy matter. For more than twelve years her mother-in-law had embittered her domestic life. But she did not fail to recognise the hand of the Lord in it. She was led to see, that God, who accomplishes His purposes by instruments, made use of the jealousy and fierceness of her mother's temper to humble and purify her own lofty spirit. God educed *her* good out of another's evil. It was a mystery which she could adore and love, although she could not fully understand it. She went out, therefore, in silence ; with tears, but without rebukes.

— —

CHAPTER XVI.

Her charities—Incident illustrative—Education of her children—Attempts to improve her own—Study of Latin—Continuance of inward desolation—Temptations—Writes to La Combe—Receives a favourable answer—July 22, 1680, the day of her deliverance after nearly seven years of inward privation—Reference to her work, the "Torrents"—Remarks —Poem.

ESTABLISHED once more in her own residence, with her little family around her, she lived a life more retired than ever. " I went," she says, " after no fine sights or recreations. When others went, I stayed at home. I wanted to see and know nothing but Jesus Christ. My closet. where I could contemplate Divine

things, was my only diversion. The Queen of France was at one time in my neighbourhood; but my mind was so taken up with other things, that she had not attraction enough to draw me out with the multitude to see her."

But retirement from the world is not necessarily retirement from duty. In her widowhood and seclusion, she did not cease to sympathize with the poor and the afflicted. Her own heart was desolate; but it was not in personal afflictions to make her forget that others also had their sorrows. As she turned her mind upon her own situation, and as she looked upon her fatherless children, she remembered the widow and the orphan. Still she had less energy in works of outward benevolence than at some former periods, But this was not owing to a change of principle or a want of pity; but is to be ascribed partly to feebleness of health, and partly to a state of inward desolation. Her strength, not only her physical vigour but her energy of purpose, was in some degree broken; but the true life, which burns without being consumed, still remained in it.

One day a domestic told her that there was a poor soldier lying in the public road, sick, and apparently unable to help himself. She gave orders that he should be brought in. He was one of those wrecks of humanity, ragged, unclean, and debased, who appear to be without home and without friends, and whom no one pities but that God who watches all men, and inspires pity in the hearts of those who are like Himself. For fifteen days she watched over him, with all the care and assiduity of a mother or sister; performing offices repugnant to a person of her refinement of feelings and manners. This was his last earthly habitation. He died at her house.

At this period she felt herself called to give some special attention to the education of her children. On the subject of early education, and especially on the influence of mothers in the forming of the intellectual and moral habits of children, she had bestowed much thought. To a reflecting mind like hers, this important subject would be very likely to suggest itself; especially when she recollected, as she often did, the loss and

injury which she herself had experienced in early life, from
inattention in this respect. At that time the subject of early
education, especially in its relation to those of her own sex, was
comparatively new ; a subject which, since her time, beginning
with the valuable and interesting work of Fénelon on Female
Education, has been discussed, analyzed, and applied with the
most successful results. In her Autobiography, she has given
some views on the treatment of children, particularly of daugh-
ters, characterized by close observation and sound judgment.

She embraced the opportunity, which Providence now seemed
to afford her, to revise and extend the elements of her own edu-
cation. Light literature, including romances and poetry, ad-
dressed chiefly to the natural, in distinction from the religious
tastes, she had laid aside years before. Her reading was limited,
for the most part, to the Bible, and works designed to elucidate
the Bible, and man's character, his continual need of Divine
grace, and his growth in the religious life. Many works on
these subjects, which from her position in the Roman Catholic
Church she would be inclined to consult, were originally writ-
ten in the Latin language. Under these circumstances, she
commenced and prosecuted the study of the Latin, without per-
haps distinctly foreseeing of how much benefit it would be to
her in her future inquiries and writings. But here, as every-
where else, God, who guides us in a way we know not, was pre-
paring her, in what she was called to do, as well as in what she
was called to suffer, to accomplish His own will.

During the three years immediately preceding the death of
her husband, and something more than the three years imme-
diately subsequent to it, namely, from 1673 to 1680, she endured
without cessation the pains of inward and of outward crucifixion.
One source of the suffering which she experienced, in this season
of privation or desolation, was, that notwithstanding the conse-
cration of herself to God, she experienced heavy and direct
temptations to commit sin. Terrible at times must have been
her mental conflicts. Her language (impossible, it is true, in
its application, but still strongly expressive of her feelings) was,

that she would rather endure the sorrows of eternal banishment from God's presence, than knowingly sin against Him.

"Under these circumstances," she says, "I felt the truth of what thou hast said, O my God, *that thou judgest our righteousness!* O how pure, how holy art thou! Who can comprehend it? I was led to see, one after another, the secret ties which bound me to earth; and which God, after He had brought them to my notice, was successively cutting asunder. All inordinate interest which I had taken in created things (that is to say, all interest in them out of God, and out of their true relations and true degree) was gradually taken away. It was thus that the process of inward crucifixion, often severely trying me, went steadily on.

"O holy Jesus!" she exclaims, in looking back upon what she then passed through, "*I was that lost sheep of Israel whom thou didst come to save.* Thou didst come to save her, *who could find no salvation out of thee.* O ye stout and righteous men! speak as much, and as proudly as you please, of the value and excellence of what you have done for God's glory. As for me, I glory only in my infirmities, since they have merited for me such a Saviour.

"Loaded with miseries of all sorts," she proceeds, "weighed down with the burden of continual crosses, I at last gave up hope. The darkness of an eternal night settled upon my soul. God seemed to have forsaken me. But thanks be to His grace, my heart bowed in entire and holy submission. Lost as I seemed to myself to be, I could not cease to love.

"Believing, as I did, in the strange position of my mind, that I could never again be acceptable to God, and never be received by Him, I distinctly and fully recognised His justice and goodness, and could not repress the longing desire I had to do something, or to suffer something, to promote His glory. I could praise the name of the Lord out of the depths, to which no lower deep seemed possible."

Finding no satisfactory relief from others, she wrote to Francis de la Combe. The special occasion of her writing was this:—

One of the male domestics in her family, becoming interested in religious subjects, was desirous of connecting himself with the Barnabites. He naturally consulted Madame Guyon on the subject ; and she was advised by her half-brother, La Mothe, to write to La Combe, who, as Superior of the Barnabites at Thonon, in Savoy, could undoubtedly give them all the requisite information and advice.

" I had always retained for him a secret respect and esteem as one who was truly devoted to God, and I was pleased with this opportunity of recommending myself to his prayers. I gave him an account of my depression and sorrow of mind, and of what I then supposed to be the case, that God no longer took pleasure in me, but had separated Himself from me."

Father La Combe was a man of ability as well as of personal inward experience. He took a view of her case entirely different from that taken by others. His experience enabled him at once to make a distinction between sorrow and sin ; and to reject the opinion she had formed, that the griefs she experienced were an evidence of her having offended God. On the contrary, he took the ground, that she ought to regard these afflictions as an evidence of the goodness and mercy of God, who was thus painfully but kindly removing the earthly props on which her spirit had leaned. This view, so entirely different from the opinions entertained at this time by herself, could not fail to give her some encouragement, although she was not as yet able fully to receive it.

The correspondence with Father La Combe, kept up at intervals for many years, commenced early in the year 1680. About the middle of July she wrote to him a second time, and made the particular request, that, if he received it before the 22d of July, a day memorable in her religious history, he would make her the subject of special supplication. The letter arrived, although the place of its destination was quite distant, the day before the time specified. And the person to whom it was addressed had too much piety and too deep a sense of his obligations to the author of it, to suffer a request, offered in such an

humble and sorrowing spirit, to pass unheeded. It was a day of prayer both with him and with her. It was a day also of the hearing of prayer. The sceptre of mercy was extended. On that favoured day, after nearly seven years of inward and outward desolation, the cloud which had rested so dark and deeply passed away, and the light of eternal glory settled upon her soul.

She was led for the first time to see, under the intimations of the Holy Spirit, that all things were just the reverse of what she had supposed,—that affliction is mercy in disguise, that we possess by first being deprived, that death precedes life, that destruction in the spiritual experience turns to renovation, that out of the sorrows and silence of inward crucifixion, and from no other source, must grow the jubilees of everlasting bliss. God was given back ; *and all things with Him.* All sights and sounds, all beauties of heaven and of earth, the trees and flowers below, and the stars of heaven in their places, and social pleasures and earthly friendships, whatever the intellect could perceive or the heart could relish,—she could enjoy them all, in their appropriate place and degree, because, in her victory over self, she was enabled to place and appreciate them in their true and Divine relation,—*all in God, and God in all.*

" On the 22d of July 1680, that happy day," she says, " my soul was delivered from all its pains. From the time of the first letter from Father La Combe, I began to recover a new life. I was then, indeed, only like a dead person raised up, who is in the beginning of his restoration, and raised up to a life of hope rather than of actual possession ; but on this day I was restored, as it were, to perfect life, and set wholly at liberty. I was no longer depressed, no longer borne down under the burden of sorrow. I had thought God lost, and lost for ever ; but I found Him again. And He returned to me with unspeakable magnificence and purity.

" In a wonderful manner, difficult to explain, all that which had been taken from me, was not only restored, but restored with increase and with new advantages. In thee, O my God, I found

it all, and more than all! The peace which I now possessed was all holy, heavenly, inexpressible. What I had possessed some years before, in the period of my spiritual enjoyment, was consolation, peace—the *gift* of God rather than the Giver; but now, I was brought into such harmony with the will of God, that I might now be said to possess not merely consolation, but the *God* of consolation; not merely peace, but *the God of peace.* This true peace of mind was worth all that I had undergone, although it was then only in its dawning.

"Sometimes, it is true, a sad suggestion presented itself,— that the life of nature might, in some way, reinstate itself. So that there was a wakeful spirit within me. I *watched;* and was enabled, by Divine grace, to meet and repel the approaches of evil in that direction. In this renovated state, I felt no disposition to attribute anything to myself. Certainly it was not I myself who had fastened my soul to the Cross, and under the operations of a providence, just but inexorable, had drained, if I may so express it, the blood of the life of nature to its last drop. I did not understand it then; but I understood it *now.* It was the Lord that did it. It was God that destroyed me, that He might give me the true life."

In one of her books on religious experience, entitled the " TORRENTS," in which she endeavours to describe the progress of the soul towards God, illustrating the subject by torrents taking their rise in hills and mountain tops, and rolling onward towards the ocean, she has given her views of the process of inward crucifixion, derived from her own experience. It should, in fact, be regarded as a statement of what she herself passed through; and ought to be read, in connexion with, and as illustrative of what she has said, on the same subject, in her Life.

In giving her views on particular subjects, I have not limited myself to her remarks made at a particular time, but have, in order to give her precise views, combined statements made at different times and at different places of her works.

And it is in accordance with these views that I think we may properly introduce here one of her poems.

THE DEALINGS OF GOD, OR THE DIVINE LOVE IN BRINGING THE SOUL TO A STATE OF ABSOLUTE ACQUIESCENCE.

'Twas my purpose, on a day,
To embark and sail away.
As I climb'd the vessel's side,
LOVE was sporting in the tide;
" Come," He said,—" ascend—make haste,
Launch into the boundless waste."

Many mariners were there,
Having each his separate care;
They, that row'd us, held their eyes
Fix'd upon the starry skies;
Others steer'd or turn'd the sails
To receive the shifting gales.

Love, with power Divine supplied,
Suddenly my courage tried;
In a moment it was night,
Ship and skies were out of sight;
On the briny wave I lay,
Floating rushes all my stay.

Did I with resentment burn
At this unexpected turn?
Did I wish myself on shore,
Never to forsake it more?
No—" My soul," I cried, " be still;
If I must be lost, I will."

Next He hasten'd to convey
Both my frail supports away;
Seized my rushes; bade the waves
Yawn into a thousand graves
Down I went, and sank as lead,
Ocean closing o'er my head.

Still, however, life was safe;
And I saw Him turn and laugh:
" Friend," He cried, " adieu! lie low,
While the wintry storms shall blow;
When the spring has calm'd the main,
You shall rise, and float again."

Soon I saw Him with dismay
Spread His plumes, and soar away,
Now I mark His rapid flight;
Now He leaves my aching sight ·
He is gone whom I adore,
'Tis in vain to seek Him more

How I trembled then and fear'd,
When my LOVE had disappear'd!
" Wilt thou leave me thus," I cried,
" Whelm'd beneath the rolling tide?"
Vain attempt to reach His ear!
LOVE was gone, and would not hear.

Ah! return and love me still;
See me subject to thy will;
Frown with wrath, or smile with grace
Only let me see thy face!
Evil I have none to fear;
All is good, if Thou art near.

Yet He leaves me,—cruel fate!
Leaves me in my lost estate;
Have I sinn'd? Oh, say wherein?
Tell me, and forgive my sin!
King, and Lord, whom I adore,
Shall I see thy face no more?

Be not angry—I resign
Henceforth all my will to thine.
I consent that Thou depart,
Though thine absence breaks my heart
Go then, and for ever, too;
All is right that Thou wilt do.

This was just what LOVE intended;
He was now no more offended;
Soon as I became a child,
Love return'd to me and smiled.
Never strife shall more betide
'Twixt the Bridegroom and His bride.

CHAPTER XVII.

Sanctification as compared with justification—The importance of striving after it—State Madame Guyon at this time—Her work, "The Torrents"—Some sentiments from descriptive of her own experience—Singular illustration, by which she shows the difference between common Christians and others—The depth of the experience implied in true sanctification—The question whether all must endure the same amount of suffering in experiencing sanctification—Poem.

THEOLOGIANS very properly make a distinction between justification and sanctification. The two great moral and religious elements, namely, entire self-renunciation and entire faith in God through Jesus Christ, are involved in both of these religious experiences, and give to them a close relationship; without, however, confounding them and making them one. They are related to each other, without ceasing to be separate.

Justification, while it does not exclude the present, has special reference to the *past*. Sanctification, subsequent to justification in the order of nature, has exclusive reference to the present and future. Justification inquires, How shall the sin, which is past, be forgiven? Sanctification inquires, How shall we be kept from sin at the present time and in time to come? Justification, in its result upon individuals, removes the condemnatory power or guilt of sin; while sanctification removes the power of sin itself.

No man can be a Christian who is not justified. But no intelligent Christian can rest satisfied with justification alone. "He hungers and thirsts after righteousness." He, who professes to be a Christian, and yet has not this hungering and thirsting after a heart that is sanctified, has no good reason to believe that he has ever known the blessedness of a heart that is justified. "By their fruits," says the Saviour, "ye shall know them." Sanctification is the fruit.

A sanctified heart is only another expression for a holy heart —a heart from which selfishness is excluded, which loves God with all its power of love. From this time, Madame Guyon professed to love God with such love.

Whether we call this state of experience pure love or perfect love, whether we denominate it sanctification or assurance of faith, is perhaps not very essential. Certain it is, that it seemed to her, without professing or presuming to be beyond the possibility of mistake, that she loved her heavenly Father, in accordance with what the Saviour requires of us, with her whole power of loving. And accordingly she could no longer hesitate to apply to herself some of the strongest expressions, descriptive of the inward life, which are found in the Scriptures. She could say, with the apostle, " I live; yet not I, but Christ liveth in me; and the life which I now live in the flesh, I live by the faith of the Son of God, who loved me, and gave himself for me" (Gal. ii. 20). She understood, as she never did before, the import of the same apostle in the eighth chapter of Romans: " There is therefore now no condemnation to them which are in Christ Jesus, who walk not after the flesh, but after the Spirit; for the law of the spirit of life in Christ Jesus hath made me free from the law of sin and death" (Rom. viii. 1, 2). She, who a short time before believed herself outcast, had now the faith and the courage—a courage based upon faith and adorned with the deepest humility—to appropriate the beautiful conclusion of the same chapter, " *I am persuaded that neither death, nor life, nor angels, nor principalities, nor powers, nor things present, nor things to come, nor height, nor depth, nor any other creature, shall be able to separate us from the love of God, which is in Christ Jesus our Lord"* (ver. 38, 39).

The Torrents is obviously a work drawn chiefly from her own experience. In the latter part of it, she describes the state of her mind at this period, without, however, any distinct reference to herself, except that she occasionally speaks in the first person, as if forgetting for a moment the style of narration which she had adopted.

" Great was the change which I had now experienced; but still, in my exterior life, I appeared to others quite simple, unobtrusive, and common. And the reason was, that my soul was not only brought into harmony with itself and with God, but

with God's providences. In the exercise of faith and love, I endured and performed whatever came in God's providence, in submission, in thankfulness, and silence. I was now in God and God in me; and where God is, there is as much simplicity as power. And what I did was done in such simplicity and childlikeness of spirit, that the world did not observe anything which was much calculated to attract notice.

" I had a deep peace which seemed to pervade the whole soul, and resulted from the fact, that all my desires were fulfilled in God. I feared nothing; that is, considered in its *ultimate results and relations*, because my strong faith placed God at the head of all perplexities and events. I desired nothing but what I now had, because I had a full belief that, in my present state of mind, the results of each moment constituted the fulfilment of the Divine purposes. As a sanctified heart is always in harmony with the Divine providences, I had no will but the Divine will, of which such providences are the true and appropriate expression. How could such a soul have other than a deep peace, not limited to the uncertainties of the emotional part of our nature, but which pervaded and blessed the whole mind! Nothing seemed to diminish it; nothing troubled it.

" I do not mean to say that I was in a state in which I could not be afflicted. My physical system, my senses, had not lost the power of suffering. My natural sensibilities were susceptible of being pained. Oftentimes I suffered much. But in the centre of the soul, if I may so express it, there was Divine and supreme peace. The soul, considered in its connexion with the objects immediately around it, might at times be troubled and afflicted; but the soul, considered in its relation to God and the Divine will, was entirely calm, trustful, and happy. The trouble at the circumference, originating in part from a disordered physical constitution, did not affect and disturb the Divine peace of the centre.

" One characteristic of this higher degree of experience was a sense of inward purity. My mind had such a oneness with God, such a unity with the Divine nature, that nothing seemed to

have power to soil it and to diminish its purity. It experienced
the truth of that declaration of Scripture, that ' to the pure all
things are pure.' The pollution which surrounds, has no power
upon it ; as the dark and impure mud does not defile the sun-
beams that shine upon it, which rather appear brighter and
purer from the contrast.

"But though I was so much blessed, I was not conscious of
any merit, nor tempted by any suggestions of merit in myself.
Indeed, I seemed to be so united with God, so made one with
the centre and sum of all good, that my thoughts did not easily
turn upon myself as a distinct object of reflection ; and, con-
sequently, it would not have been an easy thing for me to attach
to myself the idea of merit. If I had done virtuously and meri-
toriously by a *laborious effort*, the idea of merit would more
naturally and readily have suggested itself, and I might have
been tempted to indulge thoughts of that kind. But now that
God had become the inward operator, and every movement was
a movement originating, as it were, in a Divine inspiration, and
as a holy life had become as natural to me as the life of nature
formerly had been, I could not well attribute to myself what
evidently belonged to God. To Him, and to Him only, to His
goodness and His grace, I attributed all worthiness, all praise.

"It was one of the characteristics of my experience at this
time, that I could not move myself, or bring myself into action,
from the principle of self, because self was gone. I stood silent
and unmoved in the midst of God's providences, until the time
of movement came, which was indicated by these providences.
Then I decided, when God called me to decide, and with God to
help me to decide.

"From this time, I found myself in the enjoyment of liberty.
My mind experienced a remarkable facility in doing and suffer-
ing everything which presented itself in the order of God's pro-
vidence. God's order became its law. In fulfilling this law, it
experienced no inward repugnance, but fulfilled its own highest
wishes, and therefore could not but be conscious of the highest
inward liberty. When the soul loses the limit of selfishness.—

a limit which fixes the soul in itself,—it has no limit but in God, who is without limits. What limit, then, can be placed to the length and breadth of its freedom ?

" I regard the deprivations and the sufferings of Job, and his subsequent restoration to prosperity and to the manifestations of the Divine favour, as a history which illustrates, as if in a mirror, the process of inward death and inward resurrection which is experienced by those who arrive at the state of full interior transformation. God first took away everything, and then restored everything, as it were, a hundred-fold. And so in the inward life. Our worldly possessions, our property, our influence, our reputation, our health, are taken away, if God sees it necessary ; He then smites our domestic and other affections, which have persons for their objects rather than things, either by smiting and withering the affections in themselves, or in the objects to which they are attached. He then proceeds to crucify the subject of the Divine operation, to any attachment to and reliance on his outward works as a ground of merit and acceptance. In its death to everything where self reigns instead of God, the mind dies also to any sense of its own inward exercises and virtues, so far as they are a ground of self-gratulation and complacency. Nor does this process stop, till the life of nature, which consists in inordinate attachments, is entirely exterminated. But the soul cannot live without a life of some kind. There are but two, and can be but two principles of moral life in the universe ; one, which makes ourselves, or the most limited private good, the centre ; the other, which makes God, who may be called the Universal Good, the centre. When *self* dies in the soul, God lives; when *self* is annihilated, God is enthroned.

" In this state of mind I did not practise the virtues *as virtues*. That is to say, I did not make them distinct objects of contemplation, and endeavour to practise them, as a person generally does in the beginnings of the Christian life, by a separate and constrained effort. I seemed to practise them naturally, almost instinctively. The *effort*, if I had made one, would have been

to do otherwise. It was my *life* to do them. Charity, sincerity, truth, humility, submission, and every other virtue, seemed to be involved in my present state of mind, and to make a part of it; being, each in its appropriate place, an element of life."

Christians in a higher state of religious experience, those especially who are in a state of assured faith and love, may be compared to fountains which flow out of themselves. In the language of the Saviour, the water which is in them is a " *well of water springing up to everlasting life.*" It is true, that, like the waters of Siloa, which came from the sides of Mount Zion, and which were pleasing to God and to His people, they generally flow *softly;* but they flow abundantly and constantly. Nor is it a small thing, that they do not flow in artificial channels, which men's hands have cut for them, but in those which God has appointed; " at their own sweet will," as some one has expressed it, and yet in reality without any will of their own. And bearing life to others, as well as having life in themselves, the trees grow and flowers bloom on their banks; and when the weary traveller comes there, he finds the cooling shade above, as well as the refreshing draught beneath.

The work of sanctification, wherever it exists, is a work which enters deeply into our nature. Neither reason, nor experience, nor Scripture, authorizes us to speak of it, when it truly exists, as a *superficial* work; that is to say, a work near the surface and easy to be done. It is not the application of something which alters and polishes the outside merely. It is not, properly speaking, a remodelling and improvement of the old nature, so much as a *renovation.*

Some things go under the name of sanctification, to which that term is not strictly applicable. The man of whom the Saviour speaks in the Gospel, could say, very truly, " *I fast twice in the week;* I give tithes of all I possess." Many persons who have subjected themselves to the greatest outward austerities, have complained that they did not experience that communion and acceptance with God, which they had anticipated.

Some persons, in addition to the rectification of the outward nature, have had a degree and kind of inward experience which is truly remarkable. It is not an experience, which, properly speaking, can be described as sanctification ; but is sometimes taken for it. These persons have been much exercised on the subject of a holy life ; they have experienced much anxiety in regard to it ; and in consequence of the new views they have had, and the inward victories they have obtained, have been the subjects of a high degree of joy. Sometimes the joy, owing in part, I suppose, to some peculiarities of mental character, is sudden, intense, overwhelming. They suppose themselves wholly and for ever conquerors. Not being in a situation fully to analyze their feelings, it is not wonderful that they make mistakes, and ascribe wholly to grace what is partly due to nature ; attributing to religion what belongs to physical or selfish excitement. Experience often shows that the sanctification which they profess under such circumstances, has not those elements of kindness, of forbearance and meekness, of permanent faith and of inward subjection and nothingness, which are necessary to characterize it as true. It is a sanctification evidently limited and imperfect, because it was not able to reach and subdue that terrible refuge and fortress of evil, the *natural will*

If these views are correct, they tend to diminish very much the danger sometimes supposed to attend this subject, which, in a few words, is this. If we allow the possibility of sanctification in the present life, we shall, from time to time, find persons who will profess this blessing, without possessing it ; a mistake which cannot well exist without being more or less injurious. The same danger attends the doctrine, that we may possess religion in any degree whatever short of sanctification. A man may profess religion without possessing it, and the mistake may be very injurious. And in all cases whatever, where the profession is not accordant with the reality, those evils cannot fail to follow which are naturally attendant upon error.

But if sanctification is so thoroughly explorative and renovat-

ing, and if it be generally understood to be what it really is, people will be cautious in making the profession. At least, if the profession is falsely made, the error will easily be detected. He, to whom the grace of sanctification can be truly ascribed, is one with Christ—a man meek, contented, benevolent, and devoutly acquiescent in whatever bears the stamp of providence— a man who goes hither and thither on errands of wisdom and mercy, without tumult and noise ; doing good to others without asking or expecting return ; in his spirit, where the Holy Ghost dwells, divinely peaceful, because he is in harmony with God. Such a man, on his lips, his countenance, his actions, his life, has a Divine seal.

There is one question which naturally arises here. Is it absolutely necessary to undergo all which Madame Guyon passed through, in order to experience these results ? I think that this question may properly be answered in the negative. Some resist the operation of God, because they are afraid of God ; some, because in the process of the inward operation they do not understand what He is doing and to what He is tending ; and still more because they love the world and the things of the world, more than they love God and the things of God. Resistance on the part of the creature, from whatever cause it may arise, implies and requires aggressive acts of trial, infliction, and reproof, on the part of Him whose right it is to rule. And the greater the resistance, the greater must be the blow which aims to subdue it. Those who resist much, will suffer much.

" Some persons are not brought to this state of freedom from the world and of union with God, without passing through exceeding afflictions, both external and internal. And this happens partly through ignorance, and partly and more generally through SELF-WILL. They are slow to learn what is to be done, and equally reluctant to submit to its being done. God desires and intends that they shall be His ; but they still love the world. They would perhaps be pleased to have God for their portion ; but they must have something besides God They would like to have God and their idols at the same time

And there they remain for a time, fixed, obstinate, inflexible. But God loves them. Therefore, as they will not learn by kindness, they must learn by terror. The sword of Providence and the Spirit is applied successively to every tie that binds them to the world. They are smitten within and without; burned with fire; overwhelmed with the waters; peeled and scathed and blasted to the very extremity of endurance; till they learn in this dreadful baptism the inconsistency of the attempted worship of God and Mammon, and are led to see, that God is and ought to be the true and only Sovereign."

But souls in whom grace is triumphant, are not beyond or above the cross. Such grace enables us to bear the cross, but it does not deliver us from it. Madame Guyon was willing to follow in the steps of the Saviour whom she loved. Christ had crowned her; and perhaps it was a crown of thorns. But He himself had worn it; and that was enough to make it infinitely dear to her heart. *Spiritually*, she had entered into *rest*. But the rest of earth ought not to be confounded with the rest of heaven. The one sleeps amid roses, and is wrapped in sunshine; the other has a dwelling-place with clouds and tempests for its canopy, with thorns and briars for its covering. She welcomed, therefore, the cross still, now and in all time to come, till her head should be laid in the grave. The following poem expresses some of her sentiments on this subject :—

THE JOY OF THE CROSS.

Long plunged in sorrow, I resign
My soul to that dear hand of thine,
 Without reserve or fear :
That hand shall wipe my streaming eyes ;
Or into smiles of glad surprise
 Transform the falling tear.

My sole possession is thy love ;
In earth beneath, or heaven above,
 I have no other store :
And though with fervent suit I pray,
And importune thee, night and day,
 I ask thee nothing more.

My rapid hours pursue the course,
Prescribed them by love's sweetest force
 And by thy sovereign will,
Without a wish to escape my doom ;
Though still a sufferer from the womb,
 And doom'd to suffer still.

By thy command, where'er I stray,
Sorrow attends me all my way,
 A never-failing friend ;
And, if my sufferings may augment
Thy praise, behold me well content,
 Let *Sorrow* still attend !

Adieu ! ye vain delights of earth,
Insipid sports, and childish mirth,
 I taste no sweets in you ;
Unknown delights are in the cross,
All joy beside to me is dross ;
 And Jesus thought so too.

The *Cross !* O ravishment and bliss—
How grateful e'en its anguish is ;
 Its bitterness how sweet !
There every sense, and all the mind,
In all her faculties refined,
 Taste happiness complete.

Souls, once enabled to disdain
Base, sublunary joys, maintain
 Their dignity secure;
The fever of desire is pass'd,
And Love has all its genuine taste,
 Is delicate and pure.

Self-love no grace in Sorrow sees,
Consults her own peculiar ease :
 'Tis all the bliss she knows ;
But nobler aims true Love employ,
In self-denial is her joy,
 In suffering her repose.

Sorrow and Love go side by side ;
Nor height nor depth can e'er divide
 Their heaven-appointed bands ;
Those dear associates still are one,
Nor, till the race of life is run,
 Disjoin their wedded hands.

Jesus, avenger of our fall,
Thou faithful lover, above all
 The cross have ever borne !
O tell me—life is in thy voice—
How much afflictions were thy choice,
 And sloth and ease thy scorn !

Thy choice and mine shall be the same,
Inspirer of that holy flame
 Which must for ever blaze !
To take the cross and follow thee,
Where love and duty lead, shall be
 My portion and my praise.

CHAPTER XVIII.

Uncertainty as to her future course—Thoughts of a Nunnery—Decides against—Proposals of marriage—All such propositions decided against—Course still uncertain.—Short season of comparative retirement and peace—Poem.

In this new and encouraging state of her feelings, the question now pressed, What course should she take during the remainder of her life ? She believed, and she had some support for her belief in the Scriptures, that inaction, or rather a suspension of action, until Providence indicates the course to be taken, with some degree of clearness, is the only true and safe action. At such times, Providence requires no other kind of action than that of *waiting.*

And this action is far from being unimportant, because it implies a resigned and submissive spirit—a rejection of all un-

holy motives and impulses—a sincere desire to know the truth
—and a recognition of God's readiness to impart it. Indeed, to
make men wait submissively and patiently until He sees fit to
permit and authorize their action in subordination to His own
time and manner of action, is a part, and a merciful and import-
ant part, of God's discipline of His children.

The first plan which suggested itself, was to arrange her af-
fairs and to go into a nunnery. *There*, in retirement and silence,
it seemed to her, as she looked at the subject on its first being
presented, that she might serve God and benefit her fellow-
creatures, without the hazards to which she had formerly been
exposed. Many were the names cherished in her own personal
recollections, and celebrated in history, of those, worn out with
the cares and sorrows of the world, who had thus sought God
and that peace of God which passes understanding, in places of
religious seclusion. She thought of Genevieve Granger, of her
own sainted sister, who first watched over and instructed her in
the Ursuline seminary ; the Marys and the Catharines of other
times, the De Chantals and the St. Theresas, came to recollec-
tion. But it required no great reach of thought to conclude,
that those who go to the convent, or any other place, without
being led there by the wisdom and signature of an overruling
providence, will fail to find God, whatever may be the professed
object of their search, either as the guide or the end of their
journey. There was another and a higher question first to be
answered, What is God's will ? Looking at this proposed course
in the light of the Divine will, and, in order to know that will,
considering it in its connexion with what she owed to her family
and the world, she decided against it.

The situation of her children, in particular, had weight in this
decision. She was still the head of a family, and could not dis-
regard the claims and duties of that responsible relation. " I
was still restricted in my movements," she says, " in having two
children given me in so short a time before my husband's death.
If I had been left with my eldest son alone, I should probably
have placed him at some college, and have gone myself into the

Convent of the Benedictines. But the situation of my younger children precluded all thoughts of this kind. God had other designs upon me."

Among other things was the question of a second marriage. Proposals were made by three different persons. At the middle age of life, possessed of great wealth, with a high reputation for intelligence and refined culture, and entitled to move in the leading circles of society, the question was one which brought itself home to her situation, sympathies, and prospects of usefulness. Carrying this matter, as she did everything else, to God, she came to the conclusion that she was called to another sphere of responsibility and duty. The question was decided on general principles. She says, " There was one of these persons, in particular, whose high birth and amiable exterior qualities, might, under other circumstances, have had an influence on my inclinations. But I was resolved to be God's alone."

Thus bidding adieu to the world, without shutting herself out of the world, she awaited the course of events. Her present position, however, and field of labour, did not satisfy her. She had an inward conviction, without being discontented or anxious, that the purposes of God were not fulfilled in it. She seemed to see a hand in the clouds which beckoned her away, but she knew not whither. There seemed to be a voice in her spirit, a voice uttered secretly but authoritatively, which said, that there were other duties and other crosses before her. Providence had not unfolded its intentions. But she knew that the sign of God would be written on her awakened spirit in His own good time.

Meanwhile she enjoyed a short season of comparative retirement and rest. It was now the summer of 1680. "O my Lord," she says, "what happiness did I not largely taste, in my solitude and with my little family, where nothing interrupted my tranquillity! Living near Paris, but out of its limits, I enjoyed the advantages of the country as well as of the city. My younger children were of an age which did not require from me much personal care and attention, especially as I was assisted in

taking care of them by persons well qualified for that office. I
often retired into a forest near my residence ; and many were
the hours and days of religious communion and happiness which
I passed there." In the simple and affecting language of one of
her poems,—

Here sweetly forgetting and wholly forgot,
 By the world and its turbulent throng,
The birds and the streams lend me many a note,
 That aids meditation and song.

Ye desolate scenes, to your solitude led,
 My life I in praises employ,
And scarce know the source of the tears that I shed,
 Whether springing from sorrow or joy.

Though awfully silent, and shaggy, and rude,
 I am charm'd with the peace ye afford ;
Your shades are a temple where none will intrude—
 The abode of my lover and Lord.

Ah ! send me not back to the race of mankind,
 Perversely by folly beguiled ;
For where in the crowds I have left shall I find
 The spirit and heart of a child ?

Here let me, though fix'd in a desert, be free,
 A little one, whom they despise ;
Though lost to the world, if in union with Thee,
 I am holy, and happy, and wise.

CHAPTER XIX.

1680—Remarkable incident in a church—Effect on her mind—Consulted by a person on a
mission to Siam—Asks his opinion on her plan of going on a mission to Geneva—His ad
vice—Visit of Bishop D'Aranthon at Paris—Consults him—Decides to leave for Gex—
Charities during the winter of 1680—Efforts for the spiritual good of others—Preparations
for departure—Trials of mind—Remarks upon them and the opinions of others.

It is to this period, either the summer or early in the autumn
of 1680, that we refer the following incident. " I was obliged,"
she says, " to go to Paris about some business. Having entered
into a church that was very dark, I went up to the first confessor
I found there. I had never seen him before, and have never
seen him since. I made a simple and short confession ; but with

the confessor himself, aside from the religious act, I did not enter into conversation. And accordingly, he surprised me much in saying of his own accord, ' I know not who you are, whethei maid, wife, or widow ; but I feel a strong inward emotion to exhort you to do what the Lord has made known to you that He requires of you. I have nothing else to say.'

" I answered him, Father, I am a widow, who have little children. What else could God require of me, but to take due care of them in their education ? He replied, ' I know nothing about this. You know if God manifests to you that He requires something of you, there is nothing in the world which ought to hinder you from doing His will. *One must leave one's children to do this.'* "

This remark, coming in this unexpected manner, touched her in a point of great interest. The conviction had gradually formed itself in her mind, that she must leave her present residence, and labour somewhere at a distance. But how could she leave her children ? This question caused her some perplexity; but she was not long in perceiving, that it is easier to the holy mind to leave one's children, however strong their claim upon the affections, than to leave any path of duty which God's providence clearly points out. The words, heard under circumstances so singular, reminded her of the words of the Saviour : *" He that loveth father or mother more than me, is not worthy oj me ; and he that loveth son or daughter more than me is not worthy of me."* (Matt. x. 37, 38.)

She had nearly concluded, though with some doubts, that she was called to religious labours in that part of France and Savoy which borders on the Republic of Geneva, and perhaps in Geneva itself. If, in the state of her affairs, she could not very conveniently, or consistently, devote herself to labours among the unchristianized heathen, she would, by labouring in the distant and rude towns and provinces at the foot of the Alps, sustain a position hardly less trying in itself, or less beneficial in its consequences. While deliberating, she was visited by a religious friend from a distance, who came, in part, to consult her

on a design of going on a mission to Siam. With some reluctance he opened the subject. As his age and infirmities seemed to disqualify him for so difficult and distant an enterprise, she did not hesitate to discourage him.

But said she, " I have reason to think, that God has sent you here not merely to get an opinion in regard to *your* mission, but to give an opinion in regard to *mine*. I need your assistance and your advice." Her friend kept the subject under consideration for some days ; and at last gave an opinion favourable to her plans, subject only to this condition, that she should first submit the matter to Bishop D'Aranthon, who bore the title of Bishop of Geneva, although he resided at Anneci, twenty miles south of Geneva, and under whose directions she would naturally be placed in going into that part of France. It was the opinion of this person, that if D'Aranthon approved, she should go ; but if not, as he was in a situation especially fitted to judge of it, she should give up the design.

To this view she readily assented. It seemed so important to ascertain fully the views of Bishop D'Aranthon, and such was the interest felt by this person himself, that he offered to go personally to Anneci, and lay the subject before him. Madame Guyon hesitated somewhat, because, although he was full of religious fervour, and wished to spend his last days in attempting to convert the Siamese, he was physically unfitted, at his period of life, to endure much hardship. While they were thus considering, two travellers, both of them religious persons, called with no object apparently but that of resting, and stated that Bishop D'Aranthon was then in Paris.

He was an humble, sincere man. As Protestants, we would naturally consider him to be in some errors ; but he had the great merit of being sincere. The people, over whose religious interests he presided, were for the most part poor, engaged in agricultural pursuits, and simple in their thoughts and manners. They dwelt partly in Savoy and partly in France ; in sterile out romantic regions, situated at the foot of the Alpine ranges. Sympathizing with a people, whose lot could be mitigated and

rendered happy only by the influences of religion, he loved them, and laboured most sincerely and faithfully. And it was a great satisfaction to him to find any person, especially such a woman as Madame Guyon, willing to co-operate in spreading among them the knowledge of Jesus Christ.

Madame Guyon visited him without delay, and she speaks of but one visit to him. The author of the Life of D'Aranthon says that there were a number of interviews. The good Bishop received her frankly and kindly. She stated her situation, experience, and fixed purpose to devote herself to the service of God. But how and where, she knew not; except that the concurrence of providences, combined with something within her, seemed to indicate that she might, perhaps, labour profitably in the distant part of France, and the contiguous portion of Savoy. It had occurred to her also, to employ the substance which God had given her, in forming a charitable establishment for the resort of those who might be found truly willing to serve God, and might need such aid. "The Bishop," she says, "approved my design."

She determined, in concurrence with D'Aranthon, and also Father La Combe, whom she thought it proper to consult by letter, to leave Paris, as soon as her affairs could be adjusted, and reside at Gex, until Providence should indicate some other field of labour. Gex is in the extreme east of France, within the modern department of Ain, twelve miles from Geneva. It is a town of some note, situated at the foot of Mount St. Claude, one of the summits which constitute the celebrated Alpine range, called the Jura mountains.

As, however, the arrangements for so long a journey, and so complete a change could not be fully made until late in the autumn, it was determined to postpone her departure till the spring or summer of the next year. Meanwhile, however, she was not idle. In addition to the cares and labours incident to her removal, she declined no labour, which the warmest Christian charity and fidelity required her to undertake for others.

In the winter of 1680, which was very long and severe, there

was a scarcity in France. Amid the dense population of Paris and its suburbs, it might perhaps be denominated a *famine*. Aroused by the cries of distress, Madame Guyon made every effort to relieve the many persons who stood in need. For a considerable time she distributed some hundreds of loaves of bread at her house every week, besides charities of a more private nature. In addition, she made arrangements for a number of poor boys and girls, and kept them at work.

God not only gave her strength and means to do it, but she adds, that He " gave such blessings to my alms, that I did not find that my family lost anything by it." " True charity," she remarks further, " instead of wasting or lessening the substance of the donor, blesses, increases, and multiplies it profusely. If men fully believed this, how much that is now uselessly dissipated, would be given to the poor, which would scarcely bless those who might receive it more than those who might give."

She was assiduous also, although in a somewhat private manner, for the spiritual good of others. She mentions a number of individuals, and one whole family in particular, whom she thinks she was the means of greatly benefiting in this respect. The cases were similar to many others to which she alludes in her history; but they show that the sentiment of benevolence, the principle of doing good, had taken strong and permanent possession of her mind. The righteous shall say unto the Saviour at the last day, " Lord, when saw we thee an hungered, and fed thee ? or thirsty, and gave thee drink ? When saw we thee a stranger, and took thee in ? or naked, and clothed thee ? Or when saw we thee sick, or in prison, and came unto thee ? *And the King shall answer and say unto them : Verily I say unto you, Inasmuch as ye have done it unto one of the least of these my brethren, ye have done it unto me.*" (Matt. xxv. 37-40.)

As her departure approached, she made every preparation proper and necessary. Some important arrangements were to be made as to her property, of which she regarded herself as merely the stewardess ; and while, therefore, she could not

employ it in personal gratifications on the one hand, she could not wholly neglect it on the other. She made such provision as seemed to be desirable, for those friends and relatives, as well as others, whom Providence had made especially dependent on her. Her two sons she placed in the care of persons who would see everything done, which could reasonably be expected, for their morals and education. Her little daughter it was her intention to take with her.

But she experienced, at this juncture, some trials, both inward and outward. Clear as the course proposed was to her own mind, and strongly as it was approved by many religious persons in whom she had confidence, there were others to whom it appeared objectionable. "One day," she says, "when I was thinking over my plans, I found myself looking at them in the human light rather than in God's light, and I found myself tempted and staggered. The thought arose, *perhaps I am mistaken.* At this moment an Ecclesiastic came in, who was in the habit of visiting at my house, and said to me very promptly, that the undertaking was rash and ill-advised. I confess that I had some feelings of discouragement.

" But going to my Bible, to see what light I could find there, I opened at Isaiah xli. 14, as follows : ' Fear not, thou worm Jacob, and ye men of Israel. I will help thee, saith the Lord, and thy Redeemer, the Holy One of Israel.' And opening at the 43d chapter, I read as follows : ' When thou passest through the waters, I will be with thee ; and through the rivers, they shall not overflow thee. When thou walkest through the fire, thou shalt not be burnt; neither shall the flame kindle upon thee ; for I am the Lord thy God, the Holy One of Israel, thy Saviour.' As I thus read, my heart was strengthened. My doubts fled away. Relying on God, what occasion had I to fear ? I resolved to go, although I might appear a fool in the eyes of others ; regardless of the censures of those who know not what it is to be a servant of God, and to receive and obey His orders."

Her trial in regard to her children was very considerable ; but

F

she was enabled, through grace, entirely to surmount it. She loved them; "especially," she says, "my youngest son. I saw him inclined to good, and everything seemed to favour the hopes I had conceived of him. I was not insensible to the risk of leaving him to another's education. My daughter was at this time ill of a very tedious fever. Providence was pleased, however, so to order it, that she recovered her health in season to take the journey with me. The ties with which God held me closely united to Himself, were infinitely stronger than those of flesh and blood. The laws of my sacred marriage obliged me to give up all, to follow my spouse whithersoever it was His pleasure to call me. Though from time to time I had doubts and trials of mind before I went upon this religious mission, after my departure I never doubted of its being God's will.

"And though men, who judge of things only according to the success which follows them, have taken occasion, from my subsequent disgraces and sufferings, to judge of my calling, and to run it down as error, illusion, and imagination, it is that very persecution, and the multitude of strange crosses (*of which this imprisonment which I now suffer is one*),* which have confirmed me in the certainty of its truth and validity. Nay, I am more than ever convinced, that the resignation which I have made of everything, is in pure obedience to the *Divine will*. The Gospel effectually, in this point, shows itself to be true, which has promised to those that shall leave all for the love of God, 'a hundred-fold in this life, *and persecutions also*.'

"And have not I infinitely more than a hundred-fold, in so entire a possession as thou, my God, hast taken of me; in that unshaken firmness which thou givest me in my sufferings; in that perfect tranquillity in the midst of a furious tempest, which assaults me on every side; in that unspeakable joy, enlargedness, and liberty which I enjoy, at the very time of an imprisonment rigorous and severe? I have no desire that my imprisonment should end before the right time. I love my chains. Everything is equal to me, as I have no will of my own, but purely

* She wrote this when a prisoner in the Convent of St. Marie

the love and will of Him who possesses me. My senses indeed have not any relish for such things; but my heart is separated from them, and borne over them; and my perseverance is not of myself, but of Him who is my life; so that I can say with the apostle, '*It is no more I that live, but Jesus Christ that liveth in me.*' And if His life is in me, so my life is in Him. It is He *in whom I live, and move, and have my being.*

CHAPTER XX.

July 1681, leaves Paris—Manner of leaving and reasons of it—Her companions—Her child makes crosses, and then weaves a crown for her—Stops at Corbeil—Meets the Franciscan, formerly instrumental in her conversion—Conversation—Sails for Melun—Meditations—References to her poetry—Poem.

SHE left Paris, as nearly as can now be ascertained, early in July 1681. Considerable opposition to her designs manifested itself in some quarters, which rendered it possible, at least, that efforts might be secretly and perhaps violently made to prevent her departure. Her half-brother, La Mothe, who seems to have felt that he had some claims, or at least some expectations, on her property, had influence in high places, especially with the Archbishop of Paris, who had influence with the king. Much regard was not paid to the liberty of the subject. Not unfrequently persons were seized suddenly and sent to the prison of Vincennes, or the Bastile, by orders secretly and maliciously obtained.

Madame Guyon knew this, and at a later period she had experience of it. She thought it best, therefore, not to place herself in a situation where any attempt of this kind could be made upon her. Accordingly she departed privately from Paris, in a boat on the Seine. With her little daughter five years of age, attended only by a devout woman, whom she calls Sister Garnier, and two female domestics; one of whom, I suppose, was the

maid-servant to whom God gave so much of her spirit, and who shared for many years her labours and imprisonments.

She went forth with a definite object ; but still she might say in some sense, that she went forth " not knowing whither she went." She was now in her thirty-fourth year. Home and friends she might be said to know no more ; she became a representative of what she aptly calls the " apostolic life," with the world for her country, and all mankind for her brethren. From this time also we may number what she calls her "years of banishment." Wanderings, persecutions, imprisonments, exile, were her portion.

Alone upon the waters, she adored and rejoiced in God in silence. Still something within her whispered sadness to her heart. Her situation seemed to resemble that of the apostle Paul, when he went up, for the last time, to Jerusalem. " I go bound," he says, " in the spirit unto Jerusalem, not knowing the things that shall befall me there ; save that the Holy Ghost witnesses in every city, saying, *that bonds and afflictions abide me.*" Her little daughter sat in the boat, and employed herself in cutting the leaves and twigs which she had gathered on the river banks, or as they had floated by on the water, into the shape of crosses. In this way she made a great number ; and then, apparently unconscious of what she was doing, she fastened many of them to the garments of her mother. Her mother, at first, did not particularly notice what she was doing ; but directing her attention to it soon afterwards, she found herself almost literally covered with crosses. Having borne the cross in times past, and seeing but little prospect of a different result in future, she could not help looking on the act of her child as a sort of symbol and foreshadowing of what she would be called to endure. Sister Garnier remarked to Madame Guyon, " The doings of this child appear to be mysterious." And turning to the child, she said, " My pretty child, give me some crosses too." " No," she said ; " they are all for my dear mother." But she gave her one to stop her importunity.

But what was the surprise of Madame Guyon, when she saw

her daughter a little afterwards weaving together a crown of leaves and river flowers. She came and insisted on placing the crown upon her head; saying, "*After the cross you shall be crowned.*" This perfected the symbol. First the trial, and then the reward; the night of affliction succeeded by the dawning and the noon-day of joy. First the Cross, and then the Crown. This gave the transaction, though the doing of a little child, the character of a sign of Providence. And though "bonds and afflictions" awaited her, she could add, with the apostle, "*None of these things move me ; neither count I my life dear unto me, so that I might finish my course with joy.*"

Their boat stopped at Corbeil, a pleasant town of some size, seventeen miles from Paris. Her stay was short. But she met there the pious Franciscan whose conversation had been so much blessed to her in the early part of her religious history. She had kept up a correspondence with him for many years, and looked upon him as one of the most experienced and valuable of her religious friends. Their interview recalled many pleasant recollections, and was calculated to fill their hearts with gratitude. She related the dealings of God, which had resulted in her present design. The Franciscan, now advanced in years and mature in judgment, approved her plans, and invoked the Divine blessing upon them.

Once more upon the Seine, she saw with pleasure the impulse of oar and sail. The tree grew upon the banks; the flower bent its stalk to the waters; the breeze wafted odours; the birds sang in the branches. But there was nothing which she could dissociate from God; in *all* she heard God's voice; in *all* she saw God's glory. She saw the husbandman as he went to his home—his cottage beneath the trees on the river's bank; and she could not help thinking, in the secret of her heart, that earth had no home for her. But though a pilgrim, she was not alone; though homeless, she had a habitation not made with hands.

The state of her mind is found delineated in her poems. No person but a Christian of confirmed and thorough piety could have written the following beautiful stanzas, evidently drawn

from her own experience. Poetry is the *heart expressed;* or, at all events, there is no poetry where there is no heart. The poetry of Madame Guyon, whatever defects may attach to it, has the merit of expressing precisely what she *was,* and what she *felt.* These stanzas are emphatically the sentiments of the day and the hour; the spirit and voice of the world's wanderer.

GOD EVERYWHERE TO THE SOUL THAT LOVES HIM.

O Thou by long experience tried,
Near whom no grief can long abide;
My Lord! how full of sweet content,
I pass my years of banishment.

All scenes alike engaging prove
To souls impress'd with sacred love;
Where'er they dwell, they dwell in Thee,
In heaven, in earth, or on the sea.

To me remains nor place nor time;
My country is in every clime;
I can be calm and free from care
On any shore, since God is there.

While place we seek, or place we shun,
The soul finds happiness in none:
But with a God to guide our way,
'Tis equal joy to go or stay.

Could I be cast where Thou art not,
That were indeed a dreadful lot;
But regions none remote I call,
Secure of finding God in all.

My country, Lord, art Thou alone:
No other can I claim or own;
The point where all my wishes meet,
My law, my love; life's only sweet.

I hold by nothing here below;
Appoint my journey, and I go;
Though pierced by scorn, opprest by pride,
I feel the good,—feel nought beside.

No frowns of men can hurtful prove
To souls on fire with heavenly love;
Though men and devils both condemn,
No gloomy days arise for them.

Ah, then! to His embrace repair,
My soul,—thou art no stranger there;
There love Divine shall be thy guard,
And peace and safety thy reward.

CHAPTER XXI.

Arrives at Lyons—Remarks—Proceeds to Anneci—Remarks on this journey—Religious services at the tomb of St. Francis de Sales—Arrives at Gex, 23d of July 1681—Death of M. Bertot—Appointment of La Combe—Inward religious state—Benevolent efforts—New views of the nature of her mission—Sanctification by faith—Visit to Gex—Personal labours with La Combe—Favourable results.

THE boat stopped at Melun, a pleasant town, twenty-five miles south-east of Paris. Immediately she took passage with her companions,—with the exception of Sister Garnier, who stopped at Melun,—in one of the public conveyances that travelled

between Melun and Lyons. Lyons, formerly the second city of France for beauty, commerce, and opulence, is situated at the confluence of the Rhone and Saone, two hundred and twenty miles south-east of Paris. Distinguished as it was for its public structures, besides other objects of interest, she spent no longer time in it than was necessary to recover a little from the exhaustion of her journey. She could not indulge curiosity, except in subordination to the claims of religious duty and of God's glory.

From Lyons she took the most direct and expeditious route to Anneci, the residence of Bishop D'Aranthon. Speaking of this journey, she says, " It was very fatiguing. The toils of the day were followed by almost sleepless nights. My daughter, a very tender child and only five years of age, got scarcely any sleep, perhaps three hours a night. And yet we both bore so great a fatigue without falling sick by the way. My daughter showed no uneasiness, and made no complaint. At other times half this fatigue, or even the want of rest which I endured, would have thrown me into a fit of sickness. God only knows both the sacrifices which He induced me to make, and the joy of my heart in offering up everything to Him. Had I been possessed of kingdoms and empires, I should have offered them all up with the greatest joy, in order to give Him the highest marks and evidences of love.

" As we passed from town to town, I made it my practice, when we arrived at the public inn, to go into the nearest church, and spend my time in acts of devotion, till summoned to my meals. And when travelling, I did not cease to pray inwardly and commune with God, although those with me did not perceive, or at least comprehend it. My communion with God, and my strong faith in Him, had a tendency to sustain my spirits and render me cheerful. Disengaged from the world, and devoted exclusively to God's work and will, I found myself uttering the pleasure of my heart aloud in songs of praise. We passed through some dangerous places, especially between Lyons and Chamberri. And at one time our carriage broke down. But

God wonderfully preserved us. He seemed to be to us *a pillar of fire by night, and a pillar of cloud by day.*"

She arrived at Anneci on the 21st of July 1681. Next day, some religious services, which had special reference to her arrival, were performed by the bishop at the tomb of St. Francis de Sales. The memory of this distinguished man was exceedingly dear to her. She seemed to feel a special union with him, and to hold, as it were, with his departed spirit, " the holy intercourse of friend with friend ; united with him in Christ, and with Christ in God, who binds all His people, both the dead and the living, in one immortal tie."

The 22d of July was a day which, since the year 1668, when she first knew the blessedness of believing, she had never per- mitted to pass without special observance. On this day, nine years before, she had given herself to God in the most solemn manner, with the *formality of a written act.* To this she refers when she says, " It was there, at the tomb of St. Francis de Sales, that I renewed my spiritual marriage with my Redeemer, *as I did every year on this day.*" She was refreshed by the re- collection of the striking passage in the Prophet Hosea, " *And I will betroth thee unto me for ever ; yea, I will betroth thee unto me in righteousness, and in judgment, and in loving-kindness, and in mercies. I will even betroth thee unto me in faithfulness ; and thou shalt know the Lord.*"

On the 23d of July, she continued her journey, making a short stop in Geneva at the house of the French consul, where religious services were performed. She speaks of it as having been a day of much spiritual consolation. " It seemed to me," she says, " as if God united Himself to me in a powerful and special manner." Near the close of the day, she passed again within France, which she had left in going to Anneci and Geneva ; and, making her way along the base of the Jura mountains, reached Gex. She took up her residence at the house of the Sisters of Charity, who received her very kindly.

M. Bertot, whom, as her authorized Director, Madame Guyon had consulted for many years, and in whom she placed great

confidence, seems to have been a man of learning and piety, characterized by a high degree of caution. She says he was retired and difficult of access; and not at all inclined to think favourably of any religious experience which partook much of the marvellous and extraordinary. Nevertheless, on being consulted in relation to her mission, he gave his approval of it. A short time after she saw him on this subject, he was taken ill, and died. His works, containing some letters of Madame Guyon on spiritual subjects, were published after his death.

One of the first acts of Bishop D'Aranthon, after her arrival at Gex, was to appoint Director, in Bertot's place, Father La Combe. The selection met her views and wishes. Bertot's views and experience were not altogether accordant with hers.

Madame Guyon speaks of the early part of her residence at Gex as characterized by sweet and happy peace of mind and most intimate communion with God. Many times she awoke at midnight, with such a presence of God in her soul, that she could no longer sleep, but arose and spent hours in prayer and praise and Divine communion. On one occasion her exercises were connected with the scripture, " Lo, I come to do thy will, O God ;" which was brought to her mind very forcibly, and so applied to her own situation and feelings as to cause the most devout and pleasing reflections. " It was accompanied," she says, " with the most pure, penetrating, and powerful communication of grace that I had ever experienced. And here I may remark, that, although my soul was truly renovated, as to know nothing but God alone, yet it was not in that strength and immutability in which it has since been."

She was now on a field of labour remote from the noise and temptations of cities, to which she had looked forward with great interest. She had come without any prescribed course of action. But he who has the heart of a true missionary, will find something which can be done benevolently and religiously, wherever he goes ; and that, too, without the formalities and aids of antecedent arrangements. God opens the way to those that love Him. In connexion with other religious persons, she

endeavoured to do good to the poor, the ignorant, and suffering, especially in giving religious instruction.

She merely alludes to her labours incidentally and briefly. She was skilled in making ointments and applying them to wounds, and thought she might be very beneficial to those who were afflicted in that way, especially the poor. And she contemplated devoting herself wholly to benevolent measures of this kind. It was obviously her expectation to labour very much as she had laboured in times past; praying, instructing, visiting the sick, and giving to the needy; with the simple difference, that now her labours were to be performed in a different situation and among a different class of people. Her labours and charities were such that Bishop D'Aranthon wrote her a polite letter, expressive of his gratitude.

But it was not long before a new voice began to utter itself in her heart. The thought, or the voice, which God puts within us, is often at variance with mere human wisdom. In more than one sense can it be said, that " God's thoughts are not as our thoughts." He not unfrequently leads His people in a way which they know not. In God's view the *time* of the thing is as essential as the thing itself. In sending her from Paris to the foot of the Jura, among a poor and unknown people, He imposed a mission upon her which she did not know, and which He did not design that she should know—a burden which she understood afterwards, but not *now*.

The voice inwardly, in the form of a new and imperious conviction, began to speak. Something within her seemed to say, that this was not the special and great work which God had called her to perform. Her mind was perplexed, and she was at a loss what course to take. At this time Father La Combe came to Gex. He advised her to set apart a season of special supplication for the purpose of ascertaining more definitely what the will of the Lord might be. But on endeavouring to carry this advice into effect, she thought it best to leave the subject to the decisions of Providence.

God never has failed, and never will fail to make known His

will, in His own time and way, to those who have true and un-
reserved hearts to *do* His will. In fact, His will exists in His
present providences; they are the letters in which it is written.
And the heart that perfectly corresponds to God's providences,
perfectly corresponds to His will. It was God's will that she
should go, *not knowing whither she went.* A cloud rested upon
her path. *The seal of her mission was not yet broken.* What
could she do then but wait, adore, and be silent? And this was
her answer, practically at least, to La Combe—a man much less
advanced than herself. "God," she thought in her heart, "will
not fail to indicate to me what course I should take, when, on
the one hand, He finds me ready to do His commands, and when
on the other He is ready to make His commands known. I
leave, therefore, everything with Him, and with His providences.
THY WILL BE DONE."

The work which the Lord had assigned her, was wholly dif-
ferent from what she had anticipated. God often works thus.
Thus, at the foot of the Alps, when she thought her great
business was to make ointments, and cut linen, and bind up
wounds, and tend the sick, and teach poor children the alphabet
and the catechism (important vocations to those whom Provi-
dence calls to them), she uttered a word from her burdened
heart, in her *simplicity*, without knowing or thinking how widely
it would affect the interests of humanity, or through how many
distant ages it would be re-echoed. And that word was, Sancti-
fication by Faith.

Both the thing and the manner of the thing struck those who
heard her with astonishment. Sanctification itself was repug-
nant; and sanctification by *faith* inexplicable. In the Pro-
testant Church, it would have been hardly tolerable; but in the
Roman Catholic Church, which is characterized by ceremonial
observances, the toleration of a sentiment which ascribes the
highest results of inward experience *to faith alone*, was impos-
sible. So that, instead of being regarded as an humble and
devout Catholic, as she supposed herself to be, she found herself
suddenly denounced as a heretic. But the Word was in her

heart, formed there by infinite wisdom ; and in obedience to that deep and sanctified conviction which constitutes the soul's inward voice, she uttered it; uttered it *now*, and uttered it *always*, " though bonds and imprisonments awaited her."

She used discretion, however ; but not hypocrisy. She did not esteem it advisable to propose the highest results of the religious life to those who had hardly made a beginning, and who had not, as yet, experienced the blessing of justification. But when she met with those who believed in Christ as a Saviour from the penalty of a violated law, she seemed to be impelled by a sort of religious instinct, originating in her own blessed experience, to recommend Him also as a Saviour from present transgression, as a Saviour who can and does communicate His own spirit of truth, meekness, gentleness, purity, and holiness of heart to those who, in the spirit of entire self-renunciation, look to Him believingly for these great blessings. She said what was in her, in God's time, without variation and without fear, scarcely knowing what she did.

Her friend the Franciscan had made some suggestions on the course which she might find it expedient to pursue. He seems to have understood the state of things at Gex, especially among that class of persons entitled the New Catholics, with whom it was thought probable that she might be called particularly to labour. " He mentioned," she says, " a number of things about them, in order to show me that my views on religious experience, and my experience, were quite different from what I should be likely to find among them. He gave me to understand that I must be very cautious in letting them know that I walked in the *inward path ;* that is to say, in a life which rests upon *faith;* assuring me, if I were not so, that I could reasonably expect nothing but persecutions from them."

But it was difficult for her to understand and receive this advice. The way of God had become so clear to her, that she did not readily perceive how others, in the foolishness of the natural heart, might stumble at it. And if they did stumble at it, was it not the way of God still ? And ought it not to be

proclaimed as such? " It is in vain," she remarks, in connexion
with this conversation, "to contrive to hide ourselves from the
blow, when God sees it best for us to suffer, and especially when
our wills are utterly resigned to Him, and totally passed into
His. O Saviour, how didst thou submit to the blow, yea, how
didst thou smite, as it were, upon thyself, in submission to thy
Father's holy will! I am thine, solemnly devoted to the one
thing of being like Thee, of being conformed to Thee. Thou
didst suffer; and I will suffer with Thee. I refuse nothing.
If it be thy will, my own hand shall strike the wound into my
own bosom."

She said, on proper occasions, what she had to say without
concealment. It was now evident that God, for this very pur-
pose, had sent her there. God sent her abroad, that she might
preach the more effectually at home. He placed her at the cir-
cumference, that beginning, not " at Jerusalem," but at the
furthest place from Jerusalem, she might operate back from the
circumference to the centre. The woman's voice that uttered
itself in self-devoted banishment, at the foot of the Jura, was
heard in due time in the high places of Paris. When she had
spoken, her eyes were opened in relation to her position. Some
believed and rejoiced; some disbelieved and reproached her,
and were angry.

At this juncture, of those whose learning and position in
society rendered their concurrence particularly important, one
individual only stood by her, both in sentiment and action—
Father La Combe. Providence favoured and supported her here.
He was her spiritual Director; understood her principles and
experience; had something, although lingering far behind her,
of the same thorough inward life. On his return to Thonon, he
invited her to go with him. This invitation she accepted, as
the excursion would be favourable to her enfeebled health, and
entirely within the limits of the present sphere of her labours.
They decided to take the nearest way across the Leman lake.
Boats were continually crossing, which offered them a passage.
Embarked in her little vessel, she was now on the wave of

those waters, and in the bosom of those mountains, which
philosophers and poets have delighted to behold, and have loved
to celebrate :—

> " Clear, placid Leman ! thy contrasted lake,
> With the wide world I dwelt in, is a thing
> Which warns me, with its stillness, to forsake
> Earth's troubled waters for a purer spring."

It was in the sight of the place where she now was, that Gibbon
and Voltaire subsequently resided and wrote. These very
waters, and the cliffs and cottages and snow-crowned summits
that hung over them, have since inspired the genius of Rousseau
and Byron. With deep feeling *they* admired these wonderful
works ; *she*, with no less admiration of the works, admired them
still more, as the mighty mirror of the God who made them.
They drew their inspiration from the mountains, which, though
formed of adamant, must sooner or later crumble and pass away ;
she drew her inspiration from the God of the mountains, who
endures for ever.

Before they reached the eastern side of the lake, one of those
sudden and fierce storms arose, to which this body of water is
subject. The dark clouds wrapped them ; their little boat
dashed violently upon the waves ; the boatmen were in conster-
nation. But to her the storm brought no terror. Faith, which
places God in the centre—God, who is love under all circum-
stances, in the storm as well as in the sunshine—had equalized
all. Calmly she awaited the result. God protected the little
company, and they arrived safely at their place of destination.

Twelve days she stayed at Thonon, at the Ursuline Convent,
a portion of the time in retirement, separate from the world, but
not alone. God was with her. But she never forgot the mission
which she now felt was committed to her—namely, the procla-
mation, to all who bear the name of Christ, of Holiness based
upon Faith, as their present privilege and possession. To ac-
complish her for this work, God had not only established her
position in society, and given her vast powers of thought, but,
what was still more necessary, had subjected her inmost nature

to the terrible discipline of His providences, and to the flaming
scrutiny of His Holy Spirit.

At this time her mind was very much taken up with the
spiritual condition of La Combe—nominally, her Director. But
really the spiritual direction was with the one to whom God had
actually given the deepest experience and the largest measures
of His grace. The relation in which they stood to each other,
gave them frequent opportunities of conversation. He was pre-
pared to listen to her, independently of other considerations,
because she had been the instrument, many years before, of his
advancement in religion, if not of his first religious experience.
She saw that he had much; but she felt that he ought to have
more.

His religious state, as she has delineated it, was precisely this.
Intellectually he received the doctrine of sanctification, as some-
thing to be experienced *now*. On this point he did not doubt.
His prayers, his resolutions, his efforts, attended by Divine grace,
were not in vain. His experience failed, in having too large a
share of the apparitional and emotional. He attached an undue
value to sights and sounds, and to emotions of mere joy, con-
sidered as the exclusive or the principal evidences of religion.
It was obviously very hard for him to walk in the narrow way
of faith alone.

"Father La Combe," she says, " having walked a long time
by *testimonies*, as he called them, that is to say, by *sensible* marks
and signs, could not easily remove himself from that way of
living, and enter upon a better one. He was too much dis-
posed to seek for those things which satisfy human sense and
reason. Hard was it for him to walk in the poor and low and
despised way of entire self-renunciation and of simple faith. No
one can tell what it cost me, before he was formed according to
the will of God. It was hard for him to die entirely to self. I
did not grieve when I saw him suffer. I had such a desire for
his spiritual progress and perfection, that I could willingly have
wished him all the crosses and afflictions imaginable, that might
have conduced to this great and blessed end. He lay like a

heavy burden upon my spirit. I had no resource but to carry it to the Lord, who had placed it upon me.

La Combe renounced all, that he might receive all. He wanted no other signs or tokens of his acceptance, than the declaration of God's words, that all who give themselves to Him to do His will in faith, are safe. He could not but foresee, that doctrinal views so different from those which were generally entertained, must occasion remark, and would probably excite permanent and deep opposition. But he had grace and strength sufficient to leave all in the Lord's hands.

Recognising in Madame Guyon the instrument, under God, of his own spiritual renovation and progress, he entertained for her those sentiments of respect and of Christian affection, which both her natural and Christian character seemed justly to claim. From this time their history is, to some extent, linked together. Believing that the Gospel had power to purify and perfect, as well as to save from the infliction of punishment, they did what they could to realize this great result, and to make their fellow-beings *holy*. In their common trials, as well as in their common labours, they sympathized with each other, and endeavoured to strengthen the latter, and to alleviate the former, by a written correspondence carried on for many years. They met with rebukes, opposition, and imprisonments. But God, who had given them the promise, was with them to the end.

CHAPTER XXII.

Account of the hermit of Thonon, Anselm—Return to Gex—Thrown from a horse—Labours —The case of a poor woman—Sermon of La Combe on Holiness—Called to account— Views of Bishop D'Aranthon—Proposes to Madame Guyon to give up her property and become prioress of a Religious House at Gex—Her refusal—Remarkable conversation between D'Aranthon and La Combe—Remarks upon D'Aranthon's course and character— Opposition to Madame Guyon.

"At Thonon," she says, " I found a hermit, whom the people called Anselm,—a person of the most extraordinary sanctity

that had appeared for some time. God had wonderfully drawn him from Geneva at twelve years of age. With the permission of the cardinal, at that time Archbishop of Aix, in Provence, he had taken the habit of hermit of St. Augustine, at the age of nineteen. This man and another person lived together in a little hermitage, which they had prepared for themselves, where they saw nobody but such as came to visit them in their solitary place. He had lived twelve years in this hermitage. He seldom ate anything but pulse, prepared with salt and sometimes with oil; with the exception that three times a week he made his meals of bread and water. He wore for a shirt a coarse hair-cloth, and lodged on the bare ground. He was a man of great piety, living in a continual state of prayer, and in the greatest humility. He had been the instrument, in God's hands, of many remarkable things.

"This good hermit, who had been acquainted with Father La Combe for some time, and had learned something of me, seemed to have a clear perception of the designs of God in relation to us. God had showed him, as he assured us, that we were both destined, in His providence, for the guidance and aid of souls; but that this mission of God would not be fulfilled in us, without our experiencing at the same time various and strange crosses."

At the expiration of twelve days she returned to Gex, by the way of Geneva,—a longer route, but avoiding the exposures of an open boat upon the lake. The French consul proposed to her to complete the remainder of her journey, only ten miles, on horseback, and offered one of his own horses. " I had some difficulty," she remarks, " in accepting this proposal, as I was not much acquainted with riding on horseback. The consul assuring me, however, that the horse was very gentle, and that there was no danger, I ventured to mount him. There was a sort of smith standing by, who looked at me with a wild, haggard look. This man, just as I had got fairly seated upon the animal, took it into his head to strike him with a heavy blow upon the back, which made him start very suddenly. The result was, that I was thrown upon the ground violently, falling upon my

temple, and injuring two of my teeth and the cheek-bone. I was so much stunned and hurt, that I could not proceed immediately; but after resting awhile and recovering myself, I took another horse, and with a rider beside me, to render any necessary assistance, I proceeded on my way."

At Gex she continued to labour, as God gave her opportunity. There was a poor woman from the neighbouring country, who seems to have been religious, in the common acceptation of the term, and even eminently so. " She was one," says Madame Guyon, " on whom the Lord had conferred very singular graces. She was in such high religious reputation in the place from which she came, that she passed there for a saint. Our Lord brought her to me, in order that she might understand and see the difference between that religion which consists in the possession of spiritual endowments and gifts, and that which consists in the possession of the Giver."

This woman passed through the same struggle, and experienced the same blessing which others experienced; no longer a great Christian by being great, but by being little; no longer great in her own eyes because she had experienced much, but great in the eyes of God, because she had become nothing in herself.

This case illustrates the nature of a portion of her labours at this time. She endeavoured to establish and instil permanent principles of practical Christianity, believing, as she did, that true Christianity, considered in its renovating and sanctifying relations, does not consist in having God's gifts merely, but chiefly and especially in having God himself in the soul by a perfect union with His will. She felt herself particularly called upon to point out this difference, between *emotional* experience, which feeds upon what is *given*, both good and bad, and *volitional* experience, which feeds upon what *is*, namely, upon God's will alone ; or, what is the same thing, upon " *every word which proceedeth out of His mouth.*" And on the basis of this distinction, she sometimes intimates, that the doctrines of sanctification, or of inward holy living, may be reduced for the most part, to

the two great principles of self-renunciation on the one hand, and of perfect union with the Divine will on the other. He who has nothing in himself, has all in God.

About this time Father La Combe was called to preach on some public occasion. The new doctrine, as it was termed, was not altogether a secret. Public curiosity had become excited. He chose for his text the passage in Psalm xlv. 13—"*The king's daughter is all glorious within; her clothing is of wrought gold.*"

By the king he understood *Christ;* by the king's daughter, the *Church.* His doctrine was, whatever might be true in regard to men's original depravity, that those who are truly given to Christ, and are in full harmony with Him, are delivered from it; that is to say, are "all glorious within." Like Christ, they love God with a love free from selfishness, with *pure* love. Like Christ, they are come to do the will of the Father. Christ is formed in them. They not only have faith in Christ, and faith in God through Christ, but, as the result of this faith, they have Christ's disposition. They are now in a situation to say of themselves individually, in the language of the apostle Paul, " I live ; and yet not I, *but Christ liveth in me.*"

He did not maintain that all Christians are necessarily the subjects of this advanced state of Christian experience, but endeavoured to show that this is a *possible* state; that, however intense human depravity may be, the grace of God has power to overcome it; that the example of Christ, the full and rich promises, and even the commands, give encouragement to effort, and confidence in ultimate victory. And without making allusions to himself, or to the remarkable woman whose experience and instructions had revived the doctrine of present santification, now almost forgotten, although not unknown to the pious of former times, he could not hesitate to maintain that there *have been,* that there *may be,* and that there *are,* truly *holy* hearts in this depraved world. On this basis, he preached HOLINESS, not merely as a thing to be proclaimed, but to be experienced,—not merely as theme of pulpit declamation, but as a matter of personal realization.

Great was the consternation when it was found that men were not merely *required* to be holy, but, what is practically a different thing, were *expected* to be holy. The requisition was admitted ; but the belief of its practical possibility, and the expectation of the fulfilment of it, which would imply a close scrutiny into the irregular lives of many, were rejected as visionary, and condemned as heretical. La Combe, accordingly, although he was a man whose learning and eloquence entitled him to no small degree of consideration, was called to account.

An ecclesiastic of considerable standing and influence with Bishop D'Aranthon not only declared that the sermon was full of errors, but, conscious perhaps of some irregularities, which the doctrine of practical holiness might not easily tolerate, he took the position that it was preached against himself personally. He drew up eight propositions, expressive of sentiments which ought not to pass unnoticed.

Madame Guyon asserts, that he inserted in these propositions statements which La Combe had not advanced, and adjusted them as maliciously as possible. He sent them to one of his friends at Rome, that their heretical character might be ascertained by the proper ecclesiastical authorities, and the author might feel in due season, the discriminating and repressive hand of the Inquisition. No formal condemnation, however, was pronounced. Probably the authorities at Rome, watchful as they generally are in the matter of heretical tendencies, did not consider the movements of an ecclesiastic as yet almost unknown, and residing in a remote and obscure place, as threatening any very great evils, even if considerably divergent from the strict line of Roman Catholic orthodoxy. La Combe escaped this time.

Bishop D'Aranthon had the sagacity to perceive, that the responsibility of this movement, which both excited his curiosity and alarmed his fears, rested chiefly upon Madame Guyon. He did not hesitate to express his sincere regard for her talents and virtues ; but he could not conceal from himself the fact, that her piety and intellectual ascendency rendered her opinions the more dangerous, if they were not true. He determined there-

fore, after considerable consultation with some of his ecclesiastics, that she should not continue to labour within his diocese, unless in a different way and on different principles. He had approved of her coming, as an executor of charities, and not as a teacher of dogmatics.

But he adopted a novel plan, more ingenious than wise. He proposed to her to give her property, or that portion still within her control, to one of the religious houses at Gex, and to become herself the prioress of it. Desirous of preventing her departure, he reasoned, very naturally, that her position as prioress of a religious community, would give scope to her fertile and active powers of thought and piety, without furnishing opportunity to diffuse her exertions and influence beyond its limits, and thus good would be realized without the existing dangers. The proposition does not appear to have been in all respects impracticable. She probably would have had no difficulty in disposing of that portion of her property which had not been settled on her children, and which still stood in her own name, for some religious purpose;—indeed, she repeatedly declared her readiness to do it;—but the inward voice, *the voice of God in the soul*, declared imperatively, that the new and higher mission to which God had called her, could not be fulfilled by such a course. She based her refusal upon two propositions: FIRST, that she could not consistently and regularly become prioress, because she had not passed through the regular period prescribed to noviciates; and, SECOND, because by remaining permanently at Gex, she would incur the hazard and the sin of opposing and defeating the obvious designs of God in regard to her.

The good man had his heart too much set upon his design to receive this unfavourable decision with entire equanimity. In this position of affairs, Father La Combe visited Anneci. He found the bishop somewhat dissatisfied and afflicted; and the following conversation took place between them:—

D'Aranthon.—You must absolutely engage this lady to give her property to the religious house at Gex, and become the prioress of it.

La Combe.—You know, sir, what Madame Guyon has told you of the dealings of God with her, and of what she has considered her religious vocation, both when you saw her at Paris, and also since she had been in this region. She has given herself up to do God's will. For this one thing, she has quitted all other things; and I do not believe that she will accept your propositions, if she has any fear that by so doing she will put it out of her power to accomplish the designs of God in regard to her. She has offered to stay with the sisters at the religious house at Gex, as a boarder. If they are willing to keep her as such, she will remain with them; if not, she is resolved to retire, temporarily, into some convent, till God shall dispose of her otherwise.

D'Aranthon.—I know all that; but I likewise know that she is so very obedient to you as her spiritual adviser and director, that, if you lay your commands upon her, she will assuredly comply with them.

La Combe.—That is the very reason, sir, why I hesitate. Where great confidence is reposed, we should be very careful how we abuse it. I shall not compel Madame Guyon, on the ground of the confidence she has reposed in me, or of the spiritual authority which I possess over her—coming as she does from a distant place—after having made such sacrifices of her property as she has, to give up the whole of the remainder of it to a religious house, not yet fully established, and which, if it ever should be, cannot be of any great use under the existing circumstances.

D'Aranthon.—I do not accept your view of the subject. Your reasons, permit me to say, are without application and value. If you do not make her do it, I shall suspend and degrade you.

La Combe.—Be it so, sir. I cannot do what I believe to be wrong. I am ready not only to suffer suspension, but even death itself, rather than do anything against my conscience.

La Combe perceived that these things indicated anything rather than harmony and safety. Not knowing but some sudden measures might be taken, which would prejudice her security,

he immediately sent Madame Guyon some account of this interview, by express. But she continued calmly in her work, visiting the sick, relieving the poor, and instructing the ignorant; and especially inculcating on all the necessity of a *heart wholly given to God*. And in doing this, she began to touch upon a subject, which is rather of a delicate nature in the Church of which she was a member. She thought it necessary, with all possible discretion and kindness, to distinguish between the religion of forms and the religion of reality, between outward religion and inward religion, between genuflexions and signs of the cross made upon the exterior of the person, on the one hand, and prostrations and crucifixions of that which is interior, on the other. This seemed to her very important, although she admitted that forms and ceremonies were good, and to some extent necessary, in their place. In doing this, she took a course which was never forgotten nor forgiven.

But this was not all. She had learned the value of the Bible. In the eleventh or twelfth year of her age, as a pupil in the Dominican convent at Montargis, she one day found a Bible in the room assigned her. "I spent," she says, "whole days in reading it; giving no attention to other books or other subjects from morning to night. And having great powers of recollection, I committed to memory the historical parts entirely." From that time the Bible was dear to her. Her constant references to the Scriptures would be a decisive proof of this, even if we had not the additional and remarkable evidence, that she afterwards wrote and published, in the French language, twenty volumes of practical and spiritual commentary on the Sacred Writings. She felt it her duty, therefore, in opposition to the prevalent views among her own people at that time, to recommend and to urge the reading of the Bible. She regarded this as essential. This was another and great ground of offence.

Previous to this, Bishop D'Aranthon, with a kindness creditable to him as a man and a Christian, had visited Madame Guyon. She speaks of this visit in the following terms: "Soon after my arrival at Gex, Bishop D'Aranthon came to see us. I

spoke to him of the religion of the heart. He was so clearly convinced, and so much affected, that he could not forbear expressing his feelings. He opened his heart on what God required from him. He confessed his own deviations. Every time, when I spoke to him on these subjects, he entered into what I said, and acknowledged it to be the truth. But the effect of what I said was done away in a considerable degree by others. As soon as persons who sought for pre-eminence, and could not suffer any good but what came from themselves, spoke to him, he was so weak as to let himself be imposed upon with impressions against the truth. This foible, with others, has hindered him from doing all the good which otherwise he might have done in his diocese."

D'Aranthon seems to have been a good man ; sincere, benevolent, laborious. He encouraged the coming of Madame Guyon into his diocese, and received her with kindness and respect. When she conversed with him on the importance of possessing a heart truly redeemed and sanctified through the blood of Christ, the good bishop could not but feel that her conversation, woman though she was, made him a wiser and a better man. But he was wanting in *fixedness of purpose.*

Some were jealous of woman's influence ; others loved sin more than they feared woman, and would have felt no uneasiness at Madame Guyon's eloquence, if not employed in denouncing their own baseness ; and others very sincerely believed that her doctrines were more nearly allied to Protestantism, than to Roman Catholic orthodoxy. These persons had an effect upon D'Aranthon, who gradually, but apparently with reluctance, assumed the attitude of opposition.

He returned from Gex to Anneci. The course subsequently taken by La Combe, and especially his sermon, increased his fears. It naturally confirmed him in this state, when he learned that the new doctrine, involving the free and common use of the Bible, and the value of ecclesiastical observances and ceremonies, was extending itself. In this state of mind he made the propositions mentioned, thinking that her time would be so occupied

with the duties of her position as to prevent efforts in the dis-
semination of her doctrines ; and that if not, her poverty would
render her dependent, and they could thus exact that compliance
from her weakness, which they had no expectation of extorting
from her moral principle.

From this time D'Aranthon, if he could not strictly be re-
garded as an enemy, ceased to be a friend. Thus she was left
without any one on whom she could rely for adequate protection,
exposed to various trials, which were calculated severely to test
her patience and faith. Her doctrine was denounced as here-
tical ; her character was aspersed ; and she was exposed to
personal inconveniences and dangers.

We have some notices of her inward experience at this time.
" In God I found," she says, " with increase everything which
I had lost. In my long state of special trial and deprivation,
my seven years' crucifixion, my intellect, as well as my heart,
seemed to be broken. But when God gave back to me that
love which I had supposed to be lost, although I had never
ceased to love Him, He restored the powers of perception and
thought also. That intellect, which I once thought I had lost
in a strange stupidity, was restored to me with inconceivable
advantages. I was astonished at myself. The understanding,
as well as the heart, seemed to have received an increased capa-
city from God ; so much so that others noticed it, and spoke of
its greatly increased power. It seemed to me that I experienced
something of the state which the apostles were in, after they had
received the Holy Ghost. I knew, I comprehended, I was
enabled to do intellectually as well as physically, everything
which was requisite. I had every sort of good thing, and no
want of anything. I remembered that fine passage, which is
found in the apocryphal book called the Wisdom of Solomon.
Speaking of WISDOM, the writer, in the seventh chapter, says,
' *I prayed, and understanding was given me ; I called upon God,
and the spirit of Wisdom came to me. I loved her above health
and beauty, and chose to have her instead of light ; for the light
that cometh from her never goeth out. All good things together*

came to me with her, and innumerable riches in her hands.'
Wisdom came to me in Christ. When Jesus Christ, the Eternal
Wisdom, is formed in the soul, after the death of the first Adam,
it finds in Him all good things communicated to it."

We are not to understand from the expressions just quoted
that God, in all cases, or even generally, accompanies the reno-
vation and sanctification of the heart with a greatly increased
expansion and power of the intellect. Religion is good for the
intellect; it helps the intellect; clearing the mists of passion
and removing the incumbrances of prejudice, and giving an in-
creased degree of clearness and energy, both of perception and
combination.

In the case of Madame Guyon, her powers were rapid and
vast beyond ordinary examples; and having been prostrated so
many years, they appeared at the time of her restoration the
more rapid and more vast and wonderful by the contrast. Add
to this that clearness and energy, which the renovation of the
heart, by being formed into Christ's image, always gives, and
I think we have an adequate explanation of the strong terms in
which she expresses herself.

CHAPTER XXIII.

Approaching trials—Consolations from Scripture—A dream—Some causes of the opposition
against her—Frustrates the designs of an ecclesiastic upon an unprotected girl—Opposi-
tion and ill treatment from this source—A party against her—In consequence she leaves
Gex—Crosses the Genevan Lake to Thonon—Poem.

It was now fully evident that trials, which would be likely
to be very severe, awaited Madame Guyon. The sacrifices she
had made and the benevolence of her mission, were no security
against them. "I saw," she says, "that crosses in abundance
were likely to fall to my lot. The sky gradually thickened;
the storm gathered darkness on every side. But I found support
and consolation in God and His Word. A passage in the twelfth

chapter of Hebrews was particularly blessed to me. 'Let us run with patience the race that is set before us, looking unto Jesus, the author and finisher of our faith; who, for the joy that was set before Him, endured the cross, despising the shame, and is set down at the right hand of the throne of God. *For consider Him who endured such contradiction of sinners against Himself, lest ye be wearied and faint in your minds.*' I had no sooner read this consoling passage, than I prostrated myself, for a long time, with my face on the floor. I offered myself to God, to receive at His hand all the strokes which His providence might see fit to inflict. I said to Him, Thou didst not spare thine own beloved Son. It was thy holy one, thy loved one, that thou didst account worthy to suffer. And in such as most fully bear His image, thou dost still find those who are most fitted to bear the heaviest burden of the cross."

Even her dreams, which by a natural law of the mind's action repeat, although they sometimes greatly diversify, our waking perceptions and thoughts, seemed mysteriously to confirm her foreboding of sorrows to come. "I saw," she says, "in a sacred and mysterious dream (for such I may very well describe it), Father La Combe fastened to an enormous cross, deprived of clothing, in the manner in which they paint our Saviour. I saw around him, while hanging and suffering in this manner, a frightful crowd; which had the effect to cover me with confusion, and threw back upon myself the ignominy of a punishment, which at first seemed designed for him alone. So that, although he appeared to suffer the most pain, it fell to my lot to bear the heaviest reproaches. I have since beheld the intimations of this dream fully accomplished."

The alienation of Bishop D'Aranthon, which could not long be kept secret, had its influence. But still it was her faithfulness in proclaiming salvation by the cross of Christ, and her fixedness of purpose in practically opposing wickedness, which arrayed against her the greatest numb r. and those the most virulent and uncompromising.

A single instance will illustrate this remark. An ecclesiastic

at Gex, prominent alike by position and personal influence, endeavoured to form an intimacy with a beautiful female resident at the Religious House, of which Madame Guyon was a temporary inmate. Her greater knowledge of the world enabled Madame Guyon to see, much more distinctly than the unprotected and unsuspicious maid herself, the dangers to which she was exposed. Animated by humanity, as well as Christian charity, she not only warned the girl of the dangerous artifices which beset her, but endeavoured to instruct her in the principles of religion, and to lead her to a knowledge of Jesus Christ. The girl was distinguished for powers of mind, and gave her most vigorous thoughts to the great subject thus presented to her.

" God so blessed my efforts," says Madame Guyon, " that this interesting maid, under the guidance of the great inward Teacher, became truly pious; giving herself to God apparently with her whole heart." Naturally she became reserved and guarded towards the ecclesiastic mentioned. This man became from this time the bitter enemy of Madame Guyon, and all who sympathized with her.

He formed a little party and put himself at the head of it, the sole object of which was to render Madame Guyon's situation as uncomfortable as possible, and ultimately to drive her from Gex. Beginning, after the manner of those with whom the end sanctifies the means, with secret insinuations unfavourable to her character, he pursued his object in various ways, with a perseverance worthy of a better cause. " This ecclesiastic," she says, " began to talk privately of me in a manner calculated to bring me into contempt. I was not ignorant of what he was doing; but having, by Divine grace, learned the great lesson of pitying and forgiving my enemies, I let everything pass unnoticed and in silence.

" At this time there came a certain friar to see the person of whom I am speaking. The friar, who mortally hated Father La Combe, on account of his greater regularity and religious principle, combined his efforts with the other, to drive me from the Religious House in which I resided, and thus leave them to

manage there in their own way, without any opposing influences All the means which they could devise they practised for that purpose. They succeeded, after a time, in gaining over one of the sisters of the House, who acted in the capacity of house-steward ; and soon afterwards they gained the prioress."

Her situation was rendered as uncomfortable and unpleasant as possible. " I was disposed," she says, " to do all the good I could, physically as well as mentally ; but being of a delicate frame, I had but little strength. I had employed two maid-servants to aid me and my daughter, but finding that the Religious Community, in which I resided, had need of them, the one for a cook, and the other to attend the door and other purposes, I consented that they should have their services. In doing this, I naturally supposed that they would occasionally allow me their aid, especially as I had given them all the funds which I then had in possession, and had thus put it out of my power to employ other persons. But under the new influences and designs, I was not allowed to realize this reasonable expectation. I was compelled to do my sweeping and washing and other domestic offices, which I had a right to expect, in part at least, from them."

Another part of the system of vexation consisted in attacks upon her room at night. By some sort of contrivance known only to those who were in the secret, frightful images were made to appear in her room or at the windows. Frightful sounds were uttered. The sashes of the room were broken. But though she was thus subjected to inconvenience and disturbance, she says that the calm peace of her soul was wholly unbroken.

Among other things, the ecclesiastic at the head of these movements, caused all the letters sent to her from friends abroad, and also the letters which she sent to them, to be intercepted. He had at one time twenty-two intercepted letters lying on his table. His object was, she says, " to have it in his power to make what impressions he pleased, no matter how unfavourable, on the minds of others, and to do it in such a manner that I should neither be able to know it, nor to defend myself, nor to

send my friends any account of the manner in which I was treated."

She had ties which bound her to Gex. She had made impressions which could not easily be obliterated. The good girl whom she rescued from the artifices of the ecclesiastic, she says, " grew more and more fervent, by the practice of prayer, in the dedication of herself to the Lord, and more and more tender in her sympathy with me." And this was only one instance among many. But still she thought the providences of God indicated that the time had come when she should leave the place. It seemed to her, after a deliberate and prayerful consideration, that at Thonon, where she could more easily receive advice and assistance from La Combe, she might suffer less, and do more good. And in a few days more, she embarked again in a little boat, with her two maid-servants and her young daughter. Probably this was early in the spring of 1682. She had resided at Gex something more than half a year. This was the second time she had crossed the Leman Lake. There were no storms that day—neither was there storm nor trouble within. The calm lake, decorated in its vernal beauty, was nature's happy image of her own pure and peaceful mind. Without complaint, believing that God was glorified in what she had done and suffered, she went forth once more, a pilgrim and a stranger, to seek other associates, meet other trials, and sow seed for God in other places.

The following poem describes her feeelings at this time :—

THE CHRISTIAN'S HOPES AND CONSOLATIONS CONTRASTED WITH THE WORLD'S UNBELIEF AND RUIN.

My heart is easy, and my burden light;
I smile, though sad, when God is in my sight.
The more my woes in secret I deplore,
I taste thy goodness, and I love thee more.

There, while a solemn stillness reigns around,
Faith, love, and hope, within my soul abound:
And while the world suppose me lost in care,
The joys of angels unperceived I share.

Thy creatures wrong thee, O thou Sovereign Good !
Thou art not loved, because not understood ,
This grieves me most, that vain pursuits beguile
Ungrateful men, regardless of thy smile.

Frail beauty and false honour are adored ;
While Thee they scorn, and trifle with thy word ;
Pass, unconcern'd, a Saviour's sorrows by,
And hunt their ruin with a zeal to die.

CHAPTER XXIV.

Arrives at Thonon—Interview with Father La Combe—He leaves Thonon for Aost and Rome—Her remarks to him—Confidence that God would justify her—Cases of religious inquiry—Endeavours to teach those who came to her—Some characteristics of a soul that lives by faith—References to her daughter—Visited at Thonon by Bishop d'Aranthon—Renewal of his proposition—Final decision against it—Her position in the Roman Catholic Church—References to persons who have attempted a reform in that Church—Attacks upon the character of La Combe in his absence—General attention to religion at Thonon—Manner of treating inquirers—Views of sanctification—Pious laundress—Opposition by priests and others—Burning of books—Remarks.

In the spring of 1682 she reached Thonon. It is a consider-able place, sixteen miles north-east of Geneva, situated on the eastern side of the lake, near the mouth of the Drance. It is the capital of Chablais, one of the provinces of the Duchy of Savoy. Having reached this place she became resident, as a boarder, in the Ursuline Convent, with her little family.

The day after her arrival, Father La Combe left Thonon for the city of Aost, some sixty or seventy miles distant. Learn-ing the unexpected arrival of Madame Guyon, he visited her before he left. He expressed his sympathy in the trials she was called to endure ; and said that he was sorry to leave her in a strange country, persecuted as she was by every one, without any to advise and aid her. And the more so, as it was his in-tention to proceed from Aost, whence he was called on business of a religious nature to Rome. And he might be detained at Rome by those who had authority over him, for some time.

Undoubtedly this was a disappointment to Madame Guyon. She did not wish anything which came to her in God's provi-

dence, to be otherwise than it was. She says, " I replied to him, ' My Father, your departure gives me no pain. When God aids me through His creatures, I am thankful for it. But I value their instrumentality and aid, only as they are subordinate to God's glory, and come in God's order. When God sees fit to withdraw the consolations and aids of His people, I am satisfied to do without them. And much as I should value your presence in this season of trial, I am very well content never to see you again, if such is God's will.' " Well satisfied to find her in such a frame of mind, he took his leave and departed.

It was not the practice of Madame Guyon *to be in haste to justify herself.* This course, so different from that which is commonly pursued, which might perhaps appear questionable, she adopted on religious principle. At Gex her doctrines had been attacked ; her peace assailed by personal rudenesses and violence ; and, what must have been deeply afflicting to a woman constituted as she was, secret insinuations, unfavourable to her moral character, were circulated with unfeeling industry. But she left all with God. She believed that innocence and truth will always find, in God's time and way, a protector. Never will He fail to speak and act for the innocent and the upright, if they will only put their trust in Him in this thing as in others. The truly holy heart will always say, Let God's will be accomplished *upon* me, as well as accomplished *for* me. If it be God's will that I should suffer rebuke, misrepresentation, and calumny, let me not desire the removal of the yoke which His hand has imposed upon me, until He himself shall desire it. *She left her vindication with God, and she found Him faithful.*

It seems to have been her intention to spend a few weeks after her arrival at Thonon in retirement, as she needed rest, both physically and mentally. Accordingly, she had a room appropriated to her own private use, where, with her Bible before her, she passed many hours in acquiring spiritual knowledge and in Divine communion. But something which had more of heaven than earth in it, breathed in her voice, embodied itself in her manners, and shone in the devout serenity of her coun-

tenance; so that it was not necessary for her to set up formally as a preacher, and she had no inclination to do so. Her sermon was her life; and her eloquent lips only made the application of it. Wherever she went, she found those whom she calls her *children*. They came to her continually that she might break to them the living bread.

"My inward resignation and quiet," she says, " was very great. For a few days I remained alone and undisturbed, in my small and solitary room. I had full leisure to commune with God and to enjoy Him. But after a short time a good sister, who desired conversation on religious subjects, frequently interrupted me. I entered into conversation, and answered everything she desired, not only from a regard and love for the girl herself, but from a fixed principle I had of strictly conforming to whatever God's providence seemed to require of me. Although this season of solitary communion with God was very precious to me, I was obliged to interrupt it, whenever His providence required. As soon as any of those who sought salvation through Christ, *my little children*, if I may call them such, came and knocked at my door, God required me to admit the interruption. In this way He showed me that it is not actions, *in themselves considered*, which please Him, but the inward spirit with which they are done; and especially the constant ready obedience to every discovery of His will, even in the minutest things.

"I endeavoured to instruct the good sisters, who came to me, in the best way I could. Some of them could perhaps be regarded as truly religious; but after an imperfect manner. It was my object to instruct them in the way of living by simple faith, in distinction from living *ceremonially;* and thus to lead them to rest upon God alone through Christ. I remarked to them, that the way of living by faith was much more glorious to God, and much more advantageous to the soul, than any other method of living; and that they must not only cease to rely much upon outward ceremonies, but must not rely too much upon sights and sounds, in whatever way they might come

G

to the soul; nor upon mere intellectual illuminations and gifts, nor upon strong temporary emotions and impulses, which cause the soul to rest upon something out of God and to live to self. There is a mixed way of living, partly by faith, and partly by works; and also the simple and true way of living, namely, by faith alone, which is the true parent not only of other states of the mind, but of works also.

"There are not many souls that reach this state; and still fewer that reach it at once. Nature cries out against the process of inward crucifixion, and the greater number stop short. Oh, if souls had courage enough to resign themselves to the work of purification, without having any weak or foolish pity on themselves, what a noble, rapid, and happy progress would they make! But, generally speaking, men have too little faith, too little courage, to leave the shore, which is something tangible and solid, and has the support of sense, and to go out upon the sea, which has the supports of faith only. They advance, perhaps, some little distance; but when the wind blows and the cloud lowers, and the sea is tossed to and fro, then they are dejected, they cast anchor, and often wholly desist from the prosecution of the voyage.

"Oh thou, who alone dost conduct holy souls, and who canst teach ways so hidden and so lost to human sight, bring to thyself souls innumerable, which may love thee in the utmost purity. Such holy souls are the delight of God, '*who delights to be with the children of men ;*' that is to say, with souls childlike and innocent, such as are set free from pride, ascribing to themselves, separate from God, only nothingness and sin.

"Such souls, which are no longer rebellious, but *are broken to the yoke, are one with God,* and are one with Him to such a degree, that they not only look at Him *only,* but they look at everything else *in Him.* Beautifully expressive of a spirit quiet and united with God, is that passage of Jeremiah where it is said, '*He sitteth alone and keepeth silence, because he hath borne God's yoke upon him.*' (Lam. iii. 28.)

"How perfectly contented is such a soul! It is more satisfied

in its trials, its humiliation, and the opposition of all creatures, when these things take place by the order of Providence, than it would be with the highest success and triumph by its own choice. Oh, if I could express what I conceive of this state! But I can only stammer about it."

In this part of her Autobiography, we find some brief references to her daughter. Separated from her other children, this child was a source of great consolation to her. Finding her situation at Gex not favourable to her health, she had previously sent her for a short time to Thonon. Her feeling allusions show that her union with God did not diminish her interest in humanity; and that the natural affections, when properly subordinated, are not inconsistent with the highest religious affections. "In great peace of mind," she says, "I lived in the House of the Ursulines with my little daughter. As we now resided among those who spoke a different dialect, my daughter soon forgot, in a considerable degree, the use of the French language. She played with the little girls that came down from the neighbouring mountains; but while she contracted something of their elasticity and freeness, she lost something in the delicacy and agreeableness of her manners. She was sometimes fretful; but as a general thing her disposition, as it ever had been, was exceedingly good. Her good sense and her turns of wit, for one of her age, were surprising. God watched over her."

Madame Guyon had been at Thonon but a short time, when Bishop D'Aranthon came there on some business. They met once more, and had much conversation. The Bishop pressed her very much to return to Gex, and take the place of prioress. She says, " I gave him my reasons against it. I then appealed to him as a bishop, desiring him to take care, and to regard nothing but God in what he should say to me. He was struck with a kind of confusion, and then said to me, 'Since you speak to me in this manner, I cannot advise you to it. We are not at liberty to go contrary to what appears to be our religious calling. All I can say now, after what has passed between us, is, that I desire you to render to the House of Gex all the assistance which

you properly can.' This I promised to do; and as soon as I received a remittance from Paris, I sent them a hundred pistoles, with the design of doing it annually as long I should remain in his diocese."

When he left her, he yielded to the influence of others, and accordingly sent her word again, that it was his conviction that she ought to engage herself at Gex; and that, so far as his influence or authority could properly be exercised, he required her to do it. "I returned for answer," she says, " that I had reason to regard him at the present time as under human influence, and as speaking *as a man;* and that I felt it my duty to follow the counsel he had given me, when he seemed to me to be under a purer and higher influence, and to speak *as from God."*

The separation now became more marked and complete. And from this time onward, Madame Guyon understood, more distinctly and fully than at any former period, the position which she held in the Roman Catholic Church. She was *in* the Church, but not *with* it; in it in *form,* but not with it in *spirit.* Her associations with it were strong; her attachment to it was great; but discerning very clearly the distinction between inward and outward religion, between that which adheres to the ceremony and that which renovates the heart, she mourned over the declensions and desolations around her. She felt, however, that while she pointed out the speculative and practical errors which existed, provided she did it with a proper spirit, and sustained herself by Catholic authorities, she had a right to claim and maintain her position in the Church, until she should be formally excluded from it. She was very much in the position of certain pious persons who, without ceasing to be members, have laboured from time to time in that Church, with the design of restoring the doctrine of faith and the spirit of practical piety; and who are known historically, in reference to the period at which most of them appeared, as the *Reformers before the Reformation.*

There have been in the Roman Catholic Church, from time to time, pious men and women, who have laboured sincerely and oftentimes effectually for the true life of love and faith in

the soul. If they have loved their system much, and have felt sad
at the idea of schism, they have loved salvation and piety more.
Sometimes their labours have been received and recognised; and
they have been spoken of as the models of piety, without the im-
putation of heresy; but more frequently their motives have been
impeached, their efforts opposed, and in some instances exile and
imprisonment have been the consequence. Some appeared before
the Protestant Reformation, and some since. To those who are
acquainted with ecclesiastical history, it will indicate the class
of persons to whom we refer, if we mention the Dominican monk,
John of Vincenza, who laboured as far back as 1250; Thauler,
the celebrated preacher of Strasburg, who is mentioned with
high respect and commendation by Luther; Gerard Groot, and
Florentius Radewin, leaders and teachers in the society or sect
in the Catholic Church, called the Brethren of the Life in Com-
mon; John of the Cross, whose writings, although not schis-
matical in reference to the doctrines and forms of Roman
Catholicism, breathe a deeply devout and enlightened spirit.
To these we might add the names of Ruysbroke, Canfield,
Thomas-à-Kempis, Boudon, John de Castanifa, the reputed
author of the "Spiritual Combat," Michael de Molinos, who
died in prison (while Francis de Sales, who seems to me to have
taught essentially the same experimental doctrines, was can-
onized), Fénelon, and many others.

The position of many of these persons illustrates that of
Madame Guyon. Of their piety there can be no reasonable
doubt. They were persons of faith and true simplicity of heart,
who wished, although they found themselves amid various em-
barrassments, to do all possible good in the situation in which
Providence had placed them. They did not and could not be-
lieve, that an outward form, however scriptural and important,
could effectually avail themselves or others, when separate from
an appropriate state of heart.

It was not sufficient, in their view, to teach men to make the
sign of the cross, and practise genuflexions, nor to do other
things in themselves purely ceremonial. They preached the

doctrine of a new heart; they required, in the name of Him for whom they boldly spoke, " repentance towards God and faith in the Lord Jesus Christ." And such being their views and practice, if they cannot be regarded as schismatics or separatists, they may justly be described as *reformers*. Such was the position of Madame Guyon—one of great usefulness, but which could not well escape a large share of trial and sorrow.

La Combe had no sooner departed than the party at Thonon, opposed to the new movement, began to assail his character. Madame Guyon had her feelings greatly tried by the extravagant stories which were told her. But these statements were so obviously dictated by prejudice and passion, and so variant in many particulars from what she knew to be the truth, that they confirmed rather than diminished her favourable opinions of him. She did not, however, say much upon the subject; simply remarking, " Perhaps I may never see him again; but I shall ever be glad to do him justice. It is not he who hinders me from engaging at Gex, as some of the remarks which are made seem to imply. The reason, and the only reason of my refusing to comply, is the inward conviction, of which I cannot divest myself, that God does not call me to it."

Some said to her,—" But it is the opinion of the Bishop that you should go there. Ought he not to judge in the case? Who could know what the will of God is on such a question better than the Bishop?" To this suggestion it was not in her nature or her principles, to give any other than a respectful attention. But such was the clearness of her spiritual perception, such the inward signature which God and His providences had written upon her heart, that she could not do otherwise than she did; although it undoubtedly violated some of the prepossessions of her people in favour of Episcopal advice and authority.

This matter, therefore, was permanently decided; and she gave her attention anew and undividedly to the work before her. In the spirit of unremitting labour where God called her to labour, she did what she could; and the good seed, small though it might seem to be to human eye, became a hundred-

fold, because God blessed it. Her presence, preceded as it had been by her reputation for piety and a knowledge of the inward state, was the signal for a great spiritual movement in Thonon. There was something in souls who had sought heaven by works alone, and on the compensatory principle of so much happiness for so much labour and suffering, which whispered to them that God in His providence had sent them a messenger who might aid them in the knowledge of a better way.

The consequence was that her room was continually visited, in a few weeks after her arrival at Thonon, by persons seeking instruction. She divided them into three classes; those without religion; those who gave evidence of religion, but had no faith for anything above the mixed method of life, the way of mingled sin and holiness; and those who, under the special operation of God's Spirit, were hungering and thirsting after entire righteousness.

When those came to her who were without religion, and perhaps had been endeavouring to extract heaven from the merit attached to their supposed good works, she endeavoured to convince them of the folly of their course, by showing them the intricacies of the human heart, the depths of sin, and the impossibility of acceptance with God, except through the application of the atoning blood of Christ, received through faith.

When those came who had some little hope of an interest in the Saviour, some degree and power of life though feeble, she gave them directions suited with great skill to their case, calculated to resolve conscientious perplexities, to strengthen courage, and help their advancement. Entire victory was so much beyond their present ideas and hopes, that, to propose it now, might have operated as a discouragement.

When those came who desired to be wholly the Lord's, and, in the language of Scripture, were *hungering* and **thirsting** that they might bear the fulness of the Divine image, she endeavoured to impart those higher and deeper instructions which they seemed able to understand and bear.

She did not hesitate to say at once, on all occasions where

God's providence called her to say it, that the entire sanctifica-
tion of the heart through faith, is the Christian's privilege and
duty. But she laid "the axe to the root of the tree." She
thought it necessary, in the first place, that they should under
stand what sanctification is. On this point, taught by her own
experience, she felt it very desirable that there should be no
mistake. She felt it her duty to say to them, that a rectified
intellectual perception is not sanctification. Nor, if we add,
strong emotions and *stop there*, do we attain to it. Nor, if we
go still deeper, and add to both what is still more important,
good desires, good and right affections, and *stop there*, can we
account ourselves as wholly the Lord's. Holiness goes even
further than this. It requires the strong fortress of the *Will*.
The WILL, which embodies in itself both the head and the
heart, the perceptions, the emotions, and the desires, and is in
fact the sum and representation of the whole, must be given to
the Lord.

Upon this point she was in the habit of trying those who pro-
fessed to be seeking the entire sanctification of the heart. The
searching question was—were they willing to be NOTHING—*no-
thing in themselves*, in order that the Lord might be ALL IN ALL?
Could they say that they moved simply as they were moved
upon by the Holy Ghost? If so, then the life of nature was
slain ; their souls had become the temple of the Living God.

Among other persons who sought her acquaintance, was a
woman who was not only religious, but, according to the ordinary
rules of judgment, eminently religious. She had grace, perhaps
great grace ; but not to the exclusion of the life of nature. She
says, " I saw clearly that it is not great gifts which sanctify,
unless they are accompanied *with a profound humility*. No one
can be regarded as wholly alive to God, and thus as a true *saint*
of God, who is not *wholly dead to self*. This woman, in con-
nexion with her great intellectual lights, and strong emotions,
and the true faith to some degree, regarded herself as a truly
holy person ; but her subsequent life showed that she was very
far from the state which she professed.

" O my God," she adds, " how true it is that we may have of thy gifts, and yet may be very full of ourselves! How very narrow is the way, how strait is the gate, which leads to the true life in God! How little must one become, by being stripped of all the various attachments which the world places about him, so that he shall have no desire and no will of his own, before he is small enough to go through this narrow place."

Another class not only watched her general conduct, but, under religious pretences, made their appearance at her religious conversations, which seem to have been open to all, with the object "of watching her words, and criticising them." The religious life, like all other life, has its appropriate outward expressions and signs. And such was her deep insight into religious character, derived partly from her own varied personal experience, that she distinguished with great ease the objects and characters of those who visited her. To those who came for the purpose of extracting something which they could criticise and condemn, she had nothing to say. " Even when I thought to try to speak to them," she says, " I felt that I could not, and that God would not have me do it. They went away not only disappointed but dissatisfied. They alluded scornfully to my silence, which they regarded as stupidity; and some of them were so angry as to characterize as fools those who had come to see me.

" On one occasion, when persons of this description had just left me, an individual came, with some appearance of anxiety and hurry, and said, ' It was my design to have put you on your guard, and to apprize you that it might not be advisable to speak to those persons; but I found myself unable to get hither in season to do it. They were sent, with no friendly purpose, to find something in your remarks which they could turn to your disadvantage.' I answered this person, ' Our Lord has been before you in your charitable purpose; for such was my state of mind, that I was not able to say one word to them.' "

She did not appear as a *preacher*. Her efforts were private; and entirely consistent with that sense of decorum which adorns

the female character. They consisted of private prayer and conversation with individuals; sometimes of mutual conversations or conferences, held with the inconsiderable number of persons assembled in a small room. To these methods she added, with great effect, that of written correspondence. The instrumentality was humble, but the impression was great. The Lord blessed her; and for a time, soon after her arrival at Thonon, she had favour with the great body of persons there.

Amid this general approbation and even applause, "the Lord," she says, "gave me to understand that the 'apostolic state,' (that is, the state in which persons find themselves specifically and especially devoted to the spiritual good of others,) if it be entered into in purity of spirit and without reserve, will always be attended with severe trials. I remembered the words of the multitude, which preceded the Saviour at the time of His triumphant entry into Jerusalem—' *Blessed is he that cometh in the name of the Lord;*' and the words of the same changeable multitude a few days afterwards, when they exclaimed, ' *Away with him! Crucify him, crucify him!*' And while I was thus meditating on what the Saviour experienced, and from whom, and was making the application of it to my own case, one of my female friends came in, and spoke to me particularly of the general esteem which the people had for me. I replied to her, ' *Observe what I now tell you, that you will hear curses out of the same mouths, which at present pronounce blessings.*' "

" Great was my consolation," she says, " never did I experience greater in my whole life, than to see in the town of Thonon, a place of no great extent, so many souls earnestly seeking God. Some of these seemed to have given their whole hearts to God, and experienced the highest spiritual blessings. Among them were a number of girls of twelve or thirteen years of age. It was interesting to see how deeply the Spirit of God had wrought in them. Being poor, they industriously followed their work all the day long; but having acquired a fixed habit of devotion, they sanctified their labours with silent prayer and inward communion. Sometimes they would so arrange their daily labour,

that a number of them could carry on their work at the same place ; and then they would select one, who read to them while the others pursued their task. They were so humble, so innocent, and sincere, that one could not see them without being reminded of the innocence and purity of primitive Christianity."

She mentions particularly a poor woman, a laundress. "This poor woman," she says, " was the mother of five children. But her poverty, and the cares of her family, were not the only source of trouble. She had a husband distempered both in mind and in body. He seemed to have nothing left mentally but his angry dispositions, and nothing left physically but just strength enough in his unparalyzed arm to beat his suffering wife. Yet this poor woman, now become, under God's grace, rich in faith, bore all with the meekness and patience of an angel. By her personal labours she supported both her five children and her husband. Her poverty was extreme ; her suffering from other causes great ; but amid her trials and distractions, she kept constantly recollected in God ; and her tranquillity of spirit was unbroken. When she prayed, there was something wonderful in it.

" Among others there was a shopkeeper, and a man whose business it was to make locks. Both became deeply religious ; and, as was natural, they became intimate friends with each other. Learning the situation of the poor laundress, they agreed to visit her in turn, and to render her some assistance by reading to her. But they were surprised to learn, that she was already instructed by the Lord himself in all they read to her. God, they found, had taught her inwardly by the Holy Ghost, before He had sent, in His providence, the outward aid of books and pious friends to confirm His inward communications. So much was this the case, that they were willing to receive instruction from her. Her words seemed Divine."

This woman attracted the notice of certain persons of some name and authority in the Church. They visited her ; and, as her method of worship was somewhat out of Church order,

they reproved her, and told her it was very bold in her to prac-
tise prayer in the manner she did. They said it was the busi-
ness of priests to pray, and not of women. They commanded
her to leave off prayer, in the methods in which she practised it,
and threatened her if she did not. The woman was ignorant,
except so far as she had learned something from the Bible, and
as God had inwardly taught her. God gave her words in reply.
She said, that what she did was in conformity with Christ's
instructions. She referred them to the thirteenth chapter of
Mark, where Christ instructed His disciples to pray ; noticing
particularly the remark which is added, namely, " *What I say
unto you, I say unto all.*" This passage, she said, authorized
all to pray, without specifying priests or friars, or giving them
any privilege in this respect above others. She told them,
moreover, that she was a poor and suffering woman, and that
prayer helped her ; and that, in truth, without the consolations
of religion, of which prayer is the appropriate and natural ex-
pression, she could not support her trials.

She referred also to her former life. She had formerly been
without religion, and was a wicked person. Since she had
known religion, and held communion with God in prayer, she
had loved Him, and she thought she could say she loved Him
with her whole soul. To leave off prayer were to lose her spiri-
tual life. Therefore she could not do it. She also directed
their attention to other persons, who had recently come into a
state similar to her own. Take twenty persons, she said, who
are religious, and observe their life. Take twenty other persons
who do not practise prayer and know nothing of the religion of
the heart, and make the same observation. And judge then,
whether you have any good reason for condemning this work
of God.

" Such words as these," says Madame Guyon, " from such a
woman, might have fully convinced them. But instead of that,
they only served to irritate them the more." They threatened
her with a withdrawal of the privileges of the Church, unless
she promised to desist from her course ; that is to say, unless

she promised not only to renounce the reading of the Bible, and the practice of inward and outward prayer, but to renounce Christ himself. Her answer was, that she had no choice in the matter. The decision was already made. Christ was Master, and she must follow Him. They put their threats into execution to some extent. But she remained stedfast.

The persons who represented the dominant part of the orthodox Church in Thonon, finding their efforts in a great measure ineffectual, next took the course of ordering all the books without exception, which treated of the inward religious life, to be brought to them ; and they burned them with their own hands in the public square of the place. " With this performance," says Madame Guyon, " they were greatly elated."

In a letter found in the Life of Bishop D'Aranthon, the writer says, " We have burnt five of the books on these subjects. We have not much expectation of getting possession of many others, for the men and women who read them, have their private meetings or assemblies, and have resolved that they will burn the books themselves, rather than let them fall into our hands."

Madame Guyon gives us further to understand, that some of the persons engaged in these things, were apparently religious ; but religious in the common *mixed way*, partly human and partly Divine, partly from earth and partly from heaven. Consequently, so much of their actions as was not from God was from that which is the opposite of God, namely, Satan. And this was particularly the case in their treatment of the pious girls who, being poor and obliged to work continually, formed little neighbourhood associations ; prosecuting in this way their work together, and those who were strong helping the weak. The eldest presided at these little meetings ; and the one best qualified for that task was appointed reader. They employed themselves in spinning, weaving ribbons, and other feminine occupations. Prayer and religious love made all pleasant. Such assemblies are not uncommon among Protestants, but the prevalent religious party at Thonon considered them inconsistent with the Roman Catholic methods. And, accordingly, they separated

these poor but happy girls from each other, deprived them, as a punishment, of their usual church privileges, and drove some of them from the place.

It is painful to speak of these things. I do not suppose that aspersions, cruelties, persecutions, are limited altogether to Roman Catholics. Some will say, that conduct of this kind is the natural result of that interest in religious institutions which is implied in true faith. This may, perhaps, be true in a certain sense. But add *more faith ;* and then the evil will not be likely to result. A *little* faith makes us love the cause of religion ; but it leaves us in *fear*, which would not be the case if we had more faith. We tremble for the ark of God, as if not God, but some son of Obed-edom, or other weak and human agent, were the keeper of it. Faith and fear are the opposites of each other, both mentally and theologically. When priests have persecuted, I would not in all cases, nor generally, attribute it to self-interest, or the fact of "their craft being in danger." Self-interest, especially among those who have felt the influences of religion, is not the only principle of human action. Persecutions have been practised by those who verily thought they were doing God service. These good people of Thonon had confounded the Church with the ceremonies of the Church ; and when Madame Guyon felt it her duty to indicate the difference between the substance and the shadow, the spirit and the letter, touching the ceremonial it is true, but still with the gentleness of a woman's hand, then the good Catholics, to whom the ceremonial was undoubtedly very dear, were all in arms. Their consternation was real, not affected. They forgot that God is able to take care of the Church without employing Satan's instrumentality. Hence their injustice, their cruelty— not because they had faith, but because they had not more faith ; not because they loved the Church, but because they had forgotten the mighty power and the pledged promise of the God of the Church. Of some who did evil, Christ, who is the true light, said, *Father, forgive them, for they know not what they do.* Of those who do good, but are persecuted for it, the same

Christ has said, *Blessed are they who are persecuted for right eousness' sake, for theirs is the kingdom of heaven.*

CHAPTER XXV.

Conversion of a physician —Further persecution—Some opposers become subjects of the work of God—Striking instances of the care of Providence—Visit to Lausanne—Establishment of an hospital at Thonon—Removal to a small cottage a few miles distant—Return of La Combe—Her opposers appeal to Bishop D'Aranthon—He requires Madame Guyon and La Combe to leave his diocese—Rude and fierce attacks upon her—Decides to leave Thonon—Her feelings—La Combe—His letter to D'Aranthon—Remarks of Madame Guyon on some forms of religious experience—On living by the moment.

SHE mentions a number of incidents, some of them of considerable interest, in connexion with this revival of God's work. " One day," she remarks, " I was sick. A physician of some eminence in his profession, hearing that I was ill, called to see me, and gave me medicines proper for my disorder. I entered into conversation with him on the subject of religion. He acknowledged that he had known something of the power of religion, but that the religious life had been stifled by the multitude of his occupations. I endeavoured to make him comprehend, that the love of God is not inconsistent with the duties of humanity ; and that therefore the employments which God in His providence assigns us, are no excuse for irreligion, or for any state of mind short of a strong and consistent piety. The conversation was greatly blessed to him. And he became afterwards a decided Christian."

Those persons, who made the opposition to this Divine work, among their other acts of cruelty, seized upon a person of considerable distinction and merit, and beat him with rods in the open street. The crime charged against him was, that, instead of confining himself to the common forms of prayer, he prayed extemporaneously in the evenings. The man was a priest, of the Congregation of the Oratory. It was alleged also, that he was in the practice of uttering a short, fervent prayer, in the

same manner, on Sabbath days, which had the effect gradually and insensibly to lead others to the use and practice of the like.

Speaking of the persons who thus violently beat this good man, and of others, she says, "They greatly troubled and afflicted all the good souls, who had sincerely dedicated themselves to God; disturbing them to a degree which it is difficult to conceive; burning all their books which treated of inward submission and of the prayer of the heart, in distinction from mere outward and formal prayer; refusing absolution to such as were in the practice of it, and driving them by their threats into consternation and almost into despair."

But this state of things, which had the appearance of crushing religion, gave occasion for a remarkable exhibition of God's power and grace. Even some of these men, obviously without religion, led to reflect upon their own characters by the sad lesson of the violence which they themselves had exhibited, became, after a short time, humbled in heart. Through Divine grace they not only ceased from their evil works, but became experimentally and practically new creatures in Christ Jesus. "And then," she says, "the Lord made use of them to establish religion and the life of prayer in I know not how many places. They carried books, which treated of the inward life, into those very places where they had formerly burned them. In things of this nature it was not difficult for me, in the exercise of faith, to see the presence and the wonderful goodness and power of the Lord."

Some little incidents of a private and domestic nature, illustrate her trust in God.

"God," she says, "took care of all my concerns. I saw His providence incessantly extended to the very smallest things. I had sent to Paris for some papers. Months passed, but the papers did not come. Looking at it in the human light, the disappointment and the loss were great. But I left it wholly with the Lord. After some months I received a letter from an ecclesiastic at Paris, stating that the papers were in his possession, and that he would soon come to see me and bring them.

" At another time I had sent to Paris for a considerable number of articles necessary for my daughter. They were sent, but did not arrive. The report was, that they had reached the Leman Lake, were put on board a boat, and were lost. I could learn no further tidings about them. But I left it wholly with the Lord. Having done all that was suitable, if they were found, *it was well;* if they were lost, it was *equally well.* At the end of three months they were brought to me, having been found in the house of a poor man, who had not opened them, and did not know who brought them to his house.

" On another occasion I sent to Paris for money to meet my expenses for a year. I received it in a bill of exchange on some person in Geneva. A person was sent from Thonon to Geneva to receive it in specie. The money was deposited in two bags, and placed on the man's horse. The man rather carelessly gave the horse to be led by a boy a little distance. As the boy went along, directing his way through the market of Geneva, the money fell off without being noticed by him.

" At that very moment I arrived myself, approaching the market-place on the other side. Having alighted from the conveyance, I proceeded a few steps, and the first thing I noticed was my bag of money. There was a great multitude of people in the place; but the bag was not perceived by them; or if it was, it was left untouched. Many such things have attended me, which to avoid prolixity I pass by. These may suffice to show the continual protection of God towards me."

Meanwhile the work of God continued. Sinners were conversed with; those who were religious prayed; those without religion began to believe and were saved. When opportunity offered, Madame Guyon, whose efforts were unwearied, extended her labours into the neighbouring villages. On one occasion she made an excursion by water to Lausanne, situated on the lake, about fourteen miles from Thonon, and nearly opposite to it.

" In our return," she says, " we experienced a severe tempest. We were in a dangerous place, when it came upon us, and nar-

rowly escaped being swallowed in the waves. God was pleased to protect us. A few days afterwards a small vessel foundered nearly in the same place, with thirty-three persons in it."

About this time Father La Combe, who had returned from Rome, formed the plan of establishing an Hospital at Thonon. Subordinate to the general plan, the ladies of Thonon formed a society, the object of which was, after the practice which prevailed in France, to aid the families of the sick at the hospital, as well as the sick themselves. There had been no institution of that kind before in that part of the country. "Willingly," says Madame Guyon, "did I enter into this plan. With no other funds than what Providence might please to furnish, and some useless chambers, which the gentlemen of the town gave us, we began our effort. We dedicated the place to the holy child Jesus. God enabled me to furnish the first beds obtained. Several other persons soon joined us in this benevolent effort. In a short time we were not only enabled to place in the building twelve beds, but found three very pious persons, who gave themselves, without salary, to the service of the hospital.

"I assumed the office of furnishing it with the requisite medicines, which were freely given to such poor as had need of them. The good ladies associated in this undertaking, were so hearty in it, that through their care and charity the hospital was in every respect very well maintained and served. They joined together also in providing for the sick who could not go to the hospital ; and I gave them some little regulations, such as I had seen adopted in France, which they made the rules of their associations, and continued to keep up with tenderness and love."

Madame Guyon arrived at Thonon about April 1682, and remained little more than two years. During the latter part of this period she experienced a severe sickness, of which she has given some account. After her recovery she found herself so infirm, that she thought it necessary to change her residence, and to obtain one which, by being a little more remote from the water, would be more favourable to her. The house was in a

more healthy position, some miles from the lake. It was inconvenient, except in its position ; but it was the only one in that neighbourhood unoccupied, which she could obtain.

" It had a look," she says, " of the greatest poverty, and had no chimney except in the kitchen, through which one was obliged to pass to go to the chamber. I gave up the largest chamber to my daughter and the maid. The chamber reserved to myself, was a very small one ; and I ascended to it by a ladder. Having no furniture of my own except some beds, quite plain and homely, I bought a few cheap chairs, and such articles of earthen and wooden ware as were necessary. I fancied everything better on wood than on plate. Never did I enjoy a greater content than in this hovel. It seemed to me entirely conformable to the littleness and simplicity which characterize the true life in Christ."

The change did not diminish her influence. It could not well be diminished, while the conviction remained so prevalent, that she was a woman taught of God. At Thonon her adversaries, who were in the wrong position of fighting against God, had been foiled at every point. And what seemed to render their case the more hopeless, Father La Combe, whose talents and piety gave him a prominent position, had returned after a long absence from Rome, without being condemned for his alleged heresies. At this juncture of affairs, the adversaries of the religion of the heart adopted a new, and as the result showed, a more effective mode of attack.

They complained to Bishop D'Aranthon, that the Church, especially in her prescribed forms and ceremonies, was in danger. The fact that La Combe had united his influence to that of Madame Guyon, had given the new spiritualism a consequence which demanded attention. They said, that if he did not take some repressive measures as bishop, he could not be considered as doing his duty to the Church. Already the evils of novel opinions, or of actual schism, had been experienced in Spain. Already the Spiritual Guide of Michael de Molinos had announced doctrines in Italy, which were justly considered as allied

to those of Protestantism. How then was it possible, that he should remain undecided or inactive ?

Such considerations in a mind easily influenced, aided by his sincere and strong attachment to the Church *as it then was*, aroused D'Aranthon to decisive action. He not only required all priests and others under his authority to oppose the progress of the new views, but insisted that Madame Guyon and La Combe should leave his diocese. Madame Guyon wrote to him, but without effect.

Referring to some benevolent efforts she had made, she says, " All these things, which cost but little, and o ved all their success to the blessing that God gave them, drew upon me and my friends new persecutions. Every day my opposers invented some new slander. No kind of stratagem, or malicious device in their power, did they omit. The dissatisfaction of Bishop D'Aranthon with me was obviously greater than ever, especially when he saw that my efforts of a benevolent and religious nature, which undoubtedly he sincerely disapproved in some respects, rendered me beloved by others. He said peevishly, that ' I won over everybody to my party.' Another remark implied, that he could be patient with my doctrines if they were confined to myself, and were not spread abroad. And finally, he openly declared, that ' he would no longer submit to have me in his diocese.' And what rendered my position the more trying, he extended his unkind treatment to my friends. The prioress of the Ursulines, with whom I had resided a considerable part of my time at Thonon, received a large share of it."

When those in power and authority have come to the conclusion to crush those who are weaker, there are never wanting persons to aid in carrying the decision into effect; not only men from whom better things could be expected, but especially rude men of contracted minds and selfish hearts, who resort to measures which enlightened and benevolent men could not approve. This sort of opposition was employed against Madame Guyon. She resided at some distance from the more settled parts of the country, with her little daughter and one or two female domes-

tics; but otherwise wholly unprotected. She says, "I was greatly contented in my small and rude residence. Hoping to remain there for some time, I had laid in such provisions as were necessary for me; but Satan, the great instigator of evil, did not long permit me to remain in such sweet peace.

"It would be difficult for me to enumerate all the unkindness and cruelty practised towards me. The little garden near my cottage, I had put in order. Persons came at night and tore it all up, broke down the arbour, and overturned everything in it; so that it appeared as if it had been ravaged by a body of soldiers. My windows were broken with stones, which fell at my feet. All the night long persons were around the house, making a great noise, threatening to break it in, and uttering personal abuse. I have learned since who put these persons upon their wicked work.

"It was at this time that notice reached me *that I must go out of the diocese.* Crimes were tolerated; but the work of God, resulting in the conversion and sanctification of souls, could not be endured. All this while I had no uneasiness of mind. My soul found rest in God; I never repented that I had left all to do what seemed to me to be His will. I believed that God had a design in everything which took place; and I left all in His hands, both the sorrow and the joy."

The union of priests, bishop, and people against her, she regarded as an obvious indication of Providence, that, in the language of Scripture, she must "shake off the dust of her feet against them," and go to another city. And what were the feelings under which she was thus compelled, for a second time, to leave her field of labour, and to go again, she knew not whither? "My soul," she says, "leaving all to God, continued to rest in a quiet and peaceable habitation. O thou, the great, the sole object of my love! If there were no other reward for the little services which we are able to perform than this calm and fixed state, above the vicissitudes of the world, would it not be enough? The senses, indeed, are sometimes ready to start aside, and to run off like truants; but every

trouble flies before the soul which is entirely subjected to God.

" By speaking of a fixed state, I do not mean one *which can never decline or fall*, that being only in heaven. I call it fixed and permanent, in comparison with the states which have preceded it, which, being in the mixed life, and without an entire and exclusive devotedness to God, are full of vicissitudes and variations. Such a soul, one which is wholly the Lord's, may be troubled ; but sufferings affect only the outside, without disturbing the centre. Neither men nor devils, though they discharge all their fury against it, can permanently harm a soul free from selfishness, and in union with the Divine will. No sufferings whatever could ever affect it, neither more nor less, neither within nor without, *were it not permitted for wise purposes from above.*"

The pressure was applied with equal skill and power to La Combe also. Such were the ecclesiastical relations between him and the bishop, that the wish of the latter, and still more his injunction, that he should depart from the diocese, rendered it inconsistent, and perhaps impossible for him to remain. The only charge alleged against him was that he was associated with Madame Guyon in the diffusion of a spirituality which was both novel and heretical.

Madame Guyon wrote to the bishop without effect. La Combe also wrote to him. His letter, of which the following is an abridgment, is given in full in the bishop's Life.

TO BISHOP D'ARANTHON.

" In accordance with your desire, sir, I am about to leave your diocese. Not merely because your wish has been so strongly expressed, that it naturally has the effect of an injunction, but because God, the Eternal wisdom, has indicated, in the arrangements of His providence, that the time of my departure has arrived. I recognise the instrumentality ; but I do not forget Him who operates through the instrument. It was by God's order that I came. It is by God's order that I depart.

" You have known my views on the subject of Sanctification; for I communicated them to you in private. And prompted by a sense of duty, I expressed a strong wish that they might be blessed to yourself *personally*. This was the beginning of a course of treatment, which, without giving utterance to the spirit of complaint, I may justly characterize as unusual and hard. I will not now undertake to justify myself against the persecutions experienced. I may, perhaps, be excused for saying, however, that my adversaries have professed to sit in judgment upon what they have never studied, and did not understand. They obtained, nevertheless, an access to the ear of the bishop, which was refused to us. We have this consolation, which silences every murmur, that God in His wisdom permitted it.

" Pardon, respected sir, the feelings of a poor ecclesiastic, who thinks he has known something of the power of the inward life, if in leaving the scene of his labours, in a cause so dear as that of true holiness of heart, he drops a tear of regret at the desolation which he witnesses. Sad and terrible will be the account which must at last be rendered for the opposition raised against a cause for which Christ shed His blood—a cause dear to God, who in His goodness had sent from France to our poor Savoy, a lady whose example and instructions could hardly have failed to extend in every direction the love of holiness.

" But she and others will carry to other places those doctrines of the interior life, which have been banished from the churches over which you preside. Of what value is the Church, and of what value are labours for the Church, without the inward life, without the religion of the heart? By what unhappiness is it, respected sir, that you, who have laboured for your diocese so much, and in many respects so successfully, have permitted this crown of your labours to be taken from you? I speak in kindness and sincerity. Why have the advocates of experimental religion been banished? Why have you smitten me with an ecclesiastical *interdiction*—me, who have been attached to your interests, submissive to your orders, and jealous for your autho-

rity? My conscience bears me testimony, that I would have given more than one life, if I had possessed it, for *you;* for the good of your own soul, and of those under your charge. This has been my prayer, many years earnestly offered, that you, and others through you, might know the full power of God's inward grace. In the bonds of the gospel, I go hence to other lands. Times and places change, but the deep prayer of my heart, which I trust will yet be answered, remains unaltered.

<div align="right">" FRANCIS DE LA COMBE."</div>

Various remarks of Madame Guyon, made from time to time in connexion with these events, seem to me profitable. On one occasion, speaking of a religious friend, whose character was defective in some respects, she says, " Formerly it was with great difficulty that I could bear her manners, characterized as they were by an unrestrained vivacity. But since God has given me grace to regard everything, and to love everything *in its relation to Himself,* I find a great facility in bearing such defects and faults of my neighbour. The principle of bene-volent sympathy has become strong, so that I feel for all, and have a readiness to please and oblige every one, and such a com-passion for their calamities and distresses as I never had before.

" I make, however, a distinction. I more easily bear the defects of beginners in the Christian life, than of those more advanced and stronger. Towards the first I feel my heart enlarged with tenderness ; I speak to them words of consolation. Towards the latter I feel more firmness of purpose. When I see defects in advanced souls, I cannot, without much inward suffer-ing, forbear reproving them. The more any soul is favoured with eminent grace, the more easily is it united to me ; the more violent, also, is the weight and suffering I feel for it, if it slip or turn aside ever so little. Such have been the dealings of the Lord with myself, that I seem to discern with great clear-ness both the strength and weakness of its principles ; so that perceiving where it fails and what it wants, I feel myself bound in religious duty to declare it.

" In my intercourse with others, I can converse much with the weak ; but I am not inclined to converse much with the strong. With those who are in the beginnings of the religious life, and who need instruction, the principle of holy love, acting under the direction of Providence, leads me to converse on such topics, and for so long a time as seems to be necessary. I feel that I am doing good. But conversation, for the sake of conversation, with those who are so advanced that they do not need it, and when the providence of God does not especially call to it, is repugnant to me. The human inclination, which corrupts everything, is apt to mingle with it. The same things which would be right and profitable when God, by the intimations of His Holy Spirit, draws us to them, become quite otherwise when we enter into them of ourselves. This appears to me so clear, that I prefer being a whole day with the worst persons, in obedience to God, to being one hour with the best only from choice and a human inclination."

She observes, " that a man is far from experiencing the full grace of God, who desires martyrdom, but is restless under the yoke of Divine providence, which places martyrdom beyond his reach, and requires him to glorify God in the humblest and most retired avocations of life. The true desire, the right desire, is that which comes in the Divine order ; and the Divine order can never be known and appreciated, except in connexion with a knowledge of the developments of the present moment. At one time the apostle Paul made tents in God's order ; at another time, he preached eloquently on Mars' Hill, at Athens, *in the same Divine order ;* but in both cases he glorified God equally. If we are right in motive, and right in place, exercising all the requisite faith in God at the same time, ALL WILL BE WELL."

The following stanza from one of her poems, may be regarded as expressive of her feelings at this time :—

" Father adored ! thy holy will be done ;
Low at thy feet I lie ;
Thy loving chastisement I would not shun,
Nor from thine anger fly.
My heart is weak, but wean'd from all bestne,
And to thy will resign'd whate'er betide."

CHAPTER XXVI.

Season of retirement—Commences writing her larger treatises—"Spiritual Torrents"—
Feelings with which she commenced this work—Its name—The progress of the soul com-
pared to torrents descending from the mountains—Abstract of it—Remarks.

IN the year 1683, at Thonon, Madame Guyon first began her formal treatises on religious experience. Worn down with continual conversation, she gave out that she stood in need of retirement, and would not see company for a number of days. With some difficulty people would consent to leave her in repose even for a short time. In this season of religious retirement, she had very full and joyous communion with God.

Endeavouring to ascertain in what way she could most glorify God, it occurred to her, that in periods of physical debility, she might do something more with her pen. The suggestion caused her serious deliberation, and some trial of mind. But as soon as she became satisfied that it was God's will, she no longer hesitated, though she felt in some respects unqualified for an undertaking so important. She commenced her work, entitled the "SPIRITUAL TORRENTS."

"When I first took up my pen for this purpose," she says, "I knew not the first word I should write. The subject was dark and mysterious. But it gradually opened to my mind; suitable considerations presented themselves readily and abundantly. Feeling relieved and strengthened, I was enabled to write an entire treatise on the principle of Faith, considered in its inward and sanctifying action."

The title is suggested, partly by its own appropriateness, and partly by Amos v. 24,—"But let judgment run down as waters, *and righteousness as a mighty stream.*" In the French and Latin versions, the words TORRENS and TORRENT are used. "Let righteousness roll down as *a mighty torrent.*"

Some of the principles of this work, written with great vigour of imagination and language, although deficient in some degree in logical development, are as follows :—

1. Souls, coming as they do from God, who is the great ocean of life, have an instinctive and strong tendency, when that element of moral and religious life, which they have lost by the Fall, is restored to them by Divine grace, to return again and mingle in eternal union with that Divine source.

2. And this tendency depends upon nature, as well as origin. God, from whom the soul came, and in whose likeness it is made, is holy. Holiness loves holiness. It cannot be otherwise. And just in proportion as the fallen soul is restored by Divine grace and made holy, precisely in that degree, and on the ground of a likeness of nature, is there a tendency to unite with God.

3. But the instinct of return is different in different persons. This is illustrated by streams or torrents. From the ocean they came;—to the ocean they are returning. But all streams do not flow alike.

4. Some torrents are feeble in their beginning. They acquire strength; but gradually and slowly. Sometimes they meet with an impediment, which makes them no better than a standing pool. When they have escaped, they still retain their former characteristics; and wind onward circuitously and slowly. They are not altogether without life and utility. Here and there their banks are green; and a few scattered flowers drink refreshment from their waters. After a while they depart from sight; perhaps their inconsiderable waters are dissipated and drunk up in the wide expanse of some arid plain. Perhaps they pass on and are lost in some other larger river, or are mingled and lost in the bosom of some lake. They do not reach the ocean.

5. Other torrents seem to start from a fuller fountain, and more rapidly to increase. They expand into rivers. Many are the vessels, larger and smaller, which they bear; rich the merchandise which floats upon them; but they seem to grow sluggish in their own opulence. Winding here and there, they empty themselves at last into some bay, or sound, or other arm of the sea, and there are lost.

6. There are other torrents which represent those who *hunger and thirst after righteousness*, who cannot and will not be satis-

fied, till their souls are brought into the most intimate union with God. If these torrents are turned from their course, they resume it as soon as possible, and by the nearest possible direction. If they meet with obstacles so extensive as to stop them entirely, they do not become inert and stagnant, but they get strength moment by moment, accumulating wave upon wave, till they pass triumphantly over them. They bear their treasures; but they will not stop. They nourish the flowers upon their banks, but they leave them to shine in their beauty and fragrance, and pass on. They are not satisfied, till they reach and mingle with the great ocean. There they are made one with the water of waters; they become a part of it; vast navies float upon its bosom; the world's commerce passes over it.

She makes a distinction between a will perfectly harmonious, and a will merely submissive. A will entirely harmonious carries with it the *heart* as well as the conscience. The will of an obedient servant, who does what he is bound to do, is submissive. The will of the affectionate son, who not only does what he is bound to do, but *loves* to do it, is not only submissive but is harmonious, is not only concordant but is *one*. So that when Madame Guyon insists so much as she does on a perfect union with the Divine will as the highest result of Christian experience, she means a union *which carries the heart with it.*

And then the question comes, How is this harmony to be brought about, which places the centre of all human wills in the centre of the Eternal Will? And the answer is, just in proportion as we dislodge the human life from its own centre, which is Self, it has a tendency, by the law of its own nature, to seek the True Centre, which is God. But what is it for the human life to be loosened and dislodged from its own centre? It is to recognise in everything its entire dependence on God, and to be willing to receive every such thing in God's way, in God's time, and on God's conditions. In the first place, it must renounce salvation from itself, in order that it may receive salvation from God through Christ. And then, in the exercise of the same self-

renunciation, it must be willing to receive also its strength, its wisdom, its moral and religious good, what may be called *its daily spiritual bread*, from God, living upon the Divine Fountain which flows unceasingly to those who are willing to receive life from the Divine Life, through the operation of the Holy Ghost dwelling in the soul.

Here the struggle begins, and is continued. When men begin to see that they are lost *out of God*, and put forth their hands and struggle in the right direction, they then begin to feel, and not till then, the strength of the chains which bind them. The first struggle is to renounce all fondness and all claim for agency and merit in the matter of their salvation from the penalty of their past sins. So that the first crucifixion of self begins at the cross of Christ.

Terrible is the struggle oftentimes at this point. God can never yield, because, being the Eternal Truth, He never can violate the truth. It is an eternal truth, or if it be preferred, an eternal *law* in morals,—the opposite of which is an eternal false-hood, because it never was and never can be the law,—that, where there is crime, there must be suffering. And suffering which attends upon crime, and is the *necessary result of crime*, is not merely suffering, but is retribution, is *punishment*. This relation of crime and punishment God can never alter, unless, by an arbitrary act, He can change right into wrong and wrong into right, which would be inconsistent with the very idea of God. God, therefore, in the person of His Son, not only know-ing but realizing in Himself the immutability of the requisitions of the law, took the penalty of its violation on Himself, in order that man, who had incurred the penalty by sin, might be for-given. And it was not merely an exhibited or apparent suffer-ing, which God "manifested in the flesh" endured—not a mere *spectacle*, but a real suffering. God, therefore, because He cannot possibly meet him on any other ground or in any other place, unless He meets him as a righteous judge, meets man in the cross of Christ;—He meets him on Calvary and not on Sinai. And the first act of submission, the first act in which

man recognises God as the Giver of the true life, *is, and must be there.*

But this is only the beginning of the work. The purchase of forgiveness in Christ is the purchase of *a new life ;* and all additional blessings flow through Him. Man is to be detached from his own centre in the matter of forgiveness; and from the same centre, which is Self, in everything else. As every good thing really comes from God; so every good thing must be *received* and *recognised* as coming from him in the exercise of faith. Here we see the necessity of inward crucifixion, and the principles on which it must be conducted. The soul must be detached from everything on which it rests *out of God.*

There are two great principles on which this result depends; that by which, in the language of Madame Guyon, we become *nothing in ourselves,* and give ourselves to God entirely ; and the other is, that we fully believe in God as *accepting* the offering which we have thus made. And here often we find the exercise and trial of our faith. Strong faith is requisite. Relying simply upon the promise, given and pledged to all those who are fully consecrated, we are to receive God as our God and portion, for the present and the future, in all that He now is, and in all that He can be to us in time to come ; in the plan of salvation, in the administration of His providences, and in the "daily bread" of His grace, dispensed to us moment by moment. And He becomes to us in this way, not only all that He is in fact, but all that we *can desire Him to be ;* because, relying on His promises, we find our desires already fulfilled by anticipation ; although His present administration in respect to us may be, in some respects, mysterious and trying.

At this point Madame Guyon describes accurately and minutely, the further progress of inward crucifixion. She draws chiefly from what she herself had passed through, and had witnessed in other cases.

And what is particularly worthy of notice is, that she shows, in souls that are prepared for it by Divine grace, how the principle of *Faith* develops itself step by step, and in higher and

higher degrees, in precise accordance with the process of inward crucifixion. Just in proportion as the soul is sundered from the ties which bound it inordinately to the earth, it increases in the strength of its faith, and rises into harmony with God. She describes the progress of the inward life, not merely by degrees of crucifixion, but chiefly and especially by *degrees of faith.*

The soul, in the first degree of faith, has a true life in God, but not a full or perfect life. The soul, in this degree, loves God, but it adheres too strongly and takes too much delight in the *gifts* of God, considered *as separate from God himself.* It recognises and loves, in general, the providences of God; but when they become personally very afflictive, it is apt to show something of restlessness and unsubmission. Combined with a disposition to do the will of God, there is too much of " *empressement,* " or undue eagerness to do it, and not enough of that humility and quietness of spirit, which waits for His time of doing it.

In the second and other higher degrees of faith, the soul becomes detached from these faults and sins. But there still remain others. The soul, for instance, in this stage of its progress, rests more or less upon a human arm;—human opinions, which are adverse to its course, cause it trouble; human approbation and human applause sometimes give it strength, which would be better if it came directly from God. But God, operating by outward processes, takes away one prop after another, till the soul (which it cannot do, without an increase of faith corresponding to the facts and process of such inward crucifixion) rests solidly upon the great Centre, and upon that centre alone.

Such are some of the doctrines of this interesting work. The terms in which she describes the successive steps of a thorough inward crucifixion, remind one strongly of her own personal history. She describes in a great degree, though not exclusively, *from herself.* And this, while it contributes to the interest of the work, constitutes in reality one of its defects, considered as a work to be read and followed by others. It would not be entirely safe to take the experience of any individual in all its

particulars, as the precise mode of the Divine operation in all other cases. It may be proper to add further, that she was constitutionally imaginative. Consequently, viewing things in a clear and strong light, she expresses herself more strongly than a person with less imagination would be likely to do. Her expressions, therefore, especially when compared with what she says, from time to time, in other places, may sometimes justly be received in a modified sense.

———

CHAPTER XXVII.

Leaves Thonon—Mount Cenis—Her feelings—Persons that accompanied her—Circumstances which led her to go to Turin—Marchioness of Prunai—Her journey through the Pass of Mount Cenis, and reception and labours at Turin—Religious feelings—Correspondence—Advice to a young preacher—Of Dreams—The Dream of the sacred island.

SHE decided, for various reasons, to attempt to reach Turin, the capital of Piedmont, situated one hundred and thirty-five miles south-east from Geneva, and a little more from Thonon. Its site is on a vast plain at the foot of the Alps, on the Italian side, and at the confluence of the rivers Doria and Po.

The route would be, I suppose, from Thonon to Chambery, through Geneva and Anneci, and from Chambery through Montmeillant, to the celebrated Alpine pass of Mount Cenis, and thence to Susa and Turin.

Mount Cenis was not passable then, as it has since been rendered by the efforts of the French Government, for carriages; but those who went over it were obliged to go on foot or on mules, or were carried in litters borne by porters. A journey along frightful precipices, and over mountains piled to the clouds, accompanied too by the reflection that those who were prosecuting it had no home, no resting-place, must have been exceedingly trying to any one whose mind was not sustained by strong faith.

"The words," she says, "which are found in the Gospel of Matthew, were deeply impressed upon my mind. '*The foxes have holes, and the birds of the air have nests, but the Son of man hath not where to lay his head.*'

"This I have since experienced in all its extent, having no sure abode, no refuge among my friends, who were ashamed of me, and openly renounced me at the time when there was a great and general outcry against me ; nor among my relations, the most of whom declared themselves my adversaries, and were my greatest persecutors ; while others looked on me with contempt and indignation. My state began to be like that of Job, when he was left of all. Or perhaps I might say with David, '*For thy sake I have borne reproach ; shame hath covered my face ; I am become a stranger to my brethren, and an alien unto my mother's children ;* a reproach *to men, and despised of the people.*'"

She was accompanied by Father La Combe, her spiritual director ; by another ecclesiastic of high standing and merit, who had been for fourteen years a teacher in theology, whose name is not given ; and a young lad from France, who had been apprenticed to some mechanic trade. The females in this little company were Madame Guyon and her little daughter, and one of the maid-servants who came with her from France, a poor and humble girl, but rich in that unchangeable faith which rests upon inward renouncement ; who recognised in Madame Guyon a spiritual mother, and with something of a martyr's spirit shared in her wanderings and labours, and suffered with her in her long imprisonments.

The men went through the mountain passes on mules, the females on litters. She who but a few years before had resided amid the ease and elegancies of the capital of France, was now a wanderer, with the precipice at her feet and the avalanche above her head. But God is the God of the rock and of the mountains, as well as of the cultured field and valleys ; and she saw in these mighty and terrific piles, which the lightnings had smitten but not destroyed, which the thunders had struck but

H

never removed from their places—an emblem of the strength of that arm on which her soul rested.

God had prepared her a refuge in Turin. There was at that time in the city of Turin a lady of distinguished rank, the Marchioness of Prunai, distinguished alike by her position in society, her powers of mind, and her sincere piety. Her brother was at that time the principal Secretary of State to the Duke of Savoy. The Marchioness had been a woman of sorrow, having been left a widow at an early period of life. She had quitted the noise and splendour of the Court for the more silent satisfaction of a retired life. "This lady," says Madame Guyon, "was one of extraordinary piety. With many things in her situation which might have furnished inducements to a different course, she nevertheless continued a widow, notwithstanding repeated offers of marriage. Her great object in doing this was, that she might, with less distraction, consecrate herself to Christ without reserve."

There was a similarity in their respective situations which could not fail to interest her. The position of Madame Guyon touched the chord of heart-felt sympathy. Having heard of her sickness at Thonon, and the troubles likely to await her there, she sent her a letter by express, conveying her Christian and friendly sympathy, and inviting her to come to Turin and reside with herself. In a subsequent letter, which repeated the invitation more strongly, she included Father La Combe.

"As the invitation was given," says Madame Guyon, "without any anticipation of it, and any design on our part, it was natural and reasonable for us, under the circumstances of the case, to believe that it was God's will for us to go. And we thought it might be the means of His appointment, seeing ourselves chased on the one side and desired on the other, to draw us out of the reproach and persecution under which we laboured."

This little company, with the world's curse and with God's blessing, were winding their way through the valleys of the Maurienne, and over the cliffs of Mount Cenis, and along the banks of the Doria. The Lord, who casts up a highway for

His ransomed people to walk in, directed their steps. They were received at Turin by the Marchioness with all that kindness and Christian affection which her letters had led them to expect. La Combe remained but a short time. He received an invitation from the Bishop of Verceil, a considerable town of Piedmont, about forty miles from Turin. To this he thought it his duty to accede.

Turin was not regarded by Madame Guyon as a permanent field of labour. It was a place of refuge and of rest; but still in some degree a place of religious effort. Her labours seem to have been chiefly with persons who held a position of influence in the religious world.

"It pleased God," she says, "to make use of me in the conversion of two or three ecclesiastics. Attached to the prevalent views and practices, their repugnance to the doctrines of faith and of an inward life was at first great. One of these persons at first vilified me very much. But God at length led him to see his errors, and gave him new dispositions."

The writings of Madame Guyon, all in French, have been published in their collected form, in forty volumes. Some of her works, published separately, particularly her Life, have passed through numerous editions. The ease, vivacity, and the effect of what she wrote upon numerous persons, were remarkable. At Paris, at Gex, at Thonon, at Turin, at home and abroad, in the convent and the prison, her pen was constantly employed. It is hardly possible to name a period during her life, when she did not keep up a wide correspondence. All classes of persons shared in her labours in this way, if there was any prospect of doing them good. Five printed volumes remain to us. She received many letters from Paris during her residence at Gex; especially from persons who had a reputation for holiness.

Among her correspondents we find, beside her spiritual Directors, M. Bertot and Father La Combe, the names of Poiret, a man celebrated for his knowledge, especially in the mystic or experimental theology, the Abbé de Wattenville of the city of

Berne, Mademoiselle de Venoge of Lausanne, M. Monod, a man
of some distinction both in science and in civil life, the Baron
Metternich, the Marquis de Fénelon, who for some time was the
French ambassador in Holland, and Fénelon, Archbishop of
Cambray. To these, among many others now unknown, we
may add the four daughters, all of them duchesses in rank, of
the celebrated Colbert, together with two of their husbands, the
Dukes of Chevreuse and Beauvilliers.

From time to time we propose to give portions of her corre-
spondence. Dates and names are sometimes gone; but that
does not essentially alter its value. Her letters generally relate
to experimental religion.

" When the heart is once gained," she says, speaking of
preachers, " all the rest is soon amended. But when, instead
of faith in Christ and the renovation of the heart, they direct
their hearers to the practice of outward ceremonies chiefly, but
little fruit comes of it. If priests were zealous in inculcating
inward instead of *outward* religion, the most desirable results
would follow. The shepherds, in tending their flocks, would
have the spirit of the ancient Anchorites. The ploughman, in
following the plough, would hold a blessed communion with
God. The mechanic, fatigued with his labours, would find rest,
and gather eternal fruits in God. Crimes would be banished;
the face of the Church would be renewed; Jesus Christ would
reign in peace everywhere. O the inexpressible loss which is
caused by a neglect of inward religion! What a fearful account
will those persons be obliged to render, to whom this hidden
treasure has been committed, but who have concealed it from
their people!"

A letter, addressed to a young man when he was about enter-
ing the ministry, is as follows:—

" SIR,—The singleness of spirit and the candour with which
you have written, please me much. You are about to preach the
Gospel of Christ. I will avail myself of the confidence you have
placed in me, and endeavour to make one or two suggestions.

" In the first place, a person in the responsible and solemn situation to which you are called, should never preach *ostentatiously ;* in other words, with the purpose of showing your intellectual power, your learning, and eloquence. Preach in a plain, simple manner ; and let me add, that the matter is still more important than the manner. Be careful *what* you preach, as well as *how* you preach. Preach nothing but the Gospel,—the *Gospel of the kingdom of God.* And, it is exceedingly desirable, that you should preach it as a kingdom *near at hand ;* as something not a great way off, but to be received and realized *now.* Aim at the heart. If men seek the kingdom of God *within them,* in the exercise of faith and in right dispositions, instead of outward ceremonies and practices, they will not fail to find it.

" Always remember that the soul of man was designed to be the *Temple of the living God.* In that temple, framed for eternity, He desires to dwell much more than in temples made with human hands. He himself built it. And when, in the exercise of faith, we permit Him to enter, He exercises there a perpetual priesthood. God, therefore, is ready to come, and to take up His abode in the heart, if men are desirous of it. But men themselves have something to do. Teach those to whom you preach, to disengage their minds from the world, to be recollected and prayerful, and with sincerity and uprightness to seek, in the language of the Psalmist, ' the Lord and his strength, *to seek his face evermore.*' (Ps. cv. 4.)

" Again, to render your preaching truly effective, it must be the product of love, and of entire obedience to the Spirit of God ; flowing from a real inward experience ; from the fulness of a believing and sanctified heart. And, if this be the case, your sermons will not, I think, partake of a controversial spirit, which is much to be avoided. Men who are controversial, led away by strong party feelings, are apt to utter falsehoods, when they think they are uttering the truth. Besides, nothing, so far as I can perceive, so much narrows and dries up the heart as controversy.

"Shall I be permitted to make one other suggestion? It is very desirable, in the earlier part of your ministry especially, that you should spend a portion of your time, and that perhaps not a small portion, in communion with God *in retirement.* Let your own soul first be filled with God's Spirit; and then, and not otherwise, will you be in a situation to communicate of that Divine fulness to others. No man can give what he has not; or if a man has grace, but has it in a small degree, he may, in dispensing to others, impart to them what is necessary for himself. Let him first make himself one with the great Fountain, and then he may always give, or be the instrument of giving, without being emptied.

"How wonderful, how blessed are the fruits, when the preacher seeks the Divine glory alone, and lets himself be moved by the Spirit of God! Such a preacher can hardly fail of gaining souls to Him who has redeemed them with His blood. Preach in this manner, and you will find that your sermons will be beneficial, to yourself as well as to others. Far from exhausting you, they will fill you more and more with God, who loves to give abundantly, when, without seeking ourselves, and desirous of nothing but the promotion of His own glory, we shed abroad what He gives us upon others.

"And, on the other hand, how sad are the effects, when men preach with other views, and on other principles;—men *who honour God with their lips when their hearts are far from Him.* They are not more injurious to others, than they are miserable in themselves. I close with my supplication, that God may not only instruct you in these things, but, moreover, place you in a situation which will be most accordant with the Divine glory and your own good.

"JEANNE M. B. DE LA MOTHE GUYON."

I believe it is a remark of no less a philosopher than President Edwards, that we may profitably notice our dreams, in order to ascertain from them, in part, our predominant inclinations. Still they are not to be considered as of much account.

And accordingly, but little has been said of them hitherto. One will now be given, which occurred in this period of her life.

"It was about this time," she relates, "I had a dream, which left a sweet impression on my mind. I seemed to see the wide ocean spread out before me. Many were its shoals and breakers, and its stormy waters roared. In the midst there arose an island, lofty and difficult of access where it touched the water; but in the interior, where it arose again into a lofty summit, it was full of beauty. To this, I was in some way mysteriously carried. They said it was called Lebanon. Forests of cedars, and all beautiful trees, grew there. In the wood there were lodges, where those who chose might enter; and couches of repose were spread for them. Here, in this place of Divine beauty, all things were changed from what we see them in the natural world. All was full of purity, innocence, truth. The birds sang and sported among the branches, without fear that insidious foes would watch and destroy them. The lamb and the wolf were there together in peace; so that I was reminded of that beautiful prophecy of Isaiah,—'The wolf shall dwell with the lamb, and the leopard shall lie down with the kid; and they shall not hurt nor destroy in all my Holy Mountain.'

"As I thus contemplated, who should appear but that beloved one, the spouse of holy souls, the SAVIOUR OF MEN! He condescended to come near me, to take me by the hand, and to speak to me. When we had looked round upon this Divine work, this new Paradise, He directed my attention to the wide waters which surrounded us, to its rocks and foaming breakers, and pointed out to me here and there one who was struggling onward, with more or less of courage and hope, to this island and mountain of God. Some appeared to be entirely overwhelmed in the waves, but not yet wholly gone, and the Saviour directed that such, in particular, should receive from me whatever sympathy and aid I could give them. The sweet impression which this dream left upon my spirit continued many days."

Such a dream was calculated to console her, and to confirm

her in her conviction that her great business was to aid souls, amid the multiplied perils which beset them.

————

CHAPTER XXVIII.

Her return to France—State of things in Italy—Some account of Michael de Molinos—
—Opposition to his views—Ill treatment of his followers—Course of the Count and
Countess Vespiniani—Imprisonment of Molinos, and death—Her return from Turin to
Grenoble—Reasons—Advice of a friend—Her domestic arrangements—Remarkable re-
vival of religion at Grenoble—Dealings of God with some individuals—Conversion of
a Knight of Malta—Her labours with the Sisters of one of the Convents of the city—
Establishment of an hospital for sick persons.

MADAME GUYON looked upon Turin as a place of refuge rather than a field of permanent labour. During these few months she found something to do, and her labours were not without effect. But whether it was owing to Italian usages and manners, so different from those to which she had been accustomed, or the difference of the language of the country, which, although she undoubtedly had command of it, must have been employed by her with some embarrassment, or some other reasons, she found that her mind turned back to France. France was the place of her birth; but, above all, Providence seemed to her to indicate that her labours and her sufferings would be there.

Certainly it was difficult, under the existing state of things, for the true light to shine much in Italy. The people of the Italian states have been subject to a yoke of ceremonial bondage, exceedingly adverse to a life of faith. In France, although the difficulty has been the same in kind, it has been less in degree.

To illustrate and confirm this we may mention a few facts. About this period Michael de Molinos, a Spaniard, of a respectable family and blameless life, made his appearance in Italy as a religious teacher and reformer. He published his views in a work entitled the Spiritual Guide, which in a few years passed through twenty editions in different languages. The principles of the book, which have been much misrepresented and misunderstood, were similar in many respects to those of Madame

Guyon. He maintained the high doctrine of present and effective sanctification. He attached comparatively but little value to ceremonial observances, but insisted much upon the religion of the heart, and upon faith as its constituting principle. His doctrines were received with great joy by many pious persons, in various parts of Italy. But this state of things continued only for a short time.

The watchful eye of Roman Catholic authority noticed this movement. Molinos was seized and shut up in prison with some hundreds of persons; some of them eminent for learning and piety, others distinguished for rank. Among these last were the Count and Countess Vespiniani. The Countess, strong in that power and life of faith of which by God's grace she had become the possessor, answered the judges of the Inquisition with a firmness and decision which quite astonished them. She averred that she had been betrayed by the priests to whom she had made confession; and declared openly and boldly, with all the terrors of an ignominious death before her, that she would never confess to a priest again, but to God only.

The Inquisitors, confounded at her boldness, and not daring to act with rigour against persons of such high rank, set the Countess and her husband at liberty, with some others. But Molinos, whose irreproachable life and profound piety had made a general impression, was not permitted to escape. The doctrines of the Spiritual Guide were formally examined and condemned. A circular letter, emanating from the highest ecclesiastical authority, was addressed to the prelates of Italy, apprizing them that secret assemblies were held in their dioceses, where inadmissible and dangerous errors were taught. It was enjoined to pursue to justice such as should be found adopting novelties. All suspected persons were closely examined; the books of Molinos, when found in their possession, were taken away; nor were they allowed to retain any other writings of a similar character; such, in particular, as the Easy Method of the Inward or Contemplative Life by Francis Malaval,* and the Letters, on the

* This work was translated from the French into the Italian by Lucio Labacci.

same subject, of Cardinal Petrucci. Efforts were made to save Molinos, but they were ineffectual. He died in the dungeons of the Inquisition, after many years of close confinement, in which he exhibited the greatest humility and peace of mind.

It does not appear that Madame Guyon knew much of the progress and results of this movement at this time. The greater number of those who were interested in it, resided in other parts of Italy. But she saw enough in the inordinate attachment to the existing forms, and the prevalent deadness to the life of religion in the soul, to convince her that there was but little hope of much success in the labours of one like herself, a woman, a stranger in a strange land, unfriended and comparatively unknown. Some years after, her writings were denounced as equally heretical; and the ecclesiastical condemnation of the propositions of the Spanish priest was urged as one of the reasons for treating hers in a like manner.

Under these circumstances she began to experience, more distinctly than she had previously done, the inward consciousness that God designed to use her as an instrument to effect His purposes. And she could hardly fail to see, possessing powers the strength of which she had learned from the conflicts in which she had been engaged, that her labours would probably no longer be in obscure and remote places, and among peasantry. A mere *instrument* as she was, and felt herself to be, she began, nevertheless, to feel the greatness of her personal responsibility, and the importance of the mission to which God had called her, which was designed to recall her people from the sign to the thing signified, the semblance to the possession, the ceremonial to the substance.

In the autumn of 1684 she left Turin for France. Here she came to the conclusion to go to Grenoble, about twenty-five miles from Montmeillant; and unless she returned again to Thonon and Geneva, as she could not now do with much propriety, she could hardly avoid visiting it.

She was intimately acquainted with a lady residing at Grenoble, who was so situated as to give her some aid and

advice. This lady she speaks of as " an eminent servant of God."

Grenoble, which is about one hundred miles north-west of Turin, is an ancient and populous city of France, situated on the river Isère, and rendered important by its position, its numbers, and its local influence. The lady advised her, for religious reasons and with a full knowledge of her objects, to go no further, but to take up her residence for a time in that city. Her thoughts were occupied with the subject before this time ; so much so, that the reflections of the day had sometimes given existence and character to the dreams of the night. " Before I arrived at Grenoble," says Madame Guyon, " my friend saw in a dream, that our Lord gave me a great number of children, all uniformly clad, and bearing in their spotless dress the emblem of their innocence and uprightness. Her first impression was, that God might in His providence establish me at Grenoble, for the purpose of taking care of the children of the hospital. But as soon as she told it to me, it seemed to me that another interpretation, more appropriate and likely to be fulfilled, could be given to it. The impression left upon my own mind was, that God might so far bless my labours as to give me a number of spiritual children ;—the ' *little ones* ' of the Gospel ;—children characterized by a new heart, by innocence, simplicity, and uprightness."

It appeared to Madame Guyon that she should stop for a time here ; and thinking it not best to rely upon the offices of private friendship for the accommodations necessary for her, she made arrangements to place her little daughter and the pious maidservant, her constant attendant, as boarders in one of the convents of the city. She herself took retired rooms in the house of a poor widow.

She did not visit and make acquaintances in the first instance. It had not been her custom. Her unalterable conviction, that it indicates a want of religious wisdom and faith to run in advance of the Divine providences, required her to wait and to watch, as well as to pray and to act. And the result showed

that those who trust in the Lord will find Him all that their
faith expected and required Him to be.

She sat in her solitary room in the city of Grenoble, in silent
communion with God; a stranger almost unknown. But God,
who gives all things to him who is so *poor in spirit* that he
may be said to have nothing, honours and loves the sanctified
heart. The language of Him in whom they trust is,—" *The
battle is not yours, but God's. Fear not, nor be dismayed; for
the Lord will be with you.*" (2 Chron. xx. 15, 17.)

Although, with the exception of a single family, she had
scarcely a personal acquaintance at Grenoble, it was soon gene-
rally known that Madame Guyon was in the city. The result
was, (and she speaks of it as something quite unexpected,)
that within a very few days some of the most pious persons in
the city came to see her. The fact that she was already re-
garded and denounced by many as a fugitive and heretic, did
not prevent the sympathy of pious hearts. And many of those
who thus visited her, came not merely to express their respect
and sympathy, but to receive that religious instruction which
they regarded her as eminently qualified to give. Here, as in
a greater or less degree at Paris, at Gex, at Thonon, and at
Turin, the Spirit of God attended her.

Those who thus came to her, impressed by the profound truths
which she uttered, announced to others the light and the spiri-
tual blessings they were thus receiving. And accordingly, the
number rapidly increased.

" People," says Madame Guyon, " flocked together from all
sides, far and near. Friars, priests, men of the world, maids,
wives, widows, all came, one after another, to hear what was to
be said. So great was the interest felt, that for some time I
was wholly occupied from six o'clock in the morning till eight
in the evening, in speaking of God. It was not possible to aid
myself much in my remarks by meditation and study. But God
was with me. He enabled me, in a wonderful manner, to un-
derstand the spiritual condition and wants of those who came to
me. Many were the souls which submitted to God at this time;

God only knows how many. Some appeared to be changed as it were in a moment. Delivered from a state in which their hearts and lips were closed, they were at once endued with gifts of prayer, which were wonderful. Marvellous, indeed, was this work of the Lord."

A member of one of the religious orders at Grenoble, visited her Conferences, and seems also to have sought private interviews. He was one of those persons, not unfrequently found, who, with the most favourable dispositions to become religious, fail, nevertheless, in the requisite fidelity and courage. In this conflict and vacillation of mind, he came and "laid open," as she expresses it, "all the trials of his heart to her like a little child." She gave him such instructions as seemed applicable ; and God made her the instrument of great blessings to him. "I felt," she says, "that this person, who was emptied of self in proportion as he received of the Divine fulness, was truly one of my spiritual *children*, one of the most faithful and closely united."

A number of his companions were all, in like manner, led to see their need of an interest in Christ, and to the experience of repentance. But this result, so auspicious and glorious, was incidentally the occasion of some trouble. The Superior of the Religious House to which these brethren belonged, and the Master of the Novitiates, were very much offended.

" They were grievously chagrined," says Madame Guyon, " that a *woman* should be so much flocked to and sought after. For, looking at the things as they were in themselves, and not as they were in God, who uses what instrument He pleases, they forgot, in their contempt for the instrument, to admire the goodness and grace manifested through it. The good brother, however, first converted, persevered in his efforts, and after a time persuaded the Superior of the House to come, and at least to thank me for the charities of which he knew I had been the agent. He came. We entered into conversation. The Lord was present, and was pleased so to order my words, that they reached his heart. He was not only affected, but was at last

convinced and completely gained over to the views which he at first opposed. So much so, that he bought quite a number of religious books at his own expense, and circulated them widely.

"Oh, how wonderful art thou, my God! In all thy ways how wise! In all thy conduct how full of love! How well thou canst frustrate all the false wisdom of men, and triumph over all their vain precautions!

"In this Religious House there was a considerable number of persons as Novitiates. The new spirit of religious inquiry, based upon the principle that man is a sinner, and that he must be saved by repentance and faith in Christ, and that faith in God through Christ subsequently is, and *must* be the foundation of the inward life, reached the eldest of the Novitiates. It was a marked case. As he gave his attention to the subject, he became more and more uneasy, so much so that he knew not what to do. He could neither read nor study, nor go through in the usual manner the prescribed forms of prayer, nor scarcely do any of his other duties. The member of this Religious House interested first, brought this Novitiate to me. We conversed together for some time. I was enabled, with Divine assistance, to judge very accurately of his inward state, and to suggest views appropriate to it. The result was remarkable. God's presence was manifested in a wonderful manner. Grace wrought in his heart; and his soul drank in what was said, as the parched ground of summer drinks in the rain. Before he left the room, the fears and sorrows of his mind departed. So far as could be judged at the time, he was a *new man in Christ*.

" He now studied and prayed readily and cheerfully, and discharged all other duties in such a manner that he was scarce known to himself or others. He was not only changed, but he was rejoiced to find that there was in him a *principle of life which made the change permanent*. God gave him his daily bread spiritually, as well as temporally; imparting what he could not obtain before, whatever pains he might take for it. Desiring to do good to others, he brought to me, from time to time, all the other Novitiates. All were affected and blessed,

though in different degrees. The Superior of the House and the Master of the Novitiates, ignorant of the instrumentality employed, could not forbear expressing their feelings at the change in those under their charge. Conversing one day with a person connected with the house, and expressing their surprise at the great change in the novitiates, this person said to them, 'My Fathers, if you will permit me, I will tell you the reason. It is owing to the efforts of the lady against whom, without knowing her, you formerly exclaimed so much. God has made use of her efforts for all this.'

" This, added to the favourable influences already existing, could not fail to have a very marked effect. Both the Superior and the Master were advanced in years; but they condescended, with great humility, to submit to such advice and instruction as I was enabled to give them. It was at this time, for the particular benefit of those whose minds were affected in the manner related, that I wrote the little book entitled *A Short Method of Prayer*.

" They experienced so much benefit from it, that the Superior said to me, 'I am become quite a new man. Prayer, which was formerly burdensome to me, and especially after my intellectual faculties became exhausted and dull, I now practise with great pleasure and ease. God, who formerly seemed to be a great way off, is now near; and the communion I have with Him, which is frequent, results in great spiritual blessings.'

" The Master of the Novitiates said, ' I have been a member of a Religious House these forty years, and have practised the form of prayer, and perhaps in something of its spirit ; but I can truly say, that I have never practised it as I have done since I read that little book. And I can say the same of my other religious exercises.' Among the other persons experimentally interested, were three monks, men of ability and reputation, belonging to another monastery, the members of which were in general very much opposed to me.

" God also made me of service to a great number of nuns, virtuous young women, and even men of the world. Among

those was a young man of the Order of the Knights of Malta.
Led to understand something of the peaceful nature and effects
of religion, he abandoned the profession of arms for that of a
preacher of the gospel of Christ. He became a man constant in
prayer, and was much favoured of the Lord. I could not well
describe the great number of souls, of whose spiritual good God
was pleased to make me the instrument. Among the number
were three curates, one canon, and one grand-vicar, who were
more particularly given to me. Generally speaking, those who
sought religion did not seek it in vain. There was one priest,
however, for whom I was interested, and for whom, in my
anxiety for his salvation, I suffered much. He desired religion,
while he felt the power of other and inferior attachments. He
sought it, but with a divided heart. The contest was severe;
and it was with painful emotions that I saw him, after all his
desires and efforts, go back again to the world.

"I ought to add, perhaps, that those who were the subjects
of this remarkable work, generally remained steadfast in the
faith. In the severe trials which followed, some of them were
shaken for a time, but returned again. The great body were
steadfast—immovable."

These things took place, for the most part, in the spring and
summer of 1685. The following is one of a number of incidents
connected with this state of things. "There was a sister in one
of the convents of the city, who for eight years had been in a
state of religious melancholy. No one seemed to understand her
case, or was able to give relief. I had never been in that con-
vent; for I was not in the habit of going into such places unless
I was sent for, as I did not think it right to intrude, but left
myself to be conducted by Providence. Under these circum-
stances, I was not a little surprised that, near the close of a long
summer's day, after setting of the sun, a message was suddenly
sent to me from the Prioress, requesting me to visit this House.
On my way thither, I met one of the sisters, who told me the
occasion of my being thus suddenly summoned was the afflicted
and insane state of this poor woman. She had made an attempt

to kill herself. Her earnest desire to obtain reconciliation with
God, and her deep conviction of the impossibility of securing it
by ceremonial observances alone, had produced such a conflict
in her mind, that its very foundations were shaken; but not so
much so as to deprive her of the power of correct perception for
the most part of the time.

"A person coming in to see her about this time, who had
known something of my personal history, advised her to converse
with me. Being thus made to understand the general facts of
the case, I laid it inwardly before the Lord, who enabled me to
understand it more fully. For many years, compelled as it were
by the doctrine and discipline which ascribed the highest results
to austerities and ceremonial observances, she had struggled
against those inward convictions, which assured her that there
is a better way. I endeavoured to explain to her that this
resistance must cease; that she must no longer rely upon ob-
servances, or trust to personal merits, but must trust in Christ,
and resign herself to Him alone. God was pleased to bless
these efforts. Being a woman of great capacity, she appreciated
at once the views which were presented. Submitting herself to
God through Christ, and willing to leave all things in His
hands in faith, she entered at once into the peace of Paradise.
She was so much changed, that she became the admiration of
the Religious Community. God's presence was with her con-
tinually, and her spirit and power of prayer were wonderful."

But the work did not stop here. A considerable number of
persons in the Convent gave attention to these great truths. It
was something new, with those who had practised observances
and austerities so long, to hear of reconciliation with God, by
the simple and scriptural method of faith in Christ alone. And
the announcement, coming though it did from woman's lips, but
attended with what gives the true power to every announce-
ment, namely, the *Saviour's blessing*, brought consolation to
many a mourning heart. The thorough reformation of one of
the inmates in particular, whose ungovernable dispositions had
for many years given trouble, attracted great notice. The won-

derful change thus wrought in others, and particularly in this individual, was the means of establishing an intimate friendship between the Prioress and herself.

Her labours were not limited to religious instruction. The efforts so happily made at Thonon to establish an hospital for the sick, were followed by similar efforts at Grenoble. She mentions it incidentally, in a subsequent period. " I believe I forgot to say, in the proper place, that the Lord condescended to make use of me to establish an hospital in Grenoble. Some expense was necessarily incurred in the beginning; but it was established without permanent or vested funds, on the principle of being supplied by voluntary contributions from the fund of Providence. My enemies afterwards made use of this bene-volent effort, as an occasion for speaking ill of me, alleging that I had taken property for the founding of such institutions, which had been settled on my children. This was not true. My children not only fully received what was settled upon them, but shared also in what was assigned to me. As to the hospitals, instead of ascribing their support to me or any one else, it would be better to say that they are supported only on the fund of Divine Providence, which is inexhaustible. But so it has been ordered *for my good*, that all the Lord has enabled me to do for His glory, has ever been turned by man's malignity into trials and crosses for me. Many of my trials I have omitted to parti-cularize, for the number of them has been so great."

CHAPTER XXIX.

Origin of the Monastery of the Grande Chartreuse—Visited by Madame Guyon—The ap-proach to it—Conversation between Father Innocentius and Madame Guyon—Opposition at Grenoble—Her method of prayer in religious conferences—Commences Commentaries on the Bible—Of her spiritual state—Her Commentary on the Canticles—Her sympathy with King David when occupied in writing on the book of Kings—The Short Method of Prayer—Its origin—On the writing of books as a means of good.

EIGHT miles north of Grenoble is the celebrated monastery of the Grande Chartreuse. In the year 1084, Bruno, a native of

Cologne, founder of the Order of Carthusian monks, a man of learning and piety, came to Grenoble, and requested the bishop to allow him to establish himself, for religious purposes, in some place of retirement within his diocese. Hugh, bishop of the city, strongly recommended him, and the few pious persons with him, as a place suitable to their purposes, the neighbouring desert of the Chartreuse—a place effectually precluded from intrusion by frightful precipices and almost inaccessible rocks. The proposition was readily accepted. Delighted with the prospect of separating themselves from the world, they went into this remarkable retreat; and removed almost from the possibility of worldly interruptions, they built their places of prayer. Such was the origin of the monastery of the Grande Chartreuse.

The original rule did not allow the visits of women, but was subsequently relaxed to some extent; but however this may be, we find that Madame Guyon, impelled by motives of a religious nature, visited this celebrated place. This, to a woman at least, was no small undertaking, although the distance was not great.

As the traveller approaches the Grande Chartreuse, he emerges from a long and gloomy forest, abruptly terminated by immense mountains. The pass, through which the ascent of the mountains is commenced, winds through stupendous granite rocks. At the end of this terrific defile the road is crossed by a romantic mountain torrent, over which is a rude stone bridge. The road no sooner leaves the bridge, than it turns suddenly in another direction, and thus presents at once before the traveller a lofty mountain, on the flattened summit of which the Carthusian monastery is situated, enclosed on either side by other mountain peaks still more elevated, whose tops are whitened with perpetual snows.

" No sooner is the defile passed," says a traveller who passed through it a few years before the period of which we are now speaking, " than nothing, which possesses either animal or vegetable life, is seen. No huntsman winds his horn in these dreary solitudes; no shepherd's pipe is allowed to disturb the deep repose. It is not permitted the mountaineers ever to lead their

flocks beyond the entrance of the defile; and even beasts of prey seem to shrink back from that dreaded pass, and instinctively to keep away from a desert which neither furnishes subsistence nor covert. Nothing, as we passed upward, met the eye but tremendous precipices and huge fragments of rock, diversified with glaciers in every possible fantastic form.

"Sometimes the rocks, jutting out above, overhung us, till they formed a complete arch over our heads, and rendered the path so dark that we could scarcely see to pick our way. Once we had to pass over a narrow pine plank which shook at every step. This was placed, by way of bridge, over a yawning chasm, which every moment threatened to engulf the traveller in its marble jaws. We often passed close by the side of abysses so profound as to be totally lost in darkness; while the awful roaring of the waters struggling in their cavities, shook the very rocks on which we trod."

Such are the terms in which the learned and justly celebrated Port Royalist, Claude Lancelot, speaks of his journey through these sublime rocks and over these rugged ascents and precipices. From the bridge at the termination of the defile to the level opening on the top of the mountain where the monastery is situated, the ascent is a little more than two miles. The monastery itself is a very striking object, venerable alike by its massive strength and its high antiquity. Although correctly described as situated on the summit of a mountain, it is nevertheless enclosed on two sides by stupendous rocks and peaks, of still greater height, which reach far above the clouds, and almost shut out the light of the sun. Here dwell a company of monks, about forty in number, under a General or Prior; they have a large library; many of them are men of extensive information and learning; their duties and austerities are subjected to strict rules; their mode of living is simple; and much of their time is spent in acts of devotion.

About a third of a mile below the monastery, in a little opening on the side of the ascent, is a building which may be regarded as an appendage to it, though separate from it in some

respects. The principal building at this place, and the cells around it, are occupied by lay brethren and other persons, who wish to be connected with the members of the Chartreuse, and to be under their direction, without wholly conforming to the severity of their rule. To this place, probably, and not the monastery proper, Madame Guyon ascended. The learned and venerable Prior, Father Innocentius, attended by his monks, came down to meet her. The conversation turned upon the subject of *religious faith.* She proclaimed, not authoritatively or in any way inconsistent with female modesty and propriety, the indispensable necessity, not only of justification by faith, *but of faith as the foundation of the whole inward Christian life.*

Christian candour compels us to think favourably of the religious professions and hopes of these good brethren. But the broad annunciation of faith as the foundation of everything, a doctrine which excludes all claims of personal merit, we may well suppose, extracted from them, notwithstanding their habits of quietude and silence, marked ejaculations of doubt and astonishment. Many were their ceremonial observances. Eight months of the year, if we may believe their statements, they fasted in the stricter sense of the term ; and the rest of the time they ate no meat! Was all this to go for nothing ? But it was the doctrine of Faith, in connexion with its thoroughly *sanctifying results*, which particularly attracted the notice of the Prior.

"Some six or seven years ago," says Father Innocentius, in allusion to this interview, "Madame Guyon found her way upward to our solitary home in the rocks. Although contrary to our usual custom, I thought it an occasion on which I might be excused for conversing with this lady. I took with me, however, a number of the brethren, as witnesses of what passed between us. And they will now bear me testimony, that, after the conversation, and when Madame Guyon had left us, I immediately expressed my suspicions, in very strong terms, of the soundness of her views."* It was not long before his suspicions

* La Vie de Messire Jean d'Aranthon D'Alex, Liv. III., chap. iv.—This work was published anonymously, but the author of it was Father Innocentius himself.

ripened into convictions, and he became one of the leading writers in opposition to her. Probably never before nor since have those solitary rocks listened to the voice of woman, coming among them under such circumstances, and announcing to their inmates such salutary truths.

Not long after this visit she experienced the beginnings of that practical opposition from which she had suffered in other places. " The lady, who was my particular friend," she says, " began to conceive some jealousy on account of the applause which was given me ; God permitted that she should be thus tempted and afflicted, in order that she might know herself, and become more thoroughly purified. Also some of those persons who sustained the office of Confessors in the Church, began to be uneasy, saying, that I had gone out of my place, and that it was not my proper business to aid in this manner, in the instruction and restoration of souls.

"It was easy for me," she adds, " to see the difference between those Confessors who seek nothing but God's glory, and those who make their office subservient to their own interests. Those of the first class came to see me, and approved of my labours, and greatly rejoiced in the grace of God bestowed on their penitents. The others, on the contrary, seemed to despise the good, because they contemned the instrument of it ; and tried in a secret manner to excite the town against me."

The appearance of an opposition, at first comparatively feeble, but continually increasing in violence, did not compel her immediately to remit her labours. She still continued her assemblies for conversation and prayer. She conversed much, but not without supplication mingled with it. When persons were collected together, before entering upon conversation, and from time to time when especial Divine communion seemed to be necessary, it was her practice to pray *in silence*. Such had been her devotional habits, that she entered into this state in a remarkable manner. The mind turned inward upon itself. Her closed or uplifted eye, her hands clasped together, her serene countenance abstracted from worldly influences but lighted up with a Divine

ray, left the conviction upon those who were present with her, that her soul was in a communion with the Eternal, too deep for the utterance of words. Such a conviction could hardly fail to react upon themselves, to check the current of their worldly affections, and to produce the most salutary religious impressions.

The Holy Ghost has a language *outward*, as well as inward. *Within*, it gives holy dispositions ; *without*, it shows itself in the natural signs and expressions of peace, love, forbearance, purity, desire for the good of others ; all elevated and sanctified by that holy confidence, which results from the knowledge of God's unchangeable friendship. A countenance, purified and irradiated by the Divine power of this inward illumination, necessarily has something in it which is more angelic than human.

> " There is a light around her brow,
> A holiness in those calm eyes,
> Which show, though earth may claim it now,
> Her spirit's home is in the skies."

Before the glance of that eye, the illuminated expression of that peaceful countenance, jealousy, pride, malice, impurity, revenge, selfishness, and every evil thing, stand rebuked and condemned.

At Thonon, Madame Guyon wrote the Spiritual Torrents. At Grenoble, she commenced her Commentaries on the Bible, which are, for the most part, experimental and practical. A critical and exegetical commentary cannot be written to much purpose, without a knowledge of the Hebrew language and of other dialects related to it in origin. To this knowledge she made no pretensions ; though, having some knowledge of the Latin, she was able to avail herself of some important helps in that language, as well as of commentaries in French and Italian.

Her method, for the most part, was this,—She placed the Bible before her, and studied it, both in the Latin and French translations, to ascertain, in the first place, what meaning it would present to a mind, humbly and honestly directing itself to the pursuit of the truth. In addition to this, she adopted the idea, not only that the Old and New Testaments are parts of one system, but that the import of the one can, in many cases,

best be reached and understood by a comparison of the related topics and passages of the other. And accordingly she studied them together, and interpreted the one by the other. But this was not all. The Holy Scriptures are full of truths which cannot well be received and appreciated, except in connexion with an inward experience corresponding to them. Not unfrequently the light of the mind, inspired by the inward agency of the Spirit of truth, throws light upon the outward letter. If Madame Guyon had less of that form of exegetical knowledge, which is derived from an access to the original tongues of the Scriptures, than some others, she had more, much more, of that inward, spiritual insight, which, to say the least, is equally valuable. " I wrote my Commentaries on the Scriptures," she says, " for the most part, in the night; in time taken from sleep. The Lord was so present to me in this work, and kept me so under control, that I both began and left off writing just as He was pleased to order it; writing when He gave me inward light and strength, and stopping when He withheld them. I wrote with very great rapidity, light being diffused within me in such a manner, that I found I had in myself latent treasures of perception and knowledge, of which I had but little previous conception."

Her Commentaries on the Bible have all been published; those on the Old Testament in twelve small octavo volumes, and those on the New Testament in eight. A part only were written at Grenoble. Of these volumes, the most remarkable is the work on the Canticles. Taking the view adopted by the greater number of the earlier critics, Madame Guyon regards this remarkable poem, in its higher or spiritual sense, as a conversation between the truly sanctified soul and Christ. In the concluding part of her Commentary, she brings out very fully her views of the union of the soul with Christ, and with God through Christ. This work indicated so distinctly and fully the doctrine of a heart wholly delivered, if not from everything which requires penitent humiliation and the application of Christ's blood, yet at least from all *known* voluntary sin, as a doctrine to be taught,

believed, and realized, that it became the subject of special criti-
cism and rebuke.

One passage, illustrative of the operations of her mind in the
preparation of her Commentaries, may be given here. " In
writing my Commentaries on the Books of Kings, when I gave
attention to those parts which had relation to king David, I felt
a very remarkable communion of spirit with him, as much so
almost as if he had been present with me. Even before I
had commenced writing, in my previous and preparatory con-
templations, I had experienced this union. By a remarkable
operation upon me, I seemed to comprehend very fully the great-
ness of his grace, the conduct of God over him, and all the cir-
cumstances of the states through which he had passed. In his
capacity of leader and pastor of Israel, I was deeply impressed
with a view of him, as a striking type of Christ. The Saviour
and His people are one. And it seemed to be nothing less than
that pure and holy union, which I had previously experienced in
connexion with the Saviour, which now extended itself to the
king of Israel, His antitype, and embraced him and also other
saints. It was in the experience of this intimate union with
Christ and with those who are like Him, that my words, whether
written or spoken, had a wonderful effect, with God's blessing,
in forming Christ in the souls of others, and in bringing them
into the same state of union."

She says further : " A considerable part of my comments on
the Book of Judges happened by some means to be lost. Being
desired by some of my friends to render the book complete in
that part which was wanting, I wrote over again the places
which were missing. Afterwards, when the people of the house
where I had resided were about leaving it for some reason,
the papers which had been mislaid were found. My former and
latter explications were found on comparison to be conformable to
each other with scarcely any variation, which greatly surprised
persons of knowledge and merit who examined them."

She makes the following statement in regard to the publica-
tion of the book : *A Short Method of Prayer.* " Among my

intimate friends was a civilian, a counsellor of the Parliament of Grenoble, who might be described as a model of piety. Seeing on my table my manuscript treatise on Prayer, he desired me to lend it to him. Being much pleased with it, he lent it to some of his friends. Others wanted copies of it. He resolved, therefore, to have it printed. The proper ecclesiastical permissions and approbations were obtained. I was requested to write a Preface, which I did.

"Under these circumstances this book, which within a few years, passed through five or six editions, was given to the world. The Lord has given a great blessing to this little treatise; but it has caused great excitement among those who did not accede to its principles, and has been the pretence of various trials and persecutions which I have endured."

Books are God's instruments of good as well as sermons. He who cannot preach may talk; and he who cannot do either, may perhaps write. A good book, laid conscientiously upon God's altar, is no small thing. How abundant is the evidence of this. Doddridge's Rise and Progress of Religion, Baxter's Saint's Rest, the Imitation of Christ, and many other works which might be mentioned, have exerted a wide influence of the most salutary kind, felt in every part of the world, and perpetuated from generation to generation.

CHAPTER XXX.

Analysis of The Method of Prayer—The word—Those without the spirit of prayer invited to seek it—Directions to aid persons—Additional directions—Higher religious experience—Entire consecration to God—The test of consecration—Inward holiness the true regulator of the outward life—Of gradual growth—The knowledge of our inward sins—The manner of meeting temptations—The soul in the state of pure love—The prayer of silence—The true relation of human and Divine activity—The nature and conditions of the state of Divine union—Appeal to pastors and teachers.

As the work on Prayer is frequently referred to, and was considered so important as to be made the subject of ecclesiastical condemnation, I give a concise analysis of it.

1. *Remarks in explanation of the use of the term Prayer.*

St. Paul (1 Thessalonians v. 17) has enjoined upon us "*to pray without ceasing.* Our Saviour (Mark xiii. 33) requires us "*to take heed, to watch, and to pray.*" But what is that prayer? It is obviously something more than the formal offering up of specific petitions. The prayer of which I speak, is that *state of the heart in which it is united to God in faith and love.*

A man who has this heart, may pray at all times. It is the natural, the spontaneous flowing out of the heart, in the issues of its own moral and religious life. All classes of persons, in all ages and in all situations, may pray. If they have the spirit of prayer, how can they help praying?

Prayer, then, and *religion,* are the same thing.

2. *All without the spirit of prayer are invited to seek it.*

Come, ye famishing souls, who find nought whereon to feed, come, and ye shall be satisfied! Come, ye poor afflicted ones, who groan beneath your load of wretchedness and pain, and ye shall find ease and comfort! Come, ye sick, to your Physician, and be not fearful of approaching Him, because ye are filled with diseases. Expose them to His view, and they shall be healed! Children, draw near to your Father, and He will embrace you in the arms of love. Come, ye poor, wandering sheep, return to your Shepherd! Come, sinners, to your Saviour! Let all, without exception, come! for Jesus Christ hath called all. Yet, let not those come who are without a heart; those who are without a heart are not asked; for there must be a heart, in the natural sense of the term at least, in order that there may be LOVE. But of whom can it be said, that he is really without a heart?

3. *Directions to a person very ignorant and without religion in respect to the manner in which he may properly seek it.*

I will suppose that they hardly know anything, or are hardly capable of knowing anything, *except the Lord's prayer.* And this is my direction: let them begin with what they are supposed to know, namely, the Lord's Prayer. Let them say, OUR

FATHER, and stop there; remaining in respectful silence and meditation; pondering a little upon the meaning of the words, and especially upon the infinite willingness of God to become *their* Father. And before they go further, let them utter the petition, that He may become to them individually what He is so willing to be.

Let them proceed, then, to the petition, THY KINGDOM COME. And delaying upon this as before, until they can imbibe its *spirit*, which is one of the most important things in this process, let them apply the petition, as in the preceding instance, to *themselves;* beseeching this King of glory to reign in them, and endeavouring with Divine assistance, to yield to Him the just claim He has over them, and to resign themselves wholly to His Divine government.

Then let them take another petition;—THY WILL BE DONE ON EARTH AS IT IS DONE IN HEAVEN. And here let them humble themselves before God, and earnestly supplicate, that God's will, His *whole* will, may be accomplished in their hearts, *in* them and *by* them for ever. And knowing that God's will is accomplished in us when we love Him, it is the same thing if they should pray God to enable them to love Him with all their heart. And in doing this, however sinful and unworthy they may be, let them be calm and peaceable; not disturbed and agitated, as if there were no Saviour, no Divine Shepherd, who is the daily nourishment of His people, and feeds His flock, as it were, with *Himself;* not fearful and distrustful, as if God were not merciful or might not be true to His promises, when He pledges forgiveness for Christ's sake.

4. *Additional directions for those who are beginning to seek religion.*

Persons are not to overburden themselves with frequent repetitions of set forms of prayer. Our Saviour says, *When ye pray, use not vain repetitions, as the heathen do; for they think they shall be heard for their much speaking.* Begin with the Lord's Prayer as the simplest and best. Go over it slowly, calmly, believingly; not being in a hurry to go over the whole and then

to *repeat* it, as if the result depended on the *repetition*, and the number of repetitions; but delaying upon each petition.

A second remark is, that you are to place God before you as the Being to whom you are to be reconciled, and from whom you are to receive all good. But be careful not to form *any image of the Deity.* The idea of God, whatever may be sometimes thought, can never be represented and set forth by anything which the eye beholds or the hand touches, by anything which exists in sculpture and painting. "*God is a Spirit,*" says the Saviour, "*and they that worship Him must worship Him in spirit and in truth.*"

A third remark is this,—do not forget Him who is the way, the truth, and the life, the Saviour, the second person in the ever blessed Trinity. He is the *way.* Enter to God *through* Him. Behold Him in the various states of His Incarnation. You are a man, with all of man's feebleness and temptations; —behold Him assuming humanity in order that He may sympathize with you. You are a sinner;—behold Him upon the cross, dying that you might live. In the Lord's Prayer, God offers Himself to you. Uttering that prayer in Christ, who is the mediatorial way, you receive God; and in receiving Him, you receive the true and everlasting life.

Persevere in this way, asking for few things, and such as are very essential, found in the Lord's Prayer; pausing upon each with a calm and silent looking up to God through Christ; ceasing from your own strength in order that you may find strength in the Saviour by faith.

5. *Directions applicable to persons of some degree of knowledge and education.*

Those who have more knowledge, men of reading, may very properly avail themselves of their intellectual position in furthering this great object. The directions already given are exceedingly important to them. But in addition, let them read books on *experimental* religion, delaying upon the most important truths, and praying over them, till the power which is in them, being made alive by the Holy Ghost, is felt in the heart.

Meditation also, as distinct from reading, is to be practised on similar principles. In retirement, endeavour, by a lively act of faith, to realize the relations in which you stand to God, and place yourself, as it were, in His immediate presence. In general, this is the first great thought upon which the mind should be occupied;—God is; God is *present;* God is our *Father ;* to Him we *owe all.* Let the mind repose calmly and believingly upon these great truths, and other important religious truths, in which there is substance and food for the inquiring mind, such as our lost condition by nature, Christ our Mediator, God the inward Teacher of men in the person of the Holy Ghost; dwell quietly and humbly, with the senses and thoughts withdrawn from the circumference to the centre. Thus wait upon the Lord with strong desire, but without agitation.

6. *Of an increased or higher degree of religious experience.*

The soul has at first but a little *realizing* sense of God. It says, *my* Father, it is true, but says it very *tremblingly.* But after a time it gains strength. It begins to see more and more distinctly how God, whom as a sinner it feared, can be fully reconciled. It believes more fully in God, because it believes more fully in Christ, who is the only way of access.

In this advanced state the soul begins to recognise the great truth, that our love to God should be without selfishness, and that our will should be perfectly united in His will. The servant, who only proportions his diligence to the hope of *reward,* renders himself unworthy of all reward. We must learn to seek God in distinction from His gifts, and God is in His WILL. Supposing, then, that God should smite you with afflictions without and temptations within, and should leave the soul in a state of entire aridity, do what God requires you to do, and suffer what He requires you to suffer; but in everything be resigned and patient! With humility of spirit, with a sense of your own nothingness, with the reiterated breathings of an ardent but peaceful affection, and with inward submission and quietness, you must wait the return of the Beloved. In this way you will demonstrate that *it is God himself alone* and His good pleasure

which you seek, and *not the selfish delights of your own sensations.*

7. *Of abandonment or entire consecration to God in all things.*

But this cannot well be done without the principle of *abandonment;* by which I mean that act in which we resign, abandon, or consecrate ourselves entirely to God. Those who are consecrated, have given their own wills into the keeping of God's will. Such a soul is resigned in all things, whether for soul or body, whether for time or eternity; by leaving what is past in oblivion; by leaving what is to come to the decisions of Providence; and by devoting to God, without any reserve, the *present moment;*—a moment which necessarily brings with it God's eternal order of things, and in everything, excepting sin, is a declaration to us of His will as certain and infallible, as it is inevitable and common to us all.

8. *Of the test or trial of consecration.*

God will give us opportunities to try our test, whether it be a true one or not. No man can be wholly the Lord's, unless he is wholly consecrated to the Lord; and no man can know whether he is thus wholly consecrated, except by *tribulation.* That is the test. To rejoice in God's will, when that will imparts nothing but happiness, is easy even for the natural man. But none but the renovated man, none but the religious man, can rejoice in the Divine will, when it crosses his path, disappoints his expectations, and overwhelms him with sorrow. Trial, therefore, instead of being shunned, should be welcomed as the test, and the only true test, of a true state.

Beloved souls ! There are consolations which pass away; but ye will not find true and abiding consolation except in entire abandonment, and in that love which loves the *cross.* He who does not welcome the cross, does not welcome God.

9. *Inward holiness the true regulator of the outward life.*

When we have the true life *within,* we may reasonably be expected to have the truly regulated life *without.* " Love," says St. Augustine, " *and do what you please.*" If we have love without selfishness, it will not fail to work itself out in

appropriate and right issues. The inordinate action of the senses arises obviously from the errors and perversions of the inward state. Mortify the inward man ; and you can hardly fail to mortify and regulate the outward man.

10. *Of gradual growth or advancement in the religious life.*

The soul fully given up in faith and love, is astonished to find God gradually taking possession of its whole being. One of the evidences of growth in grace is a tendency to cease from ourselves, in order that God himself, in the operation of the Holy Ghost, may exist and act in us.

A soul in this state is *prepared* for all times, places, and occasions ; for society, for worship, for outward action. When, through weakness of purpose, or want of faith, we become, as it were, *uncentred,* it is of immediate importance to turn again gently and sweetly inward ; and thus bring the soul into harmony with the desires and purposes of God. The more the soul becomes like God, the more clearly it discerns God's excellences ; and the more distinctly and fully it feels His attracting power.

11. *Of a knowledge of our inward sins when souls are in this advanced state.*

If a soul, in this intimate nearness with God, should be left to fall into any error or sin, it would be immediately thrown into the greatest confusion and inward condemnation. God becomes the incessant examiner of the soul ; but still in such a way, that the soul, moving in the Divine light, can see and examine for itself.

When we fall into errors, and even undoubted sins, the rules of inward holy living require us not to vex and disquiet ourselves ; but simply in deep humiliation and penitence, to turn calmly and believingly, without fear and without agitation, to Him who forgives willingly, to that cross of Christ, where it can be truly said, that wounded souls are healed. Great agitation and vexation of mind are not necessarily *penitence* nor the result of penitence, but are rather the result of *unbelief.*

12. *Of the manner in which we are to meet and resist temptations.*

Temptations may be resisted in two ways. One way is to resist them in a *direct contest*. The other method is, to turn away the mind from the contemplation of the evil in its outward form, and to keep it fixed, if possible, still more closely and watchfully upon God. A little child, on perceiving a monster, does not wait to fight with it, and will scarcely turn its eyes toward it; but quickly shrinks into the bosom of its mother, in entire confidence of safety; so likewise should the soul turn from the dangers of temptation to her God. " God is in the midst of her," saith the Psalmist, " she shall not be moved: God shall help her, and that right early." (Psalm xlvi. 5.)

If in our weakness we attempt to attack our enemies, we shall frequently be wounded, if not totally defeated; but by casting ourselves into the simple presence of God, in the exercise of faith, we shall find instant supplies of strength for our support. This was the succour sought for by David. " I have set," saith he, " the Lord always before me; because He is at my right hand I shall not be moved. Therefore my heart is glad, and my glory rejoiceth;—my flesh also shall rest in hope." (Psalm xvi. 8, 9.) And it is said in Exodus, " The Lord shall fight for you, and ye shall hold your peace."

13. *Of the soul in the state of pure or unselfish love.*

When we have given ourselves to God in *abandonment*, and have exercised faith in God that He does *now*, and that He will ever receive us and make us one with Himself, then God becomes central in the soul, and all which is the opposite of God gradually *dissolves itself*, if one may so speak, and passes away.

SELF is now destroyed. The soul, recognising God as its centre, is filled with a love, which, as it places God first, and everything else in the proper relation to Him, may be regarded as *pure*. It is not until we arrive at this state, in the entire destruction and loss of self, that we acknowledge, in the highest and truest sense, God's supreme existence; still less *do* we, or *can* we, have God *as a life within us.*

In experimental religion there are two great and important

I

views—perhaps there are none more important—which are ex-
pressed by the single terms, the ALL and the NOTHING. We
must become *Nothing* in ourselves, before we can receive the *All*
or *Fulness* of God.

14. *Of the practice of the prayer of silence.*

When the soul has reached this degree of experience, it is dis-
posed to practise the PRAYER OF SILENCE, so called, not merely
because it excludes the voice, but because it has so simplified its
petitions, that it has hardly anything to say, except to breathe
forth, in a desire UNSPOKEN,—*Thy will be done.* This prayer, so
simple and yet so comprehensive, may be said to embody the
whole state of the soul. And believing that this prayer is and
must be fulfilled *moment by moment*, the constant fruition crowns
the constant request, and it rejoices in what it *has*, as well as in
what it *seeks*.

The soul in this Divine prayer acts more nobly and more ex-
tensively than it had ever done before; since God himself is its
mover, and it now acts as it is acted upon by the agency of the
Holy Ghost. When St. Paul speaks of our being led by the Spirit
of God, it is not meant that we should cease from action; but
that our action should be in harmony with and in subordination
to the Divine action. This is finely represented by the prophet
Ezekiel's vision of the wheels, which had a living spirit; and
whithersoever the spirit was to go, they went; they ascended
and descended as they were moved; for the spirit of life was in
them, and they returned not when they went.

We promote the highest activity, by inculcating *a total de-
pendence on the Spirit of God as our moving principle;* for it is
in Him, and by Him alone, that "we live and move and have
our being."

15. *Of the true relation of human and Divine activity.*

In the early periods of his Christian experience man is re-
quired to labour much, strive much, act much, obviously to con-
quer himself, to smite and annul his own selfishness, to restrain
and regulate his own multiplied and unholy activity, in order
that he may be rendered submissive and quiet before God.

While the tablet is unsteady, it is obvious that the painter is unable to delineate a true copy.

It is thus in the inward life. Every act of our own unsubdued and selfish spirit, even while God is operating upon it, is productive of false and erroneous lineaments.

" If any man be in Christ," says the apostle Paul, " he is a new creature. Old things are passed away ; behold, all things are become new." But this state of things can be made to exist only by our dying to ourselves and to all our own activity, except so far as it is kept in *subordination to Divine grace*, in order that the activity of God may be substituted in its stead. Instead, therefore, of prohibiting activity, we enjoin it ; but we enjoin it in absolute dependence on the Spirit of God ; so that the Divine activity, considered as antecedent in action, and as giving authority to action, may take the place of the human. " Jesus Christ," we are told, " hath the life in Himself ;" and nothing but the grace which flows through Him is, or can be, the moral and religious life of His people.

16. *Of the nature and conditions of the state of Divine union, or union with God.*

The result of all religion is to bring us into union with God. We are made one with Him in understanding, when by renouncing our own wisdom, we seek continually and believingly for wisdom from on high ; one in affection, when we desire and love what He desires and loves ; one in will, when our purposes are as His are.

The Divine WILL never varies and never can vary, from the line of perfect rectitude on the one hand, and of perfect love on the other. This is the law of its movement, unchangeable as the Divine existence.

There can be no true moral union between God and man, until the human will is brought into harmony with the Divine.

And this life of union, which is the highest and most glorious result of our being, is the gift of God. A fundamental condition of it is, that we shall resign ourselves to Him, that we may be His in all things, and that we may receive this and all other

blessings at His hand. God alone can accomplish it. Still, the creature must *consent* to have it done. God loves His creatures; God is the source of light to them ; God in Christ is the true Saviour. But man must, at least, recognise his alienation, and in becoming willing and desirous to be saved, must expand his soul to the Divine operation. The creature, therefore, must open the window ; it is the least he can do ; but it is the sun himself, the Eternal Sun, that must give the light.

17. *Of false pretensions to a state of sanctification and Divine union.*

But some will say, that persons may feign this state who do not possess it. A person may just as well feign this state and no more, as the poor suffering man, who is on the point of perishing with hunger, can for a length of time feign to be full and satisfied. *There he is,* no matter what his pretensions may be ; his looks, his countenance, show his condition. Men may *pretend* to be wholly the Lord's, by harmony of affection and will, and by being in entire moral union with Him ; but *if they are not so,* there will certainly be something in look, in word, or in action, which will show it.

18. *Appeal to religious pastors and teachers.*

" The cause," she says, " of our being so unsuccessful in re- ᴌorming mankind, especially the lower class, is our beginning with external matters ;"—in this way, if we produce any fruit, it is fruit which perishes. We should begin with principles, which reach the interior, and tend to renovate the heart. This is the true and the ready process ; to teach men to seek and to know God in the heart—by affections rather than by forms. Thus we lead the soul to the fountain.

Impressed with the importance of the religion of the heart, I beseech all, who have the care of souls, to put them at once into the spiritual way. Preach to them Jesus Christ. He himself, by the precious blood He hath shed for those intrusted to you, conjures you to speak, not to that which is *outward*, but to the *heart* of His Jerusalem. O ye dispensers of His graces, ye preachers of His word, ye ministers of His sacraments, labour to

establish Christ's kingdom! As it is the heart alone which can oppose Christ's sovereignty, so it is by the subjection of the heart that His sovereignty is most highly exalted. Employ means, compose catechisms, and whatever other methods may be proper, but aim at the *heart.* Teach the prayer of the heart. and not of the understanding; the prayer of God's Spirit, and not of man's invention.

We have not followed precisely the language of the original, but have given the idea with some slight variations of the original arrangement. The Method of Prayer is a work remarkable, in that age, as coming from a *woman,* and still more remarkable, when contrasted with the prevalent views and practices of her Church. Its doctrines are essentially Protestant; making Faith, in distinction from the merits of works, the foundation of the religious life, and even carrying the power of faith in the renovation of our inward nature beyond what is commonly found in Protestant writers. She, however, always insisted that the doctrines which she advanced were the true Catholic doctrines. Her work, entitled *Justifications de la Doctrine de Madame de la Mothe Guyon,* shows how well qualified she was to defend her position.

———

CHAPTER XXXI.

Increased opposition—Conversation with a distinguished preacher—Effect of tne publication of the Short Method of Prayer—Conversation with a poor girl—Increased violence—Her feelings—Advised to go to Marseilles—Descends the Rhone—Incidents in the voyage—Arrives at Marseilles—Excitement occasioned—Kind treatment of the Bishop of Marseilles—Opposition from others—Conversion of a priest—Acquaintance with a Knight of the Order of Malta—Her interviews with M. Francois Malaval—Leaves for Nice—Disappointed in going from Nice to Turin—Sails for Genoa—Reflections on her exposure on the ocean—Troubles at Genoa—Departs for Verceil—Met by robbers—Other trying incidents.

THE opposition in Grenoble increased, and assumed different shapes. In some cases persons came to her to expose her views and counteract them by argument. At one time she was visited

by a distinguished preacher of the city, a man of profound learning. She says, " he had carefully prepared himself on a number of difficult questions, which were to be proposed to me for my answer. In some respects they were matters far beyond my reach ; but I laid them before the Lord, and He enabled me to answer them promptly and satisfactorily, almost as much so as if I had made them the subjects of long study. This person was apparently convinced and satisfied, and went away with a perception and experience of the love of God such as he had not known before."

The excitement against her arose partly from religious conferences and other religious efforts, and partly from her book on Prayer. This work had hardly been published, when some pious persons purchased fifteen hundred copies, and distributed them in the city and its neighbourhood. The effect was very great. " God," she says, " had made me the instrument of great good ; but Satan, who takes no pleasure in God's works, was greatly enraged. I saw clearly that the time had come when he would stir up a violent persecution against me. But it gave me no trouble. Whatever I may be made to suffer by his attacks, I am confident that all will ultimately tend to God's glory."

"Among the subjects of the Divine operation, was a poor girl, who earned her livelihood by her daily labour ;—a girl of great truth and simplicity of spirit, and one who, in her inward experience, was much favoured of the Lord. She came to me one day, and said, ' O my mother, what strange things have I seen ! I have seen you like a lamb in the midst of a troop of fierce wolves. I have seen a frightful multitude of people of all ranks and robes, of all ages, sexes, and conditions, priests, friars, married men, maids and wives, with pikes, halberts, and drawn swords, all eager for your instant destruction. On your part, you stood alone, but without surprise or fear. I looked on all sides to see whether any would come to assist and defend you, but I saw not one.'

"Some days after, those persons, who through envy were raising private batteries against me, broke forth furiously. In-

jurious and libellous statements began to be circulated. Some individuals, without any personal knowledge of me, wrote against me. Some said that I was a sorceress, and by some magic power attracted souls, and that everything in me was diabolical. Others said, that if I did some charities, it was because I coined false money ; with many other gross accusations equally false, groundless, and absurd.

"But, amid all this, my soul, full of earnest desires, *thirsted*, if I may so express it, for the salvation of my fellow-beings. When I could not speak, I wrote ; and when I could not write, nor impart my strong desires in any other way, my system was overcome in the strength of my feeling, and I sank under it."

But the providences of God seemed to indicate that her mission at Grenoble, which had been so strikingly characterized by manifestations of the Divine power, was ended. So violent was the tempest of indignation, that even her tried friends, anxious for her personal safety, advised her to leave. Camus, Bishop of Grenoble, a man of learning and piety, was friendly to her. He was a Doctor of the Sorbonne, and not long after was appointed Cardinal by Pope Innocent II.; but he was not able, though obviously of favourable dispositions, to restrain the hostile movement which now existed.

His Almoner advised her strongly to leave the city and seek refuge in Marseilles, till the storm should be over ; giving as a reason that Marseilles was his native place, that there were many persons of merit there, and that he thought, from his knowledge of the situation of things, she would be favourably received.

Leaving her daughter under the care of her favourite maidservant, in the Religious House where she was placed on their first arrival, and taking with her another girl, she left the city as secretly as possible ; influenced, in leaving in this manner, by a desire to defeat the machinations of her enemies, and by a fear of being burdened with the visits and lamentations of her friends. Early in 1686, she thus finished her mission at Grenoble. Accompanied by two females, and by the Almoner of Bishop Camus, and another very worthy ecclesiastic, she took the route

along the banks of the river Isere, till it mingles with the Rhone, a little above the ancient city of Valence. There they all embarked upon the Rhone in one of the numerous boats employed in navigating its waters.

About three miles from the city, they became satisfied that the boat (which they had taken in the expectation of overtaking another larger one) would not answer their purpose, and they were under the necessity of returning. As the boat was heavily laden, and it was difficult to ascend the river with it, the passengers all left it and went back on foot, except Madame Guyon, who was unable to walk so long a distance, and a young lad who was supposed to be competent to take the boat back. Owing either to the violence of the river, or his want of skill and strength, he found it a very difficult thing to do it. At one time he ceased his efforts entirely ; and leaving the boat to the mercy of the waves, sat down and burst into tears, saying that they must both be drowned. Madame Guyon, seeing the imminent hazard to which they were exposed, went to him ; and by remonstrating with him and encouraging him, induced him to resume his efforts. After four hours of hard labour, they reached the city ; and her companions having arrived by land, they immediately took another boat more suited to their purpose.

Nothing is said of their stopping at any of the numerous towns and cities which adorn the banks of the Rhone. Beaucaire and Tarascon with their wealth and activity, Avignon with its benevolent institutions, Arles with its amphitheatre and obelisk and other remains of high antiquity—all ceased to have attractions for those who felt that they had no home in any place where Christ, preached in His simplicity, was likely to be excluded.

The navigation of the Rhone, which is one of the most rapid rivers in Europe, is quite difficult. At one place the boat ran upon a rock with such violence as let in the water in such a manner as greatly to endanger them. There was great consternation on board ; but she speaks with devout satisfaction and thankfulness of the peace and joy of mind with which God sustained her in this threatening danger. The Almoner was as-

tonished to see that there was no sudden emotion of surprise, and no change on her countenance.

They passed down, with great diligence and rapidity, nearly the whole navigable length of the Rhone, and then leaving the mouth of the river, and coasting a few miles along the shores of the Mediterranean, they reached the ancient and celebrated Marseilles;—a city so well and so favourably known, even in the time of Cicero, that he styled it the "Athens of the Gauls." But this great and learned city furnished no refuge for this fugitive praying woman. If an army had come among them, it would scarcely have caused greater consternation. "I arrived at Marseilles," she says, "at ten o'clock in the morning; *and that very afternoon all was in uproar against me.*"

The occasion of this very sudden movement was this. She had a letter of introduction to a Knight of the Order of Malta, at Marseilles, written by one of her intimate friends in Grenoble, a man of rank, but eminently pious. Accompanying the letter, he sent the little book, entitled, A Short Method of Prayer. Although a devout man himself, the knight had a chaplain, whose opinions were not only in opposition to those of Madame Guyon, but who felt unusually zealous in exhibiting that opposition. He had probably heard of the book before, and might perhaps have known what was in it. At any rate, he examined it for a few moments, and perceiving, as he supposed, its heresies, he at once went away to stir up a party both against the doctrines of the book and its author.

Some went almost immediately to the bishop, stating to him that it was necessary to banish at once the author of a book which contained things so much at variance with what the Church considered the truth. The bishop, however, before proceeding to extremity, thought it necessary to examine the book for himself, which he did in company with one of his prebends, and he said that *he liked it very well.*

He took the pains also to send for individuals in whose judgment and piety he had confidence, among others for M. Francois Malaval, a man of great piety and of some literary eminence,

and also for a Father of the Recollets, both of whom had known Madame Guyon by reputation, and had called upon her very soon after her arrival at Marseilles. They frankly stated to him their favourable opinions of her character and writings, and also what they knew of the nature and extent of the violent opposition which she experienced. "The bishop testified much uneasiness," says Madame Guyon, "at the insults which were offered me. He also expressed a strong desire for a personal acquaintance; so much so, that I was obliged to go and see him. He received me with extraordinary respect, and begged my ex‑ cuse for what had happened. He invited me to stay at Marseilles; and assured me—notwithstanding the unpleasant circumstances existing—that he would do all in his power to protect me. He even asked me where I lodged, that he might come and see me."

"The next day," she adds, "the Almoner of the Bishop of Grenoble, and the other ecclesiastic who had accompanied us, went to see him. He received them kindly, and testified to them also his sorrow for the insults which had been offered me."

It was obvious, however, that a party was formed against her, with such elements of strength and violence in it, that she could not long remain in quiet. "Among other insults," she says, "these persons wrote to me the most offensive letters possible, though they did not know me. It seemed to me, with these indications of His providence before me, that the Lord was beginning in earnest to take from me every place of abode."

She remained at Marseilles eight days only. Short as was the time, and stranger as she was, she was enabled to do something for that cause which was dearer to her than reputation or even life. One day she entered into a church, in which some religious services were being performed. The priest, who had the direction of them, observed her; and after they were concluded, went immediately to the house in which she lodged, and stated to her, with great simplicity and frankness, his inward trials and necessities. "He made his statements," she remarks, "with as much humility as simplicity. In a very short time he was filled

with joy, and thankful acknowledgments to God. He became a man of prayer, and a true servant of God." Madame Guyon remarked that in all places where she had been subject to ill treatment and persecution, God had sustained her by some such striking manifestations of His love and grace.

During her short stay, she became acquainted with many pious persons, among others the knight to whom she brought a letter of introduction. Though a member of a military Order, like the Roman centurion in the Acts he was a " devout man, and one that feared God." " Since I have known him personally," she says, " I have esteemed him as a man whom our Lord designed to be of great service to others. I expressed my opinion to him, that it would be desirable for him to reside at Malta in closer union with those with whom he was associated, and that God would assuredly make use of him to diffuse a spirit of piety into many of them." In accordance with this advice, he soon after went to Malta ; and such was the acknowledged excellence of his character, that he was almost immediately placed in a position of high authority and influence. But we find nothing more said of him.

Her interviews with M. François Malaval must have been interesting, if he were the author, as I suppose, of the Treatise on the Inward or Contemplative Life,* already mentioned. He was a man obviously of great intellectual power ; but laboured under the disadvantage of having been blind, or nearly so, from an early period of life. But God compensated for the want of outward light by inward illumination.

He is frequently mentioned and criticised with earnestness and apparent severity, in the controversial writings of Bossuet, who was too conscious of his own vast strength to be likely to enter the lists with feeble antagonists.

Satisfied from various indications that Marseilles was not to be the field of her labours, and not knowing whither to go, it occurred to her that she might properly seek a place of refuge again with the Marchioness of Prunai. This lady, who still

* Entitled in French, Pratique Facile pour élever l'Ame à la Contemplation.

resided at Turin, or its neighbourhood, retained a strong friend-ship for Madame Guyon. Turin was a nearer and easier place of refuge than any other which now presented itself.

Accompanied by the same persons, except the Almoner, who seems to have returned to Grenoble, she left Marseilles, on the ninth day after she arrived there, for Nice. This ancient and pleasant city, situated near the Mediterranean, on the banks of the river Var, lies in the direction of Turin, and about eighty miles distant, and at a little distance from the Maritime Alps.

" I took a litter at Marseilles," says Madame Guyon, " for the purpose of being conveyed once more to the residence of the Marchioness of Prunai. I supposed that I could reach her re-sidence by passing through Nice. But when I arrived at Nice, I was greatly surprised to learn that the litter, for some reasons, could not pass the mountains which intervened. In this state of things I knew not what to do, nor which way to turn. My confusion and crosses seemed daily to increase. Alone, as it were in the world, forsaken of all human help, and not know-ing what God required of me, I saw myself without refuge or retreat, wandering like a vagabond on the face of the earth. I walked in the streets ; I saw the tradesmen busy in the shops; all seemed to me to be happy in having a home, a dwelling-place to which they could retire. I felt sadly that there was none for me."

This was a season of trial and temptation ; but we are not to infer from these expressions that her faith was shaken. Faith is tested by trial ; and oftentimes shines most brightly amid tears.—" In this uncertainty," she adds, " a person came to me, and told me that one of the small vessels which traded between Nice and Genoa, which usually reached Genoa within twenty-four hours, would sail the next day. He added that the captain would land me, if I chose, at Savona, twenty miles this side of Genoa, but so situated that I could readily find a conveyance to the Marchioness of Prunai's house. To this I consented, as I could not be furnished with any other means of getting there.

" As I embarked upon the sea," she says, " I could not help

experiencing emotions of joy. 'If I am the dregs of the earth,' I said to myself, 'if I am the scorn and the offscouring of nature, I am now embarked upon an element which, in its treachery, shows no favour. If it be the Lord's pleasure to plunge me in the waves, it shall be mine to perish in them.' There came upon us a tempest, in a place which was somewhat dangerous for small vessels; and what rendered our situation the more trying, the mariners seemed to be very wicked men. But still, as the irritated waves dashed around us, I could not help experiencing a considerable degree of satisfaction in my mind. I pleased myself with thinking that those mutinous billows, under the command of Him who does all things rightly, might probably furnish me with a watery grave Perhaps I carried the point too far in the pleasure which I took, in thus seeing myself beaten and bandied by the swelling waters. Those who were with me, took notice of my intrepidity; but knew not the cause of it. I asked of thee, my Lord, if such were thy will, some little cleft to be placed in, a small place of refuge in some rock of the ocean, there to live separate from all creatures. I figured to myself that some uninhabited island would have terminated all my disgraces, and put me in a condition of infallibly doing thy will. But, O my Divine Love, thou didst design me a prison far different from that of the rock, and quite another banishment than that of the uninhabited island. Thou didst reserve me to be battered by billows more irritated than those of the sea. Calumnies proved the outrageous, unrelenting waves to which I was to be exposed, in order to be lashed and tossed by them without mercy.

"Instead of a short day's passage to Genoa, we were *eleven days* in reaching it. But during all this time, how peaceable was my heart in so violent an agitation around me! The swelling of the sea, and the fury of its waves, were, as I thought, only a figure of that swelling fury which all the creatures had against me. I said to thee, O my Love, arm them all; make use of them all as instruments to humble me for my infidelities. I seemed to behold thy right hand armed against me; but

knowing that thy will was never at variance with the utmost rectitude and benevolence, I loved more than my life the strokes it gave me."

Owing to the storm probably, she was carried to Genoa. About a year before, the French, irritated by some proceedings of the Genoese, had bombarded their city. A large naval force, under the command of the celebrated Admiral Duquesne, " reduced to a heap of ruins," as it is given in the language of Voltaire, " a part of those marble edifices, which have gained for Genoa the name of *the Superb*. Four thousand soldiers being landed, advanced up to the gates of the city, and burned the suburbs of St. Peter d'Arena." The Genoese, from that time, had been exceedingly irritated against the French. And when Madame Guyon and her little company landed, being recognised at once as people from France, they were exposed to the marked insults of the angry populace.

She thought it necessary, therefore, to leave Genoa as soon as possible ; but she was met with another trial. The Doge had recently left the city ; and, with his attendants, had taken all the litters which could be had. She was obliged to remain there several days at excessive expense ; the charges being very much higher than at Paris. She had but little money left ; but did not forget that her *store in Providence could never be exhausted.*

After a few days and much inquiry, a sorry-looking litter was brought her, supported by two lame mules. But as she did not know precisely whether the Marchioness of Prunai resided at Turin or in the vicinity, the owner of the litter refused to make a bargain ; but offered to take her to Verceil, which was somewhat nearer than Turin, being only two days' journey distant, but in a little different direction. She adopted this alternative as the one especially presented in Providence, as she had, some time before, been repeatedly and earnestly invited by the Bishop of Verceil to come there. She thought it proper, however, to send him notice of her coming, by the ecclesiastic who had attended her from Marseilles, who set out first ; leaving

Madame Guyon and her two female assistants to come by themselves.

"Our muleteer," she says, "was one of the most brutal of men. Seeing he had only women under his care, there was scarcely any bounds to his insolence and rudeness." Before they had completed the first day's journey, they passed through a large forest, which had the reputation of being infested with robbers.

"The muleteer was afraid, and told us, if we met any of them on the road, we should be murdered, for they spared nobody. Scarcely had he uttered these words, when there appeared four men *well armed.* They immediately stopped the litter. The muleteer was exceedingly frightened. I was so entirely resigned to Providence, that it was all one to die this way or any other, in the sea or by the hands of robbers. The robbers approached the litter and looked in. I smiled upon them and made a slight bow of the head. In a moment God made them change their design. Having pushed off each other, as if each were desirous of hindering the others from doing any harm, they respectfully saluted me, and with an air of compassion, retired. I was immediately struck to the heart, O my Lord, with a full conviction, that it was thine own especial influence, a stroke of thine own right hand, who had other designs over me than thus to make me die by the hands of robbers.

"How wonderful, O my God, at this, as at many other times, has been thy protection over me! How many perils have I passed through in going over mountains, and on the edges of steep and terrible cliffs! How often hast thou checked the foot of the mule, already slipping over the precipice! How often have I been exposed to be thrown headlong from frightful heights into hideous torrents, which, though rolling in chasms far below our shrinking sight, forced us to hear them by their horrible noise! Thou, O God, didst guard me in such imminent dangers. When the dangers were most manifest, then was my faith in thee strongest. In thee my soul trusted. I felt that if it were thy will that I should be dashed headlong down the

rocks, or drowned in the waters, or brought to the end of my life in any other way, it would all be well; the will of God, whatever it might be in relation to me, making everything equal."

At the close of this day's journey, she found still further occasion for the trial of her faith and patience. " The muleteer," she says, " seeing me attended by only two young women, thought he might treat me in any manner he pleased; perhaps expecting to draw money from me. We were approaching the village where we expected to remain, at the village inn, during the night. What was our surprise, then, to hear the muleteer propose to us to stop at a mill, about a mile and a quarter short of the village—a place at which the muleteers sometimes stopped, but at which no female resided. In the mill there was only a single chamber, though there were several beds in it, in which the millers and muleteers lodged together. In that chamber, and in such company, these persons proposed to have me and my maid-servants stay. I remonstrated; and endeavoured by every possible argument to induce the muleteer to carry us to the inn, but without effect.

" At ten o'clock at night, therefore, in a strange place, we were constrained to leave our conveyance, and set out on foot, carrying a part of our clothes in our hands. The night was dark, the way unknown, and we were obliged to pass through the end of a forest, said to be the resort of plunderers. The muleteer, disappointed in his evil designs upon us, hooted after us. I bore my humiliation resignedly and cheerfully, but not without feeling it."

They arrived safely at the inn. The good people of the house, seeing them come at this late hour of the night, on foot, with their clothes in their hand, treated them very kindly. " They assured us," says Madame Guyon, " that the place we left was a very dangerous one; and did all in their power to recover us from the fatigue we had undergone."

The next morning, in consequence of an arrangement made by the muleteer, they left the litter and took passage in the post-chaise or post-waggon, which conveyed the public mails. They

reached Alexandria, one of the principal towns between Genoa and Verceil. "When the driver, according to his usual custom," says Madame Guyon, "took us to the post-house, I was exceedingly astonished, when I saw the landlady coming out to oppose his entrance. She had heard that there were women in the carriage, and taking us for a different sort of persons from what we were, she protested against our coming in. The driver was determined to force his entrance in spite of her. The dispute rose so high between them, that many officers of the garrison, together with a vast mob, collected together at the noise. I spoke to the mail carrier, and suggested that it might be well to take us to some other house; but, obstinate upon carrying his point, he said he would not. He assured the landlady that we were not only persons of good character, but persons also of piety, the evidences of which he had seen. At last, by means of his statements and urgency, he obliged her to come and see us. As soon as she had looked upon us she relented at once, and admitted us.

"No sooner had I alighted than she said to us, 'Go, shut yourselves up in that chamber, and do not stir, that my son may not know you are here; for as soon as he knows it, he will kill you.' She said this with so much emphasis, which was repeated by the maid who attended her, that if death had not possessed many charms for me, I should have been ready to die with fear. The two girls were under frightful apprehensions. When they heard any one stirring in the house, and especially persons coming to open the door of the chamber for any purpose, they thought they were coming to cut their throats. In short, they continued in a dreadful suspense between life and death till the next day, when we learned that the young man had sworn to kill any woman who lodged at the house. The reason of his taking this extraordinary course was this. A few days before, an event had happened which came near ruining him. A woman of bad principles and life had lodged at his house. While there she had privately murdered a man of some standing. Beside other evils, a heavy fine was imposed upon the house; and the

young man was exceedingly afraid of any more such persons
coming."

CHAPTER XXXII.

Arrives at Verceil—Interviews with La Combe—With the Bishop of Verceil—His kindness
—With one of the Superiors of the Jesuits—Sickness—Decides to return to Paris—La
Combe selected to attend her—Departure—Visit to the Marchioness of Prunai—Crosses
the Alps for the third time—Meets her half-brother, La Mothe, at Chamberri—Reception
at Grenoble—From Grenoble for Paris—At Paris, after a five years' absence, July 1686.

SHE arrived safely at Verceil, a pleasant and flourishing town,
on the Sessia, one of the tributaries of the Po. Having stopped
at one of the public inns, she sent notice of her arrival to Father
La Combe, who had come there soon after he left Thonon. At
Verceil, La Combe was highly esteemed. God had made use of
him as an instrument, in addition to other successful labours,
in converting several of the officers and soldiers stationed at that
place, who, from being men of scandalous lives, became patterns
of piety.

With no small emotion he met Madame Guyon again. The
feeling of satisfaction, however, was mingled with the fear that
a meeting so unexpected, and to many so inexplicable, might
furnish new occasion for calumnies.

As soon as the Bishop of Verceil heard of Madame Guyon's
arrival, he sent his niece, who took her to her own house. As
soon as he conveniently could, he came himself to see her.
With some difficulty Madame Guyon conversed in Italian, and
the Bishop's knowledge of French was imperfect. The first
interview, however, was a pleasant one ; and the satisfaction
which he felt in making her acquaintance was subsequently
much increased.

"The Bishop," says Madame Guyon, "loved God ; and it
was but natural that he should love those who had similar dis-
positions. He could hardly have conceived a stronger friendship
for me, if I had been his own sister He wrote to the Bishop

of Marseilles to thank him for having protected me in the per-
secution, and, with similar views, to Bishop Camus of Grenoble;
and in various ways expressed his interest and the affectionate
regard he felt for me. He would not listen to my going, at
present, to see the Marchioness of Prunai, but wrote to her to
come and settle with me at Verceil. He even sent Father La
Combe to exhort her to come; assuring her that he would
unite with some other pious persons, in a select Religious
Society or Congregation, established for permanent religious
objects. Neither the Marchioness nor her daughter, who was
consulted, disapproved of the plan ; but she was prevented by
ill health.

"I was visited," she adds, "by one of the superior officers or
rectors of the Jesuits resident at Verceil. His knowledge on
theological subjects was much greater than mine. We con-
versed together on topics of this nature ; and he proposed to me
several questions which he wished me to answer. The Lord
inspired me to answer them in such a manner, that he went
away not only surprised, but apparently satisfied ; so much so
that he could not forbear speaking of it afterwards."

Soon after her arrival she was attacked with sickness. "When
the Bishop," she says, "saw me so much indisposed, he came to
see me with assiduity and charity, when at leisure. He made
me little presents of fruits and other things of that nature."
When, however, he proposed to her the matter of a permanent
residence at Verceil, she says that she had a presentiment that the
plan would not succeed, and was not what the Lord had required
of her. Still, being under great obligations to him, she thought
it best to let him take what measures he might think proper for
the present ; being assured that the Lord would know well how
to prevent arrangements which should not be in accordance with
His will. The plan was entirely frustrated, by its being ascer-
tained that the air of the place was exceedingly injurious to her,
and that, in the opinion of the physicians consulted, it would
not be possible for her to remain there. The Bishop, although
much afflicted, did not hesitate to acquiesce, remarking that he

would much rather have her *live* somewhere else than *die* at Verceil.

Her friends decided that, considering the influence she was capable of exercising, it was best for her to return to Paris, as a field of labour more appropriate to the powers God had given her, than those remote and rude villages where she had expected to spend her days. As soon as it was settled, after suitable deliberation and prayer, " the Lord," she says, " wrought in my mind the conviction, that I was destined to experience yet greater crosses than hitherto. Father La Combe had the same convictions. Nevertheless he encouraged me to resign myself to the Divine will, and to become a victim offered freely to new sacrifices."

During the few months' residence at Verceil, she did not engage much in her *public* labours. Her health was not adequate to it. She continued, however, the work of writing explanations on the Scriptures. Her remarks on the Apocalypse were written at this time. She was enabled also to keep up an extensive correspondence. At this time her correspondence commenced with the Duchess de Chevreuse.

When Madame Guyon travelled, she was generally attended by some ecclesiastic. That was the custom of the times for religious persons in her situation in society. It was obviously necessary, for the most part, that she should have some male attendant; and a regard to public opinion seemed to require that he should be one who, both by profession and character, should be above suspicion. In leaving Verceil, she selected La Combe, in accordance with the opinion of her friends, to go with her. There was a special reason for this selection, additional to his high personal character, his ecclesiastical calling, and the fact of his being her spiritual Director. Some arrangements of the Religious Order to which he belonged, which were carried into effect by their Superintendent, required his presence at Paris. The suggestion, therefore, was favourably received by the General of the Order, as a thing not only proper in itself, but because the expenses of his journey thither, being of course

paid by her, would exempt the House of that Order at Paris, which was already poor, from an assessment to meet them. As it was necessary, however, that La Combe should attend to some business at the intermediate places, he set out some days before her, and waited for her at the entrance of the passage over the Alps, as a place where attendance and assistance would be indispensably necessary.

After a stay, therefore, of a few months, pleasant in every respect with the exception of the state of her health, she set out on her return by the usual route of Turin and Mount Cenis. "My departure," she says, "was a season of trial to the Bishop of Verceil. He was much affected. He caused me to be attended *at his own expense,* as far as Turin, giving me a gentleman and one of his own ecclesiastics to accompany me."

Under these circumstances, she closed her mission abroad—a mission not more interesting in its results than it was novel in its nature; and commenced her return to Paris. La Combe, before he left, wrote a letter for her encouragement under the trials which he foresaw; in which he said, "Will it not be a thing very glorious to God if He should make us serve, in the great city of Paris, for a spectacle to angels and men?" "I departed," she says, "*in the spirit of sacrifice;* ready to offer myself up to new varieties and kinds of suffering. All along the road, something within me repeated the very words of St. Paul, 'I go bound in the spirit to Jerusalem, not knowing the things which shall befall me there, save that the Holy Ghost witnesses, saying, that bonds and afflictions abide me; but none of these things move me; neither count I my life dear unto myself, so that I might finish my course with joy.' I found it my duty to hold on my way, and to sacrifice myself for Him who first sacrificed Himself for me."

In her way to Turin, she turned aside to visit the Marchioness of Prunai. "She was extremely rejoiced," says Madame Guyon, "to see me once more. Nothing could be more frank and affectionate than what passed between us." Leaving with the Marchioness her sweet words of encouragement in relation to

her benevolent labours, especially for the poor and the sick, and bidding her, after a few days' tarrying, a final adieu, she went on her way.

Travelling the usual route along the Doria to Susa, she met La Combe again, at some place near the foot of the Alps.

No doubt, as she looked down from those vast heights on the land of the Po and the Adige, she breathed forth the fervent prayer of her heart for its spiritual renewal. This prayer continually arose from her heart, for all lands and all nations :—

Ah, reign wherever man is found,
My Spouse, beloved and Divine !
Then am I rich, and then abound,
When every human heart is thine.

A thousand sorrows pierce my soul,
To think that all are not thine own ;
Ah, be adored from pole to pole ;—
Where is thy zeal ? *Arise—Be known.*

At Chamberri, the principal town of Savoy, she met her half-brother La Mothe, whom she had not seen for a number of years. Business of an ecclesiastical nature had called him thither at this time. The meeting was apparently cordial, although there was too much reason to think that he was determined to take a course injurious to Madame Guyon. La Combe thought it expedient to consult one who sustained so near a relation, on the propriety of the arrangement which required him to attend Madame Guyon to Paris ; expressing an entire willingness and even desire to resign his place to some other person. La Mothe approved of the arrangement, and expressed a strong desire that it should be carried through.

From Chamberri she proceeded to Grenoble, to which one of the females who attended her into Italy belonged. Here she met her daughter, now ten years of age, and the maid-servant, with whom she had left her. When it was understood in the city, that she had returned, a great number of persons, whom she had been the instrument of spiritually benefiting, visited her, and were filled with joy at seeing her again. But their joy was changed into sorrow, when it was understood that she must soon leave them.

Camus, bishop of the city, manifested great kindness during her stay. Public opinion had so much changed, that she was

now requested to remain, to be employed in connexion with one of the hospitals of the city.

The Bishop wrote a letter a year or two after in her behalf, when he had been raised to the Cardinalship, to his brother.

To Madame Guyon he wrote the following :—

" MADAME,—It would give me great satisfaction if I had more frequent opportunities of showing you how great is the interest which I feel in your welfare both temporal and spiritual. I am truly grateful that the suggestions I made in relation to your spiritual concerns have been found serviceable. In respect to your temporal affairs, I shall use my best endeavours to engage my brother, the Lieutenant Civil of Paris, to see that entire justice is rendered to you. Trusting that you will continue to entertain the fullest confidence in my favourable dispositions towards you, I remain, Madame, very truly and affectionately yours, THE CARDINAL CAMUS."

She spent about a fortnight in Grenoble; and then, with Father La Combe, her daughter, and female assistants, she set out for Paris. There is some uncertainty in the dates which are given in this period of her life.

She arrived at Paris the 22d of July 1686, *five years after her departure from the city.*

She returned ; but not to lay down her armour and to take her rest. She knew not what the Lord had before her, and what He designed for her, either in doing or suffering. She was now in the thirty-ninth year of her age ; young enough, with God's assistance, to do effectual work in His cause, and old enough to have gained wisdom from experience, and strength from trial. But in every situation, she had one unalterable conviction, which was the true source of her power, *that she had nothing in herself, but all in God.*

CHAPTER XXXIII.

Domestic arrangements—Finds it necessary to form new associations—Character of them—
Duchess de Beauvilliers—Duchess de Chevreuse—Character of the Duke de Chevreuse—
Begins to labour in this higher class of society—Labours of La Combe—His doctrines—
Opposition against him by La Mothe—The doctrines of Michael de Molinos—The case of
La Combe brought before M. de Harlai, Archbishop of Paris; and Louis xiv.—La Combe
writes to Madame Guyon—Is sent to the Bastile—Sympathy for him by Madame Guyon
—Their correspondence.

OF the domestic history of Madame Guyon, for some years
subsequent, we know but little. She hired a house in the city;
and once more collected her little family, consisting of her
daughter and two sons. Her reputation for piety necessarily
separated her from fashionable society.

Many of those, with whom she had been acquainted before
she left Paris, had now gone. Her own circumstances were
much altered; and it was almost a matter of necessity, that the
associations which she was now called to form, would be new.

She never forgot the humble and the poor; but the indications
of Providence seemed to call her to labour with another class of
people—a class more elevated in the view of the world, but not
easily accessible to religious influences. It is true, not "many
mighty and not many noble are called." Their position is in
some respects averse to the reception of the humbling doctrines
of the Gospel. And yet in the city of Berea there were some
" *honourable women*," and in Thessalonica also there were "not
a few of the chief women" who *believed*.

Among the acquaintances which Madame Guyon formed was
the Duchess of Beauvilliers, a daughter of the great Colbert.
Inheriting no small share of her father's intellectual power, she
was one of those rare women who combine fervour of piety with
strength of intellect. By descent and marriage in an eminent
position in French society, she was still more truly eminent by
her faith in God, her alms and good works.

The Duchess of Chevreuse resided a short distance out of
Paris. Madame Guyon visited her soon after her return; and
there met a number of persons, drawn together by that instinct

of piety which never fails to seek the company of those who are
characterized by similar dispositions. Madame Guyon formed
a little association of ladies of rank, among whom were the
Duchess of Beauvilliers, the Duchess of Bethune, and the
Countess of Guiche, with whom she met from time to time for
religious objects. It was interesting to see some of the most
distinguished ladies of the capital of France recognising the
truths of religion, and rejoicing in the experimental power of
piety.

These ladies were not ignorant of the reputation of Madame
Guyon. That which was spoken comparatively in secret was
uttered afterwards upon the house-tops. The voice which was
uttered at the foot of the Jura and the Alps, in the cottages of
the poor, and amid the solitary and inaccessible cliffs of the
Chartreuse, was repeated from province to province, till it
reached the high and public places of Paris. It was but na-
tural, therefore, that they should wish to know her. And from
this time we find her name associated, either in union or in
opposition, with some of the most distinguished names of France.

The Dukes of Beauvilliers and Chevreuse, who held some of
the highest offices in the State, sympathized with their wives in
their religious tendencies. They formed a personal acquaintance
with Madame Guyon ; made themselves familiar with her reli-
gious views and experience, and valued and sought her society.
But this could not easily have taken place, if she had been a
person of inferior talent, of rude and unpolished manners, or of
doubtful piety. In the anonymous Life of Fénelon, published at
the Hague in 1723, we find the Duke of Chevreuse spoken of
in the following terms :—

" He had a rare stock of knowledge, an easy eloquence, and a
mind so fertile in resources as to be capable of remounting in
everything to the first principles, and of forming the greatest
designs. He had also the courage to execute the designs which
he formed. In his temper he was sweet and affable ; in his
manners, polite and unaffected. He was naturally a person of
great vivacity of spirit ; but had such a control of himself that

he always appeared equal and calm. He lived in his family with his children like a good friend, as well as a good father. In a word, piety had united in him the virtues human and divine, to such a degree, that he was at the same time a good Christian, a good citizen, and a perfect friend."

Of the other, a learned writer, M. de Bausset, Bishop of Alais, speaks as follows :—" The spirit of party may refuse to the Duke de Beauvilliers the character of a great genius, because his extreme modesty and his natural reserve rendered him habitually circumspect; but M. de St. Simon, whom no one will accuse of being prodigal of praise, and who lived in habits of intimacy with the Duke de Beauvilliers, says of him that he had a *very superior mind.*" It was at the suggestion and request of Beauvilliers, who had nine daughters, that Fénelon wrote his celebrated treatise on the Education of Daughters.

These distinguished persons, who were above Madame Guyon in worldly rank, recognising the spiritual relation which God had established between them, were ready to take their appropriate position in things which related to the religious life, and to become her disciples.

Nor was it this class of persons alone who valued and sought her society. The aged and pious Abbé de Gaumont, whose whole life had been one of prayer, visited her house ; and among her personal friends was a Doctor of the Sorbonne, M. Bureau, a man distinguished for learning and piety.

In the meantime, La Combe, her spiritual Director, laboured, in different situations and under different circumstances, to effect the same great objects. The religious views and experience of La Combe had become the dearer to him the longer he lived. His efforts, originating in sincere and fervent belief, and sustained by a high degree of learning and eloquence, were not without effect; so that the poor as well as the rich—the lowly as well as the noble—might be said to have the gospel preached to them. This state of things could not long exist without exciting much attention. It soon began to be said, " Those that have turned the world upside down have come hither also."

In a city like Paris, where the attention of men was continually arrested, then as now, by a thousand novelties which have the least possible connexion with religion, the impression must have been profound and extensive, in order to have attracted so much notice in so short a time.

They made FAITH the foundation of the religious life. They did not object, it is true, to ceremonial observances and austerities when carried to a certain degree; but, on the contrary, regarded them at times as exerting a favourable influence in restraining the appetites, and in breaking up injurious habits. But they did object very strenuously to any system of observances, to any and every form and degree of labour and suffering, as having any *atoning* merit, and as furnishing a justification for past sins; insisting that salvation is by the cross of Christ, and by *faith alone*. It was another and still greater ground of offence when they added, that Christ, received by faith, can save not only from the penalty of past sins, but from the polluting and condemning power of present sins; that He has power not only to make us holy, but to *keep* us holy.

A little more than a year had elapsed, when La Combe was arrested and shut up in the Bastile. Father La Mothe was an agent in this transaction. Jealous of the relation which La Combe sustained with his sister as her spiritual Director, and offended at the religious sympathy between them, he became an enemy and a persecutor.

Madame Guyon intimates, that one cause of La Mothe's jealousy, was the uncommon popularity of La Combe as a preacher.

A short time before this, the doctrines of Michael de Molinos, already mentioned as a religious reformer in Italy, had been subjected to an ecclesiastical examination, and had been condemned. Sixty propositions selected from his writings were pronounced heretical. La Mothe and others took the ground, that the sentiments of La Combe were similar to those of Molinos, and were equally dangerous. We find in the Memoirs of D'Angeau this remark:—

"1685, July 10th.—I am informed that a Jesuit, named Molinos, has been put into the Inquisition at Rome, accused of wishing to become the chief of the new sect called Quietists, *whose principles are somewhat similar to those of the Puritans in England.*"

But Molinos went further than was common among the puritanical writers; making faith the foundation not only of justification but of *sanctification,* and insisting also upon the entire sanctification of the heart, resting upon faith as its basis in distinction from mere works, as the duty and privilege of every Christian.

Upon this basis, a hostile party, headed by La Mothe, commenced and prosecuted measures against La Combe. They appeared before M. de Harlai, the Archbishop of Paris, a man of great capacity and energy. The accounts given of the private character and habits of the Archbishop are various and conflicting. Of his zeal there can be no doubt. He examined the subject with a promptness and personal interest which showed that dissenters from the established views had but little to expect from him; and having made up his mind, he laid it before Louis XIV.

During these proceedings, attempts were made, as is usual in such times of excitement, not only to take away the personal liberty of La Combe, but to injure and destroy his religious and moral character. These attempts, which involved to some extent Madame Guyon, signally failed. But he knew too well the dispositions of his opposers, and especially the exceeding jealousy of the king in relation to everything which looked like a deviation from the established faith, to take much encouragement. In a letter which he wrote to Madame Guyon at this time, he says. "The times look heavy. The storm gathers in the sky. I know not when the thunder which threatens me will fall. But recognising, as I do, the Divine will in all my trials, I am confident that all will be welcome to me from the hand of God." Not long after, meeting her, he said, "I feel entirely resigned to those reproaches and ignominies which I have no doubt I am

about to suffer. I am desirous that you should have the same feeling of resignation; and it is my wish, therefore, that you should sacrifice me to God, as I am going to sacrifice myself to Him."

Louis XIV. listened to the statements against La Combe; but without giving the accused an opportunity to answer them. As he believed him to be heretical, the well-known instrument of tyranny, the *lettre de cachet*, which preceded cases of imprisonment under such circumstances, was issued. La Combe was suddenly arrested at dinner, on the 3d of October 1687, and immediately shut up in the Bastile.

It was not enough to put an end to his labours as a preacher. His work, entitled *An Analysis of Mental Prayer*, written originally in Latin, and translated into French, was submitted to the Inquisition at Rome, and condemned by a formal decree, September 4, 1688. How long La Combe remained in the Bastile, which has been well described as the "abode of broken hearts," is not precisely known. "In one of the dungeons of that great prison," says Madame Guyon, "he was *incarcerated for life*. But his enemies having heard that the officers of the Bastile esteemed him and treated him kindly, they took measures to have him removed to a much worse place." He was sent by the direction of the king, to a place of confinement in the town of Lourde, in the distant department of the Upper Pyrenees. He was subsequently imprisoned in the well-known castle of Vincennes near Paris, and at a later period transferred to the castle of Oleron. His imprisonments in various places extended through twenty-seven years. Thus terminated his earthly labours and hopes; at least so far as they were connected with his preaching the doctrines of faith. The only favour which he obtained from his persecutors was that of being placed, just before he died, in the hospital of Charenton, in the year 1714.

This was a heavy blow to Madame Guyon; and the more so because one of the principal instruments in it was a member of her own family. She had known La Combe at an early period of life; she had been, in a very great degree, the instrument, in

God's hands, of his conversion and religious growth; and had seen him, in the maturity of his powers, ably defending, in his sermons and in writings, the doctrines so dear to her. The result of a religious devotedness so thorough and single-hearted, was a prison, and that too without any hope of release.

Speaking of him at this time, she says, " God will reward every one according to his works. There is something in me which tells me that he fully recognises the will of God; he knows who is at the head of events, whatever may be the subordinate instrumentality, *and is satisfied.*"

And again she remarks, " One must not judge of the servants of God by what their enemies say of them, nor by their being oppressed under calumnies without any resource. Jesus Christ expired under pangs. God uses the like conduct towards His dearest servants, to render them conformable to His Son, *in whom He is always well pleased.* But few place that conformity where it ought to be. It is not in voluntary pains or austerities, but in those which are suffered in a submission ever equal to the will of God, in a renunciation of our whole selves; to the end that *God may be our all in all,* conducting us according to *His* views, and not *our own,* which are generally opposite to His. In fine, all religious perfection consists in this entire conformity to Jesus Christ; not in shining and remarkable things, whatever they may be, which men are so disposed to esteem and to publish abroad. It will be seen only in eternity who are the true friends of God. *Nothing pleases Him but Jesus Christ, and that which bears His mark or character.*"

It was not, however, in her nature, and still less in her religious principles, to forget one whose piety and sufferings so justly rendered him dear to her. At no small risk on her part, she not only furnished him with money and books, to render his situation as comfortable as possible, but continued to write to him. At one time she was obliged to use great concealment; and having written him a letter without any signature, and with the authorship concealed in other respects as much as possible, he returned the following answer :—

" To MADAME GUYON,—I hope my unknown correspondent, or rather my correspondent without a name, will be assured that I respond with all my heart to the honour which has been done me. The letter, which came to me under such peculiar circumstances, was not more kind than it was religiously instructive and edifying. I rejoice, in all sincerity, in the holy friendship which you testify for me; and it is no small satisfaction to know that one who thus feels for the exile and the prisoner is herself advancing in the life and ways of God. I can truly say, it would be difficult to increase the happiness which I feel in knowing that the heart which dictated those consoling lines to me is filled with a faith without fear, and a love without selfishness. It is such a heart which is a ' Temple of the Holy Ghost.'

" The letter is without a name, but not without a character. The image of its author, in its religious outlines, is too deeply engraven upon my heart, not to be recognised. Accept, from the shades and sorrows of my prison, my sincere and affectionate gratitude. I look upon you as one fully united in God; and it is in God that my heart embraces you.

" In my present situation, correctly supposing me to be unable to do much else for the cause we love, you propose to me to meditate and to write. But, alas! can the dry rock send forth flowing fountains? I never had much power or inclination for such efforts; and this seclusion from the world, this imprisonment, these cold and insensible walls, seem to have taken from me the power which I once had. The head, not the *heart*, seems to have become withered and hard, like the rock upon which it has leaned so many years. My harp hangs unstrung; the sound of my viol is silent. Like the Jews of old, I sit down by the waters of my place of exile, and hang my harp upon the willows. It is true, there has been some mitigation of my state. I am now permitted to go beyond the walls of my prison into the neighbouring gardens and fields, *but it is only on the condition of my labouring there without cessation from morning till evening.* What then can I do? How can I meditate? How can I

think ?—except it be upon the manner of subduing the earth,
an l of cultivating plants.

"I will add, however, that I have no choice for myself. All
my desires are summed up in one, that God may be glorified in
me. And to this end, may I be permitted once more to ask the
prayers of one who can never cease to command my highest re-
spect, or my warmest Christian affections.

<div align="right">"FRANCIS DE LA COMBE."</div>

———

CHAPTER XXXIV.

Designs of those who had imprisoned La Combe, in relation to Madame Guyon—They pro-
pose to her to reside at Montargis—She refuses—Desire of La Mothe to become her
spiritual Director—Her opposition—Tranquillity—Remarkable inward experience—Her
labours for souls, and success—Conversation with La Mothe—His efforts to compel her to
leave the city—Her reply—Her case before Louis XIV.—Position of Louis—Her impri-
sonment, Jan. 1688, in the Convent of St. Marie—Treatment experienced—Separation
from her daughter—Poetry.

THE objects of those who had thus put a stop to the labours
of La Combe, would not have been accomplished, if Madame
Guyon had been permitted to prosecute her labours in quiet.
She was in fact considered the head of the *new spirituality ;* and
it would have been hardly consistent to have prosecuted, with
so much promptness and severity, the subordinate agents, with-
out especially noticing the principal. But they had no design
to involve in doubt their character for consistency ; and had
already begun upon Madame Guyon their attack, before they
had completed it upon La Combe.

La Mothe knew very well how constant were her labours and
how great her influence. He seems to have taken his measures,
for the most part, in concurrence with the Archbishop of Paris,
and proposed to her, as the readiest means of quieting the ap-
prehensions which existed, to take up her residence at Montargis,
the place of her birth. A proposition of this kind she could not
hesitate to refuse. What security could she have, that she, who

had already been hunted from Paris to Gex, and from Gex to Thonon, and from Thonon to Grenoble and Marseilles, would not experience at Montargis the same system of rigid scrutiny and violent oppression? And besides, to flee under such circumstances, would have been an implied confession, either that her conduct had been wrong, or her principles untenable.

This, however, was the first mode of attack. And it was not difficult to foresee, if this should fail, that others would be resorted to.

"La Mothe," she says, "insisted on my taking himself for my spiritual Director—*a proposition to which I could not possibly assent.* Disappointed in this, he decried me wherever he went; and wrote to others, associated with him, to do the same. These persons wrote to me very abusive letters; and particularly insisted, that if I did not place myself under his direction, I could not fail to be ruined.

"These letters I have still by me. One Father, a member of the Order of the Barnabites, whose dispositions were not wholly unfavourable, advised me to take the proposed course, as the best which could be done, and to make a virtue of necessity. Others advised me to put myself under his direction *in pretence* merely—a course entirely abhorrent to my feelings, for I could not bear the thought of disguise or deceit. But I felt determined not to hazard my liberty or peace by assenting to any such plan.

"Amid the various trials and temptations to which I was exposed, I bore everything with the greatest tranquillity, without taking any care to justify or defend myself. Having faith in God, I left it with Him to order everything as He should see best in regard to me. And in taking this course, He was graciously pleased to increase the peace of my soul, while every one seemed to cry out against me, and to look upon me as an infamous creature, except those few who knew me well by a near union of spirit. As I was once seated in a place of worship, I heard some persons behind exclaim against me, and even some priests say, 'It was necessary to cast me out of the Church.' At this

K

trying time I left myself to God without any reserve; and 1 did not look to earthly friendships or earthly wisdom for support. I chose to owe everything to God, without any dependence for help on any creature. I would not have it said, *that any but God had made Abraham rich.* (Gen. xiv. 23.) To lose all for Him is my best gain; and to gain all without Him would be my worst loss."

During all this time she calmly but unremittingly laboured in the good cause. The outcry against her was general. There was no end to what was said of her novelties and heresies, followed up by attacks, as ungenerous as unfounded, against her private character. But notwithstanding this unfavourable state of things, " God," she says, " *did not fail to make use of me to gain many souls to Himself.* He was pleased to regard me in great kindness. In the poverty and weakness of His poor hand-maid, He gave me spiritual riches. The more persecution raged against me, the more attentively was the word of the Lord listened to, and the greater number of spiritual children were given me."

Some of these persons were involved in the trials she endured. A number were banished from the city, chiefly on the ground of having attended religious conferences at her house or with her. One was banished, she states, against whom nothing further was alleged than his having made the remark, that her little book, meaning probably her book on Prayer, was a good one.

Under these circumstances, she met one day, in one of the churches of Paris, La Mothe, whose agency in these transactions had been conspicuous, though partially concealed in regard to herself under the garb of friendship. " My sister," he said, " the time has come. It is necessary for you to decide to flee from the city. There are allegations against you of such a nature. that there seems to be no other course. You are even charged with high crimes."

Knowing as she did that the malevolence of her enemies would carry them to any extent, but conscious of her innocence, she replied, " If I am guilty of the crimes which are alleged, I

cannot be too severely punished. Let punishment come. I cannot flee, I cannot go out of the way. There are abundant reasons why I should remain where I am. I have made an open profession of dedicating myself to the Lord, *to be His entirely.* If I have done things offensive to God, whom I would wish to love, and whom I would wish to cause to be loved by the whole world *even at the expense of my life,* I ought by my punishment to be made an example to the world. I am innocent; and shall not prejudice my claims to innocence by betaking to flight."

La Mothe, who probably did not anticipate so much resolution of purpose, was angry, and turned away from her with violent threats. As her enemies had failed to banish her by *artifice,* the matter was left to take the usual course. The charges against her morals, fabrications without the slightest foundation, were given up; her high purity and integrity of character were recognised; but the excellence of her character did not remedy or mitigate the fact of her heresy. On the contrary, it seemed to render it the more dangerous. Accordingly, her case came before the Archbishop of Paris, who was clear and prompt in condemning her, and some time afterwards published an Ordinance and Pastoral Instructions to that effect; but he had not authority, without the king's order, to imprison her.

He accordingly demanded and *obtained from the king an order to secure her person.* The charges, as they were laid before the king, were these :—That she maintained heretical opinions;— That, for the purpose of inculcating these opinions, she held private religious assemblies, contrary to the practice and rules of the Church;—That she had published a dangerous book, containing sentiments similar to those of the Spiritual Guide of Michael de Molinos, which had been condemned by a Papal decree;—And that she kept up a written correspondence with Molinos, who was now imprisoned at Rome. It was contended, that it was not enough merely to stop the circulation of her writings by an ecclesiastical interdiction, but was necessary also to restrict her person, and to imprison her.

Tired of heresy within his dominions, Louis had already

revoked the Edict of Nantes, and had sent his dragoons to the various parts of France, for the purpose of breaking up and dispersing the religious assemblies of the Protestants. Not satisfied with purging France from heresies, he seems to have thought that it would be for his glory, as the eldest son of the Church, to do the same thing for Italy. With this feeling, he had employed the influence of France to hasten and secure the condemnation of Molinos.

The Pope, Innocent XI., looking upon Molinos as a truly humble and pious man, whatever might be the errors of his opinions, was averse to taking extreme measures. The influence of the King of France decided the Pope to take the course which he did. And accordingly the accusers of Madame Guyon knew how easy it would be to excite the suspicions and the indignation of Louis, by connecting the doctrines which she advocated with those of Molinos. Indeed, although she had never seen Molinos, and still less had ever corresponded with him, it cannot be well denied that there was a similarity in their religious views. The real objection against both was that their doctrines, involving, as they did, a reliance upon faith in Christ alone as the true foundation of the Christian life in all its extent, tended to subvert some of the received ideas and practices of the Roman Catholic Church.

Her accusers laid before Louis a letter, bearing the signature of Madame Guyon, which contained the following passage. It was a forged letter; but the king was not aware of the fact at the time :—

" I have great designs in hand. But since the imprisonment of Father La Combe, I am not without fears that my plans may prove abortive. I am closely watched ; and as a matter of pre-caution, I have left off holding religious meetings at my own house ; but it is my intention to hold them in other streets and houses."

This letter, in which Louis thought he saw the germs of another Protestantism springing up in his own city and under his own eye, seems to have brought him to a decision. And

accordingly, without further deliberation, he issued the requisite *lettre de cachet;* and Madame Guyon, although but partially recovered from a severe sickness, was confined as a prisoner in the Convent of St. Marie, in the suburb of St. Antoine, little more than three months after the imprisonment of La Combe.

It is not to be supposed that this sudden change occurred without any interest felt or any effort made in her behalf. A number of persons, some of them of considerable standing in society, were banished, in consequence of their sympathy in her views and in her trials. One of these was M. Bureau, who had visited her house a number of times with the Abbé de Gaumont. But under a government constituted as that of France, there was but little security for truth and justice, when powerful influences were arrayed against them. The measures against her were taken with so much skill and promptness, that they entirely baffled those who were ready and willing to aid her.

" On the 29th of January 1688," she says, " I went to the Convent of St. Marie, which was selected because the Mother Superior was known to be particularly zealous in the execution of the king's orders. I received the summons which required me to go thither, in the early part of the day. A number of hours were allowed me, before I left my house, in which I received the calls and sympathy of many friends. When I arrived at the convent, I learnt that I must be shut up alone in a small chamber which served as my prison ; and though I was feeble, I was not allowed a maid to render me assistance. The residents of the convent were prepossessed with such frightful statements in relation to me, that they looked upon me with a sort of horror. They selected for my jailer a nun, who, from the severity of her character, would treat me with the greatest rigour. Certain it is that the result verified their anticipations.

" She not only regarded me as a heretic, but obviously looked upon me as an enthusiast, a hypocrite, and disordered in mind. God alone knows what she made me suffer. As she sought to surprise me in my words, I was very careful in all my expressions ; but the more careful I was, the worse it was with me.

I made more slips, and gave her more advantages over me, in consequence of my care, besides the anxiety necessarily occasioned in my own mind by it. I then left myself as I was, and resolved, though this woman should bring me to the scaffold, by the false reports which she was continually carrying to the Mother Superior, that I would simply resign myself to my lot And thus I entered into my former peaceful condition."

Her family was again broken up. Amid various trials and labours, she had one consolation, which she valued much ;—it was the society of her little daughter, now in the twelfth year of her age. Wherever she had travelled, and taken up her abode, she had listened to her young voice, and found a mother's hopes and joys some compensation for the sorrows she was not permitted to escape. She naturally expected to be separated from the other members of her family ; but she was desirous that her daughter might remain with her.

" I thought," she says, " it would be consistent with the objects of my imprisonment, to permit my daughter to be left with me, and also one of my maid-servants. But in this I was disappointed. My daughter was most at my heart ; having cost me much care in her education. I had endeavoured, with Divine assistance, to eradicate her faults, and to dispose her to have no will of her own, which is the best disposition for a child. My heart was deeply affected when she was taken away, I knew not whither. I requested that she might be permitted to stay in another part of the convent, which would be some satisfaction, although I should not see her. But this was not granted ; nor would they allow any person to bring any news of her. *So that I was obliged to give her up, and to sacrifice her, as it were, as if she were mine no longer.*"

It would be interesting to know something more of her place of imprisonment. It is not improbable that it was the place which was used as the prison of the convent ; it being sometimes necessary, in such institutions, to subdue the refractory members, by keeping them shut up. It was a small room in an upper story, entered by a single door that opened on the outside, and

was secured by being locked and by a bar across it. It had an opening to the light and air only on one side; and this was so situated, that the sun shone in upon it nearly the whole day, which rendered it exceedingly uncomfortable in summer. Here she was enclosed in solitary imprisonment for eight months.

Madame Guyon has not said much of the place; and hence we know more of the placid resignation of the prisoner than of the prison. She herself has told it in one of her own sweet songs, which is striking by its simplicity as well as its piety, and which we give to the reader in a nearly literal translation :—

A LITTLE BIRD I AM.

A little bird I am,
 Shut from the fields of air;
And in my cage I sit and sing
 To Him who placed me there;
Well pleased a prisoner to be,
Because, my God, it pleases thee.

Nought have I else to do;
 I sing the whole day long;
And He whom most I love to please,
 Doth listen to my song;
He caught and bound my wandering wing,
But still He bends to hear me sing.

Thou hast an ear to hear;
 A heart to love and bless;
And, though my notes were e'er so rude,
 Thou wouldst not hear the less;
Because thou knowest, as they fall,
That LOVE, sweet LOVE, inspires them all.

My cage confines me round;
 Abroad I cannot fly;
But though my wing is closely bound,
 My heart's at liberty.
My prison walls can not control
The flight, the freedom of the soul.

Oh! it is good to soar
 These bolts and bars above,
To Him whose purpose I adore,
 Whose providence I love:
And in thy mighty will to find
The joy, the freedom of the mind.

CHAPTER XXXV.

Occupations in prison—The history of her life—Feelings in imprisonment—Labours and usefulness there—Letter to a religious friend—Visited by an ecclesiastical Judge and a Doctor of the Sorbonne—Examined—Her feelings—Poem.

HER physical constitution was feeble, but her mental purpose was strong. Her full heart, strong in faith and love, sustained her suffering body. It did not follow, because she was a prisoner

that she was idle. La Combe, before he had ceased tɔ be her spiritual Director, had imposed on her the duty of putting in writing the incidents of her life. She had probably made a beginning before, but she now began this work in earnest. La Combe had required her to be very particular ; and not supposing it would be seen by many beyond the circle of her personal friends, she was more minute than would otherwise have been necessary.

Writing, too, almost solely from memory, and under great disadvantages, there is a want of exactness in the arrangement, besides frequent repetitions, and it is therefore less valuable in itself, than as furnishing materials for others.

When she first received notice that she was to be shut up, God was pleased to give her not only entire resignation, but a triumphant and joyful peace ; so much so, that it shone on her countenance, and attracted the notice of the person who brought the king's order, and also of her friends. The same delightful peace continued after her imprisonment.

The doctrines of Sanctification, to which she was so much attached, involved principles peculiarly adapted to such a situation. They strike at the root of all earthly desire, as they do of all earthly support. They annihilate times and places, prosperities and adversities, friendships and enmities, by making them all equal in the will of God. So that to Joseph the prison and the throne are the same, to Daniel the lion's den and the monarch's palace are the same, because they have that in their believing and sanctified hearts, which subjects the outward to the inward, and because the inward has become incorporated by faith in that Eternal Will in which all things have their origin and their end.

Her captivity was intended to be very strict ; but still persons were allowed to see her from time to time. And few visited her without being religiously impressed by her appearance and conversation. Many of her poems also were written in this prison ; and probably no period of her life was really more useful than this.

The following letter illustrates the nature of her efforts by means of correspondence, when she was not permitted to labour in any other way :—

"MADAME,—I can assure you, that it is a great pleasure to me to witness the manifestations of God's mercy towards you, and to see the progress of your soul in religion. It is my prayer, that God may bring to a completion the work which He has begun within you. No doubt He will, if you continue faithful. Oh, the unspeakable happiness, Madame, of belonging to Jesus Christ! This is the true balm, which sweetens the pains and sorrows that are inseparable from the present life.

". . . You will pardon me for saying, in the first place, that you do not appear to me to be sufficiently advanced in inward experience, to practise silent prayer for a long time together. . . . I think it would be better to combine ejaculatory prayer with silent prayer. Let such ejaculations as the following :— *O my God, let me be wholly thine !—Let me love thee purely for thyself, for thou art infinitely lovely !—O my God, be thou my all ! Let everything else be as nothing to me ;* and other short ejaculations like these be offered up from the heart. But I think that such ejaculations should be separated from each other, and *intervened,* if I may so express it, by short intervals of silence. . . . And in this way you will be gradually forming and strengthening the important habit of silent prayer.

"And this suggests another practical remark. When you are reading on religious subjects, you would do well to stop now and then for a few moments, and betake yourself to meditation and prayer in silence ; especially when any portion of what you read touches and affects you. The object of this is to let the reading have its appropriate effect. Such reading will be very likely to edify and nourish the soul. The soul needs nourishment as well as the body. Its religious state, without something which is appropriate to its support, withers and decays.

"Do not resort to austerities or self-inflicted mortifications. They may do for others, but not for you. Your feeble health

does not allow of it. If you had a strong and sound body, and especially—which is the great point in connexion with physical mortifications—if you suffered yourself to be ruled by your appetites, I should probably give different advice.

"But there is another mortification, Madame, which I must earnestly recommend. Mortify whatever remains of your corrupt affections and your disorderly will. Mortify your peculiar tastes, your propensities, your inclinations. Among other things, learn to suffer with patience and resignation those frequent and severe pains which God sees fit to impose upon you. Learn also, from the motive of love to God, to suffer all that may happen of contradiction, ill manners, or negligence in those who serve you. In a word, mortify yourself by bearing at all times, in a Christian temper, whatever thwarts the natural life, whatever is displeasing and troublesome to the natural sensibilities; and thus place yourself in union and fellowship with the sufferings of Christ. By taking these bitter remedies, you will honour the Cross. And especially if you mortify yourself, and die, in your inward experience, to everything which is remarkable and showy. Learn the great lesson of becoming a little one, of becoming nothing. He does well who, in fasting from other things which the appetites improperly crave, lives upon mere bread and water; but he does better who, in fasting from his own desires and his own will, lives upon God's will alone. This is what St. Paul calls *the circumcision of the heart.*

"I would advise you to receive the Eucharist as often as you conveniently can. Jesus Christ, who is presented to us in that ordinance, is the *bread* of life, which nourishes and quickens our souls. I shall not fail to remember you, when I am worshipping before Him; greatly desiring as I do, that He may set up His kingdom in your heart, and may reign and rule in you. J. M. B. DE LA MOTHE GUYON."

The monotony of her prison was varied by a number of incidents. She had been in prison a short time, when she was visited by Monsieur Charon, a judge of the ecclesiastical court,

and Monsieur Pirot, a Doctor of the Sorbonne. They came to subject her to a formal examination, upon the results of which it seemed probable, that the continuance of her imprisonment would depend. With this object, although it is not improbable that the examinations had secret reference to the treatment of La Combe, as well as to herself, they repeated their visit four different times. We have the substance of what occurred at these interviews as follows :—

"*Judge.*—Is it true that when you went from France to Savoy, you went with Father La Combe, and as an associate and follower?

"*Madame Guyon.*—When I left France, La Combe had not been in France for about ten years ; and therefore to have gone with him would have been an impossibility.

"*Judge.*—Was La Combe instrumental in teaching you the doctrines of the inward life ?

"*Madame Guyon.*—In the principles of religion, in their experimental form, I had the happiness of being taught in childhood and early youth. I was not taught them by Father La Combe. I first knew La Combe in the year 1671, more than fifteen years ago, and long before I went to Savoy. He called at my house at that time, being introduced by my half-brother, Father La Mothe.

"*Judge.*—Had not La Combe some participation in the authorship of the book entitled the Short and Easy Method of Prayer ?

"*Madame Guyon.*—He had not. I wrote it in Grenoble. La Combe was not there. I had no expectation that it would be printed. A counsellor of Grenoble, seeing it on my table, examined it, and thinking it would be useful, he asked my consent to its being published. At his suggestion I wrote a Preface, and divided it into chapters.

"*Judge.*—Are we not to understand you in that book as discountenancing the use of the prescribed prayers of the Church, and even of the Lord's Prayer ?

"*Madame Guyon.*—So far from discountenancing the use of

the Lord's Prayer, I have explained the manner of using it to the best effect. I have discountenanced the use of the Lord's Prayer, and of all other prescribed prayers, as a mere *matter of form*, but for no other reason. It is not the mere repetition of prayers which renders us acceptable to God, but the possession of those dispositions of heart which the forms of prayer are intended to express.

"*Judge.*—I have before me a letter, addressed to Father Francis, of the Order of Minims, in which you express your determination to hold religious meetings; and that finding it dangerous to hold them at your own house, you will hold them in other streets and houses, but in a private manner.

"*Madame Guyon.*—What I have done is probably well known. What I intend to do, is necessarily lodged in the bosom of Him whose will is my only law. But as for that letter, it is a forgery.

"*Judge.*—By whom was the letter written? And what reason have you to think that it is a forgery?

"*Madame Guyon.*—I cannot speak of its authorship with certainty; but I have my opinions. It was laid before our king Louis, and had its effect in my imprisonment. I suppose it was written by the scrivener Gautier, whose agency in these transactions is not unknown to me. It is not in my handwriting, as can be easily shown. Besides, it is addressed to Father Francis, as being in Paris. It is known, and can be proved, that he left Paris for Amiens on the 1st of September. The letter is dated on the 30th of October. The gentleman who has the charge of the education of my sons will aid me in obtaining proof on these points, if you wish it.

"*Judge.*—I suppose you are aware that your opinions, expressed in your writings and uttered on other occasions, are regarded as heretical. I will not go into particulars. I will not attempt to prove what has been said, either by quotations or by facts, but should be pleased to hear what you have to say on this charge, made in this general way.

"*Madame Guyon.*—To declare me a heretic, does not make

me one. 1 was born in the bosom of the Catholic Church, and brought up in its principles, which I still love. It is hardly necessary for me to say that I make no pretensions to learning; that I am not a Doctor of the Sorbonne; and it is possible that I have sometimes uttered expressions which require theological emendation; and so far I readily submit myself to the correction of those who have the proper authority. I am ready to give my life for the Church. But I wish to say that I am a Catholic in the substance and spirit, and not merely in the form and letter. The Catholic Church never intended that her children should remain dead in her forms; but that her forms should be the expression of the life within them, received through faith in Christ. In doing what I have done, I had no expectation or desire of forming a separate party. But I wished to see the great principles of the inward life revived. It did not occur to me, that I was to be regarded as a heretic and separatist; but I thought I might be permitted, in the sphere which Providence had assigned me, to labour for the revival of the work of God in the soul.

" *Judge.*—I understand that you have written commentaries on the Scriptures. I should be glad to see them, and have the opportunity of examining them.

" *Madame Guyon.*—I acknowledge that I have written such remarks or commentaries on various parts of the Scriptures. They are not here. I left them in the care of a person whom I do not wish to mention at present. When I am freed from my imprisonment, I will place them in your hands."

Such was the substance, and for the most part the precise terms of these examinations, so far as they are briefly given by Madame Guyon. Monsieur Charon, who felt his official responsibility, retired in silence. The Doctor of the Sorbonne, whose position perhaps allowed a little more freedom, dropped a word favourable to Madame Guyon.

Sometimes darkness and sorrow settled in what may be termed the outside of her system, in her shattered nerves and bleeding sensibilities; but faith unchangeable, which always brings God to those who have it, made light and joy in the centre. When

none came to see her with whom she might converse, she wrote; when tired of writing the incidents of her life, she corresponded with her absent friends; when opportunities for doing good in this manner did not present themselves, she solaced the hours of solitude by writing poems. It is to this period that we are to ascribe the origin of the little poem, beginning, *Si c'est un crime que d'aimer*. The sentiment of this poem may be found in the following stanzas :—

LOVE CONSTITUTES MY CRIME.

Love constitutes my crime;
 For this they keep me here,
Imprison'd thus so long a time
 For Him I hold so dear;
And yet I am, as when I came,
The subject of this holy flame.

How can I better grow!
 How from my own heart fly!
Those who imprison me should know
 True love can never die.
Yea, tread and crush it with disdain,
And it will live and burn again.

And am I then to blame!
 He's always in my sight;
And having once inspired the flame,
 He always keeps it bright.
For this they smite me and reprove,
Because I cannot cease to love.

What power shall dim its ray,
 Dropt burning from above!
Eternal life shall ne'er decay ;
 God is the life of love.
And when its source of life is o'er,
And only then, 'twill shine no more.

CHAPTER XXXVI.

Views in relation to the continuance of imprisonment—Inward peace and triumph—Inward trials—Forgiveness towards her enemies—Attempts to involve her daughter in a marriage arrangement—The King favourable, but requires Madame Guyon's consent—The subject proposed to her by M. Charon—Her reply—Unfavourable state of things—Writes to Père La Chaise—Sickness—Renewed trials—Remarks on the dispensation of the Holy Ghost—A Poem.

"THE Prioress of the Convent," says Madame Guyon, " asked the ecclesiastical judge how the affair stood. He signified that things were in a favourable way, and that I should be discharged at an early period. And this became the common opinion in relation to it. But as for myself, I had a presentiment to the contrary. But this did not depress me. My mind was free.

The confinement of my body made me relish my mental liberty the better. The satisfaction, and even joy which I had in being a prisoner and in suffering for Christ, were inexpressible.

" The 19th of March in particular, was a memorable day. On that day, the nun who acted as my jailer, granted me the liberty, as a special favour, of going into the garden attached to the Convent. In a retired part of the garden was a little Oratory or place of prayer, which was the more calculated to favour devotional feelings by having a cross planted in it, with a carved image of the dying Saviour suspended upon it. It was there, as I was alone in acts of worship, that God was with me, and blessed me much. During the whole of that day, my mind had more of heaven than of earth in it. Language cannot express it."

On the 25th of March, she records the existence of a very different state of mind, but perhaps not less profitable. God was pleased on that day, and for a number of days following, to leave her in a state of extreme destitution and depression. Her lonely situation, her separation from her daughter, the opposition, the apparent defeat of her plans and anticipations for the good of souls, could not fail to be present to her thoughts. The pains which she thus endured were probably enhanced by her physical sufferings, from which, although we have said but little respecting them, she was not often exempt long together. These suggestions and influences were permitted to gather around her so as to furnish occasion for temptations severe and heavy. God saw fit, in His wisdom and goodness, that Satan should try her once more. All human and all heavenly support, so far as it was perceptible and consolatory, was for some days taken away. She was in the greatest sorrow of spirit. But she believed and was triumphant. Satan fled discomfited ; and the calm peace and joy of her mind returned.

" I was not insensible," she says, " to the sorrows which my persecutors occasioned me, nor ignorant, as I think, of the spirit by which they were actuated; but I had no other feelings towards them, so far as I can judge, than those of forbearance and

kindness. The reflection, that they did only what God per-
mitted them to do, which enabled me always to keep God in
sight, supported me much. When we suffer, we should always
remember that God inflicts the blow. Wicked men, it is true,
are not unfrequently His instruments; and the fact does not
diminish, but simply develops their wickedness. But when we
are so mentally disposed, that we love the strokes we suffer, re-
garding them as coming from God, and as expressions of what
He sees best for us, we are then in the proper state to look for-
givingly and kindly upon the subordinate instrument which He
permits to smite us."

She was not even permitted to know, for a considerable time,
where her daughter was placed. Her feelings, therefore, were
greatly tried, when she learned, after some time, that interested
individuals had got possession of her daughter's person, and were
endeavouring to induce her, left as she was without the aid and
advice of a mother, to pledge herself thus early in life to a mar-
riage. In the settlement of her father's estate, a considerable
amount of property had been settled upon this child. The hope
of getting possession of this property was one of the motives in
this ungenerous movement.

This beloved daughter was the child of Madame Guyon's
religious, still more than of her natural expectations and hopes.
Much had she laboured and prayed for the renovation and spiri-
tual perfection of her nature. Her sorrow, therefore, and her
trial of mind, must have been greatly increased, when she learned
that the individual thus-proposed as her daughter's husband was
a man who had scarcely a tincture of Christianity, being aban-
doned both in his principles of belief and in his morals.

They brought the matter before the king, who frequently took
a personal interest in the domestic arrangements of his subjects.
He expressed a desire that the proposed betrothment should take
place. He was willing, also, that his desire should have all the
influence which would naturally result from it; but he had so
much remains of kingly pride as to insist that Madame Guyon's
consent must first be obtained.

The king's views and wishes were conveyed to Madame Guyon through M. Charon, the ecclesiastical judge. A number of persons were present at this interview. Among others were the Mother Superior of the convent, and the guardian to Madame Guyon's children. Charon stated to her the arrangement proposed; urged the desirableness of it; the wishes of the king; and concluded with saying that, if she would consent to the betrothment of her daughter to the Marquis of Chanvalon, she should be set free from prison within eight days. The reply of Madame Guyon is worthy of notice: " God allows suffering, but never allows wrong. I see clearly that it is His will that I should remain in prison, and endure the pains which are connected with it; and I am entirely content that it should be so. I can never buy my liberty at the expense of sacrificing my daughter."

After this, things looked more unfavourably. Conversation, which had predicted her speedy release, suddenly assumed a different character. " I was now told," she says, "that my persecutors had the upper hand; and that they had succeeded in convincing the king that I was guilty of everything which had been alleged against me. And hence I naturally thought that I must be a prisoner *all the rest of my days*." The influence of the Archbishop of Paris was very great and decisive in this matter, and was entirely against her. He declared openly, that there was no hope for her, except in the renouncement of her views, and in repentance for the course she had pursued. If she would confess herself wrong and criminal, and make retractions and confessions, she could be freed; otherwise not.

She was so entirely resigned to the yoke of God, whatever it might be, that she felt afraid to shake it off by means of any mere human instrumentality. Some of her friends could not understand fully this entire trust in God. " A friend of mine," she says, " urged me to write to Father La Chaise, telling me, that I ought not to wait for God to do everything, without doing myself what was proper. Such a course would be tempting

God." Out of deference, therefore, to others, she wrote the
following letter :—

LETTER TO PÈRE LA CHAISE, CONFESSOR TO LOUIS XIV.

" REVEREND FATHER,—It is not frequently the case, that I
bring my troubles before others. And certain I am that, on the
present occasion, if my enemies had limited their attacks to the
liberty of my person and my reputation, I should have remained
in silence. But they have not only shut me in prison, and at-
tempted to blast my honour, but they have insisted that I have
failed in respect for the doctrines of the Church, and have de-
nounced me as a *heretic*.

" Permit me to say, Reverend Father, in soliciting your kind-
ness and protection, that I ask nothing which shall be found
inconsistent with justice and the truth. The judge of the
Ecclesiastical Court has been in my prison ; and has examined
the statements and papers laid before him against me, and has
pronounced them false. But these related chiefly to my private
character. In regard to my doctrines, he required some explana-
tions ; but without taking the responsibility of pronouncing
them *heretical*. On the contrary, he seemed rather to be satisfied
with what I said. I offered also to submit to his inspection all
my writings.

" Have I not reason, then, to think that it is something be-
sides my alleged want of Catholic Orthodoxy, which keeps me
in prison ? I am willing to submit myself to a *disinterested*
tribunal; but I have reason to think that my persecutors, some
of them at least, have their private aims. Private interests have
mingled in those proceedings which have brought me and which
keep me here. I think, Reverend Father, that it would be easy
for me to show by incontestable proofs, that this is the case, if
I had the opportunity to do it. How can it be otherwise, when
they come to me with *menaces ?* They ask my compliance and
consent in transactions which my feelings as a Christian and a
mother require me to resist : and they threaten me with a con-

tinuance of my troubles, if I refuse to do what my conscience compels me not to do.

"Your position, Reverend Father, has led me to appeal to you. May I not ask that you will allow yourself to look into this subject, and to be thoroughly informed in regard to it. In proclaiming the selfish ends of some of my enemies, and in asserting my own innocence, I think I say no more than I shall be able to make evident.

"I can only add, that I shall be extremely grateful for any attention and aid which you may be able to render me.
"JEANNE MARIE B. DE LA MOTHE GUYON."

She says, "I never could find that the letter produced any good effect, but rather the reverse. It was natural that La Chaise should consult with the archbishop, who assured him that I was very criminal. Counterfeit letters and papers also were shown him, which had an unpropitious influence; so that this effort came to nothing."

A report was circulated that she was to be removed to another place of imprisonment, and placed under the immediate inspection of La Mothe, a severe man, and much incensed against her. "Some of my friends," she says, "wept bitterly at the hearing of it; but such was my state of acquiescence and resignation, that it failed to draw any tears from me. An ignominious death, with which I have so often been threatened, makes not any alteration in me. Sometimes the idea crosses my mind, that it is possible, after all that has passed, that I may still be cast off from God's presence; but even this thought, terrible and overwhelming as it is, does not take away the deep peace and satisfaction which I feel in connexion with the fulfilment of God's will."

It was now the month of June 1688. "The air of the place," she says, "where I was enclosed, was so confined and heated, that it seemed like a stove." Her feeble constitution sank under it, and she was taken dangerously ill. The guardian, a counsellor in law, stated her situation to the archbishop. Harlai

offended at what he considered her obstinacy, received the application with indifference and almost with ridicule. " V,ery sick," he exclaimed ; " very sick indeed, I suppose, at being shut up within four walls, after what she has done." He granted nothing.

She was favoured, however, after a time, through the sympathy of those who had the immediate charge of the Convent, with the assistance of a maid-servant, and a physician and surgeon. It was done, it is true, in violation of the orders of her imprisonment. But Madame Guyon remarks, " It was God who put it into their hearts, and gave them the determination to do it; for had I remained as I was, without any proper attendance, I must have died. My enemies were numerous and clamorous. It was not merely death which was before me, but *disgrace.* My friends were afraid lest I should die ; for by my death my memory would have been covered with reproach, and my enemies would have triumphed ; but God would not suffer them to have that joy. After bringing me down, He was pleased to raise me up again."

One of the charges brought against her was, that she did not worship the Saints, and particularly the Virgin Mary. On what principles she maintained the consistency of her Roman Catholic profession with her refusal to worship Saints and the Virgin, is not entirely obvious,—but undoubtedly she was able to do it to her own satisfaction ; regarding, as she did, the Church at that time, as being in some things perverted and in others remiss, though not hopelessly so. She refers to the subject in the following terms :—" One day," she says, " considering in my mind why it was that I could not, like others, call upon any or the saints in prayer, though closely united to them in God, the thought occurred to me, that *domestics,* in other words, those in a merely justified state, the beginners in the Christian life, the *servants* rather than the *sons* of God, might possibly have some need of the influence and intercession of the saints ; while the *spouse* obtains everything she needs without such helps. God, regarding such a soul as purchased by the blood of Christ, and

as brought into union with Himself, and sustained in union by Christ's merits, neither seeks nor accepts any other influence, or any other intercession. Oh! how little known is the holy Author of all good!"

Soon after her recovery from sickness, she experienced another trial. The proposition of her daughter's betrothment was renewed. Again a number of persons were assembled in her room. She names Charon, Monsieur Pirot, La Mothe, and the guardian of her children. The terms of the proposition were the same as before; but her answer was the same. They paid her the compliment of saying that her treatment of them, under circumstances so embarrassing, was characterized by the highest propriety and courtesy.

An effort, also, was once more made to draw from her some retraction of her opinions. "They wanted such retractions and confessions," she says, "in order that they might serve as a proof of my guilt to posterity. Anything of this kind, under my own hand, would be an evidence, that they *were right in imprisoning me.* And that was not all. Any such papers, drawn up as they wished them to be drawn up, would tend to vindicate their sullied reputation in another respect, and to convince the world that they had properly and justly caused the imprisonment of Father la Combe. They went so far as to make alluring promises on the one hand, and to use violent threats on the other, in order to induce me to write *that La Combe was a deceiver.* I answered that I was content to suffer whatever it should please God to order or permit; and that I would sooner not only be imprisoned, but would rather die upon the scaffold, than utter the falsehoods they proposed."

"During the period," she says, "of the Old Testament dispensation, there were several of the Lord's martyrs who suffered for asserting the existence of the one true God, and for trusting in Him. The doctrine of the one true God, in distinction from the heathen doctrine of a multiplicity of gods, was the test by which conflicting opinions were tried.

"At a later period another great truth was proclaimed, that of *Jesus Christ crucified for sinners.*

"At the present time," she says, "there are those who are *martyrs of the Holy Ghost.* It is the doctrine of PURE LOVE, the doctrine of sanctification and of the Holy Ghost within us, as the Life of our own life, which is to be the test of spiritual perception and fidelity in the present and in future times. The Spirit of God, in the language of the prophet Joel, is to be poured *out upon all flesh.*

"Those, who have suffered for the doctrine of Jesus Christ *crucified for the world's sins,* have been truly glorious in the reproach and sorrows they have endured; but those who have suffered, and are destined to suffer, for the doctrine of the coming and of the triumphant reign of the Holy Spirit in men's souls, will not be less so. The doctrine of Christ crucified as an atoning sacrifice is essentially triumphant. Satan has ceased, in a great degree, to exercise his power against those who receive and believe it. But, on the contrary, he has attacked and will attack, both in body and in spirit, those who advocate the dominion of the Holy Spirit, and who have felt His celestial impulse and power in their own hearts. O Holy Spirit, a Spirit of love! let me ever be subjected to thy will; and as a leaf is moved before the wind, so let my soul be influenced and moved by the breath of thy wisdom. And as the impetuous wind breaks down all that resists it, even the towering cedars which stand in opposition; so may the Holy Ghost, operating within me, smite and break down everything which opposes Him."

The recognition of God, as one God, gave rise to the inquiry, —How does this one God, who in being one combines in Himself all that is good and true, and how *must* He, from His very nature, regard all sin; and on what principles does He forgive it? The question is solved in the announcement of the other doctrine to which she refers, namely, that of *Christ crucified.* "Without the shedding of blood there is no remission." "*He was wounded for our transgressions, and bruised for our iniquities.*" God not only hates sin, but He punishes it. He has no

more moral right or power to detach suffering from sin, than He has to detach peace and joy from holiness. The connexion between them is fixed, inseparable, and can no more change than the Divine nature can change. Where there is sin, there must be suffering; and suffering flowing from sin, and in consequence of sin, is something more than suffering; it is PUNISHMENT. But in the mystery of the mission, person, and sufferings of His Son (a mystery which even the angels unavailingly desire to look into), God has so taken this suffering upon Himself, that, without any violation of the claims of unchangeable rectitude, He can now extend forgiveness to His rebellious creatures, take them once more to His bosom, and bid them live for ever.

But there is another great truth;—namely, that of God, in the person of the inward Teacher and Comforter, dwelling in the hearts of His people, and changing them by His Divine operation into the holy and beautiful image of Him who shed His blood for them. Christ, received by faith, came into the world to save men from the penalty of sin; but He came also to save them from sin itself. The voice has gone forth—Put away all sin; Be like Christ; BE YE HOLY.

We may introduce here, as illustrative further of her labours in prison, a few passages from her letters.

EXTRACTS OF LETTERS FROM HER PRISON.

"To ——. I have just received your kind letter; and I can assure you, that it has comforted me in my *place of exile*. Sometimes I can apply to myself the expressions of the Psalmist: '*Woe is me that I sojourn in Mesech; that I dwell in the tents of Kedar; my soul hath long dwelt with him that hateth peace.*' (Ps. cxx. 5, 6.) While I am kept here by the power of my enemies, I cannot help thinking of those who need spiritual instruction. What a mysterious providence it is, which keeps me out of my place of labour, out of my *element!* It looks to me, as if there were great numbers of children asking for bread, and that there is scarcely any one to break it to them."

" To ——. It is no news to you, that I am a prisoner, and always kept under lock and key; and that, except the woman who has charge of the room in which I am shut up, I am not permitted to speak to any one either within or without, unless it be by special arrangement. I am afflicted, although I have firm trust and rest in God. And will not one, who I know is not indifferent to my situation, impart to me the great consolation of knowing, that she has given her whole heart to the Saviour!

" Oh! how sad it is to see how much opposition there is to the religion of the heart; I see and hear so much of it, that I am sometimes overwhelmed and confounded, and hardly know what I am saying or doing. I have, however, the consolation which is given to every heart that has truly found God.

" In regard to yourself, you will permit me to say, that I sometimes feel a degree of solicitude on your account. I must confess that I have some fears, lest at your tender age you may be exposed to temptations, and may turn away from God. But here, as everywhere else, I have but one resource;—I must resign you into God's hands, never ceasing to entreat Him, in the most earnest manner, for the good of your soul. Oh! what a happiness it is to be thoroughly resigned to Providence!—a resignation which constitutes the true repose of life.

" I have one word more to say. When I came here, my daughter was taken from me. Those who took her do not allow me to know where she is. You will permit me, if you can obtain a knowledge of her situation, to ask your friendly interest in her behalf. If I were a criminal condemned to death, they could not easily give more rigorous orders concerning me."

" To ——. It seems, then, that M. ——, of whom we had hoped better things, has become *unstable*. The temptations of the world have shaken, and have even overcome, his religious purposes. The more I see of the want of firmness and stability in men, the more I am bound and fastened, as it were, to God, who is without change.

" I must confess, if the heart of her to whom I now write,

were not more fully fixed in God, I should be much concerned and grieved at it. O my friend! aim higher and higher. What would I not suffer to see you wholly delivered from the inward power of sin! Without ceasing I pray to God, that He may deliver you from the life of self in all its forms; that He himself may be your WAY and TRUTH and LIFE, and that He may establish you in the blessedness of *pure love.*

" Was not our beloved Saviour looked upon and denounced in the same manner? Is it a hard matter to walk in His footsteps, and to suffer as He suffered? When I am thinking upon these things, I sometimes find my heart, in its perplexity, looking up and saying, ' *Judge me, O God! and plead my cause.*' "

We find the following memorandum, inserted in the eighth chapter of the Third Part of her Life :—

" *Completed thus far, on this the 22d of August* 1688. *I am now forty years of age, and in prison ; a place which I love and cherish, as I find it sanctified by the Lord.*"

The following poem, selected and rearranged from a longer one, is one of those translated by Cowper.

GOD'S GLORY AND GOODNESS.

INFINITE GOD! thou great, unrivall'd One!
Whose light eclipses that of yonder sun;
Compared with thine, how dim his beauty seems
How quench'd the radiance of his golden beams!

O God! thy creatures in one strain agree;—
All, in all times and places, speak of thee
Even I, with trembling heart and stammering tongue
Attempt thy praise, and join the general song

Almighty Former of this wondrous plan
Faintly reflected in thine image, man ;
Holy and just! The greatness of whose name
Fills and supports this universal frame !—

Diffused throughout infinitude of space,
Who art thyself thine own vast dwelling-place
Soul of our soul! whom yet no sense of ours
Discerns, eluding our most active powers;

Encircling shades attend thine awful throne ;
That veil thy face, and keep thee still unknown .
Unknown, though dwelling in our inmost part,
Lord of the thoughts, and sovereign of the heart.---

Thou art my bliss ! the light by which I move '
In thee, O God ! dwells all that I can love.
Where'er I turn, I see thy power and grace,
Which ever watch and bless our heedless race.

Oh ! then, repeat the truth, that never tires ;
No God is like the God my soul desires ;
He, at whose voice heaven trembles, even He.
Great as He is, knows how to stoop to me.

Vain pageantry and pomp of earth, adieu !
 have no wish, no memory for you !
Rich in God's love, I feel my noblest pride
Spring from the sense of having nought beside.

CHAPTER XXXVII.

Efforts of her friends unavailing—Madame de Miramion—Visits the Convent—Becomes acquainted with Madame Guyon—Makes known her case to Madame de Maintencn, who intercedes with Louis XIV.—Madame Guyon released by the king's order, in October 1688—Resides with Madame de Miramion.—Marriage of her daughter with the Count de Vaux—Notices of his family—Resides with her daughter—Letters—A Poem.

HER prospects of an immediate release varied. Her friends seem to have done everything which propriety would warrant. As the ear of the king, however, was reached in other quarters, they were not able, at present, to effect anything in her behalf. Her imprisonment terminated in the following manner.

There was a lady in Paris, Madame de Miramion, much distinguished for her piety and good works, who sometimes visited the Convent of St. Marie. The Prioress and the Nuns gave her a favourable account of Madame Guyon. Not satisfied, she sought her acquaintance, and learned from her own lips those lessons of the inward life upon which she herself had already entered. She needed no further evidence ; but felt that her piety rather than her crimes, had been the real source of the

aspersions cast upon her, and the secret cause which had brought her to a prison.

This lady conversed with Madame de Maintenon, whose peculiar but influential position is well known, in relation to the character of Madame Guyon, and the treatment she had experienced. The account, which she gave, made a favourable impression, which was sustained and increased by Madame de Maisonfort, a distant relative of Madame Guyon, and also by the Duchesses Beauvilliers and Chevreuse. The influence of Madame de Maintenon with Louis XIV., to whom she was at this time, or at a somewhat later period, privately married, was very great, and she now felt it her duty to exert it in favour of Madame Guyon, as she had repeatedly done in other instances for those who had innocently suffered. Embracing the first favourable opportunity, she laid the subject before Louis; but she found his mind so fully possessed with the idea of the heresies of Madame Guyon, that she desisted for a time.

With that clear discernment which characterized her, she sought another and more favourable opportunity. At this time, availing herself of all the information she had obtained, she succeeded in her efforts. The king, either convinced by her statements, or yielding to her importunity, gave orders that Madame Guyon should be freed from imprisonment. The information was communicated to her by the Prioress. The guardian of her children was present at this interesting moment. They both testified great joy at this pleasing event. She was released early in October 1688; having been imprisoned a little more than eight months.

Madame Guyon was not insensible to a change so propitious; and while she blessed God on her own account, she sympathized deeply and sincerely in the joy of her friends. But her own joy was mitigated and tranquillized by the principles of her higher experience. Her enemies had gone just so far as God permitted. It was God who had imprisoned her; it was God who had given her deliverance; and as she entered her prison with calm peace and joy, so she left it with the same feelings.

From the place of her imprisonment she went to the house of Madame de Miramion, who received her with a joy increased by the fact that God had made her an instrument in the event. She there met another distinguished lady, Madame de Montchevreuil. She was once more promptly received into the distinguished families with which she had been associated previously to her imprisonment. Those who had known her and loved her before her imprisonment, did not respect and love her the less afterwards. In a short time she had an interview at St. Cyr with Madame de Maintenon, who expressed in strong terms the pleasure which she felt in seeing her at liberty; and thus commenced an acquaintance which had some important results.

Among the persons present at this interview were the Duchesses Bethune, Beauvilliers, and Chevreuse, and the Princess d'Harcourt; a circumstance which indicates more distinctly the class of society to which she was admitted, and some portion of the field of her religious influence. She was introduced to Madame de Maintenon by the Duchess Bethune, a lady personally known to her from childhood, and very friendly to her.

Not long after, she had an interview with the Archbishop of Paris, who expressed a desire, as if not altogether satisfied with his own conduct, that she would say as little as possible of what had taken place. The opinion had already begun to prevail, that interested motives, as well as a regard for the Church, had exercised a share of influence with him. His own nephew, the Marquis of Chanvalon, had been proposed as the husband of Mademoiselle Guyon.

As it was not convenient to re-establish her family immediately, she took up her residence with Madame de Miramion. And as her imprisonment had neither broken her courage nor perplexed her faith, she immediately resumed her labours. The watchfulness of her opposers rendered it somewhat difficult for her to continue her religious conferences for prayer and conversation; but, too devoted and persevering to be foiled by ordinary obstacles, she neither ceased to make efforts, nor did her efforts cease to be availing.

At this period her labours assumed a more limited and perhaps a more exclusive form. In the earlier periods, she had laboured to do good in various ways. But at this time the question of a higher inward life, the question of sanctification, was agitated very widely, and with great interest among many persons. Persons in this situation especially sought the acquaintance and assistance of Madame Guyon. And such cases had become so much multiplied, that she now thought it her duty to give to them her special and perhaps exclusive attention.

" What sufferings," such is the import of some remarks which she makes, " have I not endured in labouring for the souls of others !—sufferings, however, which have never broken my courage, nor diminished my ardour. When God was pleased to call me to Christ's mission, which is a mission of peace and love to the sinful and the wandering, He taught me that I must be willing to be, in some sense, a partaker in Christ's sufferings. For this mission, God, who gives strength equal to the trials of the day, prepared me by the *crucifixion of self.*

" When I first went forth, some supposed that I was called to the work of gaining exterior proselytes to the Church. But it was not so. I had a higher calling. It was not a calling to build up a party, but to glorify God ; it was not a designation to make Catholics, but to lead persons, with God's assistance, to a knowledge of Christ.

" And now I think I can say further, that God does not so much design me, in my labours hereafter, for the first conversion of sinners, as to lead those who are already beginners in the Christian life, into what may be perhaps called a *perfect* conversion."

She remained at the house of Madame de Miramion, as nearly as can now be ascertained, till the early part of the year 1690. At this time her daughter was married to Louis Nicholas Fouquet, Count de Vaux. She had formed an acquaintance with him at the residences of some of her distinguished friends ; and such was the favourable impression she received of his character and morals, that she thought her daughter might be safely in-

trusted to his hands. They were married at the house of Madame de Miramion, who sympathized with Madame Guyon in an event of so much interest. As her daughter was quite young, being scarcely in her fifteenth year, she thought she consulted her duty, as well as her personal happiness, in leaving her present residence, and in residing with her a little distance out of the city.

Of the family and personal history of the Count de Vaux we know but little. He was connected, however, with the family of the Duchess of Charost. His father was Nicholas Fouquet, Marquis of Belle-Isle; a man of distinguished ability, who at the early age of thirty-eight held the important post of Superintendent of the Finances of France. Falling for some reasons, public and private, under the displeasure of his monarch, he was arrested, tried, and condemned to perpetual banishment. This was afterwards exchanged for imprisonment in the citadel of Pignerol. The common statement is, that he died in this citadel in 1680. But Voltaire, who has given a few interesting particulars of him, says that he was assured by his daughter-in-law, the Countess de Vaux, that he was released before his death, and permitted to retire to an estate belonging to his wife. Of his wife, who was a woman of piety, and of merit, in other respects, we have a short notice in Dangeau.

Fouquet, it seems, had resided for some time at Vaux, where, in the days of his prosperity, he had large possessions, and had built a splendid palace. Madame Guyon became acquainted with Monsieur Fouquet, uncle of her son-in-law, who subsequently showed her various acts of kindness, and with whom she kept up a correspondence by letter. He was not more distinguished by his position than for his ardent piety. Understanding Madame Guyon's views fully, he approved and defended them; and may be said not only to have lived in them, but to have died in them. We shall have occasion to refer to him again.

Of the surviving sons of Madame Guyon, the eldest, Armand Jacques Guyon, settled at Blois. The second received, about

this time, an appointment as an officer in the French Guards; so that there was less necessity than there had formerly been for her keeping up a separate family establishment.

The following is extracted from one of her letters :—

TO ONE WHO HAD THE CARE OF SOULS.

" Sir,—The great thing to be kept in view by religious pastors at the present time, is the distinction between outward or ceremonial religion, and inward religion or that of the heart. Religion, in its full development, is the same thing with the inward kingdom or the reign of God in the soul. And certain it is, that this inward or spiritual reign can never be established by outward ceremonies and observances alone.

" It can be nothing new to you, sir, when I remark, that the religion of the primitive disciples of Christ was characterized by being *inward*. It was the religion of the soul. The Saviour made an announcement of unspeakable importance, when He said,—' *It is expedient for you that I go away; for if I go not away, the Comforter will not come unto you.*' He seems to have intended by this announcement, in part at least, to turn their attention from outward things, and to prepare their hearts to receive the fulness of the Holy Spirit, which He looked upon as the *one thing necessary*.

" The form is merely the sign of the *thing*. I may, perhaps, give offence in saying it, and am certainly liable to be misunderstood ; but still it seems to me, that there may even be such a thing as *outward* praying, or praying in the *form* without the *spirit*. It is true the Saviour gave a form of prayer, which is a very wonderful one. Nevertheless, He rebukes long and ostentatious prayers, and disapproves of frequent repetitions. He tells the disciples, that they are not heard for their much speaking ; and assigns as a reason, that their heavenly Father knows what they want before they ask Him. He says, ' *When thou prayest, enter into thy closet, and pray to thy Father who seeth in secret, and thy Father who seeth in secret shall reward thee openly.*'

"Oh, sir! how much it is to be desired, that all persons, getting beyond mere outward supports, may have their life *from* God and *in* God! Such a day will certainly come to pass. We see already some evidences of its approach in the lives of those who, in having no will but Christ's will, live by faith; whose whole joy is in having dispositions that are *from* God and *with* God; and who regard all outward things as the mere transient signs and incidents, and not the reality of life.

"It is with earnestness, therefore, that I conjure you, sir, to aid souls to the utmost of your power, in their spiritual progress; so that they may not stop short of God's *inward reign*. The subjection of human selfishness by holy love, and the subjection of the human will by union with the Divine will, may be said to make *Christ within* us. Christ will come visibly in the clouds of heaven. But in the spiritual sense, and in some respects in the more important sense, He may come NOW; He may come TO-DAY. Oh! let us labour for His *present* coming; not for a Christ in the clouds, but for a Christ in the affections; not for a Christ seen, but for a Christ felt; not for a Christ outwardly represented, but for a Christ inwardly realized. '*Thou sendest forth thy Spirit, they are created; and thou renewest the face of the earth.*' (Ps. civ. 30.)

"On this subject it is difficult for me to express my feelings, so strong are the desires which exist in me. When will men renounce themselves that they may find God? Willingly, full willingly, I would shed my blood, I would lay down my life, if I could see the world seeking and bearing Christ's holy image. —I remain yours in our Lord,

"JEANNE MARIE B. DE LA MOTHE GUYON."

She had a brother, Gregory de la Mothe, apparently a sincere and pious man, connected with the Carthusians. To him she writes:—

TO M. GREGOIRE BOUVIÈRES DE LA MOTHE.

"MY DEAR BROTHER,—It is always with the greatest pleasure that I receive any tidings from you: but your last letter gave

me more satisfaction than any previous ones. You are the only surviving member of our family who appears to understand the dealings of God with me, and to appreciate my situation. I receive your letter as a testimonial of Christian union and sympathy.

" The Lord has seen fit to bless me much in the labours for a revival of inward religion, especially in Grenoble, where the work was very wonderful.

" I speak to you, my dear brother, without reserve. And, in the first place, my soul, as it seems to me, is united to God in such a manner that my own will is entirely lost in the Divine will. I live, therefore, as well as I can express it, out of myself and all other creatures, in union with God, because in union with His will. . . . It is thus that God, by His sanctifying grace, has become to me ALL in ALL. The self which once troubled me is taken away, and I find it no more. And thus God, being made known in things or events, which is the only way in which the I AM, or Infinite Existence, can be made known, everything becomes, in a certain sense, God to me. I find God in everything which is, and in everything which comes to pass. The creature is nothing ; God is ALL.

" And if you ask why it is that the Lord has seen fit to bless me in my labours, it is because He has first, by taking away my own will, made me a *nothing*. And in recognising the hand of the Lord, I think I may well speak of God's agency physically as well as mentally ; since He has sustained me in my poor state of health and in my physical weakness. Weak as I have been, He has enabled me to talk in the day, and to write in the night.

" After the labours of the day, I have, for some time past, spent a portion of the night in writing commentaries on the Scriptures. I began this at Grenoble ; and though my labours were many and my health was poor, the Lord enabled me, in the course of six months, to write on all the books of the Old Testament.

" I am willing, in this as in other things, to commit all to

L

God, both in doing and suffering. To my mind it is the height of blessedness to cease from our own action, in order that God may act in us.

" And this statement, my dear brother, expresses my own condition, as it is my prayer that it may express yours.

" In such a state, riches and poverty, and sorrow and joy, and life and death, are the same. In such a state is the true heavenly rest, the true Paradise of the spirit.

" In the hope and prayer that we may always be thus in the Lord, I remain, in love, your sister,

" JEANNE MARIE B. DE LA MOTHE GUYON.

" Dec. 12, 1689."

GOD THE FOUNTAIN OF LOVE TO HIS CHILDREN

[From her Poems, Churchill's Edition.

I LOVE my God, but with no love of mine,
 For I have none to give;
I love thee, Lord; but all the love is thine,
 For by thy love I live.
I am as nothing, and rejoice to be
Emptied, and lost, and swallow'd up in thee.

Thou, Lord, alone, art all thy children need,
 And there is none beside ;
From thee the streams of blessedness proceed ;
 In thee the bless'd abide.
Fountain of life, and all-abounding grace,
Our source, our centre, and our dwelling-place.

CHAPTER XXXVIII.

Fénelon—Character—Early designs—Interesting letter—Sent by Louis XIV. as a missionary to Poitou—Learns something of the religious labours of Madame Guyon—On his return, in 1688, passes through Montargis, and makes inquiries—Meets her for the first time at the country residence of the Duchess of Charost, at Beine—They return to Paris together —Letters.

AT this period, Madame Guyon's history becomes interwoven with that of Fénelon, Archbishop of Cambray, in a remarkable

manner. The remarks, however, of the Chancellor D'Agues-
seau on Fénelon, in the Memoirs of the Life of his Father, seem
to me so striking as well as just, that I am tempted to quote
them here.

"Fénelon," says the Chancellor, "was one of those uncom-
mon men who are destined to give lustre to their age; and who
do equal honour to human nature by their virtues, and to litera-
ture by their superior talents. He was affable in his deportment,
and luminous in his discourse; the peculiar qualities of which
were a rich, delicate, and powerful imagination; but which
never let its power be felt. His eloquence had more of mild-
ness in it than of vehemence; and he triumphed as much by
the charms of his conversation as by the superiority of his
talents. He always brought himself to the level of his company;
he never entered into disputation; and he sometimes appeared
to yield to others at the very time that he was leading them.
Grace dwelt upon his lips. He discussed the greatest subjects
with facility; the most trifling were ennobled by his pen; and
upon the most barren he scattered the flowers of rhetoric. The
peculiar, but unaffected mode of expression which he adopted,
made many persons believe that he possessed universal know-
ledge, as if by inspiration. It might, indeed, have been almost
said, that he rather invented what he knew than learned it. He
was always original and creative; imitating no one, and himself
inimitable. A noble singularity pervaded his whole person;
and a certain undefinable and sublime simplicity gave to his
appearance the air of a prophet."

The account which is given of him by his contemporary, the
Duke de St. Simon, is also striking. "Fénelon," says St.
Simon, "was a tall man, thin, well made, and with a large
nose. From his eyes issued the fire and animation of his mind
like a torrent; and his countenance was such that I never yet
beheld any one similar to it, nor could it ever be forgotten if
once seen. It combined everything, and yet with everything
in harmony; it was grave, and yet alluring; it was solemn,
and yet gay; it bespoke equally the theologian, the bishop, and

the nobleman. Everything which was visible in it, as well as in his whole person, was delicate, intellectual, graceful, becoming, and, above all, noble. It required an effort to cease looking at him. All the portraits are strong resemblances, though they have not caught that harmony which was so striking in the original, and that individual delicacy which characterized each feature. His manners were answerable to his countenance. They had that air of ease and urbanity, which can be derived only from intercourse with the best society, and which diffused itself over all his discourse."

Fénelon, who added ardent piety to the highest order of talents, and to the graces of expression and manner, had formed the purpose to live and act solely for the cause of God. His first plan was to go as a missionary to Canada, at that time under France, and one which could not possibly furnish any attractions to a person of his turn of mind, separate from religion. In the simplicity and love of his heart, he was willing to spend the splendid powers which God had given him, in instructing a few ignorant savages in the way of life.

Disappointed in this, he next turned his attention to Greece; and he indulged the hope that he might be permitted to preach the gospel in a land which could not fail to be endeared to him by many classical and historical recollections. There is a letter extant, written at this time, which would be interesting if in no other light than as a memorial of the youthful Fénelon, in which the warmth of his heart blends with the vividness of his imagination. It is dated at Sarlat, and was probably addressed to Bossuet. The following is a part of it :—

" Several trifling events have hitherto prevented my return to Paris; but I shall at length set out, sir, and I shall almost fly thither. But, compared with this journey, I meditate a much greater one. The whole of Greece opens before me, and the Sultan flies in terror ;—the Peloponnesus breathes again in liberty, and the Church of Corinth shall flourish once more ;— the voice of the apostle shall be heard there again. I seem to be transported among those enchanting places and those inesti-

mable ruins, where, while I collect the most curious relics of antiquity, I imbibe also its spirit. I seek for the Areopagus, where St. Paul declared to the sages of the world the unknown God. I kneel down, O happy Patmos! upon thy earth, and kiss the steps of the apostle ; and I shall almost believe that the heavens are opening on my sight. Once more, after a night of such long darkness, the dayspring dawns in Asia. I behold the land which has been sanctified by the steps of Jesus, and crimsoned with His blood. I see it delivered from its profaneness, and clothed anew in glory. The children of Abraham are once more assembling together from the four quarters of the earth, over which they have been scattered, to acknowledge Christ whom they pierced, and to show forth the Lord's resurrection to the end of time."

In this plan also he was disappointed. There was work for him in France.

It was a part of the system of Louis XIV. to establish uniformity of religion ; and he had the sagacity to see, that, in carrying out this difficult plan, he needed the aid of distinguished men. As a preliminary step, Louis had revoked the edict of Nantes. This edict, promulgated in 1598 by Henry IV., embodied principles of toleration, which furnished for many years a considerable degree of protection to the French Protestants. Intoxicated with power, and ignorant of that sacred regard which man owes to the religious rights and principles of his fellow-man, he had commenced, previously to its revocation, a series of hostile acts, entirely inconsistent with the terms and principles of the edict of Henry. The sword was drawn in aid of the Church ; blood had already been shed in some places ; and it is stated that, soon after the revocation of the protecting edict, no less than fifty thousand families, holding their religion more precious to them than worldly prosperity, left France.

So desirous was the French monarch of making the Roman Catholic the exclusive religion of his kingdom, that he united together different and discordant systems of proselytism, and

added the milder methods of persuasion to the argument of the sword. There were men among the Protestants who could never be terrified, but might possibly be convinced. And knowing their tenacity of opinion, if not the actual strength of their theological position, he was desirous of sending religious teachers among them, who were distinguished for their ability, mildness, and prudence. Under these circumstances, he cast his eye upon the Abbé de Fénelon.

The young Abbé waited upon the king. He received from the monarch's lips the commission which indicated the field and the nature of his labours. The labour assigned him was the difficult one of showing to the Protestants, whose property had been pillaged, whose families had been scattered, and blood shed like water, the truth and excellencies of the religion of their persecutors. Fénelon, who understood the imperious disposition of Louis, and at the same time felt an instinctive aversion to the violent course he was pursuing, saw the difficulty of his position. He consented, however, to undertake this trying and almost hopeless embassy on one condition only ;—namely, *that the armed force should be removed from the province to which he should be sent as a missionary, and that military coercion should cease.*

In Poitou, which Louis had assigned him as the field of his missionary labours, Fénelon first heard of Madame Guyon. He became acquainted with the remarkable story of her missionary labours, of her writings on religion and religious experience, and of the high and somewhat peculiar character of her piety. His desire to know something more of this woman had not ceased when, after nearly a three years' residence, he completed the labours of his mission to Poitou, in which he had secured the respect and affection of those from whom he differed in opinion.

On his return, in the latter part of 1688, he passed through Montargis, the early scene of Madame Guyon's life. Thinking it proper to learn all that he conveniently could of her character, before he formed that more intimate acquaintance which he

evidently designed after his return to Paris, he made all the inquiries necessary. " Questioning several persons respecting her," says M. de Bausset, " who had witnessed her conduct during her early years, and while she was married, he was interested by the *unanimous* testimonies which he heard of her piety and goodness."

At Paris, he learned more distinctly the facts which had reached him in the distant field of his missionary labours. He learned also, that she was in disgrace with the monarch. Had Fénelon, knowing as he did the jealous and imperious tendencies of the mind of Louis, consulted merely worldly interest, he would have avoided her. But, following the suggestions of his own benevolent heart, and of that silent voice which God utters in the souls of those who love Him, he did otherwise.

Fénelon met Madame Guyon, for the first time, at the house of the Duchess of Charost, who had a retired establishment at the village of Beine, a few miles beyond Versailles and St. Cyr, where Madame Guyon made frequent visits.

It would somewhat save appearances, therefore, if Fénelon could meet her here. And accordingly, their meeting at this place seems to have been the result of a private arrangement. They conversed together at much length, not on worldly subjects, for that was foreign to their feelings; not on the external arrangements and progress of the Church, for that was a subject which had been familiar to them from childhood ; but on a subject vastly more important than either, that of *inward religion.* The immense importance of the subject, the correspondence between the doctrines of a transforming and sanctifying spirituality and the deeply felt needs of his own soul, the presence and fervid eloquence of a woman, whose rank, beauty, and afflictions could not fail to excite an interest exceeded only by that of her evangelical simplicity and sanctity, made a deep impression on the mind of Fénelon.

After spending a part of the day, they both returned to Paris in the same carriage, accompanied by a young female attendant, whom Madame Guyon kept with her ; which gave them stil'

farther opportunity to prosecute this conversation, and to explain more particularly her views of religious experience and growth. From that time they were intimate friends.

"Some days after my release from prison," she says, "having heard of the Abbé de Fénelon, my mind was taken up with him with much force and sweetness. It seemed to me, that the Lord would make me an instrument of spiritual good to him; and that, in the experience of a common spiritual advancement, He would unite us together in a very intimate manner. I inwardly felt, however, that this interview, without failing to increase his interest in the subject of the Interior Life, did not fully satisfy him. And I, on my part, experienced something which made me desire to pour out my heart more fully into his. But there was not as yet an entire correspondence in our views and experience, which made me suffer much on his account.

"It was in the early part of the next day that I saw him again, (at the house of the Duchess of Bethune.) My soul desired that he might be all that the Lord would have him to be. We remained together for some time in silent prayer; and not without a spiritual blessing. The obscurity which had hitherto rested upon his spiritual views and exercises began to disappear; but still he was not yet such as I desired him to be. During eight whole days he rested as a burden on my spirit. During that time my soul suffered and wrestled for him; and then, the agony of my spirit passing away, I found inward rest. Since that time, looking upon him as one wholly given to the Lord, I have felt myself united to him without any obstacle. And our union of spirit with each other has increased ever since, after a manner pure and ineffable. My soul has seemed to be united to his in the bond of Divine love, as was that of Jonathan to David. The Lord has given me a view of the great designs He has upon this person, and how dear he is to Him."

The following letter appears to have been the first that passed between them :—

"PARIS, *November* 1688.

"To THE ABBÉ DE FÉNELON,—I take the liberty to send you

some of my writings. It is my desire that you should act the part of a censor in regard to them. Mark with your disapproval everything in them which comes from the imperfections of the creature rather than from the Spirit of God. I have other writings, which, if I did not fear to fatigue you, it would please me much to bring under your notice, to be preserved or to be destroyed as you might think them worthy of preservation or otherwise. If I should learn that you do not consider those which are now sent as unworthy of your attention, I may send the others at some future time. As I send them in the spirit of submission to your theological and critical judgment, and with entire sincerity, I count upon it that you will spare nothing which ought not to be spared. When you shall have read the sheets which I have sent to you, you will do me a favour by returning them with your corrections.

"Permit me to expect that you will deal with me without ceremony. Have no regard to me, separate from what is due to truth and to God's glory. God has given me great confidence in you; but He does not allow me to cause you trouble. And you will tell me frankly when I do so. I am ready to keep up some correspondence with you. If God inspires you with different views, let me know without hesitation. I readily submit myself to you. I have already followed your advice in the matter of confession.

"And now I will turn to another subject. For seven days past I have been in a state of continual prayer for you. I call it prayer, although the state of mind has been somewhat peculiar. I have desired nothing in particular; have asked nothing in particular. But my soul, presenting continually its object before God, that God's will might be accomplished and God's glory might be manifested in it, has been like a lamp that burns without ceasing. Such was the prayer of Jesus Christ. Such is the prayer of the Seven Spirits who stand before God's throne, and who are well compared to seven lamps that burn night and day. It seems to me that the designs of mercy, which God has upon you, are not yet accomplished. Your soul is not yet

brought into full harmony with God, and therefore I suffer. My suffering is great. My prayer is not yet heard.

"The prayer which I offer for you is not the work of the creature. It is not a prayer self-made, formal, and outward. It is the voice of the Holy Ghost uttering itself in the soul, an inward burden which man cannot prevent nor control. The Holy Ghost prays with effect. When this inward voice ceases, it is a sign that the grace which has been supplicated is sent down. I have been in this state of mind before for other souls, but never with such struggle of spirit, and never for so long a time. God's designs will be accomplished upon you. I speak with confidence; but I think it cannot be otherwise. You may delay the result by resistance; but you cannot hinder it. Opposition to God, who comes to reclaim the full dominion of the heart, can have no other effect than to increase and prolong the inward suffering. Pardon the Christian plainness with which I express myself.

<div style="text-align:right">J. M. B. DE LA MOTHE GUYON."</div>

They had opportunities of seeing each other both at Paris and Versailles. But still it was not convenient, and perhaps not proper, that they should see each other very often. But the deep interest felt by Madame Guyon, and the many questions which Fénelon found it necessary to propose to her higher experience, rendered it necessary that they should correspond. The very next day she wrote another letter, which we give in part :—

<div style="text-align:right">" PARIS, November 1688.</div>

"To THE ABBÉ DE FÉNELON,—So deeply absorbing has been the application of my soul to God on your account, that I have slept but little during the past night. And at this moment I can give an idea of my state only by saying, that my spirit, in the interest which it feels for your entire renovation, burns and consumes itself within me.

"I have an inward conviction, that the obstacle, which has hitherto separated you from God, is diminishing and passing away. Certain it is, that my soul begins to feel a spiritual like-

ness and union with yours, which it has not previously felt.
God appears to be making me a medium of communicating
good to yourself, and to be imparting to my soul graces which
are ultimately destined to reach and to bless yours. It may not
be improper to say, however, that while He is blessing and
raising you in one direction, He seems to be doing that which
may be the means of profitable humiliation in another, by
making a woman, and one so unworthy as myself, the channel
of communicating His favours. But I too must be willing to be
where God has placed me, and not refuse to be an *instrument*
in His hands. He assigns me my work. And my work is to be
an instrument. And it is because I am an instrument, which
He employs as He pleases, that He will not let me go. Never-
theless, He makes me happy in being His prisoner. He holds
me incessantly, and still more strongly than ever, in His pre-
sence. And my business there is to present you before Him,
that His will may be accomplished in you. And I cannot
doubt, that the will of God is showing itself in mercy, and that
you are entering into union with Him, because I find that my
own soul, which has already experienced this union, is entering
into union with you through *Him ;* and in such a manner as no
one can well explain, who has not had the experience of it. . . .
So easy, so natural, so prompt are the decisions of the sanctified
soul on all moral and religious subjects, that it seems to reach
its conclusions *intuitively.* . . .

Be so humble and childlike as to submit to the dishonour, if
such it may be called, of receiving blessings from God through
one so poor and unworthy as myself; and thus, the grace which
God has imparted to my own heart flowing instrumentally into
yours, and producing a similarity of dispositions, our souls shall
become like two rivers, mingling in one channel, and flowing on
together to the ocean. Receive, then, the prayer of this poor
heart, since God wills it to be so. The pride of nature, in one
in your situation, will cry out against it ; but remember that
the grace of God is magnified through the weakness of the in-
strumentality He employs. Accept this method in entire con-

tentment and abandonment of spirit, (as I have no doubt that you will,) simply *because God wills it*. And be entirely assured, that God will bless His own instrumentality, in granting everything which will be necessary to you.

"I close by repeating the deep sympathy and correspondence of spirit which I have with you.

"JEANNE MARIE B. DE LA MOTHE GUYON."

CHAPTER XXXIX.

Religious state of Fénelon—Entire consecration to God—Perplexities—Correspondence with Madame Guyon—Interesting letter in answer to one from her—On the successive steps of inward crucifixion—Of unfavourable habits of the will, and the necessity of correcting them—Of the principle of faith in its relation to reason.

THOSE who are acquainted with the personal history of Fénelon, know how fully he combined greatness of intellect with humility and benevolence of temper; so that it was not difficult for him to associate with others, or even to receive instruction in those particulars in which his own experience was defective. And accordingly he did not hesitate to state frankly those points in which he needed advice. He was already a religious man in a high sense; but still it seemed to him that he was not all that he ought to be, and not all that with Divine aid he could be. He panted for higher advancements. He could not rest, until, in the possession of victory over the natural evils of the heart, he had become one with God in freedom from selfishness, and in purity and perfectness of love.

The first struggle of his mind seemed to turn upon the point, whether he should make to God that entire and absolute consecration of himself in all things, without which it is impossible that those higher results should be realized, to which his mind was now directed.

Having taken this first and great step, he awaited the dealings of God with submission, but not without some degree of perplexity. The way was new; and it baffled in his case, as it

generally does in others, all the conjectures of merely human wisdom. The matter of forgiveness through Jesus Christ, as our Saviour, from the penalty of the violated law, was easily understood; but that of holy living, that of being kept moment by moment, in distinction from forgiveness in the first instance, presented itself as a problem attended with different incidents, and perhaps involving new principles. For two years they kept up a frequent intercourse by letter—in which it is easy to see her untiring patience and her deep religious insight. It was hard for him at first to understand, and to realize in practice, the great lesson of living by faith alone. Even at the end of some six or eight months after their correspondence commenced, he had questions to propose, and difficulties to be resolved.

In this state of things she wrote him a long letter, in which she gives a general view of the process in which the soul, that is entirely consecrated to God, undergoes the successive steps of inward crucifixion and of progressive conformity, until it realizes the highest results. She took great pains with it. It is entitled, *A Concise View of the Soul's Return to God, and of its Re-union with Him.*

To this we find a well-digested answer, at some length, from Fénelon, of which the following is a summary :—

"[PARIS,] *Aug.* 11, 1689.

" To MADAME DE LA MOTHE GUYON,—I think, Madame, that I understand, in general, the statements in the paper which you had the kindness to send to me ; in which you describe the various experiences which characterize the soul's return to God by means of simple or pure faith. I will endeavour, however, to recapitulate some of your views, as they present themselves to me, that I may learn whether I correctly understand them.

" I. The first step which is taken by the soul that has formally and permanently given itself to God, would be to bring what may be called its external powers—that is, its natural appetites and propensities, under subjection. The religious state of the soul at such times is characterized by that simplicity which

shows its sincerity, and that it is sustained by faith. So that
the soul does not act of itself alone, but follows and co-operates,
with all its power, with that grace which is given it. It gains
the victory through faith.

" II. The second step is to cease to rest on the pleasures of
inward sensibility. The struggle here is, in general, more
severe and prolonged. It is hard to die to these inward tastes
and relishes, which make us feel so happy, and which God usu-
ally permits us to enjoy and to rest upon in our first experience.
When we lose our inward happiness, we are very apt to think
that we lose God; not considering that the moral life of the
soul does not consist in pleasure, but in union with God's will,
whatever that may be. The victory here also is by faith;
acting, however, in a little different way.

" III. Another step is that of entire crucifixion to any reliance
upon our virtues, either outward or inward. The habits of the
life of SELF have become so strong, that there is hardly anything
in which we do not take a degree of complacency. Having
gained the victory over its senses, and having gained so much
strength that it can live by faith, independently of inward
pleasurable excitements, the soul begins to take a degree of
satisfaction, which is secretly a selfish one, in its virtues, in its
truth, temperance, faith, benevolence, and to rest in them as if
they were its *own*, and as if they gave it a claim of acceptance
on the ground of its merit. We are to be dead to them, con-
sidered as coming from ourselves; and alive to them only as
the gifts and the power of God. We are to have no perception
or life in them, in the sense of taking a secret satisfaction in
them; and are to take satisfaction in the Giver of them only.

" IV. A fourth step consists in a cessation or death to that
repugnance which men naturally feel to those dealings of God
which are involved in the process of inward crucifixion. The
blows which God sends upon us are received without the oppo-
sition which once existed, and existed oftentimes with great
power. So clear is the soul's perception of God's presence in
everything; so strong is its faith, that those apparently adverse

dealings, once exceedingly trying, are now received not merely with acquiescence, but with cheerfulness. It kisses the hand that smites it.

" V. When we have proceeded so far, the natural man is dead. And then comes, as a fifth step in this process, the NEW LIFE ; not merely the *beginning*, but a new life in the higher sense of the terms, the resurrection of *the life of love*. All those gifts which the soul before sought in its own strength, and perverted and rendered poisonous and destructive to itself, by thus seeking them out of God, are now richly and fully returned to it, by the great Giver of all things. It is not the design or plan of God to deprive His creatures of happiness, but only to pour the cup of bitterness into all that happiness, and to smite all that joy and prosperity which the creature has in anything *out of himself.*

" VI. And this life, in the sixth place, becomes a truly transformed life, *a life in union with God*, when the will of the soul becomes not only conformed to God practically and in fact, but is conformed to Him in everything in it, and in the relations it sustains, which may be called a *disposition* or *tendency.* It is then that there is such a harmony between the human and Divine will, that they may properly be regarded as having become one. This, I suppose, was the state of St. Paul, when he says, ' *I live ; yet not I, but Christ liveth in me.*'

" It is not enough to be merely passive under God's dealings. The spirit of entire submission is a great grace ; but it is a still higher attainment to become *flexible ;* that is to say, to move just as He would have us move. This state of mind might perhaps be termed the spirit of *co-operation*, or of *Divine* co-operation. In this state the will is not only subdued ; but, what is very important, all tendency to a different or rebellious state is taken away. Of such a soul, which is described as the Temple of the Holy Ghost, God himself is the inhabitant and the light.

" This transformed soul does not cease to advance in holiness. It is transformed without remaining where it is ; new without

being stationary. Its life is love, *all* love ; but the capacity of its love continually increases.

" Such, Madame, if I understand them, are essentially the sentiments of the letter which you had the kindness to send me.

" I wish you to write me whether the statement which I have now made corresponds with what you intended to convey.

" I would make one or two remarks further in explanation of what has been said. One of the most important steps in the process of inward restoration is to be found in the habits of the will. This I have already alluded to, but it is not generally well understood. A man may, perhaps, have a new life ; but it cannot be regarded as a *perfectly transformed life*, a life brought into perfect harmony with God, until all the evil influences of former habits are corrected. When this takes place, it is perhaps not easy to determine, but must be left to each one's consciousness. This process must take place in the will, as well as in other parts of the mind. The action of the will must not only be free and right, but must be relieved from all tendency in another direction resulting from previous evil habits.

" Another remark which I have to make, is in relation to *faith*. That all this great work is by faith, is true ; but I think we should be careful, in stating the doctrine of faith, not to place it in opposition to reason. On the contrary, we only say what is sustained both by St. Paul and St. Augustine, when we assert, that it is a very *reasonable thing to believe*. Faith is different from mere physical and emotive impulse ; and it would be no small mistake to confound those who walk by faith, with thoughtless and impulsive persons and enthusiasts.

" Faith is necessarily based upon antecedent acts of intelligence. By the use of those powers of perception and reasoning, which God has given us, we have the knowledge of the existence of God. It is by their use also, that we know that God has spoken to us in His revealed word. In that word, which we thus receive and verify by reason, we have general truths laid down, general precepts communicated, applicable to our situation and duties. But these truths, coming from Him who has a

right to direct us, are authoritative. They *command*. And it is our province and duty, in the exercise of *faith* in the goodness and wisdom of Him who issues the command, to yield obedience, and to go wherever it may lead us, however dark and mysterious the path may now appear. Those who walk by faith, walk in obscurity; but they know that there is a light above them, which will make all clear and bright in its appropriate time. We trust; but, as St. Paul says, *we know in whom we have trusted.*

"I illustrate the subject, Madame, in this way. I suppose myself to be in a strange country. There is a wide forest before me, with which I am totally unacquainted, although I must pass through it. I accordingly select a guide, whom I suppose to be able to conduct me through these ways never before trodden by me. In following this guide, I obviously go by *faith;* but as I know the character of my guide, and as my intelligence or reason tells me that I ought to exercise such faith, it is clear that my faith in Him is not in opposition to reason, but is in accordance with it. On the contrary, if I refuse to have faith in my guide, and undertake to make my way through the forest by my own sagacity and wisdom, I may properly be described as a person without reason, or as unreasonable; and should probably suffer for my want of reason by losing my way. Faith and reason, therefore, if not identical, are not at variance.

"Fully subscribing, with these explanations, to the doctrine of faith as the life and guide of the soul, I remain, Madame, yours in our common Lord, FRANCIS S. FÉNELON."

CHAPTER XL.

Remarks on Fénelon—Letter from Madame Guyon—Her remarks on faith—On the entire consecration of the will—Incident in her past experience illustrative of the doctrine of faith —Fénelon appointed, August 1689, preceptor to the Duke of Burgundy—Character of the Duke—Labours of Fénelon—The writings of Fénelon—The influence of Madame Guyon upon him—Her letter on his appointment—Revival of religion at Dijon.

THE principles of the inward life commended themselves entirely to the mind of Fénelon. It is true that these principles,

saying nothing of the support they have in the Scriptures, are found with slight variations in many of the Mystic writers; in Kempis and Thauler, in Ruysbroke, in Cardinal Bona, in Catherine of Genoa, in John of the Cross, and others; but Fénelon does not appear to have had much acquaintance with these writers at this time.

Although they were thus introduced to his notice through the instrumentality of a woman, who, though greatly accomplished in other respects, possessed but a limited knowledge of theological writings, and had learned them not so much from books as from the dealings of God with herself personally, they were nevertheless sustained by an inward conviction of their soundness. His enlightened and powerful mind, uninfluenced by the various prejudices which often prevent a correct perception, saw at once that they bore the signatures of reason and truth. And letting them have their full power upon himself, and endeavouring, with Divine assistance, to be what he felt that he ought to be, he stood forth to the world, not merely a man, *but a man in the image of Christ;* not more commended by the powers of his intellect and the perfection of his taste, than by his simplicity of spirit, his purity, and benevolence.

It is in this inward operation that we find the secret spring of that justice and benevolence, which impart unspeakable attractions and power to his writings. They seem to be entirely exempted from the spirit of selfishness, and to be bathed in purity and love. And I believe it is the general sentiment, that no person reads the writings of Fénelon without feeling that he was an eminently good and holy man.

On receiving the letter of Fénelon, Madame Guyon wrote a letter in reply, the substance of which is as follows :—

" TO THE ABBÉ DE FÉNELON,—It gives me great pleasure to perceive, sir, that you have a clear understanding of the senti ments which I wished to convey. I agree with you entirely, that faith and reason, though different principles of action, are not opposed to each other. He, however, who lives by faith,

ceases to reason on selfish principles and with selfish aims ; but submits his reason to that higher reason, which comes to man through Jesus Christ, the true conductor of souls. He who walks in faith, walks in the highest wisdom, although it may not appear such to the world. The world do not more clearly understand the truth and beauty of the life of faith, than the ancient Jews understood the Divine but unostentatious beauty which shone in the life of Christ. A worldly mind, full of the maxims of a worldly life, is not in a situation to estimate the pure and simple spirit of one whose heart is conformed to the precepts of Divine wisdom.

" You will notice, that I use the term *disappropriation*, and *entire disappropriation*, as convenient expressions for freedom from all selfish bias whatever. I perceive that you understand and appreciate entirely the idea which I endeavoured imper fectly to express ; namely, that the *disappropriation* or *unselfishness* of the will is not to be regarded as perfect, merely because the will is broken down and submissive to such a degree as to have no repugnance whatever to anything which God in His providence may see fit to send. It is true, this is a very great grace. In a mitigated sense, the will, under such circumstances, may be regarded as dead ; but, in the true and absolute sense, there is still in it a lingering life. There still remains a secret tendency, resulting from former selfish habits, which leads it to look back, as it were, with feelings of interest upon what is lost : in other words, it puts forth its purposes a little less promptly and powerfully in some directions, than it would have done if it had been required to act in others. Thus Lot's wife had determined to leave the city of Sodom : she vigorously purposed, in going forth from the home where she had long dwelt, to conform to the decrees of Providence, which required her departure ; but still, as she passed on, in her flight over the plain, there was a lingering attachment, a tendency to return, which induced her to look back. Her will, though strongly set in the right direction, did not act in perfect freeness and power, in consequence of certain latent reminiscences and attachments, which operated as a hinderance. In like manner the Jews, when they left the land

of Goshen, and were on their way to the better country which the Lord had promised them, often thought with complacency of their residence in Egypt, and of what they enjoyed there.

"In regard to the principle of FAITH, I will farther say, that it sometimes lies latent, as it were, and concealed in the midst of discomfort and sorrow. I recollect, that in the former periods of my experience I once spent a considerable time in a state of depression and deep sorrow, because I supposed I had lost God, or at least had lost His favour. My grief was great and without cessation. If I had seen things as I now see them, and had understood them then as I now understand them, I should have found a principle of restoration and of comfort in the very grief which overwhelmed me. How could I thus have mourned the loss of God's presence, or rather what seemed to me to be such loss, if I did not love Him? And how could I love Him, without faith in Him? In my sorrow, therefore, I might have found the evidence of my faith. And it is a great truth, that in *reality*, whatever may at times be the *appearance*, God never does desert, and never can desert, those who believe.

"Desiring to receive from you, from time to time, such suggestions as may occur, and believing that your continued and increased experience in religious things will continually develop to you new truth, I remain, yours in our Lord,

"JEANNE MARIE B. DE LA MOTHE GUYON."

About this time, Fénelon, selected in preference to able competitors, received from Louis XIV. the appointment of Tutor to his grandson, the Duke of Burgundy, the heir-apparent to the throne of France. Fénelon was recommended to this place by the Duke de Beauvilliers, governor to the grandchildren of the king, of whom the Duke of Burgundy was the eldest.

"Louis XIV.," says M. de Bausset, in remarking upon these appointments, "had not hesitated for a moment as to whom he should select as a governor for his grandson; nor did Monsieur Beauvilliers hesitate a single moment as to the choice of a preceptor. He nominated Fénelon to that office on the 17th of

August 1689, the very day after his own appointment." The king approved the nomination, apparently with entire cordiality; and the choice was greatly applauded in France. We have the testimony of Bossuet, who subsequently came into painful collision with Fénelon, how satisfactory and gratifying it was to him.

The appointment seems to have been unexpected by Fénelon; and certainly received without any solicitation. The duty especially assigned him, was to train up the young prince. He could not be ignorant of the vast responsibility of such an undertaking; but he did not see fit to decline it. He entered upon his duties in the September following.

His pupil, the Duke of Burgundy, had but few of the elements requisite in one destined to be the ruler of a great people. In his natural dispositions he was proud, passionate, and capricious; tyrannical to his inferiors, and haughty and disobedient to those who had the control of him.

" The Duke of Burgundy," says Monsieur de St. Simon, " was by nature terrible. In his earliest youth he gave occasions for fear and dread. He was unfeeling and irritable to the last excess, even against inanimate objects. He was furiously impetuous, and incapable of enduring the least opposition, even of time and the elements, without breaking forth into such intemperate rage, that it was sometimes to be feared that the very veins in his body would burst. *This excess I have frequently witnessed.*"

These unhappy traits of disposition were rendered the more dangerous by being found in combination with very considerable powers of intellect. It was such a character that was committed to Fénelon to be trained, corrected, and remodelled.

To this great task, upon the success of which apparently depended the hopes and happiness of France, Fénelon brought great powers of intellect, a finished education, and above all, the graces of a pure, humble, and believing heart. It was this last trait, perhaps, more than the others that have been mentioned, which had recommended him to the Duke de Beauvilliers. It was natural for him to desire that the young prince, while he had other advantages and means of culture, should not be

deprived of those connected with a religious example and with religious impressions.

Fénelon undertook this difficult task, therefore, which he knew required something more than mere intellectual culture, as a *man of faith and prayer.* It would be interesting and profitable to enter into the details of his labours. It shows with how much devotedness he engaged in them, that he wrote for the special instruction of this prince his well-known Fables and Dialogues. Each of the Fables, and also each of the Dialogues, was written on particular occasions and with particular objects; having been composed for the most part, when the teacher found it necessary to remind his pupil of some faults which he had committed, and to inculcate upon him the duty and the methods of amendment.

There is reason to suppose, that his celebrated work, the Adventures of Telemachus, published many years afterwards, was also written at this time, and with the same general object. In this remarkable work, we have a striking combination of sound judgment with great resources of imagination; so that it is difficult to say, which is most to be admired, the wisdom and benevolence of its political and moral maxims, or the richness and beauty of its imagery.

But here it is natural to make the inquiry:—What one, among all the biographers of Fénelon, has thought of ascribing the truth, purity, and love, which appear in these remarkable writings, and still more in his religious writings, the most of which appeared at a later period, to the influence of Madame Guyon? At this very time he was receiving from her private conversations and correspondence, influences and principles which can never die. With scarcely an exception, the biographers of Fénelon notice this circumstance very slightly; and in the little they have to say, speak less of the aid he received, than of the dangers he is supposed to have escaped. But it ought not to be concealed, that it was a woman's mind, operating upon the mind of their author, from which no small portion of the light which pervades and embellishes them first proceeded.

This is another among the many facts, which go to show the
vast extent, as well as the great diversity, of woman's influence.
She not only forms man in childhood and youth, by that maternal
influence which exceeds all other influence in wisdom, as well as
in efficiency ; but in maturer years her power, though less ob-
vious, perhaps, does not cease to exist. Many are the minds,
whose controlling energy is felt in the movements and the destiny
of nations, and whose names are imperishable in the monuments
of history, that have been sustained and guided in their seasons
of action and endurance, in the origination of plans of benevo-
lence and patriotism, and in the fortitude which carried them
into effect, by the inspirations of woman's genius and the gener-
ous purity of her affections.

And none need this influence more than truly *great men.*
None are so great in this life as to be beyond the need of sup-
port ; and there is something in our nature which proclaims that
the kind of support which they most frequently and most deeply
need, is to be found here. Occupied with great conceptions,
placed in trying and hazardous situations, burdened with anxie-
ties, and pressed with peculiar temptations, who need more than
they the consolations of her sympathy and the suggestions of
her prudence ?

Madame Guyon, in all her labours, appreciated relations and
effects. The soul of Fénelon, in itself, was not more dear than
that of any other person. But when she considered the rela-
tions in which he stood, and the influence which he was capable
of exerting, she felt how necessary it was that he should be
delivered from inferior motives, and should act and live only in
the Lord.

It is not surprising, therefore, that, on the very day after his
appointment, she wrote a letter, of which the following is the
substance :—

" PARIS, *August* 18, 1689.

" TO THE ABBÉ DE FÉNELON,—I have received without sur-
prise, but not without sincere joy, the news of your appointment,
in which it seems to me his Majesty has done no more than

respond to your just claims. For some time past I have had but little doubt that it would devolve upon yourself.

"The last time in which I attended the mass, at which you administered, I had an impression without being able to tell why, that I might not hereafter have so frequent opportunities to unite with you in this service. The secret prayer arose from my heart,—*O that, amid the artifices of the world to which he is exposed, he may ever be a man of a simple and childlike spirit!* I understand now, better than I did then, why it was that the Lord gave me such earnest desires in your behalf.

" I should not be surprised, sir, if you should experience some degree of natural distaste to the office, but you will commit yourself to the Lord, who will enable you to overcome all such trials. Act always without regard to *self.* The less you have of self, the more you will have of God. Great as are the natural talents which God has given you, they will be found to be useful in the employment to which you are now called, only in proportion as they move in obedience to Divine grace.

"You are called, in God's providence, to aid and to superintend in the education of a prince ;—whom, with all his faults, God loves, and has, it seems to me, designs to restore spiritually to Himself. And I have the satisfaction of believing that, in this important office, you will feel it your duty to act in entire dependence, moment by moment, on the influences of the Holy Spirit. God has chosen you to be His instrument in this work ; and He has chosen you for this purpose, while He has passed by others, because He has enabled you to recognise and appreciate, in your own heart, the Divine movement. Although you may not, on account of the extreme youth of the prince, see immediately those fruits of your labours which you would naturally desire, still do not be discouraged. Die to yourself in your hopes and expectations, as well as in other things. Leave all with God. Do not doubt that the fruit will come in its season ; and that God, through the faith of those that love Him and labour for Him, will build up that which is now in ruins. Perhaps you will be made a blessing to the king, his grandfather, also.

" This morning, in particular, my mind was greatly exercised. And as I was thinking, in connexion with your character, and your position in society, of the deep interest which I had felt, and which I continued to feel, the thought arose in my heart, *Why is it thus? why does the heavy responsibility of thus watching and praying rest upon me, and consume me? I am but a little child, an infant.* But a voice seemed to utter itself in my heart, and to reply :—*Say not that thou art a little one. I have put my word in thy mouth. Go where I shall send thee ; speak what I shall command.*

" I speak, then, because I must do what the Lord has appointed me to do, and because the Lord employs me as an instrument, and speaks in me. Already my prayer is in part answered. When the work is completed, and when I see, in the full sanctification of a soul which is so dear to me, all that I have looked for, and all that I have expected, then shall I be able to say, '*Now, Lord, let thy servant depart in peace ; for mine eyes have seen thy salvation.*'—I remain yours in our Lord,

" JEANNE MARIE B. DE LA MOTHE GUYON."

In the early part of 1689, a few months before the events of which we are now speaking, some priests and theological doctors made a visit to Dijon and its neighbourhood. And, apparently to their great surprise, they found a considerable religious movement in progress, of which Madame Guyon was the reputed author, and which was evidently sustained by the free circulation of her writings. In her return from Grenoble to Paris in 1686, she took Dijon in her way, and spent a day or two there. She left a deep impression on a few persons, especially Monsieur Claude Guillot, a priest of high character in the city. The seed thus sown in conversations, enforced by a single sermon from La Combe, sprang up and bore fruit ; so that in 1689 the new religious principles excited much attention. The persons who visited Dijon at this time, coming with some degree of ecclesiastical authority, interposed to stop this state of things. Among other things they collected *three hundred copies of the work of*

Madame Guyon on Prayer, and caused them to be publicly burned.

CHAPTER XLI.

1692—Labours of Madame Guyon—Interviews with Madame de Maintenon—Unhappiness of the latter—Institution of St. Cyr—Interviews between Madame de Maintenon and Madame Guyon—Labours of Madame Guyon with the young ladies—Letters to them—Madame Guyon visited by Sister Malin, resident at Ham—Public attention directed to her again—Interview with Peter Nicole—Interview with Monsieur Boileau, brother of the poet—Writes at his suggestion " A Concise Apology for the Short Method of Prayer"—Poisoned by one of her servants—Temporary concealment—Friendship of M. Fouquet—His sickness and death.

THE letters which passed between Madame Guyon and Fénelon, the greater part of them during this period of a little more than two years, or at most three years, occupy nearly a full volume of her printed correspondence. The same great objects led them also to seek each other's company, with a view to a more direct interchange of opinions. These interviews at one period were frequent.

She resided with her daughter till the year 1692. Here, more than anywhere else, Fénelon had interviews with her.

" The family," she says, " into which my daughter married, being of the number of the Abbé Fénelon's friends, I had frequent opportunities of seeing him. Our conversations turned upon the inward and spiritual life. From time to time he made objections to my views and experience, which I endeavoured to answer with sincerity and simplicity of spirit. The doctrines of Michael de Molinos were so generally condemned, that the plainest things began to be distrusted ; and the terms used by writers on the spiritual life, were for the most part regarded as objectionable, and were set aside. But, notwithstanding these unfavourable circumstances, I was enabled so fully to explain everything to Fénelon, that he gradually entered into the views which the Lord had led me to entertain, and finally gave them his unqualified assent. The persecutions, which he has since suffered, are an evidence of the sincerity of his belief."

But while she was thus labouring and praying to renovate and to mould anew the mind of that remarkable man, she found time and disposition to labour for others. During her residence at the house of her daughter, where, besides frequent interruptions from company, she could not fail to be constantly reminded of the claims and duties of her near relationship, her religious labours, it is true, were somewhat circumscribed. But, as soon as the new relations and interests of her daughter would permit, she felt that the claims of the great cause required her to alter her situation. And accordingly, after the lapse of about two years, she once more hired for her residence a private house in Paris.

In 1692, her acquaintance with Madame de Maintenon became somewhat intimate. This celebrated woman, although for political reasons she was not publicly acknowledged as such, had been privately married to Louis XIV. She had his confidence as well as his affections; and for many years the most important affairs of France depended, in a great degree, upon her cognizance and concurrence. Her power was felt to be hardly less than that of the king. The greatest men of the kingdom paid her homage. Everything which wealth or art could furnish, was put in requisition to render her happy. But still there was a void within her which the riches and honours of the world could not supply.

Her letters, which show her talents and many excellent points of character, disclose also a sorrow of mind which she felt could have no balm but in religion. It is not the world which can heal the wounds it has itself made.

Writing to Madame de la Maisonfort, she says :—" Why can I not give you my experience ? Why can I not make you sensible of that uneasiness which preys upon the great, and the difficulty they labour under to employ their time ? Do you not see that I am dying with melancholy, in a height of fortune which once my imagination could scarce have conceived ? I have been young and beautiful, have had a high relish of pleasure, and have been the universal object of love. In a more

advanced age, I have spent years in intellectual pleasures; I have at last risen to favour; but I protest to you, my dear Madame, that every one of these conditions leaves in the mind a dismal vacuity."*

Under these circumstances, she sought and valued the company of Madame Guyon. She needed the intercourse and advice of persons of piety. There was something in her person and manners which attracted her. She saw her from time to time afterwards; and at this time she went so far as to invite her to the royal palace at Versailles; and felt it no dishonour, as she certainly felt it a great satisfaction and relief, to hear from the lips of her misrepresented and persecuted visitant the story of a Saviour's condescension, the remedy for sin, and the victory which Christ can give over the ills of our fallen nature.

Among the objects which occupied much of the time and affections of Madame de Maintenon, was the celebrated Institution of St. Cyr, which she established in 1686. It was a charitable Institution, combining both literary and religious objects, designed for the support and education of indigent young ladies, at any period under twenty years of age; the daughters of persons who had suffered losses or spent their lives in the service of the state. Two hundred and fifty young ladies, many of them from illustrious but unfortunate families, were assembled there.

Tired of the splendour and cares of Versailles, and attracted by the quiet and benevolence of an institution founded on such principles, Madame de Maintenon spent much of her time, at this period, at St. Cyr. It was here that Madame Guyon met her still more frequently than at Versailles. St. Cyr furnished better opportunities for private and protracted conversations, by its retired and less worldly aspects; and they could meet there without exciting the suspicions of Louis. Madame de la Maisonfort, her friend and relative, was employed at this time as an instructress in the institution. In her visits also, from time to time, to the Duchess of Charost, at her residence at Beine, to

* See Voltaire's Life of Louis XIV., vol. ii. chap. 26.

whom she was now related by the marriage of her daughter, she was accustomed to take a route which led to the vicinity of St. Cyr. So that under these circumstances she found it not more agreeable to her feelings, than it was entirely convenient for her, frequently to visit there.

Madame de Maintenon, pleased and edified by the conversations and instructions of Madame Guyon, gave her liberty to visit the young ladies of the Institution, and to converse with them on religious subjects. Nothing could have been more agreeable than such a labour, for which Providence seems to have especially fitted her. The Divine presence and blessing which almost uniformly attended her in other places, did not desert her here. " Several of the young ladies," she says, " of the House or Institution of St. Cyr, having informed Madame de Maintenon, that they found in my conversation something which attracted them to God, she encouraged me to *continue my instructions to them ;* and by the great change in some of them, with whom she had previously not been well satisfied, she found she had no reason to repent it."

It was something new to the members of this institution,— some of whom were from fashionable though reduced families, while others of a more serious turn probably had nothing more than a *form* of godliness,—to hear of redemption, and of permanent inward salvation by *faith.* All of them had been accustomed more or less to the ceremonials of religion ; and it was not unnatural for them to confound the ceremonial with the substance, the sign with the thing signified. This might not have been the case in all instances ; but generally they regarded their acceptance with God as depending, in a great degree at least, on a number of outward observances, rather than on inward dispositions.

Turned by the conversation of Madame Guyon from the out ward to the inward, led to reflect upon their own situation and wants, they saw that there is something better than worldly vanity ; and began to seek a truer, sincerer, and higher position. They understood and felt deeply for the first time, that religion,

something more than the mere ceremonial, is a *life ;* and that they only are wise, and true, and happy, who *live* to God. How far this moral and religious revolution went in this institution is not known ; but it seems to have been general. A seriousness pervaded it, such as had not existed there before : there was a general recognition of the claims of God ; and the spirit of faith and prayer, of purity and of true benevolence, took, in a great degree, the place of thoughtless scepticism and frivolous gaiety

Not unfrequently she received from some of them letters, proposing inquiries on inward experience and practical duty. She sometimes wrote to them on special occasions, without being invited to it by formal inquiries. The following extracts will illustrate her labours in this way :—

" MADEMOISELLE ——. I have heard of your sickness, not without being sensibly affected by it ; but it has been a great satisfaction to find that God has been present with you, and that your outward sorrows have had an inward reward. Afflictions are the allotment of the present life ; and happy will it be, Mademoiselle, if you shall learn the great lesson of always improving them aright. This, I think, you will be able to do, if you are faithful to the *inward voice.* It is God's decision ; or, if you prefer it, it is God's *voice ;* the voice of God in the soul.

" One of the most important conditions on which we can nave this inward Divine utterance, is this,—*The soul must be in perfect simplicity ;* that is to say, it must be free from all the varieties of human prejudice and passion. It is an easy thing to grieve the Spirit of God. He dwells in and guides the soul, which, in looking at God's will alone, is in *simplicity ;* but He leaves the soul which is under any degree of selfish bias.

" In order, therefore, to hear the voice of God in the soul, we must lay aside all interests of our own. It is necessary for us to possess a mind, if we may so express it, IN EQUILIBRIO ; that is to say, balanced from motives of self neither one way nor the other.

" Not doubting that you will receive the suggestions of this letter as the result of my sincere affection, and of my earnest desire for your religious good, I remain yours,

" JEANNE M. B. DE LA MOTHE GUYON."

The following appears to have been written to a married lady; but probably one with whom Madame Guyon had previously become acquainted at St. Cyr :—

" MADAME ——. Our friend N—— has departed. She was a choice and excellent young woman ; and, in leaving a world where she endured so many trials, she has received the recompense of her labours and sufferings.

" You are right, Madame, in saying that it is not common for us to meet with such treasures of grace. They are indeed more rare than can be expressed. Few, very few, go, as she did, to the bottom of the heart.

" The great majority of those who profess an interest in religious things—religious teachers and guides, as well as seekers of religion—stop short, and are satisfied with the outside and surface of things. They ornament and enrich the exterior of the ark, forgetting that God commanded Moses to begin with the inside and overlay it with gold, and afterwards to ornament the outside. Like the Pharisees of old, they make clean the outside of the cup and platter, but leave the inside impure. In other words, while they endeavour to make a good appearance to men outwardly, they are inwardly full of self-love, of self-esteem, of self-conceit, and of self-will. How different the religious state, if such it may be called, of these persons from that of our departed friend !

" Why do you make a difficulty, Madame, in speaking to me about your dress ? Should you not be free, and tell me all ? You have done well in laying aside the unnecessary ornament to which you refer. I entreat you never to wear it again. I am quite confident also, that, if you would listen to the secret voice which speaks in the bottom of your heart, you would find more

things to put off. Perhaps you will say, that you must regard your husband's feelings. This is true ; but I am persuaded, that, in his present favourable dispositions, you will please him as much by laying aside those ornaments as by wearing them.

" Consider what you owe to God, and promptly crucify all the pretexts of nature. You will never make any such crucifixion of the desires and pretensions of the natural life, without drawing down some returns of Divine grace upon you.

" A Christian woman should be distinguished by a neat and modest dress, but not so affected and ornamented as to attract attention. It is not necessary, however, to lay down an invariable rule. You should wear apparel suited to your situation in life ; but you will pardon me for suggesting the propriety and duty of putting off those superfluous ribbons. I am confident that, in so doing, you will not be less pleasing in the eyes of your husband ; and that you will be much more so in the eyes of Him whom you wish to please above all.

" I am desirous, when you write to me, that you should feel the greatest confidence and freedom. Do not be afraid to propose questions upon things which the world might regard as trifling. So far from lessening my esteem for you, it will have quite a different effect, because I infer from your anxiety in such particulars, that you have a disposition to give yourself wholly to God. It is a sign, I think, that God, in making you attentive and careful in the smallest things, is laying the foundations of His inward work in the very centre of the heart.

" Most earnestly I beseech you to be faithful to Him. In following the Divine guidance, and in doing the Divine will, you will find a thousand times more satisfaction than in the pleasures which the world can impart to you.

" Thus desiring that you may be guided and kept, I remain yours in our Lord, JEANNE M. B. DE LA MOTHE GUYON."

A religious movement in such an institution as that of St. Cyr, could not well take place without being extensively known. Her opposers, who seem to have supposed that her zeal would

be checked by the discipline of her first imprisonment, were once more on the alert.

It was not only at Paris, at Dijon, at Versailles, and St. Cyr, that her influence was felt; but there began to be evidences of .t in other places. A single incident will illustrate this :—A sister Malin, resident at Ham, in the then province of Picardy, was so deeply impressed with the necessity of religious instruction, that she came to Paris for the sole purpose of obtaining such instruction from Madame Guyon. She had charge of an institution for the education of girls; and seemed desirous to learn the truth for others as well as herself. To cases of this kind Madame Guyon always gave a prompt and earnest attention.

Persons also sought her society who had no faith in her doctrines, but were either anxious to obtain further information, or to convert her to their own views. There were many such; and among them was Peter Nicole, known extensively by a multiplicity of writings on various subjects, and as the friend and literary associate of Arnauld, the Port-Royalist. " An acquaintance of mine," she says, "an intimate friend also of Monsieur Nicole, had often heard him speak against me. This person thought that it would not be difficult to remove the objections of Nicole, if we could be made personally acquainted, and have opportunities of conversation. He thought this important, because many had received their impressions from him. Accordingly, although with some reluctance on my part, we met.

" After some little conversation, he referred to my book, entitled the Short and Easy Method of Prayer, and made the remark that it *was full of errors.* I proposed that we should read the book together; and I desired him to tell me frankly and kindly those things in the book which seemed objectionable; expressing the hope, at the same time, that I might be able to meet and answer them. He expressed himself well satisfied; and, accordingly, we read the book through together with much attention.

" After we had read it partly through, I asked him to specify

M

his objections; but he replied, that, so far, he had none. After
we had completed the book, I repeated the question. 'Madame,'
said Nicole, 'I find that my talent is in writing, and not pre-
cisely in personal discussions of this kind. If you have no
objections, I will refer you to a learned and good friend of mine,
Monsieur Boileau. He will be able to indicate the imperfections
of the book; and perhaps you will be able to profit by his sug-
gestions.'"

Nicole was a very learned man, and a great master of reason-
ing. But he had probably never read the book, and hence his
peculiar and not very creditable position at this time. A year
or two afterwards, however, he published a book, in which he
strongly attacked the opinions held by Madame Guyon, and
others, or rather their opinions *as he understood them.**

A few days after this interview, she saw his friend, Monsieur
Boileau, a brother of the French poet and satirist. "He intro-
duced the subject," she says, "of my little book on Prayer. I
told him the state of mind in which I wrote it. He remarked
that he was entirely persuaded of the sincerity of my intentions;
but he said that the book was liable to fall into the hands of
some who might misapply it. I asked him the favour to point
out the passages in it, which caused this anxiety. Accordingly,
we looked over the book together; and when he came to such
passages, I gave explanations, which seemed to satisfy him.

"When we had finished, he said, 'Madame, all that is wanted
is a little more in the way of explanation.' And he pressed me
very much to write something additional and explanatory, which
I agreed to do. A few days after, I completed what he wished
me to write, and sent it to him for examination; and he seemed
to be well satisfied. I revised it once or twice; and he urged
me much to print it."

It was printed some time afterwards, and is entitled, A concise
Apology for the Short and Easy Method of Prayer.

Constantly labouring in the cause of religion, blessed in those

* *Réfutation des Principales Erreurs des Quiétistes, contenues dans les livres censurés
par l'ordonnance de Monseigneur l'Archevêque de Paris 'De Harlai), du 16 Octobre 1694.*

labours continually to an extent seldom witnessed, listened to
with great attention by the ignorant, and criticised or attacked
by the learned, her name came once more into general notice,
and excited a general hostility. The outcries were loud, deep,
and revengeful. Her enemies, seeing the difficulty of quenching
the light of her piety by any ordinary means, resorted to the
most dreadful measures. Attempts were made, through one of
her servants, who seems to have been bribed for that purpose, to
put her to death by poison. She refers to this painful incident
very briefly.

" One of my servants," she says, " was prevailed upon to give
me poison. After taking it, I suffered such exquisite pains, that,
without speedy succour, I should have died in a few hours. The
servant immediately ran away, and I have never seen him since.
At the time it did not occur to me that I was poisoned, until
my physicians came in, and informed me that such was the case.
My servant was the immediate agent; but I am in possession of
circumstances which go strongly to show that others originated
it. I suffered from it for seven years afterwards."

So great was the excitement that she thought it prudent to
live in entire concealment for some months. No one knew
where she was, except Monsieur Fouquet, the uncle of her son-
in-law. He obtained by authority which he had from her, the
the funds necessary for her support; and kept her advised of the
movements of her enemies.

Madame Guyon hoped, by retiring for a time altogether from
notice, there would be some cessation to these attacks. But she
was mistaken. As soon as she disappeared, the report was cir-
culated, that she had gone into the provinces to disseminate her
doctrines there; so that her retirement tended rather to increase
than to allay the ferment. Under these circumstances she
thought it best to return home.

Soon after this, occurred the sickness and death of her friend
Monsieur Fouquet. In him she found one who not only sym-
pathized in her religious views and feelings, but aided her much
as an adviser in her affairs. Madame Guyon seems to have had

entire confidence in his religious experience, practical prudence, and friendly dispositions. And in consequence of the family connexion now existing between them, she could consult him without being subjected to the suspicions and misinterpretations which might have attended the presence and aid of other persons. His last moments were moments of triumphant peace. The following letter was written to him by Madame Guyon, a short time before his death :—

" To MONSIEUR FOUQUET.—Regarding your departure as near at hand, I cannot help saying that, in losing you, I lose one of my most faithful friends; perhaps I may add, that I lose the only friend in whom, under existing circumstances, I can repose with entire confidence in all things. I feel my loss; but the sorrow which I experience does not prevent my rejoicing in the happiness which is yours. It is not your situation which is to be regretted, but rather that of those who are left behind. God, who has made us one in spirit, has announced the hour of separation. May the blessing of our Divine Master rest upon you !

" Go then, happy spirit ;—go, and receive the recompense reserved for all those who have given themselves to the Lord in a love which is pure. As we have been united in time, may we be united in eternity. Let your parting prayer be for her who is left behind, and for the spiritual children whom the Lord has given her, that in all time, and in all things, they may be faithful to His adorable will.

" Farewell ;—and, as you ascend to the arms of Him who has prepared a place for you, be an ambassador for me, and tell Him that my soul loves Him.

" JEANNE M. B. DE LA MOTHE GUYON."

CHAPTER XLII.

Efforts in her behalf—She objects to the course proposed—Bossuet—His character and position—Alarmed at the progress of the new doctrine—Interview with Madame Guyon—Second interview—The conversation—Effect upon Madame Guyon—Correspondence between them—Attacked with a fever.

IN this state of things, some of the friends of Madame Guyon undertook some measures in her behalf. Fearing either some acts of personal violence, or some impressions on the minds of those in authority, which might perhaps lead to a renewed imprisonment, they drew up a memorial to the king, the object of which was to give a correct account of the incidents of her life and of her motives of action, with a view to vindicate and to protect her. This memorial was drawn up with the concurrence and approbation of Madame de Maintenon, who thought it proper to show it to Madame Guyon.

"This paper," says Madame Guyon, "although it was a pleasing evidence of the kindness of those who had a share in framing it, gave me some uneasiness. I had some doubts whether it was the will of God that I should be protected and vindicated in that manner. I was jealous of myself, lest I should be found improperly resting upon a human arm, or too eager to be relieved from that burden of trial, which God's wisdom had seen fit to impose. I earnestly requested my friends not to take this course, but to leave me to the natural developments of Providence. They respected my wishes; and the memorial was accordingly suppressed."

The new spirituality, as it was sometimes termed, particularly arrested the attention of Bossuet, Bishop of Meaux, at this time confessedly the leader of the French Church. And if we estimate him chiefly by his intellectual strength, he deserved to be so. Possessed of vast learning and not greater in the amount of his knowledge than in the powers which originated and controlled it, he brought to the investigation of religious subjects

the combined lights and ornaments of research, of reasoning, and of rich imagination.

By his work, entitled, *A History of the Variations of the Doctrines of the Reformed Churches*, in which he had subjected the doctrines of Luther and of the other Protestant reformers to a severe scrutiny, he had not only acquired a splendid reputation, but had placed himself in a position which led him to be regarded by Roman Catholics as emphatically the *defender of the faith*. This reputation was so dear to him, that he had for many years, as if by strong instinct, fixed his withering eye on the slightest heretical deviations. He knew well what was going on in France. But he who had broken the spear with the strongest intellects of the world, felt some reluctance to entering the lists with *a woman*.

It seemed to him impossible that Madame Guyon, whatever might be her talents and personal influence, could produce an impression, either in Paris or elsewhere, which could be dangerous to the Church. And if it were so, was it not enough, that D'Aranthon and Father Innocentius, men of distinguished ability and of great influence, had already, in the early and distant places of her influence, set in motion measures of opposition ; measures sustained at Paris by the efforts of La Mothe and De Harlai, of Nicole and Boileau, aided by a multitude of subordinate agencies ?

But the result did not correspond with his anticipations. If such distinguished men as the Dukes of Beauvilliers and Chevreuse, and more than all, if such a man as Fénelon, on whom the hopes of France had fastened as its burning and shining light, had come under this influence, to what would these things lead ? It seems never to have occurred to him, that the hand of the Lord might be in all this. He is not wise who thinks lightly of the influence of a woman who has the great intellectual powers, accomplished manners, and serious and deep piety of Madame Guyon. But God has chosen the weak things of the world to confound the things which are mighty. Has He not declared, and has He not sustained the declaration by the

history of spiritual movements in all ages of the world, that He has selected "*things which are not, to bring to nought things that are ?*"

God will so work, and employ such instrumentality, as to glorify Himself. It was not Madame Guyon, but *God in her*, who produced these results. She had undergone those deeply searching and purifying operations of the Holy Spirit which consume the pride and power, "the hay and the stubble" of nature, and leave the subject of it *nothing in himself*. She could find no term which so exactly expressed her situation as the word *Nothing*. But it was a favourite idea with her also, that the ALL of God—His presence, wisdom, and power—dwells, more than anywhere else, in the *nothing* of the creature. This, which Bossuet seems not fully to have understood, was the source of her influence.

The case of Fénelon, in particular, troubled him; Fénelon, whose talents he knew, whose friendship he valued, and of whose piety and influence he had the highest hopes. He determined, therefore, though with some reluctance, to put forth his own great strength, and to risk his own splendid reputation, in the attempt to extinguish this new heresy. But he had known Madame Guyon only by report; and he thought it due to charity and truth, to form a personal acquaintance as a means of more distinctly ascertaining her views. He accordingly visited her, for the first time, at her residence in Paris, with the Duke of Chevreuse, in September 1693. The conversation was at first of a general character. Bossuet remarked, that he had formerly read, with a degree of satisfaction, her Treatise on Prayer, and Commentary on the Canticles. The Duke directed his attention to the work entitled THE TORRENTS. He immediately cast his eye rapidly over some passages. A few moments after, he remarked, without condemning anything, that some things required explanation.

Bossuet made a number of remarks on the necessity and reality of an inward and spiritual life, which were highly gratifying to Madame Guyon. The interview terminated with a pro-

position on her part, which was accepted by Bossuet, that he should examine at his leisure all her writings, and make known more definitely his opinions upon them.

A second meeting took place, January 30, 1694. In the interval, the Duke of Chevreuse, with the permission of Madame Guyon, in order to give him a full view of her history and character, put into the hands of Bossuet the manuscript of her Autobiography. He read it carefully, and politely wrote a letter to the duke, expressive of the interest he felt in it.

All her printed works also were submitted to him, so that Bossuet felt prepared to state some of the objections which he felt to her views.

At the request of Bossuet, both this and his previous interview were kept as secret as possible. The reason he gave was, that the relations existing between him and the Archbishop of Paris, who was probably jealous of his superior knowledge and reputation, were such as to render it desirable. At his request, also, he met her at the house of one of his own friends, the Abbé Jannon, in the street Cassette, near the Convent or House of the religious association, called the Daughters of the Holy Sacrament.

A small part of the conversation is given by Madame Guyon in her Autobiography. What is wanting can, I think, be made up, in a considerable degree, from her subsequent correspondence with Bossuet, and her work entitled, A concise Apology for the Short Method of Prayer. With these aids I have ventured to give the following conversation, as expressive of the substance of what passed, without attempting the precise terms of it. It is rendered remarkable by the topics, and the relation of the parties; and it should not be forgotten, that, while Madame Guyon stood foremost among women of intellect as well as piety, Bossuet was at that time the most distinguished of the theologians of Europe.

Bossuet.—The doctrines which you advance, Madame, involve the fact of an inward experience above the common experience of Christians, even those who have a high reputation for piety.

Madame Guyon.—I hope, sir, it will not be regarded as an offence, if I indulge the hope and belief, that a higher experience, even a much higher one, is practicable than that which we commonly see.

Bossuet.—Certainly not. But when we see persons going so far as to speak of a love to God without any regard to self, of the entire sanctification of the heart, and of Divine union, have we not reason to fear that there is some illusion ? We are told that there is " none that doeth good and sinneth not."

Madame Guyon.—There is no one, except the Saviour, who has not sinned. There is no one who will not always be entirely unworthy. Even when there is a heart which Divine grace has corrected and has rendered entirely upright, there may still be errors of perception and judgment, which will involve relatively wrong and injurious doing, and render it necessary, therefore, to apply continually to the blood of Christ. But while I readily concede all this, I cannot forget that we are required to be like Christ ; and that the Saviour Himself has laid the injunction upon us to love God with all our heart, and to be perfect as our heavenly Father is perfect. My own experience has added strength to my convictions.

Bossuet.—Personal experience is an important teacher. And as you have thus made a reference to what you have known experimentally, you will not think it amiss, Madame, if I ask whether you regard yourself as the subject of this high religious state.

Madame Guyon.—If you understand by a holy heart one which is wholly consecrated and devoted to God, I see no reason why I should deny the grace of God, which has wrought in me, as I think, this great salvation.

Bossuet.—The Saviour, Madame, speaks in high terms of the man who went up into the temple, and smote upon his bosom, and said, " God be merciful to me a sinner."

Madame Guyon.—It is very true, sir, that this man was a sinner ; but it is also true, that he prayed that God would be merciful to him ; and God, who is a hearer of prayer, did not mock either his sorrows or his petitions, but granted his request.

If I may speak of myself, I think I may say, that I too have uttered the same prayer; I too have smitten upon my bosom in the deep anguish of a rebellious and convicted spirit. I can never forget it. Months and years witnessed the tears which I shed; but deliverance came. My wounds were healed; my tears were dried up; and my soul was crowned, and I can say with thankfulness, is now crowned with purity and peace.

Bossuet.—There are but few persons who can express themselves so strongly.

Madame Guyon.—I regret that it is so; and the more so, because it is an evidence of the want of *faith.* Men pray to God to be merciful, without believing that He is willing to be merciful; they pray for deliverance from sin and for full sanctification, without believing that provision is made for it; and thus insult God in the very prayer they offer. Can one like yourself, who has studied the Scriptures so long and so profitably, doubt of the rich provisions of the Gospel, and deny, in the long catalogue of the saints of the Catholic Church, that any of them have been sanctified?

Bossuet.—I am not disposed, Madame, to deny, that the doctrine of sanctification, properly understood, is a doctrine of the Catholic Church. I cannot forget the rich examples in a St. Francis de Sales, in a St. Theresa, and in the celebrated Catharines. But I cannot deny, that I am slow to admit the existence of this great blessing in individual cases. The evidence should be very marked. This, you will admit, is a proper precaution. And conceding that the promises of God are adequate to these great results, and admitting the general truth of the doctrine of sanctification, I must still offer inquiries which involve very serious doubts as to some of its aspects, as presented in your writings.

Madame Guyon.—I have always been ready, sir, to confess my ignorance; and having no system to maintain, and no object to secure, separate from the doing of God's will and the manifestation of His glory, I have no reluctance in submitting what I have said to your correction

Bossuet.—In looking over the manuscript which gives some account of your own personal history, in which I have generally been interested and satisfied, I was somewhat surprised to see that, in a certain passage, you speak of yourself as the woman of the Apocalypse.

Madame Guyon.—There is something of this kind. As I read the passage in the Apocalypse, which speaks of the woman who fled into the wilderness, I must confess, as I thought of myself as driven from place to place for announcing the doctrines of the Lord, it did seem to me that the expressions might be applied *not as prophetic of me, but as illustrative of my condition.*

Bossuet.—I accept your explanation in this particular entirely, and will proceed to some things which seem to me essential. It is not merely my object to criticise, but, in part at least, to obtain explanations, that I may understand the subject more fully, and know, in the situation in which I am placed, what course it is proper to take. You will excuse me, therefore, for asking what you mean by being in the state which is variously denominated the state of holiness, of pure love, and of Christian perfection?

Madame Guyon.—This question might be answered in various ways. But as some of these terms, in their application to human nature, are in some degree odious, and at least liable to be misunderstood, I will say here, that I understand much the same thing as by being in the state of entire self-renunciation. He who is NOTHING, lost to himself, dead to his own wisdom and strength, and, in the renouncement of his own life, lives in God's life, may properly be called a holy man; and, in a mitigated sense of the term, may perhaps be called a perfect man. True lowliness of spirit, accompanied by such faith in God as will supply the nothingness of the creature from the Divine fulness, involves the leading idea of what, in experimental writers, is denominated Christian perfection. Perhaps some other name would express it as well.

Bossuet.—I am glad to find, Madame, that you entertain

such views of Christian perfection as are consistent with lowliness of spirit. The Saviour himself says, " *He that is least among you all, the same shall be great.*" And the Apostle of the Gentiles, eminent as he was in sanctity, describes himself as the " *least of the apostles.*" (Luke ix. 48 ; 1 Cor. xv. 9.) Eminently holy persons feel their dependence and nothingness more entirely than others.

But is it a mark, Madame, of Christian lowliness to disregard principles and practices sanctioned by the wisdom and piety of many ages ? In your Short Method of Prayer, some expressions seem to imply that the austerities and mortifications practised in the Catholic Church are not necessary.

Madame Guyon.—I admit that my views and practices differ in this particular from those of some others. My view now is this. Physical sufferings and mortifications, which tend to bring the appetites into subjection, are of great value ; they are a part of God's discipline, which He has wisely instituted and rendered operative in the present life : but then they should not be self-sought or self-inflicted, but should be received and submitted to, as they come in God's providence. In other words, crosses are good ; our rebellious nature needs them ; not those, however, which are of merely human origin, but those which God himself makes and imposes.

Bossuet.—I am doubtful whether your views on this subject ought to be considered satisfactory. But we will leave them for the present.

I might ask again, Is it consistent with true lowliness of spirit, to lay down the principle, as you have done in THE TORRENTS, that souls in the highest religious state may approach the Sacramental Communion, and partake of the sacred element without special preparation ?

Madame Guyon.—I am entirely confident, sir, that the highest religious experience is not and cannot by any possibility be opposed to the truest humility. Further, I fully appreciate the great importance of a careful and thorough preparation for the Holy Eucharist. But still it does seem to me that a soul, wholly

devoted to God and living in the Divine presence, moment by moment, if it should be so situated as not to enjoy the ordinary season of preparatory retirement and recollection, would still be in a state to partake of the sacramental element.

Bossuet.—If you design, Madame, to limit the remark made in THE TORRENTS to some extreme case, it will be regarded. I suppose, as less objectionable. I have no other desire than that of ascertaining what is true. I do not object to the doctrine of Christian Perfection, or of Pure Love, or whatever other name may be given to it, in its general form ; but I have serious objections to particular views and forms of expression sometimes connected with it. I find in your works modes of expression which strike me as peculiar. Without delaying, therefore, on the general features of the doctrine, I will take the liberty to direct your attention to a number of things which characterize it, in part, as it appears in your writings. I find, in expression at least, what strikes me as very peculiar, that you make God *identical with events.* You say that to the sanctified soul everything which exists, with the exception of sin, is God.

Madame Guyon.—It seems to me proper to observe, in the first place, that the doctrines of sanctification are sometimes erroneously or imperfectly represented in consequence of the imperfection of language. As they are the doctrines of a life almost unknown to the world, it is natural that they should have no adequate terms and phrases ; so that we express ourselves awkwardly and with difficulty. Is it unreasonable, under these circumstances, to ask the favour of a candid and charitable interpretation ?

Bossuet.—I admit, Madame, the existence of the difficulty to which you refer, and think it should be considered.

Madame Guyon.—With this concession on your part, I proceed to admit on mine, that the assertion, taken just as it stands, namely, *that every event is God*, is not true ; even when made with the exception of those things which are sinful. But I still affirm that the expression has a definite and important meaning to the truly sanctified soul. Such a soul. in a manner and

350 LIFE AND RELIGIOUS EXPERIENCE

degree which ordinary Christians do not well undeistand, re-
cognises the fact, that God sustains a definite relation to every-
thing which takes place. God is in events; and if He is the
centre and controller of the universe, He cannot be out of them.
The sanctified soul not only speculatively recognises the relation
of God to events, but feels it; that is, it is brought into a
practical and realized communion with God through them.
You will find this form of expression in the writings of Catharine
of Genoa.

Bossuet.—I notice also that you sometimes speak as if the
will of God, as well as outward events, were identical with God
himself. I think, Madame, you will perceive on reflection, that
such statements, whatever may be said in defence of them, are
likely to be misunderstood, and, in point of fact, are not strictly
true. We always use the term MAN as including the *whole* of
man, and of course as including something more than the mere
will of man. In like manner, we use the term God as expres-
sive of the whole of God, His intellect and affections, as well as
His will. So that to speak of the will of God, which is but
a part, as identical with God, which is the whole, is necessarily
erroneous.

Madame Guyon.—I have no disposition to object to the cor-
rectness of your remark. But I ought to say, perhaps, that in
speaking of the will of God as identical with God himself, I
used the terms in a mitigated or approximated and not in a
strict or absolute sense. But, while I make this concession, I
am still inclined to say, that practically and religiously we may
accept the will of God as God himself, not only without injury,
out with some practical benefits.

Certain it is, that God is manifested in His will in a peculiar
sense. We can more easily make a distinction between God
and His power, and between God and His wisdom, than between
God and His *will.* The will or purpose of God, in a given case,
necessarily includes something more than the mere act of willing:
it includes all that God can think in the case, and all that God
can feel in the case. And I must confess, that the will of God,

whenever and wherever made known, brings out to my mind more distinctly and fully the idea, and presence, and fulness of God, than anything else. This is so much the case, that, whenever I meet with the will of God, I feel that I meet with God; whenever I respect and love the will of God, I feel that I respect and love God; whenever I unite with the will of God, I feel that I unite with God. So that practically and religiously, although I am aware that a difference can be made philosophically, God and the will of God are to me the same. He who is in perfect harmony with the *will* of God, is as much in harmony with God himself, as it is possible for any being to be. The very name of God's will fills me with joy.

Bossuet.—I notice that the terms and phrases which you employ, sometimes differ from those with which I frequently meet in theological writings. And perhaps the reason, which you have already suggested, explains it in part. But still they are liable to be misunderstood and to lead into error; and hence it is necessary to ascertain precisely what is meant. You sometimes describe what you consider the highest state of religious experience as a state of *passivity;* and at other times as *passively active.* I confess, Madame, that I am afraid of expressions which I do not fully understand, and have the appearance at least of being somewhat at variance with man's moral agency and accountability.

Madame Guyon.—I am not surprised, sir, at your reference to these expressions; and still I hardly know what other expressions to employ. I will endeavour to explain. In the early periods of man's religious experience, he is in what may be called a *mixed life;* sometimes acting from God, but more frequently, until he has made considerable advancement, acting from himself. His inward movement, until it becomes corrected by Divine grace, is self-originated, and is characterized by that perversion which belongs to everything coming from that source. But when the soul, in the possession of pure or perfect love, is fully converted, and everything in it is subordinated to God, then its state is always either passive or passively active.

But I am willing to concede, which will perhaps meet your objection, that there are some reasons for preferring the term *passively active;* because the sanctified soul, although it no longer has a will of its own, is never strictly inert. Under all circumstances and in all cases, there is really a distinct act on the part of the soul, namely, an *act of co-operation with God;* although, in some cases, it is a simple co-operation with what *now is,* and constitutes the religious state of submissive acquiescence and patience; while in others it is a co-operation with reference to what *is to be,* and implies future results, and consequently is a state of movement and performance.

Bossuet.—I think, Madame, I understand you. There is a distinction, undoubtedly, in the two classes of cases just mentioned; but as the term *passively active* will apply to both of them, I think it is to be preferred. You use this complex term, I suppose, because there are two distinct acts or operations to be expressed, namely, the act of preparatory or *prevenient* grace on the part of God, and the co-operative act on the part of the creature; the soul being passive, or merely perceptive, in the former; and active, although always in accordance with the Divine leading, in the other.

Madame Guyon.—That is what I mean, sir; and I feel obliged to you for the explanation.

Bossuet.—Is your doctrine, then, in this particular, much different from that of antecedent or prevenient grace, which we generally find laid down in theological writers, and implies, in its application, that there is no truly good act on the part of the soul, except it be in co-operation with God?

Madame Guyon.—I do not know that the difference is great; perhaps there is none at all. I am willing to acknowledge that I am not much acquainted with theological writers.

Bossuet.—Would it not be desirable, Madame, that those who exercise the function of public teachers should have such an acquaintance? As women are not in a situation to go through a course of theological education, it has sometimes seemed to me that it would be well for them to dispense with public missions.

Madame Guyon.—I do not doubt, sir, that your remark is well meant. The want of such qualifications as those to which you refer, has frequently been with me a subject of serious consideration, and of some perplexity. Nevertheless I sincerely believe, that it is God who has given me a message, in an humble and proper way, to my fellow-beings; but I am aware of its imperfect utterance. But, in His great wisdom, He sometimes makes use of feeble instruments. And I have thought, as He condescended, on one occasion at least, to employ a dumb animal to utter His truth, He might sometimes make use of a woman for the same purpose.

Bossuet.—I merely refer to the subject, without wishing to press it. I should be sorry to say anything which would imply a limitation to the wisdom and providence of God.

Another thing in your writings is this. You speak of those who are in the state of unselfish or pure love, which I suppose you regard as the highest religious state, as contemplating the *pure Divinity;* implying in the remark that they contemplate God in a different way from what is common with other Christians.

Madame Guyon.—What I mean is this. There are two ideas of God; the COMPLEX, and the simple or PRIMARY. In the order of mental development, the complex is first; but in the order of nature, the simple or primary idea is first. The complex idea is that which embraces God, not so much in Himself as in His attributes,—His power, wisdom, goodness, and truth. The beginners in the religious life are very apt to stop and rest in this idea; and they can hardly fail to lose by it. To think of God's power, making His power a distinct and special subject of attention, *is not to think of God.* To think of God's benevolence also, in this specific and individualizing manner, is not to think of God; but is merely to think of a certain attribute which pertains to Him. It is well understood, I suppose, that we may form an idea of matter, in distinction from the attributes of matter; and that we may form an idea of mind, in distinction from the attributes of mind ;—a notion or idea, which is simple and undefinable, it is true, but which has a real existence. And in like

manner we may form an idea of God, in distinction from the
attributes of God. It is not only possible to do this, but it is
impossible not to do it, on the appropriate occasions of doing it.
The very idea of an attribute implies an idea of a subject to
which the attribute belongs. To speak of the attributes of the
human mind or of God, independently of the idea of such mind
or of God considered as distinct from such attributes, would be
an absurdity. There are two ideas of God, therefore; the one
of God as a subject, the primary idea, which is simple and unde-
finable; the other of God as a combination of separate Divine
attributes, which is complex, and is consequently susceptible of
analysis and definition. God, revealed in the first idea, and
considered, not as a mere congeries of attributes, but as the sub-
ject or entity of such attributes, is what I call the Pure Divinity.
Persons in the sanctified or unitive state, in distinction from the
meditative or mixed state, generally receive and rest in God as
developed in the first or primary idea. It is natural to them to
do so, and it is not more natural than it is appropriate and pro-
fitable. When they depart from that idea, it is almost a matter
of course that they indulge in meditative and discursive acts,
which tend to separate them from the true centre; and they
thus lose that consciousness of oneness with God.

Bossuet.—Permit me to ask, Madame, whether you mean in
these remarks to discourage meditative and discursive acts, such
as are implied in an analysis and due consideration of the Divine
attributes?

Madame Guyon.—Not at all. Such acts are very important;
but they have their appropriate place, and are much more suited
to lower states of experience than that purified and contempla-
tive state of which we are now speaking.

Bossuet.—The distinctions you have made, and the explana-
tions you have given, although not obvious without considerable
reflection, seem to me reasonable and satisfactory. But I must
confess, that I cannot allege a personal acquaintance with that
experience which unites the soul with God as He is developed
in the primary or elementary idea.

Madame Guyon.—I hope, sir, that you will not take it amiss, when I say, that I regret that you find it necessary thus to speak of a defect of personal experience. The theology of the head is often obscure and uncertain, without the interpretation of the higher theology of the heart. The head sometimes errs ; but a right heart never.

Bossuet.—I hope, Madame, that I have experienced something of the grace of God ; but I am free to acknowledge, that I have not arrived at what you and other writers who sympathize with your views, call the *fixed state.* Is it possible, that any one should believe, that Christians, however devoted they may be, will arrive at a state in the present life, where there are no vicissitudes, and perpetual sunshine ?

Madame Guyon.—In this form of expression, and others like it, it is not meant, that the sanctified soul is not characterized, in its experience, by any vicissitudes whatever. But still, when the soul has experienced this great grace, the mind is comparatively at rest. Is a fixed state less desirable than an unfixed state ? Is there anything to be especially commended in the changes, the alternations of energy and weakness, of faith and unbelief, which characterize ordinary Christians ? All that is meant is a state established, comparatively firm, based more upon principle than upon feeling, and that lives more by faith than emotion. Those who live by faith, who see God equally in the storm and the sunshine, and rejoice equally in both, know what I mean ; while those who do not, can hardly fail to be perplexed.

Bossuet.—I will now mention one thing, which seems to me worthy of special notice. Those who arrive at the highest religious state are so far above the common wants, or rather suppose themselves to be so, as not to recognise and urge them in acts of supplication. But the Scriptures command us to pray always, to pray without ceasing. The language of the Saviour is, " *Ask,* and ye shall receive ; *seek,* and ye shall find ; *knock,* and it shall be opened unto you." It seems very clear, that prayer is a thing not only of perpetual command, but of perpetual obligation.

Madame Guyon.—I am pleased, sir, that you have introduced

this subject. So far from the truth is it, that persons who have experienced the blessing of PURE or PERFECT LOVE, cease to pray, that it is much nearer the truth to say, that they pray always. Certain it is, that the prayer is always in their hearts, although it may not always be spoken. We sometimes call this state of mind the *prayer of silence*. It is perhaps a prayer too deep for words; but it is not on that account to be regarded as *no prayer*. Do you state your difficulty precisely as you wish to have it understood?

Bossuet.—It is not easy for me to understand what prayer is, unless it be *specific*. And in order to give my difficulty a precise shape, I will say, that the system of present sanctification, or pure love, seems to exclude *specific* requests.

Madame Guyon.—And, supposing it to be so, which is not the case, is that state of mind to be thought lightly of, which does not ask for particular things?—which says to the Lord continually, I do not ask for this or that, I have no desire or petition for anything in particular, *but desire and choose for myself only what God desires and chooses?* I admit that this, in general, is the state of mind in those who have experienced the blessing of a perfectly renovated life. Their state of mind is one of praise rather than of petition. They have asked, and have received. If, at a given time, they ask for nothing in particular, it is because they are full now.

Persons in this state of mind cannot easily separate *God's will* from *what now is*. What God gives them now, He *wills to give them now;* and in that will, which always excludes sin, but often permits temptation and suffering, they are satisfied; they rest. They experience in themselves the fulfilment of those blessed directions of the Saviour, which none but a holy heart can fully receive and appreciate :—

" Wherefore take no thought, saying, What shall we eat? or, what shall we drink? or, wherewithal shall we be clothed? (for all these things do the Gentiles seek;) for your heavenly Father knoweth that you have need of all these things. But seek ye first the kingdom of God and his righteousness; and all these

things shall be added unto you. Take, therefore, no thought
for the morrow; for the morrow shall take thought for the things
of itself."

In these words there is to my mind a Divine meaning, such
as the world does not understand. Take my own situation. My
wants are already supplied, richly, abundantly, and running
over. What *can* I ask for when my soul rests in God, and is filled
with the fulness of God; and when He leaves me neither time
nor strength for anything but to receive His favours, and to
bless Him?

Bossuet.—Will you permit me to ask, in connexion with one
of your remarks, whether you mean *literal* fulness?

Madame Guyon.—I do not know, sir, that I understand the
precise import of your question.

Bossuet.—I am led, Madame, to ask the question, by an asso-
ciation suggested by your expressions. In reading your Life, I
notice that upon more than one occasion you speak of such
effusions of grace, that your very physical system dilated, as it
were, and enlarged with them, so as to render it necessary to
relieve yourself by some readjustments of your apparel.

Madame Guyon.—I recollect that there was a time in my re-
ligious experience, when my emotions were so strong, that my
physical system was, on one or two occasions, very much affected;
so that I obtained some relief in the way you have mentioned.
And as, in writing my Life, my Director required me to be very
particular and to write everything, I thought myself bound to
mention the circumstance. Nor do I know that there is any-
thing very astonishing in the fact. Remarkable effects are some-
times produced upon the physical system by excited natural
emotions, as well as those which are religious. I was quite
overcome; and it was necessary for my friends to render me
assistance as seemed to them best; but I do not consider emo-
tive excitement as always identical with true religious experience,
and still less with the highest kind of experience. Great phy-
sical agitation, originating in strong emotions, is generally con-
nected, either directly or indirectly, either at the time or at some

antecedent period, with a high degree of inward resistance. But, in the highest degree of experience, all such resistance is taken away; and there is quietness, such as the world does not know; a great inward and outward calm.

Bossuet.—Let us return to the subject of which we were speaking. If I understand you, your soul *rests:* that is, is satisfied with what it now has in God; and you have nothing to pray for *in particular.*

Madame Guyon.—I think the term *rest* expresses this state very well. It is the rest of *faith.* But such a state does not exclude prayer. On the contrary, the sanctified soul is, by the very fact of its sanctification, the continual subject of that prayer which includes all other, namely, *Thy will be done.* When the whole Church can utter that prayer with a true heart, the world will be renovated. I wish, however, to correct what may perhaps be an error in your view of the subject. This prayer is not at all inconsistent with *specific* prayer. God, who has a regard to our situation and the relations we sustain, and has the control of the mind that has given all up to Himself, does not fail to inspire the consecrated soul with specific desires appropriate to times, places, and persons.

Bossuet.—You will notice that it is not so much my object to criticise your explanations as to receive them; and, where I do not regard them as entirely satisfactory, to make them the subject of future meditation. I proceed, then, to say that the state of mind which you advocate is supposed to lead to inaction.

Madame Guyon.—I do not readily see, sir, how such a statement could well apply to myself, who have hardly known, whatever may be true of my mind, what it is to rest outwardly and physically.

Bossuet.—I think, Madame, it will not; but such an impression could hardly arise without some foundation for it. And I should be glad to hear what can be said of an idea which is certainly an unfavourable one.

Madame Guyon.—The foundation, sir, of this idea is in the fact, I suppose, that the truly holy soul ceases from all action,

which has its *origin in merely human impulse.* It is the charac-
teristic of souls which are in this state, that they move as they
are moved upon by the Holy Ghost. " As many as are led by
the Spirit of God, they are the sons of God." (Rom. viii. 14.)
They move, therefore, in God's order ; neither falling behind by
indolence, nor precipitated by impetuosity. They move in God's
Spirit, because they are sustained by faith ; benevolent, just,
immutable in their purpose, so far as immutability can be pre-
dicated of anything that is human, but always without violence.
Such sometimes appear inactive, because their action is without
noise. But they are God's workmen—the true builders in His
great and silently-rising temple ; and they leave an impression
which, although it is not always marked and observable at the
time, is deep, operative, and enduring. In this respect, at least,
I think we may say that they are formed in the Divine likeness.
God is the great operator of the universe ; but what He does, is
generally done in silence. The true kingdom of God comes
" without observation."

Bossuet.—I will not pursue these inquiries farther at present.
except in one particular. Some expressions, Madame, in your
writings, seem to imply the extinction of all desire. Man is a
perceptive and sentient being ; and I do not hesitate to say, that
the extinction of all desire, so far from rendering him more
religious, would render him a brute.

Madame Guyon.—This difficulty is almost identical with one
already considered ; still it may not be improper to give it a
separate notice. Those who have gained the inward victory,
very frequently speak of the extinction of desire as a charac-
teristic of this state, and as an evidence of it. How can those
desire, who already have everything ? How can those be in
want who are already full ? But I suppose that their meaning is,
and can be, only this. They have lost all natural or unsancti-
fied desire. They do not desire anything in themselves and of
themselves ; anything *out of God*, in the sense of being irrespec-
tive of His will.

Bossuet.—Why, then, do they not say what they mean ? The

form of expression. as we frequently find it, is certainly a pecu-
liar one.

Madame Guyon.—In the first place, sir, if their meaning is
understood, as I think it would be likely to be by most persons,
the more concise expression is the preferable one. But there is
perhaps a special reason for their expressing themselves in the
manner they do. The state in which they are is not only one
of right or sanctified desire, but of very strong faith. Their
faith necessarily takes the form of believing that everything in
their situation, with the exception of sin, is in accordance with
God's will, and cannot be otherwise. Consequently all their
desires are perfectly met in the occurrences of each moment;
and this is done, not only so perfectly but so quickly, that the
desire and the fulfilment of the desire are not very distinct in
the consciousness, but seem to be mingled together ; so much so
that the person does not, in general, have a distinct recollection
of the desire. Hence it is natural for such persons, for this rea-
son, as well as because all unsanctified desires are in reality
dead, to speak of their being without desire.

A number of other topics were taken up in the course of the
conversation. One was the transmission of Divine grace from
herself to others, which she had spoken of in her writings, as if
it were a perceptible or sensible transmission ; adding, that the
Divine power or influence, which was transmitted through her-
self as an instrument, returned back with all its blessedness to
her own soul, when it was not received by others. The difficulty
is, that she describes things as they *seemed* to be, and not as
they really are ; and thus gave to the spiritual operation a sen-
sible or material character, which is not appropriate to it.

When, for instance, she was in the company of persons seri-
ously disposed, but still without religion, her mind was not only
prayerful, but sad and burdened on their behalf. When she
witnessed in these persons a disposition to receive the truth, she
at once experienced relief; her prayer was answered ; the bur-
den was removed. So that *apparently*, and looking at the sub-
ject in the merely human light, something seemed to pass sen-

sibly and literally from herself to others. And describing the thing according to the *appearance*, rather than according to the *fact*, she justly gave occasion for the inquiries and criticisms of Bossuet.

Another matter of inquiry was this. While she freely spoke of the subjection of her natural selfish life, and of her renovation and union of spirit with the Divine life, some passages in her writings seemed to imply, that there was such a want of any thing. remarkable in her state, that she found it difficult to describe it or speak of it. She says, for instance, in her Autobiography, "My state has become simple, and without any variations. It is a profound annihilation. I find nothing in myself to which I can give a name."

She explained these passages by saying, that they were to be understood in a comparative sense. Beginners in the religious life are necessarily inquisitive, agitated, active, but often spasmodic and variable in their action, and full of various kinds of emotion. It is obvious, therefore, that almost every day and hour presents something in their experience, which may be made the subject of notice and of interesting conversation. But the soul, in a higher state of experience, has reduced the multiplicity and agitations of nature to the one simple principle of union with God's will by faith. God is immutable ; therefore there is a centre of rest.

The beginners in science, in the mathematics for instance, advance from step to step with great effort. Their efforts attract notice, because they are made in various ways, and under a variety of motives and excitements. When they miss in their calculations, they are depressed with sorrow. When they are successful, and find their problems fully solved, they run to tell their neighbours, and sometimes shout with joy. But it is not so with the great masters of the science, a Newton for instance. These last, while they are inwardly thoughtful and operative, are nevertheless always calm, and often silent ; because they are not seekers and progressers in the ordinary sense of the terms, but have *the mathematics in themselves.* And so in relation to

anything else; religion among other things. The more we know and possess of it, the greater is our simplicity and rest of spirit.

It was in this way that she endeavoured to explain her own state. The life of faith, when faith is perfect, is a very simple one. The principle of faith is to the soul, considered in its relation to God, what the principle of gravitation is to the physical universe; uniting all, harmonizing all, but always without confusion and noise, and with the greatest simplicity of operation.

In giving some account of her own state, she uses an illustration which is worthy of some notice, although I am not sure that it is in all respects an appropriate one. Bossuet was examining her on the point of her inability to originate, by her own movement, distinct inward acts. In explaining herself, she said that the truly purified soul, in the simplicity of its temper and in its relations to God, seemed to her to be like the *pure water*.

"Nothing," she says, "is more simple than water; nothing is more pure. In this respect it may be regarded as an emblem of the holy soul. But this is not all. Among other things, water has the property of yielding readily and easily to all impressions which can be made upon it. And here we have another striking incident of resemblance. As water yields with inconceivable readiness to the slightest human touch, so does the holy soul yield, without any resistance, to the slightest touch of God; that is to say, to the slightest intimations of the Divine will. Again, water is without colour; but it is susceptible of all colours. So the holy soul, colourless in itself, reflects the hues, whatever they may be, which emanate from the Divine countenance. Again, water has no form; but takes the form of the vessels, almost endless in variety, in which it is contained. So the holy soul takes no position or form of itself, but only that which God gives it."

And these statements she did not hesitate to apply to herself. Her soul had nothing of itself. It had its form, its brightness, and its movement in God. What God desired, she desired;

what God willed, she willed; what God said, she said. Her business was co-operation, not origination. There was a voice in her spirit, inaudible but always heard, or rather inaudible to men, but always heard by Him who inspired it, which responded, in harmony with all holy beings, with a UNIVERSAL AND ETERNAL AMEN.

This conference continued the whole afternoon and evening. It was a trying day to Madame Guyon. The acute and discriminating mind of Bossuet, formed to grapple with the most difficult subjects, subjected her to an examination such as she had never passed through before. But he had the satisfaction of finding her, to a degree beyond his anticipations, ready to acknowledge where she was wrong, to explain where she was obscure, and to defend herself where she knew and felt herself to be right. But still it was a season which required quickness of thought, entire purity of intention, and religious patience.

Bossuet, who had been an instructor of princes, was no stranger to the presence and intercourse of polite and courtly men; but still he was more addicted to books than to society, and thought more of arguments than of manners. He was a *great* man, but, accustomed to the supremacy of his intellectual power, he was apt to be dictatorial and rough in his greatness. And this ponderous roughness of manner, which corresponded well with the weighty and strong movement of his intellectual action, was but little conciliated and softened by the presence and the finer sensibilities of woman.

Madame Guyon refers to this peculiarity of Bossuet, not in the way of complaint, but merely in explanation of what she endured in this and some subsequent conferences. " He was evidently," she says, " unfavourably affected towards me by the secret efforts of some persons. He spoke almost with violence, and very fast, and hardly gave me time to explain some things which I wished to explain. I was so agitated, in one or two instances, by his authoritative and apparently dictatorial manner, that I entirely lost my recollection. We parted from each other very late in the evening; and I returned home so wearied and

overcome with what had passed between us, that I was sick for several days."

Bossuet seems, in general, notwithstanding his prepossessions, to have been satisfied with this interview.

"As there were some things," she says, "which he could not understand, or to which he could not reconcile himself, I wrote several letters to him after this interview, in which I endeavoured to elucidate these difficulties. He was so kind as to send me a long letter in return, of more than twenty pages, from which it very clearly appears that he was somewhat embarrassed by the newness of the subject, and in consequence of the imperfect knowledge he had of the interior ways of the Holy Spirit, of which none are able to judge except from experience."

This suggestion, which implies a want of intellectual perception on the part of Bossuet, arising from a want of inward experience, may sound strange. And truth requires us to say, if we may judge from the evidences of a serious and consistent life, that, if he was eminently learned and intellectual, he was also decidedly moral and religious. At the same time, it is entirely evident that he would have understood and appreciated his opponents better, particularly Madame Guyon, if he had stood in the same rank in the gradations of inward experience. It is impossible for a man to philosophize correctly on the natural passions, who has had no knowledge of them himself. And it is the same in religion. In order to describe religion, we must first know it; and to describe it and elucidate it in its different degrees, we must know it in those degrees.

A short time after this interview, she was seized with a violent fever. It continued forty days. It seemed probable that she would not recover. Her soul rested calmly in God; never more so than when the great change appeared near at hand. She was enabled to dictate a few letters, to be sent to her religious friends. In them she expressed the earnest prayer, that God would finish in those to whom she thus wrote, the good work which He had begun. She said, if she had been the instrument of any good to them, she was merely an instrument,

and the honour belonged to God alone ; and it was her prayer, that He might fully accomplish and preserve that which was His own, namely, the spirit of an entire renunciation of themselves. She exhorted them to bear the cross patiently, and to follow Jesus Christ with hearts filled with His pure love. If she should be taken from them now, she wished them to look upon it as an event illustrating anew the wisdom and goodness of God ; and was desirous, while they turned their thoughts and hearts to Him as the source of all truth and all good, that they would cease to think of her, and would let her pass from their memory as a thing unknown.

CHAPTER XLIII.

1695—Opposition continues—Louis xiv. appoints three commissioners, Bossuet, De Noailles, and Tronson, to examine her doctrines—Their character—She lays before them the work entitled Justifications—The first meeting of the commissioners—Exclusion of the Duke of Chevreuse--Course taken by Bossuet—Interviews subsequently with the Bishop of Chalons and Tronson—No condemnation passed at this time—Of the articles of Issy— Retires for a time to the Convent of St. Mary in Meaux— Her remarks on a charge of hypocrisy made against her—Poem.

WHATEVER impressions might have been left upon the mind of Bossuet by these conferences, they did not satisfy the public. Madame Guyon was almost universally considered as the teacher of a new doctrine. Her character was assailed, as well as her doctrine. She wrote, therefore, to Madame de Maintenon, requesting that a number of suitable persons might be selected for the purpose of judging both of her doctrine and morals ; and offering to submit to any confinement and restraint, until it should please the king to appoint such persons.

To this request Madame de Maintenon returned an answer to the Duke of Chevreuse, who was instructed to inform Madame Guyon, that she had laid the subject before the king, who not only approved of a new examination of her writings, but thought

that persons eminent for their virtues and talents should be employed on the occasion. And, accordingly, in a short time he appointed three commissioners, Bossuet, Bishop of Meaux, Monsieur Tronson, Superior of the Seminary of St. Sulpitius, and Monsieur de Noailles, Bishop of Chalons, to make inquiries, and to do what they thought proper in the case.

The persons were all eminent men. The Bishop of Chalons was afterwards appointed Archbishop of Paris, and subsequently a Cardinal. The Superior of St. Sulpitius was a man eminent alike for his talents and virtues. Of Bossuet we have already had occasion to speak.

The selection of such distinguished men was itself a marked tribute, at least to the great intellectual power and personal influence of Madame Guyon.

Madame Guyon sent, at their request, the manuscript of her Autobiography, so far as it was then written, her book on Prayer, The Torrents, and manuscript Commentaries. At this time she prepared with great labour her valuable work, entitled, *Justifications of the Doctrine of Madame Guyon.* In this she endeavours to sustain and justify her views, by quotations from a multitude of writers on experimental religion ; not omitting even the Greek and Latin Fathers. She sustains herself, in particular, by references to the writings of St. Dionysius, St. Bernard, John Climacus, Catharine of Genoa, John of the Cross, St. Theresa, Henry Suso, Thomas-à-Kempis, Gerson, Ruysbroke, Thauler, John de S. Samson, Harphius, Blosius, Ruis de Montoya, and others.

She writes, " In order to facilitate the examination, and spare the commissioners as much time and trouble as I could, I collected together a great number of passages out of approved spiritual writers, for the purpose of showing that my own statements and views were in accordance with those of such writers, and with the Holy Scriptures. It was a large work. Having written it out, I caused it to be transcribed on separate quires of paper, and sent in this manner to the three commissioners. By remarks appended to these extracts, I endeavoured to clear up

some doubtful and obscure passages in my writings. When I first wrote, the troubles in relation to Michael de Molinos had not broken out; so that I used less precaution in expressing my thoughts than I might otherwise have done, not imagining that my expressions would be turned into an evil sense. This work was entitled the *Justifications*. It cost me fifty days' labour; but it seemed to me sufficient to clear up and establish my case."

The first meeting of the commissioners was appointed in August 1694, at the house of Bossuet; probably in his own diocese, and in Meaux. At the appointed time, Madame Guyon went there, accompanied by the Duke of Chevreuse. The Bishop of Chalons came also; but Tronson was sick, and did not come.

Bossuet was not at home when they arrived. This gave Madame Guyon a favourable opportunity to explain her sentiments to the Bishop of Chalons, who was a man of candour as well as piety. He listened kindly and patiently to her remarks; uniting the civility of the gentleman and the Christian with a sincere disposition to do justice.

Towards evening Bossuet came in. After a little time spent in general conversation, he opened a packet, apparently containing papers in relation to their meeting. He then turned to the Duke of Chevreuse, and observed that the affair, having relation to matters of doctrine, was entirely ecclesiastical; and as the decision of such cases belonged exclusively to bishops, he did not think it proper for one who was not a bishop to be present. The presence of any person, not a member of the commission, would tend to interrupt and diminish their freedom. The Duke of Chevreuse was not a man either to resist such an intimation, or to be offended at it, and very readily withdrew.

Madame Guyon was somewhat affected at this incident. And recollecting how much she had suffered, both physically and mentally, in her former interviews with Bossuet, she thought she needed the presence and assistance of some one who understood both her character and opinions. The Duke of Chevreuse, in

compliance with her earnest request, had kindly consented to
render his aid. De Noailles seems to have had no objection to
his being present, but did not openly advocate it; Bossuet was
entirely decided, and would not consent to it.

"I was greatly surprised," says Madame Guyon, "at the ex-
clusion of the Duke. I must confess that the reason assigned for
his exclusion seemed to me rather a pretence, than a reason
assigned in good faith. I could not but think that the Bishop
of Meaux was unwilling to have present a man of such an esta-
blished character, who might afterwards be a witness to the
world of what passed between us. What could be more natural
than the presence of a person so eminent in the world, so famous
both for piety and learning, so greatly interested in the clearing
up of these matters, that both he and others might be undeceived,
if, against my intention, I had instilled notions into them con-
trary to the purity of the faith? Such a witness might have
served to confound me, if I had spoken differently from what he
had been accustomed to hear me speak. He might have been
undeceived himself, and been instrumental in undeceiving others,
if in these peaceable conferences I had been convicted of errors.
This was one of the things proposed and anticipated, when the
measure of appointing commissioners to examine me was first
suggested. But why do I thus allude to subordinate instru-
ments, as disappointing my expectations? We are apt to look
at men and at men's doings. *It was God who did not permit
them.*"

The Bishop of Meaux exhibited his characteristic vivacity of
expression and manner; so much so, as sometimes, in the opinion
of Madame Guyon, to violate the ordinary rules of kindness and
civility. For instance, she observes, "I was then proceeding to
show the bishop that the doctrines in my writings were in con-
formity with those which appear in other approved writers on
inward experience. He replied to my remarks, that he was
much surprised at my ignorance. And not satisfied with dis-
tinctly asserting my want of knowledge, he did not hesitate to
cast ridicule upon my modes of expression; and obviously en-

deavoured to darken, and to turn into mere jargon, everything which I said; especially when he observed that Monsieur de Noailles began to be touched and affected by the turn of our conversation. When I am treated in this violent manner, I am apt to become confused and forgetful. And, accordingly, I thought it proper to drop the discourse with Bossuet, and said nothing."

"De Noailles," she adds, "treated me with all possible civility. When I directed my conversation to him, he took the pains to write down some of my answers. Noticing the rough manner of Bossuet, he endeavoured to soften and ward off the blows from me, as much as he could."

After this conference, she adds, "I went to see the Bishop of Chalons again. I found him alone, and had a free conversation with him. Although some persons had tried to prejudice him against me, he appeared to be well satisfied, and repeated several times that he saw nothing which required to be changed, either in my views of prayer, or in anything else. He suggested, however, that, in consequence of the existing state of things, it might be well for me to live in a manner as retired as possible, but that, in other respects, I should go on as I had done; and said, that he would pray to God to augment His goodness towards me."

She had not as yet seen the other commissioner, Monsieur Tronson. It was thought proper, therefore, that she should visit him at his country residence at the village of Issy, not far from Paris. She was attended there by the Duke of Chevreuse. She says, "I conversed with Monsieur Tronson with all the freedom imaginable. He was very particular and exact in his examinations, more so than the others. Formal questions were put, and answers corresponding to them were given, which were taken down in writing by the Duke of Chevreuse. When the examination was completed, the Duke made the remark to Monsieur Tronson, 'You cannot fail to see, sir, as it seems to me, the evidences of her sincerity and uprightness.' He answered, 'I feel it well.' And that expression was not unworthy of this distin-

N

uished servant of God, who judged, in relation to the matter before him, not only by his understanding, but by the *feelings of his heart.* I then took my leave, with the consolation of believing, from his appearance at least, that Monsieur Tronson was well satisfied, although a forged letter against me had been sent to him."

Such were the favourable sentiments of De Noailles and Tronson towards her, that no condemnation of any kind was passed at this time. Still the public voice, generally clamorous beyond what is just, was not silenced.

"After these successive examinations," says Madame Guyon, "which resulted in proving nothing against me, it would have been a natural supposition that my opposers would leave me at peace. But it was quite otherwise. So far from being propitiated, either by the defect of evidences against me, or by the evidences in my favour, they seemed to be inspired with new energy in their hostile efforts. Nothing was proved; but the Bishop of Meaux was not entirely satisfied. Under these circumstances, it seemed to me best to propose to him to put myself for a time under his more immediate inspection. I made the offer to take up my residence within his diocese, in some religious house or community, in order that he might become the better acquainted with me. He seemed pleased with the plan, and proposed that I should become for a time a temporary resident in the Convent of St. Mary, in Meaux. Perhaps his readiness to accept this proposal was not altogether disinterested. Supposing that, if it were carried into effect, it would tend to allay the existing excitement and alarm, he remarked to Mother Elizabeth Pickard, the prioress of the convent, that it would be as good to him as the Archbishopric of Paris or a cardinal's hat. When she told me of it, I replied, God will not permit him to have either the one or the other."

The result verified the remark. It seemed to the commissioners, that something further remained to be done. The king, at least, would expect something more. They agreed, therefore, to continue their meetings for the purpose of considering such

topics, in the hopes that something might be agreed upon, which should furnish a common basis of belief and action.

On account of the ill health of Monsieur Tronson, their conferences were continued at Issy. The result of their deliberations, which came before the public in the course of a few months, was the document, which was afterwards so frequently mentioned in the debates of that period, under the denomination of the *Articles of Issy.*

These celebrated articles, thirty-four in number, indicate the views of the authors of them on the subject of PURE LOVE, or the highest inward experience. They are drawn up with care, and express, in a manner unexceptionable, some of the leading ideas in the doctrines of a holy life. If they are defective, it is not so much by what they say, as by what they leave unsaid. The express the truth, but not the *whole* truth. There are some points in inward experience which they do not reach. With this view of them, Madame Guyon gave her assent to them, when presented to her some time after this.

Meaux is twenty-five miles north-east from Paris, on the Marne. For that place Madame Guyon set out in January 1695, accompanied by the faithful maid-servant, La Gautière, who had shared in her labours and travels for the past fourteen years. The conveyance in which they travelled became involved in the snows, and could not at once be extricated; so that they were detained some hours, and suffered much from the cold.

Being obliged to leave the carriage, "we sat upon the snow," she says, "resigned to the mercy of God, and expecting nothing but death. The snow melted upon our garments; and both of us, the girl and myself, were exceedingly chilled; but I never had more tranquillity of mind. My poor maid was also entirely submissive and quiet, although we saw no likelihood of any one coming to our succour, and were sure of dying if we remained there. Occasions like these are such as show whether we are perfectly resigned to God or not. At length some waggoners came up, who with difficulty drew us through the drift. It was ten o'clock at night when we arrived at Meaux. The people of

the convent, who had received some notice of our coming, had given over expecting us, and had retired to rest."

After considerable delay, the nuns were called up, the bishop was informed of their arrival, and they were formally admitted.

In speaking of Bossuet, Madame Guyon says, " He had his good intervals, but he was not beyond the reach of personal and interested motives. And in regard to myself, I cannot doubt that he was under the influence of persons who endeavoured to excite him against me."

In this remark she probably had in mind an observation said to have dropped from him, that her coming to Meaux so promptly, and in such uncomfortable weather, was a mere *artifice ;* indicating a readiness to fall in with his wishes, and to take a proper course, which did not really exist.

The charge of artifice, or rather of hypocrisy, coming from a man of so high character, naturally arrested her attention. It was perhaps a false, or at least an exaggerated report ; but she believed it, at the time, to be true. She makes the following remarks upon it :—

" Those men, who look at the tree with an evil eye, account its fruits to be evil. I am said to be charged with being a hypocrite. But by what evidence is the charge supported? It is certainly a strange hypocrisy, which voluntarily spends its life in suffering ; which endures the cross in its various forms, the calumny, the poverty, the persecution, and every kind of affliction, without any reference to worldly advantages. I think one has never seen such a hypocrisy as this before.

" So far as I understand the subject, hypocrites have generally two objects in view : one is to acquire money, the other is to acquire popularity. If such are the leading elements involved in hypocrisy, I must do myself the justice to say, that I disclaim any acquaintance with it. I call God to witness, that I would not have endured what it has been my lot to endure, if by so doing I could have been made empress of the whole earth, or have been canonized while living. It was not earth, but God that called me. I heard a voice which I could not disobey. I

desired to please God alone; and I sought Him, not for what He might give me, but only for Himself. I had rather die, than do anything against His will. This is the sentiment of my heart; a sentiment which no persecutions, no trials, have made me alter.

" It is true, that my feeble nature has sometimes been greatly burdened. Sorrows have come in upon me like a flood. I have been obliged to say with the Psalmist, '*All thy waves and thy billows have gone over me ;*' and with Jeremiah, '*Thou hast caused the arrows of thy quiver to enter into my reins.*' Being accounted by everybody a transgressor, I was made to walk in the path of my suffering Saviour, who was condemned by the sovereign pontiff, by the chief priests, the doctors of the law, and the judges deputed by the Romans. But the love of God rendered my sorrows sweet. His invisible hand has supported me. My purpose has remained unchanged. Happy are they who are sharers with Christ in suffering."

THE ACQUIESCENCE OF PURE LOVE.

[From the Translations of her poems by Cowper.]

Love! if thy destined sacrifice am I,
　　Come, slay thy victim, and prepare thy fires;
Plunged in thy depths of mercy, let me die
　　The death which every soul that lives, desires

I watch my hours, and see them fleet away:
　　The time is long that I have languish'd here
Yet all my thoughts thy purposes obey,
　　With no reluctance, cheerful and sincere

To me 'tis equal, whether love ordain
　　My life or death, appoint me pain or ease ,
My soul perceives no real ill in pain
　　In ease or health no real good she sees.

One good she covets, and that good alone—
　　To choose thy will, from selfish bias free;
And to prefer a cottage to a throne,
　　And grief to comfort, if it pleases thee.

That we should bear the cross is thy command,
　　Die to the world, and live to self no more;
Suffer, unmoved, beneath the rudest hand;
　　When shipwreck'd pleased, as when upon the shore

CHAPTER XLIV.

1695—Sickness—Visited by Bossuet—Singular conversation—Reference to a sermon of Bossuet—Receives recommendations from him and the prioress and nuns—Leaves Meaux for Paris—Excitement occasioned—Conceals herself five months—Seized by order of the king, and imprisoned in the Castle of Vincennes—State of her mind—Poems.

IN the convent at Meaux, she remained six months as a voluntary resident. It was suggested by Bossuet that it might be desirable for her to remain there three months; but, further than that, there was no limitation of time suggested; but she was free to leave whenever she pleased. From the middle of January to the last of February, she was sick. After her recovery Bossuet came one day to the convent, and showed her a Pastoral Ordinance and Letter (the same undoubtedly usually prefixed to his work, entitled, Instructions on Prayer), in which he had noticed and condemned some of the prevalent religious errors, as he considered them.

He asked her to add her signature to the letter, accompanied by certain statements which would involve the idea that she had fallen into the very errors named in it. To this she very naturally objected. She said, however, that she would add at the end of his pastoral letter whatever she could properly place there. She accordingly wrote a few words, expressive probably of her desire to know and to teach the truth only, and of her readiness to submit to the decisions of the Church, and added her name. Bossuet, taking up the paper, said it was very well, with the exception that she did not say, as she ought to have done, that she was a heretic;—adding, that it was his desire and expecta-tion that she would acknowledge herself guilty of all the errors condemned in the Pastoral Letter.

"I am quite certain, sir," replied Madame Guyon, "that you say this merely to try my feelings. I came into your diocese, and placed myself under your care, in order that you might the more readily and fully ascertain my character and life. Is it

possible that a prelate will so abuse the good faith thus reposed in him, as to try to compel me to do things which my conscience requires me not to do? I hoped to find in you a FATHER; and I trust that I shall not be deceived."

"I am a father," said Bossuet; "but I am a *father of the Church*. But, in short, it is not a question of words. It is not a thing to be talked about, but to be done. All I can say is, if you do not sign what I require, I will come with witnesses; and, after having admonished you before them, I will inform the Church of you, and we will cut you off as we are directed in the Gospel."

"Then," said Madame Guyon, "I can appeal to God alone as the witness of my sincerity. I have nothing farther to say. I am ready to suffer for Him. And I hope He will grant me the favour to let me do nothing against my conscience. I say this, I hope, without departing from the respect I owe to you as a bishop."

Bossuet, finding her resolute, then proposed that she should admit and declare that there were errors in the Latin work of La Combe on inward experience. This also she refused; and he turned and went away in anger.

The nuns of St. Mary stood by, and beheld this interview with great interest, and with some degree of astonishment. The Prioress remarked to Madame Guyon, that her too great mildness emboldened the bishop to treat her in that rough manner; adding that his mind was of such a cast, that he was apt to be violent with those who were meek and quiet, but more gentle with those who were courageous and firm of purpose.

He came afterwards in the same spirit, and with the same demands; and met with the same prompt refusal. He then, yielding either to his sense of justice, or to the necessity of the case, took a different course. He gave Madame Guyon to understand, although he was not himself altogether satisfied with her views, that he should have less to say, and should express less dissatisfaction, if her enemies would permit him to rest. In one of his letters to the Prioress, he said expressly that "he had

examined the writings of Madame Guyon with great care, and found in them nothing censurable, except some terms which were not wholly conformed to the strictness of theology; but that a woman was not expected to be a theologian."

At a certain time, when the nuns and the prioress were conversing with him about her, he said, " I regard her just as you do ; I see nothing wrong in her conduct ; but her enemies torment me, and wish me to find evil in her." He testified also to the Archbishops of Paris and Sens, that he esteemed her much, and had been edified by her.

Madame Guyon understood well the intellectual power of Bossuet. He was the first orator in France ; perhaps the first in the world at that time. She speaks of a sermon which she heard him preach at Meaux, as one of astonishing power. It arrested her attention the more, because it was on the subject the most interesting to her—that of the higher forms of inward experience. It was on the occasion of the celebration of the mass. " He stated things in it," she says, " much more strongly than I had myself done. He said that he was not master of himself under the view which was then spread around him of those awful mysteries ; and that, under such circumstances, he was obliged to confess and announce the great truths of God, even if they should be against and should condemn himself."

The Prioress of the convent was present at this time. She asked Bossuet how he could persecute Madame Guyon, when it was obvious that he himself preached the same sentiments. He answered that it was not anything in himself which did it, but the violence of her enemies.

In these more propitious dispositions, after nearly six months' residence at Meaux, he gave her a paper or certificate with his name subscribed, in which, while he did not explicitly condemn her doctrines, and made indeed but slight references to them, he spoke in very favourable terms of her character and conduct. As the time of her departure from Meaux approached, the prioress and nuns of the convent, who esteemed her very much, gave her another certificate. It was in the following terms :—

" We, the prioress and nuns of the Visitation of St. Mary of Meaux, certify that Madame Guyon, having lived in our house, by order of our Lord Bishop of Meaux, our illustrious prelate and superior, during the space of six months, far from giving us any cause of trouble or uneasiness, has afforded us much edification. We have remarked, in all her conduct and in all her words, a great regularity, simplicity, sincerity, mortification, meekness, and Christian patience; a true devotion and esteem for whatever pertains to our most holy faith, especially the mystery of the incarnation and of the holy infancy of our Lord Jesus Christ. It would be a favour and of great satisfaction to our whole community, if the said lady would choose, as a place of retreat, to spend the rest of her days in our house. This protestation is made without any other view than that of giving testimony to the truth.

" Done this 7th of July, and signed,

"FRANCES ELIZABETH LE PICKARD, *Prioress*.
Sister MAGDALEN AIMÉE GUETON.
Sister CLAUDE MARIE AMOURI."

" As I had now been at Meaux," says Madame Guyon, " six months, though I had engaged to stay there only three, I asked the bishop if he desired anything further from me. He said he did not. I then told him that I had now need to go to Bourbon; and asked him if it would be agreeable to him, if I should return with the expectation of spending the remainder of my days with the good nuns of the Convent of St. Mary; adding, in relation to them, that our spirits had been cemented in the bonds of mutual love.

" He appeared to be much pleased with the suggestion, and said that the nuns had been much edified by me, and that he should always receive me with pleasure. In connexion with some remarks in relation to my departure, I told him that either my daughter, the Countess of Vaux, or some of my friends, would come for me, and take me away. On hearing this, he turned to Mother Pickard, the prioress, and said to her that he

was about leaving on a visit to Paris; and that he was very desirous, if the ladies referred to should come, that they should be received well, and lodged in their house, as long as they might be willing to stay."

On the eighth of July, the Duchess of Mortemar, one of the most intimate friends of Madame Guyon, came to the convent, accompanied by her daughter, Madame de Morstein. They remained till the afternoon of the next day, and then returned with Madame Guyon to Paris.

It was no sooner known that she was again in Paris, than the whole city seemed to be in an uproar. Her enemies started at once into life. The king was alarmed; Madame de Maintenon, carried away by the popular current, and ceasing to retain her former favourable sentiments, was angry; and Bossuet himself, so far as he was accessible to the influences of personal interest, had reason to fear that he had committed an error by too great 'enity. Certain it is, that he took the singular course, hardly reconcilable with a high sense of honour, of writing to her, and requesting her to return the certificate, which, but just before, he had given.

In answer to the application for this certificate, which seemed to Madame Guyon to be a matter of considerable consequence, she wrote to the prioress of the convent at Meaux, that she had placed it in the hands of some members of her family; that her friends, after the various attacks which had been made upon her character, had need of it for her vindication; and, as they had now possession of it, there was no reason to think they would be willing to part with it. From this time we may date a more distinct and settled aversion to her on the part of Bossuet.

The party against her was so violent, that it was evident she would not be able to remain at large for any length of time. Finding it unsafe to remain at the house of her daughter, she hid herself for a few days at the house of one of her friends in the Faubourg St. Germain. Concealing her intentions as much as possible, she soon after obtained an obscure tenement in the Faubourg St. Antoine, where she remained concealed

witn her maid-servant, La Gautière, about five months. " Here,"
she says, " I passed the day in great solitude, in reading, in
praying to God, and working."

In the meanwhile, the police officers of Paris had orders to
ascertain where she was. On the 27th of December 1695,
Monsieur des Grez, one of the members of the police, ascertained
her lodgings, and arrested her. She was kept in custody three
days, awaiting the decision whether she should be imprisoned in
a convent, or in one of the state prisons. It was a question of
so much perplexity, that it seemed necessary to consult M. de
Noailles, who had recently been appointed Archbishop of Paris.
Accordingly, Madame de Maintenon wrote to him as follows :—
" The king orders me, sir, to inform you, that Madame Guyon
is arrested. What would you think it best to do with this
woman, her friends, and papers ? The king will be here (at
Versailles) all the morning. Write to him immediately."

The result was that she was shut up in the celebrated castle
of Vincennes.

This castle, situated in the forest of Vincennes near Paris, is
used both as a military fortress and as a state prison, and is
hardly less celebrated than the Bastile. It is often mentioned
in history. Many, in earlier and in later times, have been the
agonizing sorrows and the scenes of blood it has witnessed.

The imprisonment of Madame Guyon was considered a matter
of so much consequence, that the Marquis of Dangeaux, who held
at this time an important situation at the court of Louis XIV.,
and who kept a chronicle of the court from the year 1684 to
1720, mentions it, among the other memorable things of that
period, in the following terms :—

" 1696, Jan. 20th.—The king caused Madame Guyon to be
arrested a few days ago, and sent to the castle of Vincennes,
where she will be strictly guarded, apparently for a long time.
She is accused of having maintained, both by word of mouth
and by her writings, a very dangerous doctrine, and one which
nearly approaches to *heresy*. She has imposed upon many per-
sons of eminent virtue. A long search was made for her, be-

fore she could be taken.　She was found in the Faubourg St. Antoine in great concealment."

In this her second imprisonment, Madame Guyon had the same inward supports which had sustained her at other times. Her faithful maid, La Gautière, was arrested and imprisoned with her.　In her subsequent imprisonment in the Bastile, they were separated from each other.　In the prison of Vincennes, they occupied the same cell, which was a great consolation.

She was subject here, as she had previously been, to a close examination.

In regard to Father La Combe, she declared, in opposition to the unfounded and unceasing insinuations of her enemies, that her long intercourse with him had never been sullied by anything opposite to the innocence of religion, and that she regarded him as an eminently holy man ; and frankly admitted that, ever since his imprisonment, she had kept up a correspondence with him.

In regard to her doctrines, she answered her examiner, that she might have been wrong in particular expressions ; but she could not acknowledge, with her present views, that she had ever held false doctrines.　She expressed a willingness to submit to any condemnation of her works, founded upon the imperfection and erroneous tendencies of her language ; but would not deny anything in them in the sense in which she understood it, and in which she meant it to be understood.　In this sense she expressed herself resolute in making no retractions whatever.

Under such circumstances, there was, of course, but little prospect of any immediate release from her imprisonment.

A little incident occurred, which illustrates the application of her religious principles.　On a certain day, probably through some failure of her usual inward recollection, she had become a little anxious, and undertook to study and frame her answers beforehand.　The consequence was such as may be generally expected, when we depart from that simplicity of spirit which is "careful for nothing."　She says, "I answered badly.　God, who had so often caused me to answer difficult and perplexing

questions with much facility and presence of mind, punished me now, even by stopping me short on easy matters with confusion. It served to show me the inutility of our arrangements on such occasions, and the safety of trusting in God.

"Those who depend chiefly on human reason are apt to say that it is necessary to look before us, and to make our preparations; and that to do otherwise, is to expect miracles, and to tempt God. Leaving others to do as they think best, I must say for myself, that I find no safety but in resigning myself entirely to God; doing what He calls me to do in the moment of action, and leaving everything with Him in submission and humble faith. The Scriptures, as it seems to me, abound everywhere with texts enforcing such a resignation. '*Commit thy way unto the Lord*,' says the Psalmist; '*trust also in Him, and He shall bring it to pass. And He shall bring forth thy righteousness as the light, and thy judgment as the noon-day*,' (Ps. xxxvii. 5, 6.) The Saviour, speaking of those who are brought before kings and rulers for His name's sake, says, '*Settle it, therefore, in your hearts, not to meditate before what ye shall answer; —for I will give you a mouth which all your adversaries shall not be able to gainsay nor resist*.' God does not lay a snare for us in such passages. He consults our good, when He requires us to renounce all merely human foresight and policy, and trust wholly in Him."

Speaking of her general state of mind, she says, "I passed my time in great peace, content to spend the remainder of my life there, if such should be the will of God. I employed part of my time in writing religious songs. I, and my maid La Gautière, who was with me in prison, committed them to heart as fast as I made them. Together we sang praises to thee, O our God! It sometimes seemed to me as if I were a little bird whom the Lord had placed in a cage, and that I had nothing to do now but to sing. The joy of my heart gave a brightness to the objects around me. The stones of my prison looked in my eyes like rubies. I esteemed them more than all the gaudy brilliancies of a vain world. My heart was full of that joy which

thou givest to them who love thee in the midst of their greatest crosses."

A number of her poems have allusion to her imprisonment. At this period she wrote a considerable portion of the volumes in verse which have been since published. They illustrate the state of her mind, and throw some light upon her character and doctrines.

PRISONS DO NOT EXCLUDE GOD.

STRONG are the walls around me,
　　That hold me all the day;
But they who thus have bound me,
　　Cannot keep God away:
My very dungeon walls are dear,
Because the God I love is here.

They know, who thus oppress me,
　　'Tis hard to be alone;
But know not, One can bless me,
　　Who comes through bars and stone:
He makes my dungeon's darkness bright,
And fills my bosom with delight.

Thy love, O God, restores me
　　From sighs and tears to praise;
And deep my soul adores thee,
　　Nor thinks of time or place:
I ask no more, in good or ill,
But union with thy holy will.

'Tis that which makes my treasure,
　　'Tis that which brings my gain;
Converting woe to pleasure,
　　And reaping joy from pain.
Oh, 'tis enough, whate'er befall,
To know that God is All in All.

GOD KNOWN BY LOVING HIM.

'Tis not the skill of human art,
　　Which gives me power my God to know;
The sacred lessons of the heart
　　Come not from instruments below.

Love is my teacher. He can tell
　　The wonders that He learnt above:
No other master knows so well;—
　　'Tis Love alone can tell of Love.

Oh! then, of God if thou wouldst learn
　　His wisdom, goodness, glory see;
All human arts and knowledge spurn,
　　Let Love alone thy teacher be.

Love is my master. When it breaks,
　　The morning light, with rising ray,
To thee, O God! my spirit wakes,
　　And Love instructs it all the day

And when the gleams of day retire,
　　And midnight spreads its dark control,
Love's secret whispers still inspire
　　Their holy lessons in the soul.

THOUGHTS OF GOD IN THE NIGHT.

[Extracted and slightly altered from a longer poem, translated by Cowper.]

O NIGHT! propitious to my views,
Thy sable awning wide diffuse!
Conceal alike my joy and pain,
Nor draw thy curtain back again,
Though morning, by the tears she shows,
Seems to participate my woes.

Ye stars! whose faint and feeble fires
Express my languishing desires,
Whose slender beams pervade the skies
As silent as my secret sighs,
Those emanations of a soul
That darts her fires beyond the pole;—

Your rays, that scarce assist the sight,
That pierce, but not displace the night,
That shine, indeed, but nothing show
Of all those various scenes below,
Bring no disturbance, rather prove
Incentives to a sacred love.

Thou moon! whose never-failing course
Bespeaks a providential force,
Go, tell the tidings of my flame
To Him who calls the stars by name;
Whose absence kills, whose presence cheers,
Who blots or brightens all my years.

While, in the blue abyss of space,
Thine orb performs its rapid race;
Still whisper in his listening ears
The language of my sighs and tears;
Tell him, I seek him far below,
Lost in a wilderness of woe.

Ye thought-composing, silent hours,
Diffusing peace o'er all my powers;
Friends of the pensive! who conceal,
In darkest shades, the flames I feel;
To you I trust, and safely may,
The love that wastes my strength away

How calm, amid the night, my mind!
How perfect is the peace I find!
Oh! hush, be still, my every part,
My tongue, my pulse, my beating heart !
That love, aspiring to its cause,
May suffer not a moment's pause.

Omniscient God, whose notice deigns
To try the heart and search the reins,
Compassionate the numerous woes
I dare to thee alone disclose,
Oh! save me from the cruel hands
Of men who fear not thy commands

LOVE, all-subduing and Divine,
Care for a creature truly thine;
Reign in a heart disposed to own
No sovereign but thyself alone;
Cherish a bride who cannot rove,
Nor quit thee for a meaner love.

THE ENTIRE SURRENDER.

PEACE has unveil'd her smiling face,
And woos thy soul to her embrace;—
Enjoy'd with ease, if thou refrain
From selfish love, else sought in vain ;—
She dwells with all who truth prefer,
But seeks not them who seek not her.

Yield to the Lord with simple heart,
All that thou hast, and all thou art ;
Renounce all strength but strength Divine
And peace shall be for ever thine;
Behold the path which I have trod—
My path till I go home to God.

GLORY TO GOD ALONE.

O LOVED! but not enough, though dearer far
Than self and its most loved enjoyments are ;
None duly loves thee, but who, nobly free
From sensual objects, finds his ALL in thee.

Glory of God! thou stranger here below,
Whom man nor knows, nor feels a wish to know,
Our faith and reason are both shock'd to find
Man in the post of honour, thee behind.

My soul! rest happy in thy low estate,
Nor hope nor wish to be esteem'd or great:
To take the impression of a Will Divine,
Be that thy glory, and those riches thine.

Confess Him righteous in His just decrees,
Love what He loves, and let His pleasures please;
DIE DAILY ; from the touch of sin recede ;
Then thou hast crown'd Him, and He reigns indeed.

CHAPTER XLV.

696—Bossuet writes on the inward life—His book, entitled Instructions on Prayer, approved by the Bishop of Chartres and the Archbishop of Paris—Fénelon refuses his approbation—Writes to Madame de Maintenon, giving his reasons—Origin of the work entitled the Maxims of the Saints—Remarks on it.

DURING a considerable part of the year 1695, the mind of Bossuet seems to have been occupied, in various ways, with the topics which thus agitated the religious portion of the community.

The doctrines of holy living, in the form in which they were now presented, new as they were to most persons in that age, were nevertheless not new in the history and experience of the world. Pious men of other ages had known them ; felt them; taught them. They had their history, therefore, as well as their exegetical and theological relations. To the subject in its various relations, Bossuet had decided to give an increased and vigorous attention. Indeed, it was not his character to enter upon any subject indolently and carelessly. He read much ; and that, too, in writers who had hitherto attracted but little of his notice. He thought much, and conversed and observed much. And in the early part of the following year, after eight months of assiduous study, he was enabled to embody the result of his reading and reflections in his work (one of the ablest, unquestionably, in the long catalogue of his remarkable writings), entitled *Instructions on the States of Prayer.*

When Bossuet thought it proper to write at all, he expected to write as a *master.* Indeed, the public expectation, which was always disappointed when he failed to leave his competitors behind, did not allow him to do otherwise. Writing as a leader and master of his art, he wrote also as a master of the public mind. His decisions, when given in a manner worthy of his

high character, so influenced the public sentiment, that they had almost the effect of the combined wisdom and piety of a council. If he met with opposition, he expected to overcome it; but, generally speaking, he had ceased to expect it, because he had so long ceased to experience it. But whether opposed or not, he knew that he deserved to be listened to; and he did not expect to write or to speak to careless and indifferent ears. "What you write," says the Abbé de Rance in one of his letters, "*is decisive.*" And such was the general feeling in France.

He took the precaution, however, at this time, as the result seemed to be more doubtful than in some other cases, to sustain himself by the approval of distinguished men. Who knew but that a new Protestantism, arising out of these discussions, would spring up in the very bosom of France? How important it was, then, that the blow about to be given should be so well aimed, and inflicted with so much power, as entirely and for ever to prostrate these movements? If he had but little to fear from an intellectual conflict with Madame Guyon, he might have much to fear from heads and hearts too pure to be perverted by selfish considerations, and too strong to be trifled with, which were under her remarkable influence.

With such views and feelings, he wrote this celebrated treatise—a large work in ten books. Of the ability of the work no one can doubt. It is profound in learning, and brilliant with eloquence. But he was offended with Madame Guyon; he knew that the king was offended also; and when he touched upon her character and writings, he was more critical and denunciatory than just.

His work, begun in 1695, was completed early in 1696, but was not published till the following year. It was not his intention to publish it, until it could be submitted to the examination, and be sustained by the approbation, of some of the most distinguished men in France. It was accordingly submitted, at an early period, to M. Godet des Marais, Bishop of Chartres, and to M. de Noailles, appointed in the preceding year Arch-

bishop of Paris. Both were able men, and readily gave their testimonials in favour of the work.

To these important testimonials Bossuet was desirous of adding that of the recently appointed Archbishop of Cambray. The high character of Fénelon, added to the influential position he now held, had given a currency and popularity to the doctrines of Madame Guyon. It was natural, therefore, for Bossuet to consider it desirable to diminish his influence in that respect, by obtaining his signature to a work which condemned those doctrines.

Fénelon examined the manuscript with care; and although impressed with the ability which characterized it, he refused to give his approbation to it.

If the book had merely condemned doctrines, without implicating the character of persons, it might have been otherwise. His objection was not so much to the general doctrines of the book, although he might not have been altogether satisfied in that respect, as to the manner in which the writer spoke of the opinions and character of Madame Guyon.

Others, who were comparatively ignorant of her character, might perhaps conscientiously condemn her; but, as for himself, he felt that he had no such plea. He knew her well; he was entirely convinced of her sincerity; he had taken pains to ascertain her meaning in passages of her writings which seemed obscure and difficult. But this was not all. He remembered, with feelings of gratitude, the deep interest she had taken in his religious welfare, the prayers she had offered, the conversations she had held, the letters she had written, and the blessing which had attended these various efforts.

Was it possible for him, with a heart humbled and subdued, with a will which corresponded with what he supposed to be right and with the right only, to give his signature and approbation to a book which spoke in severely disparaging terms of one of whom he entertained the most favourable opinions, and to whom he was thus indebted?

He knew that his refusal would not only be an offence to

Bossuet, but would expose him also to the dissatisfaction of the king, and would be likely to blast his worldly prospects. But he did not hesitate.

The following are passages from a letter addressed to Madame de Maintenon :—

"*August,* 2, 1696.

"MADAME,—When the Bishop of Meaux proposed to me to approve of his book, I expressed to him, with tenderness, that I should be delighted to give such a public testimony of the conformity of my sentiments with those of a prelate whom I had ever regarded, from my youth, as my master in the science of religion. I even offered to go to Germigny to compose, in conjunction with him, my approbation. I said, at the same time, to the Archbishop of Paris, to the Bishop of Chartres, and to Monsieur Tronson, that I did not, in fact, see any shadow of difficulty between me and the Bishop of Meaux, on the fundamental questions of doctrine ; *but that, if he personally attacked Madame Guyon in his book, I could not approve of it.* This I declared six months ago. The Bishop of Meaux gave me his book to examine. At the first opening of the leaves, I saw that it was full of *personal* refutation. I immediately informed the Archbishop of Paris, the Bishop of Chartres, and Monsieur Tronson, of the perplexing situation in which the Bishop of Meaux had placed me."

After adding that he could not approve of a book in which many unfavourable things are said of Madame Guyon, without doing an injury to himself as well as injustice to her, he proceeds in the same letter to give his reasons.

" I have often seen her. Every one knows that I have been intimately acquainted with her. I may say farther, that I have esteemed her, and that I have suffered her also to be esteemed by illustrious persons, whose reputation is dear to the Church, and who had confidence in me. I neither was nor could be ignorant of her writings, although I did not examine them all accurately at an early period. I knew enough of them, however, to perceive that they were liable to be misunderstood ; and must

confess that I was induced by some feelings of early distrust to examine her with the greatest rigour. I think I can say I have conducted this examination with greater accuracy than her enemies, or even her authorized examiners, can have done it. And the reason of my saying this is, that she was much more candid, much more unconstrained, much more ingenuous towards me, at a time when she had nothing to fear.

" I have often made her explain what she thought respecting the controverted points. I have required her, in frequent instances, to explain to me the meaning of particular terms in her writings, having relation to the subject of inward experience, which seemed to be mystical and uncertain. I clearly perceived, in every instance, that she understood them in a perfectly innocent and catholic sense. I followed her even through all the details of her practice, and of the counsels which she gave to the most ignorant and least cautious persons ; but I could never discover the least trace of those wrong and injurious maxims which are attributed to her. Could I then conscientiously impute them to her by my approbation of the work of the Bishop of Meaux, and thus strike the final blow at her reputation, after having so clearly and so accurately ascertained her innocence ?

" Let others, who are acquainted with her *writings* only, explain the meaning of those writings with rigour, and censure them. I leave them to do it if they please. But, as for myself, I think I am bound in justice to judge of the *meaning of her writings from her real opinions, with which I am thoroughly acquainted;* and not of her opinions, by the harsh interpretations which are given to her expressions, and which she never intended."

The work of Bossuet, although not yet published, was everywhere spoken of. It was generally understood also, that it did not meet with the approbation of Fénelon. Bossuet and Fénelon were, therefore, at variance ; two men who embodied more of public thought and public attachment than any other two men in France. And, singular as it may seem, the object of controversy between them was a poor captive woman, who was at

this very time shut up in the fortress of Vincennes, and employed in making religious songs.

It was not possible for a man of Fénelon's reputation and standing, towards whom so many eyes were now turned, to remain silent. Under these circumstances, enlightened by his own experience as well as by history, he gave to the world his work, entitled, *The Maxims of the Saints*, in January 1697.

In this celebrated work, it was his object to state some of the leading principles found in the most devout writers on the higher inward experience. The work of Bossuet, although it embraced a multitude of topics, might be justly described as an attack upon Madame Guyon. The work of Fénelon, without naming her, was designed to be her defence. It was an exposition of her views as Fénelon understood them, and as she had explained them to him in private. I propose to give the substance of these maxims. As they are drawn in part from the mystic writers, we meet frequently with expressions peculiar to those writers.

MAXIMS OF THE SAINTS.

[The maxims of the Saints;—or Maxims having relation to the experiences of the Inward Life and the doctrines of Pure Love, by Fénelon, Archbishop of Cambray.]

ARTICLE FIRST.

Of the love of God, there are various kinds. At least, there are various feelings which go under that name.

First, There is what may be called mercenary or selfish love ; that is, that love of God which originates in a sole regard to our own happiness. Those who love God with no other love than this, love Him just as the miser his money, and the voluptuous man his pleasures ; attaching no value to God, except as a means to an end ; and that end is the gratification of themselves. Such love, if it can be called by that name, is unworthy of God. He does not ask it ; He will not receive it. In the language of Francis de Sales, " it is sacrilegious and impious."

Second, Another kind of love does not exclude a regard to

our own happiness as a motive of love, but requires this motive
to be subordinate to a much higher one, namely, *that of a regard
to God's glory.* It is a mixed state, in which we regard our-
selves and God at the same time. This love is not necessarily
selfish and wrong. On the contrary, when the two objects of it,
God and ourselves, are relatively in the right position, that is to
say, when we love God as He ought to be loved, and love our-
selves no more than we ought to be loved, it is a love which, in
being properly subordinated, is unselfish and is right.

ARTICLE SECOND.

I. Of the subjects of this mixed love all are not equally
advanced.

II. MIXED LOVE becomes PURE LOVE, when the love of self is
relatively, though not absolutely, lost in a regard to the will of
God. This is always the case, when the two objects are loved
in their due proportion. So that pure love is mixed love *when
it is combined rightly.*

III. Pure love is not inconsistent with mixed love, but is
mixed love carried to its true result. When this result is at-
tained, the motive of God's glory so expands itself, and so fills
the mind, that the other motive, that of our own happiness,
becomes so small, and so recedes from our inward notice, as to
be *practically* annihilated. It is then that God becomes what
He ever ought to be—the centre of the soul, to which all its
affections tend ; the great moral sun of the soul, from which all
its light and all its warmth proceed. It is then that a man
thinks no more of himself. He has become the man of a " *single
eye.*" His own happiness, and all that regards himself, is entirely
lost sight of, in his simple and fixed look to God's will and
God's glory.

IV. We lay ourselves at His feet. Self is known no more ;
not because it is wrong to regard and to desire our own good,
but because the object of desire is withdrawn from our notice.
When the sun shines, the stars disappear. When God is in the

soul, who can think of himself? So that we love God, and God
alone ; and all other things IN and FOR God.

ARTICLE THIRD.

In the early periods of religious experience, motives, which
have a regard to our personal happiness, are more prominent
and effective than at later periods ; *nor are they to be condemned.*
It is proper, in addressing even religious men, to appeal to the
fear of death, to the impending judgments of God, to the terrors
of hell and the joys of heaven. Such appeals are recognised in
the Holy Scriptures, and are in accordance with the views and
feelings of good men in all ages of the world. The motives
involved in them are powerful aids to beginners in religion ;
assisting, as they do, very much in repressing the passions, and
in strengthening the practical virtues.

We should not think lightly, therefore, of the grace of God,
as manifested in that inferior form of religion which stops short
of the more glorious and perfected form of pure love. We are
to follow God's grace, and not to go before it. To the higher
state of PURE LOVE we are to advance step by step ; watching
carefully God's inward and outward providence ; and receiving
increased grace by improving the grace we have, till the dawn-
ing light becomes the perfect day.

ARTICLE FOURTH.

He who is in the state of pure or perfect love, has all the
moral and Christian virtues in himself. If temperance, forbear-
ance, chastity, truth, kindness, forgiveness, justice, may be re-
garded as virtues, there can be no doubt that they are all in-
cluded in holy love. That is to say, the principle of love will
not fail to develop itself in each of these forms. St. Augustine
remarks, that love is the foundation, source, or principle of all
the virtues. This view is sustained also by St. Francis de Sales
and by Thomas Aquinas.

The state of pure love does not exclude the mental state
which is called *Christian hope.* Hope in the Christian, when

we analyze it into its elements, may be described as the desire
of being united with God in heaven, accompanied with the ex-
pectation or belief of being so.

<div align="center">ARTICLE FIFTH.</div>

Souls that, by being perfected in love, are truly the subjects
of sanctification, do not cease, nevertheless, to grow in grace.
It may not be easy to specify and describe the degrees of sancti-
fication ; but there seem to be at least two modifications of
experience after persons have reached this state.

1. The first may be described as the state of *holy resignation.*
Such a soul thinks more frequently than it will, at a subsequent
period, of its own happiness.

2. The second state is that of *holy indifference.* Such a soul
absolutely ceases either to desire or to will, except in co-opera-
tion with the Divine leading. Its desires for itself, as it has
greater light, are more completely and permanently merged in
the one higher and more absorbing desire of God's glory, and
the fulfilment of His will. In this state of experience, ceasing
to do what we shall be likely to do, and what we may very
properly do in a lower state, we no longer desire our own salva-
tion merely as an eternal deliverance, or merely as involving
the greatest amount of personal happiness ; but we desire it
chiefly as the fulfilment of God's pleasure, and as resulting in
His glory, and because He Himself desires and wills that we
should thus desire and will.

3. Holy indifference is not inactivity. It is the furthest pos-
sible from it. It is indifference to anything and everything out
of God's will ; but it is the highest life and activity to anything
and everything in that will.

<div align="center">ARTICLE SIXTH.</div>

One of the clearest and best-established maxims of holiness
is, that the holy soul, when arrived at the second state men-
tioned, ceases to have desires for anything out of the will of God.

The holy soul, when it is really in the state called the state of

NON-DESIRE, may, nevertheless, desire everything in relation to the correction of its imperfections and weaknesses, its perseverance in its religious state, and its ultimate salvation, which it has reason to know from the Scriptures, or in any other way, that God desires. It may also desire all temporal good, houses and lands, food and clothing, friends and books, and exemption from physical suffering, and anything else, so far and only so far, as it has reason to think that such desire is coincident with the Divine desire. The holy soul not only desires particular things, sanctioned by the known will of God; but also the fulfilment of His will in all respects, unknown as well as known. Being in faith, it commits itself to God in darkness as well as in light. Its NON-DESIRE is simply its not desiring anything out of God.

<div style="text-align:center">ARTICLE SEVENTH.</div>

In the history of inward experience, we not unfrequently find accounts of individuals whose inward life may properly be characterized as *extraordinary*. They represent themselves as having extraordinary communications;—dreams, visions, revelations. Without stopping to inquire whether these inward results arise from an excited and disordered state of the physical system or from God, the important remark to be made here is, that these things, to whatever extent they may exist, *do not constitute holiness.*

The principle, which is the life of common Christians in their common mixed state, is the principle which originates and sustains the life of those who are truly " *the pure in heart,*" namely, the principle of *faith working by love,*—existing, however, in the case of those last mentioned, in a greatly increased degree. This is obviously the doctrine of John of the Cross, who teaches us, that we must walk in the *night of faith;* that is to say, with night around us, which exists in consequence of our entire ignorance of what is before us, and with faith alone, faith in God, in His Word, and in His Providences, for the soul's guide.

Again, the persons who have, or are supposed to have, the visions and other remarkable states to which we have referred.

are sometimes disposed to make their own experience, imperfect as it obviously is, the guide of their life, considered as separate from and as above the written law. Great care should be taken against such an error as this. God's word is our true rule.

Nevertheless, there is no interpreter of the Divine Word like that of a holy heart; or, what is the same thing, of the Holy Ghost dwelling in the heart. If we give ourselves wholly to God, the Comforter will take up His abode with us, and guide us into all that truth which will be necessary for us. Truly holy souls, therefore, continually looking to God for a proper understanding of His Word, may confidently trust that He will guide them aright. A holy soul, in the exercise of its legitimate powers of interpretation, may deduce important views from the Word of God which would not otherwise be known; but it cannot add anything to it.

Again, God is the regulator of the affections, as well as of the outward actions. Sometimes the state which He inspires within us is that of holy love;—sometimes He inspires affections which have love and faith for their basis, but have a specific character, and then appear under other names, such as humility, forgiveness, gratitude. But in all cases there is nothing holy, except what is based upon the antecedent or "prevenient" grace of God. In all the universe, there is but one *legitimate Originator*. Man's business is that of *concurrence*. And this view is applicable to all the stages of Christian experience, from the lowest to the highest.

ARTICLE EIGHTH.

Writers often speak of *abandonment*. The term has a meaning somewhat specific. The soul in this state does not renounce everything, and thus become brutish in its indifference; but renounces everything *except God's will.*

Souls in the state of abandonment, not only forsake outward things, but, what is still more important, *forsake themselves.*

Abandonment, or self-renunciation, is not the renunciation of faith or of love or of anything else, except *selfishness.*

The state of abandonment, or entire self-renunciation, is

generally attended, and perhaps we may say, carried out and perfected, by temptations more or less severe. We cannot well know, whether we have renounced ourselves, except by being tried on those very points to which our self-renunciation, either real or supposed, relates. One of the severest inward trials is that by which we are taken off from all inward sensible supports, and are made to live and walk by faith alone. Pious and holy men who have been the subjects of inward crucifixion, often refer to the trials which have been experienced by them. They sometimes speak of them as a sort of inward and terrible purgatory. " Only mad and wicked men," says Cardinal Bona, " will deny the existence of these remarkable experiences, attested as they are by men of the most venerable virtue, who speak only of what they have known in themselves."

Trials are not always of the same duration. The more cheerfully and faithfully we give ourselves to God, to be smitten in any and all of our idols, whenever and wherever He chooses, the shorter will be the work. God makes us to suffer no longer than He sees to be necessary for us.

We should not be premature in concluding that inward crucifixion is complete, and our abandonment to God is without any reservation whatever. The act of consecration, which is a sort of incipient step, may be sincere ; but the reality of the consecration can be known only when God has applied the appropriate tests. The trial will shew whether we are wholly the Lord's. Those who prematurely draw the conclusion that they are so, expose themselves to great illusion and injury.

<div align="center">ARTICLE NINTH.</div>

The state of abandonment, or of entire self-renunciation, does not take from the soul that moral power which is essential to its moral agency ; nor that antecedent or prevenient grace, without which even abandonment itself would be a state of moral death ; nor the principle of faith, which prevenient grace originated, and through which it now operates ; nor the desire and hope of final salvation, although it takes away all uneasiness

and unbelief connected with such a desire; nor the fountains of love which spring up deeply and freshly within it; nor the hatred of sin; nor the testimony of a good conscience.

But it takes away that uneasy hankering of the soul after pleasure either inward or outward, and the selfish vivacity and eagerness of nature, which is too impatient to wait calmly and submissively for God's time of action. By fixing the mind wholly upon God, it takes away the disposition of the soul to occupy itself with *reflex acts;* that is, with the undue examination and analysis of its own feelings. It does not take away the pain and sorrow naturally incident to our physical state and natural sensibilities; but it takes away all uneasiness, all murmuring;—leaving the soul in its inner nature, and in every part of its nature where the power of faith reaches, calm and peaceable as the God that dwells there.

ARTICLE TENTH.

God has promised life and happiness to His people. What He has promised can never fail to take place. Nevertheless, it is the disposition of those who love God with a perfect heart, to leave themselves entirely in His hands, irrespective, in some degree, of the promise. By the aid of the promise, without which they must have remained in their original weakness, they rise, as it were, above the promise; and rest in that essential and eternal will, in which the promise originated.

So much is this the case, that some individuals, across whose path God had spread the darkness of His providences, and who seemed to themselves for a time to be thrown out of His favour and to be hopelessly lost, have acquiesced with submission in the terrible destiny which was thus presented before them. Such was the state of mind of Francis de Sales, as he prostrated himself in the church of St. Stephen des Grez. The language of such persons, *uttered without complaint,* is, " *My* God, *my* God, why hast thou forsaken me?" They claim God as *their* God, and will not abandon their love to Him, although they believe, at the time, that they are forsaken of Him. They

choose to leave themselves, under all possible circumstances, entirely in the hands of God : their language is, even if it should be His pleasure to separate them for ever from the enjoyments of His presence, " *Not my will, but thine be done.*"

It is perhaps difficult to perceive, how minds whose life, as it were, is the principle of *faith*, can be in this situation. Take the case of the Saviour. It is certainly difficult to conceive how the Saviour, whose faith never failed, could yet believe Himself forsaken ; and yet it was so.

We know that it is impossible for God to forsake those who put their trust in Him. He can just as soon forsake His own word ; and, what is more, He can just as soon forsake His own nature. Holy souls, nevertheless, may sometimes, in a way and under circumstances which we may not fully understand, believe themselves to be forsaken, beyond all possibility of hope ; and yet such is their faith in God and their love to Him, that the will of God, even under such circumstances, is dearer to them than anything and everything else.

ARTICLE ELEVENTH.

One great point of difference between the First Covenant, or the covenant of works, which said to men, " *Do this and live,*" and the Second Covenant, or the covenant of grace, which says, " *Believe and live,*" is this :—The first covenant did not lead men to anything that was perfect. It shewed men what was right and good ; but it failed in giving them the power to fulfil what the covenant required. Men not only understood what was right and good, but they knew what was *evil ;* but, in their love and practice of depravity, they had no longer power of themselves to flee from it.

The new or Christian covenant of *grace*, not only prescribes and commands, but gives also the *power to fulfil.*

In the practical dispensations of divine grace, there are a number of principles which it may be important to remember.

1. God being Love, it is a part of His nature to desire to *communicate Himself* to all moral beings, and to make Himself

one with them in a perfect harmony of relations and feelings. The position of God is that of giver; the position of man is that of recipient. Harmonized with man by the blood and power of the Cross, he has once more become the *infinite fulness*, the original and overflowing fountain, giving and ever ready to give.

2. Such are the relations between God and man, involved in the fact of man's moral agency, that man's business is to *receive*.

3. Souls true to the grace given them, will never suffer any diminution of it. On the contrary, the great and unchangeable condition of continuance and of growth in grace is *co-operation with what we now have*. This is the law of growth, not only deducible from the Divine nature, but expressly revealed and declared in the Scriptures:—" *For whosoever hath, to him shall be given, and he shall have more abundance; but whosoever hath not, from him shall be taken away even that he hath.*"—Matt. xiii. 12.

A faithful co-operation with grace, is the most effectual preparation for attracting and receiving and increasing grace. This is the great secret of advancement to those high degrees which are permitted; namely, a strict, unwavering, faithful co-operation, *moment by moment*.

4. It is important correctly to understand the doctrine of co-operation. A disposition to co-operate, is not more opposed to the sinful indolence which falls behind, than to the hasty and unrighteous zeal which runs before. It is in the *excess* of zeal, which has a good appearance, but in reality has unbelief and self at the bottom, that we run before God.

5. Co-operation, by being calm and peaceable, does not cease to be efficacious. Souls in this purified but tranquil state are souls of power; watchful and triumphant against self; resisting temptation; fighting even to blood against sin. But it is, nevertheless, a combat free from the turbulence and inconsistencies of human passion; because they contend in the presence of God, who is their strength, in the spirit of the highest faith and love, and under the guidance of the Holy Ghost, who is always tranquil in His operations.

ARTICLE TWELFTH.

Those in the highest state of religious experience desire nothing, except that God may be glorified in them by the accomplishment of His holy will. Nor is it inconsistent with this, that holy souls possess that natural love which exists in the form of love for themselves. Their natural love, however, which, within its proper degree, is innocent love, is so absorbed in the love of God, that it ceases, for the most part, to be a distinct object of consciousness; and practically and truly they may be said to love themselves IN and FOR God. Adam, in his state of innocence, loved himself, considered as the reflex image of God and for God's sake. So that we may either say, that he loved God in himself, or that he loved himself IN and FOR God. And it is because holy souls, extending their affections beyond their own limit, love their neighbour on the same principle of loving, namely, IN and FOR God, that they may be said to *love their neighbours as themselves.*

It does not follow, because the love of ourselves is lost in the love of God, that we are to take no care, and to exercise no watch over ourselves. No man will be so seriously and constantly watchful over himself as he who loves himself IN and FOR God alone. Having the image of God in himself, he has a motive strong, we might perhaps say, as that which controls the actions of angels, to guard and protect it.

It may be thought, perhaps, that this is inconsistent with the principle in the doctrines of holy living, which requires in the highest stages of inward experience, to avoid those reflex acts which consist in self-inspection, because such acts have a tendency to turn the mind off from God. The apparent difficulty is reconciled in this way. The holy soul is a soul *with* God; moving as God moves; doing as God does; looking as God looks. If, therefore, God is looking within us, as we may generally learn from the intimations of His providences, then it is a sign that we are to look within ourselves. Our little eye, our small and almost imperceptible ray, must look in, in the

midst of the light of His great and burning eye. It is thus that we may inspect ourselves without a separation from God.

On the same principle, we may be watchful and careful over our neighbours; watching them, not in our own time, but in God's time; not in the censoriousness of nature, but in the kindness and forbearance of grace; not as separate from God, but in concurrence with Him.

ARTICLE THIRTEENTH.

The soul, in the state of pure love, acts in *simplicity*. Its inward rule of action is found in the decisions of a sanctified conscience. These decisions, based upon judgments that are free from self-interest, may not always be *absolutely* right, because our views and judgments, being limited, can extend only to things *in part;* but they may be said to be relatively right: they conform to things so far as we are permitted to see them and understand them, and convey to the soul a moral assurance, that, when we act in accordance with them, we are doing as God would have us do. Such a conscience is enlightened by the Spirit of God; and when we act thus, under its Divine guidance, looking at what *now is* and not at what *may be*, looking at the *right* of things and not at their relations to our personal and selfish interests, we are said to act in *simplicity*. This is the true mode of action.

Thus, in this singleness of spirit, we do things, as some experimental writers express it, *without knowing what we do*. We are so absorbed in the thing to be done, and in the importance of doing it rightly, that we forget ourselves. Perfect love has nothing to spare from its object for itself, and he who prays perfectly is never thinking how well he prays.

ARTICLE FOURTEENTH.

Holy souls are without impatience, but not without trouble; are above murmuring, but not above affliction. The souls of those who are thus wholly in Christ may be regarded in two points of view, or rather in two parts; namely, the natural appe-

tites, propensities, and affections, on the one hand, which may be called the inferior part; and the judgment, the moral sense, and the will, on the other, which may be described as the superior part. As things are, in the present life, those who are wholly devoted to God may suffer in the inferior part, and may be at rest in the superior. Their wills may be in harmony with the Divine will; they may be approved in their judgments and conscience, and at the same time may suffer greatly in their physical relations, and in their natural sensibilities. In this manner, Christ upon the cross, while His will remained firm in its union with the will of His heavenly Father, suffered much through His physical system; He felt the painful longings of thirst, the pressure of the thorns, and the agony of the spear. He was deeply afflicted also for the friends He left behind Him, and for a dying world. But in His inner and higher nature, where He felt Himself sustained by the secret voice uttered in His sanctified conscience and in His unchangeable faith, He was peaceful and happy.

ARTICLE FIFTEENTH.

A suitable repression of the natural appetites is profitable and necessary. We are told that the body should be brought into subjection. Those physical mortifications, therefore, which are instituted to this end, denominated austerities, are not to be disapproved. When practised within proper limits, they tend to correct evil habits, to preserve us against temptation, and to give self-control.

The practice of austerities, with the views and on the principles indicated, should be accompanied with the spirit of recollection, of love, and prayer. Christ himself, whose retirement to solitary places, whose prayers and fastings are not to be forgotten, has given us the pattern which it is proper for us to follow. We must sometimes use force against our stubborn nature. "Since the days of John, the kingdom of heaven *suffereth violence;* and the violent take it by force."

ARTICLE SIXTEENTH.

The simple desire of our own happiness, kept in due subordination, is innocent. This desire is natural to us; and is properly denominated the principle of SELF-LOVE. When the principle of self-love passes its appropriate limit, it becomes selfishness. Self-love is innocent; selfishness is wrong. Selfishness was the sin of the first angel, "who rested in himself," as St. Augustine expresses it, instead of referring himself to God.

In many Christians a prominent principle of action is the desire of happiness. They love God and they love heaven; they love holiness, and they love the pleasures of holiness; they love to do good, and they love the rewards of doing good. This is well; but there is something better. Such Christians are inferior to those who forget the nothingness of the creature in the infinitude of the Creator, and love God for His own glory alone.

ARTICLE SEVENTEENTH.

No period of the Christian life is exempt from temptation. The temptations incident to the earlier stages are different from those incident to a later period, and are to be resisted in a different manner.

Sometimes the temptations incident to the transition-state from mixed love to pure love are somewhat peculiar, being adapted to test whether we love God for Himself alone.

In the lower or mixed state the methods of resisting temptations are various. Sometimes the subject of these trials boldly faces them, and endeavours to overcome them by a direct resistance. Sometimes he turns and flees. But in the state of pure love, when the soul has become strong in the Divine contemplation, it is the common rule laid down by religious writers, that the soul should keep itself fixed upon God in the exercise of its holy love as at other times, as the most effectual way of resisting the temptation, which would naturally expand its efforts in vain upon a soul in that state.

ARTICLE EIGHTEENTH.

The will of God is the ultimate and only rule of action. God manifests His will in various ways. The will of God may in some cases be ascertained by the operations of the human mind, especially when under a religious or gracious guidance. *But He reveals His will chiefly in His written word.* And nothing can be declared to be the will of God, which is at variance with His written or revealed will, which may also be called His *positive* will.

If we sin, it is true that God permits it; but it is also true, that He disapproves and condemns it as contrary to His immutable holiness.

It is the business of the sinner to repent. The state of penitence has temptations peculiar to itself. He is sometimes tempted to murmuring and rebellious feelings, as if he had been unjustly left of God. When penitence is true, and in the highest state, it is free from the variations of human passion.

ARTICLE NINETEENTH.

Among other distinctions of prayer, we may make that of vocal and silent, the prayer of the *lips* and the prayer of the *affections.* Vocal prayer, without the heart attending it, is superstitious and wholly unprofitable. To pray without recollection in God and without love, is to pray as the heathen did, who thought to be heard for the multitude of their words.

Nevertheless, vocal prayer, when attended by right affections, ought to be both recognised and encouraged, as being calculated to strengthen the thoughts and feelings it expresses, and to awaken new ones, and also for the reason that it was taught by the Son of God to His Apostles, and that it has been practised by the whole Church in all ages. To make light of this sacrifice of praise, this fruit of the lips, would be an impiety.

Silent prayer, in its common form, is also profitable. Each has its peculiar advantages, as each has its place.

There is also a modification of prayer, which may be termed

the *prayer of silence.* This is a prayer too deep for words. The common form of silent prayer is voluntary. In the prayer of contemplative silence, the lips seem to be closed almost against the will.

ARTICLE TWENTIETH.

The principles of holy living extend to everything. For instance, in the matter of *reading,* he who has given himself wholly to God, can read only what God permits him to read. He cannot read books, however characterized by wit or power, merely to indulge an idle curiosity, or to please himself alone.

In reading this may be a suitable direction, namely, to read but little at a time, and to interrupt the reading by intervals of religious recollection, in order that we may let the Holy Spirit more deeply imprint in us Christian truths.

God, in the person of the Holy Ghost, becomes to the fully renovated mind the great inward Teacher. This is a great truth. At the same time we are not to suppose that the presence of the inward teacher exempts us from the necessity of the outward lesson. The Holy Ghost, operating through the medium of a purified judgment, teaches us by the means of books, especially by the word of God, which is never to be laid aside.

ARTICLE TWENTY-FIRST.

One characteristic of the lower states of religious experience is, that they are sustained, in a considerable degree, by meditative and reflective acts. As faith is comparatively weak and temptations are strong, it becomes necessary to gain strength by such meditative and reflective acts, by the consideration of various truths applicable to their situation, and of the motives drawn from such truths. Accordingly, souls array before them all the various motives drawn from the consideration of misery on the one hand, and of happiness on the other ; all the motives of fear and hope.

It is different with those who have given themselves wholly to God in the exercise of pure or perfect love. The soul does

not find it necessary to delay and to meditate, in order to discover motives of action. It finds its motive of action a motive simple, uniform, peaceable, and still powerful beyond any other power, in its own principle of life.

Meditation, inquiry, and reasoning, are exceedingly necessary to the great body of Christians; and absolutely indispensable to those in the *beginnings* of the Christian life. To take away these helps would be to take away the child from the breast before it can digest solid food. Still they are only the *props*, and not the life itself.

ARTICLE TWENTY-SECOND.

The holy soul delights in acts of contemplation; to think of God and of God only. But the contemplative state, without any interruption, is hardly consistent with the condition of the present life. It may be permitted to exist, however, and ought not to be resisted, when the attraction towards God is so strong, that we find ourselves incapable of profitably employing our minds in meditative and discursive acts.

ARTICLE TWENTY-THIRD.

Of the two states, the meditative and discursive on the one hand, which reflects, compares, and reasons, and supports itself by aids and methods of that nature, and the contemplative on the other, which rests in God without such aids, the contemplative is the higher. God will teach the times of both. Neither state is, or ought to be, entirely exclusive of the other.

ARTICLE TWENTY-FOURTH.

In some cases God gives such eminent grace, that the contemplative prayer, which is essentially the same with the prayer of silence, becomes the habitual state. We do not mean, that the mind is always in this state; but that, whenever the season of recollection and prayer returns, it habitually assumes the contemplative state, in distinction from the meditative and discursive.

It does not follow that this state, eminent as it is, is invariable.

Souls may fall from this state by some act of infidelity in themselves; or God may place them temporarily in a different state.

ARTICLE TWENTY-FIFTH.

" *Whether, therefore,*" says the Apostle, " *ye eat or drink, or whatsoever ye do, do all things to the glory of God,*" 1 Cor. x. 31. And in another passage he says, " *Let all things be done with charity,*" 1 Cor. xvi. 14. And again, " *By love serve one another,*" Gal. v. 13 :—passages which, with many others, imply two things; *first,* that everything which is done by the Christian ought to be done from a holy principle ; and, *second,* that this principle is love.

ARTICLE TWENTY-SIXTH.

Our acceptance with God, when our hearts are wholly given to Him, does not depend upon our being in a particular state, but simply upon our being in that state in which God in His providence requires us to be. The doctrine of holiness, therefore, while it recognises and requires, on its appropriate occasions, the prayer of contemplation or of contemplative silence, is not only not inconsistent with other forms of prayer, but is not at all inconsistent with the practice of the ordinary acts, duties, and virtues of life. It would be a great mistake to suppose, that a man who bears the Saviour's image, is any the less on that account a good neighbour or a good citizen ; that he can think less or work less when he is called to it ; or that he is not characterized by the various virtues, appropriate to our present situation, of temperance, truth, forbearance, forgiveness, kindness, chastity, justice. There is a law, involved in the very nature of holiness, which requires it to adapt itself to every variety of situation.

ARTICLE TWENTY-SEVENTH.

It is in accordance with the views of Dionysius the Areopagite, to say, that the holy soul in its *contemplative* state, is occupied

with the *pure* or spiritual *Divinity*. That is to say, it is occupied with God, in distinction from any *mere image of God*, such as could be addressed to the touch, the sight, or any of the senses.

And this is not all. It does not satisfy the desires of the soul in its contemplative state, to occupy itself merely with the attributes of God; with His power, wisdom, goodness, and the like; but it rather seeks and unites itself with the *God* of the attributes. The attributes of God are not God himself. The power of God is not an identical expression with the God of power; nor is the wisdom of God identical with the God of wisdom. The holy soul, in its contemplative state, loves to unite itself with God, considered as the *subject* of His attributes. It is not infinite wisdom, infinite power, or infinite goodness, considered separately from the existence of whom they can be predicated, which it loves and adores; but the *God* of infinite wisdom, power, and goodness.

ARTICLE TWENTY-EIGHTH.

Christ is " the way, and the truth, and the life." The grace which sanctifies as well as that which justifies, is by Him and through Him. He is the true and living way; and no man can gain the victory over sin, and be brought into union with God, without Christ. And when, in some mitigated sense, we may be said to have arrived at the end of the way by being brought home to the Divine fold and reinstated in the Divine image, it would be sad indeed if we should forget the way itself, as Christ is sometimes called. At every period of our progress, however advanced it may be, our life is derived from God through Him and for Him. The most advanced souls are those which are most possessed with the thoughts and the presence of Christ.

Any other view would be extremely pernicious. It would be to snatch from the faithful eternal life, which consists in knowing the only true God and Jesus Christ His Son, whom He hath sent.

ARTICLE TWENTY-NINTH.

The way of holiness is wonderful, but it is not miraculous. Those in it, walk by simple faith alone. And perhaps there is nothing more remarkable nor wonderful in it, than that a result so great should be produced by a principle so simple.

When persons have arrived at the state of DIVINE UNION, so that, in accordance with the prayer of the Saviour, they are made one with Christ in God, they no longer seem to put forth distinct inward acts, but their state appears to be characterized by a deep and Divine repose.

The continuous act is the act of faith, which brings into moral and religious union with the Divine nature; faith which, through the plenitude of Divine grace, is kept firm, unbroken.

The appearance of absolute continuity and unity in this blessed state is increased perhaps by the entire freedom of the mind from all eager, anxious, unquiet acts. The soul is not only at unity with itself in the respects which have been mentioned, but it has also a unity of *rest*.

This state of continuous faith and of consequent repose in God is sometimes denominated the *passive* state. The soul, at such times, ceases to originate acts which precede the grace of God. The decisions of her consecrated judgment, are the voice of the Holy Ghost in the soul. But if she first listens passively, it is subsequently her business to yield an active and effective co-operation in the line of duty which they indicate. The more pliant and supple the soul is to the Divine suggestions, the more real and efficacious is her own action, though without any excited and troubled movement. The more a soul receives from God, the more she ought to restore to Him of what she hath from Him. This ebbing and flowing, if one may so express it, this communication on the part of God and the correspondent action on the part of man, constitute the order of grace on the one hand, and the action and fidelity of the creature on the other.

ARTICLE THIRTIETH.

It would be a mistake to suppose, that the highest state of inward experience is characterized by great excitements, by raptures and ecstasies, or by any movements of feeling which would be regarded as particularly extraordinary.

One of the remarkable results in a soul of which faith is the sole governing principle, is, that it is entirely peaceful. Nothing disturbs it. And being thus peaceful, it reflects distinctly and clearly the image of Christ; like the placid lake, which shows, in its own clear and beautiful bosom, the exact forms of the objects around and above it. Another is, that having full faith in God and divested of all selfishness and resistance in itself, it is perfectly accessible and pliable to all the impressions of grace.

ARTICLE THIRTY-FIRST.

It does not follow, that those who possess the graces of a truly sanctified heart, are at liberty to reject the ordinary methods and rules of perception and judgment. They exercise and value wisdom, while they reject the *selfishness* of wisdom. The rules of holy living would require them every moment to make a faithful use of all the natural light of reason, as well as the higher and spiritual light of grace.

A holy soul values and seeks wisdom, but does not seek it in an unholy and worldly spirit. Nor, when it is made wise by the Spirit of wisdom, who dwells in all hearts that are wholly devoted to God, does it turn back from the giver to the gift, and rejoice in its wisdom *as its own.*

The wisdom of the truly holy soul is a wisdom which estimates things *in the present moment.* It judges of duty from the facts which *now are;* including, however, those things which have a relation to the present. It is an important remark, that the present moment necessarily possesses *a moral extension;* so that, in judging of it, we are to include all those things which have a natural and near relation to the thing actually in hand. It is in this manner that the holy soul lives in the present, com-

mitting the past to God, and leaving the future with that ap‧
proaching hour which shall convert it into the present. "Sufficient
to the day is the evil thereof." To-morrow will take care of
itself; it will bring, at its coming, its appropriate grace and
light. When we live thus, God will not fail to give us our
daily bread.

Such souls draw on themselves the special protection of Pro-
vidence, under whose care they live, without a far extended
and unquiet forecast, like little children resting in the bosom
of their mother. Conscious of their own limited views, and
keeping in mind the direction of the Saviour, *Judge not that
ye be not judged,* they are slow to pass judgment upon others.
They are willing to receive reproof and correction ; and, separate
from the will of God, they have no choice or will of their own
in anything.

These are the children whom Christ permits to come near
Him. They combine the prudence of the serpent with the sim-
plicity of the dove. But they do not appropriate their prudence
to themselves as their own prudence, any more than they ap-
propriate to themselves the beams of the natural sun, when they
walk in its light.

These are *the poor in spirit,* whom Christ Jesus hath declared
blessed ; and who are as much taken off from any complacency
in what others might call their merits, as all Christians ought
to be from their temporal possessions. They are the "little
ones," to whom God is well pleased to reveal His mysteries,
while He hides them from the wise and prudent.

ARTICLE THIRTY-SECOND.

The children, in distinction from the mere servants of God,
have the *liberty of children.* They have a peace and joy, full
of innocency. They take with simplicity and without hesita-
tion the refreshments both of mind and body. They do not
speak of themselves, except when called to do it in providence,
and in order to do good. And such is their simplicity and truth
of spirit, they speak of things just as they appear to them at the

moment; and when the conversation turns upon their own works or characters, they express themselves favourably or unfavourably, much as they would if they were speaking of others. If, however, they have occasion to speak of any good of which they have been the instrument, they always acknowledge, with humble joy, that it comes from God alone.

There is a liberty, which might more properly be called *license.* There are persons who maintain that purity of heart renders pure, in the subjects of this purity, whatever they are prompted to do, however irregular it may be in others. This is a great error.

ARTICLE THIRTY-THIRD.

It is the doctrine of Augustine, as also of Thomas Aquinas, that the principle of holy love existing in the heart, necessarily includes in itself, or implies the existence, of all other Christian virtues. He who loves God with all his heart, will not violate the laws of purity, because it would be a disregard of the will of God, which he loves above all things. His love, under such circumstances, becomes the virtue of *chastity.* He has too much love and reverence for the will of God to murmur or repine under the dispensations of His providence. His love, under such circumstances, becomes the virtue of *patience.* And thus this love becomes by turns, on their appropriate occasions, all the virtues. As his love is perfect, so the virtues which flow out of it, and are modified from it, will not be less so.

It is a maxim in the doctrines of holiness, that the holy soul is crucified to its own virtues, although it possesses them in the highest degree. The meaning of this saying is this : The holy soul is so crucified to self in all its forms, that it practises the virtues without taking complacency in its virtues *as its own*, and even without thinking how virtuous it is.

ARTICLE THIRTY-FOURTH.

The Apostle Paul speaks of Christians as *dead.* "Ye are dead," he says, "and your life is hid with Christ in God." (Coloss. iii. 3.) These expressions will apply, in their full im-

port, only to those Christians who are in the state of unselfish or pure love. Their death is a death to selfishness. They are dead to pride and jealousy, self-seeking and envy, to malice, inordinate love of their own reputation, anything and everything which constitutes the fallen and vitiated life of nature. They have a new life, which is "hid with Christ in God."

ARTICLE THIRTY-FIFTH.

Some persons of great piety, in describing the highest religious state, have denominated it the *state of transformation*. But this can be regarded as only a synonymous expression for the state of PURE LOVE.

In the *transformed* state of the soul, as in the state of PURE LOVE, love is its life. In this principle of love all the affections of the soul, of whatever character, have their constituting or their controlling element. There can be no love without an object of love. As the principle of love, therefore, allies the soul with another, so from that other which is God, all its power of movement proceeds. In itself it remains without preference for anything; and consequently is accessible and pliant to all the touches and guidances of grace, however slight they may be. It is like a spherical body, placed upon a level and even surface, which is moved with equal ease in any direction. The soul in this state, having no preferences of itself, has but one principle of movement, namely, that which God gives it. In this state the soul can say with the Apostle Paul, "*I live; yet not I, but Christ liveth in me.*"

ARTICLE THIRTY-SIXTH.

Souls which have experienced the grace of sanctification in its higher degrees, have not so much need of set times and places for worship as others. Such is the purity and the strength of their love, that it is very easy for them to unite with God in acts of inward worship, at all times and places. They have an interior closet. The soul is their temple, and God dwells in it.

This, however, does not exempt them from those outward

methods and observances which God has prescribed. Besides, they owe something to others; and a disregard to the ordinances and ministrations of the Church could not fail to be injurious to beginners in the religious life.

ARTICLE THIRTY-SEVENTH.

The practice of *confession* is not inconsistent with the state of pure love. The truly renovated soul can still say, *Forgive us our trespasses.* If it does not sin now, deliberately and knowingly, still its former state of sin can never be forgotten.

ARTICLE THIRTY-EIGHTH.

In the transformed state, or state of pure love, there should be not only the confession of sins, properly so called, but also the confession of those more venial transgressions, termed *faults*. We should sincerely disapprove such faults in our confession; should condemn them and desire their remission ; and not merely with a view to our own cleansing and deliverance, but also because God wills it, and because He would have us to do it for His glory.

ARTICLE THIRTY-NINTH.

It is sometimes the case, that persons misjudge of the holiness of individuals, by estimating it from the incidents of the outward appearance. Holiness is consistent with the existence, in the same person, of various infirmities ; (such as an unprepossessing form, physical weakness, a debilitated judgment, an imperfect mode of expression, defective manners, a want of knowledge, and the like.)

ARTICLE FORTIETH.

The holy soul may be said to be united with God, without anything intervening or producing a separation, in three particulars.

First.—It is thus united *intellectually ;*—that is to say, not by any idea which is based upon the senses, and which of course

could give only a material image of God, but by an idea which is internal and spiritual in its origin, and makes God known to us as a Being without form.

Second.—The soul is thus united to God, if we may so express it, *affectionately.* That is to say, when its affections are given to God, not indirectly through a self-interested motive, but simply because He is what He is. The soul is united to God in love without anything intervening, when it loves Him for His own sake.

Third.—The soul is thus united to God PRACTICALLY ;—and this is the case when it does the will of God, not by simply following a prescribed form, but from the constantly operative impulse of holy love.

ARTICLE FORTY-FIRST.

We find in some devout writers on inward experience, the phrase SPIRITUAL NUPTIALS. It is a favourite method with some of these writers, to represent the union of the soul with God by the figure of the *bride and the bridegroom.* Similar expressions are found in the Scriptures.

We are not to suppose that such expressions mean anything more, in reality, than that intimate union which exists between God and the soul, when the soul is in the state of pure love.

ARTICLE FORTY-SECOND.

We find again other forms of expression, which it is proper to notice. The union between God and the soul is sometimes described by them as an " *essential* " union, and sometimes as a " substantial " union, as if there were a union of essence, substance, or being, in the literal or physical sense. They mean to express nothing more than the fact of the union of pure love, with the additional idea that the union is firm and established ; not subject to those breaks and inequalities, to that want of continuity and uniformity of love which characterize inferior degrees of experience.

It is the holy soul of which St. Paul may be understood especially to speak, where he says, "*As many as are led by the Spirit of God, they are the sons of God.*" (Rom. viii. 14.)

Those who are in a state of simple faith, which can always be said of those who are in the state of pure love, are the "little ones" of the Scriptures, of whom we are told that God teaches them. "I thank thee," says the Saviour, "O Father, Lord of heaven and earth, that thou hast hid these things from the wise and prudent, and hast revealed them unto babes." (Luke x. 21.) Such souls, taught as they are by the Spirit of God which dwelleth in them, possess a knowledge which the wisdom of the world could never impart. But such knowledge never renders them otherwise than respectful to religious teachers, docile to the instructions of the Church, and conformable in all things to the precepts of the Scriptures.

ARTICLE FORTY-FOURTH.

The doctrine of pure love has been known and recognised as a true doctrine among the truly contemplative and devout in all ages of the Church. The doctrine, however, has been so far above the common experience, that the pastors and saints of all ages have exercised a degree of discretion and care in making it known, except to those to whom God had already given both the attraction and light to receive it. Acting on the principle of giving milk to infants and strong meat to those that were more advanced, they addressed in the great body of Christians the motives of fear and of hope, founded on the consideration of happiness or of misery. It seemed to them, that the motive of God's glory, in itself considered, a motive which requires us to love God for Himself alone without a distinct regard and reference to our own happiness, could be profitably addressed, as a general rule, only to those who are somewhat advanced in inward experience.

ARTICLE FORTY-FIFTH.

Among the various forms of expression indicative of the highest experience, we sometimes find that of " Divine union," or " union with God."

Union with God, not a physical but moral or religious union, necessarily exists in souls that are in the state of pure love. The state of " Divine union " is not a higher state than that of pure love, but may rather be described as the same state.

Strive after it ; but do not too readily or easily believe that you have attained to it. The traveller, after many fatigues and dangers, arrives at the top of a mountain. As he looks abroad from that high eminence, and in that clear atmosphere, he sees his native city ; and it seems to him to be very near. Overjoyed at the sight, and perhaps deceived by his position, he proclaims himself as already at the end of his journey. But he soon finds that the distance was greater than he supposed. He is obliged to descend into valleys, and to climb over hills, and to surmount rugged rocks, and to wind his tired steps over many a mile of weary way, before he reaches that home and city, which he once thought so near.

It is thus in relation to the sanctification of the heart. True holiness of heart is the object at which the Christian aims. He beholds it before him, as an object of transcendent beauty, and as perhaps near at hand. But as he advances towards it, he finds the way longer and more difficult than he had imagined. But if on the one hand we should be careful not to mistake an intermediate stopping-place for the end of the way, we should be equally careful on the other not to be discouraged by the difficulties we meet with ; remembering that the obligation to be holy is always binding upon us, and that God will help those who put their trust in Him.

" Whatsoever is born of God, *overcometh the world ;* and this is the victory that overcometh the world, EVEN OUR FAITH." (1 John v. 4.)

In the preceding view I have omitted a number of passages which were exclusively Roman Catholic in their aspect, in being of less interest and value to the Protestant reader than other parts.

— — —

CHAPTER XLVI.

1697—The appointment of Fénelon as Archbishop of Cambray—Importance attached to his opinions—Opinions of some distinguished men on the " Maxims of the Saints"—Decided course of Bossuet—Feelings of Louis XIV. towards Fénelon—Characters of Bossuet and Fénelon compared—The true question between them—Notices of some of the more important publications of Bossuet—Remarks on the work entitled " A History of Quietism" —Correspondence with the Abbé de Rancè.

In the contest arising in other quarters, Madame Guyon was comparatively forgotten. The publication of the " Maxims of the Saints" at once turned all thoughts and eyes to Fénelon.

The theological and controversial position of Fénelon had become the more important, and attracted the more attention, in consequence of his eminent ecclesiastical rank. Such had been his success as a missionary in Poitou, so conscientious and faithful his labours as tutor of the Duke of Burgundy and the other grandchildren of the king, that he had been appointed, a little more than a year previous to this time, Archbishop of Cambray; with the understanding that he should continue to spend at least three months of the year at Versailles, in the instruction of the young princes.

Fénelon had not used the name of Madame Guyon; but his work so clearly recognised the doctrine of Pure Love, that he was naturally regarded as her expounder and defender. The doctrines she advocated had given great offence; and the public feeling, heightened by the instrumentality of prominent ecclesiastics, could not be satisfied with permitting her to remain at large. If the views of Madame Guyon were heretical and her personal efforts dangerous, the heresy was not diminished, and the danger was not less, under the present auspices. Was it right and manly on the part of the principal agents in these

transactions, that Madame Guyon should be condemned, and
the Archbishop of Cambray, who had added the authority of his
great learning and influence to her opinions, should be approved?
—that one should be imprisoned, and that the other should
escape without notice ? These were questions which naturally
arose at the present time.

The position of Fénelon was no longer a matter of uncer-
tainty. On the great question of the fact and of the mode of
present sanctification, he had spoken in a manner too clear to be
mistaken. And those who understood his character knew that
he was too conscientious either to abandon his position, or to be
unfaithful in defending it, without a change in his convictions.
Naturally mild and forbearing in his dispositions, he was in-
flexible in his principles. Incapable of being influenced by flat-
teries on the one hand, or threats on the other, he asserted only
what he believed ; and he felt himself morally bound to defend
the ground he had taken, although he had no disposition to do
it otherwise than in the spirit of humility and candour. It be-
came necessary, therefore, on the part of his opponents, either to
concede that he was right, or to show that he was wrong ; either
to admit that the alleged heresy was not a heresy, or to include
a name so distinguished in the category of those who had devi-
ated from the strictness of the Catholic faith.

Some of the leading men in France, De Noailles, Pirot, a
theologian of great eminence, Tronson, and some others, gave
an early attention to the book of Fénelon, and examined it with
care. The spirit of piety which pervaded it was so pleasing to
some of them that they seemed unwilling to condemn it. Mon-
sieur de Noailles in particular, Archbishop of Paris and a cardi-
nal, and Godet-Marais, Bishop of Chartres, men whose opinions
could not fail to have great weight, saw so much of truth and
merit in the work, that they were disposed to let it pass in
silence. But it was not so with Bossuet, whose feelings seem
to have become somewhat exasperated towards the new sect.

"Take your own measures," said Bossuet ; "I will raise my
voice to the heavens against those errors so well known to you.

I will complain to Rome, to the whole earth. It shall not be said that the cause of God is weakly betrayed. Though I should stand single in it, I will advocate it."

The courage of Bossuet had a support which was better known to himself than to others. He knew that in attacking the doctrines of Fénelon, he should be found a defender of the opinions of the throne.

If Louis XIV. had no love for Madame Guyon, he had as little, and perhaps less, for Fénelon. Their minds were differently constituted. There was no common bond of sympathy. In obedience to public sentiment, and in accordance undoubtedly with his own convictions of duty, he had nominated Fénelon to the archbishopric of Cambray; but his want of personal interest in him was so distinctly marked as to be noticed and mentioned both by the Duke of St. Simon and the Chancellor D'Aguesseau. There was something peculiarly commanding in the personal appearance of Fénelon. His mind, possessing that moral simplicity and strength which he inculcated in his writings, left its impress of calm and dignified serenity in his countenance, and gave a character to his manners. Vice withdrew from him; and hypocrisy stood abashed in his presence. These writers observe that Fénelon, while he possessed a great superiority of genius, exhibited also an elevation of moral and personal character, *of which the king of France stood in awe.*

Bossuet, aroused once more to a sense of his position as the guardian of the Church, and strong also in the favour of the king, no longer concealed his intentions. Fénelon, on the other hand, although he foresaw what it would cost him, was equally ready to defend a doctrine which he believed to be in accordance with the Scriptures, and sanctioned by the opinions of many authorized writers. The distinguished character of the combatants gave increased interest to the controversy. Men looked on with a sort of awe, as they beheld this conflict of the two great minds of France. " Then," says the Chancellor D'Aguesseau, " were seen to enter the lists two combatants, rather equal than alike; one of them of consummate skill, covered with the laurels he

had gained in his combats for the Church, an indefatigable warrior. His age and repeated victories might have dispensed him from further service; but his mind, still vigorous and superior to the weight of years, preserved, in his old age, a great portion of the fire of his early days. The other, in the strength and manhood of earlier life, was not as yet much known by his writings; but, enjoying the highest reputation for his eloquence and the loftiness of his genius, he had long been familiar with the subject that came under discussion. A perfect master of its facts and language, there was nothing in it which he did not comprehend; nothing in it which he could not explain; and everything he explained appeared plausible."

Bossuet had the experience of age; Fénelon had the energy of manhood. Bossuet had the greater powers of argument; Fénelon possessed the richer imagination. Both were masters of style, but in different ways : the one spoke and wrote with the confidence, and something of the dogmatism, of a teacher; the other, in gentler accents, seems to converse with us as a friend.

Bossuet was naturally a man of strong passions, strengthened probably by controversy, and that ascendency over other minds, which it had become the habit to concede to him. Fénelon was naturally mild and amiable, without the weakness which often attaches to amiable dispositions ;—and this interesting trait had been strengthened by the principles he had inculcated, and by his personal piety. Both were eminently eloquent in the pulpit, as well as in their writings; but their eloquence partook of the peculiarities of their characters. The one was argumentative and vehement; stronger in the thunders of the law than in the invitations of the Gospel; carrying the intellects and hearts of his hearers, as if by a mighty force. The other, rejecting on principle those arts of authority and of intellectual compulsion, which he felt he had the power to apply, won all hearts by the sweet accents of love.

In the long list of great names of English theology and literature, we do not recollect any who, standing alone, fully represent these distinguished men. It might aid, however, our conceptions

of them, if we should add, that Bossuet can hardly fail to remind
one of the expansive and philosophic mind of Burke, combined
with the heavy strength and dictatorial manner of Johnson.
Fénelon had a large share of the luxuriant imagination of Jeremy
Taylor, chastened by the refined taste and classic ease of Addison.

This was in reality the great question between them : Can a
man be holy in this life or not? Can he love God with all his
heart or not? Can he " walk in the Spirit ;" or must he be more
or less immersed in the flesh? Fénelon very correctly said, when
he was charged by Bossuet with introducing a new spirituality,
" It is not a *new* spirituality which I defend, but the *old.*" There
probably has not been any period in the history of the Church,
in which the doctrine of present sanctification has not been agi-
tated ;—not a period, in which, while the great mass of Christians
have complained of the " body of sin" which they have carried
about with them, there have not been some who have been deeply
conscious of the constant presence and indwelling of the Holy
Ghost, and of their entire union with God.

At one time the views and feelings of Bossuet and Fénelon on
this subject approximated. To a considerable portion of the
work of Bossuet, entitled, *Instructions on Prayer,* Fénelon would
have cheerfully assented. In repeated instances, Bossuet spoke
favourably of the doctrines of Madame Guyon, except a few pecu-
liarities of expression. But new influences had arisen ; strongly
marked parties had made their appearance ; new causes of dis-
trust and alienation had presented themselves ; and what at first
seemed a harmless exaggeration of the authorized doctrines of
the Church, at last assumed the form of an *odious heresy.*

The publications in this controversy occupy more than two
quarto volumes of the writings of these distinguished men.

The advocates of Fénelon and of Madame Guyon maintained,
that the doctrines found in their writings were supported by a
continuous succession of testimonies from the time of the Apostles
down to that period.

In answer, Bossuet published his work, entitled, *The Tradi-
tionary History of the New Mystics.* This treatise does not enter

into the subject in its full extent; being occupied chiefly with an examination of the opinions of Clement of Alexandria, and of passages which are found in the works that are circulated under the name of Dionysius the Areopagite. It is an interesting specimen of theological and literary criticism, conducted with great ingenuity, but with doubtful success.

Another work soon appeared, entitled, *A Memoir of the Bishop of Meaux, addressed to the Archbishop of Cambray, on the Maxims of the Saints.* Five distinct papers or articles appeared, at different times, under this title. The first is dated July 15, 1697.

The doctrine of Fénelon may be reduced to three leading propositions. First, The provisions of the Gospel are such, that men may gain the entire victory over their sinful propensities, and live in constant and accepted communion with God. Second, Persons are in this state, when they love God with all their heart; in other words, with pure or unselfish love. Third, There have been Christians, though probably few in number, who, so far as can be decided by man's imperfect judgment, have reached this state; and it is the duty of all, encouraged by the ample provision which is made, to strive to attain to it.

It is obvious, I think, that Bossuet felt considerable reluctance in attacking this doctrine in its general form. He felt much safer in directing his objections against the development of it in *particulars.* Accordingly, in the third section of the first Memoir, he selects forty-eight propositions, or more truly and properly, forty-eight sentences and parts of sentences, to which he makes objections more or less specific and important. Some of these objections are strongly put undoubtedly; others appear to be founded upon a misconception; and others, again, are illustrations of those mere verbal criticisms, to which almost every literary and theological performance is exposed in consequence of the imperfection of language.

Another work of Bossuet is entitled *An Answer to four Letters of the Archbishop of Cambray.* Fénelon had written the letters to which he refers, in answer to the *Memoir of the Bishop of Meaux.* The work of Fénelon is characterized by forbearance

and kindness. He endeavoured to carry into the controversy the principles of his belief and heart. The work of Bossuet gives painful evidence that his increased interest in the discussion had begun to be embittered by feelings of impatience and personal alienation.

There is another important work of Bossuet, entitled, *A Summary of the Doctrine of the Archbishop of Cambray*, written both in French and Latin. To this work Fénelon made a reply which attracted much attention. Bossuet, in allusion to this reply, made the following remark in one of his subsequent publications :—" *His friends say everywhere, that his reply is a triumphant work ; and that he has great advantages in it over me. We shall see hereafter whether it is so."*

On this remark, which seemed to indicate a degree of asperity of feeling, Fénelon commented afterwards, in a letter which he addressed to Bossuet, in the following terms :—" May Heaven forbid that I should strive for victory over any person ; least of all, over you ! It is not man's victory, but God's glory, which I seek ; and happy, thrice happy, shall I be, if that object is secured, though it should be attended with *my* confusion and *your* triumph. There is no occasion, therefore, to say, *We shall see who will have the advantage.* I am ready now, without waiting for future developments, to acknowledge that you are my superior in science, in genius, in everything which usually commands attention. And in respect to the controversy between us, there is nothing which I wish more than to be vanquished by you, if the positions which I take are wrong. Two things only do I desire,—TRUTH and PEACE ;—*truth* which may enlighten, and *peace* which may unite us."

Among other publications of Bossuet, in this remarkable controversy, were the two learned treatises in Latin, entitled, *Mystici in Tuto*, and *Schola in Tuto*. The object of the last-mentioned treatise is to show, that the schoolmen did not recognise and teach the doctrine of PURE LOVE ; at least in the sense in which Fénelon understood it. In this opinion, I think it may be conceded that Bossuet is generally correct.

The object of the other work is to show that the class of

writers denominated the Mystics, who are experimental rather than speculative and critical, are also either equally ignorant of it or are equally opposed to it. Some of these writers are such imperfect masters of the art of literary composition, they express themselves with so little of rhetorical precision, that it would be an easy thing for an ingenious man, who paid more attention to the word than to the thought, to perplex them by the aid of their own declarations, and to place them even in opposition to themselves, out of their own writings. But, as a general statement, nothing can be more clear than that these writers agree in this doctrine. It is their favourite doctrine. They abound in expressions and passages, so strong, so remarkable, that we cannot help the conviction, that their hearts, as well as their heads, speak. They taught perfect love, because it seemed to some of them at least, that they had it.

But we will not undertake to go through with this enumeration. Take it all in all, the subject of discussion, the men who were engaged in it, its multiplied relations, the historical, theological, and literary ability displayed in it, it was a controversy perhaps not exceeded in interest by any of which we have record. Fénelon was not idle. He showed himself at home on every proposition, and not more a master of language than of every form of legitimate argument.

Bossuet, surprised at the strength and skill of his antagonist, and exposed to defeat after fifty years of victory, made a renewed and still more vigorous effort in a new work, which he denominated the History of Quietism, which is as much narrative in its character as argumentative. Of this work, Charles Butler, in his Life of Fénelon, speaks in the following terms:—" In composing it, Bossuet availed himself of some secret and confidential writings which he had received from Madame Guyon, also of private letters written to him by Fénelon, during their early intimacy, and of a letter which, under the seal of friendship, Fénelon had written to Madame de Maintenon, and which, in this trying hour, she unfeelingly communicated to Bossuet. The substance of these different pieces, Bossuet connected toge-

ther with great art,—he interwove in them the mention of many curious facts, gave an entertaining account of Madame Guyon's visions and pretensions to inspiration ; and related many interesting anecdotes of the conduct of Louis XIV. and of Madame de Maintenon during the controversy. And this was not all. He so dignified his narrative from time to time with bursts of lofty and truly episcopal eloquence ;—he deplored so feelingly the errors of Fénelon ;—he presented his own conduct during their disputes in so favourable a view, and put the whole together with such exquisite skill, and expressed it with so much elegance and even brilliancy of language, as excited universal admiration, and attracted universal favour to its author. In one part of it he assumed a style of mystery, and announced ' that the time was come, when it was the Almighty's will, that the secrets of the union (that is to say, of the undue intimacy between La Combe, Fénelon, and Madame Guyon) should be revealed.' A terrible revelation was then expected ; it seemed to appal every heart ; it seemed that the existence of virtue itself would become problematical, if it should be proved that Fénelon was not virtuous."

This performance of Bossuet, which in its literary features deserves all the encomium which Butler has passed upon it, could not fail to excite universal attention. There is a letter of Madame de Maintenon extant, which shows the eagerness with which it was read. " They talk here (at Versailles) of nothing else ; they lend it ; they snatch it from one another ; they devour it." There was a natural desire on the part of men of taste to read anything that came from the hand of Bossuet. But under the existing circumstances, religious zeal, more than anything else, instigated the principle of curiosity. When the Church was in danger, how was it possible to remain indifferent? There were some also, like the Athenian who was tired of hearing Aristides called the Just, wearied with what was constantly said of the disinterestedness and virtue of Fénelon, who seized with avidity upon everything that promised to obscure the lustre of his character.

When this remarkable work appeared, the consternation of the friends of Fénelon was very great. Strong in the confidence of his own integrity, and never doubting the care of an over-ruling Providence, Fénelon, who wished to retain a Christian spirit in the bitterness of controversy, had at first no intention to answer it. But his friends informed him, particularly the Abbé de Chanterac, on whose opinions he had great reliance, that the impression against him was so strong as to render a full refutation of it absolutely necessary. On further reflection, therefore, he wrote the reply, under the title of an *Answer to the History of Quietism*, in about six weeks. The work of Bossuet appeared in the middle of June ; the reply of Fénelon was published on the third of August.

If the work of Bossuet was ingenious and eloquent, as any-thing which appeared from his pen could hardly be otherwise, the reply of Fénelon was not less so. " A nobler effusion," says Butler, " of the indignation of insulted virtue and genius, elo-quence has never produced. In the very first lines of it, Fénelon placed himself above his antagonist, and to the last preserves nis elevation."

" Notwithstanding my innocence," says Fénelon, "I was always apprehensive that the controversy might take the shape of a dispute in relation to facts. I well knew, that such a dispute between persons who sustained the office of Bishop, must occa-sion no small degree of scandal. If, as the Bishop of Meaux has a hundred times asserted, my work on the Maxims of the Saints in relation to the Interior Life, considered in its theolo-gical and experimental aspects, is full of the most extravagant contradictions and the most monstrous errors, why does he in-troduce other topics, and have recourse to other discussions, which must be attended with the most terrible of scandals? Why does he reveal to libertines what he terms, speaking of myself, a woful mystery, a prodigy of seduction? Why, when the propriety of censuring my book is the sole question, does he travel out of its text, and introduce other matters?

" The reason of this course is here. The Bishop of Meaux

begins to find it difficult to establish the truth of his accusations of my doctrine. In his inability to convict me of theological error, he calls to his aid the personal history of Madame Guyon, and lays hold of it as he would of some amusing romance, which he thought would be likely to make all his mistakes of my doctrine disappear and be forgotten. And not only this, he attacks me personally. No longer satisfied with unfavourable insinuations, he boldly publishes on the house-top what he formerly only ventured to whisper. And, in doing this, I am obliged to add, that he has recourse to a mode of proceeding, which human society condemns not only as wrong, but as odious.

" The secret of private letters, written in intimate and religious confidence, (the most sacred after that of confession,) has nothing sacred, nothing inviolable to him. He produces my letters to Rome; he prints letters which I wrote to him in the strictest confidence. But all will be useless to him;—he will find *that nothing that is dishonourable ever proves serviceable.*"

In some passages of the work of Bossuet the complaint is made, that improper influences had been used, that cabals and factions were in motion in Fénelon's favour. Fénelon replied by asserting, if such were the case, it could not be ascribed to himself personally, who was at that time banished from the court in a state of exile. " The Bishop of Meaux," he says, " complains that cabals and factions are in motion; that passion and interest divide the world. Be it so. But what interest can any person have to stir in my cause? I stand single, and am wholly destitute of human help; no one, that has a view to his interest, dares look upon me. ' Great bodies, great powers,' says the bishop, ' are in motion.' But where are the great bodies, the great powers that stand up for me? These are the excuses the Bishop of Meaux gives, for the world's appearing to be divided on his charges against my doctrine, which at first he represented to be so completely abominable as to admit of no fair explanation. This division, in the public opinion, on a matter which he represented to be so clear, makes him feel it advisable to shift

the subject of dispute *from a question of doctrine to a personal charge.*"

"If the Bishop of Meaux," he adds, "has any further writing, any further evidence to produce against me, I conjure him not to do it by halves. Such a proceeding, which leaves a part untold, is worse than any full and open publication. Whatever he has against me, I conjure him to announce it, and to forward it instantly to Rome. I thank God that I fear nothing which will be communicated and examined judicially. I fear nothing but vague report and unexamined allegation."

He concludes by saying, "I cannot here forbear from calling to witness the adorable Being whose eye pierces the thickest darkness, and before whom we must all appear. He reads my heart. He knows that I adhere to no person, and to no book; that I am attached to Him alone and to His Church; that, incessantly, in His holy presence, I beseech Him, with sighs and tears, to shorten the days of scandal, to bring back the shepherds to their flocks, and to restore peace to His Church; and, while He once more reunites all hearts in love, to bestow on the Bishop of Meaux as many blessings as the Bishop of Meaux has inflicted crosses on me."

"Never did virtue and genius," says Butler, "obtain a more complete triumph. Fénelon's reply, by a kind of enchantment, restored to him every heart. Crushed by the strong arm of power, abandoned by the multitude, there was nothing to which he could look but his own powers. Obliged to fight for his honour, it was necessary for him, if he did not consent to sink under the accusation, to assume a port still more imposing than that of his mighty antagonist. Much had been expected from him; but none had supposed that he would raise himself to so prodigious a height as would not only repel the attack of his antagonist, but actually reduce him to the defensive."

Much to the credit of Fénelon, he seemed entirely willing that his own high character should stand or fall with that of Madame Guyon. The king of France had shown himself decidedly hostile to her: Madame de Maintenon. once her warm friend.

had either adopted new views, or fallen under unpropitious influences; the prominent men of the Church were almost all united against her; her character, as well as her opinions, had been assailed; and, apparently deserted by every one, she was at the present time shut up in prison. Fénelon, who had a mind too pure to estimate virtue by the public favour or the want of public favour which attended it, was not the person to forsake her at this trying time.

Bossuet attacked her, in a manner not the most ingenuous, by secret insinuations. Fénelon defended her by facts and arguments. He not only produced the honourable testimonials both in respect to her piety and morals, which had been given her by Bishop D'Aranthon some time before, but he drew a strong argument in her favour from the conduct of Bossuet himself, who had repeatedly examined her in relation to her opinions, who had expressed himself in a favourable manner on more than one occasion, who just before her imprisonment at Vincennes had administered the sacramental element to her, and given her an honourable written testimonial.

In the second century, in the reign of Marcus Aurelius, a religious sect sprang up called the Montanists, from Montanus, a Phrygian by birth; probably a man of piety, whose speculative opinions on religion were vitiated by a mixture of error. His doctrines attracted the attention of the churches of that period, and were condemned as heretical. His reputation for piety, however, was so great, that he drew after him many followers; among others, two distinguished Phrygian ladies, Priscilla and Maximilla, whose zeal was such that they were willing to become his disciples at the great and perhaps criminal expense of leaving their families. Priscilla, in particular, became one of the active teachers and leaders of the sect.

Bossuet compared Fénelon and Madame Guyon to Montanus and his friend and prophetess Priscilla. Fénelon exclaimed against the comparison, as calculated to bring odium upon him. Bossuet, in justifying what he had said, admitted that, though Montanus and Priscilla were closely connected with each other

in their religious views and efforts, there never had been any reason to suspect any improper intercourse between them, and that the relation between them was nothing more than a community and intercourse of mere mental illusion. And in making reference to them, he wished to be understood as merely saying, that the relation of Madame Guyon and Fénelon was of the same nature.

This partial retraction did not entirely satisfy Fénelon. "Does my illusion," he says, " even in the modified form in which you now present it, resemble that of Montanus? That enthusiastic and deluded man detached from their husbands two wives, who followed him everywhere. The result of his instructions and example was to inspire in them the same false spirit of prophecy with which he himself was actuated. And it cannot be unknown to you, that, in the unhappy and wicked excitements to which their system led, two of them, Montanus and Maximilla, strangled themselves. And such is the man on whom succeeding ages have looked with disapprobation, and even with horror, to whom you think it proper to compare me. And you say farther, that I have no right to complain of the comparison. And I say in reply, that I have undoubtedly less reason to complain for myself, than I have to grieve for you ;—you, who can coolly say, that you accuse me of nothing, and cast no improper reflection upon me, when you make such a comparison. I repeat that you have done a greater injury to yourself than to me. But what a wretched comfort is this, when I see the scandal it brings into the house of God ! I can rejoice in no dishonour which you may incur by such attempts to injure myself. Such joy belongs only to heretics and libertines."

" The scandal was not so great," says the Chancellor D'Aguesseau, " while these great antagonists confined their quarrel to points of doctrine. But the scene was truly afflicting to all good men, when they attacked each other on facts. They differed from each other so much in their statements that it seemed impossible that both of them should speak the truth ; and the public saw with great concern that one of the two prelates must

be guilty of prevarication. Without saying on which side the truth lay, it is certain that the Archbishop of Cambray contrived to obtain, in the opinion of the public, the advantage of probability."

At this time, among the distinguished men of France, was the Abbé de Rancè. In early years a man of the world, and devoted to its pleasures and honours, his conversion was remarkable. But from the day that his eye was opened to the truth of God, and his heart felt its influences, he left no doubt of his purpose to live to God alone. Established in the office of regular Abbot of the monastery of La Trappe, he projected and carried into effect a wonderful reform of the monks under his care, who had previously become immersed in sloth, and abandoned to shameful excesses. The keen eye of this remarkable man, from the rocks and forests of his almost impenetrable seclusion, watched with great attention the contest between Fénelon and Bossuet. The following letters, addressed to Bossuet, will show what his feelings were ;—and if a man so pious, and in general so candid, could express himself with so much severity, I think we can infer from it how deep must have been the general feeling. De Rancè distinctly acknowledged the importance of the principle of faith ; it would be uncharitable to doubt that he himself was a sincere *believer ;* but attaching great importance to those physical restraints, humiliations, and sufferings, which go under the name of *austerities,* he was alarmed at the diminished estimation in which they appeared to be held in the writings of Madame Guyon and Fénelon. This I think was the secret of the peculiar tone of his letters.

"La Trappe, *March* 1697.

" To the Bishop of Meaux.—I confess, sir, that I cannot be silent. The book of the Archbishop of Cambray has fallen into my hands. I am unable to conceive how a man like him could be capable of indulging in such phantasies, so opposite to what we are taught by the gospel, as well as by the holy tradition of the Church. I thought that all the impressions, which might

have engendered in him this ridiculous opinion, were entirely
effaced; and that he felt only the grief of having listened to
them; but I was much deceived. It is known that you have
written against this monstrous system—that is, that you have
destroyed it; for whatever you write, sir, is decisive. I pray to
God that He may bless your pen, as He has done on so many
other occasions; and that He may gift it with such energy, that
not a stroke it makes but what shall be a blow. While I cannot
think of the work of the Archbishop of Cambray without indig-
nation, I implore of our Lord Jesus Christ that He will give
him grace to be sensible of his errors."

In a letter of the 14th of April following, the Abbé de Rancè
expresses himself still more harshly, respecting the book of the
Archbishop of Cambray :—

" If the chimeras of these fanatics were to be received," says
he to Bossuet, " we must close the book of God;—we must
abandon the gospel, however holy and necessary may be its prac-
tices, as if they were of no utility;—we must, I say, hold as
nothing the life and actions of Jesus Christ, adorable as they are,
if the opinions of these mad men are to find any credence in the
mind, and if their authority be not entirely extirpated from it.
It is, in short, a consummate impiety, hidden beneath singular
and unusual phrases, beneath affected expressions and extraordi-
nary terms, all of which have no other end than to impose upon
the soul and to delude it."

The letters of the Abbé de Rancè, contrary in all probability
to his own expectations, were made public, and great efforts were
made to circulate them. As the letters were not addressed to
Fénelon, and were apparently written with no design of their
being published, he did not make any formal reply to them. A
few months afterwards, however, he had occasion to address a
Pastoral Letter to the clergy of his own diocese. The letter,
while it did not entirely exclude some other appropriate topics,
was a learned and eloquent defence of the doctrine of PURE LOVE,
as expressing a true, desirable, and possible form of Christian
experience. This letter seemed to Fénelon to furnish a suitable

opportunity to open a correspondence with De Rancè. He accordingly sent to the Abbé a copy of it, accompanied by the following letter, addressed to the Abbé himself :—

"CAMBRAY, *October* 1697.

"To THE ABBÉ DE RANCÈ.—I take the liberty, my reverend father, of sending you a Pastoral Letter, which I have issued respecting my book. This explanation seemed to me to be necessary, as soon as I perceived from your letters, which were made public, that so enlightened and experienced a man as yourself had conceived me in a manner very different from my meaning. I am not surprised that you believed what was said to you against me, both with regard to the past and the present. I am not known to you ; and there is nothing in me which can render it difficult to believe the evil which is reported of me. You have confided in the opinion of a prelate whose acquirements are very vast. It is true, my reverend father, that if you had done me the honour to write to me respecting anything which may have displeased you in my book, I should have endeavoured either to remove your displeasure, or to correct myself. In case you should be thus kind, after having read the accompanying pastoral letter, I shall still be ready to profit by your knowledge, and with deference. Nothing has occurred to alter in me those sentiments which are due to you, and to the work which God has performed through you. Besides, I am sure you will not be hostile to the doctrine of disinterested love, when that which is equivocal in it shall be removed ; and when you are convinced how much I should abhor to weaken the necessity of desiring our beatitude in God. On this subject I wish for nothing more than what St. Bernard has taught with so much sublimity, and which you know better than I do. He left this doctrine to his children as their most precious inheritance. If it were lost and forgotten in the whole world beside, it is at La Trappe, where we should still find it in the hearts of your pious ascetics. It is this love which gives their real value to the holy austerities which they practise. This pure love, which leaves nothing to

P

nature, by referring everything to grace, does not encourage illusion, which always springs from the natural and excessive love of ourselves. It is not in yielding to this pure love, but in not following it sufficiently, that we are misled. I cannot conclude this letter without soliciting of you the aid of your prayers, and of those of your community. I have need of them ;—you love the Church ;—God is my witness that I wish to live but for her, and that I should abhor myself, if I could account myself as anything on this occasion.—I shall ever be, with sincere veneration, yours, &c.—FRANCIS, ARCHBISHOP OF CAMBRAY."

Such was the reputation for piety of the Abbé de Rancè, that few men in France at that time, perhaps none, could have done Fénelon so much injury. But how calmly and triumphantly does the gentle and purified spirit of Fénelon carrry him above the violence which issued from the solitude of La Trappe ! De Rancè had faith ; but not enough to subdue the fears, the agitations, and the injustice of nature.

The faith of Fénelon was of that triumphant kind which can forgive its enemies, and turn the other cheek to him who has smitten us. "We know not," says M. de Bausset, in his Life of Fénelon, "whether the Abbé de Rancè replied to this letter. It must have caused him some regret for having expressed himself with so much asperity concerning a bishop who wrote to him with such mildness and esteem. *It is certain, however, that the name of the Abbé of La Trappe was heard no more in the course of this controversy.*"

––––

CHAPTER XLVII.

1697-1699—The controversy brought before the Pope—He appoints commissioners—Divisions in regard to it—The decision delayed—Dissatisfaction of the King—He writes to the Pope—Banishes Fénelon—Letter of Fénelon to Madame de Maintenon—Interest in the behalf of Fénelon by the Duke of Burgundy—Conversation of the King with the Duke of Beauvilliers—His treatment of the Abbé Beaumont and others—Letter of Fénelon to the Duke of Beauvilliers—Second letter to the King—Condemnation of Fénelon.

IT was seen at an early period of the controversy, that there was no probability of its being settled by any tribunal short of

the highest authority of the Roman Catholic Church. Innocent XII., a man of a benevolent and equitable spirit, filled the papal chair. The subject was pressed upon him with great earnestness, by persons supposed to act in accordance with the wishes of Louis XIV.

It was a matter of great grief to the Pope, that such a controversy on such a subject should be brought before him. He had indulged the hope that the business might be settled in France by mild and conciliatory measures ; and went so far as to order his nuncio to express this wish. The suggestion was entirely unavailing. Louis was so strongly impressed that the doctrine of Fénelon was heretical ; it had caused such great discussions and divisions in France ; and in many ways it had been so brought before his notice, and had so implicated itself in his various relations, that it had become a personal concern. Nothing would satisfy him but its formal condemnation.

The position of Innocent was a trying one. Such were the relations between him and the king of France, that it would probably have occasioned much difficulty between them, if he had declined giving attention to this matter.

The Pope appointed a commission of twelve persons, called *consultors*, to examine the book of Fénelon and give an opinion upon it. They were directed to hold their meeting in the chamber of the master of the Sacred Palace. Having discussed the principles and expressions of the book, in twelve successive sittings, they found themselves so divided in opinion, that no satisfactory result could reasonably be anticipated. They were accordingly dissolved.

His next step was to select a commission or congregation of cardinals, in the hope that they would be able to come to some conclusion. This body also had twelve sittings. They found themselves, however, greatly divided ; came to no conclusion, and were dissolved.

He then appointed a new congregation of cardinals. They met in consultation no less than fifty-two times. The result of their deliberations was, but by no means with entire unanimity,

that they extracted from Fénelon's work a number of proposi-
tions which they regarded as censurable, and reported them to
the Pope. After they had advanced so far, they held thirty-
seven meetings to settle the form of the censure. In addition
to these more formal meetings, private conferences on the sub-
ject were frequently held by the Pope's direction, and sometimes
in his presence.

The cardinals Alfaro, Fabroni, Bouillon, and Gabriellio, and
some others perhaps of less note, took the side of Fénelon. Men
of no ordinary learning and power, they maintained with great
ability, that the doctrine in question had authority and support
in many approved Catholic writers. They did not hesitate, in
the least, to defend the statements repeatedly made by Fénelon
in his arguments with Bossuet and on other occasions, that it
was a doctrine not only received but greatly cherished by many
pious and learned men in all ages of the Church ; by Clement,
Cassian, Dionysius, Thauler, Gerson, De Sales, John of the
Cross, St. Theresa, the Bishop of Bellay, and others ; and to
this they were willing to add, that there was not more of such
learned and pious authority in its favour, than there was of
Scripture and reason. Gabriellio said, on one occasion, expressly,
that it was a doctrine conformed to the Scriptures, the Fathers,
and the Mystics.

They did not, however, in maintaining the doctrine of pure
love, exclude the idea of a suitable regard to our own happiness.
They seem to have taken the ground, that God and ourselves,
considered as objects of love, are incommensurable ; and conse-
quently, that the motive of God's love, exceeding the other be-
yond all comparison, practically absorbs and annihilates it. So
that a soul wholly given to God, may properly be said to love
God alone. But the doctrine of GOD ALONE does not exclude
other things, since God is *All in All.* In other words, in loving
God for Himself alone, who is the sum of all good, we cannot
help loving ourselves, our neighbour, and everything else in
their proper place and degree. Alfaro, in concluding some re-
marks, at one of these meetings, read a letter addressed many

ages before, by St. Louis of France, to one of his daughters, in which ne advised her to do everything from the principle oi *pure love*.

Among other things, they expressed no small degree of dissatisfaction with the course the controversy had taken in certain respects; remonstrating strongly against the attempt to confound doctrines with men, to implicate the permanency of truth with the imperfections of character, and to support a doubtful argument by personal defamation. It was much to their credit, when they saw the efforts constantly made in high places and low, to destroy the character of Fénelon, that they gave their opinions freely and boldly in his favour. " Consider a moment," said Cardinal Bouillon, " who it is that you propose to condemn, a distinguished Archbishop, prudent and wise in the government of his diocese, who combines with a literary taste and power not exceeded by that of any other person in the kingdom, the utmost sanctity of life and manners." They went so far as to intimate, that, if the doctrine of PURE LOVE were condemned, sustained as it was by such a weight of authority and argument, and encircled as it was by so many strong affections,—it could hardly fail to produce a schism in the Church.

The leading men on the other side were the Cardinals Massoulier, Pantiatici, Carpegna, Casanata, and Granelli. Their arguments were directed against the doctrine, partly in its general form, and partly against particular expressions and views, which characterized it, in the writings of Fénelon. So far as their arguments were general, they were very much the same as are employed against it at the present day. They maintained that it was a state too high to be possessed and maintained in the present life; that there were many things in the Scriptures against it; that the exaggerated expressions in the mystical or experimental writers of the Catholic Church ought to be received in a modified sense; that it was either modified or rejected by a great majority of their theological writers and other writers not of the mystical class; and that

it had been attended, in a number of instances, with practical disorders.

The contest between the two parties was animated, and sometimes violent. For a time it seemed doubtful what would be the result. The discussion was thus continued from 1697 to 1699, a period of nearly two years, under the eye and in the presence of the Pope. The king of France, who was in frequent communication with Bossuet, became impatient, on learning doubts which he did not himself entertain, and a delay which he did not anticipate.

In order to hasten an issue, he had written at an earlier period a letter to the Pope, in which he denounced the book of the Archbishop of Cambray, *as erroneous and dangerous,* and as already censured by a great number of theological doctors and other learned persons. He added, that the explanations more recently given by the Archbishop were inadmissible; and concluded by assuring the Pope, that *he would employ all his authority to obtain the due execution of his Holiness's decree.*

This letter, drawn up by Bossuet, was dated the 26th of July 1697.

The desires and feelings of the king were made known in other ways still more painful. When Fénelon was first appointed Archbishop of Cambray in 1695, his character was so much esteemed and his services were regarded so important, that the king insisted he should spend three months in the year at Versailles in the instruction of the young princes.

Six days after the date of the letter to the Pope, the king wrote a letter or order to Fénelon, which might properly be denominated an order of banishment, in which he required him to leave Versailles, and repair to the diocese of Cambray, *and forbade him to quit it.* It was added further, that he was not at liberty to delay his departure any longer than was absolutely necessary to arrange his affairs.

Those principles of inward experience, which so triumphantly sustained Madame Guyon in her imprisonment, received a new confirmation in the victory which they now achieved in Fénelon.

The very moment he received from the king the order which thus banished him from all places out of his own diocese, he wrote the following letter to Madame de Maintenon. Bausset says, that he copied it from the original manuscript in Fénelon's handwriting :—

" VERSAILLES, *Aug.* 1, 1697.

" In obedience to the king's commands, Madame, I shall depart from this place to-morrow. I would not pass through Paris, did I not feel it difficult to find anywhere else a man fit to attend to my affairs at Rome, and who would be willing to make the journey thither. I shall return to Cambray with a heart full of submission, full of zeal, of gratitude, and of the greatest attachment towards the king. My greatest grief is, that I have harassed and displeased him. Not a day of my life shall pass over, that I will not pray to God to bless him. I am willing to be still more humbled. The only thing that I would implore of his Majesty is, that the diocese of Cambray, which is guiltless, may not suffer for the faults that are imputed to me. I solicit protection only for the Church; and I limit this protection to the circumstance of being free to perform the little good that my situation will permit me to perform as part of my duty.

" It only remains, Madame, that I request your forgiveness for all the trouble I may have caused you. God knows how much I regret it; and I will unceasingly pray to Him, until He alone shall occupy your whole heart. I shall, all my life, be as sensible of your past goodness, as though I had never forfeited it; and my respectful attachment towards you, Madame, will never diminish."

" We may easily conceive," says Bausset, " what an effect this letter, every line of which breathes nothing but mildness, affection, and serenity, had upon Madame de Maintenon. Recalling all her former friendship for Fénelon, she could not conceal from herself the active part which she had taken in his present disgrace. It cannot, indeed, be doubted, that this letter left a painful and durable impression upon her heart. She tells

us, herself, that her health was impaired in consequence; and
that she did not conceal the cause of her illness from Louis XIV.
The monarch himself seemed, at first, to be a little hurt; and
could not help peevishly exclaiming to her, as he marked her
affliction,—*So it seems, Madame, we are to see you die in conse-
quence of this business.*"

The Duke of Burgundy, who had owed so much to Fénelon,
was no sooner informed of the order of exile, than he hastened to
throw himself at the feet of the king, his grandfather. He ap-
pealed to himself and to the renovation of his own heart and
life, as a proof of the purity of the life and maxims of his faithful
and affectionate instructor. Louis was touched by an attach-
ment so ingenuous and generous. But fixed in his principles of
belief, and invariable in whatever he had decided, he merely
replied to the young prince, "*My son, it is not in my power to
make this thing a matter of favour. The purity of religious faith
is concerned in it. And Bossuet knows more on that subject than
either you or I.*"

On the second of August, Fénelon departed from Versailles,
never to return again. He remained at Paris only twenty-four
hours. He cast a tender and last look towards the seminary of
St. Sulpitius, in which he had spent the peaceful and happy
years of his youth. A motive of delicacy, nevertheless, forbade
his entering its walls. He feared that he might involve in his
own sorrow and disgrace his former friend and instructor, Mon-
sieur Tronson, who had the charge of it. He, however, wrote
him a few lines, in which he expressed his veneration and
gratitude; and, asking the continuance of that good man's
prayers, of which he said he had much need in his sufferings,
he went on his way.

It was but a few months after he had reached Cambray, and
was assiduously engaged in his religious duties among his own
people, when he received intimations that the way was open for
his return on certain conditions. To this he refers in a letter
to the Abbé de Chanterac, dated Dec. 9, 1697 : "It is reported,"
he says, "that the only means by which I can appease the king,

obtain my return to court, and prevent all scandal, is to remove the present unfavourable opinions by an *humble acknowledgment of error.* But I assure you, that I have no present nor future idea of returning to court. If I am in error, it is my desire to be undeceived. But as long as I am unable to perceive my error, it is my purpose to justify my position with unceasing patience and humility. Be assured that I will never return to court at the expense of truth, or by a compromise, which would leave the purity either of my doctrine or of my reputation in doubt."

The friends of Fénelon were, to some extent, involved in his calamities. Foremost among them was the Duke of Beauvilliers. He believed in the doctrine of pure love, originated and sustained by faith in the Son of God ; and he had experienced in his own renovated heart the effects which this doctrine, more than any other, is calculated to produce. He was the avowed and known friend of Madame Guyon, as well as of Fénelon The king was offended with him. Taking Beauvilliers aside, soon after the banishment of the Archbishop of Cambray, he told him how much he was dissatisfied at his connexion with a person whose doctrines were so much suspected. He intimated to him distinctly, that his continuance in such a course would be likely to be attended with the most unpleasant consequences.

Beauvilliers assured him of his entire conviction, that the princes who had been under the care of the Archbishop of Cambray had not been infected with any erroneous or dangerous doctrine. He then proceeded to say,—"I remember, Sire, that I recommended to your Majesty the appointment of Fénelon to be the preceptor of the Duke of Burgundy. I can never repent that I did so. I have been the friend of Fénelon ; I am his friend now. I can submit to whatever your Majesty may impose upon me ; but I cannot eradicate the sentiments of my heart. The power of your Majesty has raised me to my present position ; the same power can degrade me. Acknowledging the will of God in the will of my king, I shall cheerfully withdraw from your court whenever you shall require it ; regretting that I have

displeased you, and hoping that I may lead hereafter a life of greater tranquillity."

The king, overawed by the nobleness of his sentiments, or fearing the rashness of the course which he had threatened, permitted him to remain in his place.

On the 2d of June 1698, the king deprived the Abbé Beaumont and the Abbé de Langeron of their title of sub-preceptors. " The former was *Fénelon's nephew*; the latter was his most *tender and faithful* friend. Messieurs M. Dupuy and De Leschelle, gentlemen who held situations about the person of the young prince, were dismissed on the same day, and ordered to quit the court. The pretext for their dismission was their partiality for the spiritual maxims of the Archbishop of Cambray. The real motive was their *affectionate and inviolable fidelity towards him.*

" All of them had been concerned in the education of the Duke of Burgundy for nine years ;—and the excellence of this education has been detailed. They were dismissed without receiving the slightest reward for their services. Thus severely were punished the men, who had transformed the vices of the Duke of Burgundy into virtues; a severity which could have been justified only, had they changed his virtues into vices."

Fénelon felt more deeply the disgrace and suffering of his friends than his own ; but he maintained the same equanimity and triumphant faith, which had supported him hitherto. In a letter, which he wrote at this time to the Duke of Beauvilliers, we find the following expressions, which indicate very clearly, how patient and lovely is the heart that is wholly given to God :—

" I cannot avoid telling you, my good duke, what I have at heart. Yesterday I spent the day in devotion and prayer for the king. I did not ask for him any temporal prosperity, for of that he has enough. I only begged that he might make a good use of it ; and that, amidst such great success, he might be as humble as if he had undergone some deep humiliation. I begged that he might not only fear God and respect religion, but

that he might also love God, and feel how easy and light His yoke is to those who bear it less through fear than love. I never found in myself a greater degree of zeal ; or, if I may venture to use the expression, of affection to his person.

" Far from being under any uneasiness at my present situation, which might have suggested unpleasant feelings against him, I would have offered myself with joy to God, for the sanctification of the king. I even considered his zeal against my book as a commendable effect of his religion, and of his just abhorrence of whatever has to him the appearance of novelty. Desirous that he might be an object of the Divine favour, I called to mind his education without solid instruction, the flatteries which have surrounded him, the snares laid for him in his youth, the profane counsels that were given him, the distrust that was with so much pains instilled into him against the excesses of certain professors of devotion ; and lastly, the perils of greatness, and so great a multiplicity of nice affairs. I own, that with all these things in view, I had great compassion for a soul so much exposed. I judged his case deserved to be lamented ; and I wished him a more plentiful degree of mercy to support him in so formidable a state of prosperity. In all this I had not, as I apprehended, the least interested view ; for I would have consented to a perpetual disgrace, provided I knew that the king was entirely after God's own heart.

" As far as relates to myself, all I can say is, I am at peace in the midst of almost continual sufferings. Trusting in God's assistance to sustain me, the scandals which my enemies cast upon me shall neither exasperate nor discourage me."

One object of these proceedings of the king of France, was to make an impression at Rome. They were a part of a plan of intimidation ; but they did not have the *immediate* effect anticipated. Public opinion was still divided ; there had been a want of unanimity in the debates and decisions of the congregation of the cardinals at Rome ; the Pope himself hesitated to give a decision.

Under these circumstances, Louis, near the close of the year

1698, wrote another letter, which was despatched to the Pope by
an extraordinary courier. It was as follows :—

"MOST HOLY FATHER,—At the time when I expected from
the zeal and friendship of your Holiness, a prompt decision upon
the book of the Archbishop of Cambray, I could not learn, with-
out grief, that this decision, so necessary to the peace of the
Church, *is still retarded by the artifices of those who think it
their interest to protract it.* I see so clearly the fatal conse-
quences of this delay, that I should not consider myself as duly
supporting the title of eldest son of the Church, were I not to
reiterate the urgent entreaties which I have so often made to
your Holiness, and to beg of you to calm, at length, the anxieties
of conscience which this book has caused. Tranquillity can now
be expected only from the decision that shall be pronounced by
the common father ;—but let it be clear and precise, and capable
of no misinterpretations ;—such a decision, in fact, as is necessary
to remove all doubt with regard to doctrine, and to eradicate the
very root of the evil. I demand, most holy Father, this decision,
for the good of the Church, the tranquillity of the faithful, and
for the glory of your Holiness. You know how truly sensible I
am, and how much I am convinced of your paternal tenderness.
To such powerful and important motives, I would add, the
attention which I entreat you to pay to my request, and the filial
respect with which I am,
 " Most holy Father, your truly devoted Son,
 " LOUIS."

 Under such circumstances as these, on the 12th of March
1699, a decree was issued under the signature of the Pope, con-
demning the book of Fénelon, or perhaps more properly condemn-
ing twenty-three propositions, purporting to be extracted from
it. The Pope, however, took the pains to say, and to have it
understood, that they were condemned in the sense which they
might bear, or which they were actually regarded as bearing
in the view of others, and not in the sense in which they were

explained by Fénelon himself. " The Pope," says Monsieur de Bausset, " had openly declared on many occasions, that neither he nor the cardinals had intended to condemn the explanations which the Archbishop of Cambray had given of his book."

To such a condemnation Fénelon could have comparatively but little objection. It was really not a condemnation of himself, but of others who undertook to speak and to interpret for him. While he was sincere and firm in his own belief, he had no disposition to defend the misconceptions and perversions of other people. To what extent, however, he availed himself of the suggestion which thus dropped from the Pope, we have no means of knowing. Certain it is, whatever view he took of the act of condemnation, he made no complaint. He thought it his duty to be submissive to the higher authorities of his Church. He received the news of his condemnation on the Sabbath, just as he was about to ascend his pulpit to preach. He delayed a few moments; changed the plan of his sermon, and delivered one upon the duty of submission to the authority of superiors.

From that time he ceased to write controversially upon the subject. But, without regarding what was said by others, and in the discharge of his own duties among his own people, he never ceased to inculcate in his life, his conversations, and his practical writings, the doctrine of pure love. He thought it his duty to avoid certain forms of expression, and certain illustrations which had been specifically condemned in the papal decree, and which were liable to misconception; but it is not easy to see that he went further. In other words, he condemned sincerely what he understood the Pope to condemn; and he did this without any change, further than has already been intimated, either in his life or opinions.

CHAPTER XLVIII.

Character of Fénelon—Labours—Method of preaching—Visits among his people—The pea-
sant who lost his cow—The feelings of Fénelon, when the palace was burnt—Conduct
during war—Respect in which he was held by the belligerent parties—Hospitality—Ex-
tract from the Chevalier Ramsay—Of the spirit of quietude or quietism ascribed to him—
Meditations on the infant Jesus—His forbearance and meekness in relation to others—
Views on religious toleration—Feelings in relation to his separation from his friends—
Correspondence with the Duke of Burgundy—His death.

As the personal history of Fénelon is closely connected with
that of Madame Guyon, we propose to occupy a few pages further
with some incidents of his life, and with some general views of
his character.

At an early period Fénelon had devoted himself to the ministry
of Jesus Christ. After he was appointed Archbishop of Cambray,
he had but one object, that of benefiting his people. This was
particularly the case after he was confined by the royal order to
his own diocese. We do not mean to imply, that he had a more
benevolent disposition then, but he had a better opportunity to
exercise it. With a heart filled with the love of God, which can
never be separated from the love of God's creatures, it was his
delight to do good.

He was very diligent in visiting all parts of his diocese. He
preached by turns in every church in it; and with great care and
faithfulness, examined, instructed, and exhorted both priests and
people.

In his preaching he was affectionate and eloquent, but still
very plain and intelligible. Excluding from his sermons super-
fluous ornaments as well as obscure and difficult reasonings, he
might be said to preach from the heart rather than from the head.
He generally preached without notes, but not without premedi-
tation and prayer. It was his custom, before he preached, to
spend some time in the retirement of his closet; that he might
be sure that his own heart was filled from the divine fountain,
before he poured it forth upon the people. One great topic of
his preaching was the doctrine, so dear to him, and for which he
had suffered so much, of PURE LOVE.

He was very temperate in his habits, eating and sleeping but little. He rose early; and his first hours were devoted to prayer and meditation. His chief amusement, when he found it necessary to relax a little from his arduous toils, was that of walking and riding. He loved rural scenes, and it was a great pleasure to him to go out in the midst of them. " The country," he says, in one of his letters, " delights me. In the midst of it, I find God's holy peace." Everything seemed to him to be full of infinite goodness; and his heart glowed with the purest happiness, as he escaped from the business and cares which necessarily occupied so much of his time, into the air and the fields, into the flowers and the sunshine of the great Creator.

But in a world like this, where it is a first principle of Christianity that we should forget ourselves and our own happiness in order that we may do good to others, he felt it a duty to make even this sublime pleasure subservient to the claims of benevolence. He improved these opportunities to form a personal acquaintance with some of the poor peasants in his diocese, and their families, and to counsel and console them. Sometimes, when he met them, he would sit down with them upon the grass; and inquiring familiarly about the state of their affairs, he gave them kind and suitable advice;—but above all things, he affectionately recommended to them to seek an interest in the Saviour, and to lead a religious life.

He went into their cottages to speak to them of God, and to comfort and relieve them under the hardships they suffered. If these poor people presented him with any refreshments in their unpretending and unpolished manner, he pleased them much by seating himself at their simple table, and partaking cheerfully and thankfully of what was set before him. He shewed no false delicacy because they were poor, and because their habitations, in consequence of their poverty, exhibited but little of the conveniences and comforts of those who were more wealthy. In the fulness of his benevolent spirit, which was filled with the love of Christ and of all for whom Christ died, he became in a manner one of them, as a brother among brothers, or as a father among his children.

There are various anecdotes which illustrate his condescension and benevolence. In one of these rural excursions he met with a peasant in much affliction. Inquiring the cause of his grief, he was informed by the man that *he had lost his cow.* Fénelon attempted to comfort him, and gave him money enough to buy another. The peasant was grateful for the kindness of the archbishop, but still he was very sad. The reason was, although the money given him would buy a cow, it would not buy the cow he had lost,—to which he seemed very much attached. Pursuing his walk, Fénelon found, at a considerable distance from the place of his interview with the peasant, the very cow which was the object of so much affliction. The sun had set, and the night was dark ; but the good archbishop drove her back himself to the poor man's cottage.

The revenues which he received as Archbishop of Cambray were very considerable ; but he had learned the difficult though noble art of being poor in the midst of plenty. He kept nothing for himself. His riches were in making others rich ; his happiness, in making the poor and suffering happy. When at Versailles in the instruction of the young princes, the news came that a fire had burned to the ground the archiepiscopal palace at Cambray, and consumed all his books and writings. His friend, the Abbé de Langeron, seeing Fénelon conversing with a number of persons, and apparently much at his ease, supposed he had not heard this unpleasant news, and began with some formality and caution to inform him of it. Fénelon, perceiving the solicitude and kindness of the good Abbé, interrupted him by saying that he was acquainted with what had happened ; and added further, although the loss was a very great one, that he was really less affected in the destruction of his own palace, than he would have been by the burning of a cottage of one of the peasants.

So elevated and diffusive were his religious principles, that they rendered him the friend of all mankind. It was not necessary for him to stop and inquire a man's creed or nation, as a preliminary to his beneficence. Occasions were not wanting which illustrated this remark. The war, which raged near the commencement of the eighteenth century, between France and

Bavaria on the one side, and England, Holland, and Austria on the other, drew near to the city where he resided. Cambray, formerly the capital of a small province of the same name in the north of France, is not far from the Netherlands, which has sometimes been denominated the battle-field of Europe. At the time of which we are speaking, large armies met in its vicinity, and battles were fought near it. At this trying time, not only the residence of Fénelon, but other houses beside, hired by him for the purpose, were filled with the sick and wounded, and poor people driven from the neighbouring villages. The expense he thus incurred, absorbed all his revenues ; but he had no inclination to spare either time, money, or personal effort in these acts of benevolence ; acts which were shown as kindly and as freely to the enemies of his country, taken prisoners in the war, as to those of his own nation.

The sight of the wretched condition of the refugees in his palace was painful ; many were suffering from the want of proper clothing ; others were in agony in consequence of their wounds, and others were afflicted with distempers that were infectious ; but nothing abated his zeal. He appeared among them daily with the kindness of a parent ; dropping words of instruction and consolation, and testifying by his tears how much he was moved with compassion.

The marked respect in which he was held, was not confined to the French army alone. He was held in equal veneration by the enemy. The distinguished commanders opposed to France, the Duke of Marlborough, Prince Eugene, and the Duke of Ormond, embraced every suitable opportunity of showing their esteem ; sending detachments of their men to guard his meadows and his corn : and causing his grain to be transported with a convoy to Cambray, lest it should be seized and carried off by by their own foragers. In the discharge of his religious duties, he went abroad among the people of his diocese, without regard to the hostile armies which occupied the territory. As he went, in the discharge of these duties, in the spirit of Him who came to bring peace on earth and good-will to men, he had faith in a

Divine protection. So far from any violence being offered to him, the English and Austrian commanders, when they heard that he was to take a journey in that part of the diocese where their armies were situated, sent him word that he had no need of a French escort, and that they would furnish an escort themselves. It is said that even the hussars of the Imperial troops did not hesitate to do him service. So true it is that men who live in the spirit of the Gospel do, by the very force of their virtue, disarm the hostility of nature.

Among those who were taken prisoners at the battle of De-main and conducted to Cambray, was Count, afterwards Marshal Munich. Although he was characterized by great enterprise and bravery, and had an almost exclusive taste for arms, he was deeply affected by what he saw of the peaceful virtues and the truly Christian generosity of Fénelon. He was then young, but was afterwards one of the most distinguished commanders in the armies of Russia. His name is associated, in the history of war, with sanguinary and victorious campaigns in the Crimea. Raised to the highest place of worldly honour by his talents and courage, he suddenly fell under the displeasure of the Empress Elizabeth in 1741, and was banished to Siberia, where he remained an exile twenty years. He was restored by Peter III. But in all the vicissitudes of his life, in peace and war, in the court and in the camp, disgraced and suffering in the deserts of Siberia, or free and honoured in the halls of princes, he delighted, to the very close of his life, to remember the happy days which he passed, as a prisoner of war, in the society of Fénelon; instructing and soothing, as it were, the agitations of his own wild and turbulent spirit by recounting the virtues and actions witnessed at Cambray.

At this very period there was another visitant at Cambray of a very different character, the celebrated Cardinal Quirini, whose whole life, as remote as possible from the pursuits of war, was devoted to learned researches and useful studies. In the prosecution of literary objects, he visited almost all parts of Europe, and became acquainted with the most distinguished literary men. In the account of his travels, which he wrote in Latin, he speaks very particularly of his interview with Fénelon.

"I considered," he says, "Cambray as one of the principal objects of my travels in France. I will not even hesitate to confess, that it was towards this single spot, or rather towards the celebrated Fénelon who resided there, that I was most powerfully attracted. With what emotions of tenderness I still recall the gentle and affecting familiarity with which that great man deigned to discourse with me, and even sought my conversation; though his palace was then crowded with French generals and commanders-in-chief, towards whom he displayed the most magnificent and generous hospitality. I have still fresh in my recollection all the serious and important subjects which were the topics of our discourse. My ear caught with eagerness every word that issued from his lips. The letters which he wrote me, from time to time, are still before me;— letters which are an evidence alike of the wisdom of his principles and of the purity of his heart. I preserve them among my papers, as the most precious treasure which I have in the world."

It is an evidence both of the kindness and faithfulness of Fénelon, that he endeavours in these very letters to recall the Cardinal Quirini from a too eager and exclusive pursuit of worldly knowledge, to that knowledge of Jesus Christ which renews and purifies the soul.

Strangers from all parts of Europe came to see him. Although the duties of hospitality became a laborious work to him, amid the multiplicity and urgency of his other employments, he fulfilled them with the greatest attention and kindness. It was pleasing to see how readily he suffered himself to be interrupted in his important duties, in order to attend to any, whatever might be their condition and whatever their wants, who might call upon him. He did not hesitate to drop his eloquent pen, with which he conversed with all Europe, whenever Providence called him to listen to the imperfect utterance of the most ignorant and degraded among his people. And, in doing this, he acted on religious principle. He would rather suffer the greatest personal inconvenience, than injure the feelings of a fellow-man.

"I have seen him," says the Chevalier Ramsay, "in the course

of a single day, converse with the great and speak their lan-
guage, ever maintaining the episcopal dignity; afterwards dis-
course with the simple and the little, like a good father instruct-
ing his children. This sudden transition from one extreme to
the other, was without affectation or effort, like one who, by the
extensiveness of his genius, reaches to all the most opposite dis-
tances. I have often observed him at such conferences, and
have as much admired the evangelical condescension by which
he became all things to all men, as the sublimity of his dis-
courses. While he watched over his flock with a daily care,
he prayed in the deep retirement of internal solitude. The many
things which were generally admired in him, were nothing in
comparison of that Divine life by which he *walked with God like
Enoch*, and was unknown to men."

Fénelon, in the language of those who knew his virtue, but
still were willing to say something to his discredit, was denomi-
nated a *Quietist*. This term is susceptible of a good and a bad
meaning. That quietude is bad which is the result of the igno-
rant and unbelieving pride of self; but it is not so with that
quietude which is the result of an intelligent and believing
acquiescence in the will of God. There is certainly great grace
in being truly and religiously quiet in spirit. It is a remark to
be found in some of the pagan philosophers, that man can never
be truly happy, until he arrives at such an inward tranquillity
as excludes not only unprofitable actions, but even useless
thoughts. Heathenism had light enough to perceive the truth ;
but, rendered weak in its sins, it had not power enough to realize
it. It is Christianity alone which reveals the way, the truth, and
the life. It is Christianity, realized in the presence and opera-
tions of the Holy Spirit, which gives that Divine peace which
nature perceives to be necessary, but which God alone can im-
part. The quietude which was ascribed to Fénelon was that
inward rest which the Saviour calls *peace ;* and of which it is
declared there is no peace to the wicked. It was that state of
mind which the Saviour not only denominates peace, but which
he describes as *my* peace, in other words *Christ's* peace, " the

peace of God which passeth understanding," that supported the Archbishop of Cambray, in the trials he endured, and in the duties of humanity and religion which he was called to discharge.

"He dismissed, as fast as they arose," says an anonymous writer, " all useless ideas and disquieting desires, to the end that he might preserve his soul pure and in peace ; taken up with God, detached from everything not Divine. This brought him to such a simplicity as to be far from valuing himself for his natural talents, accounting all but dross, *that he might win Christ, and be found in Him.*"

Among his religious meditations we find the following :—

" I adore thee, O infant Jesus ! naked, weeping, and lying in the manger. Thy childhood and poverty are become my delight. O that I could be thus poor, thus a child, like thee ! O Eternal Wisdom ! reduced to the condition of a little babe, take from me the vanity and presumptuousness of human wisdom. Make me a child with thee. Be silent, ye teachers and sages of the earth ! I wish to know nothing, but to be resigned, to be willing to suffer, to lose and forsake all, *to be all faith.* The WORD *made flesh!* Now silent, now He has an imperfect utterance, now weeps as a child. And shall I set up for being wise ? Shall I take a complacency in my own schemes and systems ? Shall I be afraid lest the world should not have an opinion high enough of my capacity ? No, no ;—all my pleasure shall be to *decrease*, to become little and obscure, to live in silence, to bear the reproach of Jesus crucified, *and to add thereto the helplessness and imperfect utterance of Jesus a child.*"

" To die to all his own abilities," says the writer to whom we have just now referred, " must have been a thing more painful to him than any other. He understood thoroughly the principles of almost all the liberal sciences. He had studied the ancients of all kinds, poets, orators, and philosophers. He was well acquainted both with their faults and with their beauties. Yet he rejected that pompous erudition which so powerfully tends to swell the mind with pride. He thought it his duty to renounce all the false riches of the mind, and to be wise with sobriety. This

is what those learned men and teachers, who are always contend-
ing about frivolous questions, will never be able to comprehend."

It was one characteristic of this remarkable and deeply pious
man, that he bore the passions and faults of others with the
greatest equanimity. He was faithful, without ceasing to be
patient. Believing that the providence of God attaches to time
as well as to things, and that there is a time for reproof as well
as for everything else, a time which may properly be denomi-
nated *God's time*, he waited calmly for the proper moment of
speaking. Thus keeping his own spirit in harmony with God,
he was enabled to administer reproof and to utter the most
unpleasant truths without a betrayal of himself, and without
giving offence to others.

"It is often," he said, "*our own imperfection which makes
us reprove the imperfections of others ;*—a sharp-sighted self-
love of our own, which cannot pardon the self-love of others.
The passions of other men seem insupportable to him who is
governed by his own. Divine charity makes great allowances
for the weaknesses of others, bears with them, and treats them
with gentleness and condescension. It is never over-hasty in
its proceeding. The less we have of self-love, the more easily
we accommodate ourselves to the imperfections of others, in order
to cure them patiently, when the right season arrives for it. Im-
perfect virtue is apt to be sour, severe, and implacable. Perfect
virtue is meek, affable, and compassionate. It thinks of nothing
but doing good, bearing others' burdens. It is this principle of
disinterestedness with regard to ourselves, and of compassion for
others, which is the true bond of society."

It was a natural result of his principles, that he inculcated
and practised *religious toleration*. Without being indifferent to
the principles and forms of religion, he had a deep conviction
that the appropriate weapon of religion, in its defence and in its
extension, is that of *love*. A man's belief is and ought to be
sacred. We may try to correct it by kind argument ; but in
every act beyond that, we violate the laws of the mind, as well
as the claims of morals, and act without authority. Such were

the views of Fénelon ; which he inculcated at a time and under circumstances which showed the firmness of his purpose as well as the benevolence of his heart.

When he was appointed a missionary among the Protestants of Poitou, he accepted this difficult and delicate office, only on the condition that the king should remove all the troops, and all appearance of military coercion, from those places to which he was sent. In the latter period of his life, in the year 1709, he was visited by a young prince at the episcopal residence. The Archbishop recommended to him, very emphatically, never to *compel* his subjects to change their religion. "Liberty of thought," said he, "is an impregnable fortress, which no human power can force. Violence can never convince ; it only makes hypocrites. When kings take it upon them to direct in matters of religion, instead of protecting it, they bring it into bondage. You ought, therefore, to grant to all a legal toleration ; not as approving everything indifferently, but as suffering with patience *what God suffers ;* endeavouring in a proper manner to restore such as are misled, but never by any measures but those of gentle and benevolent persuasion."

Fénelon had many friends affectionately attached to him, in Versailles, Paris, and other parts of France ; but in his banishment he saw them but very seldom. Many of them were persons of eminent piety.

"Let us all dwell," he says in one of his letters, "in our only CENTRE, where we continually meet, and are all one and the same thing. We are very near, though we see not one another ; whereas others, who even live in the same house, yet live at a great distance. God reunites all, and brings together the remotest points of distance in the hearts that are united to Him. I am for nothing but unity ; that unity which binds all the parts to the centre. That which is not in unity is in separation ; and separation implies a plurality of interests, *self* in each too much fondled. When self is destroyed, the soul reunites in God ; and those who are united in God are not far from each other. This is the consolation which I have in your absence, and

which enables me to bear this affliction patiently, however long
it may continue."

"Oh! what a beautiful sight," he said frequently, "to see
all kinds of goods in common, nobody looking on his own know-
ledge, virtue, joys, riches, as his peculiar property! It is thus
that the saints in heaven possess *everything in God*, without
having *anything of their own*. It is the fiux and reflux of an
infinite ocean of good, common to all, which satiates their desires,
and completes their happiness. Perfectly poor in themselves,
they are perfectly rich and happy in God, who is the true source
of riches. If this poverty of spirit, which, in depriving us of
self, fills us with love, prevailed here below as it should do, we
should hear no more those cold words of *mine* and *thine*. Being
one in the abandonment of self, and one in harmony with God,
we should be all at the same time rich and poor in unity."

After Fénelon left Versailles, he never had the opportunity
of seeing his beloved pupil, the Duke of Burgundy ; and it was
a number of years before they had the means even of corre-
sponding with each other. But the Duke never forgot him ; and
Fénelon, on his part, never ceased to counsel and encourage.

"Offspring of Saint Louis!" he says, in one of his letters
written a short time before the lamented death of the prince,
"be like him, mild, humane, easy of access, affable, compassion-
ate, and liberal. Let your grandeur never hinder you from con-
descending to the lowest of your subjects,—yet in such a manner
that this goodness may never weaken your authority, nor lessen
their respect. Suffer not yourself to be beset by insinuating
flatterers ; but value the presence and advice of men of virtuous
principles. True virtue is often modest and retired Princes
have need of her, and therefore ought to seek her out. Place no
confidence in any but those who have the courage to contradict
you with respect, and who love your prosperity and reputation
better than your favour. Make yourself to be loved by the good,
feared by the bad, and esteemed by all. Hasten to reform yourself,
that you may labour with success in the reformation of others."

The effect of the correspondence of Fénelon with the Duke of

Burgundy may be seen, among other evidences which he gave, from the following letter :—

TO THE ARCHBISHOP OF CAMBRAY.

" MY DEAR ARCHBISHOP,—I will endeavour to make use of the advice you give me. I ask an interest in your prayers, that God will give me His grace so to do. Desire of God more and more, that He will grant me the love of Himself above all things else ; and that I may love my friends and love my enemies IN Him and FOR Him. In the situation in which I am placed, I am obliged to listen to many remarks, and sometimes to those which are unfavourable. When I am rebuked for taking a course which I know to be a right one, I am not disquieted by it. When I am made to see that I have done wrong, I readily blame myself. And I am enabled sincerely to pardon all, and to pray for all, who wish me ill or who do me ill.

" I do not hesitate to admit that I have faults ; but I can also add, that I have a fixed determination, whatever may be my failings, to give myself to God. Pray to Him without ceasing, that He will be pleased to finish in me what He has already begun, and to destroy in me those evils which proceed from my fallen nature.—In respect to yourself, you may be assured that my friendship is always the same."

Fénelon died in 1715, at the age of sixty-five. His work was accomplished. It was found after his death that he was without property and without debts. United to Christ, he had no fear. As he had the spirit, so he delighted in the language of the Saviour. His dying words were, " THY WILL BE DONE."

There is, perhaps, not another man in modern times, whose character has so perfectly harmonized in its favour all creeds, nations, and parties. His religion expanded his heart to the limits of the world. It was natural, therefore, that the whole human race should love his memory. In the time of the French Revolution, when the chains fastened by the tyranny of ages, were rent asunder by infuriated men, who, in freeing themselves

from outward tyranny, forgot to free themselves from the domi-
nation of their own passions, the ashes of the good and great of
other days, in the forgetfulness of all just distinctions, were
scattered by them to the four winds of heaven. But they wept
over and spared the dust of Fénelon.*

CHAPTER XLIX.

Of the influence of Madame Guyon on Fénelon—Woman's influence—Madame Guyon
transferred from Vincennes to Vaugirard—Religious efforts there—Interference of the
Archbishop of Paris—Feelings of the King towards Madame Guyon—His treatment of
some members of the Seminary of St. Cyr—Removes a son of Madame Guyon from his
office—Proceedings of Bishop of Chartres—Feelings of Madame Guyon in relation to
Fénelon—Visited by the Archbishop of Paris, who reads to her a letter from La Combe—
Her feelings—A Poem.

THE natural traits of Fénelon, remarkable in themselves, were
still more remarkable in the beauty of their combination. Reli-
gion added to the attractions of his character. At an early period
of his life he was a religious man ;—religious in the ordinary
sense of the term, and with a reference to the common standard.

It is impossible to separate the influence of the instructions, of
the exhortations and prayers, and personal life and example of
Madame Guyon, from the benevolent labours and the sublime
faith of Fénelon.

* [We fear that the French Revolutionists were not quite so reverential as the text would
indicate. The following brief statement of a visit by an accomplished lady, will interest
the reader.—ENGLISH ED.

"I visited Cambray in 1841. The Revolution had done its perfect work in his palace,
cathedral, and *first* tomb ! His memory is revered as the good and great Fénelon. Rue Féne-
lon, Place Fénelon, and his name given as the Christian name in the families of the citizens,
shows the estimation he is yet held in. The people spoke of him as if he had lived but yester-
day ; his present tomb was raised by the venerable Louis Belmas, who was lying in state
twenty-four hours after his death, when we visited the palace—it was designed by David, in
1825, and is simple and truthful to history. The Revolutionists in 1793 destroyed the vener-
able cathedral, in which lay the remains of its venerable Archbishop. Their blushing
posterity have, by way of making some atonement for their lawless violence, erected a
monument to the memory of a man whose name is immortalized by his talents in the liter-
ary world, and in the Christian world, by a Christian piety which will shed its sweet influ-
ence for ever on the hearts of those who believe that God is Love !

"The few remains of Fénelon were collected and deposited in the new tomb ; his coffin
had been melted into bullets in 1793."—A. S. K.]

And if any female should think these pages worthy of her perusal, let her gather the lesson from these statements, that woman's influence does not terminate, as is sometimes supposed, with the moulding and the guidance of the minds of children. Her task is not finished when she sends abroad those whom she has borne and nurtured in her bosom, on their pilgrimage of action and duty in the wide world. Far from it. Man is neither safe in himself, nor profitable to others, when he lives dissociated from that benign influence which is to be found in woman's presence and character;—an influence which is needed in the projects and toils of mature life, in the temptations and trials to which that period is especially exposed, and in the weakness and sufferings of age, hardly less than in childhood and youth.

But it is not woman, gay, frivolous, and unbelieving, or woman separated from those Divine teachings which make all hearts wise, that can lay claim to the exercise of such an influence. But when she adds to the traits of sympathy, forbearance, and warm affection, which characterize her, the strength and wisdom of a well-cultivated intellect, and the still higher attributes of religious faith and holy love, it is not easy to limit the good she may do, in all situations and in all periods of life.

To the last moment of his life, Fénelon bore the most decided testimony to the virtues of Madame Guyon; while his own personal history and doctrines were conclusive evidence of the influence she had exerted. When the controversy between Fénelon and Bossuet commenced, Madame Guyon was a prisoner in the castle of Vincennes. And we naturally return to the story of her remarkable life.

From the period in which she gave herself wholly to God, she was calm and patient. The walls which enclosed her had no terrors to a heart that recognised the presence of God as distinctly in sorrow as in joy. Not that her feeble constitution did not suffer, or that she did not feel deeply her separation from her friends, but she had inward supports, which enabled her to rise above such sufferings; and with Paul and Silas she sang songs in prison.

Madame Guyon was imprisoned in the castle of Vincennes on the 31st of December 1695. She was allowed the company of the pious maid-servant who had so long attended her, and was her daughter in the Gospel; but she was not permitted, except under great restrictions, to see her relatives and other friends, or to correspond with them. Either because her physical system would not bear such close and long-continued confinement, or because the principal agents in restraining her were touched with some degree of pity, after the expiration of nearly a year she was imprisoned at Vaugirard, a village in the immediate neighbourhood of Paris, the 28th of August 1696. Her pious maid-servant was detained for a longer period at Vincennes.

At Vaugirard, from which she was subsequently transferred to the Bastile, she remained till September 1698. Her prison at Vaugirard seems to have been a place of confinement connected with a monastery at that village. It was understood by her that she would have a little more liberty than was allowed her at Vincennes; and her strong desire to benefit souls returned. She saw her friends more frequently than she had recently done; she corresponded with them, and endeavoured to inspire the true life of faith in the sisters of the monastery, whenever she had opportunity to speak to them.

The Archbishop of Paris, at whose request she had been transferred to Vaugirard, became alarmed. He knew the feelings of the king, and that it was indispensable that these things should stop. Accordingly she was reduced to the painful necessity of signing a paper, in which she agreed expressly to cease from such labours, on the 9th of October 1696. She promised to place herself under the watch and direction of the curate of the seminary of St. Sulpitius; and, without his express permission, to receive no visits, hold no conversations, and write no letters.

To one whose life it was to do good, such a prohibition must have been exceedingly painful. But, as she was entirely in the power of others, she could not well do otherwise than submit. Any other course would have merely resulted in the severer imprisonment of Vincennes. Her only resource now was prayer.

It is remarkable, that a man whose mind was occupied with plans of vast extent, such as perhaps no French monarch before him had entertained, should enter into a contest, which may well be called a personal contest, with an unprotected woman. But so it was.

After the remarkable attention to religion in the Female Seminary of St. Cyr, which was attributed to the influence of Madame Guyon, and supposed to be conducted on principles allied to those of Protestantism, Louis, greatly offended, not only insisted on the exclusion of Madame Guyon, but came to St. Cyr personally, instituted an examination into the state of things himself, and removed from the seminary three of the most pious ladies connected with it. The only reason assigned was their sympathy with the new doctrine of an inward and purified life sustained by faith. So that, like Fénelon, she was obliged to suffer, not only in her own person, but in the person of her friends.

Madame Guyon's second son, a young man of promise, had been appointed a year or two previous a lieutenant in the king's guards. Nothing was alleged against his character or conduct; but such was the king's hostility to Madame Guyon, and his determination to crush her effectually, that he unceremoniously removed her son from the public service.

The zeal of the king was seconded by the prompt and effective co-operation of a number of the bishops. This was particularly the case with Godet Marais, Bishop of Chartres, within whose diocese St. Cyr was situated. As the alleged heresy had made its appearance in a seminary for whose religious character and interests he felt especially responsible, he issued an ecclesiastical ordinance, in which he condemned the writings of Madame Guyon, as *false, rash, impious, heretical, and tending to renew the errors of Luther and Calvin.*

Not satisfied with this, he instituted personally a minute examination of all the rooms and private apartments of the seminary of St. Cyr, and took away all the writings of Madame Guyon which he found there; and among other things some

manuscripts and letters of Fénelon. Madame Maisonfort, a pious and highly educated lady, who had the immediate charge of the seminary, remonstrated against such violent and unjust proceedings, without effect.

These transactions, and others like them, took place from 1695 to 1698. They added to the sorrows of Madame Guyon's imprisonment; but did not lead her to doubt for a moment the goodness and truth of God. Both at Vincennes and at Vaugirard, she kept herself informed, to a considerable extent, of the progress of events. But nothing touched her feelings so deeply as the trials of Fénelon. She had been the instrument, in the hands of Providence, of bringing to his notice the great doctrine of present and entire holiness. With the greatest earnestness and perseverance, she had watched for him and prayed for him; had warned and entreated him. She had the happiness of seeing her labours and prayers answered. Appreciating also his great learning, his powers of reasoning and imagination, and his cultivated taste, she naturally indulged the hope, that he might illustrate and successfully propagate those religious views which she regarded as so important.

But darkness had gathered upon the prospect, which would otherwise have been so cheering. When the secular arm had united with the religious, and kings were in alliance with bishops, there seemed but little hope. When she thought of these things, as she sat alone in her solitary cell, tears sometimes filled that bright eye which the lapse of half a century had not yet made dim.

When she had been at Vaugirard nearly two years, the doors of her prison suddenly opened. Her old acquaintance, Monsieur de Noailles, Archbishop of Paris, accompanied by Monsieur Lachetardie, the curate of the seminary of St. Sulpitius, presented himself before her. With a seriousness of air, which seemed to him to be warranted by the occasion, the archbishop informed her of the reasons of his coming. He held in his hand a letter, and read it. It purported to be from Father La Combe, addressed to Madame Guyon, in which La Combe, without

naming them, referred distinctly to irregularities into which they had both fallen, and exhorted her to repent. The letter was no sooner read, than the archbishop and the curate, unfavourably impressed by insinuations which seemed to imply guilt, conjured her, in the most earnest and solemn manner, to do homage to truth, and to merit forgiveness by a sincere confession of her faults.

But, worn down as she was by the sorrows of her imprisonment, her offended innocence gave her strength to reply. She said, however, but little. And it was simply this. The letter which had been read to her, which she was not permitted to see, was either a forgery; or Father La Combe, worn out by the severity of his long imprisonment, had entirely lost his powers of perception and memory, and had written it, without knowing what he wrote, at the instigation of another. Further than this, she did not think it her duty to notice this accusation. Her perfect self-possession, her serious and unaffected air of innocence, the conviction which suddenly flashed upon their own minds, that an attempt had been made to destroy the most devoted and virtuous of women by the foulest of means, compelled them to leave her prison with a shame to themselves, hardly less than the sorrow which they brought to her.

The secret history of this atrocious movement is not well known. The long banishment and imprisonments which La Combe had suffered, as an advocate of the doctrines of Madame Guyon, had affected both his mental and physical system. So obviously was this the case, that those who had the charge of him thought it necessary to transfer him from the place of his imprisonment, in a distant part of France, to the public hospital for sick and lunatic persons established in the village of Charenton, a few miles from Paris. On his way thither, he was lodged a few days in the castle of Vincennes, where the paper to which we have referred was prepared, and his signature was obtained. Shortly after his arrival at Charenton he died; but it was satisfactorily ascertained, that at the time of his death, and for some time before, he had not sufficient power of perception and rea-

soning to know what he did, and to render him accountable for his acts. These circumstances were not known to the Archbishop of Paris, when the paper, which he was requested to convey to Madame Guyon, was put into his hands.

The historians of the life of Fénelon agree in asserting, that this ungenerous and wicked attempt was aimed as much, perhaps still more, at Fénelon, as at Madame Guyon. The enemies of Fénelon were astonished at the powers of argument and of eloquence which he displayed in his controversy with Bossuet. They saw themselves on the point of being defeated; and, as Fénelon never denied his acquaintance with Madame Guyon and his sincere respect and friendship for her, they seemed to have but one way left to them, that of destroying his reputation and throwing doubt upon his morals, by first destroying hers. If there had been anything wrong between Madame Guyon and La Combe, " it was expected," says Butler, " that the ascertainment of the fact would indirectly operate to the detriment of Fénelon, by exposing his connexion with her to a like suspicion." The attempt did not succeed; but originating in the deepest depravity, and aimed as she knew it to be at Fénelon as well as nerself, it could not fail to inflict a deep wound upon her already afflicted spirit.

The following stanzas, without being a translation of any one poem, embody sentiments which are found in many :—

THE LIGHT ABOVE US.

THERE is a light in yonder skies,
A light unseen by outward eyes ;—
But clear and bright to inward sense,
It shines, the star of Providence.

The radiance of the central throne,
It comes from God, and God alone ;—
The ray that never yet grew pale,
The star that " shines within the veil.

And faith, uncheck'd by earthly fears,
Shall lift its eye, though fill'd with tears,
And while around 'tis dark as night,
Untired, shall mark that heavenly light.

In vain they smite me. Men but do
What God permits with different view ;—
To outward sight they wield the rod,
But faith proclaims it all of God.

Unmoved, then, let me keep my way,
Supported by that cheering ray,
Which, shining distant, renders clear
The clouds and darkness thronging near.

CHAPTER L.

1698—Transferred to the Bastile—Some account of it—Extract from a letter—Man of the iron mask—Madame Guyon's maid-servant imprisoned in the Bastile—Her personal history—Religious character—Letters—Death—Situation of Madame Guyon—The religious support she experienced.

THE failure of the attempt to ruin the character of Madame Guyon, and to involve that of Fénelon, seems to have exasperated her enemies more and more. They obtained an order from the king, which required her to be transferred from Vaugirard to one of the towers of the Bastile. She became a prisoner in that abode of wretchedness in September 1698.

The prison, in which Madame Guyon was now incarcerated, has become historical. It has been demolished, it is true; but, while an interest in the history of the human race remains, it will not cease to be remembered. Its erection began in the year 1370, and it was composed of high and large towers, united together by thick walls enclosing two large courts, which were separated from each other by other walls; the whole being enclosed by a deep and wide ditch. At the base of all the towers were dungeons. Each tower, eighty feet in height above the dungeon, consisted of four stories. The dungeons were below the level of the ground; some of them admitted a little light; others were perfectly dark. There was no stove or fireplace in any of them. It was in these dreadful abodes, that the two princes of Armagnac were immured by the orders of Louis XI.; one of whom, overcome by the weight of wretchedness and despair, lost his reason; the other, set at liberty upon a change of the government, published an account of his sufferings.

Above the dungeons rose successively four apartments, all of which were prisons, and were in the form of irregular polygons; eighteen feet across the floor and eighteen feet high; except the upper story, which was a little smaller. The walls were twelve feet thick at the highest part of the tower, and they increased in thickness as they approached the bottom. The doors of the

Q

prisons in the towers were of oak, and double; each three inches in thickness. Each of the prisons above the dungeon had one window, secured, on the outside, by an iron grate of prodigious strength. The chimneys also were secured by iron grates, crossing the vent at proper distances. The floors were laid with stone or tiles.

Each tower had its name, and each apartment its number; so that it was not necessary to say who the prisoners were when orders were given in respect to them, or when they happened to be the subjects of conversation; but only to mention them in the language of the place, as No. ONE, in the tower *du Trésor*, No. TWO, in the tower *de la Comté*, and so on. Most of the apartments had the same kind of furniture, both as to the number of articles and their quality. It usually consisted of a bed, a table, a chair, a basin, and a large earthen pitcher for holding water, a brass candlestick, a broom, and a tinder-box.

When the prisoners entered these dreadful abodes, their names were entered in a register, with the dates of their arrival, and the specification of the towers and the numbers of the towers, to which they were assigned. Everything was taken from them, except such clothing as was absolutely necessary. The large and stony apartments, in which they were enclosed, if they were so much favoured as to escape an incarceration in the dungeons, were exceedingly cold in winter; and as they were not capable of ventilation, the prisoners suffered no less from the unpleasant heats of summer; a grievance which was increased by the steams issuing from the water that putrified in the ditch below. Iron cages, and other instruments of torture, were kept in reserve for those who were refractory.

In one of these abodes of sorrow Madame Guyon was shut up four years; and, so far as anything appears on the subject, in entire solitary confinement. It was thought necessary, that twelve feet of thick wall, built up on every side, should guard her against making any further exertions in the cause of Christ. Shut out from the world, from her friends, from the pleasant light of the sun, she had nothing to do but to bow in the silence

and acquiescence of religious trust. Deprived of the privilege of seeing her friends, she was not even allowed to write to them.

But the evidence of her whole life shows what her feelings must have been; and that her faith did not cease to be triumphant, even in this aggravated trial. In one of her letters, written just before her removal to the Bastile, and in anticipation of her imprisonment there, which she naturally regarded as a precursor of still harsher treatment, she says:—" I feel no anxiety in view of what my enemies will do to me. I have no fear of anything but of *being left to myself.* So long as God is with me, neither imprisonment nor death will have any terrors. Fear not. If they should proceed to extremities, and should put me to death, *Come and see me die.* Do as Mary Magdalene did, who never left Him that taught her the science of PURE LOVE."

In noticing the date of Madame Guyon's imprisonment, I could not help being reminded, that but a few feet from her, perhaps in the next dungeon, was the celebrated prisoner known in history as the Man of the Iron Mask. A very few persons knew who he was; and the secret has died with them. The common supposition is, that he was a twin brother of Louis XIV.; and that, to prevent his putting forth pretensions to the throne, he was shut out from all intercourse with men, and even all knowledge of himself. For the purpose of entire concealment he wore a mask, of which the lower part had steel springs, contrived so that he could eat without taking it off.

An old physician of the Bastile, who had often attended this remarkable man, declared that he had never been allowed to see his face, though he had often examined his tongue and other parts of his person. When Madame Guyon was shut up in the Bastile, the Man of the Iron Mask had been a solitary prisoner thirty-seven years. Probably he did not know his own history; he had scarcely been allowed to see any human being from infancy; he lived in the most cruel exclusion from all that makes life desirable, shut out from nature, from knowledge, and from man.

The question naturally arises, Was he excluded from religious knowledge? Had he the consolations of religion? Did he know of that peaceful home, where the wicked cease from troubling, and where the weary are at rest? No one can tell. But we know this :—if the woman of faith and prayer, who was shut up within the same massive walls, had known his unparalleled situation, he would have had all that her purified and believing spirit could have given of warmest sympathy and of earnest supplication.

Madame Guyon was imprisoned in the Bastile in 1698. Nearly at the same time, her maid-servant, who remained at Vincennes after she was transferred to Vaugirard, was also removed to the Bastile. Madame Guyon became acquainted with her at Paris, at an early period of her widowhood. She was the instrument, in the hands of God, of leading her, then a young girl, to the knowledge of Christ. And seeing in her the traits of good judgment and firmness of purpose, she employed her as a domestic.

When she left Paris for the distant parts of France and Savoy, she took this maid-servant with her. It is a proof of the confidence of her mistress, that her surviving daughter, Marie Jeanne Guyon, was intrusted to her special and almost exclusive care. She was with Madame Guyon at Gex, Thonon, and Grenoble.

When she left Grenoble in 1686, she left her daughter behind in the care of this maid. On her return from Grenoble to Paris, her maid-servant came with her. When Madame Guyon was first imprisoned in the Convent of St. Mary, they were designedly separated. There is some reason to suppose, that the maid-servant was imprisoned at the same time in the castle of Vincennes. Afterwards we find them together, in voluntary seclusion, in the Convent of the Visitation at Meaux. When Madame Guyon returned to Paris, and found it necessary to conceal herself in an obscure house in the street of St. Anthony, this maid was with her. She was discovered by the agents of the police, from the circumstance, that all the persons going into the house were seen to enter it by means of private keys, and without knocking at the door.

So deeply imbued was the maid with the principles of the mistress, that, when Madame Guyon was imprisoned at Vincennes, it was thought necessary that her maid-servant should be incarcerated with her. They were separated when Madame Guyon was transferred to Vaugirard.

It is not enough to say of this faithful woman, that she was pious. Her piety, founded upon the principles of consecration and faith, was intelligent, whole-hearted, and persevering.

One of the remarkable things in her character, which is too much overlooked by Christians, was her appreciation of God's providence. She desired to be what God would have her to be, and to be nothing more and nothing less. She had not a doubt that God, who had given remarkable powers to Madame Guyon, had called her to the great work in which she was employed. But knowing that her beloved mistress could not go alone, but must constantly have some female attendant, she had the conviction equally distinct, that she was called *to be her maid-servant.* She could not well avoid the conclusion, that this field of labour was the sphere of Providence to her ; and though, in a worldly point of view, it might not have had great attractions, she accepted it with cheerfulness, and filled it with fidelity. And He, who called her to this work, alone can tell how much the world is indebted to the prayers and humble but necessary labours of this pious servant.

She was a person of a strong understanding. Her letters shew this. She took a strong hold of the truth ; and her purpose was fixed to maintain it. Nothing could turn her from what she believed to be the will of God. Threatenings and promises were employed to induce her to say something to the disadvantage of Madame Guyon. But her faith was not of that kind which can be bought with money. And she seems to have been imprisoned chiefly for the purpose of preventing her from saying or doing anything openly or publicly in her favour. It is at least difficult to divine any other adequate motive.

She did not allow herself to spend time in estimating the comparative value of God and Mammon. She crucified and trampled

Q2

under foot all that stood between her soul and the divine **will.**
She could say in simplicity and truth, but without repining,—

> " Oh ! cease, my wandering soul,
> On restless wing to roam ;
> All this wide world, to either pole,
> Has not for thee a home."

Her imprisonment, therefore, as she looked forward to another
and dearer abode, was less severe to her than it might have been
to others. But this was owing to her state of mind, and not to
any alleviation and kindness on the part of those who troubled
her. After the departure of Madame Guyon from Vaugirard,
she was in solitary confinement, the most trying situation pos-
sible. She was not even allowed to correspond with her friends.
She found means to write a few letters ; but not owing to any
kindness or permission of those who kept her in prison.

The following letter to her brother, found in the French edi-
tion of the Life of Madame Guyon, evidences her consistent and
well-established piety.

[*Prison of* Vincennes, —— 1697.]

" My very dear Brother,—I do not know that I shall ever
have the consolation of seeing you again. I should be glad to
see you, and still more on your account than on my own. That
is to say, I should be glad, if it were God's will; for I have no
desires and no consolations separate from Him. Whenever I am
permitted to see you, I shall speak freely in relation to Madame
Guyon. If I have hitherto been somewhat reserved in regard to
her, I can mention reasons for it which will satisfy you.

" I am sensible, my dear brother, of the good disposition of
your heart ; and well I know that you love me. I never can
forget your great care and concern in relation to my welfare,
when we were about to part from each other ; and how much
troubled you were in seeing me forsake the advantages the world
held out.

" But God called me, and I was obliged to go. It was the
will of my heavenly Father that I should be separated from
everything that bound me down to earth. It was God who gave

me strength to withstand the solicitations of a brother's love. If your house, my dear brother, had been made of precious stones, and if I could have been treated and honoured in it as a queen, yet I should have forsaken all to follow God, who called me, not to pleasures, but suffering. I had inward as well as outward crosses ; but, gently and joyfully, I went on, following God. I prayed in myself, that I might be faithful to the cross.

" And now, my dear brother, if I had stopped and attempted to explain and to reason with you at that time, what would you have said ? What would you have done ? You would have said, I was very unwise, very foolish. With very good intentions on your part, you would have raised a multitude of objections, and have obstructed my greatest good. You would have stood in the way of what I cannot fail to regard as my greatest consolation, yea, my boundless joy, my sweet repose, *which is in all things to do the will of God.* I can truly say, that, standing in God's will, and doing and suffering His will, I have something which strengthens, animates, and encourages me ; I am fed with a nourishment which the world cannot give. And, on the other hand, not to do God's will, when it is presented before me, is more dreadful to me than hell. If, when I was called to leave my friends and home, and go with Madame Guyon, I had refused to do it, the grace of God would have been taken from me and given to another. And after such unfaithfulness and such loss, what could I have done ? I should never have had repose or quiet of soul, which is to be found in God only.

" But I can talk and reason with you now, my dear brother, without fear. Your arguments and wishes can now have but little effect in placing an obstacle between myself and the sufferings to which God calls me. There is but little danger of my getting away from the prison of Vincennes, where I have been confined twice. I have been in prison this last time nearly three years. Whether I shall ever be released again in this life I know not. Perhaps I shall have no other consolation in this life than what I find in suffering.

" I am not allowed any materials for writing ; nor is it an

easy thing for written communications to pass in and out of my cell. Unexpectedly, however, I obtained some sheets of paper; and, using soot instead of ink, and a bit of stick instead of a pen, I have been enabled to write this. But I do it in the utmost hazard and jeopardy. It is my hope that you will receive what I write, and that, with the Divine blessing, it may one day be a means of comforting you in my imprisonment; for it seems to me that you have a hundred times more trouble and concern about it than I have. Not a day passes in which I do not thank God that He has imprisoned me here. I cannot forget the time when I laid myself upon His altar, to be His in joy and in sorrow; and I regard my imprisonment as a pleasing evidence that He did not reject the sacrifice. In permitting me to suffer for Him, He has done me a great favour.

"I feel for those who have afflicted and persecuted us. I indulge the hope, that God will, in time, open the eyes of those among them who are upright, but have acted wrongly from false views. It is my desire especially, that they may be led to understand and appreciate the character of Madame Guyon; ' *a precious stone*,' I may well call her, whose brightness has not been dimmed, but rather embellished, by their attempts to tarnish it. Having been with her twelve years, I think I know her character thoroughly. If it is a blessing to have her personal acquaintance, it is an honour also to share in her sufferings. Having been the constant witness of her devoted piety, I hope I have imbibed something of her spirit. It has seemed to me, that I have seen the divine nature manifested in her in a remarkable manner; and, whenever I discover the traces and footsteps of God, I make haste to follow.

"We are now separated from each other; I am in this prison alone, she in another place; but we are still united in spirit. The walls of a prison may confine the body, but they cannot hinder the union of souls. It is the love of Christ which unites us. It is in Christ, and for Christ's sake, that I love her, and that we love each other; and my love is continually increasing.

"Do not wonder, my dear brother, that I do not go into par-

ticulars. Is it not enough to say, that she was an instrument in the hands of God to bring me to a knowledge of Himself,— that God whom I now love, and whom I shall love for ever? She taught me the great lesson of self-denial, of dying to the life of nature, and of living only to the will of God. I never can forget the diligence she used, the patience she exhibited, and the holy love which animated her on my behalf. So do not wonder that I love her. Yea, I love her because she loves the God whom I love; and it is with a love which is real, living, and operative. And this love has the power of uniting our hearts in a manner which I am unable to express; but it seems to me, that it is the beginning of that union which we shall have in heaven, where the love of God will unite us all in Him.

"With this discovery of my feelings, my dear brother, and hoping that you will now be at rest in the matters which have hitherto troubled you, I bid you adieu.—* * *."

The following is a letter from the same to an ecclesiastic.

"TO GOD BE ALL THE GLORY.

"REVEREND FATHER,—I will endeavour to explain to you the sentiments of my heart in as few words as possible. That I suffer I do not deny; but it is a satisfaction to say, that I bear the cross *willingly*. I would rather die than be unwilling to bear it. Nothing could express my sorrow and wretchedness, if I should find in myself an impatient disposition. I bless the Lord that He has given me other sentiments. I feel that I am not only resigned to God, but entirely given up to Him. Most tenderly do I love His holy will; and I shall not cease to love and adore it, whatever may be His dispensations towards me. And therefore do I esteem myself happy in being a prisoner for the Lord's sake.

"It is true, that I hear the sighing and crying of outward nature; but let it complain. That inner nature which has its life from *faith*, pays no attention to it. So strong is my heart in the Lord, that I have ceased to trouble myself about any new cross. It seems as if I had become inured and hardened to trial

Is there anything which I do not feel ready to suffer? I love the cross with a true love, because I see God in it, and it makes me more nearly acquainted with Him.

"I am now separated from my beloved mistress, Madame Guyon. If it be the will of God that I shall no more see her on earth, I have no doubt that I shall see her in heaven. The power of man does not reach there. Even in this life our separation from each other in person does not cause a separation in spirit. I love her as being made one with her in Christ;—IN Him and FOR Him. So closely are we united, though separated in body, that, when I pray to God, she seems to be always present with me. Being one with Christ, I do not know how I could separate from her without separating myself from the Saviour. Our union, therefore, shall never be broken; neither in earth nor in heaven. It is a union of the cross upon earth, and a union of the possession of God in eternity. It is this hope which enlivens my soul.

"I think, Reverend Father, you would not regard me as expressing myself too strongly in relation to my love for Madame Guyon, if you knew what a blessing she has been to me. God made her the instrument of revealing Himself to my heart. And I experienced her advice and aid in all that subsequent struggle, which was necessary in denying and subduing the life of nature, and bringing it into subjection. Under her instructions and prayers, the love of Christ grew so strongly within me, that it seemed to be written and engraven, as it were, upon my heart, in characters deep and never fading. And the more I love God, the more closely I find myself bound to her. Who, then, shall separate us? Neither persecutions nor prisons, neither men nor devils, nor anything else, shall separate us from the love of Christ;—and what, then, shall separate us from each other? It is always in the sweet and lovely heart of Jesus, where my life reposes, that I find her. O Saviour! I lift up my heart and hands unto Thee, and return Thee thanks for uniting me to one who loves Thee so tenderly and purely.

"I repeat again, that, in my imprisonment, nature suffers

grievously; but yet I would not be without suffering. It is in the utmost sincerity I assert, that I have a secret fear of being without suffering. The *cross*, in the sense of suffering for Christ, is dear to me. I have espoused it with an inconceivable force and ardour, and would be faithful to it as long as I live. In the consecration, which I have made to God, I have reserved nothing. Both body and spirit are entirely His. Let him do with me whatever He pleases. I have no desire, no purpose, no will of my own, separate from the will of God. The continual prayer of my heart is,—THY WILL BE DONE."

Such were the devout dispositions of this pious maid. If she had consented to say a word unfavourable to Madame Guyon, she would undoubtedly have been set at liberty, and perhaps rewarded. But although she was poor, and in prison, the world had not riches enough to seduce her principles and pervert her integrity. It was a saying of the Saviour, that the " poor have the Gospel preached unto them." And He who is the author of the Gospel, and who has all hearts in His hands, knows full well, whoever else may be ignorant of it, that, among the neglected and forgotten, among the poor of this world, there have been, and there still are, those who are rich in faith;—those upon whose love, patience, and Christian integrity, angels in heaven look down with the deepest interest. If they are the world's servants, they are the Lord's children. Unknown among men, their names are written in the Lamb's book of life. Without homes on earth, they have habitations appointed for them in the skies.

The confinement of Madame Guyon in the Bastile, is briefly alluded to in the Memoirs of Dangeau. He writes from Versailles, " Nothing is talked of here," he says, " but the Bishop of Meaux's last publication against the Archbishop of Cambray, in which the whole doctrine of Madame Guyon is exposed. This lady is in the Bastile, where Monsieur de la Reine (chief of the police of Paris) has already interrogated her several times by order of the king. She is said to defend herself with great ability and firmness."

Madame Guyon had not been long in the Bastile before the report was circulated that she was dead. The report arose under peculiar circumstances, and passed for a time uncontradicted. It reached the ears of Fénelon ;—and at a time when her enemies had not ceased to make efforts to destroy her character. He supposed it to be true, that she had done with the things of this world. All the personal motives which had rendered him anxious to sustain her, had ceased. And at that late hour, if he had renounced her and her writings, he might have been restored to the favour of Louis XIV. But he took the opportunity to bear the most decided testimony to her virtues. And in doing it, he added, "*It would be infamous weakness in me to speak doubtfully in relation to her character, in order to free myself from oppression.*"

The maid-servant, and not the mistress, had gone to her reward. And so long had they laboured and suffered together, and so closely were they associated in men's minds, that it is not surprising that what was true of one should be attributed to the other. Under what circumstances this pious servant died, we know not. We can only assert with confidence, without receiving it from human lips, that when her dying head reposed upon the tattered couch, or upon the stony floor of her prison, she did not repent that she gave up all for Christ.

In what way Madame Guyon sustained the long years of her imprisonment in the Bastile, we have now no means of ascertaining. Her situation then, and afterwards, was such as to compel her to silence. Every prisoner who entered the Bastile was obliged to take an oath, by which he bound himself to maintain an inviolable secrecy with respect to all that he had seen or heard there. If, at any subsequent period of her life, she had made known the particulars of her suffering there, and especially if she had made any complaint, it would only have resulted in her being subjected to the same sufferings again.

But it is not difficult to conjecture what she must have under-one. It is well understood that there are few persons, however

vigorous they may be in body or in mind, even of those who are supported by religion, that can sustain, for a great length of time, the dreadful ravages of solitary confinement.

In the few memorials that have escaped the terrible silence of the Bastile, it is affecting to notice the various resorts of suffering humanity to escape from its calamities. The prisoner looks upward, but he sees no sun ; he gazes at the straggling and dim light of his window, but it shows him no green fields and woods ; he listens and hears, or thinks he hears, a voice coming up from the streets below, which reminds him of a child or brother ; but, alas ! child and brother, and the hopes and happiness of home are no longer his. Sad and weeping, he walks from side to side of his dark room ; till, finding his mind sinking under a sorrow which it is his duty to strive against, he resorts to any sort of occupation or amusement, however unsuitable it might be under other circumstances.

" The histories of the Bastile," says a writer, " are full of attempts to train spiders by supplying them with food, and to avert the horrors of reflection by ascertaining the dimensions of the room, or counting the studs upon the door. Some have spent whole days in pouring water from one dish into another ; or in disposing, in fanciful arrangements, the pieces of which their fagots were composed."

If the stoutest men have sunk under these calamities, if their heads have become grey, and their hearts been broken, we may well suppose that it could be no other than a place of extreme trial and sorrow to a feeble and delicate woman. Those natural affections which bound her to her kindred and friends were equally strong, and equally liable to be wounded. She had a daughter and sons and many beloved friends, from whom she was entirely cut off. But God was with her ; and she felt that all was well so long as she had the Divine favour.

In a single passage of her Autobiography, she refers to this subject. " I, being in the Bastile," she says, " said to thee, O my God ! if thou art pleased to render me a spectacle to men and angels, thy holy will be done ! All that I ask is, that thou

wilt be with and save those who love thee ;—so that neither life
nor death, neither principalities nor powers, may ever separate
them from the love of God which is in Jesus Christ. As for me,
what matters it what men think of me, or what they make me
suffer, since they cannot separate me from that Saviour whose
name is engraven in the very bottom of my heart ? If I can
only be accepted of Him, I am willing that all men should de-
spise and hate me. Their strokes will polish what may be
defective in me, so that I may be presented in peace to Him,
for whom I die daily. Without His favour, I am wretched.
O Saviour! I present myself before thee an offering, a sacrifice.
Purify me in thy blood, that I may be accepted of thee."

It was a part of her principles, and of her experience, to see
all things in the light of God. Men, even *wicked* men, were but
the instruments of higher purposes. Men had imprisoned her ;
but they did not do it without God's permission. This faith,
although it did not prevent suffering, stopped all complaint.
And sometimes it so opened the fountains of joy, that here, as
at Vincennes, the stones of her prison looked like rubies in her
sight. Here, too, she composed songs and sung them ; but the
voice of her pious maid-servant, which mingled with hers in her
former imprisonment, was now silent. She mourned and re-
joiced, she wept and sung *alone*.

———

CHAPTER LI.

Advocates of pure love called Quietists—Traits of religious character connected with the
origin of the name—Meekness and simplicity, which characterize the true Quietist—The
Quietist in affliction—In action—When suffering injury—In prayer—Other religious
traits—Selections from the poems of Madame Guyon.

IN the time of Madame Guyon and Fénelon, the advocates of
the doctrine of Pure Love were frequently called *Quietists*. In
the controversy between Bossuet and Fénelon, this name, as i'

it implied some reproach, was almost constantly applied to them. It was not a name of their own seeking ; but, having been frequently applied, it became after a time a recognised designation. It had been previously applied to Michael de Molinos and his followers.

The term, in the proper and right sense, undoubtedly indicates some characteristic traits in their experience and lives. There is no trait which more distinctly and fully characterizes the subjects of a truly purified and perfected love, than *meekness of spirit.* And in this especially we are to look for the origin of the name. How can those be otherwise than calm and serene, as well as happy, who love God with all their heart, and their neighbour as themselves ? Regarding themselves as nothing, and loving God above all things, they are exempt from those personal pretensions, which are the opposite of a meek and quiet spirit. It is impossible for them to have pure love without assured faith ; and the same faith, which is the parent of love, is the parent of a childlike, humble, and acquiescent temper.

The true Quietist is a man also of *simplicity* of spirit. In the language of Scripture he has that " single eye," which makes the whole body full of light. Human passion, that is, *unsanctified* passion, has lost its power over him. His mind has assumed a unity of character, harmonious in itself and in its movement. This is the result of its supreme love to God, which, in subordinating and regulating every other love, reduces all principles of action and all motives into one. So that, instead of being many men in one through the diversity of self, he is one man in God through the unity of love.

The Quietist, having undergone the purifying baptism of faith and love, is resigned and acquiescent in those circumstances and in that place, whatever it may be, which God in His providence has allotted him. If he is afflicted, he knows that it is good for him to suffer ; and the tears which he sheds only give a new beauty to the peaceful serenity which shines through them. If he is poor, he is content to be without the earth's treasures, accounting himself rich in the possession of inward wealth with

outward destitution. If, on the other hand, the Lord has made him rich in this world's goods, he sees distinctly that his riches are the gift of another; and he is entirely content and happy in renouncing all claims for himself, and in being merely the Lord's steward. He loves to be just where the Lord would have him to be. So that, whether we find him in wealth or in want, in prison or on the throne, in the presence of his own people and in the peace of his own family, or in the deprivations of exile, he is always *at home*.

It might, perhaps, be supposed, from the name, that those who bore it failed in being faithful labourers. But it would be a a great error to suppose, that the man who is quiet, because his heart has perfect rest in God, is a man who fails to fulfil his duty. His rest of spirit would necessarily cease, if he neglected any action which duty imposed upon him. Nor is his action without influence. On the contrary, if he has power with God, as he evidently has in his private supplications, he has also power with men in his outward intercourse. Perhaps no man has more influence; but still, the influence is of such a gentle and unobtrusive kind, that, in general, it does not excite much attention at the time of its exercise.

Some Christians, in particular emergencies, produce a great impression on the religious community, by their efforts;—all eyes are turned towards them;—they pass through the religious and moral hemisphere like meteors in the sky; throwing out a degree of light and heat, but scattering also at times a desolating fire; brilliant for a time, but not unfrequently soon expiring. But the persons of whom we are now speaking, more nearly resemble the sun; advancing silently and brightly in their position; sometimes hidden from our sight in clouds, but never jostled from their true line of movement. Everybody notices the meteor; scarcely any one thinks of the sun.

It is in the true Quietist that we find the spirit of forgiveness exhibited in a remarkable degree. He loves his enemies. Unkind expressions are not heard upon his lips. This benevolent and forgiving spirit is the natural result of the holy love which

is " gentle and easy to be be entreated, full of mercy and good
fruits, without partiality and without hypocrisy."

Realizing the importance of having his own feelings constantly
tried and purified, he has thus a powerful motive to receive with
kindness, and to bear with patience, the evil looks and words of
others. And here also his assured and prevailing faith enables
him to look above the creature, and to see the wisdom of God
manifested, in constantly educing the sanctification of the Chris-
tian from the transgressions of the sinner. So distinct and
powerful is this feeling, that, while he suffers in his own person,
and cannot fail to look with compassion on those who treat him
with unkindness, he is, at the same time, truly grateful that
God so regards him as to make him suffer.

"If thou receivest an injury from any man," says Molinos,
"remember that there are two things in it, viz., the sin of him
who does it, and the suffering which is inflicted on thyself. The
sin is against the will of God, and it greatly displeases Him
though He permits it. But the suffering which thou art called
to endure, is not in opposition to His will. But, on the contrary,
He wills it for thy good. Wherefore, thou oughtest to receive
it as from His hand."—(*Spiritual Guide*, chap. ix.)

The Quietist does not strive for mastery. In various situations
he seeks those things which make for peace. If he mourns over
the ordinary dissensions of life, still more does he turn away
from extreme violence and bloodshed.

The Quietist is a man of prayer. Without undervaluing that
prayer, appropriate to times and places, he has a prayer which
is with him always. In souls in the state of pure love, the in-
spirations and impulses of faith and of holy desire can never die.
There is in them a fountain springing up to everlasting life.
God is in us, if we have the love and faith to admit Him there;
and it is God that teaches us how to pray.

The views of Fénelon on this subject are striking. Writing
on that passage in Luke where the disciples ask the Saviour to
teach them how to pray, he utters his heart in the form of a
supplication. " O Lord ! I know not what I should ask of thee.

Thou only knowest what I want ; and thou lovest me, if I am thy friend, better than I can love myself. O Lord! give to me, thy child, what is proper, whatsoever it may be. I dare not ask either crosses or comforts : I only present myself before thee. I open my heart to thee. Behold my wants, which I myself am ignorant of ; but do thou behold, and do according to thy mercy. Smite, or heal! Depress me, or raise me up. I adore all thy purposes without knowing them. I am silent, I offer myself in sacrifice. I abandon myself to thee. I have no more any desire but to accomplish thy will. Lord, teach me how to pray! Dwell thou thyself in me by thy Holy Spirit !"

The Quietist cannot easily be restricted by party lines. His principles may more nearly agree with the principles of one party than of another ; and among the various social, civil, and religious divisions which exist, he may be more likely to act with one party than with another. But it is impossible for him, living as he does *by the moment*, to pledge himself absolutely to a particular course of conduct in time to come.

The writings and labours of the Quietists, few and feeble as those comparatively were who bore that name, would not have produced such a sensation in Europe, if they had not touched and probed some long-existing evils. In the list of modern reformers, Fénelon certainly is entitled to a highly honourable place.

Michael de Molinos had lived for his fellow-men. It is an evidence of the greatness of his labours that, when possession was taken of his papers, there were found among them letters from persons desiring information on religious subjects, to the number of twenty thousand. He was tried, condemned, and shut up in the dungeons of the Inquisition ; where, after the expiration of twelve years, he closed his life. It is affecting to see with what calmness and entire faith in God he enters that dungeon door, from which he knew there was no return. Taking by the hand the friar who attended him, and one of his opposers, he merely said, " Farewell ;—at the day of judgment we shall see each other again ; and then it will appear on which side truth

is, whether on yours or on mine." Whether honoured or dishonoured, whether in freedom or in prison, he could say, It is all well. He knew in a sense, which brought the purest peace into his heart, that the agents in his humiliation and suffering were but the executioners of a Divine purpose, which was full of wisdom and goodness.

The same sweet serenity, the same peaceful resignation, is seen in La Combe, in Alleaume and Bureau, in Falconi, in Fénelon, in the Countess Vespiniani, in Madame de Maisonfort, in Madame Guyon, and in others who suffered in Spain, Italy, and France. They were willing that the purposes of God should be accomplished in them *by suffering*.

Ecclesiastical history shows how frequently the advocates of pure or perfect love, resulting in a Divine quietness of spirit, have made their appearance; and how much they have suffered under the charge of heresy. They have felt bound, with however little prospect of its being accepted, to give their testimony. They appeared in Catalonia in Spain, about the year 1352; and were suppressed through the efforts chiefly of Sanci, Archbishop of Tarragon, and Nicholas Rosetti, the Inquisitor. They again appeared in 1623, in Andalusia; particularly at Seville, the capital. Andrew Pachecho, Bishop of Seville, Inquisitor-General of Spain, employed very severe measures against them. Many were either formally banished, or fled to distant places to avoid the keen pursuit of the Inquisitors. Seven of the leading persons among them were burnt at the stake. But here we see the same triumphant faith, the same holy and universal love; in a word, that blessed spirit of resignation and benevolence, which "loves its enemies, blesses them that curse us, does good to them that hate us, and prays for them which despitefully use us and persecute us." This seems to me the true test of a perfected Christianity.*

When the Waldenses passed through that fiery trial, the story of which forms one of the most thrilling chapters of history, the cry of vengeance went through Europe. Crom-

* See *Dictionnaire Historique des Cultes Religieux*. Art. *Illuminés*.

well pointed his terrible thunder. Milton wrote his sublime
sonnet.

> " Avenge, O Lord ! thy slaughtered saints, whose bones
> Lie scatter'd on the Alpine mountains cold."

When the celebrated religious establishment of Port-Royal
was destroyed, and its inmates were driven out and scattered
abroad never more to return, they uttered the wail of their sor-
row wherever they went. The infirm old nun, ninety years of
age, the last that left those hallowed precincts, lifted her withered
hand, and exclaimed in terrific accents to Monsieur D'Argenson,
the agent of the king :—" To-day, sir, is the hour of *man ;* but
be assured, that another day, the day of *God's righteous retribu-
tion,* is not far distant." As the residents of those dear abodes
of piety and learning cast their last looks upon ruined walls
and desolated fields, they applied the language of the Psalmist,
" O God ! the heathen are come into thine inheritance ; thy
holy temple have they defiled, and made Jerusalem a heap of
stones." Bitter and terrible were their denunciations of the
king ;—the same Louis XIV. who had so often closed the dun-
geons of Vincennes and the Bastile on the Lord's people. And
when they heard the victories of their country's enemies, the
victories of Hochstet and Ramillies, and when they learned the
desolation in the king's family, the death of his son, and of his
son's son, and of the Duke of Brittany, the three successive
heirs of the throne, all dying suddenly and awfully, it seemed to
them, that the loud cry of their anguish and of their prayer was
answered, and they rejoiced in the vengeance which had come on
their oppressor.

And the question arises here, as it has often arisen :—Can we
expect anything other, or anything better than this ? Is it pos-
sible for human nature, even aided by Divine grace, to rise to
such a height, that it can not only smile in the midst of its own
sufferings, but ask for peace and blessing to its enemies ? How-
ever this question may be answered, we know that such was the
spirit of Christ ; and we know also, that such ought to be, and

must be, the spirit of those who are fully formed into the image of their Master and elder Brother.

This patient and forgiving spirit gives its Christian consistency and beauty to the sufferings of the Quietists. The same Louis who demolished Port-Royal, and banished the Huguenots, laid his heavy hand on Fénelon; deprived him of his offices and honours; exiled him from all cities and places out of the limits of Cambray; disgraced, imprisoned, and banished his friends; and exacted an ecclesiastical condemnation from the unwilling court of Rome. But such was the power of the religious principles which Fénelon had adopted, that this unkind and cruel treatment called forth no unkind emotions.

It is not so much they who are smitten by their enemies, as God who is smitten through them. To the world, therefore, they make no appeal. The voice they utter is a voice unheard by men. Their heart and their eye are steady to the eternal throne; and they accept no comfort, no wisdom, no strength, which has not God for its author.

It seemed to be but justice and truth, to speak thus favourably of those who have borne the name of Quietists. History, which is often written by men allied to particular sects and parties, has covered them with reproach. No people, as it seems to us, were ever more closely united to God; and yet, if we were at liberty to believe the statements of polemics and ecclesiastical annalists, we should reckon them among the weakest, if not the worst. They themselves, however, ask no defender. The life they live is " by faith on the Son of God;"—and he who can trust his soul with Christ, need not hesitate to trust his reputation. From the beginning they have committed their cause to Him in whom they have believed; in full confidence that He would raise up those, in His own good time, who would do justice to their principles. It was the motto of Fénelon, AMA NESCIRI, *Love to be unknown.*

Under the name of Quietist, no new party, no additional sect, will or can arise. The word *sect*, like the word *party*, implies division. Holy love seeks and tends to unity. It is a pleasing

and auspicious circumstance, that those who possess a truly humble and acquiescent spirit, founded on such love, are found, from time to time, in many sects. The principal of supreme love, therefore, which brings every inward evil into subjection, may exist in connexion with speculative differences; especially such as relate to the outward forms or ceremonials of religion. Faith in God through the Saviour seems to be all that is necessary.

Christ gives us strength to realize in ourselves His image. Study His life, and see what transcendent beauty and power are found lodged in a meek and quiet spirit. Follow Him, and mark Him in all situations, from the weakness of the manger to the matured and agonizing sufferings of the cross;—and behold the moral beauty of Him who, in all trials and sorrows, in all temptations and oppositions, is still a conqueror. His own words have pronounced a blessing upon that meekness which was the great ornament of His Divine life. He has told us to learn of *Him*;—and, in assigning a reason for this direction, He has announced the leading trait of His character: "Take my yoke upon you, and learn of ME; *for I am meek and lowly in heart;* and ye shall find rest to your souls."

The following are selections from Cowper's translations of the poems of Madame Guyon.

TRUTH AND DIVINE LOVE REJECTED BY THE WORLD.

O LOVE, of pure and heavenly birth !
O simple TRUTH, scarce known on earth !
Whom men resist with stubborn will ;—
And, more perverse and daring still,
Smother and quench with reasonings vain,
While error and deception reign.

The world is proud, and cannot bear
The scorn and calumny ye share ;—
The praise of men, the mark *they* mean,
They fly the place where ye are seen.
PURE LOVE, with scandal in the rear,
Suits not the vain: it costs too dear.

Whence comes it that, your power the same
As His on high from whom you came,
Ye rarely find a listening ear,
Or heart that makes you welcome here ?—
Because ye bring reproach and pain,
Where'er ye visit, in your train.

Then let the price be what it may,
Though poor, I am prepared to pay ;—
Come shame, come sorrow ; spite of tears,
Weakness, and heart-oppressing fears,
One soul, at least, shall not repine
To give *you* room : come, reign in mine !

THE TESTIMONY OF DIVINE ADOPTION.

How happy are the new-born race,
Partakers of *adopting grace !*
How pure the bliss they share
Hid from the world and all its eyes,
Within their heart the blessing lies,
And conscience feels it there.

The moment we BELIEVE, 'tis ours:
And if we love with *all our powers*
The God from whom it came,
And if we serve with hearts sincere,
'Tis still discernible and clear,
An undisputed claim.

But ah ! if *foul and wilful sin*
Stain and dishonour us within,
Farewell the joy we knew ;
Again the slaves of Nature's sway,
In lab'rinths of our own we stray,
Without a guide or clue.

The chaste and pure, who fear to grieve
The gracious Spirit they receive,
His work distinctly trace;

And strong in undissembling love,
Boldly assert, and clearly prove,
Their hearts His dwelling-place.

O messenger of dear delight !
Whose voice dispels the deepest night,
Sweet, peace-proclaiming Dove !
With thee at hand to soothe our pains,
No wish unsatisfied remains,
No task but that of LOVE.

'Tis LOVE unites what SIN divides :
The centre where all bliss resides
To which the soul once brought,
Reclining on the first great Cause,
From His abounding sweetness draws
Peace, passing human thought.

Sorrow foregoes its nature there,
And life assumes a tranquil air,
Divested of its woes ;
There, sovereign goodness soothes the breast,
Till then, incapable of rest,
In sacred sure repose.

CHAPTER LII.

On the religion of prisons—Madame Guyon released in 1702, after four years' imprisonment —Banished during her life to Blois—State of health—Visited by many persons, foreigners as well as others—Publication of her Autobiography—Feelings towards her enemies—Extract from Thauler—Religious state—Letters near the close—Her character—Address to her spiritual children—Sickness and death.

WHEN piety, under the name of heresy, becomes a crime, the prayers and tears of the dungeon are as acceptable to God as those that arise within the walls of a church. In the course of the year 1686, a few years before the imprisonment of Madame Guyon, one hundred and forty-seven persons, almost all of them Huguenot Protestants, against whom nothing could be brought except their religion, were sent to the Bastile alone. In the year 1689, the number chiefly of members of the same religious sect, was sixty-one ; persons who shewed the sincerity of their

faith by their sufferings, and who esteemed their liberty less than their religion. A full history of the Bastile would illustrate the virtues and sufferings of the Jansenists, as well as of the Huguenots.

Madame Guyon was in the Bastile four years, from 1698 to 1702. At the time of her liberation, she was fifty-four years of age. She was allowed, after her release, to visit her daughter, the Countess of Vaux, who resided either in Paris or in the immediate vicinity. But the associations connected with her personal history and name were such, and such was the influence she was still capable of exerting, that she was permitted to remain there only for a short time. Her afflictions, without ceasing to exist, assumed a new form. The sorrows of a distant exile followed the anguish of solitary imprisonment. She was banished to Blois, a considerable city, one hundred miles southwest from Paris, on the Loire.

The city is one of ancient date, beautiful in its location, and of some historical celebrity; but it is not known what particular reasons induced the king to select it as the place of her banishment, in preference to any other. Her banishment was for life; but it was some consolation that her eldest son, Armand Jacques Guyon, was settled with his family either within the limits of the city, or at a place not far distant.

From this time to her death, in 1717, her life ceased to be diversified with incidents which it would be important or interesting to lay before the reader. The extreme deprivations and trials of the Bastile had effectually broken a constitution but feeble before. Few could have withstood, even so well as she did, those solitary hours, in which day and night were hardly distinguished from each other, those damp walls, the colds of winter and the impure heats of summer. Her age, therefore, combined with her ill health, prevented her from engaging in those works of outward benevolence which had illustrated the earlier part of her life.

In a passage which she wrote during this period, she says:—
"My life is consecrated to God, to *suffer* for Him, as well as to

enjoy Him. 1 came out of my place of confinement in the Bastile; but, in leaving my prison, I did not leave the cross. My afflicted spirit began to breathe and recover itself a little after the termination of my residence there; but my body was from that time sick and borne down with all sorts of infirmities. I have had almost continual maladies, which have often brought me to the very verge of death."

The long period of her banishment was thus added to the long period of her imprisonment, during which she was called to glorify God by submission and by private prayer, rather than by active labours. She did not, however, cease to be useful. She glorified God by her patience under sufferings, and by her more private efforts in conversing with others, and by her written correspondence.

Numbers of religious people, some from foreign countries, and among others some persons of high rank from Germany and England, came to see her. They had heard of her labours and sufferings; and came either to receive the benefit of her conversation and instructions, or to pay the homage of sincere respect to her character. It was through the instrumentality of some one of these persons, whose name is not now known, that her Autobiography was first published.

Such had been the dispensations of providence in relation to her, that she at last felt it her duty to consent to its publication; —with one condition only, that it should not be published until after her death. Having re-examined and corrected it, she placed it, near the close of her life, in the hands of an English gentleman of rank;—one of those who visited her from religious motives at Blois, and in whom she had entire confidence.

Great numbers of persons came to see her. Religion was the great subject of her discourse. Forgetful of herself, she regulated her remarks exclusively by a regard to the spiritual state and the wants of those who thus had interviews with her. It would not be easy to estimate the good she was capable of doing, and which she was actually the means of doing, in this way.

There is some reason to suppose that she was closely watched during her banishment; and it is probable that some came with no other purpose than that of ensnaring her in her words. To this she refers :—" I am not afraid of the snares which any of those who come to see me endeavour to lay for me. Conscious of my own innocence and uprightness, I do not feel at liberty to take those precautions which a merely worldly wisdom might suggest. I leave all with God. O worldly prudence! How opposite do I find thee to the single heart and the simplicity of Jesus Christ! I leave thee to thy partisans. As for me, all my prudence, all my wisdom, consists in following Christ in His simple and lowly appearance and conduct. If a change in my conduct, and a resort to worldly artifice, would make me an empress, I could not do it. Or if, on the other hand, that simplicity of conduct which follows God and trusts in God alone were to cause me all the heaviest sufferings, I could not depart from it."

In another passage of her work, which bears the date of December 1709, she says, " I entreat all such persons as shall read this narrative, not to indulge in hard or embittered feelings against those who have treated me with unkindness."

Near the close of her Autobiography, she writes, " *In these last times*, if I may so express myself, I can hardly speak at all of my inward dispositions. The reason is, that my state has become *fixed;*—simple in the motives which govern it, calm in its reliance on God, and without any variation. So far as *self* is concerned, it may be described as a profound annihilation. I see nothing in myself, nothing of the natural operation of the mind distinct from the grace of God, to which I can give a name. All that I know is, that God is infinitely holy, righteous, and happy; that all goodness is in Him; and that, as to myself, I am a mere NOTHING.

" To me every condition seems equal. As God is infinitely wise and happy, all my wisdom and happiness are in Him. Everything which, in the state of nature, I should have called my own, is now lost in the divine immensity, like a drop of

water in the sea. In this divine immensity the soul sees itself
no more as a separate object: but it discerns every object in
God; without discerning or knowing them as such *intellectually*,
but by faith and by the affectionate feelings of the heart. God
is not only in the soul itself, constituting its true life, but is in
everything else. Viewed in relation to the *creature*, everything
is dark;—viewed in relation to *God*, everything is light;—and
God will always enlighten and guide those who are truly His,
so far as is proper and of real advantage. My soul is in such a
state, that God permits me to say, that there is no dissatisfied
clamour in it, no corroding sorrow, no distracting uncertainty,
no pleasure of earth, and no pain which faith does not convert
into pleasure; nothing but the peace of God which passes un-
derstanding, *perfect* peace. And nothing is of *myself*, but all
of God.

"If any persons think there is any good in me, separate from
God, they are mistaken; and, by indulging in any such thoughts,
they do injury to the Lord whom I love. All good is *in* Him,
and *for* Him. The greatest satisfaction I can have is the know-
ledge, that *He is what He is;* and that, being what He is, *He
never will or can be otherwise.* If I am saved at last, it will be
the free gift of God; since I have no worth and no merit of my
own. And in the deep sense that I am nothing of myself, I am
often astonished that any persons should place confidence in me.
I have often made this remark. Nevertheless, in this, as in
other things, I have, and can have, no will of my own. I must
do what the Lord would have me do. Although poverty and
nakedness belong to me in *myself*, yet God helps me to answer
and instruct those who come to me, without difficulty. Appro-
priate words, such as the occasion requires, seem to be given me
by that divine Agent who rules in my heart. As I seek nothing
for myself, God gives me all that is necessary, apparently with-
out seeking or studying for it.

"I feel much for the good of souls. It seems to me that I
should be willing, in my own person, to endure the greatest
sufferings, if it might be the means of bringing souls to the

knowledge and love of God. Whatever wounds the Church
of God, wounds me. Deeply do I desire her prosperity. He
whom my soul loves keeps me by His grace, in great simplicity
and sincerity of spirit. I have but one motive,—that of God's
glory. And in this state of mind, I possess what may be called
a freedom or enlargedness of spirit, which elevates me above
particular interests and particular things; so that, in themselves
considered, and separate from the will of God, such particular
things, whatever they may be, and whether prosperous or ad-
verse, have no effect upon me, but my mind entirely triumphs
over them."

Among the last letters which she wrote, was the following to
her brother, Gregory de la Mothe; an humble and pious man,
connected with the Order of the Carthusians.

<div align="right">" BLOIS, —— 1717.</div>

" MY DEAR BROTHER,—The letter which you had the kind-
ness to send me was received in due time. In the few words
which I am able to return in answer, permit me to say :—sepa-
ration from outward things, the crucifixion of the world in its
external relations and attractions, and retirement within your-
self, are things exceedingly important *in their time*. They con-
stitute a preparatory work; but they are not the *whole* work.
It is necessary to go a step further. The time has come when
you are not only to retire *within* yourself, but to retire *from*
yourself;—when you are not only to crucify the outward world,
but to crucify the inward world; to separate yourself absolutely
and wholly from everything which is not God. Believe me, my
dear brother, you will never find rest anywhere else.

" The time of my departure is at hand. For a considerable
time past, I have had it on my mind to write and tell you so.
If you can come and see me, before that last hour arrives, I shall
receive you with joy. When I am taken from you, be not sur-
prised, and let not your heart be troubled. Whatever may
happen, turn not your eye back upon the world. Look forward
and onward to the heavenly mansions;—be strong in faith;—

fight courageously the battles of the Lord.—I remain, in love, your sister, JEANNE M. B. DE LA MOTHE GUYON."

The following letter, to one of her religious friends, was written probably only a few weeks before her death :—

"BLOIS, —— 1717.

"To ——. I can only say at present, my dear friend, that my physical sufferings are very severe, and almost without intermission. It is impossible for me, without a miraculous interposition, to continue long in this world under them. I solicit your prayers to God, that I may be kept faithful to Him in these last hours of my trials.

"Last night, in particular, my pains were so great as to call into exercise all the resources and aids of faith. God heard the prayer of His poor sufferer. Grace was triumphant. It is trying to nature; but I can still say in this last struggle, that I love the hand that smites me.

"I remember that, when I was quite young, only nineteen years of age, I composed a little song, in which I expressed my willingness to suffer for God. My heavenly Father was pleased, for wise purposes, to call me early to this kind of trial. A part of the verses to which I refer is as follows :—

"By sufferings only can we know
　The nature of the life we live;
The trial of our souls, they show,
　How true, how pure, the love we give.
To leave my love in doubt would be
No less disgrace than misery.

I welcome, then, with heart sincere,
　The cross my Saviour bids me take:
No load, no trial is severe,
　That's borne or suffered for His sake:
And thus my sorrows shall proclaim
A love that's worthy of the name.

Repeating my request for an interest in your supplications, I remain,—Yours, in our Saviour.

"JEANNE M. B. DE LA MOTHE GUYON."

The following appears to have been written to an ecclesiastic :—

"BLOIS, —— 1717.

"DEAR AND REVEREND BROTHER IN CHRIST,—I have had a great desire that your life might be spared. Earnestly have I

asked it of the Lord, if it were His will, because it seemed to
me to have a connexion with the progress of His work in the
world. In respect to my own situation, all I can say is, that
my life seems to me to hang on a slender thread. I make no
account of its continuance; although I know well that God can
raise me up in a moment, if He has anything further for one who
accounts herself as *nothing* to do here in the world. If my work
is done, I think I can say, I am ready to go. In the language
of the proverb, I have already ' one foot in the stirrup,' and am
willing to mount and be gone, as soon as my heavenly Father
pleases.

" I take the liberty to send through you my affectionate salu-
tations to our friend B. and his family; and, in behalf of all our
common friends, it is my earnest prayer that God would be all
things to them. Let us all say with one accord, ADVENIAT
REGNUM TUUM; *Thy kingdom come.* Sometimes this kingdom,
in consequence of the prevalence of wickedness among men, has
the appearance of being at a distance. But the darkness of the
times does not extinguish the light of faith. In His own good
time, God will put a stop to the torrent of iniquity. Out of the
general corruption, He will draw a chosen people, whom He will
consecrate to Himself. *O that His will might always be done!*
This is all we can desire.

" I will close with only adding, that it is impossible for me to
express the regard and love which our friends in this place have
for you.—Yours, in our common Lord,

" JEANNE MARIE B. DE LA MOTHE GUYON."

On the character of Madame Guyon it is hardly necessary to
add much here. Her writings indicate, in some particulars, a
defect of education; but they illustrate the greatness of her
intellectual power. Without such power it would not have been
possible for her to have exerted the personal influence which so
remarkably attended her. Whatever company she might be in,
such was her quickness of perception and her natural flow of
language, that her mind could hardly fail to take an ascendant

position. There seemed to be a natural disposition, on the part of those who listened to her conversation, to yield to that mental superiority which God had given her. The power which characterized her conversation was not less obvious in her writings. Though written, for the most part, under the most disadvantageous circumstances, they are full of thought; and of *such* thought and such relations of thought as are sure to excite both thought and feeling in others.

Her powers of imagination, as well as her powers of perception and reasoning, were very great. They gave, as it seems to me, a somewhat peculiar character to her conceptions and her modes of expression; so much so that it is often necessary to compare one passage with another, and sometimes to modify the expressions, in order to reach the true meaning.

But if her intellect was of the highest order, it is true nevertheless, it was her rich and overflowing heart, renovated and sanctified by the grace of God, which gave the crowning beauty to her character. Her religion was the religion of God. It was nothing of man's devising; no patchwork of human ingenuity, inscribed over with hints and recognitions of man's merits. It is difficult to read her life and writings, without a distinct feeling that her soul was the temple of the Holy Ghost. Those who were with her during her life, those who saw her and conversed with her, felt it to be so. And this was the great secret, whatever may have been her natural powers, of the remarkable religious influence which attended her. God was with her.

As the light of holiness arises upon the world, and as the names of those whose lives have been practical illustrations of a pure and perfected love, become more and more dear to the church, it can hardly be supposed that the name of Madame Guyon will be overlooked or forgotten. Forgetful of herself, she had no purpose, no desire, of being remembered.

In the closing part of her Biography, we find some parting counsels and encouragements to those then living, whom she had been instrumental in bringing to the knowledge of Jesus Christ:—

" Nothing is greater than God; nothing is less than myself.
God is rich; I am poor. And yet, being rich in God, I want
nothing. To me life and death are the same: because I desire
nothing but what God desires. God is LOVE. All good is IN
Him; all good is FOR Him.

" My children in the gospel! Many things have been said in
relation to myself. I will not deceive or mislead you. It be-
longs to God to enlighten you, and to give you either esteem or
disesteem for myself. The particular labours of my past life,
what I have said and what I have written, have, in a considerable
degree, passed away from my recollection. Giving myself to the
present moment, and the *duty which now is*, I remember but
little or nothing in relation to them. I leave them all with God.
Separate from God, I want neither justification nor esteem. I
want only to keep my place, and to go no more out from that
place and that duty which God assigns; and thus to remain
established in the great and Divine Centre. I want nothing,
therefore, but God and His glory. Let Him, therefore, glorify
Himself, just as He sees best, either by establishing my reputa-
tion among men, or by destroying it. In His will they are the
same to me; bearing equal weight in the balance.

" My dear children! Christ is the TRUTH. And if I have
spoken truth to you, it is because I have spoken what Christ has
spoken. I pray God to enlighten you always, to give you by
His illuminating influences the clear discernment of His holy
will, that no false light may ever lead you to the precipice. *Holy
Father, sanctify them through thy truth.*

" Christ said, in reference to His disciples :—*For their sakes
I sanctify myself, that they also may be sanctified through the
truth.* O blessed Saviour! say the same thing in behalf of
these, thy little ones. Sanctify thyself, by being a holy life in
their spirits, IN them and FOR them. Teach them, that they
also are sanctified, when they have all things from thee, and
nothing from themselves; when, in the possession of nothing
they can call their own, they have that holiness which thou
alone canst give

" My children ! Let Christ alone be all in all, IN and FOR us ; in order that the work of sanctification, resting upon the basis of Divine truth, may be carried on and perfected in our souls. To Christ belongs all wisdom, all strength, all greatness, all power and glory. To ourselves, considered as separate from Christ, belongs nothing but poverty, emptiness, weakness, and misery. Let us, then, while we recognise and abide in our no-thingness, pay homage to the power and the holiness of Christ. In this way we shall find all that we want. If, in the spirit of self-reliance, we seek anything *out of Christ*, then we are not His true followers. The truth abideth not in us. We deceive ourselves ; and in that state shall never become the true saints of God.

" Holy Father ! I now commit these children into thy hands. Hear the prayer of thine handmaid. Keep them in thy truth, that the lie may not come near them. To assume any merit out of thee, to attribute any merit to one's-self, is to be in the lie. Make them know this to be the great truth, of which thou art jealous. All language which deviates from this principle is falsehood. He who speaks only of the ALL OF GOD, and NOTHING OF THE CREATURE, is in the truth ; and the truth dwelleth in him ; usurpation and selfishness being banished from his heart. My children, receive this from one who has been to you as a mother ; and it will procure you life. Receive it *through* her, but not as *for* her : but as OF and FOR GOD. Amen.

" GLORY BE TO THE LORD JESUS CHRIST."

In the beginning of the month of March 1717, she had a very severe attack of sickness, from which she never recovered. Dur-ing her sickness she conversed with her friends, and wrote a few letters ; but she had no doubt that her labours were drawing to a close. God's hour, that hour to which she had long looked with interest, had arrived. Already those with whom, either as friends or as enemies, she had been associated in the earlier part of her life, Harlai, La Combe, Fénelon, Beauvilliers, Bossuet, the powerful monarch of France, all had been called hence. At

last the summons came to her also. She received it without surprise, and without repugnance. She went down to the grave, as her life would lead us to anticipate, in perfect resignation and peace. She had given her soul to God. No clouds rested upon her vision ;—no doubts perplexed the fulness of her hope and joy. At half-past eleven o'clock on the night of the 9th of June 1717, she died ; aged sixty-nine years.

A short time before her death she wrote a Will ;—from which the following passage is an extract. It is an affecting evidence of the depth of her piety, and that she relied on Jesus Christ alone :—

"In the name of the Father, Son, and Holy Ghost."

"This is my last will and testament, which I request my executors, who are named within, to see executed.

"It is to thee, O Lord God, that I owe all things; and it is to thee, that I now surrender up all that I am. Do with me, O my God, whatsoever thou pleasest. To thee, in an act of irrevocable donation, I give up both my body and my soul, to be disposed of according to thy will. Thou seest my nakedness and misery without Thee. Thou knowest that there is nothing in heaven, or in earth, that I desire but Thee alone. Within thy hands, O God, I leave my soul, not relying for my salvation on any good that is in me, but solely on thy mercies, *and the merits and sufferings of my Lord Jesus Christ.*"

Her remains were interred in the Church of the Cordeliers, at Blois, where a monument was erected to her memory with a beautiful Latin inscription upon it. Such a departure, preceded by such a life as we have described, might be called a *transition* rather than death. She *went home.*

> " Rest, gentle spirit, rest !
> Thy conflicts o'er ; thy labours done
> Angels thy friends ; thy *home*
> The presence of the Holy One."

SeedSowers
P.O. Box 3317
Jacksonville, FL 32206
800-228-2665

904-598-3456 (fax) www.seedsowers.com

REVOLUTIONARY BOOKS ON CHURCH LIFE

The House Church Movement (*Begier, Richey, Vasiliades, Viola*) 9.95
How to Meet In Homes (*Edwards*) ... 10.95
An Open Letter to House Church Leaders (*Edwards*) 4.00
When the Church Was Led Only by Laymen (Edwards) 4.00
Beyond Radical (*Edwards*) ... 5.95
Rethinking Elders (*Edwards*) ... 9.95
Revolution, The Story of the Early Church (*Edwards*) 8.95
The Silas Diary (*Edwards*) ... 9.99
The Titus Diary (*Edwards*) ... 8.99
The Timothy Diary (*Edwards*) .. 9.99
The Priscilla Diary (*Edwards*) ... 9.99
Overlooked Christianity (*Edwards*) .. 14.95
Rethinking the Wineskin *(Viola)* .. 8.95
Who is Your Covering? *(Viola)* ... 6.95

AN INTRODUCTION TO THE DEEPER CHRISTIAN LIFE

Living by the Highest Life (*Edwards*) .. 8.99
The Secret to the Christian Life (*Edwards*) 8.99
The Inward Journey (*Edwards*) ... 8.99

CLASSICS ON THE DEEPER CHRISTIAN LIFE

Experiencing the Depths of Jesus Christ (*Guyon*) 8.95
Practicing His Presence (*Lawrence/Laubach*) 8.95
The Spiritual Guide (*Molinos*) .. 8.95
Song of the Bride (*Guyon*) ... 9.95
Union With God (*Guyon*) ... 8.95
The Seeking Heart (*Fenelon*) ... 9.95
Intimacy with Christ (*Guyon*) ... 10.95
Spiritual Torrents (*Guyon*) ... 10.95
The Ultimate Intention (*Fromke*) .. 10.00
Genesis *(Guyon)* ... 9.95
Exodus (*Guyon*) ... 9.95
Leviticus, Numbers & Deuteronomy (*Guyon*) 10.95
Job (*Guyon*) ... 9.95
Judges *(Guyon)* .. 9.95
James, I John & Revelation (*Guyon*) ... 12.95

IN A CLASS BY THEMSELVES

The Divine Romance (*Edwards*) .. 8.99
The Story of My Life as told by Jesus Christ (Four gospels blended) 14.95
Acts in First Person .. 9.95

THE CHRONICLES OF THE DOOR *(Edwards)*
The Beginning.. 8.99
The Escape ... 8.99
The Birth .. 8.99
The Triumph.. 8.99
The Return .. 8.99

THE WORKS OF T. AUSTIN-SPARKS
The Centrality of Jesus Christ 19.95
The House of God... 29.95
Ministry .. 29.95
Service .. 19.95
Spiritual Foundations ... 29.95
The Things of the Spirit .. 10.95
Prayer ... 14.95
The On-High Calling .. 10.95
Rivers of Living Water ... 8.95
The Power of His Resurrection 8.95

COMFORT AND HEALING
A Tale of Three Kings *(Edwards)* 8.99
The Prisoner in the Third Cell *(Edwards)* 5.99
Letters to a Devastated Christian *(Edwards)* 7.95
Healing for those who have been Crucified by Christians *(Edwards)* 8.95
Dear Lillian *(Edwards)* ... 5.95

OTHER BOOKS ON CHURCH LIFE
Climb the Highest Mountain *(Edwards)* 9.95
The Torch of the Testimony *(Kennedy)* 14.95
The Passing of the Torch *(Chen)* 9.95
Going to Church in the First Century *(Banks)*................ 5.95
When the Church was Young *(Loosley)* 8.95

CHRISTIAN LIVING
Final Steps in Christian Maturity *(Guyon)* 12.95
Turkeys and Eagles *(Lord)* .. 8.95
Life's Ultimate Privilege *(Fromke)* 10.00
All and Only *(Kilpatrick)*.. 7.95
Adoration *(Kilpatrick)* ... 8.95
Bone of His Bone *(Huegel)* ... 8.95

Call for a free catalog at 800.228.2665